Unmasking Ideology in Imperial and Colonial Archaeology

Vocabulary, Symbols, and Legacy

UCLA COTSEN INSTITUTE OF ARCHAEOLOGY PRESS
Ideas, Debates, and Perspectives

Volume 1. *Settlement, Subsistence and Social Complexity: Essays Honoring the Legacy of Jeffrey R. Parsons,* edited by Richard E. Blanton

Volume 2. *Chinese Society in the Age of Confucius (1000–250 BC): The Archaeological Evidence,* by Lothar von Falkenhausen

Volume 3. *Settlement and Society: Essays Dedicated to Robert McCormick Adams,* edited by Elizabeth C. Stone

Volume 4. *Blood and Beauty: Organized Violence in the Art and Archaeology of Mesoamerica and Central America,* edited by Heather Orr and Rex Koontz

Volume 5. *Information and Its Role in Hunter-Gatherer Bands,* edited by Robert Whallon, William A. Lovis, and Robert K. Hitchcock

Volume 6. *Classic Maya Political Ecology: Resource Management, Class Histories, and Political Change in Northwestern Belize,* edited by Jon C. Lohse

Volume 7. *Empires & Diversity: On the Crossroads of Archaeology, Anthropology, & History,* edited by Gregory E. Areshian

Unmasking Ideology in Imperial and Colonial Archaeology

Vocabulary, Symbols, and Legacy

Edited by
Bonnie Effros and Guolong Lai

Ideas, Debates, and Perspectives 8
Cotsen Institute of Archaeology Press
University of California, Los Angeles
2018

The Cotsen Institute of Archaeology Press is the publishing unit of the Cotsen Institute of Archaeology at UCLA.

The Cotsen Institute is a premier research organization dedicated to the creation, dissemination, and conservation of archaeological knowledge and heritage. It is home to both the Interdepartmental Archaeology Graduate Program and the UCLA/Getty Master's Program in the Conservation of Archaeological and Ethnographic Materials. The Cotsen Institute provides a forum for innovative faculty research, graduate education, and public programs at UCLA in an effort to positively impact the academic, local and global communities. Established in 1973, the Cotsen Institute is at the forefront of archaeological research, education, conservation and publication, and is an active contributor to interdisciplinary research at UCLA.

The Cotsen Institute of Archaeology Press specializes in producing high-quality academic volumes in nine different series, including *Monumenta Archaeologica, Monographs, World Heritage and Monuments, Cotsen Advanced Seminars,* and *Ideas, Debates, and Perspectives*. Through a generous endowment by Lloyd E. Cotsen, longtime Institute volunteer and benefactor, the Press makes the fruits of archaeological research accessible to scholars, professionals, students, and the general public. Our archaeological publications receive critical acclaim in both academic communities and the public at large.

Edited by Barbara Kohl
Designed by Carol Leyba
Index by Matthew White

Support from the Robert and Margaret Rothman Endowment at the Center for the Humanities and the Public Sphere at the University of Florida

Library of Congress Cataloging-in-Publication Data
Names: Effros, Bonnie, 1965- editor, author. | Lai, Guolong, editor, author.
Title: Unmasking ideology in imperial and colonial archaeology : vocabulary, symbols, and legacy /
 edited by Bonnie Effros and Guolong Lai.
Description: Los Angeles : Cotsen Institute of Archaeology Press, University of California, Los Angeles, 2018.
 | Series: Ideas, debates, and perspectives ; Volume 8 | Includes bibliographical references and index.
Identifiers: LCCN 2017052053 | ISBN 9781938770135 (alk. paper)
Subjects: LCSH: Archaeology--Political aspects. | Archaeology--Social aspects. | Antiquities--Collection and
 preservation--Political aspects. | Antiquities--Collection and preservation--Social aspects. | Imperialism--
 Social aspects.
Classification: LCC CC175 .U56 2018 | DDC 930.1--dc23
LC record available at https://lccn.loc.gov/2017052053

To David, Max, and Simon, for offering many welcome distractions,

B.E.

To the loving memory of my father,

Lai Binghua (1931.9.21–2017.12.26),

L.G.L.

Contents

List of Figures..ix

Contributors...xiii

Introduction: The Global Reach of Imperial and Colonial Archaeology
 BONNIE EFFROS AND GUOLONG LAI ...xxi

I. Defining Approaches to Imperial and Colonial Archaeology................1

1. Archaeology and Imperialism: From Nineteenth-Century New Imperialism
to Twentieth-Century Decolonization
 MARGARITA DÍAZ-ANDREU..3

2. German Archaeology in Occupied Europe during World War II:
A Case of Colonial Archaeology?
 HUBERT FEHR ...29

II. Colonialism and Nationalism ...59

3. Problematizing the Encylopedic Museum: The Benin Bronzes and
Ivories in Historical Context
 NEIL BRODIE...61

4. Digging up China: Imperialism, Nationalism, and
Regionalism in the Yinxu Excavation, 1928–1937
 GUOLONG LAI...83

5. "They have not changed in 2,500 years": Art, Archaeology, and
Modernity in Iran
 TALINN GRIGOR ..121

III. Indigenous Voices ...147

6. The Entanglement of Native Americans and Colonialist Archaeology
in the Southwestern United States
 CHIP COLWELL..151

7. The History of Archaeology through the Eyes of Egyptians
 WENDY DOYON...173

8. Indigenous Voices at the Margins: Nuancing the History of French Colonial
 Archaeology in Nineteenth-Century Algeria
 BONNIE EFFROS ...201

9. Critiquing the Discovery Narrative of Lady Mungo
 ANN MCGRATH ...227

IV. Archaeology, Art, and Exoticism ..257

10. In the Shadow Zone of Imperial Politics: Archaeological Research in
 Buryatiia from the Late Nineteenth Century to the 1940s
 URSULA B. BROSSEDER ...259

11. Imperial Archaeology or Archaeology of Exoticism? Victor Segalen's
 Expeditions in Early Twentieth-Century China
 JIAN XU...275

12. Four German Art Historians in Republican China
 LOTHAR VON FALKENHAUSEN ...299

V. Colonial and Post-Colonial Legacies ..355

13. French Archaeology and History in the Colonial Maghreb:
 Inheritance, Presence, and Absence
 MATTHEW M. MCCARTY..359

14. The Colonial Origins of Myth and National Identity in Uganda
 PETER R. SCHMIDT..383

15. Japanese Colonial Archaeology in Korea and Its Legacy
 YANGJIN PAK...403

16. The Cloth of Colonization: Peruvian Tapestries in the Andes and
 in Foreign Museums
 MAYA STANFIELD-MAZZI..427

Index ...453

List of Figures

2.1. Propaganda for the Flemish division of the Waffen-SS, published in
Belgium in 1943 ..33

2.2. Map of then-current territory of Poland, showing alleged settlement
areas of Germanic tribes in the Late Roman period.................................38

2.3. Map of then-current territory of Poland: "Our beautiful German
eastern land"...45

2.4. Title page of journal *Wiadomości Archeologiczne* (1940), vol. 16............50

2.5. Exhibition of "Germanic Heritage in the Vistula Region," Kraków 194151

3.1. Bronze equestrian figure presented to Liverpool trader John Henry
Swainson by Oba Ovonramwen in 1892 ..63

3.2. Benin bronzes and ivories on display in Liverpool World Museum,
March 2016...78

3.3. Benin bronze head advertising Liverpool World Museum,
Liverpool city center, September 2015 ...78

4.1. Dong Zubin and local officials from Anyang county arranging for
the first archaeological excavation at Xiaotun, Anyang, Henan on
October 12, 1928 ...85

4.2. Fu Sinian and Li Ji in front of Anyang archaeological working station
at Xiaotun, Anyang, Henan, in 1931 ..87

4.3. Carl Bishop in the field in China ..93

5.1. Ruins of Persepolis, Iran, fifth century BCE, with 1971 Tent City
visible in background ..122

5.2. Gate of Nations, Persepolis, Iran, fifth century BCE123

5.3. Tomb of Cyrus the Great, Pasargadae, Iran, fifth century BCE123

5.4. Archaeological Museum designed after the Sassanian palace at Ctesiphon;
architect André Godard, Tehran, Iran, 1936–1939127

5.5. Tent City preserved in a state of ruin for post-revolutionary propaganda
purposes, Persepolis, Iran, 1990s ...132

5.6. Technicians working on the light-and-sound system at Persepolis
in preparation for 2,500-year celebration ceremonies, Persepolis, Iran,
September–October 1971 ...134

5.7. Then-high-level technology left from the 1971 celebrations, Persepolis,
Iran, 2007 ..141

6.1. The main pueblo left standing at Casa Grande, Arizona.......................154

6.2. Pueblo Bonito at Chaco Canyon, New Mexico.................................156

6.3. Frederick Webb Hodge and George Gustav Heye pose with Zunis....................157
6.4. Cliff dwellings at Puyé, New Mexico..160
7.1. Wellcome excavations in the Sudan, 1912–1913 ...175
7.2. University of Pennsylvania Museum excavations at Memphis, Egypt, 1915.......177
7.3. Princeton University excavations at Antioch, Syria, 1936181
7.4. Wellcome excavations in the Sudan, 1912–1913, showing camp and workers
 at Jebel Moya ..186
7.5. Princeton University excavations at Antioch, Syria, 1934, in the final stage
 of excavating a Roman mosaic..194
8.1. Map of Algeria ...202
8.2. "Col de Ténia"...203
8.3. Ruins of a Roman aqueduct near Algiers ...207
8.4. Like nearly all statues in Musée d'Alger, this representation of Neptune
 from Cherchel, which had been the Romans' principal port and naval base,
 was badly damaged ...208
8.5. Franciade Fleurus Duvivier..210
9.1. Location map of Lake Mungo, Australia ..228
9.2. Investigators of the cremation burial of Mungo Lady: Thorne, Bowler,
 Jones and Allen at Joulni, on Lake Mungo Lunette, in 1989230
9.3. John Mulvaney preparing to take latex peel of Mungo Lunette section in
 August 1974 ..235
9.4. Mutti Mutti elder Alice Kelly on Lake Mungo Lunette near the
 burial site of Mungo Lady, June 1989 ...242
9.5. The Aboriginal Sites Committee of the New South Wales National
 Parks and Wildlife Service, 1981 ..243
9.6. Discovery Ranger Ernest Mitchell at the Lake Mungo site that is
 open to guided-tour visits, April 2013 ...248
10.1. Pyotr Kuzminich Kozlov ..264
10.2. Map of Buryatiia and northern Mongolia with modern towns and
 excavation sites mentioned in the text..265
10.3. Iulian Tal'ko-Gryntsevich ...267
10.4. In Urga 1924, showing members of the Mongol-Tibetan expedition
 led by Pyotr Kozlov ...270
11.1. Segalen's team and locals in front of tomb...279
11.2. Cliff tomb at Jiading, Sichuan ...285
11.3. A page from Segalen's *Stèles* ...292
12.1. Gustav Ecke ...300
12.2. Victoria Contag-von Winterfeldt...300
12.3. Eleanor von Erdberg-Consten...303

12.4. Max Loehr ..303

12.5. Handover of the Werner Jannings Collection to the National Palace Museum,
January 22, 1946 ..319

13.1. Performance of patrimony play in theater of Carthage.................................365

13.2. Festival to celebrate martyrdom of Perpetua and Felicitas in
Carthage amphitheater, 1903 ..369

13.3. Entrance to Chapel of Perpetua and Felicitas in Carthage amphitheater...........370

13.4. Punic room in Musée Lavigerie, ca. 1900 ...373

14.1. Key sites associated with oral traditions in Uganda and Tanzania.....................384

14.2. Plan view map of Bigo excavations in 1960..391

14.3. Bigo entrenchment after clearing and before excavations in 1960......................393

15.1. Government-General Museum of Korea (1915–1997)407

15.2. Excavation of Sŏbong-ch'ong (tomb of the Swedish Phoenix) in 1926.............409

15.3. Number of archaeological excavation in South Korea, 2007–2014...................419

15.4. Total spending on archaeological work in South Korea, 2005–2014.................419

16.1. *Tapestry Tunic with Profile Face and Stepped Fret Motifs*, Wari,
ca. 600–1000 CE ..429

16.2. *Tapestry Tunic with Tocapu Motifs*, Inca, ca. 1530 CE...........................433

16.3. *Tapestry with Coat of Arms and Vair Pattern*, Spanish colonial,
sixteenth century ...439

16.4. *Tapestry Altar Frontal with Roses and Animals*, Spanish colonial,
ca. 1600 CE ..440

16.5. *Tapestry Tunic with Flowers, Butterflies, and Jewels*, Spanish colonial,
ca. 1600 CE ..443

Contributors

Neil Brodie (Ph.D., University of Liverpool, 1991) studied archaeology and has held positions at the British School at Athens, the McDonald Institute for Archaeological Research at the University of Cambridge, where he was Research Director of the Illicit Antiquities Research Centre, Stanford University's Archaeology Center, and the Scottish Centre for Crime and Justice Research at the University of Glasgow. He is presently Senior Research Fellow on the Endangered Archaeology in the Middle East and North Africa project at the University of Oxford. He has published extensively on issues concerning the trafficking and repatriation of cultural objects, including serving as co-author (with Jennifer Doole and Peter Watson) of the report Stealing History commissioned by the Museums Association and ICOM-UK to advise upon the illicit trade in cultural material. He also co-edited *Archaeology, Cultural Heritage, and the Antiquities Trade* (University Press of Florida, 2006, with Morag M. Kersel, Christina Luke and Kathryn Walker Tubb), *Illicit Antiquities: The Theft of Culture and the Extinction of Archaeology* (Routledge, 2002, with Kathryn Walker Tubb), and *Trade in Illicit Antiquities: The Destruction of the World's Archaeological Heritage* (McDonald Institute for Archaeological Research, University of Cambridge, 2001, with Jennifer Doole and Colin Renfrew). He has worked on archaeological projects in the United Kingdom, Greece, and Jordan, and continues to work in Greece.

Ursula B. Brosseder (Ph.D., Freie Universität, Berlin, 2001), is an archaeologist at Bonn University in the Department of Prehistory and Early Historical Archaeology. She is a specialist in the Early Iron Age of Europe and the Late Iron Age in the Eurasian Steppes as well as the prehistory and early historical periods of Mongolia. Her own fieldwork focuses on Mongolia and Siberia. She is the author of *Studien zur Ornamentik hallstattzeitlicher Keramik zwischen Rhônetal und Karpatenbecken*, Universitätsforschungen zur Prähistorischen Archäologie 106 (Habelt, 2004), and the co-editor with Bryan K. Miller of *Xiongnu Archaeology: Multidisciplinary Perspectives of the First Steppe Empire in Inner Asia* (Vor- und Frühgeschichtliche Archäologie, Rheinische Friedrich-Wilhelms-Universität Bonn, 2011). She has recently been affiliated with the School of Historical Studies at the Institute for Advanced Study (2013–14), and has published in recent years mainly on archaeology of the Xiongnu period in Mongolia and its connection with Eurasia.

Chip Colwell (Ph.D., Indiana University, 2004) is Curator of Anthropology at the Denver Museum of Nature & Science. He conducts research on Native American culture and history, and cares for the objects that express the story of living cultures that form the nexus of the human experience and are at the heart of what it means to be human. He has held fellowships with the Center for Desert Archaeology, American Academy of Arts & Sciences, and US Fulbright Program. He is the author or co-author of nine books and nearly fifty articles and book chapters, the former including *Living Histories: Native Americans and Southwestern Archaeology* (AltaMira Press, 2010), *Crossroads of Culture: Anthropology Collections at the Denver Museum of Nature & Science* (University Press of Colorado, 2010, with S. E. Nash and S. H. Holen), *Inheriting the Past: The Making of Arthur C. Parker and Indigenous Archaeology* (University of Arizona Press, 2009), *Ethics in Action: Case Studies in Archaeological Dilemmas* (Society for American Archaeology Press, 2008, with J. Hollowell and D. McGill), *Massacre at Camp Grant: Forgetting and Remembering Apache History* (University of Arizona Press, 2007), and *History Is in the Land: Multivocal Tribal Traditions in Arizona's San Pedro Valley* (University of Arizona Press, 2006, with T. J. Ferguson). His publications have received honors, including the National Council on Public History Book Award and the Gordon R. Willey Prize of the American Anthropological Association.

Margarita Díaz-Andreu (Ph.D., Complutense University of Madrid, 1990) is a Research Professor at the Institució Catalana de Recerca i Estudis Avançats (ICREA, Catalan Institute for Research and Advanced Study), and is based at the University of Barcelona (UB). History of archaeology is one of her main areas of research, together with identity, heritage, and prehistoric rock art. Her publications include *Archaeological Encounters* (Cambridge Scholars, 2012), *Diccionario histórico de arqueología en España* (Marcial Pons, 2009), *A World History of Nineteenth-Century Archaeology: Nationalism, Colonialism and the Past* (Oxford University Press, 2007), *The Archaeology of Identity* (Routledge, 2005), and has been the guest editor of journal issues titled *Childe, 50 Years After* (*European Journal of Archaeology* 12, 2009) and *The Ethics of Archaeological Tourism* (*International Journal of Historical Archaeology*, 2013). She has successfully supervised three doctoral students on the history of archaeology dealing with Iran, England, and Mexico, and is currently supervising two more doctoral projects. She is currently the principal investigator for the Arqueología Sin Fronteras project, funded by the Ministerio de Economía y Competitividad, which is focused on the international reach and influence of Spanish archaeologists in the twentieth century; the project has sponsored two conferences and an exhibition and is fostering a number of oral history undertakings.

Wendy Doyon (M.A., University of Washington, 2007) is a doctoral candidate in history at the University of Pennsylvania, where she is writing the first in-depth study on the history and political economy of archaeological fieldwork in Egypt. Using museum and university archives, her research reconstructs the contributions and extent of the network of Egyptians who played an active but often publicly invisible role in successful North American and European excavations of ancient Egypt and other parts of the Ottoman Empire. She has held research fellowships at the Institute of Historical Research in London and the American Research Center in Egypt. She holds an M.A. in museology from the University of Washington, and has published several articles on the history of archaeology and museums. Her recent essays have appeared in the journal *British Museum Studies in Ancient Egypt and Sudan* and the edited volume *Histories of Egyptology: Interdisciplinary Measures* (Routledge, 2015).

Bonnie Effros (Ph.D., University of California, Los Angeles, 1994) became the Chaddock Chair of Economic and Social History in the Department of History at the University of Liverpool in fall 2017. She was previously Professor of History and the Rothman Chair and Director of the Center for Humanities and the Public Sphere at the University of Florida in Gainesville. Her publications on early medieval history and archaeology include *Caring for Body and Soul: Burial and the Afterlife in the Merovingian World* (Penn State University Press, 2002), *Merovingian Mortuary Archaeology and the Making of the Early Middle Ages* (University of California Press, 2003), and *Creating Community with Food and Drink in Merovingian Gaul* (Palgrave, 2002). She is co-editor with Isabel Moreira of the forthcoming *Oxford Handbook of the Merovingian World*. Over the past decade, she has turned her research focus to an examination of the history of nineteenth-century French archaeology, with *Uncovering the Germanic Past: Merovingian Archaeology in France, 1830–1914* (Oxford University Press, 2012). With support of fellowships from the National Endowment for the Humanities and the School of Historical Studies at the Institute for Advanced Study, she has just completed a new book entitled *Incidental Archaeologists: French Officers and the Rediscovery of Roman North Africa* (Cornell University Press, forthcoming).

Hubert Fehr (Ph.D., Albert-Ludwigs-Universität Freiburg, 2003) studied prehistoric and medieval archaeology, medieval history, and Roman archaeology in Freiburg and Vienna. After he finished his dissertation titled "Germans and Romans in the Merovingian Realm," he participated in the European Union–funded project, Archives of European Archaeology (AREA). From 2004 to 2008, he worked as an archaeologist at the Bavarian State Office for the protection of

monuments in Munich. In 2009, he returned as Akademischer Rat (Assistant Professor) to the Institute of Archaeological Sciences at Freiburg University, where he taught prehistoric and early historic European and medieval archaeology. In 2016, he began working with the Bayerische Landesamt für Denkmalpflege and has been tasked with regional patrimony issues. His research is focused on the archaeology of late antiquity and early medieval Europe as well as the history of German archaeology in the nineteenth and twentieth centuries. Among other works, he is the author of *Germanen und Romanen im Merowingerreich: Früh-geschichtliche Archäologie zwischen Wissenschaft und Zeitgeschehen* (De Gruyter, 2010), and the co-author with I. Heitmeier of *Die Anfänge Bayerns: Von Raetien und Noricum zur frühmittelalterlichen Baiovaria* (EOS Verlag, 2012), and with Ph. v. Rummel of *Die Völkerwanderung: Theiss Wissen kompakt* (Theiss, 2011).

Talinn Grigor (Ph.D., Massachusetts Institute of Technology, 2005) is Professor of Art History in the Program for Art History, University of California-Davis; previously she worked in the Department of Fine Arts at Brandeis University. Her research concentrates on the cross-pollination of architecture and (post)colonial politics, focused on Iran and India. Her first book, *Building Iran: Modernism, Architecture, and National Heritage under the Pahlavi Monarchs* (Prestel, 2009) examines the link between official architecture and heritage discourses in twentieth-century Iran. *Contemporary Iranian Visual Culture and Arts: Street, Studio, and Exile* (Reaktion, 2014) explores Iranian visual culture through the premise of the art historical debate of populist versus avant-garde art that extends into the identity politics of the exile. A co-edited book with Sussan Babaie, entitled *Persian Kingship and Architecture: Strategies of Power in Iran from the Achaemenids to the Pahlavis* (I. B. Tauris, 2015), investigates the architectural legitimization of royal power through Iran's long history. Her articles have appeared in the *Art Bulletin, Getty Research Journal, Third Text, Journal of Iranian Studies, Thresholds,* and *DOCOMOMO*, among others. Past grants and fellowships include the Getty Research Institute, Cornell University, Center for Advanced Study in the Visual Arts at the National Gallery of Art, Soudavar Memorial Foundation, Soros Foundation, Roshan Cultural Heritage Institute, and Aga Khan at MIT. Her current work deals with the turn-of-the-century European art-historiography and its links to eclectic-revivalistic architecture in Qajar Iran and the British Raj.

Guolong Lai (Ph.D., University of California, Los Angeles, 2002) is Associate Professor of Chinese Art and Archaeology at the University of Florida. He has

published widely on topics related to early Chinese art and archaeology, Chinese paleography, museology, collecting history and provenance studies, and heritage conservation in modern China. His book, *Excavating the Afterlife: The Archaeology of Early Chinese Religion* (University of Washington Press, 2015), was selected to be included in the Mellon Foundation's Art History Publishing Initiative and received the Society for American Archaeology's Honorable Mention-Book Award in the Scholarly Category (2016). He co-edited a conference volume *Collectors, Collections, and Collecting Arts of China: Histories and Challenge* (University Press of Florida, 2014), and co-authored two exhibition catalogues—*Terracotta Warriors: The First Emperor and His Legacy* (Asian Civilizations Museum, 2011) and *A Bronze Menagerie: Mat Weights of Early China* (Isabella Stewart Gardner Museum, distributed by University of Pittsburgh Press, 2006). He was the founding editor in 2014 of the bilingual (Chinese and English) academic journal, *Zhejiang University Journal of Art and Archaeology* and associate editor of the *Bulletin of the Jao Tsung-I Academy of Sinology* (Hong Kong).

Matthew M. McCarty (D.Phil., Oxford University, 2010) is a classical archaeologist and ancient historian whose work focuses on the edges of the Roman Empire, ancient religion, and the relationships between material objects and knowledge. As an Assistant Professor at the University of British Columbia, his teaching covers topics including Roman archaeology, conflict in Roman religious life, and comparative analysis of the Roman and Han Chinese empires. He also directs the Apulum Mithraeum III Project, an excavation aimed at understanding the ritual and social dimensions of a Roman "mystery cult." He is currently completing a monograph based on his dissertation, *Empire and Worship in Roman Africa* (Cambridge University Press), which focuses on child sacrifice and the agency of Roman hegemony in re-shaping fundamental premises about the gods, society, ritual, and personhood in the ancient Maghreb. In his next book project, *The Materiality of Religion in the Roman World*, McCarty will write a history of religion in the Roman world based on the archaeological record using cults of Mithras (including the one he is excavating) and site-based cases. His published articles and chapters cover a range of themes from concepts of historical continuity to the cognitive dimensions of ritual practice to the problems with using the concept of "heritage" to shape archaeological agendas in North Africa. He was a previously a member of the Princeton Society of Fellows, served as Lecturer in Ancient History at Worcester College (Oxford), Lecturer in Classics and Ancient History at the University of Warwick, and was the Andrew W. Mellon Postdoctoral Fellow in the Humanities at Yale University.

Ann McGrath (Ph.D., La Trobe University, 1984) is Director of the Australian Centre for Indigenous History at the Australian National University and Professor of History. She has researched and published history projects relating to gender and colonialism, and deep history and digital history in world heritage landscapes. She has published various articles, chapters, and books, including *Born in the Cattle: Aborigines in Cattle Country* (Allen and Unwin, 1987), co-authored *Creating a Nation* (McPhee Gribble Publishers, 1993), edited *Contested Ground: Australian Aborigines under the British Crown* (Allen and Unwin, 1995), and with Ann Curthoys authored *How to Write History People Want to Read* (Palgrave Macmillan, 2011). She has won various prizes for her writing and films, including *Message from Mungo* (2014), which won the United Nations of Australia Prize for Indigenous Recognition. In 2016, she won the John Douglas Kerr Medal for Distinction in Research and Writing Australian History. Her most recent book is *Illicit Love: Interracial Sex and Marriage in the United States and Australia* (University of Nebraska Press, 2015).

Yangjin Pak (Ph.D., Harvard University, 1996) studied archaeology and art history of Korea first at Seoul National University (B.A.) and Chinese archaeology in the Department of Anthropology at Harvard University (M.A. and Ph.D.). His area of specialty includes the northern frontiers of China and the Korean peninsula, and he has written a number of academic papers and books on the archaeology of prehistoric and early historical periods of Northeast China and Korea. He is Professor of Archaeology in the Department of Archaeology at Chungnam National University, South Korea, and has served as Director of the University Museum and Vice President for International Affairs of the Chungnam National University. He is currently President of the Society for East Asian Archaeology, the largest scholarly organization of English-speaking specialists in East Asian archaeology.

Peter Schmidt (Ph.D., Northwestern University, 1974) is Professor of Anthropology and African Studies and former Director of the Center for African Studies at the University of Florida. He has held academic posts at Brown University, Makerere University (Uganda), the University of Dar es Salaam, the University of Asmara (Eritrea), and the University of California-Berkeley. He has conducted research in Ghana, Tanzania, Uganda, Gabon, and Eritrea, starting his fieldwork in oral traditions and archaeology in 1969. He is the author or editor of nine books and many articles, chapters, and films in historical archaeology, African archaeology, ethnoarchaeology, heritage, community archaeology, and human rights. He helped to create new departments of archaeology at the University of

Dar es Salaam and the University of Asmara, where he has also served as Dean of the College of Arts and Social Sciences and Chief Curator of Archaeology in the National Museum of Eritrea. His most recent book is *The Death of Prehistory* (with S. Mrozowski, Oxford University Press, 2013).

Maya Stanfield-Mazzi (Ph.D., University of California, Los Angeles, 2006) is Associate Professor of Art History at the University of Florida. She specializes in art of the pre-Columbian and colonial Andes, especially that of colonial Peru. Her recent book, *Object and Apparition: Envisioning the Christian Divine in the Colonial Andes* (University of Arizona Press, 2013), explores how Christianity was given visual form in the Andes, especially in painting and sculpture. She is now researching liturgical textiles from Spanish America, including tapestry-woven cloths from Peru. Stanfield-Mazzi received a Fulbright-Hays fellowship for her dissertation research, and in fall 2015 was a visiting fellow at the Sainsbury Research Unit at the University of East Anglia.

Lothar von Falkenhausen (Ph.D., Harvard University, 1988) is Professor of Chinese Archaeology and Art History and former Associate Director of the Cotsen Institute of Archaeology at the University of California, Los Angeles, where he has taught since 1993. He does not have a B.A., but he studied at Bonn University, Peking University, Kyoto University, and Harvard University, earning an M.A. in East Asian Studies (1982) and a Ph.D. in anthropology from Harvard. His research concerns the archaeology of the Chinese Bronze Age, focusing on large interdisciplinary and historical issues on which archaeological materials can provide significant new information. He has published copiously on musical instruments, including a book, *Suspended Music: Chime Bells in the Culture of Bronze Age China* (University of California Press, 1993); Chinese bronzes and their inscriptions; Chinese ritual; regional cultures; trans-Asiatic contacts; the history of archaeology in East Asia; and method and theory in East Asian archaeology. His *Chinese Society in the Age of Confucius (1000–250 BC): The Archaeological Evidence* (Cotsen Institute of Archaeology Press, 2006) received the Society for American Archaeology Book Award. Falkenhausen was co-principal investigator of an international archaeological project on ancient salt production in the Yangzi River basin (1999–2004) and is presently serving as Instructor of Record of the International Archaeological Field School at Yangguanzhai, Xi'an (2010–present).

Jian Xu (Ph.D., Peking University, 2000) is Professor of the Department of History at the Sun Yat-sen University in Guangzhou in the People's Republic of

China. Trained as an archaeologist, his research interests focus on Bronze Age archaeology of South China and Southeast Asia, history of Chinese archaeology and museology, and cultural heritage studies. His recent books include *Alternative Traditions in Pre-1949 Chinese Archaeology* (Beijing: Science Press, 2012) and *Bronze Weapons before the Eastern Zhou* (Shanghai Classics Press, 2014). He has published extensively on the reception of Western archaeological thought in China, the future of Chinese archaeological collections, and nationalist archaeology.

INTRODUCTION

The Global Reach of Imperial and Colonial Archaeology

Bonnie Effros and Guolong Lai

Myths of the "Indiana Jones" type, which portray archaeologists conquering and exploring exotic landscapes in search of hidden treasures, have encouraged the public to dream romantically of archaeological adventures abroad. Academic discussions of figures like Aurel Stein (1862–1943), Hiram Bingham (1875–1956), and Langdon Warner (1881–1955), reputed to be the models for Steven Spielberg's "hero" (Heaney 2010; Jacobs 2010), have nonetheless drawn out the underlying tensions between such fictional accounts and the ugly realities they elide. There is no denying the closely entangled relationship among archaeology, imperialism, capitalism, and war (Díaz-Andreu 2007; Hamilakis 2007b; Trümpler 2010). Although popular sentiment in the West has tended to embrace the adventure rather than ponder the legacy of archaeological explorers like Heinrich Schliemann (1822–1890) or August Pitt Rivers (1827–1900), imperial powers' allegations of having "discovered" archaeological sites (see McGrath, this volume) or "saved" world heritage from neglect or destruction were often pretexts for the expansion of political influence and disruption of the legal jurisdiction of target nations and coveted territories (Meskell 1998; see Fehr, this volume). Consequently, those whose lives were entangled in some way with ancient monuments or artifacts often fell victim to the imperial war machine, their lands confiscated, artifacts or ancestors looted (see Colwell and McGrath, this volume), or the ancient remains in their midst purchased at a small price. Archaeologists thus often gained a reputation for being part and parcel of the process of conquest, and locals took to calling some archaeologists, like Victor Segalen (1878–1919), "foreign devils" (Hopkirk 1980; see Xu, this volume). They blamed such foreign arrivals for destroying the historical and cultural patrimony of their lands and, in

exceptional cases, were able to prevent them by any means possible from study-
ing, destroying, or otherwise appropriating ancient remains for purposes under-
stood to be counter to local interests (Jacobs 2013).

Imperial armies just as colonial authorities pillaged, disfigured, and otherwise
claimed landscapes that comprised integral parts of the oral history and traditions
of Indigenous communities. In the case of Egypt, they also capitalized on the
manual labor of Indigenous populations that enabled them to effectively extract
these resources to their own benefit (see Doyon, this volume). The destruction of
archaeological sites and the removal of choice artifacts from their original contexts
for the purpose of adorning the museums of metropolitan cities, whether Lon-
don, Berlin, Tokyo, New York, Paris, Rome, or Liverpool, was all too frequently
the hidden (or not so hidden) price tag of so-called scientific archaeological and
ethnographic expeditions (Bourget, et al., 1998; Marchand 2009; see Brodie, this
volume). And, indeed, such abusive activities were often responsible for setting in
motion Indigenous archaeological traditions within regions under threat of con-
quest, whether parts or former parts of the Ottoman Empire (Bahrani, Çelik, and
Eldem 2011; Gutron 2010; Reid 2002; Shaw 2003; see Doyon, this volume),
early twentieth-century China (see Lai, this volume), or Korea under Japanese
occupation (see Pak, this volume). In conquered territories like Algeria, officers
and civilian colonists created museums to house prized artifacts in closer reach
than metropolitan institutions. However, their displays were directed almost
exclusively at the settlers rather than the Indigenous inhabitants, with narratives
aimed at inculcating recent arrivals with a sense of belonging and connection to
their new land (Effros 2016). In this process of appropriation, the actual prove-
nance of the artifacts in question was often forgotten or erased (see Stanfield-
Mazzi, this volume).

Although collecting activities by foreign or imperial powers were often
undertaken in the name of "saving" physical remains of long-lost civilizations from
destruction, these one-sided narratives of "discovery" by imperial agents and colo-
nizers were an effective means of staking claims to territory (Oulebsir 2004).
Control of archaeological interpretation also worked in favor of historical claims
to territory, such as allegations of their direct descent from the ancient communi-
ties that created the monumental sites in question (see McCarty, this volume). In
this way, imperial and colonial archaeological activities served to marginalize or
obliterate the living memories that connected contemporary populations with
ancient remains (Hamilakis 2007a). In the competitive race to appropriate large
quantities or select groupings of coveted items, imperial just as colonial archaeol-
ogists thereby destroyed the fragile bonds that connected these often ancient arti-
facts and spaces with resident populations who had lived with them for centuries

(see Effros, this volume). In only rare cases, such as Iran, was it possible for Indigenous communities to refute assertions of privileged knowledge about the antiquities in question and limit imperial expansion; the Pahlavi dynasty in Iran effectively harnessed such rhetoric effectively over the course of the twentieth century as part of its strategy to resist European imperial initiatives. It proved a successful ploy but one used to such great excess in the late twentieth century that it helped catalyze the nationwide revolt that led to the Islamic Revolution in 1979 (see Grigor, this volume).

Bridging the gap between myth and reality in the appropriation of antiquities by imperial and colonial regimes, this volume of collected essays is the fruit of a workshop held at the University of Florida in January 2015, and co-sponsored by a grant from the American Council of Learned Societies/Chiang Ching-kuo Foundation for International Scholarly Exchange's Comparative Perspectives on Chinese Culture and Society, in addition to funding from the Robert and Margaret Rothman Endowment at the Center for the Humanities and the Public Sphere at the University of Florida and the University of Florida Office of Research. In addition, the Rothman Endowment supported some critical production expenses for this volume. The initial objective in bringing together the contributors represented here was to assess from a comparative perspective the historical role and legacy of archaeological research in colonial discourse, conflict zones, and contested regions around the world in the nineteenth and twentieth centuries. By including scholarly research based on six continents with scholars from four, moreover, the gathering was intended to give participants working in the history of archaeology and anthropology the opportunity to learn about the global dimensions of a phenomenon in fields that too infrequently encourage geographic comparisons. It is clear that the directionality of appropriated objects frequently did not fit received knowledge of the exclusive movement of artifacts from East to West, mainly into European collections. Other objects moved North to South (Gänger 2014) or West to East (see Pak, this volume). During the course of the workshop proceedings, however, it quickly became evident that we needed to open our frame of reference to address not just colonial archaeology but imperial science more generally, since many acts of appropriation of antiquities occurred in zones not formally colonized but under imperial threat (on these distinctions, see Díaz-Andreu and Fehr, this volume).

From the start in organizing the workshop and the present volume, it was our contention that it is beneficial to practitioners in the disciplines of anthropology, archaeology, art history, and history, to assess critically the origins of the basic tenets, practices, methodologies, and collections used in their fields today. Indeed, the practice of archaeology and the process of collecting aesthetically pleasing

objects, just as often as more exotic, humble, and unfamiliar artifacts, forced researchers and collectors "to decenter and rethink their aesthetic prejudices and cultural histories" (Marchand 2015: 200). While not all scholars easily fit into an Orientalist narrative or personally identified with the goals of imperialism (see Brosseder, von Falkenhausen, and Xu, this volume), deeper understanding of the legacy of the imperial and colonial context in which their disciplines developed and upon at least some aspect of which the tenets of their field rests (Gosden 1999), should not remain relegated to the margins but instead should be meaningfully integrated in research today. Knowledge of this past is essential to moving forward with archaeological projects, particularly when Indigenous populations remain deeply connected to the sites under consideration and are directly affected by their interpretation (Colwell-Chanthaphonh and Ferguson 2008; McNiven and Russell 2005; see also Colwell, McCarty, and McGrath, this volume).

In inviting contributions from authors working on interdisciplinary projects in and around the edges of the disciplines of anthropology, archaeology, art history, and history, we expected and were gratified to see the highly productive exchanges that resulted. Our objective was to center a subject all too frequently left to the edges of or omitted altogether disciplinarily or nationally focused projects. All scholars who participated in the workshop share a deeply held commitment to research that is meaningfully intertwined with archaeological practices and material. Although there were certainly challenges in communicating across national traditions and disparate disciplines, the diversity of disciplinary approaches lent new insight into intractable problems in our shared research interests and thus proved to be assets rather than obstacles. Rather than reinventing the wheel as we tackled our individual projects, participants in the gathering were exposed to a broad array of interpretive strategies currently being used by scholars to tackle the thorny issues characteristic of the history of archaeology, and especially that which has occurred in transnational contexts. Following revision of the original essays presented at the workshop, it was possible to see the advances possible as a consequence of these exchanges. And, indeed, an important reward of the meeting was that these exchanges continue to bear fruit both through personal connections, the essays contained in this volume, and future projects.

To facilitate exchange at our workshop and promote synchronicity in the essays that resulted from these productive discussions, each of the contributors to the volume was invited to contemplate a number of common issues. They were asked: What were the processes by which colonial archaeology was justified, executed, and funded? And how can we gain a better understanding of the institu-

tions, organizations, and conditions that made this contradictory stance feasible? Participants were thus collectively encouraged to identify the level of dissimulation, whether conscious or not, that was necessary for archaeological practitioners to undertake colonial archaeology successfully. Indeed, a central theme of the volume is the high cost of the myth of archaeology in imperial and/or colonial territories as discovering, preserving and interpreting antiquities in self-serving ways. By this means, the essays nuance understanding of how entangled archaeological undertakings were in the web of imperial politics, military, and legal institutions, and economic facets of colony building. Each contributor has thus drawn attention to the reality that archaeological missions fueled imperial and colonial ambitions while frequently ignoring, neglecting, or disqualifying Indigenous approaches to these same objects and monuments. As those pieces that focus on the most recent eras demonstrate, these narratives have had a powerful afterlife in shaping post-colonial archaeological institutions and landscapes, even when such narratives seem to have been entirely at odds with the objectives of the new regimes (see McCarty and Schmidt, this volume). Indigenous professionals trained in metropolitan universities or through integration in imperial fieldwork were not able easily or practically to abandon the intellectual paradigms and institutional frameworks in which they came of age and invent entirely new approaches to fieldwork in short periods of time (see Doyon and Grigor, this volume). The current and future generations will be responsible for taking steps to ameliorate biased approaches and interpretations in their disciplines and separate themselves critically from the nineteenth-century imperial and colonial origins of their fields (see Lai and Pak, this volume).

The collected volume thus enhances research in the history of archaeology by asking how it is possible to advance field-specific methodologies beyond the outlines of what was laid out by Bruce Trigger nearly thirty years ago (1989). With this purpose in mind, many of the contributors address the question of how they have met the challenges of lacunae in the archives and writing histories that go against the grain of imperial and/or colonial discourse (Stoler 2009). They assess, moreover, to what extent it is possible to reintegrate repressed or largely lost Indigenous perspective into studies of imperial archaeology after these voices were either delegitimized or entirely excluded from participation in excavations and conservation (see Doyon, Effros, and Lai, this volume). The volume as a whole identifies commonalities in the research strategies and shares lessons learned, so that those engaged in documenting the history of archaeology can avoid unnecessarily reinventing approaches when at least certain features of existing methods may be shared among very disparate geographical and chronological contexts.

The project is a timely one, given the continuing struggles of now independent states like Greece and Nigeria to regain the objects and monuments confiscated by earlier colonizing regimes. Which works of art are valued by their North American and European collectors, and which ones get restored, are uneven circumstances that reveal much about the imbalances created by imperial and colonial powers to their former possessions (see Brodie, this volume). Moreover, given the thriving market in plundered antiquities in Iraq and more recently in Syria (Bernhardsson 2010; Brodie, Doole, and Renfrew 2001; Rose-Greenland 2015), it is useful to be able to contextualize recent news headlines in the context of much older European arguments that these very same pre-Islamic antiquities had little or no connection to the Indigenous population (Bénabou 1975: 9–12). Of late, it has become evident that international organizations like UNESCO are not the impartial arbiters they once claimed to be (Meskell et al. 2014). Great interest in these subjects may be measured by the rapidly growing number of monographs and articles addressing colonial and imperial archaeology cited in the pages above.

The sixteen studies contained herein individually address a global array of imperial and/or colonial interactions affecting material culture, largely but not exclusively from the perspectives of archaeology and anthropology, in the nineteenth and twentieth centuries. They have been organized here thematically rather than temporally both in order to underline commonalities that cross geographic boundaries and object types, and also to avoid marginalizing any single region under discussion. The volume opens with two introductory essays, one that distinguishes imperial from post-colonial practice (Díaz-Andreu), and a second that identifies some of the distinctions between the hallmarks of imperial and colonial archaeological undertakings within Europe, in this case in regions occupied by the Third Reich (Fehr). Despite the disparate conditions of imperial and colonial appropriation of ancient remains in different parts of the world, the collection has allowed us to identify certain features of these undertakings as fairly universal. For one, all of the essays here underline the widespread recognition of material remains as powerful bearers of meaning, whether contingent on classical or more recent history or a more creatively constructed (and often politically motivated) visions of past (Abu-El-Haj 2001).

Moreover, as each of these studies makes clear, in the hands of archaeological interpreters, antiquities nearly always worked in tandem with written sources, whether ancient or invented, to undergird either narratives promoted by metropolitan authorities in support of desired political developments or worldviews that emanated from the lands in which they were trained and often still employed. And, they used this voice to give life to the antiquities coopted in these ventures,

whether archaeological or human. The first themed section of the volume thus turns to intersections between imperialism and nationalism, with essays on the British sack of Benin in 1897 (Brodie); the tensions between imperialist and nationalist claims to Chinese antiquities following the unification of China in 1927 (Lai); and the Pahlavi dynasty's use of Iran's pre-Islamic antiquities to promote its status as a "civilized" and modern nation (Grigor).

This is not to say that ancient monuments and artifacts were inactive or mute, since indeed they had the ability both to become the center of ritual activities and attract collectors (Hodder 2011). It is evident from the essays in this volume that material remains were often multivalent. Such vessels were capable of holding multiple meanings simultaneously, or in some cases underwent a remarkable series of transformations and metamorphoses that gave them new meanings that reflected the circumstances in which they were collected, interpreted, and displayed (Kopytoff 1989). In both cases, they represented, at least temporarily, invaluable tools in imperial and colonial administrative and military machines. For this reason, the control of scientific inquiry, in addition to the physical object or its historical genealogy, was absolutely essential to success in driving home pointed, and sometimes contradictory, messages to both metropolitan and subject populations. In the second thematic cluster of the volume, the essays focus on the place of the Indigenous voice in imperial and colonial archaeological exploration. The contributions include an analysis of the entangled relationship between Native Americans and archaeological exploration in the American Southwest (Colwell); the lived experience of rural archaeological laborers on foreign-sponsored excavations in Egypt (Doyon); the erasure of Arab and Berber voices from archaeological exploration in French colonial Algeria (Effros); and the resistance of Indigenous Australians to "discovery" narratives in prehistoric archaeology (McGrath).

Ancient monuments and artifacts, often encountered through the guise of archaeological study, became the object of collecting and represented essential but highly mutable ingredients in identity building and the brand of mythmaking integral to successful nations, colonies, and empires (Díaz-Andreu and Champion 1996; Kohl and Fawcett 1995). However, not all archaeologists, or art historians fit the imperial model neatly even if they were representatives of imperial powers. Many scholars had genuinely intellectual reasons for undertaking archaeological, anthropological, art historical, or ethnographic exploration that went far beyond the benefits they received as a consequence of their status as imperial agents or foreign nationals. Even if their objectives were personal, their privileged standing and access to resources unavailable to Indigenous residents not only allowed them the ability to travel with relative freedom and comfort in the lands

in question but also imbued them with a sense of superior wisdom over the populations whom they encountered in the course of their journeys. In the third section of the volume focused on archaeology, art history, and exoticism, the essays address the role of archaeological research in Buryatia and Mongolia, contested territory in the Great Game between Russia and Britain (Brosseder); the eclectic and controversial archaeological expeditions of Victor Segalen in China (Xu); and the varied experiences and careers of four German expatriates who studied art history in Republican China (von Falkenhausen).

The contributors to the volume also make evident that physical remains had powerful agency, and that in many cases these meanings outlived their imperial interpreters and regimes that politicized their presence. Working from both the perspective of imperial powers and/or their colonial "possessed," each of the contributors in this volume has questioned why archaeological heritage or ancient human remains offered such a rich source of mythmaking, even if sometimes disputed, in imperial or colonial contexts. They query how and why material artifacts constituted such a volatile set of symbols by which former colonies or nations formerly subject to imperial depredation redefined themselves during and subsequent to decolonization. Likewise, they often retained powerful symbolism in the landscapes of post-colonial regimes, mutating in response to political change. The fourth thematic cluster of the volume thus addresses colonial legacies, including the struggle in modern Tunisia to come to terms with its pre-Islamic past (McCarty); the manipulation of oral traditions and archaeological excavations at the archaeological site of Bigo and its implications for post-colonial Uganda (Schmidt); the lasting imprint of the Japanese colonial archaeology on the development of archaeological practice in North and South Korea (Pak); and the fate of Peruvian tapestries, whose provenance and significance were erased in the course of Peru's transition through colonial occupation and post-colonial statehood (Stanfield-Mazzi).

The significance of this explorative and comparative approach has been to address not only conservation and heritage management issues but also identify the array of ideologies and institutions that legitimized destructive behaviors in the name of "saving cultures." The subject is relevant because its effects are still present and ongoing, and have not gotten milder with the passage of time (Brodie, Doole, Renfrew 2001). Museums continue to be understood as respected cultural institutions and places of learning, but are market-driven institutions (Hamilakis and Duke 2007). They have far too infrequently been called out as the instigators or at best silent witnesses of the damage caused by colonial archaeology in spite of their display cases being filled with its plunder (Coombes 1997). Even in the case of antiquities excavated more than a century ago, many institutions do

ideological violence today by suppressing these histories and profiting from the riches such undertakings netted (Bernhardsson 2010; see Brodie, this volume). By addressing imperial and colonial archaeology from a transnational perspective, the contributors demonstrate how supra-national approaches to this difficult history can help museums curators rethink and make more culturally sensitive choices when displaying artifacts collected during eras of explosive imperial and colonial expansion, and avoid collecting today that profits from conditions of war. It is the moral and civic duty of these institutions to give recognition to the processes by which their collections came to be even in the recognition that it may not be possible to restore artifacts to their original contexts.

REFERENCES CITED

Abu-El-Haj, Nadia
 2001 *Facts on the Ground: Archaeological Practice and Territorial Self-Fashioning in Israeli Society.* University of Chicago Press, Chicago.
Bahrani, Zainab, Zeynep Çelik, and Edhem Eldem (editors)
 2011 *Scramble for the Past: A Story of Archaeology in the Ottoman Empire, 1753–1914.* SALT, Istanbul.
Bénabou, Marcel
 1975 *La résistance africaine à la romanisation.* Librairie François Maspero, Paris.
Bernhardsson, Magnus
 2010 *Reclaiming a Plundered Past: Archaeology and Nation Building in Modern Iraq.* University of Texas Press, Austin.
Bourget, Marie-Noëlle, Bernard Lepetit, Daniel Nordman, and Maroulis Sinarellis (editors)
 1998 *L'invention scientifique de la Méditerranée, Égypte, Morée, Algérie.* Éditions de l'École des hautes études en sciences sociales, Paris.
Brodie, Neil, Jennifer Doole, and Colin Renfrew (editors)
 2001 *Trade in Illicit Antiquities: The Destruction of the World's Archaeological Heritage.* McDonald Institute, Cambridge.
Colwell-Chanthaphonh, Chip, and T. J. Ferguson (editors)
 2008 *Collaboration in Archaeological Practice: Engaging Descendant Communities.* AltaMira Press, Lanham, MD.
Coombes, Annie E.
 1997 *Reinventing Africa: Museums, Material Culture, and Popular Imagination in Late Victorian and Edwardian England.* Yale University Press, New Haven, CT.
Díaz-Andreu, Margarita
 2007 *A World History of Nineteenth-Century Archaeology: Nationalism, Colonialism, and the Past.* Oxford University Press, Oxford.
Díaz-Andreu, Margarita, and Timothy Champion (editors)
 1996 *Nationalism and Archaeology in Europe.* Routledge, London.

Effros, Bonnie
 2016 Museum Building in Nineteenth-Century Algeria: Colonial Narratives in French Collections of Classical Antiquities. *Journal of the History of Collections* 28(2): 243–59.
Gänger, Stephanie
 2014 *Relics of the Past: The Collecting and Study of Pre-Columbian Antiquities in Peru and Chile, 1837–1911.* Oxford University Press, Oxford.
Gosden, Chris
 1999 *Anthropology and Archaeology: A Changing Relationship.* Routledge, London.
Gutron, Clémentine
 2010 *L'archéologie en Tunisie (xixe-xxe siècles). Jeux généalogiques sur l'Antiquité.* Karthala, Paris.
Hamilakis, Yannis
 2007a *The Nation and Its Ruins: Antiquity, Archaeology, and the National Imagination in Greece.* Oxford University Press, Oxford.
 2007b From Ethics to Politics. In *Archaeology and Capitalism: From Ethics to Politics*, edited by Yannis Hamilakis and Philip Duke, pp. 15–40. Routledge, London.
Hamilakas, Yannis, and Philip Duke (editors)
 2007 *Archaeology and Capitalism: From Ethics to Politics.* Routledge, London.
Heaney, Christopher
 2010 *Cradle of Gold: The Story of Hiram Bingham, a Real-Life Indiana Jones, and the Search for Machu Picchu.* Palgrave Macmillan, New York.
Hodder, Ian
 2012 *Entangled: An Archaeology of the Relationship between Humans and Things.* Wiley-Blackwell, Oxford.
Hopkirk, Peter
 1980 *Foreign Devils on the Silk Road: The Search for the Lost Cities and Treasures of Chinese Central Asia.* London: John Murray.
Jacobs, Justin
 2010 Confronting Indiana Jones: Chinese Nationalism, Historical Imperialism, and the Criminalization of Aurel Stein and the Raiders of Dunhuang, 1899–1944. In *China on the Margins*, edited by Sherman Cochran and Paul G. Pickowicz, pp. 65–90. Cornell University Press, Ithaca, NY.
 2013 Langdon Warner at Dunhuang: What Really Happened? *The Silk Road* 11: 1–11.
Kohl, Philip, and Fawcett, Claire (editors)
 1995 *Nationalism, Politics and the Practice of Archaeology.* Cambridge University Press, Cambridge.
Kopytoff, Igor
 1988 The Cultural Biography of Things: Commoditization as Process. In *The Social Life of Things: Commodities in Cultural Perspective*, edited by Arjun Appadurai, pp. 64–94. Cambridge University Press, Cambridge.

Marchand, Suzanne
 2009 *German Orientalism in the Age of Empire: Religion, Race, and Scholarship.* Cambridge University Press, Cambridge.
 2015 "The Dialectics of the Antiquities Rush." In *Pour une histoire de l'archéologie XVIIIe siècle–1945. Hommage de ses collègues et amis à Ève Gran-Aymerich,* edited by Annick Fenet and Natacha Lubtchansky, pp. 191–206. Ausonius, Bordeaux.
McNiven, I. J., and L. Russell (editors)
 2005 *Appropriated Pasts: Indigenous Peoples and the Colonial Culture of Archaeology.* Altamira Press, Lanham, MD.
Meskell, Lynn
 1998 Archaeology Matters. In *Archaeology under Fire: Nationalism, Politics, and Heritage in the Eastern Mediterranean and Middle East,* edited by Lynn Meskell, pp. 1–12. Routledge, London.
Meskell, Lynn, C. Liuzza, E. Bertacchini, and D. Saccone
 2014 Multilateralism and UNESCO World Heritage: Decision-Making, States Parties and Political Processes. *International Journal of Heritage Studies.* http://dx.doi.org/10.1080/13527258.2014.945614.
Oulebsir, Nabila
 2004 *Les Usages du patrimoine. Monuments, musées et politique coloniale en Algérie (1830–1930).* Éditions de la Maison des sciences de l'homme, Paris.
Reid, Donald M.
 2002 *Whose Pharaohs? Archaeology, Museums, and Egyptian National Identity from Napoleon to World War I.* University of California Press, Berkeley.
Rose-Greenland, Fiona
 2015 ISIS at the Mosul Museum: Material Destruction and Our Moral Economies of the Past. *Perspectives: A Publication of the Theory Section of the American Sociological Association* 37(1): 18–21.
Shaw, Wendy M. K.
 2003 *Possessors and Possessed: Museums, Archaeology and the Visualization of History in the Late Ottoman Empire.* University of California Press, Berkeley.
Stoler, Laura Ann
 2009 *Along the Grain: Epistemic Anxieties and Colonial Common Sense.* Princeton University Press, Princeton, NJ.
Trigger, Bruce G.
 1989 Alternative Archaeologies: Nationalist, Colonialist, Imperialist. *Man* (n.s.) 19: 355–70.
Trümpler, Charlotte (editor)
 2010 *Das Große Spiel: Archäologie und Politik zur Zeit des Kolonialismus (1860–1940). Begleitbuch zur Ausstellung beim Ruhr Museum, Weltkulturerbe Zollverein, Essen, 12. Februar–13. Juni 2010.* Dumont, Cologne.

DEFINING APPROACHES TO IMPERIAL AND COLONIAL ARCHAEOLOGY

In this methodology section, our two contributors define and address the distinctions among imperial, colonial, and post-colonial archaeology as practiced in the nineteenth and twentieth centuries. Margarita Díaz-Andreu focuses on how imperialism and colonialism, and their aftermath, globally influenced the development of archaeology and archaeological practice. She gives primary attention to the social background of those who were actively interested in archaeology, the institutions that supported the practice of archaeology, and the narratives created to legitimize the curation and study of antiquities.

In a second paper, Hubert Fehr elucidates the meaning of colonial archaeology in an unusual case study, namely that undertaken by National Socialist Germany in Europe during the course of World War II. He compares the policies and rhetoric in occupied Western and Northern Europe with the Germans' regime of occupation in East Central and Eastern Europe (especially Poland and Soviet Union). While the war in Western Europe followed the traditions of previous imperialist wars, German authorities occasionally declared parts of the conquered territory to be colonies of the German Reich. In order to bring out more clearly the colonial aspects of the work of German archaeologists working in occupied Eastern Europe, Fehr examines the extensive plundering of archaeological collections in Eastern Europe, which was quite different than contemporary policies in German-occupied Western and Northern Europe, where public property of archaeological collections was generally respected. Therefore, whereas in the east, the possibility of conducting archaeological research was extremely limited if not completely prohibited, German authorities in the west encouraged joint

archaeological work by German and local archaeologists. A very similar pattern affected the politics governing universities and other research facilities, which in general continued their work in the west while all universities in the east were shut down and replaced by newly founded German institutions with German personnel. Finally, in the case of the organization of archaeological heritage management, here again, the general rule was that the institutions in occupied Eastern Europe were shut down and replaced by newly founded German successor institutions. By contrast, in Western Europe, German authorities encouraged local governments to found new local institutions and create stronger laws for the protection of archaeological monuments.

CHAPTER 1

Archaeology and Imperialism: From Nineteenth-Century New Imperialism to Twentieth-Century Decolonization

Margarita Díaz-Andreu

It is widely accepted today that archaeology is not the value-free, neutral social science it was previously thought to be. One of the areas in which this has been demonstrated is in the relationship between archaeology and ideologies such as nationalism and imperialism. It has been argued elsewhere that nationalism stimulated the very creation of archaeology as a discipline, and informed not only the organization of archaeological knowledge, but also its very infrastructure (Díaz-Andreu and Champion 1996: 3). Regarding imperialism, it is unnecessary to explain that empires have existed for millennia, practically since the state appeared as a form of political organization. However, throughout its history, imperialism—the imposed rule of a state over a territory beyond its frontiers—has changed in nature. The nineteenth century represented one of the moments of transformation, as at that time the nature of imperialism was modified and molded by several factors, including industrial capitalism in its quest for new markets and cheap labor (Kocka 2010: 15–16). New imperialism, as this type of imperialism is known, resulted in renewed impetus for expansion, which led to the imperial control and colonial subjugation of increasingly large areas of the world. Industrial capitalism was ideologically sustained by nationalism and imperialism. These were state policies and political ideologies that came to be intimately connected (Baumgart 1982). This chapter explores how archaeology became enmeshed in, and influenced and also reinforced the politics of the time, and in particular how it became entangled with imperialism. It also assesses whether the demise of imperialism brought an end to the relationship between state politics and the study of the past.

Some scholars favor the term "colonial archaeology" over "imperial archaeology." In this article, the first term has been avoided unless we are strictly referring to the archaeology undertaken in the formal empire. The reason for this relates to its ambiguity on two accounts. First, "colonial archaeology" is often used to mean not the archaeology undertaken by imperial subjects in the late-modern colonized world, but rather current analyses of the material remains from the colonial period, meaning either the fifteenth to the eighteenth centuries (Lyons and Papadopoulos 2002; Montón Subías et al. 2015; South 1994) or other periods (Dietler and López Ruiz 2007; Lyons and Papadopoulos 2002; Stein 2005; Webster and Cooper 1996). Second, the term "colonial" excludes the archaeology undertaken by imperial subjects in countries that, although politically independent, were under an effective economic and cultural control from imperial centers, often imposed by force. These countries will be referred to here under the term "informal empire," although it would have also been possible to refer to them as "semi-colonial," following some other scholarly traditions (Varouhakis 2015; see Lai, this volume).The term also excludes the practice of archaeology in areas of countries such as the United States or Norway reserved for Indigenous communities that had once been free to exploit the entire territory, a practice that will be denominated as "internal colonialism." The archaeology in these types of countries and areas was very similar to that undertaken in the colonies, which is why in the following discussion several examples of archaeology in the imperial world are selected from them.

The account given in the following pages is structured in two major periods, the first being the nineteenth century and first decades of the following century, and the second the period after decolonization. Before dealing with imperialism, however, some information about nationalism will be provided, as this ideology constituted the basis for a new understanding of imperialism and also for what happened after decolonization.

The Archaeology of New Imperialism: From Nationalism to New Imperialism

An understanding of how the nature of nationalism changed during the nineteenth and early twentieth centuries, and the relationship of this political ideology with imperialism, is important for grasping the overall evolution of archaeology in the imperial world. In the first decades of the nineteenth century, nationalism was an ideology, the scope of which its proponents limited to a few countries in the world. This is because they believed in a limiting "threshold principle." Under this principle, a nation had to be economically viable and, given these

parameters, it was believed that only large states were entitled to be nations. This type of nationalism is known as "civic" or "political" nationalism, and in it, ethnic and linguistic factors were secondary. Instead state history, a literary and artistic tradition (all these elements understood through a narrative of progress), and a territory were key factors. When nationalism emerged as a political ideology, the idea of the nation was linked to an understanding of individuals as free and possessing political rights. Individuals' self-fulfillment was linked to citizenship and patriotism, and it was expected that they would be willing to defend the nation, even at the cost of their lives. In the model of "civic" nationalism, colonies were not considered ethnic units but the sum of different groups. This type of nationalism was the direct heir of the Enlightenment and, therefore, the principles followed were the "common good," "utility," and "veritas" (the Truth) (Hobsbawm 1990: 18–19; Smith 1991: 10; for archaeology see Díaz-Andreu 2007: chapter 3).

However, the idea of the nation changed during the nineteenth century. By 1880, "civic" nationalism had eventually been absorbed into a new type of nationalism that scholars refer to as "ethnic" or "cultural" nationalism. The seeds of this new understanding had been planted much earlier and were noticeable from the 1820s, at the time that Greece and most of Latin America gained independence (Díaz-Andreu 2007: chapter 4). In this new type of nationalism, nations were defined as units formed by individuals who shared a common history, formed part of the same group, spoke the same language, shared a distinctive set of customs, and, mainly from the 1840s, were of the same race (a term that meant for most people something similar to what we would call ethnicity today). Importantly for the discussion in this article, in addition to all this, it became increasingly important to have a proven capacity for conquest, to the extent that the success of nations began to be measured by their imperial accomplishments. In the nineteenth century, imperialism was, therefore, not only an economic activity, but also very much entangled with politics and the perception individuals had of their own country's position in the world of nations (Baumgart 1982; Hobsbawm 1990: 22; Smith 1976: 74–75).

In the nineteenth century—and during much of the century that followed—it was assumed that the concept of nation was objective and unproblematic. Within the framework of ethnic nationalism, a particular understanding of the nation developed in which a direct correlation was made among language, race, and nation (or, as the latter became increasingly known, culture) (Delanty and Kumar 2006; Díaz-Andreu 2007: chapter 12 and passim). Racism—the term, by then closer to the meaning we give to it today—grew in importance and, in order to explain its success, it is pertinent to remember that the notion of the nation was connected to the ideals of progress, freedom, and patriotism. It was

due to their conviction that progress was the motor of historic development that many scholars believed in racism. Because economic and industrial progress had taken place in the imperial powers, there was no doubt about the racial superiority of their subjects. The pale skin of those living in the imperial centers created a visible way to identify racial supremacy, and skin color became an easy measure of racial status. In racial terms, other Western countries, including many in Europe where people had slightly darker skin and hair, lagged behind the imperial powers. These were followed by many others around the world. At the bottom of the racial pyramid were areas of the world dominated by colored people who had been organized in non-state societies until the arrival of the Europeans.

From today's perspective, nineteenth-century racism is a clear illustration of an extremely conservative political attitude. At the time, however, it was a subject on which the great majority of intellectuals agreed, as they associated Western ideals with progress and the good and righteous. Exceptions to the rule were few and far between. It would only be in the twentieth century that the hideous consequences of racism made the world reject prejudices based on racial differences and, for a few decades, become wary of nationalism as an ideology (Banton 1969; Barkan 1992; Mosse 1988; Shipman 2004). World War II was the period of extreme influence of racism, and during these years one could also apply the concept of colonialism to the practice of archaeology by some Europeans—mainly Germans—in certain European countries (see Fehr, this volume).

ARCHAEOLOGY IN IMPERIAL CENTERS

As may be seen in this volume, in the nineteenth and early twentieth centuries there were several centers of imperial power. Some had overseas empires and others did not. At first the main overseas imperial centers were Britain and France, and later Germany, Belgium, Italy, and Japan. There were also other empires that expanded in territories that were not overseas and therefore are usually forgotten in the literature. These were Russia and the United States, where the continuous extension of their frontiers—eastward in the former and westward in the latter—represented the multiplication several fold of their territories at the expense of neighboring areas. To these empires, one could add others that were in decline and would be obliterated between the end of the nineteenth century and World War I. These were the Ottoman, Austro-Hungarian, Dutch, Spanish, and Portuguese empires. By the end of the nineteenth century, the rest of the world was, with a few exceptions, either directly colonized or under imperial influence. This was the framework in which archaeological work took place in the imperial centers and the colonized world.

The study of the past changed significantly in the nineteenth and early twen-
tieth centuries in the imperial centers. Thucydides had already used the term
"archaeology" in antiquity, but in Europe it was only revived in the early modern
period by scholars with a renewed interest in the past. From the Renaissance to
the Reformation, and even later, the term most commonly used to refer to the
past was "antiquity," and those dealing with it were called antiquaries and anti-
quarians. Antiquarianism led to the emergence of collections of antiquities that
were kept and exhibited in cabinets of curiosities in the homes of the wealthy and
in many churches. In contrast to antiquarianism, the term "archaeology" denotes
professionalization. The transition from antiquarianism to archaeology, which
was not always linear, took place in the nineteenth century in the context of
nationalism, imperialism, and the formation of the modern state (Díaz-Andreu
2007: chapters 11–13).

During the period in which "civic" nationalism predominated—as explained
in the previous section, mainly during the first half of the nineteenth century—
the past that sustained the ideology of nationalism was classical antiquity. The
ideas expressed by the Greco-Roman authors and the art produced by the artists
of the period were the canon by which to measure wisdom, knowledge, and civi-
lization. Knowledge of the classical past was linked to freedom, independence, and
progress, and it was from this perspective that national histories were addressed.
This practice explains why royal collections included classical antiquities from the
Enlightenment onward, that of the czars of Russia being an example (Norman
1997). It also explains why the first university chairs in archaeology in the Old
World were for those specializing in the classical period, 1802 in Kiel, 1818 in
Leiden, and 1847 in Paris, with a precedent of Uppsala in 1662 (Díaz-Andreu
2007: 38; Jensen 2004: 64; Gran-Aymerich 1998: 115; Klindt-Jensen 1975: 26).

The classical antiquities studied in the imperial centers were those of the
ancient world of that country if the country was located in one of the areas that had
belonged to the Roman Empire. Particular attention was paid to the antiquities of
Italy and Greece, in the case of the latter country first through copies, and, as soon
as the political situation made it possible, by visiting the originals (Díaz-Andreu
2007: chapters 4 and 5). Archaeologists focused their studies on monuments,
inscriptions, coins, and sculptures. Nevertheless, beyond the Greco-Roman civiliza-
tions, other types of antiquities also increasingly became poles of attraction. The rea-
son for this was the equation established between the classical past and civilization.
This made it possible, by extension, for scholars to become interested in other, non-
classical past civilizations. An example of an acceptable non-classical past can be
found in northern Europe, where the classical model encouraged an interest in runic
inscriptions and megalithic monuments (Klindt-Jensen 1975; Randsborg 1994).

The transformation of nationalism from "civil" to "ethnic" had an effect on the range of archaeologies supported by scholars and also by the state. In order to legitimize the nation's character, and indeed to prove its own existence, it became essential to put together a national history. In addition to history, many other disciplines became professionalized in the nineteenth century in connection with the new characterization of nationalism. Philology, history, and geology were among the earliest and these were joined in the middle decades of the century by geography, archaeology, and physical anthropology (Barton 2003; Engel 1983; O'Connor 2005; Urry 1993). In the case of archaeology, ethnic nationalism made it conceivable to professionalize not only the study of classical and other monumental antiquities, but also the archaeology of the prehistoric and medieval periods. However, the professionalization of the archaeology of these periods had difficulties to overcome. In prehistoric archaeology the methods of stratigraphy, typology, and seriation had to be developed before archaeologists' interpretations were considered to have sufficient rigor to be accepted as part of national history (Schnapp 1996: 321). In the case of medieval archaeology, the difficulty of professionalization was related to the generalized conviction that written texts were a more precise historic source than material remains. These difficulties meant that the professionalization of prehistoric and medieval archaeology did not take place until the very end of the nineteenth century and mainly during the early decades of the twentieth century (Callmer et al 2006; Effros 2012; Gerrard 2003; Wienberg 2014).

IMPERIAL ARCHAEOLOGY

As seen above, national and imperial archaeology coexisted in the imperial centers. The relationship between imperialism and archaeology can be studied from different points of view and here three will be chosen: institutionalization, the human base of archaeology, and the imperial narrative.

Institutionalization

Institutionalization is a very precise measure of the degree of interest a particular discipline has raised in society. This is because institutionalization needs investment and therefore requires the political and/or economic elites of a country to be convinced of the relevance of a particular professional practice before they agree to support it. In the case of archaeology, the main types of institutions that have been sustained since the nineteenth century are museums, universities, and government offices dealing with antiquities. To these, we should add learned societies, which were not necessarily related to professionalization as they preceded it.

One of them was the Batavian Society of 1778, which was the origin of a museum in Dutch Indonesia (Díaz-Andreu 2007: 216–22; Djojonegoro 1998). During the period under study, the nineteenth and early twentieth centuries, the number of institutions that backed the study of the past continued to grow. This period also saw the introduction of legislation, establishment of state offices for the management of archaeology, and organization of the teaching of archaeology. However, a comparison between the number of institutions established in the imperial centers and the colonies makes it clear that there were many more in the former than the latter.

There is no pattern to the order in which institutions were established in each region of the imperial world. The way in which archaeological knowledge was institutionalized depended very much on the circumstances and the personalities of the actors in charge. In this respect, it is useful to compare how the colonies of South and Southeast Asia founded institutions. Some imperial powers favored the establishment of learned societies and museums (as already mentioned this was the case in Indonesia), others set up foreign schools (Indochina), and yet others government heritage offices (India) (Díaz-Andreu 2007: chapter 8). However, after a time, all of these institutions were eventually set up in all the colonies except Australia and Africa. The imperial powers judged these two continents to have the most uncivilized societies and therefore the information provided by archaeology was considered ineffectual. It was assumed that these societies had changed little throughout their history and therefore anthropology sufficed to offer adequate information about them. Although there were some museums in Australia, in areas such as central Africa they were only founded (if at all) in the years immediately before independence in the mid-twentieth century (Anderson and Reeves 1994; Ardouin 1997; Mulvaney 1987). In these areas, training in archaeology only started well into the second half of that century.

The only institution established in both the formal and the informal empire by the imperial powers was the foreign school. These were set up mainly in areas where either the great classical civilizations had developed—Italy, Greece, Egypt, Mesopotamia—or there had been other major civilizations, such as those of Indochina (where the École Française d'Extrême Orient, French School of the Far East, EFEO, was opened) (Clémentin-Ojha and Manguin 2006; Deichmann 1986; Gras 2010; Vian 1992; Wallace-Hadrill 2001; Wright 1996). Foreign schools were founded first by countries such as Germany and France with a state-interventionist model, in which the government backed them financially. Countries following a utilitarian model, such as Britain and the United States, in which private funding was encouraged, had to wait longer before the state decided that foreign schools were a good investment in order to avoid the risk of lagging

behind in the imperial race for classical knowledge. The differences between these types of countries also had an impact on how archaeological expeditions were funded, either by the state in the European continental model or mainly by private sponsors in the utilitarian model.

Independent countries under imperial influence invested in national institutions that paralleled as much as they could the powerful and influential institutions set up in the imperial metropolises. In some cases, however, foreign scholars were appointed to run them, given the lack of expertise in the country to fill the posts or the refusal to recognize Indigenous archaeologists as experts. An example of a foreign archaeologist filling in for the lack of experts in the country was the case of Max Uhle in Peru and Chile (Kaulicke et al. 2010). Importantly, in order to protect their antiquities from the empires' greed for new collections, an increasing number of independent (or semi-independent) countries passed laws banning the export of antiquities, although in some cases they were unable to enforce them. The more their governments shared the nationalist ethos with the Western powers, the more effort they put into controlling their antiquities. Some examples of countries that promulgated legislation outlawing the export of antiquities are Greece in 1827, Egypt in 1835, Colombia in the 1860s, Turkey in 1874 and then again in 1884, and China in 1930 (Díaz-Andreu 2007: passim, see 463; Lai, this volume).

The Human Base of Archaeology

In the imperial world, imperial agents, officers, scholars, scientists, and explorers were the first to undertake explorations contributing to the knowledge formation of the new territories. Once settlers had become established in them, the social base of those dealing with the material remains of the past became closer to that of the imperial metropolises. As in the metropole, in the colonies most of those interested in antiquities were amateurs, but in contrast to the most Westernized countries, army officers represented an important contingent as they were among those who had received an education (especially among the highest ranks), and in peacetime they had plenty of free time on their hands (Malarkey 1984; Mitchell 1998). Practitioners were also drawn from other occupations. In French Algeria, for example, James Malarkey has concluded from his analysis of those who wrote for the *Annuaire de la Société archéologique de la province de Constantine* between 1856 and 1876 that, as well as army officers, there were doctors, teachers, settlers, members of the clergy, and explorers (Malarkey 1984: 141). The literature, however, has only recently admitted that workers also need to be considered, an issue that is discussed in this volume by Wendy Doyon (see also Aguirre 2012; Berg 2013; Shepherd 2003).

The greater involvement of archaeologists from the imperial centers in the archaeology of areas beyond their nation's frontiers was related to the economic strength of their nation, whether rich governments—or wealthy sponsors—supported their studies (see an example of one of such explorer in Xu, this volume). Those who became professionals worked in the institutions established either in the imperial centers or in the colonies. They, together with the amateurs, comprised a loyal readership for learned societies and specialized journals, almost always published in the imperial centers, for they were rarely economically viable in non-imperial countries. Their interest was not neutral, as the nationalities of those involved in the colonial world were skewed towards the imperial center in power. Thus, there were no French archaeologists in India and no Dutch archaeologists in Indochina. Scholars from other parts of Europe who became interested in the past of areas of the world which were not under their own country's rule had two options—either to move to the imperial country in question or to abandon their research. Examples of the former were the German-born Indian expert Friedrich Max Müller, who moved to England, and Aurel Stein, who also moved from Austro-Hungary to England to specialize in China (van der Bosch 2002; Whitfield 2004). An example of the latter type of archaeologist was the Spaniard, José Ramón Mélida, who had to abandon his interest in Egyptian antiquities as he could find no financial support for it and instead decided to focus on Spanish archaeology (Díaz-Andreu 2007: 404, 2008).

Although most of the archaeologists in the colonial world came from the imperial centers, there were also a small number of colonial subjects who became interested in the past of their own country. An early example is the Egyptian Rifa'a al-Tahtawy (1801–1873), who studied in Paris and became one of Egypt's modernizers. He and other Egyptians who had studied in the School of the Ancient Egyptian Language encountered opposition from the then-head of the Antiquities Service, the Frenchman Auguste Mariette, in their attempts to engage with pharaonic Egypt. As the German scholar Heinrich Brugsch, the school's director, explained:

> The Viceroy was highly satisfied with my work, the minister of education [Ali Mubarak] was delighted, and the director of government schools almost burst with envy.... [M]y old friend Mariette worried that it might lead the Viceroy to have it up his sleeve to appoint officials who had studied hieroglyphics to his museum. No matter how much I tried to set his mind at ease, he remained so suspicious that he gave the order to museum officials that no native be allowed to copy hieroglyphic inscriptions. The persons in question were thus simply expelled from the Temple [the Museum] (in Reid 1985: 235).

Other examples of local scholars interested in antiquities were the artist Raden Saleh (1811–1880) from Indonesia, who lived in Europe for twenty years and developed an interest in antiquities (Djojonegoro 1998: 23–25), and Rajendra Lal Mitra (1823–1891), a key figure in the Bengal Renaissance, a historian and archaeologist who wrote *Antiquities of Orissa* (1872). He was the librarian of the Asiatic Society in Bengal from 1846 and later its vice president, and would become its first Indian president in 1885 (Singh 2004). Other examples refer to scholars from countries belonging to the informal empire. Among them the Ottoman Hamdi Bey (1842–1910) should be mentioned. From the 1880s he was the main promoter of legislation, the modernizer of the Archaeological Museum of in Constantinople (modern Istanbul), and the first advocate of scientific excavations and archaeological publications (Eldem 2004). All had received some training in the imperial centers. For Tunisia see Bacha (2013) and McCarty (this volume). A final case to be mentioned here is that of the Chinese geologist, Ding Wenjiang, the key figure in Paleolithic studies in the Republic of China, who had been trained in Scotland (Fiskesjö and Chen 2004; for Fu Sinian and Li Ji, see Lai, this volume).

The informal empire had a mix of local and imperialist archaeologists. The balance in numbers between them depended on the degree of Westernization and the type of archaeology. The less Westernized the country, the more imperial archaeologists it had. There was also a strong relationship between the density of remains of ancient civilizations and the number of imperial archaeologists in the area. Hence, in the countries of southern Europe that had belonged to the Western world for a long time, such as Spain and Italy, there were only a few imperial archaeologists and most of them (but not all) focused on the classical period. In other areas of the world such as China there were many more imperial archaeologists, most of them focusing on the material remains of ancient civilizations, particularly those that had left written texts at sites associated with the Silk Road. In the last decades of the nineteenth century the growing acceptance of prehistory as a discipline explains why an increasing number of imperial archaeologists also became interested in the most ancient human periods. Again, both Spain and China could be chosen as examples to illustrate this (Fiskesjö and Chen 2004; Gran-Aymerich 1998: 308–18; Vialet 2011).

The Imperial Narrative: Racism, Monumentality, and Hegemony

Imperial archaeologists, regardless of where they worked, created origin narratives for the imperial world. The power of the classical model in nineteenth-century archaeology—that is, the consideration given to the ideas expressed by

Greco-Roman authors and the art and monuments of those peoples as the canon by which wisdom, knowledge, and civilization were measured—explains many of the interpretations advanced by imperial and colonial archaeologists. The monumental remains of bygone civilizations received better treatment than those of non-state societies. In addition, monumental civilizations that also had translatable written texts were considered superior to those without intelligible writing systems. Devoid of monuments, the alleged inferiority of non-state societies both present and past became widely accepted. The assumption was that there was little point in studying those remains in areas where tribal societies were predominant since uncivilized peoples had not changed over time and the information that archaeology could obtain compared unfavorably to that gathered by anthropologists. There were, however, some exceptions to this rule (see, e.g., Basak 2011; Mitchell 2001), although these usually resulted from private initiatives without proper sponsorship.

The admiration for the classical past meant that in colonies whose territories had been under the rule of the Roman empire, classical archaeology took precedence over the study of any other type of remains (Alexandropoulos 2003; Bacha 2008; En-Nachioui 1995; Mattingly 1996; Oulebsir 2004; Effros, this volume; McCarty, this volume). In North Africa, Roman archaeology was seen as the origin of Western civilization, thus legitimizing the European colonization of the territory. In a similar way, in the Northern Pontic area and the Crimea, the rich Scythian burials were regarded as a source of prestige for Russia. Scythians had been in contact with classical Greece, and Russian scholars strove to connect them with the Slavs, the ancient people from whom the Russians themselves were descended (Volodina 2001). Beyond the areas with Greco-Roman remains, the archaeology of ancient civilizations was prioritized. Nevertheless, in comparison to the remnants of classical glory, non-classical monuments and material culture were always perceived as exotic and inferior. Thus the archaeology of ancient civilizations such as the Khmer in Indochina and the Maya in Mexico was considered to a certain extent to be primitive and of mediocre quality (Bernal 1980: chapters 4 and 5; Díaz-Andreu 2007: 230–52, 187, 190).

The perception of inferiority was not only articulated culturally but also, crucially, expressed in racial terms. Racism had long historical roots, but in the framework of the belief in progress, a more intolerant form of racism emerged in the 1840s. It was only the terrible consequences of the practices inspired by this ideology during World War II that led to the end of its pre-eminence. In the century before that happened, racism became directed towards the "Other," not only beyond one's frontiers, but also within them. This ideology impeded acceptance of native antiquities in areas such as Latin America, where, after an initial period

of institutionalization in Mexico and Peru (Bernal 1980; Díaz-Andreu 2007: chapter 4; Earle 2008; Florescano 1993; Gänger 2014), there was a rejection of the Indigenous past that was only overcome from the 1870s. Also, because of racism, monuments located in areas where the local population was considered to be very low down in the hierarchy of races were thought to be too sophisticated to have been produced by the local population. Instead, many proposed that these remains had been built or designed by white Europeans (see Schmidt, this volume).

The knowledge developed in imperial metropolises was not normally imposed by force, either in the imperial nations themselves or in the formal and informal colonies (although it could be used to legitimize force!). It often spread through the activities of learned societies, which enjoyed general conformity because of the socialization that took place in them. These activities included exhibits in both large and local museums, in universal exhibitions, publications in widely circulated journals, and international conferences, which were used dynamically to give imperial archaeologists the authority of expert observers. Any news about the archaeology of the colonies and the informal empire gained prestige by its announcement in the imperial centers, either by means of lectures or publications. Scholars from the colonial world earned respect and social recognition by sending archaeological and anthropological collections—often as gifts—to the major museums in the metropolis. Colonizers returning home also brought collections and displayed them as symbols, as Lahiri (2000: 688) puts it, of their "colony-returned gentleman" identity (see Brodie, this volume, for a discussion on the cultural appropriation of the Benin Bronzes at the end of the nineteenth century; Brosseder, this volume, for a discussion on cultural appropriation in the Russian empire, taking Buryatiia as a case study; and Stanfield-Mazzi, this volume, regarding Peruvian tapestries). In addition to the means by which knowledge spread, hegemony was also established by creating models: to the classical model discussed above we could add the models related to prehistoric archaeology. The sequence generated for European prehistoric material served as a standard to follow when establishing typologies and describing prehistoric archaeological finds elsewhere in the world. The inadequacy of this procedure meant that the prehistoric archaeological cultures around the world were considered inferior to those of Europe (examples of this can be found in Dennell 1990; Coye 1993: 115–21).

It has been pointed out that there were a few native archaeologists who managed to be acknowledged as experts in the colonies. Although at first sight this may seem incongruous given the imperial narrative of using antiquities to legitimize the inferiority of the colonized, it is not so if we take into account the flex-

ibility of the past. The past provides a mirror image of the future archaeologists aspire to for their country. If the colonizers drew on antiquity to demonstrate the inferiority of the colonialized peoples, the latter used this same past to validate the unique character of their territories and peoples. Archaeological evidence is quite versatile. It needs interpretation and the limits of possible interpretations are often not set very narrowly. Some authors have used the concept of mimicry, alluding to the practice by colonized subjects of "mimicking" the colonizers (cf. Bhabha 1994). Others have referred to resistance to indicate some of the practices of native archaeologists in their colonized lands. The interest taken in antiquities by some local intellectuals in the colonial world, together with their endeavors to generate alternative visions of the past, may be seen as an attempt by the colonized to appropriate the discourse of the past, to produce alternatives to the accounts created by imperial archaeologists, and to resist their attempts to be the only valid interlocutors of the colony's past.

The Archaeology of Twentieth-Century Decolonization: Political Background

In comparison to the large body of literature on archaeology and nationalism, and also the many writings on how the discipline was affected by colonialism, very little has been published on the effects of decolonization. In the following pages a first approach to this subject will be attempted.

The first years of the twentieth century, up to World War I and, with a bit more difficulty, up to World War II, can be considered as an extension of nineteenth-century imperialism (for the interwar years up to 1950, see von Falkenhausen's chapter on Germans in China), although there were some remarkable events before the turn of the century, such as the end of the Spanish empire in 1898. However, major changes in the world map occurred at the end of the Great War. It was then that the Ottoman and Austro-Hungarian empires collapsed, affecting the political division of Eastern Europe and the eastern Mediterranean. The two main imperial powers at the time, Britain and France, benefitted from this, as did other emerging powers, mainly Germany and Italy. In the Far East, Japan emerged as a new power with the control of Taiwan (1895), the southern half of the island of Sakhalin (1905), Korea (1910), and, from 1935, the invasion of Manchuria. In contrast to the expansionist nature of these old and new empires, an alternative was presented by the United States. In 1904, President Theodore Roosevelt in his State of the Union address reinterpreted the by-then, many-decades-old Monroe Doctrine of 1823 opposing European colonization of any American lands. In the new interpretation it was

the right of the United States to arbitrate in Latin America in cases of "flagrant and chronic wrongdoing by a Latin American nation." This policy opened the doors to US intervention in Latin American politics throughout the twentieth century and up until the present.

The conclusion of World War II brought the age of empires to an end. The Atlantic Charter of 1941 agreed to by the US and British governments included eight "common principles." With this agreement, both governments committed to support the liberalization of international trade and the restoration of self-government for all countries that had been occupied before or during the war. The independence of the Italian colonies—Ethiopia, Libya, Eritrea, and Somalia—was a direct result of Italy's downfall in the war. The movement towards decolonization, however, did not stop with recently occupied countries. The two main imperial powers, Britain and France, had shown their vulnerability when they were seriously threatened or even invaded by Germany. The opportunity offered by the fragile state in which Europe was left after the war was seized on by the colonized as the opportunity to proclaim independence. Their expectations had also been raised by the treaty and the belief that they deserved independence after their population's active participation in the war effort. In 1947, the British colonies of India and Pakistan obtained independence and were followed by Burma and Ceylon in 1948 and the Dutch colony of Indonesia in 1949. In the 1950s and early 1960s, many French colonies gained independence, including the several countries into which Indochina was divided and the North African protectorates—Morocco and Tunisia—and the colony of Algeria. In sub-Saharan Africa the process of decolonization was also launched in the early 1950s, and by the 1960s most countries had achieved independence.

Nevertheless, in order to understand the political background of the world after World War II, it is essential not only to talk about decolonization, but also the Cold War. At the end of the conflict, following the brief period of cooperation after the Yalta Conference of February 1945, when the UN was created, good feelings between the United States and Soviet Union soured, as shown at the Potsdam Conference in July. Both countries soon became embroiled in a struggle over areas of influence. The Korean War of 1950–53 was the first open conflict in which two opposing military alliances were created: NATO and the Warsaw Pact, and the Korean conflict was followed by the Vietnam War (1955–75). The term "Iron Curtain" graphically represented the division of the world into two major blocks. Another idiom created in the early 1950s was "Third World," referring to countries that were not aligned either with the Soviet communist bloc or the NATO capitalist bloc during the Cold War (Sauvy 1961), although some confusion was created when the term also came to mean extremely poor, non-industrialized countries.

FROM IMPERIALIST TO NATIONALIST ARCHAEOLOGY

The new map of the world did not differ much from that of the imperial era. With a few exceptions, borders stayed the same, although governments changed. This obviously allowed survival of the administrative structures, institutions, and even ideologies established during the colonial period. This continuity explains the easy transition from imperialism to nationalist ideologies in the newly independent countries. Many of the local elites in the colonized world had received their political education from the colonizers with whom they shared an understanding of the nation as a cultural entity with its own history, whose only legitimate type of government was national self-government. Several decades of colonialism had produced a great deal of literature describing the peculiarities of their territories. Having learned about the cultural idiosyncrasy of their own lands, they now logically perceived their own colonial land as a unit with its own history and culture, that is, a nation. The versatility of the past has already been commented on above. The reverse reading of the imperial narrative was the nationalist reading of the new nations' past. Only one example of this will be provided here, although many can be found in the literature and in this volume (see, e.g., Grigor's chapter in this volume on Iran). Nigerian politician, Abubakar Tafawa Balewa, who would become the first (and last) prime minister after Nigeria's independence in 1960, while introducing the Antiquities Bill in 1953, argued that, in contrast to what had been imported,

> our antiquities and traditional arts are Nigerian.... [O]wing to the absence of written records, the old arts of Nigeria represent a large part of the evidence of our history, it is necessary to protect and preserve our history and artistic relics because of their importance to Nigeria and in order that our people today and in the future may study and get inspiration from them (in Folorunso 2011: 808).

Archaeology was put to work in the service of an emerging national identity. Decolonization did not mean a complete shift in the social base of archaeology everywhere, that is, on the professional basis of who was interested in archaeology, although, in addition to the amateurs, the professional basis of archaeology was widened. Professionals' nationality, however, was not homogeneous in the postcolonial world. The process of making archaeology a more scientific (and less amateurish) discipline, which had already begun in the nineteenth and early twentieth centuries with good examples in the colonial world (see Oulebsir 2004; Sengupta and Lambah 2012), also affected the colonial world and continued after independence. In some cases this only involved archaeologists from the country

itself, with Saudi Arabia (Zarins 2012) and China (Lai, this volume) being exam-ples of this process. In most cases, however, a few archaeologists from the former imperial power remained in place for some years, as happened in Morocco (Díaz-Andreu 2015: 62–63) and Nigeria (Sandelowsky 2011: 769–70).

THE INSTITUTIONALIZATION OF ARCHAEOLOGY IN POST-COLONIAL NATIONS

As explained in the first part of this chapter, the institutional basis of archaeolo-gy was established during the colonial period, although there was no fixed formu-la by which institutionalization took place. In some territories, museums were the first to be established, while in others it was a foreign school and or educational centers that were established at the start. Other developments related to institu-tionalization, such as legislation and specialist journals, also appeared in some areas earlier than in others. In parallel to the increasing professionalization of archaeology after independence, there was an expansion in the number of archae-ological institutions. The examples of India and Pakistan are a good illustration: after 1947, university education in archaeology was organized, specialized labora-tories such as those for radiocarbon dating were established, and a few archaeo-logical journals were founded. The last of these included *Pakistan Archaeology* (Government of Pakistan), *Ancient Pakistan* (Peshawar University), *Ancient India* (Government of India), *Indian Archaeology—A Review* (Government of India), *Ancient Nepal* (Government of Nepal), and *Puratattva—Bulletin of the Indian Archaeological Society and Man and Environment* (Indian Society for Prehistoric and Quaternary Studies) (Chakrabarti 1982: 339). At the end of the 1970s there was optimism about the health of the discipline: "Today there are few world areas of comparable size where knowledge of the ancient past is growing so rapidly and over so broad a geographical and chronological spectrum" (Jerome Jacobson in Chakrabarti 1982: 337).

In contrast to the above-mentioned dynamism, in sub-Saharan Africa (with the exception of the southern tip of the continent), the institutionalization of archaeology continued to be weak for several decades. The lack of native archae-ologists in the years immediately before and after decolonization explains why the initiative of scholars of European origin was so important in the establish-ment of archaeological institutions. This was the case of Kenya and to a certain point Tanzania, where the Kenyan-born son of British missionaries, Louis Leakey, and his wife Mary, were instrumental in establishing archaeology's aca-demic credentials (Lane 2012). From 1940, Leakey was curator of the Coryndon Museum in Nairobi, and it was there that he established the Centre for Prehis-

tory and Paleontology in 1962 (Murray 2001: 810). Academic archaeology was also developed in Nigeria after independence in 1960. In that country, institutes of African studies with provisions for archaeological research were established at the University of Ife, University of Ibadan, and University of Nigeria-Nsukka. However, archaeologists' power to impose salvage archaeology was minimal and much data were lost (Folorunso 2011: 808). In other poorer countries, such as Malawi, institutionalization was extremely weak, with understaffed museums, inadequate legislation, and no universities in which to train archaeologists (Juwayeyi 2011). This was also the case of Namibia under South African rule (Sandelowsky 2011). This institutional weakness was the reason for the establishment of foreign institutes that helped to provide a base for the archaeologists of the past imperial powers like the British Institute in Eastern Africa founded in Nairobi, Kenya, in 1960.

In some cases, the institutions founded in certain countries after decolonization reflected the events taking place in the Cold War. A very clear example of this is the two countries that resulted from the Korean War (1950–53). Although some of the institutions established during the years of Japanese dominion continued (see Pak, this volume), in North Korea, the newly created Institute of Korean Material Culture of 1952 was influenced by Soviet archaeology (Lee 2013). In South Korea, by contrast, scholars trained in the United States or American archaeologists interested in Korea played a key role in the development of archaeology (Nelson 2006: 48–51).

Decolonization in the imperial centers

Internal colonialism—that which was imposed on non-state societies by settlers and their descendants in areas as diverse as North America, northern Scandinavia, Japan, Russia, and Australia—was also profoundly weakened during the years of decolonization following World War II. During the years 1939–45, the mass extermination of Jews, Gypsies, and other groups by Germany's National Socialist government led, at the end of the conflict, to agreements that were intended to prevent similar policies in the future. One of the measures then adopted was the declaration of the Charter of Human Rights in 1948, which served as the basis for many social movements, including the civil rights movements of the 1950s and 1960s. Within this framework, so-called "action anthropology" emerged. This type of anthropology was committed to studying communities while assisting them with the practical issues that were major concerns in the community. Action anthropology was the idea of Sol Tax, a professor of anthropology at the University of Chicago (Stanley 1996; Wax 2008). He had an

active role in the organization of the Chicago American Indian Conference in 1961, in which Native Americans were given a voice for the first time. In it, discussion revolved around the policy of the United States towards their communities that had crystallized in the US-state "termination policy" or "policy cancellation." This policy assumed that American Indians were disappearing and voluntarily merging with the rest of the nation (Stanley 1996: S133). The acceptance of indigenous views in this conference and shortly afterward in other similar actions extended to other areas previously under the aegis of the British Empire, including Australia where the local section of ICOMOS (the International Council on Monuments and Sites) adopted the Burra Charter with Guidelines for the Conservation of Places of Cultural Significance in 1979. This charter, which has gone through several editions since the initial one, undermined the privileged elitist position held until then by non-native heritage managers. The spirit created by the Burra Charter has also been seen in discussions at the World Archaeological Congress since it was first held in 1986, and in the book series *One World Archaeology* that emerged from it. Most of the measures related to the decolonization of internal colonialist archaeology, including new legislation and institutions, have been taken up in North America (see Colwell, this volume), Australia (see McGrath, this volume) and New Zealand, and many other countries, including those in Latin America, are now following suit.

CONCLUSIONS

This chapter has presented an overview of the relationship between imperialism and archaeology in the last two hundred years. Two major periods have been identified, the first covering the nineteenth century and the first decades of the following century, and the second from World War II, leaving the interwar period between the First and Second World Wars as a hinge epoch between imperialism and the post-colonial era. Following a brief summary of the main historical events related to the topic under analysis in each of these two periods, the discussion of imperial and post-colonial archaeology has been structured into three main axes: the institutionalization of archaeology, the human base of such activities, and the ideology of imperial and post-colonial archaeologies.

Several types of imperialism have been proposed here, including formal imperialism or colonialism, in which a state has political control over territories beyond its frontiers. In this type of imperialism, most, if not all, archaeologists come from the imperial power. In the case of informal imperialism, control is not (at least overtly) political and, therefore, individuals or representatives of different nations may compete for control of the past, its archaeological monuments,

and narratives. A final type of imperialism is informal colonialism, in which settlers from state societies, or their descendants, inhabit an area with non-state communities, and become interested in the region's archaeology. As explained above, the imposition of the imperial view of the past, in which colonized people were considered inferior, was not always carried out by force. Instead the archaeological institutions established organized exhibitions and published books and articles that created narratives and discouraged alternative views of the past as unauthorized.

Imperial archaeology was an ideological by-product of nationalism. This explains why, after decolonization, little effort was needed to transform existing archaeological narratives of the newly-created states into ones that served nationalist objectives. As shown above, the professionalization of archaeology continued in the new political framework, including in non-state ethnic communities in countries like the United States and Australia. The professionalization of members of these communities is one of the latest steps taken in the universalization of the language of the past as a way of legitimizing group identity. The only reaction against this use of the past has emerged recently in the actions of the so-called Islamic State, with the destruction of important archaeological sites such as Palmyra and the murder of a leading archaeologist associated with the remains (Shaw 2015). Only time will tell whether their actions will be followed by others, but for the moment they seem to be an isolated reaction against archaeology as a useful source of identity creation and social stability.

REFERENCES CITED

Aguirre, R. D.
 2012 The Work of Archaeology: The Maudslays in Late Nineteenth-Century Guatemala. In *Entangled Knowledge: Scientific Discourses and Cultural Difference*, edited by K. Hock and G. Mackenthun, pp. 229–46. Waxmann Verlag, Münster.
Alexandropoulos, Jacques
 2003 Regards sur l'impérialisme de la Rome antique en Afrique du Nord. In *Idée impériale et impérialisme dans l'Italie fasciste. Journée d'étude organisée par le groupe ERASME le 4 avril 2003 à Toulouse*, edited by A. Bianco and P. Foro, pp. 7–19. Collection de l'E.C.R.I.T. 9. Université de Toulouse-Le Mirail, Toulouse.
Anderson, Margaret, and Andrew Reeves
 1994 Contested Identities: Museums and the Nation in Australia. In *Museums and the Making of "Ourselves": The Role of Objects in National Identity*, edited by F. E. S. Kaplan, pp. 79–124. Leicester University Press, Leicester.

Ardouin, Claude Daniel (editor)

 1997 *Museums and Archaeology in West Africa*. Smithsonian Institution Press, Washington, DC.

Bacha, Myriam

 2008 La constitution d'une notion patrimoniale en Tunisie, XIXe–XXe siècles: émergence et apport des disciplines de l'archéologie et de l'architecture. In *Chantiers et défis de la recherche sur le Maghreb contemporain*, edited by P.-R. Baduel, pp. 159–78. Karthala-IRMC, Paris-Tunis.

 2013 *Patrimoine et monuments en Tunisie*. Presses Universitaires de Rennes, Rennes.

Banton, Michael

 1969 Social Aspects of the Race Question. In *Four Statements on the Race Question*, edited by UNESCO, pp. 17–29. United Nations Educational, Scientific and Cultural Organization, Paris. Available at unesdoc.unesco.org/images/0012/001229/122962eo.pdf.

Barkan, Elazar

 1992 *The Retreat of Scientific Racism: Changing Concepts of Race in Britain and the United States between the World Wars*. Cambridge University Press, Cambridge.

Barton, Ruth

 2003 "Men of Science": Language, Identity and Professionalization in the Mid-Victorian Scientific Community. *History of Science* 41: 73–119.

Basak, Bishnupriya

 2011 Collecting Objects: Situating the Indian Collection (1884–1945) in Pitt Rivers Museum, Oxford. *Studies in History* 27(1): 85–109.

Baumgart, Winfried

 1982 *Imperialism: The Idea and the Reality of British and French Colonial Expansion, 1880–1914*. Oxford University Press, Oxford.

Berg, I.

 2013 Dumps and Ditches. Prisms of Archaeological Practice on Kalaureia in Greece. In *Making Cultural History: New Perspectives on Western Heritage*, edited by A. Källén, pp. 173–83. Nordic Academic Press, Lund.

Bernal, Ignacio

 1980 *A History of Mexican Archaeology*. Thames and Hudson, London.

Bhabha, Homi K.

 1994 *The Location of Culture*. Routledge, London.

Callmer, Johann, Meyer, Michael, Struwe, Ruth, and Theune-Vogt, Claudia (editors)

 2006 *The Beginnings of Academic Pre- and Protohistoric Archaeology (1830–1930) in a European Perspective*. Berliner Archäologische Forschungen 2. Verlag Marie Leidorf, Berlin.

Clémentin-Ojha, Catherine, and Pierre-Yves Manguin
 2006 *A Century in Asia: The History of the Ecole Française d'Extrême-Orient, 1898–2006*. Editions Didier Millet/Ecole française d'Extrême-Orient, Singapore.
Coye, Noël
 1993 Préhistoire et Protohistoire en Algérie au XIXe siècle: les significations du document archéologique. *Cahiers d'Études Africaines* 33(1): 99–137.
Chakrabarti, Dilip K.
 1982 The Development of Archaeology in the Indian Subcontinent. *World Archaeology* 13: 326–43.
Deichmann, F. W.
 1986 *Vom internationalen Privatverein zur Preussischen Staatsanstalt. Zur Geschichte des Instituto di Corrispondenza Archeologica*. Verlag Philipp von Zabern, Mainz.
Delanty, Gerard, and Krishnan Kumar (editors)
 2006 *The SAGE Handbook of Nations and Nationalism*. Sage, London.
Dennell, Robin
 1990 Progressive Gradualism, Imperialism and Academic Fashion: Lower Palaeolithic Archaeology in the 20th Century. *Antiquity* 64: 549–58.
Díaz-Andreu, Margarita
 2007 *A World History of Nineteenth-Century Archaeology: Nationalism, Colonialism and the Past*. Oxford Studies in the History of Archaeology. Oxford University Press, Oxford.
 2008 Revisiting the 'Invisible College': José Ramón Mélida in Early 20th Century Spain. In *Histories of Archaeology: Archives, Ancestors, Practices*, edited by N. Schlanger and J. Nordbladh, pp. 121–29. Berghahn Books, Oxford.
 2015 The Archaeology of the Spanish Protectorate of Morocco: A Short History. *African Archaeological Review* 32(1): 49–69.
Díaz-Andreu, Margarita, and Timothy Champion
 1996 Nationalism and Archaeology in Europe: An Introduction. In *Archaeology and Nationalism in Europe*, edited by M. Díaz-Andreu and T. Champion, pp. 1–23. UCL Press, London.
Dietler, Michael, and Carolina López Ruiz (editors)
 2007 *Colonial Encounters in Ancient Iberia. Phoenician, Greek and Indigenous Relations*. University of Chicago, Chicago.
Djojonegoro, Wardiman
 1998 The History of the National Museum. In *Indonesian Art: Treasures of the National Museum, Jakarta*, pp. 12–29. Periplus, Periplus Editions, Jakarta.
Earle, Robert
 2008 *The Return of the Native: Indians and Mythmaking in Spanish America, 1810–1930*. Duke University Press, Durham, NC.

Effros, Bonnie
 2012 *Uncovering the Germanic Past: Merovingian Archaeology in France, 1830–1914.* Oxford Studies in the History of Archaeology. Oxford University Press, Oxford.

Eldem, Edhem
 2004 An Ottoman Archaeologist Caught between Two Worlds: Osman Hamdi Bey (1842–1910). In *Archaeology, Anthropology and Heritage in the Balkans and Anatolia: The Life and Times of F. W. Hasluck, 1878–1920,* Vol. 1, edited by D. Shankland, pp. 121–49. Isis Press, Istanbul.

En-Nachioui, El Arby
 1995 Las primeras excavaciones en Volubilis (Marruecos): ¿arqueología, historia o simple colonización? *Pyrenae* 26: 161–70.

Engel, A. J.
 1983 *From Clergyman to Don: The Rise of the Academic Profession in Nineteenth-Century Oxford.* Clarendon Press, Oxford.

Fiskesjö, Magnus, and Xingcan Chen
 2004 *China before China: Johan Gunnar Andersson, Ding Wenjiang, and the Discovery of China's Prehistory.* Monograph 15. Museum of Far Eastern Antiquities, Stockholm.

Florescano, Enrique
 1993 The Creation of the Museo Nacional de Antropología de México and Its Scientific, Educational and Political Purposes. In *Collecting the Pre-Columbian Past,* edited by E. H. Boone, pp. 81–104. Dumbarton Oaks Research Library and Collection, Washington, DC.

Folorunso, Caleb Adebayo
 2011 The Practice of Archaeology in Nigeria. In *Comparative Archaeologies: A Sociological View of the Science of the Past,* edited by L. R. Lozny, pp. 807–26. Springer, New York.

Gänger, Stefanie
 2014 *Relics of the Past: The Collecting and Study of Pre-Columbian Antiquities in Peru and Chile, 1837–1911.* Oxford University Press, Oxford.

Gerrard, Chris
 2003 *Medieval Archaeology. Understanding Traditions and Contemporary Approaches.* Routledge, London.

Gran-Aymerich, Évelyne
 1998 *Naissance de l'Archéologie Moderne, 1798–1945.* Centre National de la Recherche Scientifique, Paris.

Gras, Michel
 2010 *A l'école de toute l'Italie: Pour une histoire de l'Ecole française de Rome.* Collection de l'École Française de Rome, vol. 431.

Hobsbawm, Eric J.

 1990 *Nations and Nationalism since 1780: Programme, Myth, Reality.* Cambridge University Press, Cambridge.

ICOMOS

 1979 *The Burra Charter.* ICOMOS, Paris. Available at http://australia.icomos.org/publications/burra-charter-practice-notes/burra-charter-archival-documents.

Jensen, O. W.

 2004 Earthy Practice: Towards a History of Excavation in Sweden, in the 17th and 18th Centuries. *Current Swedish Archaeology* 12: 61–82.

Juwayeyi, Yusuf M.

 2011 Excavating the History of Archaeology in Malawi. In *Comparative Archaeologies: A Sociological View of the Science of the Past,* edited by L. R. Lozny, pp. 785–806. Springer, New York.

Kaulicke, Peter, Manuela Fischer, Peter Masson, and Gregor Wolff (editors)

 2010 *Max Uhle (1856–1944): Evaluaciones de sus Investigaciones y Obras.* Fondo Editorial de la Pontificia Universidad Católica del Perú, Lima.

Klindt-Jensen, Ole

 1975 *A History of Scandinavian Archaeology.* Thames and Hudson, London.

Kocka, Jürgen

 2010 *Writing the History of Capitalism.* German Historical Institute, Washington, DC.

Lahiri, Nayanjot

 2000 Archaeology and Identity in Colonial India. *Antiquity* 74: 687–92.

Lane, Paul

 2012 East Africa. In *The Oxford Companion to Archaeology.* Oxford University Press, New York.

Lee, Hyeong Woo

 2013 The Politics of Archaeology in North Korea: Construction and Deterioration of Toh's Knowledge. *International Journal of Historical Archaeology* 17: 401–21.

Lyons, Claire L., and John K. Papadopoulos (editors)

 2002 *The Archaeology of Colonialism.* Getty Research Institute, Los Angeles.

Malarkey, James

 1984 The Dramatic Structure of Scientific Discovery in Colonial Algeria: A Critique of the Journal of the Société archéologique de Constantine (1853–1876). In *Connaissances du Maghreb: sciences sociales et colonisations,* edited by J.-C. Vatin, pp. 137–60. Recherches sur les Sociétés Méditerranées. Centre National de la Recherche Scientifique, Paris.

Mattingly, David J.

 1996 From One Imperialism to Another: Imperialism and the Magreb. In *Roman Imperialism: Post-Colonial Perspectives,* edited by J. Webster and N. Cooper, pp.

49–70. Leicester Archaeology Monographs 3. School of Archaeological Studies, University of Leicester, Leicester.

Mitchell, Peter J.

1998 The South African Stone Age in the Collections of the British Museum: Content, History and Significance. *South African Archaeological Bulletin* 53: 26–36.

2001 Andrew Anderson and the Nineteenth Century Origins of Southern African Archaeology. *Southern African Humanities* 13: 37–60.

Montón Subías, Sandra, María Cruz Berrocal, and Apen Ruiz (editors)

2015 *Archaeologies of Early Modern Spanish Colonialism.* Springer, New York.

Mosse, George L.

1988 *The Culture of Western Europe: The Nineteenth and Twentieth Centuries.* Westview Press, Boulder and London.

Mulvaney, D. John

1987 Patron and Client: The Web of Intellectual Kinship in Australian Anthropology. In *Scientific Colonialism: A Cross-Cultural Comparison,* edited by N. Reingold and M. Rothenberg, pp. 55–77. Smithsonian Institution, Washington, DC.

Murray, Tim (editor)

2001 *Encyclopedia of Archaeology: History and Discoveries,* Vol. II. ABC-CLIO, Santa Barbara, CA.

Nelson, Sarah M.

2006 Archaeology in the Two Koreas. In *Archaeology of Asia,* edited by M. T. Stark, pp. 17–36. Blackwell Studies in Global Archaeology. Blackwell, Oxford.

Norman, Geraldine

1997 *The Hermitage: The Biography of a Great Museum.* Jonathan Cape, London.

O'Connor, Anne

2005 The Competition for the Woodwardian Chair of Geology: Cambridge, 1873. *British Journal for the History of Science* 38(4): 437–61.

Oulebsir, Nabila

2004 *Les usages du patrimoine: Monuments, musées et politique coloniale en Algérie (1830–1930).* Fondation de la Maison des sciences de l'homme, Paris.

Randsborg, Klaus

1994 Ole Worm: An Essay on the Modernization of Antiquity. *Acta Archaeologica* 65: 135–69.

Reid, Donald M.

1985 Indigenous Egyptology: The Decolonization of a Profession. *Journal of the American Oriental Society* 105: 233–46.

Sandelowsky, Beatrice H.

2011 The Status of Archaeology and Anthropology in Southern Africa Today: Namibia as Example. In *Comparative Archaeologies: A Sociological View of the Science of the Past,* edited by L. R. Lozny, pp. 769–84. Springer, New York.

Sauvy, A.

1961 *Le "Tiers-Monde": Sous-développement et développement. Travaux et documents.* Cahier no 39. Les Presses Universitaires de France, Paris.

Schnapp, Alain

1996 *The Discovery of the Past.* British Museum Press, London.

Sengupta, Gautam, and Abha Narain Lambah

2012 *Custodians of the Past: 150 Years of the Archaeological Survey of India.* Archaeological Survey of India, Ministry of Culture, Government of India, New Delhi.

Shaw, Wendy

2015 Destroy Your Idols. *X-tra: Contemporary Art Quarterly* 18(1): 73–94.

Shepherd, Nick J.

2003 'When the Hand That Holds the Trowel Is Black...': Disciplinary Practices of Self-representation and the Issue of 'Native' Labour in Archaeology. *Journal of Social Archaeology* 3: 335–52.

Shipman, Pat

2004 *The Evolution of Racism: Human Differences and the Use and Abuse of Science.* Harvard University Press, Cambridge, MA.

Singh, Upinder

2004 *The Discovery of Ancient India: Early Archaeologists and the Beginnings of Archaeology.* Permanent Black, New Delhi.

Smith, Anthony D.

1991 *National Identity.* Penguin, London.

South, Stanley (editor)

1994 *Pioneers in Historical Archaeology.* Plenum Press, New York.

Stanley, Sam

1996 Community, Action, and Continuity: A Narrative Vita of Sol Tax. *Current Anthropology* 37(Special Issue: Anthropology in Public): S131–37.

Stein, Gil J. (editor)

2005 *The Archaeology of Colonial Encounters: Comparative Perspectives.* School of American Research, Santa Fe, NM.

Urry, James

1993 *Before Social Anthropology. Essays on the History of British Anthropology.* Harwood Academic Publishers, Philadelphia.

van der Bosch, Lourens P.

2002 *Friedrich Max Müller: A Life Devoted to the Humanities.* Studies in the History of Religions 94. Brill, Leiden.

Varouhakis, V.

2015 "*L'archéologie enragée*: Archaeology and National Identity under the Cretan State (1898–1913)." PhD diss., University of Southampton.

Vialet, Amélie

 2011 L'IPH sur le terrain: Une mission paléontologique française en Chine. In *Cent ans de préhistoire: L'Institut de paléontologie humaine*, edited by H. D. Lumley and A. Hurel, pp. 165–72. CNRS, Paris.

Vian, Paolo (editor)

 1992 *Speculum Mundi*. Centro internazionale di ricerche umanistiche, Unione Internazionale degli Istituti di Archeologia, Storia e Storia dell'Arte in Roma, Presidenza del Consiglio di Ministri, Rome.

Volodina, Tatyana

 2001 At the Sources of the "National Idea" in Russian Historiography. *Social Sciences* 32(3): 64–76.

Wax, Dustin M.

 2008 Organizing Anthropology: Sol Tax and the Professionalization of Anthropology. In *Anthropology at the Dawn of the Cold War: The Influence of Foundations, McCarthyism, and the CIA (Anthropology, Culture and Society)*, edited by D. M. Wax, pp. 133–42. Pluto Press, Ann Arbor, MI.

Wallace-Hadrill, Andrew

 2001 *The British School at Rome: One Hundred Years*. British School at Rome, London.

Webster, Jane, and N. Cooper (editors)

 1996 *Roman Imperialism: Post-colonial Perspectives*. School of Archaeological Studies, University of Leicester, Leicester.

Whitfield, Susan

 2004 *Aurel Stein on the Silk Road*. British Museum, London.

Wienberg, Jes

 2014 Historical Archaeology in Sweden. *Post Classical Archaeologies* 4: 447–70. www.postclassical.it.

Wright, Gwendolyn

 1996 National Culture under Colonial Auspices: The École Française d'Extrême-Orient. In *The Formation of National Collections of Art and Archaeology*, edited by G. Wright, pp. 127–42. National Gallery of Art, Washington, DC.

Zarins, Juris

 2012 Arabia and the Persian Gulf. In *The Oxford Companion to Archaeology* edited by Neil Asher Silberman, pp. 88–91. 2nd ed. Oxford University Press, New York.

German Archaeology in Occupied Eastern Europe during World War II: A Case of Colonial Archaeology?

Hubert Fehr

COLONIAL ARCHAEOLOGY AS AN ANALYTICAL CONCEPT

What is "colonial archaeology"? There are three ways to answer this question. The first meaning refers to a field of archaeology, which deals with the material remains of past and recent empires. This field has already proved to be very fruitful and has yielded a vast number of remarkable scholarly works, including Gosden (2004), Lyons and Papadopoulos (2002), and Stein (2005), to mention just a few.

The next approach takes political context as a starting point. From this perspective, colonial archaeology is a collective term for those archaeological activities that are conducted in a colonial setting and/or by archaeologists from colonial regimes. On an analytical level colonial archaeology, from this point of view, corresponds to "national" and "imperialist" archaeology. Starting from Bruce Trigger's paradigmatic paper from 1984, this approach has stimulated an impressive series of publications, too (e.g., Díaz-Andreu 2006; Trigger 1984, 2006; see also Díaz-Andreu, this volume). Nonetheless it sometimes seems that the analytical potential of this approach is limited since colonial archaeology quite often is not very different from archaeology conducted in remote parts of the metropole, meaning that colonial archaeology represents a specific form of center–periphery relations. Additionally, the distinction among national, colonial, and imperialist archaeologies often turns out to be rather diffuse, since there are many transitional stages between these general ideological concepts (see Díaz-Andreu, this volume).

While fully acknowledging the potential of the first two approaches, this paper will follow the third option, that is, to define colonial archaeology with regard to content. In this respect colonial archaeology represents a certain way of conducting archaeological work and interacting with local archaeologists and archaeological monuments. In other words, it is primarily defined as a practice and attitude, and therefore can even occur outside typical colonial contexts in a political sense.

A set of characteristic traits of colonial archaeology relating to its content is identified by analyzing a rather extreme example: German archaeologists working in the occupied parts of Eastern Europe during World War II. The choice of this example might seem idiosyncratic, since we normally do not designate phenomena within Europe as "colonial." However, as the historian Jürgen Zimmerer has observed, this narrow view itself is a relic of colonial and Eurocentric thinking, which limits the use of the terms "colonies" and "colonialism" by definition to areas outside of Europe. Within Europe, scholars prefer to speak of "occupation" and "conquest" (Zimmerer 2005: 199–202), even if the phenomena are structurally the same.

Starting from Edward Said's seminal work on "Orientalism" (Said 1978), research in recent decades has successfully uncovered colonialist thinking in modern Western scholarship. More recently this led to post-colonial approaches, which seek to overcome the problematic intellectual legacy of colonialism. While these schools of thought in the field of archaeology have been successfully integrated both in theoretical considerations (e.g., Gosden 2001) and in practical application (e.g., Webster and Cooper 1996), it is especially the wide array of current approaches that makes it necessary to give a more specific definition of colonialism before taking a closer look at my case study.

Recent scholarship agrees that colonialism is a complex phenomenon, compromising a large variety of different forms. Because of this, a rather broad definition will be used here. In his theoretical outline of colonialism, the historian Jürgen Osterhammel gives the following definition:

> Colonialism is a relationship of domination between an indigenous (or forcibly imported) majority and a minority of foreign invaders. The fundamental decisions affecting the lives of the colonized people are made and implemented by the colonial rulers in pursuit of interests that are often defined in a distant metropolis. Rejecting cultural compromises with the colonized population, the colonizers are convinced of their own superiority and of their ordained mandate to rule (Osterhammel 2005: 17–18).

Starting from this definition, Osterhammel points out three principal traits of colonialism. The first is an extreme asymmetry of power between colonizer and

colonized, in which not only individual people and certain groups but entire societies are "robbed of their historical line of development, externally manipulated and transformed according to the needs and interests of the colonial rulers" (Osterhammel 2005: 15). The second is the supposed or actual cultural dissimilarity between colonizers and colonized, in which the colonizers are convinced of their superiority and refuse any forms of cultural fusion with the colonized. The third important trait is that colonialism refers not only to political and economic realities, but also bears an ideological dimension, such as a specific interpretation of the relationship between groups (Osterhammel 2005: 15–16).

From a theoretical point of view, colonialism is not necessarily linked to the existence of colonies. Colonialism occurred without colonies as well as colonies without colonialism (Osterhammel 2005: 17). Against this theoretical background it seems logical that in the last decade historiography has identified colonialist elements in German politics during World War II more and more frequently.

While some scholars highlight the fact that the broad application of the term "colonialism" also diminishes its value as an analytical tool (Cooper 2005: 26–27, 47), it seems clear already that the application of the "colonial paradigm" has meant a substantial gain for understanding the German expansion during World War II (Kühne 2013: 340). This is especially true for those parts of occupied East Central and Eastern Europe that suffered most from the German occupation, especially Poland, the Baltic states, Belarus, and Ukraine—regions that Timothy Snyder (2010) tellingly calls the "Bloodlands." Several pioneering studies have been published, especially on German colonial aspirations toward Poland (see, e.g., Furber 2004; Kopp 2012), but also more general studies on occupied Eastern Europe (see, e.g., Baranowski 2011).

NATIONAL SOCIALIST GERMANY AND COLONIALISM

National Socialist Germany had an ambivalent attitude toward both traditional European and German colonialism. On the one hand, most German elites experienced the loss of the German colonies in sub-Saharan Africa, Asia, and Oceania enforced through the Treaty of Versailles (1918) as a national humiliation that needed to be reversed as soon as possible. On the other hand, parts of the Nazi elite were highly critical of traditional colonialism of the pre–World War I, Wilhelmine era. This outlook owed in large part to Adolf Hitler, who expressed strong disapproval of older German colonialism in his programmatic book *Mein Kampf*, written in the 1920s. In it, Hitler argued that Germany should try to gain new territory ("Lebensraum") in Eastern Europe rather than wasting resources overseas. To this end, Hitler announced that he would break with pre–World

War I foreign policy after his rise to power (Hitler 2016: 1654–57). Despite Hitler's rejection of traditional colonialism, important factions in German society continued to favor the objective of regaining the lost colonies (Linne 2008). However, they were forced to soften their propaganda since the regime's priorities were directed toward expansion in Eastern Europe.

In general the heritage of German colonialism before World War I had a twofold effect on German occupation policies during World War II. On the one hand, the negative image of Wilhelmine-era involvement in Africa and Asia caused the German occupiers some hesitation in openly calling their conquests in Eastern Europe an "act of colonialism"; on the other hand, it has been argued recently that the pre-war colonial experience contributed considerably to the brutal practices employed during the occupation of Eastern Europe during World War II. In particular, the genocide German colonial forces committed against the Herero and Nama in modern-day Namibia from 1904 to 1907 has recently been considered a precursor of the European genocidal politics of World War II (Zimmerer 2011). Other scholars refute this theory and point out the more general background of Nazi politics in European colonialism (Kühne 2013). Recent historical research has also shown that certain elements of the colonial attitude among German intellectuals toward Eastern Europe date back to the mid-nineteenth century (Kopp 2011), and thus long before the establishment of German colonies abroad.

WORLD WAR II AS A COLONIALIST (AND IMPERIALIST) WAR

This study opens with a comparison of the development of archaeology in certain occupied countries in East Central and Eastern Europe—especially Poland and the Soviet Union—with German policy in occupied territories in the west and north of Europe. Inspired by the historical interpretation asserting that National Socialist Germany actually fought two different wars during World War II, this approach starts from the premise that while German expansion into western and northern Europe resembled much in the tradition of imperialist wars, its conquests in the east clearly showed characteristic attributes of colonialism (Herbert 2014: 428–35).

To avoid any misinterpretation, it should be stressed that this "imperialist way" of occupation also led to horrific crimes against inhabitants of occupied countries, starting with Jewish citizens, who were robbed and exterminated in the course of the Holocaust. Victims also included those identified as "gypsies," homosexuals, communists, priests, members of resistance groups, and many more. In general, however, the National Socialist regime did not regard the entire

population of occupied territories as hostile and racially inferior. In particular, the populations of allegedly "Germanic" countries such as Denmark, the Netherlands, and Norway, were regarded as part of the "Germanic family." Similarly, the inhabitants of France and Belgium were considered to be closely related to the German people. Because of this perspective, regimes of the German occupation tried to influence local populations in favor of Germany and National Socialism, such as seeking volunteers for "Germanic" units within the Waffen-SS (Fig. 2.1).

Another principal objective was to exploit economic resources of the occupied countries with the least effort possible. As already mentioned previously in Osterhammel's theory, colonizers typically stress the fundamental dissimilarity between them and the colonized. This attitude, and the political consequence resulting from it, can be clearly recognized in the general outline of the German occupation regime in East Central and Eastern Europe. The German Reich planned and started to expel and even annihilate the existing population and to replace it with residents of German ethnicity. While this kind of colonialism was also planned for some regions in occupied Western Europe, in particular parts of Western France like Burgundy, similar plans in East Central and Eastern Europe went much further and had begun even during the war. According to a long-term plan of National Socialism, the war in the east should be a fight for *Lebensraum*. In other words, the main objective of the assault on Poland and thereafter the Soviet Union was to conquer and acquire vast territories, where German colonists could settle. According to the ideological concept of the *Ostraum* (Eastern space), Germans were a "people without space" (*Volk ohne Raum*), meaning

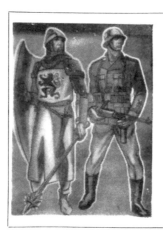

FIGURE 2.1. Propaganda for the Flemish division of the Waffen-SS, published in Belgium in 1943. From *De Vlag* (1943) 6: 10.

that they allegedly did not have sufficient territory and natural resources necessary for further growth; it was thought that the newly conquered territories would ensure the prosperity of the German people well into the future.

The name given by the National Socialist regime to the so-called Reichsprotektorat Böhmen und Mähren (Protectorate of Bohemia and Moravia) after the forced division of Czechoslovakia in March 1939 suggests a colonial attitude, similar to the so-called Generalgouvernement (General Government), which the German Reich created in Central Poland in October 1939. Hans Frank, the first notorious chief of administration in the Generalgouvernement, argued that all his policies were led by the "will of the Führer that this territory will be the first colony of the German nation" (Herbert 2014: 399).

Although Nazi leaders occasionally used the term "colony" in this context, colonialism in the traditional sense neither formed a central part of their ideology, nor was the establishment of "colonies" an important objective of their occupation policies. The establishment of colonial regimes in the occupied territories was thought rather to be an intermediate stage in the process of gaining new "living space" for the German people and extending the German Reich further toward the east. In a speech to members of the SS in November 1942, Heinrich Himmler put it this way: "Today colony, tomorrow settlement area, and the day after tomorrow: part of the Reich" (Reichsführers SS 1942).

To a certain extent, these plans were put into practice. According to the ideology of *Heim ins Reich* (back to the Reich), German-speaking minorities in several parts of Europe, who were living there sometimes for many centuries, were motivated to leave their homes. Coming from the Baltic states, southwest Russia, and Romania, in addition to South Tyrol, they were encouraged to settle in newly conquered territory, thus transforming these areas into German land. In Western Europe, for example, during a brief period in 1940, Burgundy was considered a new homeland for former inhabitants of South Tyrol. After the invasion of the Soviet Union in summer 1941, however, the plan was changed again: now Crimea was considered their new homeland.

A much worse fate was endured by various populations in Poland after September 1939 and inhabitants of the western parts of the Soviet Union after summer 1941. According to the Molotov-Ribbentrop pact from September 1939, Poland was divided into three parts. First, the western regions of Poland with Poznán and Łodz were annexed to the Reich. Second, certain central regions including Warsaw and Cracow were transformed into the *Generalgouvernement*, ruled by German officers. Third, the eastern parts of Poland, which today belong to Ukraine and Belarus, became part of the Soviet Union until the invasion in 1941, when Germany started to expand its colonial politics even farther east.

It is clear that the main obstacle to these settlement politics was the resident population. For this reason, German authorities not only started to expel tens of thousands Polish citizens (Herbert 2014: 399), but they also murdered large numbers of people regarded as racially inferior, among these millions of Jews. This politics of expulsion and annihilation continued after invasion of the Soviet Union. Right from the start, for example, German authorities planned to augment the rations of their invasion troops with food produced on the conquered land. They even considered exporting it to the Reich—in full awareness that this would lead to the death of large numbers of the resident population (Herbert 2014: 433–35). Soviet prisoners of war thus received insufficient amounts of food from their German captors, leading, in addition to other cruelties, to the death of about 2.7 million captured Soviet soldiers during the war (Herbert 2014: 444–45).

Protagonists: German Archaeological Institutions during World War II

To understand the dynamics of archaeological politics during the war, it is necessary to outline at least briefly the institutional structure of German archaeology. It consisted, on the one hand, of institutions that predated the Nazi period. Apart from archaeological museums and regional departments for archaeological heritage management, which were crucial to archaeological research from the nineteenth century, the German Archaeological Institute (DAI) played a central role. Founded in the first half of the nineteenth century, the DAI maintained branch institutes in several countries of Southern Europe and the Near East. Originally dedicated to the study of classical archaeology, it came under pressure during the Nazi period because of its focus on classical antiquity and its alleged neglect of the study of Germanic antiquity (Vigener 2012: 67–70). Members of the DAI were active during the war especially as members of the archaeological branch of the *Militärischer Kunstschutz des Heeres* (Art Protection Service of the German Army) (Fehr 2013). This institution, however, existed only in those occupied countries that were governed directly by a German military administration, including France, Belgium, Serbia, Greece, and, from 1943, Italy. In addition, there were two newly founded National Socialist institutions. These included the Reichsbund für Deutsche Vorgeschichte, which was led by prehistorian Hans Reinerth (Schöbel 2002). This institution was a branch of the so-called Kampfbund für Deutsche Kultur, led by Alfred Rosenberg who regarded himself as an intellectual mentor of National Socialism (Piper 2005). On the other hand, there was the Ahnenerbe (Inherited from the Forefathers), an organization closely affiliated

with the SS. Its preeminence owed to the fact that Heinrich Himmler, head of the SS, was very interested in Germanic prehistory and a variety of esoteric ideas that were closely related to this field (Longerich 2010: 265–308).

By 1936–37, Rosenberg's and Reinerth's attempts to gain control over all archaeological institutions in Germany had already failed, mainly because of Reinerth's arrogant manner of claiming power. The Ahnenerbe, in contrast, became increasingly influential over the same time period. Because of this imbalance of power, it has been argued repeatedly and convincingly, that Rosenberg and Reinerth had lost the fight for supremacy in German archaeology even at this early phase of the German Reich.

After Germany started the war, however, Reinerth and his limited number of followers became quite influential again. One characteristic feature of the Nazi state was a great variety of competing state and party institutions with overlapping fields of activity. Rosenberg was also the head of the foreign office of the Nazi party, and thus had influence over cultural policy in the occupied territories of Western Europe. The so-called Einsatzstab Reichsleiter Rosenberg (Reich-Leader Rosenberg Taskforce) actively looted "Jewish" art collections. Additionally, in July 1941, Hitler appointed Rosenberg as Reichsminister für die besetzten Ostgebiete (Reich Minister of the Occupied Eastern Territories). This position made him head of the German civil administration in the so-called Reichskommissariat Ostland (in the Baltic states and Belarus) and Reichskommissariat Ukraine (namely in the Ukraine and neighboring parts of Russia). Because of this position, Reinerth and his followers had free rein in Eastern Europe, while their opponents of the Ahnenerbe initially were in a position of strategic disadvantage. Himmler and his ever-growing SS empire, however, were active in various military and police/ terror duties. Furthermore, Hitler named Himmler Reichskommissar zur Festigung des Deutschen Volkstums (Reich Commissioner for the Consolidation of German Nationhood), which put him in charge of all plans concerning the "Germanization" of Eastern Europe. Himmler interpreted this position quite broadly; he regarded archaeological research about alleged ancient Germanic remains in Eastern Europe as part of his mandate. Himmler, however, sought to avoid too much direct confrontation with Rosenberg. Because of this, Ahnenerbe archaeologists working in East European countries usually limited their activities to areas in proximity to the frontline because these territories were not under the authority of Rosenberg's civil administration (Mahsarski 2011: 236, 271–72).

In summary one can say that German archaeology in the occupied territories was characterized by the fierce rivalry between old and new institutions, especially the DAI, the Einsatzstab Reichsleiter Rosenberg, and the Ahnenerbe. In many

respects, this tension also reflected a colonial attitude. Namely, archaeological heritage of occupied territories seems to have been regarded primarily as war booty, with all stakeholders trying to secure the largest share for themselves.

Key Historical Concepts of the National Socialist Regime

As previously mentioned, a key point of colonialism was maintaining the notion of cultural (and racial) dissimilarity between the colonizers and the colonized. Together with other historical disciplines, archaeology played an important role in this context. For instance, archaeological evidence was used on the one hand to show the different background and the allegedly low cultural standards of the Eastern European, primarily Slavonic, population. On the other, German archaeologists were intensively investigating the remains of ancient German tribes who once lived in the conquered space; in this way they contributed to the ideological justification of the colonialist venture.

Several historical arguments were employed to justify the colonial aspirations of the German Reich, and were supported by evidence taken from archaeology, together with history, linguistics, physical anthropology, and folklore studies. The main argument was based on a combination of linguistic and racial theories: the alleged "Nordic race" was regarded as most valuable. German scholars frequently argued that all cultural achievements in European history owed to early migrations of members of the Nordic race to the south. The supposed first wave of migration from the north was dated to the Neolithic period. They attributed both Greek and Roman civilizations, but also, for example, those of the ancient Hittites in Anatolia, to the Nordic race.

The period after the end of the Western Roman Empire, the so-called migration period, occupied an important place for German scholars: they argued that in this period, Germanic tribes not only defeated the Roman Empire but also managed to settle large parts of Europe. They were represented by the Vandals, Goths, and Suebi on the Iberian Peninsula and in North Africa; Anglo-Saxons in Britain; Franks and Burgundians in France; Lombards in Italy; and the Goths in modern Crimea and southern Russia. They argued that during the migration period, a first "Germanic" Europe, dominated by northern warriors, had existed, and now Nazi Germany sought to establish it again. Politically this argumentation—and alleged archaeological proof for it—was useful because it suggested that large parts of the population of Western Europe were of Germanic descent. Following this line of thought, some scholars argued, for example, that not only French-speaking inhabitants of Wallonia in southern Belgium were actually Germanic, but also large parts of the population of northern France (Fehr 2010: 365–86) (Fig. 2.2).

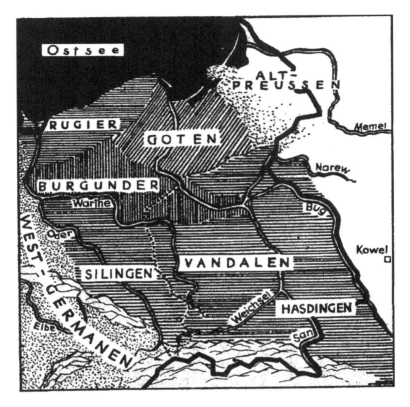

FIGURE 2.2. Map of then-current territory of Poland. Alleged settlement areas of Germanic tribes in the Late Roman period. From *SS-Leitheft* (1942) 6: 9.

Another politically important epoch was the Viking Age. Archaeological evidence of this period was used to demonstrate shared ancestry of the German people and inhabitants of Scandinavia, an area where Nazi Germany intensively tried to recruit volunteers for the "Germanic" units of the Waffen-SS. In Eastern Europe, by contrast, German scholars often followed the old, nineteenth-century "Norman theory"—developed during the late eighteenth century, this theory argued that emergence of states in Slavic areas was exclusively caused by Northern migrants, particularly in Russia during the age of Kievan Rus, in Poland during the Piast dynasty, and among the Czech under the reign of the first Přemyslids (Rohrer 2012: 50–53). During the nineteenth century, this theory was fiercely critiqued by "anti-Normanist" Russian scholars. In the twentieth century, archaeological evidence played a growing role in the debate, which sometimes even today is overshadowed by nationalism (Melnikova 2013). Considering the

political context, it was significant that German scholars in East European countries were eager to find archaeological traces of Viking influence (on the archaeological evidence, see, e.g., Duczko 2004). However, one has to bear in mind that the "Norman theory" on the origin of East European states was popular not only in Germany, but predominant among Western scholars in the mid-twentieth century (Riasanovsky 1947).

At the same time, German scholars were quite ready to argue that their local colleagues were deliberately suppressing archaeological evidence. One example of this is a visit by Herbert Jankuhn, a specialist in North European early historic archaeology and the most prominent archaeologist in the Ahnenerbe, to Prague in December 1941. In his report to the Ahnenerbe about a visit to an archaeological excavation at Prague castle, Jankuhn reasoned that the oldest layers at the site from the eleventh century as well as a warrior burial of the same period showed the original Germanic character of the site. He accused the Czech archaeologists of not publishing these finds for political reasons in order to suppress evidence for "Germanic and German influence" at the center of the Přemyslid dynasty (Jankuhn 1941).

GERMAN AND LOCAL ARCHAEOLOGISTS: COLLABORATION AND RESISTANCE

Maintaining the colonialist idea of cultural dissimilarity was especially problematic for German scholars when confronted with their local colleagues. German archaeologists working in occupied European countries were regularly in contact with local archaeologists and archaeological institutions working on the same professional level as they were. In many cases, they had been in professional communication with their colleagues for a long time before the war. During the war, there was a wide range of ways in which relations between German archaeologists and their local colleagues mutated in varying degrees as a result of the conflict. In some cases, such relations remained nearly unchanged even during the war; a well-researched example for this is the renowned Dutch settlement archaeologist Albert Egges van Giffen, in whose vast correspondence hardly any trace can be found that the Netherlands had been occupied by the German army (Eickhoff 2002: 564–73). In a few cases, local archaeologists fully supported Nazi archaeology for ideological reasons, and even took part in their archaeological excavations in Eastern Europe. A well-known example is again from the Netherlands, the Leiden prehistorian Frans Christiaan Bursch, who participated in an SS excavation in occupied Ukraine in 1943 (Eickhoff 2002: 567). Such cases, however, were quite rare. It is notable that most of these archaeologists

came from Western countries rather than from Eastern Europe, and then, only from Allied countries like Hungary. The most important Russian archaeologist who supported German research was of German descent: Mikhail Miller, a specialist in ancient history and archaeology from Rostow University (Mahsarski 2011: 261; Modl 2012: 74–75). It is likely that the small number of Eastern European collaborators was not because local archaeologists were uninterested in National Socialism, but rather because the Nazi institutions were willing to accept only colleagues from allegedly race-close Germanic countries as equal partners. Many local archaeologists in Eastern Europe lost their jobs or were forced to work as menial staff for German archaeologists.

On the opposite side of the spectrum were those archaeologists who had been in deep opposition to the nationalistic tendencies of German archaeology in the pre-war period, and whose lives were in real danger following the start of the German occupation. The most prominent example of this was the Polish prehistorian Józef Kostrzewski, who had taught at Poznán University before World War II. After the occupation of Poland, he fled from Poznán and was forced to live underground with a fake identity, always in fear that the Gestapo would catch him. His personal library was confiscated immediately. Kostrzewski, however, managed to continue his scientific work, writing several books that were published after the war (Makiewicz 2002: 522).

FATE OF UNIVERSITIES AND RESEARCH INSTITUTIONS

According to Osterhammel's definition introduced previously in this chapter, one characteristic feature of colonialism is that the colonizers prohibit any independent development of colonized society, making certain that important decisions are made in the metropolitan center or by institutions controlled by the colonial power. In the field of archaeology this primarily affected research institutions, especially universities, on the one hand, and institutions entrusted with the protection of archaeological monuments, on the other.

From the colonizers' viewpoint, control over archaeological records and their historical interpretation was also important since, as Osterhammel points out, it always included an ideological dimension. During World War II in Eastern Europe, archaeological sources were used in two ways. First, they were used to prove the idea of German superiority in comparison to the indigenous Slavic population, and second, to provide a historical justification for the German expansion toward Eastern Europe.

Moreover, the comparison of this case with development in occupied Western and Northern Europe shows the colonialist particularity of the German

occupation regime in the east. In the realm of higher education, it is possible to see a clear distinction between Western and Eastern Europe. In occupied Eastern Europe, academic life nearly came to a complete end. In Czechoslovakia, the Czech Charles University in Prague, with its well-established chair for prehistoric archaeology, was closed a couple of months following the German invasion in March 1939. Only the German Charles University in Prague, where a chair for prehistoric archaeology had first been established in 1929, continued to operate. In addition, most museums as well as the state office for the protection of monuments were taken over by German archaeologists, with only a limited number of local scholars permitted to remain in their posts (Motyková 2002: 474–75).

In Poland, all universities were closed by force, and there was no plan to reopen them after the war. This was true not only for Poznán University, whose archaeological department with Józef Kostrzewski, was regarded as the main center of anti-German tendencies in Polish archaeology, but also for the universities of Warsaw and Kraków. Indeed, faculty members of the famous Jaggelionian University in Kraków were all captured in November 1939 and many were sent to concentration camps (Mączyńska 2002: 513–14). Instead, German authorities opened the German-language Reichsuniversität Posen at Poznán, which also possessed a chair for prehistoric archaeology (Makiewicz 2002: 527–30).

In Western Europe, the situation was completely different. Most universities in the occupied Western countries continued to function during the German occupation. An interesting case is the University of Ghent in Belgium, which had been a center of critical historical research on Germany before 1939. Instead of closing the university, as was done in Eastern Europe, the German administration forced the university to accept a number of German "guest professors" like the prehistorian Kurt Tackenberg from Bonn, who was intended to influence the students and faculty staff in a pro-German direction (Fehr 2010: 502–13).

There is only one exception to the general continuity of university teaching in the occupied territories in the west: the University of Strasbourg in Alsace, which had been German-speaking before World War I. Due to the proximity of Strasbourg to the German border, its faculty fled to central France after the war began. After the invasion of France in spring 1940 and following the annexation of Alsace-Lorraine, German authorities not only prevented the faculty from returning to Strasbourg but also began to establish a new German university. The Reichsuniversität Straßburg was equipped with a chair in prehistoric archaeology and one for "West European" (i.e., Roman) archaeology (Fehr 2010: 494–96). Because the exiled members of the Université de Strasbourg continued to teach and conduct research in central France, German authorities first tried to urge the Vichy Regime to close what remained of the institutions. Subsequently,

they instituted such objectives by force and sent some of the faculty members to concentration camps.

Another way to gain influence over local academia was to establish new research institutes. Again, it seems that German authorities were much more cautious about doing so in Western Europe than in Eastern Europe. In the summer of 1941, for example, there was a debate within the German Archaeological Institute as to whether it should open a branch in Paris. This plan, however, was dropped quickly because leading members of the DAI were afraid that French scholars would interpret the establishment of such an institute as provocation (Fehr 2010: 430). One of the archaeologists working in Paris for the Kunstschutz, Wilhelm Schleiermacher, in particular, spoke against exploiting the occupation for this purpose. He argued that it was rather necessary to focus on the post-war period, when a good working relationship with local researchers would be much more valuable that an institute in Paris that would be nothing other than a "thorn in the side of French research" (Schleiermacher 1940).

In Eastern Europe, by contrast, German scholars did not feel the same need to restrain themselves. The most important research facility established there was the Institut für Deutsche Ostarbeit (Institute for Eastern German Research), which was founded in Kraków in April 1941. Located in the buildings of the closed university, it hosted a large number of German scholars and several local assistants. Among the several departments established for natural sciences and humanities, there also was a department for prehistoric archaeology, led by the prehistorian Werner Radig (Schweizer-Strobel and Strobel 2004: 242–51).

ROBBERY OF ARCHAEOLOGICAL COLLECTIONS AND FINDS AND CONTROL OF EXCAVATIONS

Concerning the treatment of archaeological collections, great differences between west and east existed in German policies. In western and northern Europe, German authorities generally respected the public property of archaeological artifacts. This approach does not mean that there was no looting of cultural property—quite the contrary, as the Einsatzstab Reichsleiter Rosenberg robbed a great number of works of art which were owned by Jewish citizens. However, this seems not to have been the case with archaeological finds, as most archaeological collections in western and northern Europe were not privately owned but the property of public museums or local archaeological societies. The military administration even tried to secure them both from destruction and looting by German troops. However, the archaeological branch of the abovementioned Kunstschutz

was not very successful with this assignment. It could not, for example, protect important megaliths of Brittany from destruction since they were used for fortification projects of the German military (Perschke 2014: 118–32).

As I have already shown elsewhere, the prime motive for the German occupation forces to establish the Kunstschutz in western Europe was the experience of World War I, when Allied propaganda successfully denounced German forces as "Vandals" and "barbarians" (Fehr 2010: 417–29). During World War II, the German military tried to avoid providing Allied media with good opportunities to do so again. Additionally, they resisted provoking unnecessary trouble among the local population. That does not mean that they had no plans to claim archaeological finds from Western Europe for Germany. However, this phase of absorption was postponed until the time after the German *Endsieg* (final victory). One member of the Kunstschutz in Paris, the classical archaeologist Hans Möbius, was even assigned to compile a list of archaeological objects in French museums that originated from Germany and should be claimed back after the end of the war (Maischberger 2002: 216).

In contrast, in Eastern Europe, German authorities and archaeologists began looting archaeological collections immediately after the German conquest. On this wide-ranging topic, there is room to mention only a few examples here. The so-called Kommando Paulsen, for example, gained notoriety for looting archaeological and other art collections in Poland in the first weeks after the German occupation. Led by a specialist for Viking Age archaeology, Peter Paulsen, this SS-Kommando was sent to Poland in order to "secure" archaeological artifacts (Mężyński 2000). The basis for their work was a list of archaeological institutions in Poland that previously had been compiled by the prehistorian Ernst Petersen from Breslau, and which was given to the general secretary of the Ahnenerbe in mid-September 1939 (Mężyński 2000: 26–33). The SS-Kommando Paulsen became notorious for their aggressive techniques. On November 9, 1939, clad in black SS uniforms, they arrived at the National Archaeological Museum at Warsaw, and started packing archaeological finds without telling the museum staff who they were and without signing receipts for the confiscated objects. The museum staff were not informed beforehand of the intruders' identity, much less the time and date of their arrival; thus they had no idea who removed the most valuable parts of their collection (Pietrowska 2004: 264–65). In the report about the looting, Paulsen argued that they concentrated on "Germanic and closely related material"; in some cases, however, such as the Late Antique golden medallion from Boroczyce, finds were taken just because they were valuable (Mężyński 2000: 61).

The ruthless behavior of German archaeologists in this case was fostered by their perception of this museum as especially hostile towards German

archaeology. With obvious satisfaction, the activity report of the Kommando mentioned that they confiscated the most valuable parts of the National Archaeological Museum in Warsaw, which had been "one of the most important and active devil's workshops against Germany" (Mężyński 2000: 61). The chaotic plundering of Polish museums came to an end after establishment of the Generalgouvernement. The head of administration, Hans Frank, prohibited further looting, not because he intended to protect the local cultural heritage but rather because he felt that it would diminish his authority if other Nazi institutions removed art objects from his sphere of control.

After the consolidation of German administration in Poland, the exploitation of archaeological monuments and artifacts gained a new dimension. First, German scholars took over important excavations for which local archaeologists' scientific interpretations did not fit their ideological orientation; there is no known similar case in occupied Western Europe. The most significant example in this context is Józef Kostrzewski's famous excavation at Biskupin, which had gained international attention before the war (see, e.g., Kostrzewski 1938). Polish archaeologists of the pre-war period had interpreted the Late Bronze and Early Iron Age settlement at Biskupin of the so-called Lusatian culture as proto-Slavic, which German scholars had refuted vehemently with regard to Biskupin Lusatian culture in general. In order to gain control of Biskupin, the Ahnenerbe took over the site and launched another excavation campaign in 1942 (Pietrowska 1997/98: 265–70). They even tried to change the name of the site by inventing the new, artificial German name "Urstätt" (Schleiff 1942).

Concerning the ambivalent attitude toward colonialism mentioned previously, an article in the journal *SS-Leithefte*, which was used for ideological instruction of all SS members, is quite revealing. The article titled, "The settler in the East is not a colonist," argued:

> Everybody who is settling in the Eastern space is plowing on sacred soil! It can happen ... that [a settler's] ... plowshare releases a proof for this, ... much more conclusive than parchment and paper. A piece of evidence of old Germanic settlement in the East. We have such evidence in the form of archaeological finds that document Germanic title to Eastern soil clearly and visibly to the whole world: everybody who is settling in the East is not a colonist, but rather the heir of our fathers, who ... had to give way from this ground because of lack of land or because wanderlust drove them away and there was no Reich to guard them by sword (Anonymous 1942: 6–7) (Fig. 2.3).

Developments similar to those that occurred in Poland in late 1939 took place in the summer of 1941 in occupied parts of the Soviet Union. More than

Unser schönes deutsches Ostland

FIGURE 2.3. Map of then-current territory of Poland:
"Our beautiful German eastern land." *SS-Leitheft* (1942) 6: 17.

in Poland, but similar to the situation that occurred in occupied France, the circumstances here were characterized by rivalry between Reinerth and Rosenberg on one side and members of the Ahnenerbe on the other. As already indicated, the Sonderstab Vorgeschichte (Special Task Force for Prehistory) and the Einsatzstab Reichsleiter Rosenberg were in a strong position because of the role of Alfred Rosenberg as Reichsminister für die besetzten Ostgebiete (Reich Minister for the Occupied Eastern Territories). Based on this authority, members of this governmental entity formed several teams of archaeologists in various parts of the occupied Soviet Union. Their main task was to "secure" archaeological collections and conduct rescue excavations. In a few cases, they carried out research

excavations. Members of the Sonderstab also published articles about "Germanic" finds in Ukraine and gave special attention to Viking-Age finds from Kiev (see, e.g., Rada 1943).

In the first phase of its activity, the Sonderstab Vorgeschichte did not transport archaeological finds to Germany. However, after the fortunes of the German army definitively declined in the winter of 1943–44, they started to move large quantities of artifacts to the Reich via Lvov and Kraków. Most objects came from the rich collections in Kiev and Dnjepropetrowsk. In addition to hundreds of boxes of finds, German authorities seized archaeological books, photographs, and archival records. Only a part of these collections could be secured by American forces after the war and subsequently returned to the Soviet Union (Heuss 2002: 549–50).

By contrast, Reinerth's and Rosenberg's rivals from the Ahnenerbe limited their activities to the hinterland of the frontlines; they were especially interested in Crimea and adjoining parts of Ukraine and Russia where the SS-Sonderkommando Jankuhn (SS Special Task Force Jankuhn) was active in 1942 and 1943. The commando, which consisted of prehistorians Herbert Jankuhn, Walter Kersten, and Wolf von Seeberg, looked for archaeological collections that they confiscated and sent to the Reich. They looted in much smaller quantities than Rosenberg's archaeologists. Most of the twenty-seven boxes of artifacts and the cargo of a truck that they sent to Berlin were lost and have not since been located. In particular, they paid special attention to the allegedly "Gothic finds" in Crimea and its vicinity. To their disappointment, however, they discovered that Soviet authorities had already transported the most valuable objects to secure places farther east in the Soviet Union. Much of the documentation, however, had been left at the museums; these materials have been lost since this period, and their absence continues to hinder research on the finds even today.

This special interest in "Gothic" finds north of the Black Sea had a much more specific background than just the typical interest of German archaeologists in all allegedly "Germanic" finds: German authorities planned to establish a large German colony in Crimea, as already mentioned above. This idea was put forward by the so-called Generalplan Ost (Master Plan East), which had been developed on behalf of Heinrich Himmler. The most complete final draft of this plan, compiled by the Berlin agrarian scientist Konrad Meyer, was finished in July 1942 (Heinemann 2006: 45–72). It described plans to transform Crimea and the neighboring Chersones territory into a Gotengau (Gothic district), including the resettlement here of German-speaking inhabitants from South Tyrol and the renaming of the cities of Simferopol as "Gotenburg" and Sevastopol as "Theoderichshafen." It is obvious that all activities of the SS-Sonderkom-

mando Jankuhn must be seen in the context of this plan, in which Heinrich Himmler himself had great interest. Himmler visited the Crimea for this reason in October 1942 (Mahsarski 2011: 265–70).

The excavation by the Ahnenerbe in Solonje near Dnjepropetrowsk in July 1943 belongs to the same political context. In this case, the actual excavation work was conducted not by members of the Sonderkommando themselves but by colleagues from other European countries, in particular Frans Christiaan Bursch and Willem de Boone from the Netherlands and Mikhail Miller from Ukraine, who collaborated with the help of twenty Soviet prisoners of war (Mahsarski 2011: 271–72).

During their mission in Ukraine and southern Russia, the Sonderkommando Jankuhn closely collaborated with the SS "Wiking" Division, which partly consisted of volunteers from occupied "Germanic" countries; it was also provided with assistance from the Sonderkommando 11b of the Einsatzkommando D of the SD (Security Service), who, at least in one museum at Maikop in the northern Caucasus region, helped members of the Sonderkommando Jankuhn to pack up archaeological finds. In addition, the Sonderkommando 11b generally arranged the transportation for the Sonderkommando. In their work, the Sonderkommando Jankuhn came very close to sites of mass murder; indeed, during the same period members of the Einsatzkommando were responsible for mass killings of Jews in the areas directly behind the frontline (Pringle 2006: 224–26).

Organization of Archaeological Heritage Management, Publications, and Exhibitions

As previously mentioned, the German authorities needed to maintain a functioning system of archaeological heritage management in order to exploit archaeology for political purposes. This was the only way to obtain a systematic overview of the archaeological sources potentially at their disposal. Additionally, they wanted to be prepared if archaeological artifacts were uncovered unexpectedly during the course of various projects. One challenge in maintaining such a system was that the institutions only worked successfully if local specialists were involved, at least initially. It is important to note that in several occupied countries, German authorities encountered well-established state authorities for the protection of archaeological monuments, especially in Denmark, Norway, and the Netherlands, but also in Czechoslovakia and Poland.

Although Western and East Central Europe were not essentially different regarding the state of archaeological heritage management, German authorities dealt with existing infrastructure in the two regions very differently. In Western

European countries, local authorities mostly stayed in office; in Norway, even the Riksantikvar Harry Fett, whom German occupiers thought was Jewish, kept his position during the war, although none other than Herbert Jankuhn suggested that he should be removed from his position (Aavitsland 2014: 469–505). The general strategy seems to have been to try to gain influence over the heads of such departments, and thus to get access to local archaeology resources. It is clear that German policy was not intended to destroy these well-functioning systems. In particular, the occupiers refrained from putting German scholars directly in charge of local archaeological institutions.

In this context, France and Belgium are interesting cases: neither country had centralized state authorities for the protection of archaeological monuments before the war. In both cases German authorities tried to develop such institutions—for political reasons, of course. In Belgium, the archaeological department at Musée Cinquantenaire took over the responsibility for all archeological sites, led by the Brussels archaeologist Jacques Breuer. It was even kept secret that this step was suggested by the German occupation forces; in public the idea was maintained that this step was taken independently by Belgian authorities (Fehr 2010: 487–91). Further plans, especially concerning the enactment of a law on excavations, however, were not realized (Beyen 2013: 425–30).

In France, domestic archaeology was traditionally conducted by local archaeological societies, which did not want central institutions from Paris to interfere in their respective spheres of influence. In September 1941 and January 1942, the Vichy government issued two laws, named after the education minister of the Vichy government, Jérôme Carcopino, which completely reorganized archaeology in France. According to the first law, formal permission was required before starting an excavation. The second law created a commission of the Centre national de la recherche scientifique (CNRS), which was in charge of all archaeological activities.

The political background of the Carcopino laws is a matter of debate among scholars. Some scholars stress the collaborationist character of the Vichy regime, and suggest that the Carcopino laws were inspired by German authorities (see Olivier 1998: 243–50; Perschke 2014: 102–103). Other scholars point to the fact that Carcopino and some of his close collaborators were already concerned with the problem of protecting the monuments before the war, and just used the opportunity under the Vichy regime to establish a legal framework, which had not been possible previously (Corcy-Debray 2003; Reboul 2009: 121–23). While it has not been possible to prove that the German authorities actually fostered the creation of the Carcopino laws like they did in Belgium, it is clear these laws were welcomed by officials of the German occupation. One occasion shows this very

clearly: the laws of the Vichy France applied only to the central and southern parts of France, which were controlled by the Vichy government, but not to German-occupied northern and western France. However, in October 1941 the German military administration explicitly allowed the first Carcopino law to be applied in occupied France as well (Corcy-Debray 2003: 331).

In contrast, in Eastern Europe German authorities completely took over archaeological heritage management. In most occupied territories, they created entirely new institutions with German scholars as staff. Normally these institutions were organized as Ländesämter für Vorgeschichte. The first of these was created in Poznán in August 1940 (Makiewicz 2002: 523). In the Generalgouvernement, the Institut für Deutsche Ostarbeit in Kraków took over this function in 1941 (Schweizer-Strobel and Strobel 2004: 245). The last two new archaeological institutions were finally founded in 1942: the Bezirksamt für die Vor- und Frühgeschichte Weißrutheniens in Minsk (Engel 1943; Gasche 2005) and, in November 1942, a Landesinstitut für Bodendenkmalpflege in Kiev (Mahsarski 2011: 271). In these institutions, local archaeologists were employed in minor positions, both because their knowledge was indispensable and there were not enough German scholars to occupy all positions.

Another striking difference between West and East may be observed in archaeological publications. In Western Europe, archaeological journals continued to be published in local languages. In some cases, even archaeological monographs with more or less subtle pro-German propaganda were published in local languages, such as in Belgium (De Maeyer 1944). In France, German authorities not only fostered the reorganization of domestic archaeology, but they also did not prevent the foundation of a new archaeological journal with a nationwide focus as a result of the Carcopino laws. The first volume of the journal *Gallia*—still one of the most prestigious journals of French archaeology—was published in 1943. From the first issue, it published articles on archaeological sites in Vichy France, as well as archaeological activities in the German-occupied zone.

In Eastern Europe, all publications in local languages were terminated. Following the conquest, in Warsaw, German authorities found the nearly complete sixteenth volume of the *Wiadomości Archeologiczne*, the scientific journal of the State Archaeological Museum. Since the contributions, which included a *Festschrift* for Joszéf Kostrzewski, contained reports on many hitherto unpublished finds, the German authorities decided to publish it, amended with a foreword that denounced the allegedly Slavo-centric content of the papers. On the front page of the journal, the Polish name of the journal was translated into German as *Archäologische Nachrichten* (Archaeological News). Also the word *Schlußband* (Final Volume) was added, indicating that there would be no further

volumes of the journal (Pietrowska 2004: 265–67) (Fig. 2.4). Instead of contin-
uing to publish existing journals in local languages in the Eastern parts of
Europe, new, German-language journals were created, such as the *Posener
Jahrbuch für Vor- und Frühgeschichte* (Poznań Yearbook for Pre- and Proto-histo-
ry) and *Altböhmen und Altmähren* (Ancient Bohemia and Moravia).

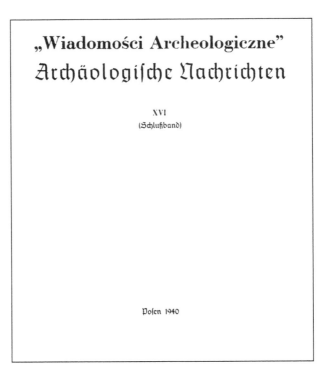

FIGURE 2.4. Title page of journal *Wiadomości
Archeologiczne* (1940), vol. 16.

The last examples in this context are the sponsorship of propaganda-driven
exhibitions of archaeology during the war. In Western Europe, such exhibitions
were aimed at a local audience with the objective of trying to win over citizens to
the Nazi cause. For this goal, it was necessary to address the population in their
own language. Thus, the texts in the exhibition *Deutsche Größe* (German Great-
ness), shown in Brussels in 1942, for example, were written in three languages:
German, French, and Flemish (Gob 2007). By contrast, similar exhibitions like
the *Germanerbe im Weichselraum* (Germanic Heritage in the Vistula Region)
shown in Kraków were exclusively made for German visitors and had texts writ-
ten only in German (Radig 1941) (Fig. 2.5).

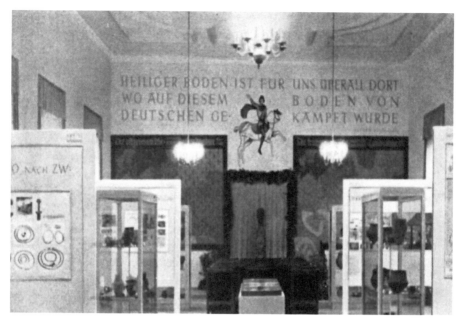

Figure 2.5. Exhibition of "Germanic Heritage in the Vistula Region," Kraków 1941.
From *Germanen-Erbe* (1941): 188, fig. 4.

In occupied Ukraine, the Einsatzstab Reichsleiter Rosenberg displayed an archaeological exhibition at Dnepropetrovsk exclusively addressed to the members of the German forces, providing them with the historical background of their military endeavor (Modl 2012: 74). There seems to have been little interest among German authorities to win over the local population to revisionist narratives through archaeological exhibitions.

Conclusion

The starting point for this paper was the recent trend in historiography to apply the term "colonialism" to the German expansion toward Eastern Europe during World War II. On the one hand, in order to grasp the specific colonialist element in this process, this paper refers to the theoretical outline of colonialism developed by Jürgen Osterhammel. On the other hand, this study systematically compares the development in Eastern Europe with events in occupied Western and Northern Europe—that is, areas where the German occupation regime more closely followed the traditional model of imperialist wars.

This comparison has shown several particularities related to the field of archaeology that can be linked to a colonialist attitude. All three characteristic traits of colonialism can be recognized in German archaeological activities in occupied Eastern Europe. More specifically, the typical asymmetry of power shows in the way the German occupation regime dealt with local archaeological institutions, which were either subordinated to the control of German authorities or replaced by newly founded institutions with German personnel.

The idea of fundamental dissimilarity between Germans and the local populations also affected the field of archaeology in two respects. On the one hand, archaeological sources were used to show the alleged cultural and racial difference between the ancient Germans and the Slavic populations of Eastern Europe. On the other, it became obvious in the ruthless way that several German archaeologists dealt with local archaeologists and archaeological collections—more than a few German archaeologists blatantly ignored all traditional rules of respect, which had been common within the scientific community.

Finally, the archaeological contribution to the ideological dimension of colonialism affected primarily two fields. Archaeology was used in the attempt to bolster German sovereignty by giving historical justification for the colonialist enterprise—paradoxically, it was argued that archaeological sources proved that the newly conquered land had once been German and thus rightfully belonged to the German Reich. In a second line of argumentation, the archaeological sources were used to argue that the alleged cultural and racial inferiority of the indigenous Slavic population had very deep historical roots—in this respect the German conquest of East Central and Eastern Europe was configured as an important project for the spread of civilization.

REFERENCES CITED

Aavitsland, Kristin Bliksrud
 2014 *Harry Fett. Historien er lengst.* Pax Forlag, Oslo.
Anonymous
 1942 Der Runenspeer von Kowel. Der Siedler im Osten ist kein "Kolonist". *SS-Leitheft* 6: 6–10.
Baranowski, Shelley
 2012 *Nazi Empire: German Colonialism and Imperialism from Bismarck to Hitler.* Cambridge University Press, New York.
Beyen, Marnix
 2013 Hoffnungen, Leistungen, Enttäuschungen—deutsche Archäologen in Belgien während des Zweiten Weltkriegs 1940–1944. In *Archäologie und Bodendenk-*

malpflege in der Rheinprovinz 1920–1945, edited by Jürgen Kunow, Thomas Otten, and Jan Bemmann, pp. 423–32. Amt für Bodendenkmalpflege im Rheinland, Bonn.

Cooper, Frederik

2005 *Colonialism in Question: Theory, Knowledge, History*. University of California Press, Berkeley.

Corcy-Debray, Stephanie

2003 Jérôme Carcopino et le patrimoine: une protection ambiguë. In *Pour une histoire des politiques du patrimoine*, edited by Philippe Poirrier and Loïc Vadelorge, pp. 321–34. Comité d'histoire du ministère de la culture, Paris.

De Maeyer, Robert

1944 *De strid om onzen boden. Een archeologisch onderzoek*. De Burcht, Brussels.

Díaz-Andreu, Margarita

2010 *A World History of Nineteenth-Century Archaeology: Nationalism, Colonialism, and the Past*. Oxford University Press, Oxford.

Duczko, Władysław

2004 *Viking Rus: Studies on the Presence of Scandinavians in Eastern Europe*. Brill, Leiden.

Eickhoff, Martijn

2002 Die politisch-gesellschaftliche Bedeutung der Archäologie während der deutschen Besetzung der Niederlande. Reflexionen am Beispiel von F. C. Bursch und A. E. van Giffen. In *Prähistorie und Nationalsozialismus. Die mittel- und osteuropäische Ur- und Frühgeschichtsforschung in den Jahren 1933–1945*, edited by Achim Leube and Morten Hegewisch, pp. 555–73. Synchron, Heidelberg.

Engel, Carl

1943 Ein Jahr Vorgeschichtsarbeit im Ostland. *Germanen-Erbe* 8: 1–10.

Fehr, Hubert

2010 *Germanen und Romanen im Merowingerreich. Frühgeschichtliche Archäologie zwischen Wissenschaft und Zeitgeschehen*. De Gruyter, Berlin and New York.

2013 Das Referat "Vorgeschichte und Archäologie" des Militärischen Kunstschutzes des Heeres in Belgien und Frankreich. In *Archäologie und Bodendenkmalpflege in der Rheinprovinz 1920–1945*, edited by Jürgen Kunow, Thomas Otten, and Jan Bemmann, pp. 401–10. Amt für Bodendenkmalpflege im Rheinland, Bonn.

Furber, David

2004 Near as Far in the Colonies: The Nazi Occupation of Poland. *The International History Review* 26: 541–79.

Gasche, Malte

2005 Die Vor- und Frühgeschichtsforschung im Reichskommissariat Ostland, 1941–1944. *Ethnographisch-Archäologische Zeitschrift* 46: 91–104.

Gob, André
 2007 Deutsche Grösse: Une exposition à la gloire de l'Empire allemand en 1942 à
 Bruxelles. In *L'archéologie nationale-socialiste dans les pays occupés à l'Ouest du
 Reich*, edited by Jean-Pierre Legendre and Laurent Olivier, pp. 337–49. Infolio
 Editeur, Gollion.
Gosden, Chris
 2001 Postcolonial Archaeology: Issues of Culture, Identity, and Knowledge. In
 Archaeological Theory Today, edited by Ian Hodder, pp. 241–61. Polity Press,
 Oxford.
 2004 *Archaeology and Colonialism: Cultural Contact from 5000 BC to the Present*. Cam-
 bridge University Press, Cambridge.
Heinemann, Isabel
 2006 Wissenschaft und Homogenisierungsplanungen für Osteuropa. Konrad Meyer,
 der "Generalplan Ost" und die Deutsche Forschungsgemeinschaft. In *Wissen-
 schaft, Planung, Vertreibung. Neuordnungskonzepte und Umsiedlungspolitik im 20.
 Jahrhundert*, edited by Isabel Heinemann and Patrick Wagner, pp. 45–72. Stei-
 ner, Stuttgart.
Heuss, Anja
 2002 Prähistorische Raubgrabungen in der Ukraine. In *Prähistorie und Nationalsozia-
 lismus. Die mittel- und osteuropäische Ur- und Frühgeschichtsforschung in den Jah-
 ren 1933–1945*, edited by Achim Leube and Morten Hegewisch, pp. 545–53.
 Synchron, Heidelberg.
Herbert, Ulrich
 2014 *Geschichte Deutschlands im 20. Jahrhundert*. C. H. Beck, Munich.
Hitler, Adolf
 2016 *Mein Kampf. Eine kritische Edition*, edited by Christian Hartmann, Thomas
 Vordermayer, Othmar Plöckinger, and Roman Töppel. 2 vols. Institut für Zeit-
 geschichte, Munich and Berlin.
Jankuhn, Herbert
 1941 Bericht über die Besichtigung der Ausgrabungen auf der Prager Burg, 12
 December. Bundesarchiv Berlin, BA BDC, File Herbert Jankuhn.
Kopp, Kristin
 2011 Gray Zones: On the Inclusion of "Poland" in the Study of German Colonialism.
 In *German Colonialism and National Identity*, edited by Michael Perraudin and
 Jürgen Zimmerer, pp. 33–42. Routledge, New York and London.
 2012 *Germany's Wild East: Constructing Poland as Colonial Space*. University of Michi-
 gan Press, Ann Arbor.
Kostrzewski, Józef
 1938 Biskupin: An Early Iron Age Village in Western Poland. *Antiquity* 12: 311–17.

Kühne, Thomas
 2013 Colonialism and the Holocaust: Continuities, Causations, and Complexities. *Journal of Genocide Research* 15: 339–62.

Linne, Karsten
 2008 *Deutschland jenseits des Äquators? Die NS-Kolonialplanung für Afrika.* Ch. Links, Berlin.

Longerich, Peter
 2010 *Heinrich Himmler: Biographie.* 2nd ed. Pantheon, Munich.

Lyons, Claire, and Papadopoulos, John K. (editors)
 2002 *The Archaeology of Colonialism.* Getty Research Institute, Los Angeles.

Mączyńska, Magdalena
 2002 Ur- und Frühgeschichte in Kraków in den Jahren 1933–1945. In *Prähistorie und Nationalsozialismus. Die mittel- und osteuropäische Ur- und Frühgeschichtsforschung in den Jahren 1933–1945*, edited by Achim Leube and Morten Hegewisch, pp. 511–516. Synchron, Heidelberg.

Mahsarski, Dirk
 2011 *Herbert Jankuhn (1905–1990): Ein deutscher Prähistoriker zwischen nationalsozialistischer Ideologie und wissenschaftlicher Objektivität.* Marie Leidorf, Rahden/Westfalen.

Makiewicz, Tadeusz
 2002 Archäologische Forschung in Poznán während des Zweiten Weltkriegs. In *Prähistorie und Nationalsozialismus. Die mittel- und osteuropäische Ur- und Frühgeschichtsforschung in den Jahren 1933–1945*, edited by Achim Leube and Morten Hegewisch, pp. 517–33. Synchron, Heidelberg.

Maischberger, Martin
 2002 German Archaeology during the Third Reich, 1933–1945: A Case Study Based on Archival Evidence. *Antiquity* 76: 209–18.

Melnikova, Elena
 2013 The "Varangian Problem": Science in the Grip of Ideology and Politics. In *Russia's Identity in International Relations: Images, Preceptions, Misperceptions*, edited by Ray Taras, pp. 42–53. Routledge, New York and Abingdon.

Mężyński, Andrzej
 2000 *Kommando Paulsen. Organisierter Kunstraub polnischer Kulturgüter während des zweiten Weltkriegs.* Dittrich, Cologne.

Modl, Daniel
 2012 Von den Menhiren der Bretagne zu den gotischen Gräbern im Dnjeprbogen— Walter Modrijan (1911–1981) und die archäologischen Unternehmungen des "Amtes Rosenberg" in Frankreich, der Ukraine und Italien zwischen 1940 und 1944. *Schild von Steier* 25: 62–93.

Motyková, Karla
 2002 Die Ur- und Frühgeschichtsforschung in Böhmen 1918–1945. In *Prähistorie und Nationalsozialismus. Die mittel- und osteuropäische Ur- und Frühgeschichtsforschung in den Jahren 1933–1945*, edited by Achim Leube and Morten Hegewisch, pp. 471–80. Synchron, Heidelberg.

Olivier, Laurent
 1998 L'archéologie française et le régime de Vichy (1940–1944). *European Journal of Archaeology* 1: 241–64.

Osterhammel, Jürgen
 2005 *Colonialism: A Theoretical Overview*, trans. Shelley L. Frisch. 2nd ed. Marcus Wiener Publishers, Princeton, NJ.

Perschke, Reena
 2014 Ausgrabungen und Zerstörungen an den Megalithen von Carnac während der deutschen Besatzung der Bretagne (1940–1944). *Archäologische Informationen* 37: 81–152.

Pietrowska, Danuta
 1997/98 Biskupin 1933–1996: Archaeology, Politics and Nationalism. *Archaeologia Polona* 35/36: 255–85.
 2004 The State Archaeological Museum in Warsaw during World War II. *Archaeologia Polona* 42:255–90.

Piper, Ernst
 2005 *Alfred Rosenberg: Hitlers Chefideologe*. Blessing, Munich.

Pringle, Heather
 2006 *The Master Plan: Himmler's Scholars and the Holocaust*. Hyperion, New York.

Rada, Hermann
 1943 Zeugen der Wikinger zu Kiew. *Germanen-Erbe* 8: 34–46.

Radig, Werner
 1941 Germanenerbe im Weichselraum. Ausstellung des Instituts für Deutsche Ostarbeit in Krakau. *Germanen-Erbe*: 186–90.

Riasanovsky, Nicholas
 1947 The Norman Theory of the Origin of the Russian State. *The Russian Review* 7: 96–110.

Reboul, Jean-Pierre
 2009 Genese et postérité des lois Carcopino. In *La fabrique de l'archéologie en France*, edited by Jean-Pierre Demoule and Christian Landes, pp. 120–33. La Découverte, Paris.

Reichsführers SS
 1942 "Heute Kolonie, morgen Siedlungsgebiet, übermorgen Reich." Manuscript of speech by Reichsführers SS, SS-Junkerschule Tölz, 23 November, pp. 180–90. Bundesarchiv Berlin, BA NS 19/409.

Reinhard, Wolfgang
 2008 *Kleine Geschichte des Kolonialismus*, 2nd ed. Alfred Körner, Stuttgart.
Rohrer, Wiebke
 2012 *Wikinger oder Slawen? Die ethnische Interpretation frühpiastischer Bestattungen mit Waffenbeigabe in der deutschen und polnischen Archäologie.* Herder Institut, Marburg.
Said, Edward
 1978 *Orientalism.* Pantheon, New York.
Schleiff, Hans
 1942 SS-Ausgrabung Urstätt im Warthegau. *Germanien:* 431–36.
Schöbel, Gunter
 2002 Hans Reinerth. Forscher—NS-Funktionär—Museumleiter. In *Prähistorie und Nationalsozialismus. Die mittel- und osteuropäische Ur- und Frühgeschichtsforschung in den Jahren 1933–1945*, edited by Achim Leube and Morten Hegewisch, pp. 321–96. Synchron, Heidelberg.
Schleiermacher, Wilhelm
 1940 Letter to Ernst Sprockhoff, 14 March. Archive of the Römisch-Germanische Kommission, Frankfurt am Main, Fasz. 1116/p. 470.
Schweizer-Strobel, Petra, and Strobel, Michael
 2004 Werner Radig: A Prehistorian's Career, 1928–1945. *Archaeologia Polona* 42: 229–45.
Stein, Gil J. (editor)
 2005 *The Archaeology of Colonial Encounters: Comparative Perspectives.* School of American Research, Santa Fe.
Snyder, Timothy
 2010 *Bloodlands: Europe between Hitler and Stalin.* Basic Books, New York.
Trigger, Bruce
 1984 Alternative Archaeologies: Nationalist, Colonialist, Imperialist. *Man* 19: 355–70.
 2006 *A History of Archaeological Thought*, 2nd ed. Cambridge University Press, Cambridge.
Trümpler, Charlotte (editor)
 2008 *Das große Spiel. Archäologie und Politik zur Zeit des Kolonialismus (1860–1940).* DuMont, Cologne.
Vigener, Marie
 2012 *"Ein wichtiger kulturpolitischer Faktor". Das Deutsche Archäologische Institut zwischen Wissenschaft, Politik und Öffentlichkeit, 1919–1954.* Marie Leidorf, Rahden/Westfalen.
Webster, Jane, and Cooper, Nicholas (editors)
 1996 *Roman Imperialism: Post-colonial Perspectives.* School of Archaeological Studies, Leicester.

Zimmerer, Jürgen

2005 The Birth of the Ostland Out of the Spirit of Colonialism: A Postcolonial Perspective on the Nazi Policy of Conquest and Extermination. *Patterns of Prejudice* 39: 197–219.

2011 *Von Windhuk nach Auschwitz? Beiträge zum Verhältnis von Kolonialismus und Holocaust.* LIT Verlag, Berlin.

SECTION II

COLONIALISM AND NATIONALISM

Colonialism and nationalism are two sides of the same coin. The latter is largely a response to, as well as conditioned by, the former. In this section, the three contributors explore the complex relationship among colonialism, nationalism, and related issues of cultural internationalism, cultural colonialism, and regionalism in the practices of archaeology and museum collecting in Nigeria, China, and Iran.

Using Britain's 1897 seizure of the Benin bronzes and ivories as a case study, Neil Brodie rebuts the notion of "cultural internationalism" that scholars such as John Merryman and James Cuno have constructed to legitimate the existence of encyclopedic museums and their claims to ownership of objects that were looted in the course of European imperial and colonial ventures. As Brodie clearly shows in this one incident alone, British invaders seized more than three thousand bronze and ivory artworks. Their subsequent sale in London was motivated by both political and commercial goals: to enforce British colonial rule, open Benin to Western trade, and cover expenses of the military expedition. In nineteenth-century colonial discourse, however, the savage sack of Benin was masked as a mission to suppress "savagery" and "superstition" and bring "civilization" to the people of Africa. Although Britain disapproved of French imperial spoilage and the foundation of the Musée Napoléon, international laws against the plunder of artworks in wartime did not prevent Britain from committing atrocities against the indigenous people of Benin, now modern Nigeria. Brodie unmasks the "cultural internationalism" of late twentieth-century encyclopedic museums as thinly

veiled nineteenth-century discourse justifying colonization under the guise of spreading the benefits of civilization.

In a similar vein, Guolong Lai discusses conflicts that impeded cooperation between the newly established Institute of History and Philology in Academia Sinica and the Freer Galley of Art in Washington, DC in the early stages of archaeological excavations at Yinxu, the last capital of China's first archaeologically attested dynasty. In his negotiations with the Chinese archaeologist Li Ji, the American archaeologist Carl Bishop used the rhetoric similar to "cultural internationalism" to cover up the imperialist practice of removing artworks from Chinese soil. However, Bishop's ambitious plan failed in large part because of the rise of nationalism in China after political unification in 1927. This chapter provides the intellectual and political background to the introduction of Western archaeology into China and the transition from imperial to national archaeology in modern China. Ironically, but not surprisingly, nationalist archaeologists adopted newly introduced Western "scientific" archaeology to fight both imperialism and regionalism.

Like China, Iran was never formally colonialized, but the dominance of Western imperialism was strongly felt and played out in the practice of archaeology throughout the reign of Reza Shah Pahlvi (1925–41). Based on a case study of Mohammad Reza Shah Pahlvi's (r. 1941–79) celebration in 1971 of the 2,500-year anniversary of the founding of the Persian Empire by Cyrus the Great, Talinn Grigor further illustrates the nationalist uses to which ancient ruins at Persepolis were dedicated in modern times. The extravagance of the Persepolis celebration ultimately undermined the political authority of the Pahlavi dynasty, contributed to the image of a corrupt monarch in the eyes of the Iranian masses, and helped catalyze the Islamic Revolution that ended the Pahlavi dynasty in 1979.

CHAPTER 3

Problematizing the Encyclopedic Museum: The Benin Bronzes and Ivories in Historical Context

Neil Brodie

European colonial expansion during the nineteenth century was accompanied by the large-scale acquisition and appropriation of cultural property from colonized territories for study and display in museums and art galleries. In 1897, in the newly occupied Benin City, in what was to become Nigeria, a British military expedition seized and subsequently sold more than 3,000 bronze and ivory artworks of ceremonial importance. This chapter employs the British invasion and plunder of Benin as a lens through which to examine the ways in which cultural discourse from the nineteenth through to the twenty-first centuries has shut down meaningful discussion about colonial misappropriations of cultural property. Despite the defeat of Napoleon in 1815 and the solidification of international opinion and later law against imperial spoliation—specifically, the seizure of artworks from around Europe by the French revolutionary and Napoleonic armies for curation and display at the Louvre—the changed norms of military conduct did nothing to stop the British at Benin, whose actions drew legitimacy from an international law that disempowered colonized people. The injustice of colonization and plunder was compounded in 1960 by Britain's failure to return the plundered material to Nigeria when the country achieved independence. The different historical strands in this chapter help to contextualize and critique early twenty-first century constructions of cultural internationalism and the encyclopedic museum, and to highlight the continuing discursive hold of those constructions on international understanding and policy in regard to the ownership of spoliated cultural property.

THE INVASION OF BENIN AND THE SACK OF BENIN CITY

In 1987, Liverpool Museum purchased a sixteenth-century copper-alloy (bronze) equestrian figure from a descendant of John Henry Swainson (Fig. 3.1), who had been a Liverpool trader active in the late nineteenth century on the Niger coast area of what is today Nigeria (Kingdon and van der Bersselaar 2008: 103). Swainson was presented with the figure as a gift by Oba Ovonramwen in 1892 when he visited the Oba in his capital of Benin City as part of a British diplomatic mission. The figure is unusual in that it was obtained peacefully and legitimately, unlike most of the Benin bronzes and ivories found in museums and private collections today, which were seized during the sack of Benin City by the British so-called punitive expedition of 1897. The figure is symbolic of a long-standing commercial relationship between the city of Liverpool and West Africa that was instrumental in causing the British invasion of Benin City. The diplomatic occasion celebrated by Oba Ovonramwen's gift to Swainson provided the pretext for the invasion.

During the nineteenth century, Liverpool, on the west coast of England, was a major commercial conduit of the British Empire (Haggerty et al. 2008). It had been the largest slaving port in Europe until the British and US governments outlawed the trans-Atlantic slave trade in 1807. In the aftermath of the slave trade, Liverpool merchants, with their intimate knowledge of the physical and political geographies of West Africa, were well placed to develop alternative "legitimate" trades. Foremost among them was the trade in oil palm (*Elaeis guineensis*) derivatives. Palm oil and palm kernel oil were increasingly in demand in Europe through the early decades of the nineteenth century, where they were important for machine lubrication, the production of candles for lighting, the manufacture of soap and, after 1870, margarine. By the second half of the nineteenth century, the organization of the palm oil trade was well established. African intermediaries or brokers arranged the transport of oil and kernels from producers inland to British merchants established in "factories" on the coast. The merchants then arranged shipment back to Britain. Demand and prices were starting to fall, however, as the Long Depression of 1873–1896 took hold and, more particularly, as mineral oils and new technologies such as electricity became more widely available (Hopkins 1968: 586; Lynn 1997: 117). To maintain a consistent level of profitability in those reduced circumstances, British merchants were under pressure either to develop new commercial strategies aimed at reducing costs or increasing the quantities of oil palm products traded, or to diversify and begin trading other raw materials. The commercial potential of rubber, for example, was beginning to be understood. Because the organization of the palm

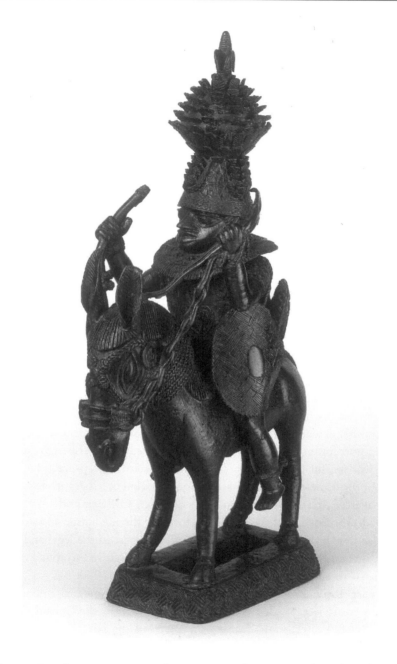

Figure 3.1. Bronze equestrian figure presented to Liverpool trader John Henry Swainson by Oba Ovonramwen in 1892. Reproduced by permission of the Liverpool World Museum.

oil trade within West Africa remained largely in African hands, commercial
development of the African interior for the financial benefit of British companies
required an extension of political control. Thus, the financial security of British
palm oil traders in coastal West Africa came to depend upon the British govern-
ment's use of military force to establish colonial territories inland that secured
access to raw materials, allowed development of markets for manufactured
goods, and ensured that profits accrued to British merchants, the British govern-
ment, and its colonial administrations. In pursuit of those ends, on June 5, 1885,
the British government declared the Oil Rivers Protectorate over the eastern
Niger delta.

Six years later, in 1891, Henry Gallwey was appointed first permanent vice-
consul for the Benin River area, which was then outside the British colonial juris-
diction of the Oil Rivers Protectorate. Gallwey was a firm believer in the neces-
sity of establishing direct trade links to oil producing areas, thereby increasing
profitability by cutting out intermediary brokers. Oba Ovonramwen's control
over trade with Benin stood as an obstacle to that goal. On March 23, 1892,
Gallwey traveled to Benin City to negotiate with the Oba, accompanied by John
Swainson, a British consular agent, and an interpreter. On March 26, Oba Ovon-
ramwen seemingly agreed to a treaty with the British, and Gallwey left the fol-
lowing day (Igbafe 1979: 41; Ryder 1969: 66–71). The treaty comprised nine
articles, whereby the Oba ceded sovereignty to Britain. Article 6 established that
"[t]he subjects and citizens of all countries may freely carry on trade in every part
of the territories of the King, party hereto, and may have houses and factories
therein." To what extent Oba Ovonramwen understood the contents of the treaty
and their import for his autonomy and Benin's independence is open to question.
The Oba was fearful of British intentions and desirous of peace. His gift to
Swainson of the bronze horse-rider seems confirmation of his gratitude that war
had been averted. The treaty negotiations between Gallwey and Oba Ovon-
ramwen had proceeded in three languages through the mediation of two inter-
preters, with neither the interpreters nor the Oba expert in the legal and diplo-
matic concepts and phraseologies of empire. The Oba refused to touch the pen
that was used to sign an X in lieu of his name (Igbafe 1970: 387–88, 1979:
43–44; Ryder 1969: 271). On the British side, the commercial interest and
intent of the treaty were made clear in a cover letter sent by the Consul-General
of the Oil Rivers Protectorate Claude Macdonald to the Foreign Office with a
copy of the treaty. It emphasized the rich natural resources of the Benin area that
would now be accessible (Igbafe 1979: 44). Macdonald seems to have been under
no illusions about the likely acquiescence of the Oba, expressing his hope that
the power of the Oba would be broken in order to open Benin for "commerce and

civilization" (Igbafe 1979: 44), an implicit admission of his belief that the Oba had not understood the terms of the document to which he had allowed the affixing of an X.

On May 13, 1893, the borders of the Oil Rivers Protectorate were extended northward and eastward, incorporating the Kingdom of Benin within what became the Niger Coast Protectorate (Ryder 1969: 278; Coombes 1994: 9). Nevertheless, Oba Ovonramwen persisted in exercising his autonomy by imposing what were, in British eyes, restrictive trade practices. He continued to close markets in his territories, tax or demand tribute from African brokers, and claim a monopoly on the trade of oil palm kernels, which were the most profitable product of his country (Igbafe 1979: 47). As early as November 1894, Deputy Consul-General Ralph Moor of the Niger Coast Protectorate made plans to establish an armed presence in Benin (Ryder 1969: 279). On September 30, 1895, John Swainson's Liverpool employer James Pinnock sent a letter to Macdonald complaining about the Oba closing down trade, and recommending that he be deposed (Coombes 1994: 30; Igbafe 1979: 50–51). In similar fashion, the four major companies trading on the Benin River (three British and one German, including James Pinnock and the large and influential Liverpool conglomerate known as the African Association) wrote to the vice-consul of the Benin district expressing a similar set of grievances (Igbafe 1979: 51). Back in London, the Foreign Office, too, was keen that British rule should be enforced throughout the Niger Coast Protectorate to develop trade (Igbafe 1979: 52). British prestige was also important. If Oba Ovonramwen continued to pursue a sovereign policy in seeming defiance of British wishes, it might undermine the security of other British colonies in the region (Igbafe 1970: 397). The by-then Consul-General Moor replied to British merchants that he was planning an expeditionary force in January or February 1897 to remove the Oba from power (Igbafe 1979: 53).

On October 15, 1896, James Phillips assumed responsibility as acting consul-general while Moor was on leave. The following month, he requested permission from the Foreign Office to use force against the Oba, emphasizing that "the revenues of this protectorate are suffering . . . we want the increased revenue which would result, badly" (Phillips, quoted in Igbafe 1979: 56). He set out from Sapele for Benin on January 2, 1897, without waiting for a reply. (When the reply did arrive—too late—on January 9, 1897, the decision was that the expedition should be deferred [Igbafe 1979: 56; Ryder 1969: 285].) Phillips's party included nine other British (including representatives of the Glasgow trading company Miller Brothers and Liverpool's African Association) and more than 200 African porters (Igbafe 1979: 57). On the evening of January 4, after leaving Ughoton,

the expedition was ambushed by armed Benin soldiers seemingly against the wishes of Ovonramwen (Roth 1903: iv; Ryder 1969: 288). All members of the expedition were killed except for a few Africans and two British participants (Igbafe 1979: 58).

The British government's response to the ambush was immediate. The Foreign Office ordered Moor back to the Niger Coast Protectorate, where Gallwey was standing in as acting consul-general. Moor arranged for the assembly of a military force numbering 1,500 British and African troops and a similar number of porters supported by nine ships of the Royal Navy, all under the command of Rear Admiral Rawson. On February 10, 1897, a three-pronged attack on Benin was launched. After heavy fighting, Benin City was taken at about 2 pm on February 18, though Oba Ovonramwen, his chiefs, and many of his subjects had fled the city only hours before (Igbafe 1979: 70; Roth 1903: ii–xi; Ryder 1969: 290). The occupying troops found extensive evidence of animal and human sacrifice (Igbafe 1979: 70–71; Roth 1903: ix–xii). After two days of looting and burning, the city was abandoned to flames on February 21 (Igbafe 1979: 72; Ryder 1960: 290). Sporadic fighting continued until Oba Ovonramwen and ten of his chiefs surrendered to the British on August 5, 1897 (Ryder 1969: 291). In the trial that followed, six chiefs were found guilty of the murder of Phillips and his expedition personnel, and two were executed by firing squad on September 4, 1897 (Ryder 1969: 293). Ovonramwen himself was sent into exile (Ryder 1969: 294).

The British occupying forces found the bronze heads and carved tusks for which Benin is now famous sitting in ritual ("juju") compounds associated with blood and sacrificial remains. In storehouses "buried in the dirt of ages," they uncovered a large number of figure-decorated bronze plaques, together with more ivory tusks and bronze castings (Bacon 1897: 87, 91). Troops seized more than 3,000 centuries-old artworks and transported them back to London, where they were sold to help defray the costs of the military expedition. Consequently, they were dispersed throughout collections and museums worldwide. Several hundred pieces were bought by the British Museum and, by 1898, about forty pieces had been acquired by the Free Public Museum of Liverpool (later Liverpool Museum) as purchases or gifts from private individuals (Forbes 1898; NML 2010: 37). In 1973, it was reported that material from Benin was to be found in five Nigerian museums, one African museum outside Nigeria, one Australian museum, thirty North American museums, and sixty-one European ones (Dark 1973: 78–81).

The February 1897 occupation of Benin secured physical control of the Niger Coast Protectorate for the British and allowed them to develop the territory for trade and reorganize agricultural production toward cash crops for

export (Shokpeka and Nwaokocha 2009). Within a few months, a rubber indus-try had been established, and in June 1897, Moor wrote to the Liverpool Cham-ber of Commerce asking for investment to improve the area for the purpose of increasing trade (Igbafe 1979: 74). The fall of Benin also opened the road for fur-ther British commercial and political penetration inland. In 1900, the Niger Coast Protectorate was merged with the territories of the Royal Niger Compa-ny to form the Protectorate of Southern Nigeria, which, with the addition of Lagos Colony in 1906, became the Colony and Protectorate of Southern Nige-ria. In 1914, this entity was merged with the Northern Nigeria Protectorate to form the colony of Nigeria.

THE DISCOURSE OF EMPIRE

For many Victorian liberals, commercial development was inseparable from Christian (Protestant) morality as a driver of sociocultural improvement (Hyam 2010: 23–25). In 1857, for example, the explorer David Livingstone pronounced his belief that the "two pioneers of civilization—Christianity and commerce—should ever be inseparable." Consul-General Macdonald concurred when he wrote his desire to open Benin for "commerce and civilization." Public justification in Britain for the colonization of Benin centered on the practice of human sacri-fice, the alleged depravity of its inhabitants, and the consequent Christian duty of the British Empire to eradicate such practices and exert a civilizing influence. Press reports made much of the evidence of sacrifice but had little to say about the commercial goals of colonization (Coombes 1994: 10–17). Thus, for the British, the commercial development of Benin was viewed as part and parcel of the civilizing process, a necessary and appropriate preventive response to the prac-tice of human sacrifice. This discursive claim legitimized the material goals of British imperial policy while preventing any consideration of the physical and political effects of colonization on Africans or reflection upon the morality of empire. The imperial discourse of "commerce and civilization" rendered such thoughts unthinkable (Said 1993: 26).

In the blood and smoke of February 1897, the Benin bronzes and ivories were not considered to be great works of art according to the then-recognized European standard (Coombes 1994: 16–27). Alan Boisragon, for example, a sur-vivor of the Phillips expedition, wrote in 1898 of the "hideous bronze heads" dis-covered by the 1897 military occupation (Boisragon 1898: 186). Reginald Bacon, who was present at the sack of Benin City, reported a more approving assessment of the "handsomely-carved ivory tusks placed on top of very antique bronze heads" (Bacon 1897: 87), but also described their place of installation in a sacrificial "juju"

compound, not a context evocative of art or science for the late Victorian reader. Gallwey, too, was appreciative of the "beautifully carved" ivory tusks and the "many pieces of brass of clever workmanship" but, again, could only discuss them in relation to their ritual context of "fetish shrines" (Gallwey 1893: 130). The artworks were received uneasily by a British public preconditioned to consider art as a mark of civilization and thus skeptical of any claims of artistic merit for the Benin pieces.

A more positive assessment of the aesthetic qualities of the Benin bronzes and ivories was only possible after their placement in European museums, a context that literally and figuratively cleansed them of unsavory associations and readied them for positive reassessment by ethnographers and art historians during the twentieth century (Barkan 1997; Coombes 1994: 22–62; Osadolor and Otoide 2008: 410–12; Plankensteiner 2007). However, the reconsidered artistic merit of the Benin objects and their encapsulation within museum vitrines situated them firmly within the cultural domain. They were made available for an introspective European dialogue about the nature of art, but failed to stimulate reflection upon the injustices of colonization. The effect of this cultural quarantine is considered further below in relation to ideas of cultural nationalism and internationalism and the claims for an encyclopedic museum. For the moment, it is enough to recognize that in the nineteenth century, this cultural discourse excluded considerations of history and politics, thereby insulating the bronzes and ivories from any discussion of the circumstances of their acquisition and their ongoing possession and display by museums outside Nigeria. But before turning to critique the idea of an encyclopedic museum, it is helpful to step back in time and revisit an earlier debate about the seizures of cultural property—namely, by French forces during the Revolutionary and Napoleonic wars.

A HISTORICAL PRECEDENT: THE MUSÉE NAPOLÉON

The seizure and subsequent sale of the Benin bronzes and ivories does not seem to have attracted any critical comment in contemporary accounts or reporting. Yet, in retrospect, this is surprising because the 1897 seizure took place at a time when international legal opinion was solidifying around the idea that works of science and art should be protected from plunder during wartime. As early as 1815, Britain had insisted that artworks taken by French revolutionary and Napoleonic armies from Europe's museums and collections (destined for display in the Musée Napoléon at the Louvre) should be returned to their rightful owners; and a succession of military codes and legal conventions during the late nineteenth century had established the principle that during wartime, artworks should not be the target of military action or plunder. The legitimacy of the Benin

seizures must be judged against these material precedents and the developing international norms of military constraint.

On August 10, 1793, the Louvre opened as the Muséum Français, on the first anniversary of the abolition of the French monarchy. It served as a depository for artworks that had been seized from the church, royalty, and aristocracy during the revolution (McClellan 1994: 95–99). The Muséum Français was intended to be a public museum, a venue where the confiscated artworks could supply enjoyment for and edification of the newly liberated and enfranchised citizenry (Bazin 1967: 169–72; Gould 1965: 13–35). It was a short step from the idea of art being the property of a liberated French citizenry to the idea of liberating art for the benefit of that citizenry (McClellan 1994: 116). In 1794, through its Committee of Public Instruction, the governing National Convention ordered French armies in Belgium to seize "monuments of interest to the arts and sciences" for display at the Louvre (McClellan 1994: 114; Sandholtz 2007: 49–50). Napoleon I's campaigns in Italy from 1796 to 1799 were accompanied by the targeted and systematic removal of important paintings and antiquities from royal and church collections. The seizures were legitimized in a series of peace treaties: with the Duke of Parma in 1796, with Venice in May 1797, and in the Treaty of Tolentino in February 1797 with the Vatican (Sandholtz 2007: 50).

In January 1797, the Louvre was renamed the Musée central des arts and made ready to receive the artistic heritage of Italy. The first convoy of material entered Paris quietly, but the second convoy, in July 1798, arrived as a triumphal procession (Bazin 1967: 174; Gould 1965: 46–64; Miles 2008: 321–24; Sandholtz 2007: 51–52). By the early 1800s, the Louvre possessed the best collection of paintings and antiquities in the world, so much so that during an interval of peace starting in 1802, British tourists were eager to cross the channel in order to visit there (Gould 1965: 75). In 1803, the Louvre was renamed the Musée Napoléon, in honor of Napoleon who crowned himself Emperor on December 2, 1804. The spoliation continued when parts of Italy were incorporated as *départements* of France and during the German campaigns starting in 1806 (Sandholtz 2007: 51).

At one time or another, various justifications were offered for this policy of targeted plunder and Parisian accumulation (Gilks 2013: 117–23; Sandholtz 2007: 53–55; Vrdoljak 2006: 24–25). First, there was the argument developed from Johann Winckelmann that the finest art could only be produced in conditions of political freedom. From this perspective, the French armies had a duty to liberate artworks from what were seen to be despotic regimes and deliver them for safekeeping to the capital of the free French republic. Second, there was the naturalizing consideration that, as the political capital of Europe, Paris should

also be its cultural capital. Third, it was believed that the accumulation of excep-
tional artworks in Paris would inspire and promote French manufacturing and
scholarship. Finally, there was the more primordial opinion that "spoils of war"
should be the appropriate reward of martial prowess. Nevertheless, and despite
these justifications, even within France, official policy was not without its critics
(Gilks 2013: 127–29). In 1796, archaeologist, architect, and art critic Antoine C.
Quatremère de Quincy addressed a series of open letters to his friend General
Miranda (Sandholtz 2007: 56), in which he formalized arguments against the
plunder of "arts and sciences." He emphasized the importance of an artwork's
original context for its appreciation and understanding, and promoted the idea
that cultural objects are the property of all nations, not just one—the "universal
republic of the arts and sciences" (Quatremère de Quincy 2009: 20 [1796]).

On June 18, 1815, Napoleon was finally defeated at Waterloo, and on June
22, the allied armies led by the British Wellington and Prussian Blücher occupied
Paris. On July 11, Prussian and Austrian troops started removing works that had
been taken by force from Germany (Miles 2008: 331; Sandholtz 2007: 60–61).
The situation regarding works from Italy obtained by treaty, however, was not so
clear-cut (Sandholtz 2007: 61–62). In favor of retention, the French could and
did claim that the transfers had proceeded according to treaty agreement and were
therefore legitimate. The simple retort was that the treaties had been signed under
duress, and they were open to disavowal. The British prince regent (the future
George IV) caused another complication when he intimated that some French
artworks might be moved to a museum or gallery in Britain (Miles 2008: 331;
Sandholtz 2007: 63). This step forced the British Foreign Secretary Castlereagh
to reply that the British government should not want to participate in the "plun-
der of Europe" and should instead be desirous of ensuring that justice be done
(Sandholtz 2007: 64–65). The Duke of Wellington entered the debate by means
of a letter to Castlereagh (September 23, 1815) arguing that the allied powers
should have no part in supporting an argument for retention that he believed was,
in French eyes, aimed at retaining trophies of war as a memorial of military victo-
ries. The allies, he insisted, "could not do otherwise than restore them to the coun-
tries from which, contrary to the practice of civilized warfare, they had been torn
during the disastrous period of the French revolution and the tyranny of Buona-
parte" (Wellington 1815, reproduced in Miles 2008: 370–75). The letter was sub-
sequently published in *The Times* on October 14, 1815.

By September 1815, representatives of Britain, Prussia, and Austria had
agreed that all artworks seized by the French Revolutionary and Napoleonic
armies should be returned to their places of origin, that the coerced treaties that
had provided cover for the seizures should not be upheld, and that no allied

power should seize any artwork that was the rightful property of France. In late September 1815, Prussian troops began overseeing the removal of artworks from French museums and arranging their transport home. The removals were not popular with the French public, and the allied soldiery was forced to face off against the angry and emotional Parisian citizenry (Miles 2008: 334–41; Sandholtz 2007: 66–67; Vrdoljak 2006: 26–29). Wellington was booed at the opera. In France, a sense of injustice about the overturning of what were seen to be legitimate treaty arrangements sometimes persisted. In 1967, the then-recently retired Louvre curator Germain Bazin opined that "restitution was effected somewhat 'illegally' (in the case of Italy in particular) because it was done in secret" (1967: 186). Nevertheless, nearly half of the spoliated material remained in France and was never returned (McClellan 1994: 200).

The Legal Context of the Benin Seizure and of Twenty-First-Century Ownership Rights

The opinions of Castlereagh and Wellington were shaped by an emerging current of European thought that was shocked by and disapproving of the plunder of artworks or other cultural property in wartime (Gilks 2013: 142–43; O'Keefe 2006: 15–16; Sandholtz 2007: 71). Quatremère de Quincy, for example, had written that "in civilized Europe, everything belonging to the culture of the arts and sciences is above the rights of war and victory" (quoted in O'Keefe 2006: 16). Legal theorists began to consider and discuss a set of international rules that would regulate the conduct of war by, among other things, restricting plunder to public property (the property of the warring state) and protecting private property. Cultural objects and institutions were also to be protected as cultural property.

The first material expression of this new international concern about the conduct of war was found in the Instructions for the Government of the Armies of the United States in the Field of 1863, drawn up by Francis Lieber for use by the Union army during the American Civil War. The Lieber Instructions had a profound effect on European legal thinking about the protection of cultural property during wartime, and the 1870–71 Franco-Prussian War precipitated a series of international declarations and codifications that further developed the Lieber Instructions. A July 1874 meeting of European nations in Brussels convened by Czar Alexander II of Russia proposed a draft convention known since as the International Declaration concerning the Laws and Customs of War (Brussels Declaration). Picking up the Brussels baton, the Institute of International Law appointed a committee to consider and develop the Brussels Declaration, concluding in September 1880 with the Oxford Manual of the Laws of War

on Land. Article 53 stated: "The property of municipalities, and that of institutions devoted to religion, charity, education, art and science, cannot be seized." These codes were not legally binding, but their principles exerted a normative effect. They reflected the growing international concern to limit the wanton depredations of war and increasingly were being incorporated into military rulebooks. So, Chapter 14.33 of the British War Office's 1894 Manual of Military Law stated that:

> [t]he seizure of scientific objects, pictures, sculptures, and other works of art or science belonging to the public has derived some sanction from the repeated practice of civilized nations; but would seem incompatible with the admitted restriction of the rights of war to depriving the enemy of such things only as enable him to make resistance, and can only be justified as a measure of retaliation.

This 1894 edition of the British Manual would have been current at the time of the 1897 invasion of Benin. On the face of it, then, the plunder of Benin appears contrary both to what was then current jurisprudence with regard to the conduct of war and to military law with regard to plunder during wartime. The British military plunder of the Qing Summer Palace outside Beijing in 1860 (Hevia 2003: 74–118), for example, had been officially condoned at the time as a deserving reward for martial endeavor, much as the French had claimed at the beginning of the century. By the 1890s, however, such practice, as the 1894 Manual stated, was considered to be something that belonged in the past, no longer to be tolerated. But the Benin seizures happened nonetheless and were considered unremarkable. To understand this apparent separation of military theory and practice, it is necessary to consider how the emerging norms of military conduct and restraint were marginalized by the discursive closure and legal recognition of the European "civilizing mission."

By the closing decades of the nineteenth century, international law was falling under the influence of "scientific" theories of sociocultural progress, which echoed liberal conceptions of commerce and civilization, and was becoming increasingly positivist in its formulation. It was becoming an exercise in science rather than in morality (Vrdoljak 2006: 47–51). One result was the exclusion of non-Europeans from its authority and protection. In 1894, for example, the leading British jurist John Westlake wrote:

> [O]f uncivilized natives international law takes no account. This is true, and it does not mean that all rights are denied to such natives, but that appreciation of their rights is left to the conscience of the state within whose recognized territorial sovereignty they are comprised (Westlake 1894, quoted in Vrdoljak 2006: 49).

A useful pretext for European seizures of the territories and resources of colonized peoples, this legal disempowerment of non-Europeans is also evident in the rules of war as they had developed by the late nineteenth century. In 1894, the British War Office's Manual of Military Law set out that the customs of war, which included a prohibition on pillage, applied only to "warfare between civilized nations" (chapter 14.9). "War, properly, so called" it opined, was considered "an armed contest between independent nations, and can only be made by the sovereign power of a state." In British minds, of course, Benin was not considered to be a civilized nation, and in any case, its sovereignty had been extinguished in 1892, when an unknown hand had scratched away independence with an "X." That is why the odd term "punitive expedition" is often chosen to describe the British action, rather than the more accurately descriptive "military invasion" or "belligerent aggression." While invasions are launched against sovereign nations, punitive expeditions are used to pacify recalcitrant subjects. Whether or not after 1892 Oba Ovonramwen considered himself a British subject is an interesting question; most likely he did not. In any event, whatever posterity now makes of the substance and legitimacy of the 1892 treaty, at the time the Oba clearly felt able to continue acting in a free and independent manner. His actions ultimately compelled Britain to dispatch a military expedition to enforce what it considered to be its legitimate rule— legitimate, that is, at least insofar as Britain made the law and enforced it. Benin found itself subject to British colonial law, which successfully repelled the protective agency of military law and which offered no protection whatsoever to works of art. Thus, the seizure of the Benin artworks was a material and symbolic expression of British imperial power and of the chauvinist body of international law that enabled and justified it. Twenty-first-century assertions of legitimate ownership are derived from this law and must be judged against its content.

Empires come and empires go, though often times there is a reckoning. Many of Napoleon's plundered artworks were returned to their dispossessed owners after the final collapse of his empire in 1815. Nazi loot, too, has, when possible, been helped on its way home. In 1945, US and British occupying forces in Germany took pains to ensure the safe return to rightful owners of artworks seized or otherwise forcibly acquired by the Nazi regime (Nicholas 1995; Sandholtz 2007: 127–66), an exercise headed up by the celebrated "Monuments Men" (Edsel 2014). Since World War II, however, demands from newly decolonized countries outside Europe for the repatriation of plundered cultural property have often been ignored or successfully resisted (Prott 2009). When Nigeria gained independence from British rule in 1960, for example, the Napoleonic and Nazi precedents of recovery and return were ignored, and the Benin artworks

remained undisturbed in collections and museums worldwide. There were no Monuments Men on hand to pursue and recover Nigerian cultural property. Nigeria has been forced to buy back pieces on the open market (Shyllon 2009: 161–63).

It is an open question why artworks stolen by imperial powers are returned when the dispossessed owners are European, as in the Napoleonic and Nazi cases, but not when they are non-European, as in the case of Benin. Dispersal and private ownership are no answers, as the example of Nazi-appropriated art shows. The struggle to locate and recover artworks stolen by the Nazis is ongoing through the courts, guided by the 1998 Washington Conference Principles on Nazi-Confiscated Art, and reflecting an international consensus that "cultural property wrongfully taken from its rightful owners should be returned" (Kaye 2009: 352). But this consensus does not apply to Nigeria or to other former colonies, an injustice that compounds the earlier injustice of plunder. The continuing refusal of the international community to engage in a constructive fashion with requests for the return of Benin artworks suggests that even in the twenty-first century, the dead hand of nineteenth-century colonial discourse and law is still palpably complicit in the affairs of Nigeria. The failure to return the bronzes and ivories to Nigeria is a refusal to accord to Nigeria rights of ownership recognized by the allied powers in Paris in 1815 and Germany in 1945. It is a denial of Nigeria's sovereign equality on the international stage.

CULTURAL INTERNATIONALISM AND THE ENCYLOPEDIC MUSEUM

In a series of papers, John Merryman has elaborated his idea of "cultural internationalism" (Merryman 1986, 1996, 2006, 2009). He takes his lead from the 1954 Hague Convention for the Protection of Cultural Property in the Event of Armed Conflict, which states in its preamble that "damage to cultural property belonging to any people whatsoever means damage to the cultural heritage of all mankind, since each people makes its contribution to the culture of the world" (Merryman 1986: 836). He counterposes cultural internationalism to "cultural nationalism," an idea he derives from a statement in the preamble of the 1970 UNESCO Convention on the Means of Prohibiting and Preventing the Illicit Import, Export and Transfer of Ownership of Cultural Property that "cultural property constitutes one of the basic elements of civilization and national culture" (Merryman 1986: 843).

Merryman argues that cultural internationalism is a good thing because it promotes the free circulation of artworks. In so doing, it enables a broad international public spread over many countries to enjoy viewing artworks, no matter

what the geographical or cultural origin of the pieces in question (Merryman 2006: 12). Furthermore, the wide circulation of artworks spreads the burden of curation, thus promoting their protection and survival (Merryman 1986: 846, 1996: 4). Merryman characterizes cultural internationalism as a "cosmopolitan" way of thinking (1986: 846). Cultural nationalism, which attributes a national interest in artworks, is, in contrast, a bad thing (Merryman 1986: 832). By aiming to prevent the movement of artworks out of their countries of origin, it is "retentionist," promoting retention over the interest in protection (Merryman 1986: 844, 866). This leads to what he terms "destructive retention" or "covetous neglect," when countries do not have the necessary human or material resources to curate artworks in their possession nor to document them or make them available for scholarly study or public viewing (Merryman 1986: 846–47). (A similar argument was made in 1794 to justify the French plunder of artworks [Gilks 2013: 119].) Merryman also finds problematic the idea that cultural objects can be tied up with constructions of cultural or national identity (1996: 4), and that claims of cultural, spiritual, or racial affinity with the producers might be translated into an ownership claim (Cuno 2008: xxxi).

Merryman's promotion of what he calls "cultural internationalism" privileges the interest of the object, and—he claims—the interest of the international community. He envisages an "object-oriented" policy of preservation, truth, and access, a policy that would prioritize the protection of objects from damage or decay, promote the utilization of objects for education and learning, and ensure the availability of objects for public viewing (2009: 187–88). He very signally fails to engage with the political and historical contexts that have enabled or caused the movement of artworks. Yet those historical contexts can be highly emotive in relation to questions of self-determination, including the right of a nation to control the disposition of its own cultural heritage. Imperial seizures of cultural property such as the Benin bronzes and ivories were direct attacks on sovereignty. It should not be surprising that the recovery of cultural property becomes a national policy goal when it is the material substance and symbol of colonization. Merryman's dismissal of cultural nationalism as a throwback to nineteenth-century romantic conceptions of nationhood—what he terms Romantic Byronism—misconstrues the problem (1986: 850, 1996: 15).

In 1991, the Edo state of southwestern Nigeria was constituted, with Benin City as its capital and with an active cultural and artistic heritage that is descended directly from the nineteenth-century kingdom of Benin (Nevadomsky and Osemweri 2007). Merryman's admonitions about the inappropriateness of Romantic Byronism do not apply in these circumstances. The Benin bronzes and ivories seized by the British are an integral part of a living tradition and in the

twenty-first century remain fundamental to the cultural identity of the Edo peo-
ple. In these circumstances, even Merryman would no doubt agree that they
should be returned to Benin City (Merryman 2009: 193). Nigeria itself, howev-
er, is a federal state and cannot lay claim to the Benin bronzes and ivories on cul-
tural grounds alone. But the national identities of post-colonial states such as
Nigeria are not, as Merryman claims, founded upon romantic claims of cultural
essence or continuity. They are constructed around the historical experience of
colonization (Hobsbawm 1990: 138). For Nigeria, the 1897 sack of Benin City
was central to that experience. Thus, a refusal to return bronzes and ivories to
Nigeria is not only a denial of sovereign equality, it is a denial of history.

Merryman's idea of cultural internationalism was influential in the 1990s'
revival of the concept of the "encyclopedic museum" (Cuno 2008: xix). Encyclo-
pedic museums are claimed to contain, curate, and display objects from many dif-
ferent cultures separated in time and space and juxtaposed in such a way as to
allow an appreciation of the cultural diversity and hybridity of humankind
(Cuno 2008: xix, 2014). Thus, it is argued that an encyclopedic museum pro-
motes tolerance and understanding of other and perhaps alien cultures, and
stands as a bulwark against ignorance, superstition, and fear of the "Other." The
cultural internationalism of the encyclopedic museum is an open system of ideas
standing in enlightened opposition to the closed and backward-looking world of
nationalist ideologies (Cuno 2008: xxxi, 2014).

The concept of the encyclopedic museum draws inspiration and claims legit-
imacy from the Enlightenment project of the *Encyclopédie*, which, starting in
1751 and under the collaborative editorship of Denis Diderot and Jean le Rond
d'Alembert, aimed to assemble and organize a systematic taxonomy of all human
knowledge (Cuno 2009: 37). In 2009, the then-director of the British Museum
Neil MacGregor wrote about the "idea of the world under one roof" (2009: 39),
casting the museum as the architectural counterpart of the *Encyclopédie* and
arguing too for museums as an embodiment of Enlightenment ideals of reason
and tolerance. For an earlier museum curator, though, and a French one at that,
the "political ideology of Revolutionary and Napoleonic France was encyclopedic
and European in its aims" (Bazin 1967: 183). The Louvre, in its incarnation as
the Musée Napoléon, with its internationalizing collection of spoliated art, was
the archetypal encyclopedic museum. For the first time, Italian masterpieces, for-
merly accessible for viewing only by an aristocratic elite engaged upon the Grand
Tour, were made available for the general public (Gilks 2013: 121). The impor-
tance for scholarship of collecting natural history specimens was also appreciat-
ed (Gilks 2013: 119–20). But the encyclopedism of revolutionary and
Napoleonic France was in its museum instantiation viewed as an oppressive and

inequitable ideology that caused the political disapproval and legal prohibition of spoliation in the decades following 1815 by Quatremère de Quincy's "universal republic of the arts and sciences"—the international community. It is at best misguided and at worst disingenuous to justify the existence of encyclopedic museums with an argument for cultural internationalism that elaborates upon a definition in the 1954 Hague Convention, without considering the convention's precedents. The 1954 Hague Convention was the end product of a process of international law-making aimed at protecting cultural property during wartime, a line that can be traced back by way of the 1907 Hague Convention with Respect to the Laws and Customs of War on Land, and through instruments and codes such as the 1880 Oxford Manual and the 1863 Lieber Instructions, to the decisive rejection by the international community in 1815 of the first encyclopedic museum, the Musée Napoléon.

But what is really at stake here, once more, is the nature of discourse. The justification for the encyclopedic museum constructs a cultural field around issues of art and access. In so doing, it excludes arguments or viewpoints derived from a more historical understanding of events. In its mystifying effect, substituting culture for history, advancing art before politics, it imitates, if not intentionally or reflexively, the imperial discourse of late nineteenth-century Britain with its confusion of civilization and commerce. Kenneth Coutts-Smith characterized this twentieth-century rendering of the "extra-historicity of art" as an exercise in "cultural colonialism" (Coutts-Smith 1991 [1976]: 14–15), something far removed from the discursive masquerade of cultural internationalism.

CONCLUSION

The sack of Benin City was just one episode in the British late nineteenth-century project of imperial expansion into Africa. The theoretical fusion of Christianity, civilization, and commerce created a powerful justificatory discourse of social and cultural improvement that opened up the continent for European colonization, settlement, and trade. Forced through by missionaries, merchants, and marines, "civilization" arrived in Africa from the barrel of a gun. The Benin bronzes and ivories were a notable, though not the only, casualty. The ownership rights of encyclopedic museums and other collections holding Benin artworks are highly problematic, anchored as they are in a legal regime of imperial aggrandizement and colonial deprivation that would not be countenanced today, maintained in apparent defiance of relevant precedents and long-established norms and laws of cultural property protection, and justified by a specious discourse of object-centered cultural internationalism. A more equitable consideration of the significance of the artworks for

the history and international standing of Nigeria is obstructed by the cultural confines of a discourse that favors the interests of the objects and their current possessors over those of the dispossessed owners.

In 2005, the Liverpool Museum changed its name to World Museum Liverpool, in so doing proclaiming its encyclopedic ambitions. In 2013, there were bronzes and ivories on handsome display there (Fig. 3.2), with Swainson's horse-rider rightfully awarded pride of place, and a sympathetic text describing the commercial motivations of British colonization. Large images of a Benin head were also to be seen advertising the museum in Liverpool's new city center for shopping and leisure development (Fig. 3.3), representing another episode, per-

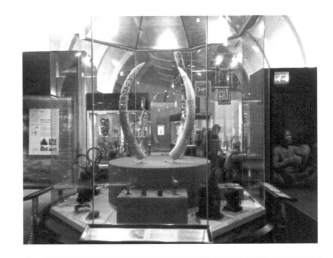

FIGURE 3.2. Benin bronzes and ivories on display in Liverpool World Museum, March 2016. Photograph by Camilla Briault.

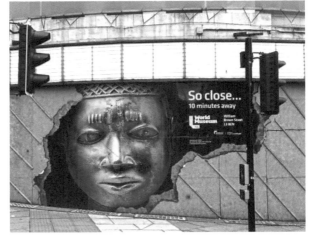

FIGURE 3.3. Benin bronze head advertising Liverpool World Museum, Liverpool city center, September 2015. Photograph by Camilla Briault.

haps, in the collective biography of the Benin bronzes and ivories, from ceremonial objects to commodities to museum-consecrated artworks to visitor attractions. These images are also a testament to their continuing importance for British culture and commerce, and to the ongoing disempowerment of the Edo people and of Nigeria.

Acknowledgments

A preliminary version of the paper that was developed for this chapter was presented in January 2015 at the workshop "Unmasking Ideology: The Vocabulary and Symbols of Colonial Archaeology," convened at the Center for the Humanities and the Public Sphere, University of Florida in Gainesville. I would like to thank Bonnie Effros and Guolong Lai for inviting me to the workshop and for making it such a worthwhile and enjoyable occasion. The research reported in this paper was supported by the European Research Council under the European Union's Seventh Framework Programme (FP7/2007-2013)/European Research Council Grant agreement no. 283873 GTICO.

References Cited

Bacon, Reginald H.
 1897 *Benin: The City of Blood.* Arnold, London.
Barkan, Elazar
 1997 Aesthetics and Evolution: Benin Art in Europe. *African Arts* 30: 36–41, 92–93.
Bazin, Germain
 1967 *The Museum Age.* Universe, New York.
Boisragon, Alan
 1897 *The Benin Massacre.* Methuen, London.
Coombes, Annie E.
 1994 *Reinventing Africa: Museums, Material Culture and Popular Imagination.* Yale University Press, New Haven, CT.
Coutts-Smith, Kenneth
 1991 [1976] Some General Observations on the Problem of Cultural Colonialism. In *The Myth of Primitivism: Perspectives on Art,* edited by Susan Hiller, pp. 14–31. Routledge, London.
Cuno, James
 2008 *Who Owns Antiquity? Museums and the Battle over Our Ancient Heritage.* Princeton University Press, Princeton, NJ.

Cuno, James (editor)
 2009 *Whose Culture? The Promise of Museums and the Debate over Antiquities.* Princeton University Press, Princeton, NJ.
Dark, Phillip J. C.
 1973 *Introduction to Benin Art and Technology.* Oxford University Press, Oxford.
Edsel, Robert M.
 2010 *Monuments Men: Allied Heroes, Nazi Thieves and the Greatest Treasure Hunt in History.* Arrow, London.
Forbes, H. O.
 1898 On a Collection of Cast Metal Work of High Artistic Value, from Benin, Lately Acquired for the Mayer Museum. *Bulletin of the Liverpool Museums* 1: 49–70.
Gallwey, Henry L.
 1893 Journeys in the Benin Country, West Africa. *Geographical Journal* 1: 122–30.
Gilks, David
 2013 Attitudes to the Displacement of Cultural Property in the Wars of the French Revolution and Napoleon. *Historical Journal* 56: 113–43.
Gould, Cecil
 1965 *Trophy of Conquest: The Musée Napoléon and the Creation of the Louvre.* Faber and Faber, London.
Haggerty, Sheryllyne, Anthony Webster, and Nicholas J. White
 2008 *The Empire in One City? Liverpool's Inconvenient Imperial Past.* Manchester University Press, Manchester.
Hevia, James L.
 2003 *English Lessons: The Pedagogy of Imperialism in Nineteenth-Century China.* Duke University Press, Durham, NC.
Hobsbawm, Eric J.
 1990 *Nations and Nationalism Since 1780: Programme, Myth, Reality.* Cambridge University Press, Cambridge.
Hopkins, Antony G.
 1968 Economic Imperialism in West Africa: Lagos, 1880–1892. *Economic History Review* (n.s.) 21: 580–606.
Hyam, Ronald
 2010 *Understanding the British Empire.* Cambridge University Press, Cambridge.
Igbafe, Philip A.
 1970 The Fall of Benin: A Reassessment. *Journal of African History* 11: 385–400.
 1979 *Benin under British Administration.* Longman, London.
Kaye, Lawrence M.
 2009 Recovery of Art Looted during the Holocaust. In *Cultural Heritage Issues: The Legacy of Conquest, Colonization and Commerce*, edited by James A. R. Nafziger and Ann M. Nicgorski, pp. 351–70. Martinus Nijhoff, Leiden.

Kingdon, Zachary, and Dmitri van den Bersselaar

 2008 Collecting Empire? African Objects, West African Trade and a Liverpool Museum. In *The Empire in One City? Liverpool's Inconvenient Imperial Past*, edited by Sheryllyne Haggerty, Anthony Webster, and Nicholas J. White, pp. 100–122. Manchester University Press, Manchester.

Lynn, Martin

 1997 *Commerce and Economic Change in West Africa: The Palm Oil Trade in the Nineteenth Century*. Cambridge University Press, Cambridge.

MacGregor, Neil

 2009 To Shape the Citizens of "That Great City, the World." In *Whose Culture? The Promise of Museums and the Debate over Antiquities*, edited by James Cuno, pp. 39–54. Princeton University Press, Princeton, NJ.

McClellan, Andrew

 1994 *Inventing the Louvre*. University of California Press, Berkeley.

Merryman, John H.

 1986 Two Ways of Thinking about Cultural Property. *American Journal of International Law* 80: 831–53.

 1996 A Licit Trade in Cultural Objects. In, *Legal Aspects of International Trade in Art*, edited by Martine Briat and Judith A. Freedberg, pp. 3–46. Kluwer Law International, The Hague.

 2006 Introduction. In *Imperialism, Art and Restitution*, edited by John H. Merryman, pp. 1–14. Cambridge University Press, Cambridge.

 2009 The Nation and the Object. In *Whose Culture? The Promise of Museums and the Debate Over Antiquities*, edited by James Cuno, pp. 183–204. Princeton University Press, Princeton, NJ.

Miles, Margaret

 2008 *Art as Plunder: The Ancient Origins of Debate about Cultural Property*. Cambridge University Press, Cambridge.

Nevadomsky, Joseph, and Agbonifo Osemweri

 2007 Benin Art in the Twentieth Century. In *Benin Kings and Rituals: Court Arts from Nigeria*, edited by Barbara Plankensteiner, pp. 255–61. Snoeck, Ghent.

Nicholas, Lynn H.

 1995 *The Rape of Europa: The Fate of Europe's Treasures in the Third Reich and the Second World War*. Macmillan, London.

NML (National Museums Liverpool)

 2010 *Liverpool's Museum: The First 150 Years*. Available at http://www.liverpoolmuseums.org.uk/wml/history/WML_150_years.pdf, accessed September 7, 2015.

O'Keefe, Roger

 2006 *The Protection of Cultural Property in Armed Conflict*. Cambridge University Press, Cambridge.

Osadolor, Osarhieme B., and Leo E. Otoide
 2008 The Benin Kingdom in British Imperial Historiography. *History in Africa* 35: 401–18.

Plankensteiner, Barbara
 2007 The "Benin Affair" and Its Consequences. In *Benin Kings and Rituals: Court Arts from Nigeria*, edited by Barbara Plankensteiner, pp. 199–211. Snoeck, Ghent.

Prott, Lyndel (editor)
 2009 *Witnesses to History: Documents and Writings on the Return of Cultural Objects.* UNESCO, Paris.

Quatremère de Quincy, Antoine C.
 2009 [1796] Extracts from Letters to General Miranda. In *Witnesses to History: Documents and Writings on the Return of Cultural Objects*, edited by Lyndel V. Prott, pp. 19–25. UNESCO, Paris.

Roth, H. Ling
 1903 *Great Benin: Its Customs, Arts and Horrors.* King, Halifax.

Ryder, Alan F. C.
 1969 *Benin and the Europeans, 1485–1897.* Longmans, London.

Said, Edward W.
 1993 *Culture and Imperialism.* London: Chatto & Windus.

Sandholtz, Wayne
 2007 *Prohibiting Plunder: How Norms Change.* Oxford University Press, Oxford.

Shokpeka, S. A., and O. A. Nwaokocha
 2009 British Colonial Economic Policy in Nigeria: The Example of Benin Province 1914–1954. *Journal of Human Ecology* 28: 57–66.

Shyllon, Folarin
 2009 Unraveling History: Return of African Cultural Objects Looted in Colonial Times. In *Cultural Heritage Issues: The Legacy of Conquest, Colonization and Commerce*, edited by James A. R. Nafziger and Ann M. Nicgorski, pp. 159–68. Martinus Nijhoff, Leiden.

Vrdoljak, Ana
 2006 *International Law, Museums and the Return of Cultural Objects.* Cambridge University Press, Cambridge.

Digging up China: Imperialism, Nationalism, and Regionalism in the Yinxu Excavation, 1928–1937

Guolong Lai

Although China was never formally colonized, the dominance of Western and Japanese imperialists in the political, social, economic, and cultural domains over the Chinese was effective in the second half of the nineteenth and the first quarter of the twentieth century (a condition sometimes called "semi-colonial" in Chinese Marxist historiography, or "informal imperialism"; see Díaz-Andreu 2007 and this volume). However, the tide began to turn in the late 1920s. After defeating regional warlords, reuniting China, and moving the capital from Beijing to Nanjing in 1927, the Guomindang (GMD, i.e., Nationalist) government, led by General Chiang Kai-shek 蔣介石 (1887–1975), initiated a vigorous nation-building campaign. In the following ten years, known as the Nanjing decade (1927–1937), the Chinese government tightened its control over foreign expeditions and prohibited the removal of antiquities from Chinese soil. It became increasingly difficult for Western and Japanese explorers and archaeologists to conduct fieldwork in China (Brysac 2002; Jacobs 2010, 2014; Meyer and Brysac 1999: 367–93; see Xu on the preceding decade, this volume). Instead, national institutions such as the Academia Sinica (Zhongyang Yanjiuyuan 中央研究院) were established to take care of cultural heritage. In the history of Chinese archaeology, this is when imperial practices came to an end and national archaeology came to the fore.

The transition from imperial to national archaeology was manifested clearly in the events surrounding the selection and excavation of the Yinxu 殷墟 site, the birthplace of modern Chinese archaeology, in Anyang, Henan province. Conflicts between national and regional archaeology also emerged. As nationalism

and academic politics became inextricably intertwined, nationalist scholars such as Fu Sinian 傅斯年 (1896–1950) and Li Ji 李濟 (1896–1979) used newly introduced Western "scientific" archaeology to fight both imperialism and regionalism. One of their weapons was national legislation on the protection of archaeological heritage (for the dialectical relationship between the antiquities rush in the West and the global trend toward the national protection of archaeological heritage, see Marchand 2015). In 1930, at the instigation of Fu, Li, and others, the GMD government issued the Law on the Protection of Ancient Relics (*Guwu baocun fa* 古物保存法), which asserted state ownership of all archaeological artifacts, established a registration system for the control of private collections, and limited the antiquities trade. State ownership extended to the right of excavation and authorization of licenses for excavation, which established the basic legal framework for protecting archaeological heritage that is still at work in the People's Republic (1949–). This chapter examines the intellectual and political context within which archaeological practice in China transformed from imperial to national.

THE SELECTION OF THE YINXU SITE

The initial excavation at Yinxu, the Ruins of Yin, near Anyang in Henan 河南安陽, led by Dong Zuobin 董作賓 (1895–1963) from October 13 to 31, 1928, constituted a key moment in the history of Chinese archaeology. A native of Henan and a corresponding member of the Institute of History and Philology of the newly established Academia Sinica, Dong had first visited this area after hearing rumors about a discovery of oracle bones in August 1928. Since a conspiracy of silence surrounded the location of these oracle bones, he secretly hired a local boy, who led him to the sand hill to the north of the village of Xiaotun 小屯. To his great excitement, Dong soon found a small piece of uninscribed oracle bone on the surface. Even though Luo Zhenyu 羅振玉 (1866–1940), the famous antiquarian and scholar, had already declared Yinxu to have been exhausted of its treasures, Dong's find raised new hopes. Dong reported on the outcome of his field trip to Fu Sinian, the director of the new institute, who asked him to prepare for the first season of excavation.

The excavation team working at Anyang in October 1928 under Dong's direction was made up of two officials and three assistants from the Henan provincial government, eleven soldiers, and fifteen local peasants (Fig. 4.1). The excavation began at a farm northwest of Xiaotun. By the end of the first day of work, they had dug four pits around the small sandy hill that Dong had identified as a promising spot during his previous visit. However, nothing was found.

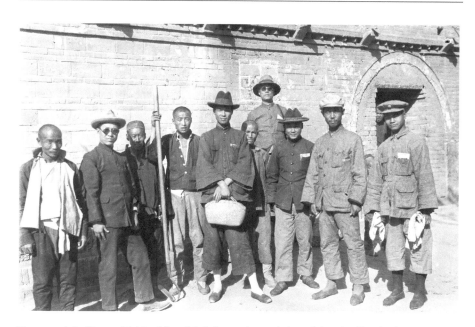

FIGURE 4.1. Dong Zubin (the third from the right) and local officials from Anyang county arranging for the first archaeological excavation at Xiaotun, Anyang, Henan on October 12, 1928. Reproduced with permission of the Institute of History and Philology, Academia Sinica, Taipei, Taiwan.

Dong came to believe that the villagers were playing a game with him. Some of the local peasants he employed swore that there was no way that any oracle bones would ever turn up at that farm. Dong suspected that they wanted to conceal the location where oracle bones were known to exist in order to avoid retribution from other villagers.

Indeed, for the inhabitants of Xiaotun, the appearance of outsiders asking for the whereabouts of bones and bronzes was nothing new. In 1910, Luo Zhenyu had identified Xiaotun as the site of the last capital of the Shang dynasty and the place where all the oracle bones that had shown up on the antique markets had been unearthed. Ever since, art dealers and collectors—some of them foreigners—had come to the village to look for treasure. The area around Anyang had been badly shaken by the political and social turmoil in the wake of the collapse of the Qing dynasty; it had suffered greatly from attacks by bandits, eventually becoming the staging ground for battles between local warlords and the Beiyang government based in Beijing. Although the Henan local government had officially banned private digging, it was an open secret that the villagers supplemented their subsistence income with such clandestine activity.

However, the preliminary excavation at the sand hill yielded no more arti-facts. Dong was obliged to shift his excavation strategy from the theoretical methods he had learned from books to interrogating the locals. He also employed local farming tools and followed the peasants' directions. By talking with farmers and carrying out private investigations, he finally solved the mys-tery: the sites that had produced the oracle bones were located within Xiaotun village proper. Although Dong was able to amass a number of small fragments of inscribed oracle bones, animal bones, human skeletons, bronzes, iron fragments, and other small objects, he was disappointed. Dong conceded that Luo Zhenyu, who had visited the site in 1915, had been right after all; the treasures of Yinxu had been so thoroughly despoiled that only these second- or third-rate artifacts remained, or so it seemed. Finding anything at all had not been easy. At the end of the October campaign, Dong wrote to Fu Sinian, suggesting that the institute give up the excavation (Chen 2011: 120–28; Dong 1929).

Dong's gloomy analysis, however, failed to dim Fu's enthusiasm for the proj-ect. It was the first and only one pursued by the newly founded institute at that time, and Fu had good reason to persist. His insistence on the Yinxu project rep-resented the younger generation's search for new historical material, a goal dis-tinctly different from the old antiquarian search for collectibles (Chen 2011: 127–28; Wang Tao 1997). Yet, there were more than scholarly considerations at stake, including social, political, and even personal factors.

Ultimately, Li Ji, a Harvard-trained anthropologist, succeeded Dong as the director of the Yinxu excavation. Under his guidance, fourteen additional seasons were spent at Anyang between 1929 and 1937 (Fig. 4.2). Scholars have often referred to the Yinxu excavation as the birth of modern Chinese archaeology (Chang 1981: 165, 1998; Chen 2011: 129–40; Wang Shimin 1986: 690; Xia 1979: 195).[1] Here the term "modern Chinese archaeology," instead of "modern archaeology in China," is deliberately used to differentiate archaeological work done by Chinese nationals from that undertaken by foreigners. Modern archae-ological thought had been introduced from the West at the beginning of the twentieth century, directly and through the mediation of Japan. By the 1920s, several archaeological field projects were being conducted in China by Western and Japanese geologists, paleontologists, and archaeologists (Chen 1997: 4–52; Li 1977: 32–48). Field archaeology conducted by native Chinese did not start until 1926, when Li Ji, joined by the geologist Yuan Fuli 袁復禮 (1893–1987), excavated the Yangshao Culture site at Xiyincun 西陰村, in Shanxi province, with the financial support of the Freer Gallery (Chen 1997; Chen 2011: 70–84).

Like their Chinese counterparts, foreign observers also emphasized this distinction. For example, the headline of a story in the *Illustrated London News*

FIGURE 4.2. Fu Sinian (right) and Li Ji in front of the Anyang archaeological working station at Xiaotun, Anyang, Henan, in 1931. Reproduced with permission of the Institute of History and Philology, Academia Sinica, Taipei, Taiwan.

(1931) on the Yinxu excavation declared: "The Archaeological Awakening of China: The First Excavations in China Conducted Entirely by Chinese. Treasures from about 1500 B.C." So strong was the obsession with Chinese national archaeology that Chinese historiography on modern archaeology has often overlooked the fact that the Yinxu excavations began as a cooperative project between the Freer Gallery of Art of the Smithsonian Institution, and the Institute of History and Philology (cf. Tong 1995; Wang Shimin 1986: 690; Xia 1979: 195).

As discussed below, the selection of the Yinxu site as the first national archaeological project was motivated by an effort to satisfy contemporary nationalist sentiment. The interrelations among imperialism, nationalism, and regionalism in modern Chinese archaeology have not yet been fully explored.[2] In this chapter, I use the term "nationalism" to refer to state nationalism—that is, how "an existing state strives to become a unified nation (the idea of nation-building) or claims that its goals embody those of a nation and essential to its nationhood" (Townsend 1992: 104). More specifically, nationalism in archaeology refers to the use of archaeology as a tool to serve the political goals of constructing or

deconstructing a nation-state (Díaz-Andreu et al. 1996; Kohl and Fawcett 1995). National archaeology that followed the Communist takeover of Mainland China was, in general, a continued development of the archaeological practices of Republican China (1912–49) during the Nanjing decade (Chang 1998).

"NEW HISTORY" AND THE
INTRODUCTION OF ARCHAEOLOGY INTO CHINA

The beginning of national archaeology was closely related to the search for a "new history of China," which started at the turn of the twentieth century. A group of nationalist historians made an effort to deconstruct the old model of dynastic historiography and construct a new model of evolutionary history (Dirlik 1978; Duara 1995; Huang 1972; Schneider 1971). It was in the midst of this productive ferment that modern archaeological thought was introduced into China.

The diminishing prominence of the traditional approach to China's history led to the rise of several new competing methodologies among Chinese scholars. Their debates were closely connected to the political and intellectual movements of the time, and the relationship between politics and academic scholarship was complex. This complexity also reflected in the discourse on the origins of modern Chinese archaeology. Later in his life, Li Ji described the Yinxu excavation retrospectively as the meeting point between Chinese traditional learning and the Western sciences in the 1970s (Chang 1981: 165–66; Li 1977: 3–49). In the late 1920s, however, Li vigorously attacked traditional Chinese antiquarianism and those scholars associated with it. Following Li Ji's later point of view, Xia Nai (1910–85), Li Ji's student and the leading archaeologist after the Communist takeover since 1949, treated the rise of modern Chinese national archaeology as the combination of traditional Chinese studies of bronzes and inscribed stones (*jinshixue* 金石學), Western sciences, and the iconoclastic May Fourth New Cultural Movement and the "Doubting Antiquity" school (Xia 1979: 193–96). Others have also elaborated on the connection between a coherent evolution of Chinese archaeology and the political movements of the twentieth century (Chen 1997: 76–87; Shaughnessy 1997: 11, n. 2). Certainly no one can deny that the iconoclastic spirit and intellectual ideals expressed in the New Cultural Movement and the "Doubting Antiquity" school influenced the development of modern archaeology in China, especially as many veterans of the movement participated in the formation of the modern disciplines of national history and archaeology. The more closely we scrutinize their connections on a social and political level, however, the more complex the relationship between the intellectual movements and the practice of archaeology appears.

For some time, nationalist historians had called on Chinese scholars to go beyond the limits of transmitted texts by including such sources as bronze and stone inscriptions, material remains, and popular and folk traditions among legitimate historiographical materials for the writing of a new national history. Archaeology, for many scholars, had the potential to supply "objective" and "true" materials for the history of the people. Along with many other Western ideas, archaeology was first introduced into China by groups of anti-Manchu nationalist students and exiled revolutionaries living in Japan at the beginning of the twentieth century. The nationalists blamed China's weakness on the lack of national consciousness; they thought that a better history—a people's history rather than the traditional histories of emperors and dynasties—would unify people and foster national consciousness and true patriotism. In the recasting of Chinese history, archaeology became the indispensable source of new and varied data.

The modern Chinese word for archaeology, *kaogu* 考古, was used in traditional Chinese learning during the Song dynasty (960–1279). For example, the earliest extant scholarly catalogue of Chinese antiquities, complied by Lü Dalin (1046–92), is entitled *Kaogutu* 考古圖. However, the modern Chinese word *kaoguxue* 考古學, which was used to translate the modern meaning of archaeology, was adopted from Japanese (*kōkogaku*). A Chinese scholar who had studied in Japan, Wang Rongbao 汪榮寶 (1878–1933), first introduced *kaoguxue* as an academic discipline in Chinese literature in *Shixue gailun* 史學概論 (Introduction to History), published in 1902 in *Yishu huibian* 譯書彙編 (Collections of Translated Works), one among many popular magazines of the time devoted to introducing new ideas into China (Chen 1997: 7; Yu 1983: 108–109).

As a scholar and radical nationalist, Zhang Binglin 章炳麟 (1868–1936) first proposed in his *Zhongguo tongshi lüeli* 中國通史略例 (Guideline for Writing Chinese History, 1900) that historical research go beyond texts and utilize archaeological materials as a supplement. Liang Qichao 梁啟超 (1873–1929) also criticized the deficiencies of traditional history in his *Xin shixue* 新史學 (New History, 1902), declaring famously that "the twenty-four dynastic histories were merely genealogies of imperial families," and that a new national history was necessary for a new nation and its citizens. In his *Zhongguoshi xulun* 中國史緒論 (Prologue to Chinese History, 1901), Liang outlined just such a new history, introducing the idea of the three prehistoric ages of stone, bronze, and iron, from Western scholarship, which the Irish archaeologist R. A. S. Macalister (1870–1950) has called "the cornerstone of modern archaeology" (cited in Daniel 1967: 90). Liang made superficial use of the Three-Age system to explain Chinese history according to ancient legends. He assigned the time before the mythical Yellow Emperor to the Stone Age and the time after the Yellow Emperor to the

Bronze Age. From Liang's presentation, it is clear that archaeology in this period
had not yet helped generate any new materials for nationalist historians. Never-
theless, it was perceived as a promising scientific methodology and useful frame-
work for constructing linear and progressive national history.

The turn of the twentieth century was marked by the archaeological discov-
ery of a wide range of hitherto unknown historical materials. In 1899, oracle
bone inscriptions were first discovered. In 1900, a large number of ancient man-
uscripts were found at Dunhuang. In 1901 and 1907, Aurel Stein (1862–1943)
discovered a substantial number of ancient wooden slips in Xinjiang. Such
thrilling finds led to Wang Guowei's 王國維 (1877–1927) famous statement in
1925 that "[a]ll new study stems from new discovery." Wang taught history along
with Liang Qichao at Qinghua in the late 1920s and developed a famous "double
evidence method," in which efforts were made to combine textual and archaeo-
logical evidence in historical research.

It is worth noting that there was consensus among anti-Manchu revolution-
aries such as Liang Qichao and ultraconservative Qing loyalists such as Luo
Zhenyu and Wang Guowei on the importance of supplementing texts with
archaeology. Further impetus was given to this movement by Gu Jiegang's 顧頡
剛 (1893–1980) search for new *cailiao* 材料 (materials or data) in the May
Fourth Folklore Studies Movement between 1918 and 1928 (Schneider 1971).
Gu's proposal was developed further by Fu Sinian in his claim that "history is the
collecting of historical data" and his hyperbolic slogan of 1928: "We are not book
readers; roving from the very top of the empyrean down to the bottom of the yel-
low springs, we rely on our hands and feet in our search for source materials!" (Fu
1980 [1928]: 1312).

As Laurence Schneider has observed, in the late 1920s, Fu Sinian "began to
cling tenaciously to the so-called individual facts and, as a matter of principle, to
avoid interpretation, elucidation, hypothesis, and deductive procedures in general"
(Schneider 1971: 305). The narrow goal of modern historical scholarship, as
defined by Fu, was to collect and preserve new data. Many scholars have con-
nected Fu Sinian's methods and goals to those of the dean of archival research,
Leopold von Ranke (1795–1886) (Du Weiyun 1995; Wang 1993: 93–95; Yu
1976: 250–51). But Wang Fansen's study of Fu Sinian's own archival materials
indicates that his knowledge of the Rankian school was extremely limited (Wang
1997). Instead of viewing Fu's practice as simply inspired by missionary zeal to
introduce Western scientific historiography into China, it is more helpful to look
at his role in the debates of the 1920s over specifically Chinese historiography
and his conflict with Gu Jiegang at Zhongshan (Sun Yat-sen) University, which
I discuss later in this chapter.

Inspired by the iconoclastic spirit of the May Fourth and New Culture movements, intellectuals of the 1920s began "doubting antiquity." Gu Jiegang, with the guidance of two professors at Beijing University, Hu Shi 胡適 (1891–1962) and Qian Xuantong 錢玄同 (1887–1939), launched the movement to reinterpret China's ancient history and historiography. He challenged the historicity of the ancient sage kings, such as those legends of the Yellow Emperor mentioned by Liang Qichao above, and took the Eastern Zhou (770–221 BCE) as the true beginning of Chinese history.

Gu began by disputing the existence of the legendary Great Yu as a historical figure and then challenged conventional notions of ancient history, proposing instead a theory of the "reversed multilayered nature of ancient Chinese history." Finally, in the later volumes of *Gushibian* 古史辨 (Critiques of Ancient History) and *Bianwei congkan* 辨偽叢刊 (Symposium on the Critiques of Spurious Literature), he and many young scholars inspired by his approach, including Fu Sinian, systematically discredited the authenticity of the transmitted classics (Gu et al. 1926– 41; Gu 1928–35). Using "doubting antiquity" as a slogan, Gu constructed a sociopolitical analysis of historical writing in an effort to detect the political agenda behind texts and criticize the traditional social order. Applause and attacks, both fervent, immediately greeted Gu's iconoclastic manifesto. Fu Sinian, who had been Gu's roommate at Beijing University, praised Gu as "the Newton and Darwin of ancient Chinese history" (Fu 1933 [1928]: 298).

Compared with their nationalist predecessors, the doubters of antiquity contributed little to the development of Chinese archaeology. French-trained historian Li Xuanbo 李玄伯 (1895–1974) tried to press Gu to go beyond transmitted texts and argued that quarrels about texts without reliable material support were futile. Those extant transmitted documents might be apocryphal or corrupt; only materials wrought at the time of the ancients could serve as a reliable basis for ancient history. Hence, for Li, "the only way to solve the problem of antiquity is archaeology" (Li 1933 [1924]). Although Gu recognized the importance of Li's recommendations, he was unwilling to discount the importance of transmitted textual materials in deconstructing the traditional historiography. After all, he argued, the results of China's archaeological projects were not likely to be available for some time, since funding for such projects had yet to be pledged by the government or wealthy donors (Gu 1933 [1925], 1933 [1926]: 57–58).

In a letter to Gu published in *Gushibian*, Hu Shi also emphasized the importance of archaeology; moreover, he suggested that it was "better to err by doubting antiquity (*yigu* 疑古) than by believing in antiquity (*xingu* 信古)" (Hu 1933 [1921]). To use a new evolutionary form for ancient history, Hu adopted

Swedish archaeologist J. G. Andersson's (1874–1960) hypothesis that the Shang dynasty was China's Stone Age or Neolithic period, in a letter to Gu dated May 30, 1923 (Hu 1933 [1923]). This was the first time that careful reflection had gone into the application of the Three-Age prehistoric model to China. (Later, this hypothesis was disproved by the Yinxu excavation.)

Although Chinese intellectuals had encountered modern archaeology as early as 1900, these ideas failed to make any significant impression on the recasting of Chinese history. Derived largely from spotty selections of secondary sources read in translation, Chinese understanding of modern archaeology remained superficial through the 1920s (Yu 1983). While a new generation of historians—Zhang Binglin, Liang Qichao, Wang Guowei, Hu Shi, and Gu Jiegang—strove to adapt new data and innovative methodology to historical research, the discourse on archaeology remained abstract, despite the fact that archaeological excavations in China, wholly dominated by foreign experts and imperial archaeologists, had already taken place. Most Chinese scholars equated archaeology with traditional antiquarianism.

CULTURAL INTERNATIONALISM AND IMPERIAL GREED

Viewed from the perspective of their professional standards, some of the imperial archaeological expeditions in China were doing first-rate fieldwork, but the questions and basic concerns with which European and Japanese imperial archaeologists approached their task were often different from those of Chinese scholars. In general, imperial archaeologists and art dealers were interested in the scientific data and works of art (see von Falkenhausen, this volume). They viewed Chinese materials from the broader perspective of natural history, the history of science, world history, and cultural internationalism. Although there were more professional and reputable groups, some of the imperial explorers in China, under the Orientalist mind-set, took advantage of the absence of a capable central government to conduct investigations that verged on looting (see Xu, this volume). They did irreparable harm to the sites. In addition, local peasants and tomb robbers, encouraged by lucrative foreign and domestic markets and sometimes commissioned directly by foreign dealers, took a terrible toll on China's archaeological heritage (Cohen 1992; Meyer and Brysac 2015).

Appalled by the damage being done to artistic treasures such as the Longmen Caves, Charles Lang Freer (1854–1919), an American collector of Chinese art, launched a series of projects in China aimed at obtaining pristine objects from carefully documented contexts, though the contexts themselves were not his interest. Considering it part of his mission, Freer attempted to set up an

American School of Archaeology in Beijing (Cohen 1992: 57–58). The Freer Gallery of Art, a gift Freer gave to the US government, was conceived by its founder as a museum and research institution aimed at "the encouragement of the study of civilization of the Far East." Archaeological fieldwork had begun in China at the instigation of the gallery's director, John Ellerton Lodge (1878–1942), in February 1923, with an expedition in association with Boston's Museum of Fine Arts that predated the official public opening of the Freer Gallery in May 1923.

Heading this and later Freer expeditions was the archaeologist Carl Whiting Bishop (1881–1942) (Fig. 4.3), who had been a student of the famous anthropologist Franz Boas (1858–1942) at Columbia University. An advocate of

FIGURE 4.3. Carl Bishop in the field in China. From the Carl Whiting Bishop Collection, Freer Gallery of Art and Arthur M. Sackler Gallery Archives, Smithsonian Institution, Washington, DC, PSA A.02 2.391-10.

the then-popular theory of hyper-diffusionism—that all civilizations originated in one place and spread to others—Bishop worked in China from 1915 and served as associate curator and associate in archaeology at the Freer Gallery of Art from 1922 to 1942 (Britton 1943; Brown 2008: 22–27; Newmeyer 1987; Wilbur 1943: 204–207; Winegrad 1993: 61–68).

In March 1925, Bishop, who was in Beijing leading the expedition sponsored jointly by the Freer Gallery and the Museum of Fine Arts, Boston, wrote to Li Ji to invite him to join the Freer field archaeology staff for excavations in China. Having received his doctorate in anthropology from Harvard University and returned to China in 1923, Li Ji had just joined the faculty at the newly established Qinghua Institute of National Learning in Beijing after two years of teaching at Nankai University in Tianjin. At Nankai, Li met Ding Wenjiang 丁文江 (1887–1936), head of the China Geological Survey and a great promoter of Western sciences in China (Furth 1970). When Ding heard that a large number of ancient bronzes had been discovered in Xinzheng, Henan province, he sent Li to investigate the site in 1923. Although resistance from local people and rumors of banditry foiled this first attempt at Chinese archaeology, Li had made the acquaintance of Bishop, who was also in Henan investigating the Xinzheng discoveries (Bishop 1924). After careful consideration and at the advice of Ding, Li accepted Bishop's invitation but advanced two conditions for participating in the Freer project: (1) excavations had to be done in cooperation with Chinese academic organizations, and (2) all cultural relics had to remain in China (Li 1977: 54–56; Li 1994 [1961]: 161–63).

At the turn of the century, these were sensitive issues. Art collectors in the United States as well as in other Western countries and Japan had begun to lay the foundation for collecting and connoisseurship of Chinese art and for training curators specializing in East Asian arts. With the help of art dealers and curators such as Ernest F. Fenollosa (1853–1908) and John C. Ferguson (1866–1945), American museums and collectors obtained thousands of outstanding works of Chinese art in the late nineteenth and early twentieth centuries (Cohen 1992: 37–73; March 1929: 34–113; Meyer and Brysac 2015; Netting 2013). One result was the increasing value of Chinese art objects, which increased, in turn, the number of foreign expeditions, while contributing to the aforementioned local theft of ancient pieces for the largely unregulated antiquities market. Paradoxically, even as increasingly stringent professional ethics standards among archaeologists and museum staff in the United States and elsewhere gave the appearance of constricting the illegal use of wealth, power, and technology to obtain art objects from other parts of the world, including East Asia, professionalism often amounted to a façade behind which Western imperial greed contin-

ued to hide (Cohen 1992: 75–100; Meyer and Brysac 2015). As the last leg of the global "antiquities rush," art treasures and artifacts were regularly transferred from Asia to the United States and Europe (Marchand 2015).

Such conditions provided context for Bishop's rather patronizing response to Li Ji's stipulation about the ownership of art objects excavated in China:

> Your touching upon the subject of removal of art objects from Chinese soil opens up a very large and important subject, with the most far reaching ramifications, and especially thorny through the vested interests—art dealers both Chinese and foreign—concerned. I have some very decided ideas in this regard, however—ideas which I feel pretty sure will meet with your warm approval and support. I have not yet thought these out to the point where I can put them adequately upon paper; but it seems to me that I am slowly working toward a solution that will be fair to all. The time was when the notion of the Powers returning any portion of the Boxer Indemnity funds would have been laughed at; yet the needed change of feeling has been brought about, and it has always given me the sincerest pleasure to know that the United States took a leading part in initiating this movement.
>
> There are several possibilities concerning the future treatment of Chinese art objects. I believe a beginning has already been made in the return of these to Chinese possession. Here, doubtless, the question of ownership, both original and actual, would come up. Another possibility is that of sending abroad loan collections, to be exhibited in certain definite foreign institutions for a period of years. It is unfortunately too true that the real greatness of China—her achievements in the past and her vast potentialities for the future—have been obscured during the past few years by news of bandits, floods, famines, and civil disorder to an extent wholly beyond the facts. No nation to-day can live to itself alone; and I for one should like nothing better than to give all the aid in my power in the direction of placing China in a proper light, particularly before the people of the United States.

Bishop's answers fit what scholars later termed "cultural internationalism" (for a critique of this idea, see Brodie, this volume). His suggestion regarding the repatriation of art objects, long-term loan collections, and international education and exhibitions remain hot topics even in today's post-colonial international settings. Although best known from John Merryman's essays on the subject (1986, 1996, 2006, 2009), the idea of "cultural internationalism" developed in parallel with the growth of the nation-state in the modern world, and some of the positive practical aspects were formalized in international conventions after the Second World

War (Iriye 1997; see also Brodie, this volume). Bishop stated that his mission was to reveal "the real greatness of China" to the people of the United States, advance "true scientific research," and bring about "the best possible understanding between the peoples." He assured Li Ji that "you would be asked to do nothing which you might feel incompatible with your allegiance to the Republic of China" (Bishop to Li, dated March 23, 1925). Earlier, Bishop had negotiated with Qiu Shanyuan 裘善元 (1890–1944), the director of the Historical Museum in Beijing, a branch of the Ministry of Education, to make himself an adviser in the field of archaeology to the Chinese government. He also secured agreement that the Smithsonian Institution be designated the sole foreign excavator and exporter of objects from China (Newmeyer 1987: 24).

Li Ji was satisfied with the answer, despite his recognition of the vague promises of Bishop's response. Subsequently, Bishop and the Qinghua Institute of National Learning arrived at the agreement that the Freer would finance an expedition directed by Li and officially sponsored by the Qinghua Institute of National Learning. By choosing to work on the Neolithic period, which was predominantly investigated through its copious pottery remains, Li Ji both avoided competing with art collectors, few of whom were interested in bits of unglazed ceramic.

In spring 1926, Li Ji and Yuan Fuli paid a call to Yan Xishan (1883–1960), the warlord of Shanxi province. Thanks to a letter of introduction from Liang Qichao, they obtained from Yan promises of local support for a field trip to the Fen River valley in the southern part of Shanxi. Since legend had it that the capital of the mythical Emperor Yao had been located in the southwest of Shanxi, Li Ji's selection of this site was influenced by current debates among Gu Jiegang and other nationalist historians concerning the historicity of the legendary emperors. Li Ji also attempted to use archaeological discovery to refute Andersson's hypothesis that the painted pottery of the Yangshao culture, at the time believed to be China's oldest Neolithic culture, originated in the West.

Excavations were carried out from October to December 1926 at the village of Xiyincun; a number of prehistoric painted potsherds and a portion of a silkworm cocoon were found. The work at Xiyincun adhered to the highest standards of professionalism in field archaeology at the time, and its impact on the development of Chinese archaeology was tremendous (Chen 1997: 145–50). These were the fruit of the first archaeological fieldwork conducted autonomously by Chinese nationals.

Although the Yangshao Culture site at Xiyincun was the first to be excavated by Chinese archaeologists, it was not usually considered to be the birthplace of Chinese archaeology. In discussing the influence of Chinese historiography on archaeology, K. C. Chang has speculated that had China's first

large-scale, national archaeological expedition involved a prehistoric site rather than Yinxu, archaeology might have developed along a completely different trajectory, oriented more toward the methods and aims of the social sciences than toward history (Chang 1981: 165). However, Xiyincun was not the only prehistoric archaeological site investigated prior to the Yinxu excavation; other, earlier examples include the Paleolithic site of Zhoukoudian near Beijing, where the famous *Homo erectus pekinensis*, or Peking Man, was found in 1921, and Neolithic sites at Yangshao village excavated under the direction of J. G. Andersson in 1921. Almost all of the archaeological sites studied by foreigners before the Yinxu excavation were prehistoric. Despite such work, rather than for lack of it, Chinese archaeology developed as a tool of Chinese historiography (von Falkenhausen 1993). The reason seems clear: Chinese national archaeology, like European archaeology, had close intellectual links with traditional historiography. In China, archaeology was closely related to Chinese nationalism and politics and thus inevitably served contemporary nationalist demands.

NATIONALISM AND THE SHIFT FROM "DOUBTING ANTIQUITIES" TO "RECONSTRUCTING ANTIQUITY"

After the collapse of the Qing dynasty, a fragmented state and power vacuum left Chinese intellectuals relatively free to voice their political and academic opinions. During the early years of the Republican period, the GMD government was too preoccupied with international and domestic political and military affairs to oversee the educational system and intellectual activities. Local warlords lacked the inclination and ability to censor academic discussions. Following the Northern Expedition of 1926–28, however, the Nationalists took control over China and advocated the "partification of education" (*danghua jiaoyu* 黨化教育) and restrictions on schools and students (Yeh 1990: 173–76). Academics rallied immediately against the threat to intellectual freedom. The eminent scholar Chen Yinke 陳寅恪 (1890–1969), for instance, together with his friend Wu Mi 吳宓 (1894–1978), vowed to preserve their intellectual integrity by refusing to be affiliated with the GMD (Wu 1992: 49). In early 1929, Chen Yinke loudly voiced his views on the importance of separating scholarship from political ideology and alluded to Patrick Henry's "Give me liberty or give me death" in a stele inscription commemorating the suicide of Wang Guowei (Lu 1995: 109–13).

By contrast, Fu Sinian reacted quite differently to the new governmental focus on science and education. He saw this as an opportunity to gain national support for archaeology, and he was willing to place archaeology at the service of the nation for what he saw as the larger good of the discipline. Almost a half-

century after the death of Fu, Du Zhengsheng, who succeeded to the director-
ship of the Institute of History and Philology in Taiwan, praised his predecessor
not only for "pioneering" the "Doubting Antiquity" movement but also for his
untiring advocacy of the "Reconstructing Antiquity" movement (Du 1995). Du
has examined archaeological practices, particularly the Yinxu excavation, to illus-
trate the accuracy of Fu's historical theory (Du 1995, 1998). However, if we are
to recognize why Yinxu was selected as the first site for national archaeology, we
must first understand the broader intellectual context for the move from "Doubt-
ing Antiquity" to "Reconstructing Antiquity." This transition was tied to the
political and intellectual climate at the beginning of the Nanjing decade.

Although Hu Shi had long been a prominent supporter of the "Doubting
Antiquity" school, when Gu Jiegang paid a call on Hu in March 1929, he was
told: "Now I've changed my mind. I no longer doubt antiquity. On the contrary,
I want to believe in antiquity" (cited in Gu Chao 1993: 171). This sharply con-
trasted with Hu Shi's earlier formulation quoted above: "Better to err by doubt-
ing antiquity than by believing in the authenticity of ancient Chinese historiog-
raphy." Du Zhengsheng attributes this change to the influence of Fu Sinian (Du
1995). However, for a better understanding of Hu Shi's change from "doubting
antiquity" to "believing in antiquity" and Fu Sinian's decision to select Yinxu as
the first site of national archaeology in China, we must look to the changing
political context.

A headline in the May 16, 1929 issue of *Xin chenbao* 新晨報, published in
Beiping (the name of Beijing after the relocation of the capital), proclaimed:
"National Government Issues Stringent Ban on Counterrevolutionary Text-
books." A junior high school textbook, *History of China* (*Benguoshi* 本國史),
published by the Commercial Press (1924) and compiled by Gu Jiegang and
Wang Zhongqi 王鍾麒 (1890–1975), was banned by the Nanjing government
because:

> [the textbook] has many falsehoods. For example, [the authors] deny the his-
> toricity of Emperor Yao's abdication and handing over of power to Emperor
> Shun and the Great Yu's controlling the waters; [the authors] claim that the Six
> Classics were forgeries; Zhou Xu's and others' murdering their fathers and
> elder brothers were revolutionary actions against the class system; Wen Jiang's
> incest was revolutionary action against the marriage system; the self-indulgence
> and unrestrained behaviors of the Wei and Jin periods were revolutionary
> actions against Confucian teachings; [they even declare that] there was no writ-
> ing before the Shang dynasty; the areas of Qi and Lü [today Shandong] during
> the Three Dynasties were lands of alien races; Zhou Xu and Wen Jiang were
> revolutionaries; Wang Mang was a socialist politician; those who indulged in

sensual pleasures and did not restrain themselves from Confucian doctrines were thinkers and philosophers. All these views not only willfully eliminate the historical facts, but also poison the young generations and shake our national confidence (*Xin Chenbao*, May 16, 1929).

After three educational professionals from Shandong filed a petition, a national committee led by Cai Yuanpei 蔡元培 (1868–1940), a senior member of the GMD government, decided to ban the textbook.

Gu was also denounced by Wang Hongyi 王鴻一 (1874–1930), a member of the legislative assembly from Shandong, for "libeling the sages and slighting the law of the National Government (*feisheng wufa* 非聖無法)." Dai Jitao 戴季陶 (1890–1949), the president of Zhongshan University at Guangzhou and a major GMD ideologue, declared that scholarly debates were permissible but "such things may not be stated in the textbooks, lest they shake our national confidence." For Dai, the belief in a common ancestor lay at the very base of national unity, and Gu's airing of his doubts was potentially harmful to the nation (cited in Gu Chao 1993: 172).

Many intellectuals viewed national unity as supremely important, and several studies of Hu Shi have demonstrated the connection between his changing views on "doubting antiquity" and his relations with the GMD government during the late 1920s and early 1930s (Shen 1993: 93–176; Yang 1991). When the Northern Expedition was initiated in 1926, Hu Shi was traveling in Europe. As he followed the string of the GMD's victories in the local press, he became more and more excited about China's prospects. At a speech in London, he explicitly expressed his support for the GMD government: "China desperately needs a modern government. The Guomindang are far more intellectually up to date than the Beiyang warlords. As long as they act in strict accordance with the Three Principles of the People, the nation will benefit. Intellectuals should support them" (cited in Shen Gangbo 1982). However, soon Chiang Kai-shek began to "purify" the GMD party. Hu was on his way back from Europe when he read the news that Cai Yuanpei, Wu Zhihui 吳稚暉 (1865–1953), and other senior members of the GMD party had all declared their support of the Nanjing government. He told a foreign friend: "General Chiang Kai-shek has won the support of a group of senior [Guomindang] officials for his purification of the party and purge of the Communists. You foreign friends may not know Cai Yuanpei and Wu Jingheng [i.e., Wu Zhihui], but I know them, and I respect their knowledge and ethics. If the new [Nanjing] government is able to gain support from these senior members of the Guomindang, it can hold its ground" (Hu 1954). On his return to China, Hu Shi communicated with senior party members and high-level officials. Although he remained dissatisfied by GMD policies on

human rights, democracy, and other issues, Hu threw his support firmly behind
the ruling party (Shen 1993: 100–53).

During the late 1920s, cultural conservatism was a dominant trait of the
GMD regime (Eastman 1976; Schneider 1971: 33). Throughout the previous
decade, Hu Shi, along with his students Fu Sinian and Gu Jiegang, had traveled
in the opposite direction. At Beijing University in the late 1910s and early 1920s,
the three men, along with other students, had founded a journal entitled *Xinchao*
新潮 (New Tide, subtitled in English *Renaissance*); their shared ambition was to
contribute to the recasting of Chinese society in modern forms.

Gu and Fu had long been comrades-in-arms. Although Gu was the elder of
the two, he submitted to Fu's leadership. After the events of May Fourth in 1919,
Fu received an official scholarship and went to Europe to study. Gu graduated,
got a job at the library, and stayed at Beijing University. While Fu was dabbling
in psychology, biology, physics, mathematics, statistics, historical linguistics, and
logic, Gu was developing his famous theory of the "reversed multilayered nature
of ancient Chinese history" under the guidance of Hu Shi. When Hu Shi next
encountered Fu, it was in Paris in September 1926, and the teacher did not hes-
itate to express his dismay with this intellectual dilettante. For over five years, Fu
had been in an intellectual slump. Hu scolded him, and urged the expatriate to
take Gu as a model. In a diary entry dated September 5, 1926, Hu noted that
"Mengzhen [Fu Sinian] is rather decadent and dissolute, and far less diligent
than [Gu] Jiegang" (cited in Du 1995: 22).

When Fu returned from Europe in the winter of 1926, his old roommate
had become a famous historian, and the first volume of the *Gushibian* (Critiques
of Ancient History) had been published. Feeling the need to establish his own
scholarly credentials, Fu accepted an invitation from Zhu Jiahua 朱家驊
(1893–1963) and Dai Jitao to direct the Departments of History and Chinese
Literature and became the head of liberal arts at Zhongshan University in
December 1926. Although Fu had mixed feelings about Gu's success, the intel-
lectual sympathies between the two men were deep, and they remained good
friends. For this reason, Fu Sinian did not hesitate to come to the aid of Gu in
1927 when his old friend ran into trouble at Xiamen University, and invited him
to teach at Zhongshan University. When Li Xuanbo employed archaeology to
bolster his critique of Gu's ideas on doubting antiquity, Fu came to the latter's
defense:

> Certainly, by digging in the earth you can find prehistoric and Shang-Zhou
> materials. But this is only the early part of China's cultural history. As for exca-
> vating texts and documents, I am afraid few will be found. Your [Gu Jiegang's]
> thesis provides the key to all the Classics, the commentaries, and the hundred

schools; it is the means to understand Chinese intellectual history fully, a mirror to Zhou and Han thought, and it is a new achievement in ancient historical studies (Fu 1933 [1928]: 297; also in Fu 1980 [1928]: 1054–55).

Early on, Fu Sinian also employed Gu's methodology in an attempt to discover different layers of historical deposits in ancient Chinese literature and the Confucian classics (Chen Zhiming 1993: 196–201). To realize his ideal of combining linguistics and history in a unified discipline, Fu Sinian established the Institute of Philology and History at Zhongshan University in 1927. No doubt it was at his invitation that Gu Jiegang wrote the editorial's opening remarks to the first issue of the *Weekly Journal of the Institute of Philology and History of National Zhongshan University*, a sort of manifesto for the Institute.

Once Gu Jiegang returned in earnest to his work on ancient history, popular culture, and folklore—areas he had worked on for years while at Beijing University—he revived a network of personal relations and was soon surrounded by a group of enthusiastic young students deeply impressed by his creative mind and eager to follow in his footsteps. Although Fu was the director of the institute, when it came to research, the laurels clearly went to Gu Jiegang. So powerful was Gu's intellectual influence that many scholars at the institute seemed as eager to emulate his methods as his devoted students. It seems that Fu Sinian could not help resenting the dominance of the friend whose career he had saved, and the two men began to argue over the institute's research mission.

By this time, the late 1920s, nationalism had become a highly complex and contested minefield in China. It was not simply an issue of conflict between Chinese and the West. For Fu Sinian's generation of nationalists, Western ideas and practices were useful tools in the struggle and the fight against Western and Japanese imperialism. They also played an important function in more strictly domestic politics (Du 1998: 20–27). Soon nationalism also became a crucial element in increasingly hard-fought struggles among Chinese academic groups.

Competition among individuals, schools, and institutes was exacerbated when the newly settled Nanjing government declared it would sponsor only those scientific and technological enterprises that would aid in the construction of a new nation. Fu Sinian persuaded Cai Yuanpei and other senior party members to press for the establishment of an Institute of History and Philology as part of the newly established Academia Sinica. While insisting that the new approaches to history and linguistics made them "sciences" much like the natural sciences, Fu attacked traditional Chinese medicine as thoroughly unscientific (Fu 1980 [1934]: 303–308). After the May Fourth Movement, the word "scientific" was laden with such connotations as "correct," "true," or "right." At the same time, "traditional" implied "incorrect," "backward," and "superstitious." Fu's impassioned

polemic, in which he exploited such connotations to the hilt, led to the ban on Chinese medical practices levied by the GMD government.

Once the Institute of History and Philology had been approved, Cai Yuan-pei appointed Fu Sinian and Gu Jiegang to lay its foundations. The joint appointment could not help but exacerbate growing tensions between the two old friends (Gu Chao 1993: 15). Fu championed the example of French sinology, insisting that the institute ought to press for the production of works of highly refined scholarship, while Gu argued that in order to produce excellent scholarship, the institute would have to assume the responsibility of popularizing scholarly insights and educating the people so as to provide a seedbed for future scholarly developments. As the two men fought and squabbled, Fu, now desperate to maintain a firm grip on the intellectual trajectory of the institute for which he had campaigned, brought about a collapse of the fifteen-year friendship. Gu Jiegang, an influential historian of his day, was excluded from the national Institute of History and Philology and never had the opportunity to return.

At exactly this moment, Fu Sinian received Dong Zuobin's report on his first visit to Yinxu in August 1928, reporting that that there were still inscribed oracle bones that might be worth excavating. Fu was excited: Yinxu was the perfect place to display his commitment to the scientific study of history and could provide a starting point for an "authentic" Chinese history that could overturn Gu Jiegang's celebrated doubts about antiquity, and at the same time, follow, or even surpass, Wang Guowei's famous "double evidence method" (Chen 2013).

Things might have turned out very differently. However, Fu Sinian's timing was right when he proposed excavating Yinxu in 1928. Earlier, in 1926, while Henan was still in the control of a warlord, the Japanese archaeologist Hamada Kōsaku 濱田耕作 (1881–1938) and Harada Yoshito 原田淑人 (1885–1974) had organized the Dongfang kaoguxue xiehui 東方考古學協會 (Oriental Archaeological Society) with Ma Heng 馬衡 (1881–1955) and others from the Beijing University (Chen 2002; Sang 2001: 114–35). Although both the archaeologists at Beijing University and the Japanese archaeologists set their sights on Yinxu, they were obliged to scuttle their plans because of the unfavorable social, political, and financial circumstances (Sakazume 1994; Yoshikai 2015). Moreover, the newly founded Institute of History and Philology certainly could have elected to make its first archaeological investigation at a different site. One of the Neolithic sites excavated by Li Ji would have offered such an option. In 1927, there was also talk of Zhongshan University's participation in the Sino-Swedish expedition to Northwest China led by Sven A. Hedin (1865–1952) and Xu Xusheng 徐旭生 (1888–1976). In fact, before he left for home in the winter of 1927, as a member of the faculty at Zhongshan University, Dong Zuobin was

charged by the Institute of Philology and History with preparing the trip to the Northwest (Xibei kexue kaocha tuan 1927). In order to firmly control the new institution, Fu Sinian was very selective in his choice of the members of the Institute of History and Philology. All the members, except the established historian Chen Yuan, were scholars who had studied abroad (Du 1998: 17). By Fu's standard, Dong Zuobin, a student of traditional learning, was not a qualified candidate. However, Fu made an exception and appointed Dong a corresponding member because of the crucial information he had provided and the importance of adding a native of Henan to the Yinxu project. (Ma Heng tried unsuccessfully to lure Dong to join the Sino-Japanese Oriental Archaeological Society in 1929; see Yoshikai 2015: 41–43.)

For national politics and the history of archaeology in modern China, the year 1928 ushered in dramatic changes. Zhang Xueliang 張學良 (1901–2001), the warlord who dominated northeastern China, agreed to change his flag and submit to the authority of the GMD government. Consequently, for the first time since the fall of the Qing, China was united under the name Republic of China. In October 1928, the Institute of History and Philology was created at Guangzhou. In that same month, Dong Zuobin conducted the survey and excavations at Anyang. In December, Li Ji met Fu Sinian at Guangzhou. Having worked with the Freer Gallery of Art, Li returned from a trip to Washington, DC, where he had met with officials of the Freer Gallery and obtained assurances of continued financial support. Fu Sinian thus appointed Li to replace Dong Zuobin and take charge of the archaeological section of the Institute of History and Philology.

WHO OWNS THE PAST?
IMPERIALISM, NATIONALISM, AND REGIONALISM IN THE 1930S

In his discussion of the historical interplay between nationalism and archaeology, Bruce G. Trigger has pointed out both the positive and negative aspects of this relationship (1989: 148–206, 1995). In terms of the development of the discipline, the nationalist approach to archaeology has gone beyond the imperial and colonial approach and progressed in the areas of theory and technology (Trigger 1995: 266–72). On a sociopolitical level, the rise of national archaeology has supported resistance to imperialism, colonialism, and racism in a number of nations. In China in the 1930s, as the GMD government labored to construct a new nation-state, archaeology provided the tools for resisting both Western imperialism and Chinese regionalism. As the Chinese nation-state became a reality, Yinxu was a battlefield where nationalists fended off both local and imperialist demands.

As the correspondence between Li Ji and Carl Bishop described above suggests, foreign archaeologists and Chinese institutions often disagreed on the subject of the ownership of artifacts. Waxing nationalist sentiments made foreign expeditions without an official Chinese sponsor increasingly difficult. But even cooperation was no panacea. Foreign art collectors had to contend with local dealers and institutions as well as the newly established national institutions, and each claim was lodged within a distinctive and often irreconcilable discourse. Moreover, an unstable political situation rendered the contest still more complex.

The intellectual debates regarding the Yinxu excavation corresponded with the political struggle between regional warlords and central government (Wang 1993: 126–27, 1997: 119–28). A close examination of the academic and administrative conflicts that erupted shows that in many cases they mirrored the political struggles between Chiang Kai-shek and the local warlord governing Henan. Thanks in part to Henan's warlord's agreement to submit to the GMD government, Li Ji won approval for excavations at Yinxu from the Henan provincial government. However, in May 1929, the soldiers protecting the staff of the Yinxu project suddenly withdrew from the site: local warlord Feng Yuxiang 馮玉祥 (1882–1948) had defied Chiang Kai-shek's ban on the assembling of local armies and now began a war against the central government. At around the same time, local bandits began to prey upon Anyang.

Under these circumstances, Li Ji's decision to ship some of the artifacts to Beiping seems utterly reasonable. Nevertheless, the local people and the provincial authorities promptly accused him of violating the agreement reached between the government of Henan and the Institute of History and Philology. The original provincial permission that Dong Zuobin received had made no mention of this issue (Chen 2011: 146–47). Only later did He Rizhang 何日章 (1893–1979), director of the Henan Provincial Library and the Henan Museum of Ethnography (Ren 2007; Ren and Zhang 2003), suggest to the provincial government that the Yinxu treasures should be exhibited in Kaifeng, the provincial capital. The local authority quickly endorsed his suggestion. When this request reached the institute, it provoked a vague response—the issue of ownership was negotiable; after all, the institute was devoted to research, not to the acquisition of artifacts (Chen 2011: 147).

In October 1929, He Rizhang informed Li Ji that the Henan authorities had decided to prohibit all digging at Yinxu by the Institute of History and Philology; the process of excavating the site was soon taken over by the Henan Museum of Ethnography. Both parties to the dispute timed their moves in accordance with the vicissitudes of the conflict between Chiang Kai-shek and Feng Yuxiang, and those who held the right to excavate Yinxu were those who held political

sway. Fu Sinian immediately began looking for ways to settle the dispute through political channels. He contacted Wu Zhihui, a senior member of the GMD party who had regular contact with Chiang Kai-shek. Through this trusted official, Chiang Kai-shek became convinced of the importance of compelling the Henan local government to cooperate with the institute's project. The capricious turns of the war, however, emboldened the local government to disregard orders from the republican government. This development drove Fu Sinian to take further steps. He traveled to Kaifeng, where he negotiated with provincial officials and scholars by day and delivered lectures by night.

To pacify regionalist sentiment, Fu Sinian assured his interlocutors and auditors that the institute he directed recognized the sensibilities of the people of Henan (Chen 2011: 148–50). He promised that as soon as the study of materials unearthed at Yinxu had been completed, they would be delivered to Kaifeng for public exhibition—the Institute of History and Philology was exclusively concerned with scholarship, not the collection of treasure. To convince the local people to see the Yinxu excavation as a national event, moreover, Fu Sinian also lectured on the use of archaeological discoveries in reconstructing national history. However, even after he had worked out the details of a new agreement with the Henan authorities, Fu found his pet project stymied by He Rizhang, who insisted that the excavation be conducted exclusively by Henan scholars. Not until the war was concluded and Chiang Kai-shek had regained control over Henan was the Institute of History and Philology permitted to work at Yinxu again. Thanks to these conflicts, local scholars and students from Henan University came to work on the Yinxu excavation.

In addition to the political conflicts between the central and regional governments, cultural conflicts between Western scientific methods and traditional Chinese learning complicated the situation. Whenever Li Ji and Fu Sinian described their plans for the Yinxu excavation, they emphasized the importance of advanced Western methods, which they praised while denigrating traditional Chinese *jinshixue* (Chen 2011: 147–48). They attacked the traditional antiquarians' obsession with written texts, which they suggested was the reason that antiquarians failed to pay close attention to non-textual artifacts and their original context. He Rizhang, they stated, possessed all of the old antiquarian shortcomings. Li Ji called antiquarian excavation "treasure hunting" and decried an unscientific emphasis on the object to the exclusion of the context that gave the object meaning.

Both Li Ji and Fu Sinian used the binary structure of "new" versus "old" to distinguish themselves from local Henan scholars: the Institute of History and Philology represented the new, the scientific, and the advanced, while the government of Henan and its representatives embodied the old, the unscientific, and

the backward (Wang 1995: 43–47, 1997: 119–28). It is true that the Henan
scholars had less Western-style scientific training. A closer look, however, sug-
gests that the "new" and the "old" were not always so distinct.

It is clear that *jinshixue* cannot fairly be regarded as wholly static and obso-
lete. In the 1920s, it was absorbing modern scientific methods and technology
and developing into a new academic discipline. For instance, Ma Heng, trained
in traditional Chinese learning and a professor of *jinshixue*, established the first
graduate program in *kaoguxue* (archaeology) under the Guoxuemen (Depart-
ment of National Learning) at Beijing University in 1922. He carried out a num-
ber of archaeological surveys and investigations at Henan, Shanxi, Beijing, and
other areas in which Xu Xusheng, Li Xuanbo, Chen Wanli 陳萬里 (1892–
1969), Gu Jiegang, Rong Geng 容庚 (1894–1983), Huang Wenbi 黃文弼
(1893–1966), and others participated (Chen 2013). In fact, all ten Chinese
members of the Sino-Swedish expedition to Northwest China led by Sven A.
Hedin and Xu Xusheng were faculty and students of Beijing University (Jia
1992).

In terms of archaeological methods, Fu Sinian and Li Ji themselves had not
received any particular training when they were students in the West. Li was
trained as a physical anthropologist, whereas Fu had dabbled in various fields
other than archaeology. Field methods were not greatly improved until Liang
Siyong (1904–54), the first Harvard-trained archaeologist, joined the Yinxu
excavation in 1931 (Li Guangmo 1997; Xia 1959 [1954]; Yin 1959 [1954]). By
contrast, *jinshixue* was as open to Western scientific methods as Li Ji was to many
techniques from Chinese traditional learning and local engineering knowledge
that he integrated into his practice at Yinxu. Those who translated books of
Western archaeological theories and methodologies from Japanese then appear-
ing in China tended to be scholars trained in traditional *jinshixue*. For example,
the main methodological work in modern archaeology, Oscar Montelius's
(1843–1921) *Die älteren Kulturperioden im Orient und in Europa* (1903), was
translated into Chinese twice, once by Zheng Shixu 鄭師許 (1897–1952) and
Hu Zhaochun 胡肇春 (*Kaoguxue yanjiu fa* 考古學研究法, 1936) and then by
Teng Gu 滕固 (1901–41) (*Xianshi Kaoguxue fangfalun* 先史考古學方法論,
1937). The influence of these translations on the development of Chinese
archaeology was tremendous. Scholars excluded by Fu Sinian from the Institute
of History and Philology also organized several associations, societies, and insti-
tutions of archaeology, and carried out their own archaeological work (Xu 2012).
For example, the National Beiping Academy, founded in 1929, had an archaeo-
logical section led by Xu Xusheng. It carried out investigations and excavations
at the Yanxiadu 燕下都 site at Yi xian, Hebei province, in 1930 and at Doujitai

鬥雞台, near Baoji, Shaanxi province, during 1933–1935 (Wang Shimin 1986: 41). That Ma Heng, who had been active in the field of archaeological investigation and excavation, was rejected by Fu Sinian for participating in the Yinxu excavation project suggests that a consensus on the definition of modern Chinese archaeology was hardly possible in the late 1920s. Political and personal biases were too powerful to allow concessions to opponents (Du 1998: 25). Only in later years was Li Ji, an outspoken critic of *jinshixue* in his early career, able to admit its positive influence on archaeology (for Li Ji's later reflection on his excavation methods at Yinxu, see Xia 2009, vol. 2: 95).

The Freer Gallery of Art withdrew from the Yinxu excavation in 1930. The vague nature of the original agreement between Bishop and Li Ji contributed to a series of disputes over the purpose of the excavation and the treatment of unearthed artifacts. The chaotic social conditions, the surge of nationalism, and the inability to conduct any archaeological excavation in China made Bishop increasingly frustrated and eventually disillusioned. His wishful plan could not be carried out. After more reconnaissance missions and very little excavations in the early 1930s, the Freer Gallery of Art program of expeditions to China was abandoned completely in 1934. The director of the gallery, John Lodge, felt that what few results came from the expedition were not worth the $30,000-a-year budget (Newmeyer 1987: 24). The rising tide of Chinese nationalism and the increasing constraints of archaeological professionalism in the United States led to the disruption of the partnership. Mirroring the conflicts at Yinxu between nationalism and regionalism, nationalist archaeology had to do battle with imperial appropriation of antiquities.

The Yinxu excavation was the first nationally supported archaeological project in modern China and the turning point in the transition from imperial to national archaeology. Although initially during the 1910s and 1920s, modern archaeology was seized upon as a tool for collecting new historical data for the construction of a new national history, its practices in the field were dominated by Western and Japanese archaeologists and explorers. Sociopolitical and intellectual changes of the late 1920s, the period during which the GMD government started to build a new nation in earnest, brought about a change in the uses to which archaeology was put in China. Those who chose Yinxu as the first site for the state-sponsored national archaeology were the nationalists and cultural conservatives bent on refuting the "Doubting Antiquity" school and reinforcing China's centuries-old textual tradition. In the end, disputes over the ownership of objects unearthed at Yinxu—first, between the local Henan government and the Institute of History and Philology and, later, between the institute and the Freer Gallery—provided the catalyst for national legislation to

safeguard cultural heritage in the 1930s and thus protected Chinese archaeological heritage from both regionalism and imperialism (Huang 2015; Lai 2016).

ACKNOWLEDGMENTS

This chapter began as a research paper for Professor Joseph W. Esherick's graduate seminar History 215 AB, Department of History, University of California, San Diego, in the winter of 1998. It was presented as "Digging Up China: Nationalism, Politics, and the Yinxu Excavations, 1928–1937" at a panel on "Sciences of the Human: Classicism, Modernism, and Nationalism in Chinese Social Sciences, 1899–1937" at the Fifty-first Annual Meeting of the Association for Asian Studies, Boston, March 13, 1999. I thank Joe, Ye Wa, and Lothar von Falkenhausen for their support and encouragement. The current version is extensively revised and updated. Thanks are also due to the Hetty Goldman Membership Fund of the Institute for Advanced Study, Princeton, for a membership in the School of Historical Studies (2014–15) while rewriting this chapter.

NOTES

[1] There are also exceptions—for example, Zhang Zhongpei regards J. G. Andersson's (1874–1960) excavations in the 1920s of the first Neolithic site at Yangshao and the Paleolithic site at Zhoukoudian as the birth of Chinese archaeology (Zhang 1999: 4).

[2] K. C. Chang, Enzheng Tong, and Lothar von Falkenhausen have written on the topics of nationalist practices and regionalism in post-1949 China (Chang 1998; Tong 1995; von Falkenhausen 1995). Yet, in the field of modern Chinese history, nationalism during the Nanjing decade has not yet been fully explored (Fitzgerald 1989; Jacobs 2010; 2014; Unger 1996).

[3] It should be noted that Zhang Binglin, who was an early advocate for archaeology, refused to recognize the authenticity and historical value of oracle bone inscriptions, although he used this issue of authenticity as political rhetoric against Luo Zhenyu and others. See Zhang (1958 [1915]: 444–45) and Tang (1996: 406–409).

[4] Although acting as an advocate for archaeology in China, Charles Freer held a typical Western formalist art historical belief that understanding works of art required no cultural context. See Milo C. Beach, "Foreword," in Lawton and Merrill (1993: 9).

[5] Correspondence in the Freer Gallery of Art records, Carl Whiting Bishop correspondence, Li Chi file, dated March 23, 1925; documents from the Freer Gallery of Art and Arthur M. Sackler Gallery Archives. Li Ji remembered that Bishop talked with him on a social occasion in Beijing after a long period of silence. However, I was able to find the above correspondence in the Freer archives when I was a predoctoral fellow at the Freer and Sackler Galleries in 2001–2002. Whether Bishop sent this letter to Li Ji, or if this is a copy of the letter Bishop wrote but never sent, is unknown. But the contents are the same. I thank the archivist Colleen Hennessey for providing copies of these documents. For Li Ji's account, see Li (1977: 56).

[6] Gu Jiegang had incensed a strident faction of students by accusing his colleague Lu Xun at Xiamen University of having plagiarized the Japanese scholar Shionoya On in his *Zhong-*

guo xiaoshuo shilüe (A Brief History of the Chinese Novel), and put his job in peril. Fu Sinian's prompt invitation to Gu to join the faculty at Zhongshan University could not immediately be accepted: Lu Xun had just moved from the Xiamen faculty to Zhongshan. He declared that should Zhongshan University hire Gu Jiegang, he would resign. Fu Sinian countered Lu's ultimatum by declaring that the position had to go to Gu, as otherwise he himself would resign. Although the university administration begged all three to work together, Lu Xun had had enough, and left for Wuhan. Lu Xun recalled his conflict with Gu Jiegang in his story "Lishui" [Controlling the Waters] (1991 [1936]). In the story, Lu Xun caricatured Gu as a stammering, red-nosed pedant, called *niaotou xiansheng*, or Mr. Birdhead, who argued against the historicity of the Great Yu on the grounds that the character Yu contains the graphic element meaning "worm." For a more balanced view of Lu Xun and Gu Jiegang's conflict, see Chen Shuyu (1996: 657–60).

[7] Du Zhengsheng argues that the authorship of this preface should belong to Fu Sinian, not Gu Jiegang (Du 1998: 11–12), ignoring the fact that an entry dated to October 21, 1927, in Gu Jiegang's diary recorded his own authorship. It is certain that some ideas expressed in the preface could also be Fu Sinian's, since Fu and Gu shared many ideas. Du has overemphasized the academic differences between Gu and Fu, which were partly the product of the rhetoric of personal politics.

[8] Gu Jiegang described his relationship with Fu Sinian to their mentor, Hu Shi, as recorded in Hu (1983: vol. 1, 535). See also Yue, Li, and Ma (1994: 316–24). Wang Fansen and Du Zhengsheng first published a short tale from the Fu Sinian Archives kept in the Institute of History and Philology that Fu Sinian wrote to attack Gu Jiegang, called "Xilun" (A Jocular Essay). In the essay, Fu satirized the methodology used by Gu in "doubting antiquity." This piece itself is undated. Du estimates that it must have been written around 1930. See Fu (1995 [undated]: 250–51) and Du's postscript. For an English translation of the tale, see Wang (1993), appendix I, 355–58.

[9] In his 1934 article, "Suowei guoyi" 所謂國醫 (So-Called "National Medicine"), Fu Sinian declared: "I would rather die than request the services of a practitioner of traditional Chinese medicine; such a request would make me unworthy of the education I have received" (Fu 1980 [1934]: 303–308).

[10] Under Feng Yuxiang's sponsorship, the Henan Provincial Museum was established in 1927. In May 1928, its name was changed to "Museum of Ethnography" in order to propagate "the ideal of national and universal harmony." In December 1930, its name was changed back to Henan Provincial Museum. See Henan bowuguan (1997).

[11] The Henan side of the story of the Yinxu conflict is largely untold. The only materials I was able to locate were two leaflets written by He Rizhang in December 1929 and on January 1, 1930, among the Fu Sinian archives, which were published by Wang and Du (1995: 74). In the explanatory text, Du and Wang have misread the text, taking the accusation leveled by another senior party member Zhang Ji 張繼 (1882–1947) against He Rizhang as having "no knowledge and no plan" as He's accusation against Fu Sinian. These two leaflets legitimate He Rizhang's suggestion that Luo Zhenyu and Yuan Fuli should direct the study. They also demonstrate that He's request that the excavated artifacts should be kept and displayed in Henan also followed the legal procedure and governmental regulation on the protection of cultural heritage of the 1920s. Unfortunately, Wang and Du simply classify He Rizhang as "a member of the old school" and dismiss the whole argument.

[12] Liang Siyong, the youngest son of Liang Qichao, received professional field training in archaeology during his graduate work at Harvard by participating the Pecos excavation directed by Alfred V. Kidder in the American Southwest. In view of Liang Qichao's interest in writing new national history, it is interesting to note that he encouraged his children to pursue professional careers in fields that were closely related to new historiography. See Li Guangmo (1997).

[13] Hu Zhaochun had studied in Japan. Teng Gu, who graduated from Shanghai Fine Art School and studied in Japan and Germany, worked mainly as an art historian.

[14] Gu Jiegang joined the National Beiping Academy in 1934 and directed its historical section. The National Beiping Academy was headed by another senior party member, Li Shizeng 李石曾 (1881–1973), and competed vigorously with the Academia Sinica for government funding.

REFERENCES CITED

Bishop, Carl Whiting
 1924 The Bronzes of Hsin-cheng Hsien. *The Chinese Social and Political Science Review* 8(2): 81–99.

Britton, Roswell S.
 1943 (Book Review) *Origin of the Far Eastern Civilizations: A Brief Handbook.* By Carl Whiting Bishop. Washington, DC: The Smithsonian Institution. 1942. *Far Eastern Quarterly* 2(3): 299–301.

Brown, Clayton D.
 2008 Making the Majority: Defining Han Identity in Chinese Ethnology and Archaeology. PhD diss., University of Pittsburgh.

Brysac, Shareen
 2002 Sir Aurel Stein's Fourth "American" Expedition. In *Sir Aurel Stein: Proceedings of the British Museum Study Day*, edited by Helen Wang. *British Museum Occasional Papers* 142: 17–22. The British Museum, London.

Chang, K. C. (Zhang Guangzhi 張光直)
 1981 Archaeology and Chinese History. *World Archaeology* 13(2): 156–69.
 1998 Ershi shiji houban de Zhongguo kaoguxue (Chinese Archaeology in the Second Half of the Twentieth Century). *Gujin lunheng* 1: 38–43.

Chen, Hongbo 陳洪波
 2011 *Zhongguo kexue kaoguxue de xingqi—1928–1949 nian lishi yuyan yanjiusuo kaogu shi* 中國科學考古學的興起—1928–1949 年歷史語言研究所考古史 (The Rise of Scientific Archaeology in China—The History of Archaeology of the Institute of History and Philology, 1928–1949). Guangxi shifan daxue chubanshe, Guilin.

Chen, Shuyu 陳漱渝
1996 *"Yige dou bu kuanshu": Lu Xun he tade lundi* 一個都部不寬恕：魯迅和他的
 論敵 ("Forgive not even one": Lu Xun and His Rivals). Zhongguo wenlian,
 Beijing.
Chen, Xingcan 陳星燦
1997 *Zhongguo shiqian Kaoguxue yanjiu, 1895–1949* 中國史前考古學研究
 1895–1949 (Researches on Chinese Prehistoric Archaeology, 1895–1949).
 Sanlian, Beijing.
Chen, Yiai 陳以愛
2002 *Zhongguo xiandai xueshu yanjiu jigou de xingqi: Yi Beida yanjiusuo guoxuemen wei
 zhongxin de tantao* 中國現代學術研究機構的興起：以北大研究所國學
 門為中心的探討 (The Rise of Modern Research Institutions in China: An
 Exploration Focusing on the Research Institute's Department of National
 Learning). Jiangxi jiaoyu chubanshe, Nanchang.
2013 Cong yigu dao chongjian de zhuanzhe—Yi Wang Guowei dui Fu Sinian de
 yingxiang wei zhongxin 從疑古到重建的轉折—以王國維對傅斯年的影
 響為中心 (The Transition from Doubting Antiquity to Reconstructing Antiq-
 uity: Centering on Wang Guowei's Influence on Fu Sinian). Compiled by
 Guoshiguan. *Jindai guojia de xingsu: Zhonghua minguo jianguo yibai nian guoji
 xueshu taolunhui lunwenji*, pp. 833–78. Guoshiguan, Taiwan.
Chen, Zhiming 陳志明
1993 *Gu Jiegang de yigu shixue* 顧頡剛的疑古史學 (The Doubting Antiquity of Gu
 Jiegang). Shangding wenhua, Taipei.
Cohen, Warren I.
1992 *East Asian Art and American Culture: A Study in International Relations.*
 Columbia University Press, New York.
Daniel, Glyn
1967 *The Origins and Growth of Archaeology.* Penguin Books, London.
Díaz-Andreu, Margarita
2007 *A World History of Nineteenth-Century Archaeology: Nationalism, Colonialism
 and the Past.* Oxford Studies in the History of Archaeology. Oxford University
 Press, Oxford.
Díaz-Andreu, Margarita, et al. (editors)
1996 *Nationalism and Archaeology in Europe.* UCL Press, London.
Dirlik, Arif
1978 *Revolution and History: The Origins of Marxist Historiography in China,
 1919–1937.* University of California Press, Berkeley.

Dong, Zuobin 董作賓

1929 Zhonghua minguo shiqinian shiyue shijue Anyang Xiaotun baogaoshu 中國民
 國十七年試掘安陽小屯報告書 (Report on the Experimental Excavation at
 Xiaotun, Anyang, in October, 1928). *Anyang fajue baogao* 1: 3–36.

Du, Zhengsheng 杜正勝

1995 Cong yigu dao chongjian 從疑古到重建 (From Doubting Antiquity to Recon-
 structing Antiquity). *Dangdai* 116: 10–29.

1998 Wuzhongshengyou de zhiye: Fu Sinian de shixue geming yu shiyusuo de
 chuangjian 無中生有的志業：傅斯年的史學革命與史語所的創建 (An
 Enterprise Out of Nothing: Fu Sinian's Revolution in the Study of History and
 the Establishment of the Institute of History and Philology). *Gujin lunheng* 1:
 4–29.

Du, Weiyun 杜維運

1995 Fu Mengzhen yu Zhongguo xinshixue 傅孟真與中國新史學 (Fu Sinian and
 Chinese New Historiography). *Dangdai* 116: 54–63.

Duara, Prasenjit

1995 *Rescuing History from the Nation: Questioning Narratives of Modern China*. Uni-
 versity of Chicago Press, Chicago and London.

Eastman, Lloyd E.

1976 The Kuomintang in the 1930s. In *The Limits of Change: Essays on Conservative
 Alternatives in Republican China*, edited by Charlotte Furth, pp. 191–210. Har-
 vard University Press, Cambridge, MA.

Fitzgerald, John (editor)

1989 *The Nationalists and Chinese Society, 1928–1937: A Symposium*. University of
 Melbourne Press, Melbourne.

Fu, Sinian 傅斯年

1933 [1928] Tan liangjian Nuli zhoukan shang de wujie 談兩件《努力週刊》上
 的誤解 (On Two Misunderstandings on the Nuli Weekly). In *Gushibian* 2,
 edited by Gu Jiegang, et al., pp. 288–301. Pushe, Shanghai and Beijing.

1980 *Fu Sinian quanji* 傅斯年全集 (Complete Works of Fu Sinian). 7 vols. Lianjing,
 Taipei.

1995 [n.d.] Xilun 戲論 (A Jocular Essay). *Zhongguo wenhua* 12: 250–51.

Furth, Charlotte

1970 *Ting Wen-chiang: Science and China's New Culture*. Harvard University Press,
 Cambridge, MA.

Gu, Chao 顧潮 (editor)

1993 *Gu Jiegang nianpu* 顧頡剛年譜 (Year by Year Biography of Gu Jiegang).
 Zhongguo shehui kexue, Beijing.

Gu, Jiegang 顧頡剛

 1933 [1925] Da Li Xuanbo xiansheng答李玄伯 (Answering Mr. Li Xuanbo). Xiandai pinglun, 1.10 (1925). In *Gushibian* 1, edited by Gu Jiegang, et al., pp. 270–75. Pushe, Shanghai and Beijing.

 1933 [1926] Zixu 自序 (Preface by the Author). In *Gushibian* 1, edited by Gu Jiegang, et al., pp. 1–103. Pushe, Shanghai and Beijing.

Gu, Jiegang 顧頡剛 (editor)

 1928–35 *Bianwei Congkan* 辨偽叢刊 (Symposium on the Critiques of Spurious Literature), 8 vols. Pushe, Beijing.

Gu Jiegang and Wang Zhongqi 王鍾麒 (compilers)

 1924 *Benguoshi* 本國史 （*History of China*). Shangwu yinshuguan, Shanghai.

Gu, Jiegang, Luo Genze, Tong Shuye, et al. 顧頡剛、羅根澤、童書業等 (editors)

 1926–41 *Gushibian* 古史辨 (Critiques of Ancient History), 7 vols. Pushe, Shanghai and Beijing.

Henan bowuguan 河南博物館

 1997 Huicui Zhongyuan wenwu, jinzhan Huaxia fengcai: Jinian Henan bowuguan chuangian qishi zhounian 薈萃中原文物，盡展華夏風采：紀念河南博物院創建七十週年 (Collecting the Cultural Relics of the Central Plain, Displaying the Features of China: Commemorating the Seventieth Birthday of the Henan Provincial Museum). *Zhongyuan wenwu* 4: 1–7.

Hu, Shi 胡適

 1983 *Hu Shi wanglai shuxinxuan* 胡適往來書信選 (Selected Correspondence of Hu Shi), 2 vols. Zhonghua, Hong Kong.

 1933 [1923] Lun di tian ji jiuding shu 論帝天及九鼎 (On God, Heaven, and the Nine Tripods). In *Gushibian* 1, edited by Gu Jiegang, et al., pp. 199–200. Pushe, Shanghai and Beijing.

 1933 [1921] Zishu gushiguan shu 自述古史觀 (A Letter on My View of Ancient History). In *Gushibian* 1, edited by Gu Jiegang, et al., pp. 22–23. Pushe, Shanghai and Beijing.

 1954 Zhuinian Wu Zhihui xiansheng 追念吳稚暉先生 (Remembering Mr. Wu Zhihui). *Ziyou zhongguo* 10(1): 5–6.

Huang, Philip C.

 1972 *Liang Ch'i-ch'ao and Modern Chinese Liberalism*. University of Washington Press, Seattle.

Huang, Xiangyu 黃翔瑜

 2015 Xiandai kaoguxue zai jindai Zhongguo de kundun ji siying (1928–1934) 現代考古學在近代中國的困頓及肆應 (The Dilemma and Response of Modern Archaeology in Modern China). *Shiwu luntan* 20: 67–102.

Iriye, Akira

 1997 *Cultural Internationalism and World Order*. Johns Hopkins University Press, Baltimore.

Jacobs, Justin

 2010 Confronting Indiana Jones: Chinese Nationalism, Historical Imperialism, and the Criminalization of Aurel Stein and the Raiders of Dunhuang, 1899–1944. In *China on the Margins*, edited by Sherman Cochran and Paul G. Pickowicz, pp. 65–90. Cornell University Press, Ithaca, NY.

 2014 Nationalist China's "Great Game": Leveraging Foreign Explorers in Xinjiang, 1927–1935. *Journal of Asian Studies* 73(1): 43–64.

Jia, Meixian 賈梅仙

 1992 Beijing daxue Kaoguxi yuanqi 北京大學考古系緣起 (The Beginning of the Department of Archaeology at Beijing University). *Wenwu tiandi* 5: 39–41; 6: 27–9.

Kohl, Philip L., and Fawcett, Clare (editors)

 1995 *Nationalism, Politics, and the Practice of Archaeology*. Cambridge University Press, Cambridge.

Lai, Guolong

 2016 The Emergence of "Cultural Heritage" in Modern China: A Historical and Legal Perspective." In *Reconsidering Cultural Heritage in East Asia*, edited by Luisa Mengoni and Akira Matsuda, pp. 47–85. Ubiquity Press, London.

Lawton, Thomas, and Merrill, Linda

 1993 *Freer: A Legacy of Art*. Freer Gallery of Art, Smithsonian Institution, Washington, DC.

Li, Guangmo 李光謨

 1997 Cong yifengxin kan Zhongguo jindai kaoguxue de faren 從一封信看中國近代考古學的發軔 (The Beginnings of Modern Chinese Archaeology: Perspectives from a Letter). *Wenwu tiandi* 5: 19–21.

Li, Ji 李濟

 1977 *Anyang*. University of Washington Press, Seattle.

 1994 [1961] Wo yu Zhongguo kaogu 我與中國考古 (Chinese Archaeology and I). First published on *Shidai zazhi*, 1 (1961), collected in *Li Ji yu Qinghua*, edited by Li Guangmo, pp. 161–66. Qinghua daxue chubanshe, Beijing.

Li, Xuanbo 李玄伯

 1933 [1924] Gushi wenti de weiyi jiejue fangfa 古史問題的唯一解決方法 (The Only Solution for the Problem of Ancient History), first published in *Xiandai pinglun* 1(3) (1924), collected in *Gushibian* 1, edited by Gu Jiegang, et al., pp. 268–70. Pushe, Shanghai and Beijing.

Lu, Dongjian 陸東鍵

1995 *Chen Yinke de zuihou ershinian* 陳寅恪的最後二十年 (The Last Twenty Years in the Life of Chen Yinke). Sanlian, Beijing.

Lu, Xun 魯迅

1991 [1936] Lishui 理水 (Controlling the Waters). In his *Gushi xinbian* 故事新編. Wenhua Shenghuo chubanshe, Shanghai, collected in 1991. *Lun Xun quanji 2*, pp. 371–86. Renmin wenxue chubanshe, Beijing.

March, Benjamin

1929 *China and Japan in Our Museum.* American Council Institute of Pacific Relations, New York.

Marchand, Suzanne L.

2015 The Dialectics of the Antiquities Rush. In *Pour une histoire de l'archéologie XVIIIe siècle—1945. Hommage de ses collègues et amis à Ève Gran-Aymerich*, edited by Annick Fenet and Natacha Lubtchansky, pp. 191–206. Ausonius, Bordeaux.

Merryman, John H.

1986 Two Ways of Thinking about Cultural Property. *American Journal of International Law* 80: 831–53.

1996 A Licit Trade in Cultural Objects. In *Legal Aspects of International Trade in Art*, edited by Martine Briat and Judith A. Freedberg, pp. 3–46. The Hague: Kluwer Law International.

2006 Introduction. In *Imperialism, Art and Restitution*, edited by John H. Merryman, pp. 1–14. Cambridge University Press, Cambridge.

2009 The Nation and the Object. In *Whose Culture? The Promise of Museums and the Debate over Antiquities*, edited by James Cuno, pp. 183–204. Princeton University Press, Princeton, NJ.

Meyer, Karl Ernest, and Shareen Blair Brysac

1999 *Tournament of Shadows: The Great Game and the Race for Empire in Central Asia.* Counterpoint, Washington, DC.

2015 *The China Collectors: America's Century-long Hunt for Asian Art Treasures.* Palgrave Macmillan, New York.

Netting, Lara Jaishree

2013 *A Perpetual Fire: John C. Ferguson and His Quest for Chinese Art and Culture.* Hong Kong University Press, Hong Kong.

Newmeyer, Sarah L.

1987 The Carl Whiting Bishop Photographic Archive in the Freer Gallery of Art: A Resource for the Study of Chinese Architecture, Archaeology, Geology, Topography, Flora, Fauna, Customs, and Culture. *Journal of East Asian Libraries* 82(1): 23–28.

Ren, Dashan 任大山

 2007　He Rizhang yu Henan bowuguan zaoqi jianshe 何日章與河南博物館早期建設 (He Rizhang and the Early Development of Henan Museum). *Zhongyuan wenwu*, 3: 106–108.

Ren, Dashan任大山, and Zhang Li 張莉

 2003　*He Rizhang yanjiu* 何日章研究 (Research on He Rizhang). Dazhong wenyi chubanshe, Beijing.

Sakazume Hideichi 坂詰秀一

 1994　Nihon kōkogakushi shūi 日本考古學史拾遺 (Small Issues in the History of Japanese Archaeology). *Risshō Daigaku Bungakubu Ronsō* 立正大学文学部論叢 99: 31–57.

Sang, Bing 桑兵

 2001　*Wan Qing Minguo de guoxue yanjiu* 晚清民國的國學研究 (The National Learning during the Late Qing and Early Republic Periods). Shanghai guji chubanshe, Shanghai.

Schneider, Laurence

 1971　*Ku Chieh-kang and China's New History: Nationalism and the Quest for Alternative Traditions.* University of California Press, Berkeley.

Shaughnessy, Edward L.

 1997　*Before Confucius: Studies in the Creation of the Chinese Classics.* SUNY Press, Albany.

Shen Gangbo 沈剛伯

 1982　Wo suo renshi de Hu Shizhi xiansheng 我所認識的胡適之先生 (The Person Mr. Hu Shi I Know). In *Shen Gangbo xiansheng wenji*, pp. 697–709. Zhongyang ribao she, Taipei.

Shen Ji 沈寂

 1993　*Hu Shi zhenglun yu jindai Zhongguo* 胡適政論與近代中國 (Hu Shi's Political Ideas and Modern China). Shangwu, Hong Kong.

Tang, Zhijun 湯志鈞

 1996　*Zhang Taiyan zhuan* 章太炎傳 (A Biography of Zhang Taiyan). Shangwu, Taipei.

Illustrated London News

 1931　"The Archaeological Awakening of China: The First Excavations in China Conducted Entirely by Chinese. Treasures from about 1500 B.C." *Illustrated London News*, June 11, 176: 1142–43.

Tong, Enzheng 童恩正

 1995　Thirty Years of Chinese Archaeology (1949–1979). In *Nationalism, Politics, and the Practice of Archaeology*, edited by Philip L. Kohl and Clare Fawcett, pp. 177–97. Cambridge University Press, Cambridge.

Townsend, James
 1992 Chinese Nationalism. *The Australian Journal of Chinese Affairs* 27: 97–130.
Trigger, Bruce G.
 1989 *A History of Archaeological Thought.* Cambridge University Press, Cambridge.
 1995 Romanticism, Nationalism, and Archaeology. In *Nationalism, Politics, and the Practice of Archaeology*, edited by Philip L. Kohl and Clare Fawcett, pp. 263–79. Cambridge University Press, Cambridge.
Unger, Jonathan (editor)
 1996 *Chinese Nationalism.* Sharpe, Armonk, ME.
von Falkenhausen, Lothar
 1993 On the Historiographical Orientation of Chinese Archaeology. *Antiquity* 67: 839–49.
 1995 The Regionalism Paradigm in Chinese Archaeology. In *Nationalism, Politics, and the Practice of Archaeology*, edited by Philip L. Kohl and Clare Fawcett, pp. 198–217. Cambridge University Press, Cambridge.
Wang Fansen 王汎森
 1993 Fu Ssu-nien: An Intellectual Biography. PhD diss., Princeton University.
 1995 Du Fu Sinian dang'an zhaji 讀傅斯年檔案札記 (Notes on Reading Fu Sinian Archives). *Dangdai* 116: 30–53.
 1997 Shenme keyi chengwei lishi zhengju 什麼可以成為歷史證據 (What Can Be Historical Evidence). *Xinshixue* 8(2): 119–28.
Wang Fansen 王汎森 and Du Zhengsheng 杜正勝
 1995 *Fu Sinian wenwu ziliao xunji* 傅斯年文物資料選集 (Selections of Relics and Documents from Fu Sinian Archives). The Institute of History and Philology, Academia Sinica, Taipei.
Wang Shimin 王世民
 1986 Beiping yanjiuyuan shixue yanjiu hui 北平研究院史學研究會 (Research Association for the Study of History in Beiping Academy), 41; Zhongguo kaoguxue jianshi 中國考古學簡史 (Brief History of Chinese Archaeology), pp. 689–95. In *Zhongguo dabaike quanshu Kaogu juan* 中國大百科全書考古學卷 (Encyclopedia Sinica, Archaeology volume). Zhongguo dabaike quanshu chubanshe, Beijing.
Wang Tao 汪濤
 1997 Establishing the Chinese Archaeological School: Su Bingqi and Contemporary Chinese Archaeology. *Antiquity* 71: 31–40.
Winegrad, Dilys P.
 1993 *Through Time, Across Continents: A Hundred Years of Archaeology and Anthropology at the University Museum.* University of Pennsylvania Press, Philadelphia.

Wu, Xuezhao 吳學昭

1992 *Wu Mi yu Chen Yinke* 吳宓與陳寅恪 (Wu Mi and Chen Yinke). Qinghua daxue, Beijing.

Xia, Nai 夏鼐

1959 [1954] Liang Siyong xiansheng zhuanlue 梁思永先生傳略 (A Brief Biography of Mr. Liang Siyong). In *Liang Siyong kaogu lunwenji*, pp, v–vi. Kexue, Beijing.

1979 Wusi yundong he Zhongguo jindai kaoguxue de xingqi 五四運動和中國考古學的興起 (The May Fourth Movement and the Rise of Modern Archaeology in China). *Kaogu* 3: 193–96.

2009 *Xia Nai riji* 夏鼐日記 (The Diary of Xia Nai). Huadong shifan daxue chubanshe, Shanghai.

Xibei kexue kaocha tuan 西北科學考查團

1927 Xibei kexue kaocha tuan faxian xishiqi shidai zhi yiwu 西北科學考查團發現新石器時代之遺物 (The Northwest Scientific Investigation Team Discovers Artifacts of the Neolithic Period), in the column by Xueshhijie xiaoxi 學術界消息 (News from the Academic Community). *Guoli Zhongshan daxue yuyan lishi xue yanjiu suo zhoukan* 國立中山大學語言歷史學研究所週刊 1(1) (November 1): 28.

Xin Chenbao 新晨報 (The New Morning News)

1929 Guofu yanjin fandong jiaocai faxing (National Government Issues Stringent Ban on Counterrevolutionary Textbooks), May 16.

Xu, Jian 徐堅

2012 *Anliu: 1949 nian zhiqian Anyang zhiwai de Zhongguo kaoguxue chuantong* 暗流：1949 年之前安陽之外的中國考古學傳統 (Undercurrents: Archaeological Traditions outside of Anyang before 1949). Kexue chubanshe, Beijing.

Yang, Tianshi 楊天石

1991 Hu Shi yu Guomingdang de yiduan jiufen 胡適與國民黨一段糾紛 (A Dispute between Hu Shi and the Nationalist Party). *Zhongguo wenhua* 4: 119–32.

Yeh, Wen-hsin

1990 *The Alienated Academy: Culture and Politics in Republican China, 1919–1937*. Harvard University Press, Cambridge and London.

Yin, Da 尹達

1959 [1954] Daonian Liang Siyong xiansheng 悼念梁思永先生 (Mourning for Mr. Liang Suyong). In *Liang Siyong kaogu lunwenji*, pp. i–iii. Kexue, Beijing.

Yoshikai Masato 吉開將人

2015 "Jindai Riben xuezhe yu Yinxu kaogu" 近代日本學者與殷墟考古 (Modern Japanese Scholars and the Yinxu Archaeology). In *Jinian Yinxu fajue bashi zhounian xueshu yantaohui lunwenji* 紀念殷墟發掘八十週年學術研討會論文集 (Proceedings of the Conference Commemorating the 80th Anniversary of

the Yinxu Excavation), edited by Li Yongdi 李永迪, pp. 25–50. Institute of History and Philology, Academia Sinica, Taipei.

Yu, Danchu 俞旦初

1983 Ershi shiji chu xifang jindai kaoguxue sixiang zai Zhongguo de jieshao he yingxiang 二十世紀初西方近代考古學思想在中國的介紹和影響 (The Introduction and Influence of Western Modern Archaeology in China at the Beginning of the Twentieth Century). *Kaogu yu wenwu* 4: 107–11.

Yu, Yingshi 余英時

1976 Shixue, shijiayu shidai 史學史家與時代 (History, Historians, and Time). In Yu, *Lishi yu sixiang* 歷史與思想, pp. 247–70. Lianjing, Taipei.

Yue, Yuxi 岳玉璽, Li Quan 李泉, and Ma Liangkuan 馬亮寬

1994 *Fu Sinian: Daqipangbo de yidai xueren* 傅斯年：大氣磅礴的一代學人 (Fu Sinian: A Scholar of Great Vision). Tianjin renmin, Tianjin.

Zhang, Binglin 章炳麟

1958 [1915] Li huo lun 理惑論 (On Clearing the Confusion). In his *Guogu lunheng* 國故論衡: *Zhangshi congshu* 章氏叢書, pp. 444–45. Shijie shuju rpt, Taipei.

Zhang, Zhongpei 張忠培

1999 Guanyu Zhongguo kaoguxue guoqu, xianzai yu weilai de sikao 關於中國考古學過去、現在與未來的思考 (On the Past, Present, and Future of Chinese Archaeology). *Chuantong wenhua yu xiandaihua* 1: 3–14.

"They have not changed in 2,500 years": Art, Archaeology, and Modernity in Iran

Talinn Grigor

Nineteenth-century archaeology is often compared to oil in the twentieth century. Despite having rich deposits of both archaeology and oil, Iran itself proved immune to the imperial aspirations of Europe. Iran, in effect, proved un-colonizable. In contrast to many places in Asia and Africa, especially neighboring Mesopotamia and the Indian subcontinent, Iran retained its political sovereignty throughout the modern era. Like oil, archaeology became one of the main battle-fields upon which domestic and colonial struggles were fought. However, the role of Iran's patrimony, from the mid-nineteenth to the late twentieth century, was not restricted to a series of public monuments, well-choreographed museums, indexes of historical landmarks, or art exhibitions and congresses. Nor should understanding of Iran's concern with patrimony be reduced to the simplistic notion that the manipulation of archaeological finds served to legitimize a royal household.

Modern Iran's relationship to its archaeology has long been about Iran's equal and rightful place in the network of modern nations and its struggles for territorial integrity and national homogeneity. As a sovereign nation, Iran took its place among "fraternal" nation-states precisely because the local elite believed that it had done so "2,500 years ago." In the eyes of those who came to rule modern Iran, from the outset, the mission of reviving what they saw as "Persia's archaeological grandeur" in museums and tourist sites was understood not only as a means to political deliverance and social welfare but also as a responsibility vis-à-vis the "civilized world" (al-Ulumi 1976: 7–8). And, with the advent of Western political and military hegemony in Asia and the formation of the system of independent

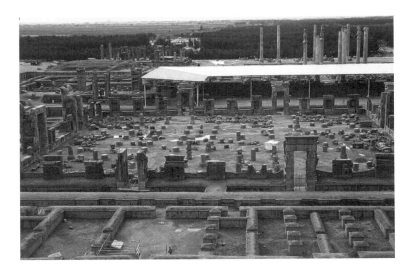

FIGURE 5.1. Ruins of Persepolis, Iran, fifth century BCE with 1971 Tent
City visible in background. Photo by Talinn Grigor.

nation-states, the local elite increasingly saw Iran as a worthy member of the
international community because of its irrefutable archaeological wealth. The
kind of modernity they wanted to emulate was to be found, first and foremost,
in Iran's ruins—in its museumized archaeology. In 1971, this same archaeology
supported one of the most fantastic political uses of ancient ruins at Persepolis—
namely, when the last king of Iran celebrated the 2500-year anniversary of the
institution of Persian monarchy (Fig. 5.1).

ARCHAEOLOGY AS COLONIAL POLITICS

Throughout the reign of Reza Shah Pahlavi (1925–41), the stories behind archae-
ological discoveries left a lasting impact on Iran's foreign diplomacy, museum cul-
ture, modern architecture, and monarchy. In both a physical and ideological sense,
debates concerning archaeological digs and the ownership of artifacts enabled the
conception of Iran as an Aryan nation, a secular state, and a civilized culture.
Archaeology also brought together locals and foreigners who contested such con-
structs. In addition to Court Minister Abd al-Hosayn Teymurtash and Prime
Minister Mohammad Ali Foroughi, and the Justice and Finance Ministers, Ali
Akbar Davar and Prince Firuz Mirza Firuz, Westerners such as the German archi-
tect and archaeologist Ernst Emil Herzfeld (1879–1947), the French architect and
archaeologist André Godard (1881–1965), and the American art historian and art

dealer Arthur Upham Pope (1881–1969) were all interested in either protecting and displaying or exporting and selling Iran's archaeological artifacts from such pre-Islamic sites as Persepolis, Pasargadae, and Susa (Figs. 5.2 and 5.3). While Iranians succeeded in erecting an archaeological museum in Tehran, Western scholars managed to export a remarkable number of archaeological artifacts to major art museums in the West—Herzfeld to the Berlin State Museum, Godard to the Louvre, and Pope to Chicago's Oriental Institute and the Philadelphia Museum of

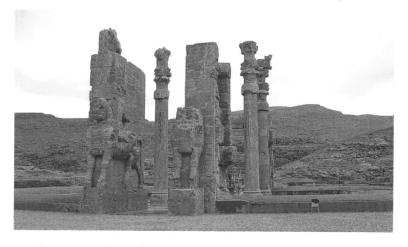

FIGURE 5.2. Gate of Nations, Persepolis, Iran, fifth century BCE.
Photo by Talinn Grigor.

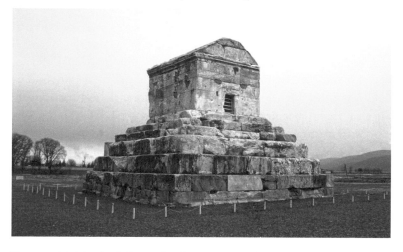

FIGURE 5.3. Tomb of Cyrus the Great, Pasargadae, Iran, fifth century BCE.
Photo by Talinn Grigor.

Art. All three saw potential, and highly lucrative, profits from Iranian archaeological excavations that were compelling both to themselves and the imperial authorities that supported them in Iran. Archaeology not only shaped Irano-Western relations but also reinvented Iran's modern sociopolitical and built environments.

Historically speaking, while Persepolis had attracted rulers from Alexander of Macedonia to Mughal Sultan Shah Jahan, its systematic excavation had to wait for Reza Shah Pahlavi and his secularist ministers to arrive on the Iranian political scene in the early twentieth century. Burned by Alexander the Great in 331 BCE, the ruins were identified in 1620 CE as the seat of the Achaemenid dynasty and were subsequently visited by numerous Western and non-Western travelers. In 1765, the German surveyor Carsten Niebuhr exposed the reliefs of Apadana Hall's eastern staircase. In 1872, Frantz Stolze documented the site photographically, leading to the attempt to excavate the Hall of One Hundred Columns by the Iranian aristocrat Motamed al-Dowleh four years later (Abdi 2001: 59–60). By the close of the nineteenth century, however, the right to excavate in Iran had become a major colonial battleground. With the royal decree of Naser al-Din Shah, an agreement was signed on August 11, 1900, "conceding to the French Republic the exclusive and perpetual right to excavate in the entire expanse of the empire" (Archives of the French Ministry of Foreign Affairs [AFMFA] 1900). While the treaty gave French scientists a monopoly over all archaeological sites, they focused their efforts on Susa, by and large disregarding Persepolis and Pasargadae.

Between the 1890s and 1921, explorers, geologists, and archaeologists such as Captain Hilarion Truilhier, Sir Henry Rawlinson, William Kenneth Loftus, Jane and Marcel Dieulafoy, and Jacques de Morgan excavated Susa. The Delegation française en Perse, directed by de Morgan, has been described by recent historians as "probably the most important archeological expedition that has left Europe" (Niknami 2000: 8; de Morgan 1895–96). From the 1850s, the choice of Susa had been politically significant for both the French and the Iranian state. The reign of the Achaemenid dynasty, founded by Cyrus II the Great (r. 559–530 BCE) and expanded by Darius I (r. 521–486 BCE), stretched from Egypt to India from 559 to 331 BCE. Susa was the first capital city of the Achaemenid empire, so presumably this was where Iran's history as a nation had begun. This period of Iranian history became significant for modern Iranian reformists and Westerners alike, for whom the Achaemenid past embodied the forgotten glory of a Persian monarchy. Symbolizing "the true spirit of the nation" for the Pahlavi reformists, this selective historical narrative became the source for the invention of national patrimony supported both by those who excavated the site and those who propagated its past grandeur and potential revival. With the

military coup of Reza Shah in 1921 and the change of royal dynasties from the Qajars to the Pahlavis in 1925, however, the nationalistic use of archaeology was prioritized in the state's agenda. The ascendance of the Pahlavis gave rise to Susa's replacement by Persepolis as the most significant and authentic site of national origin. A physically solid and rather complete archaeological entity, Persepolis was handpicked by the new regime for its undisputable majesty in showcasing the history of Iran's antiquity.

Following Reza Shah's coup and the abolition of the Qajar dynasty in 1925, the French had little power by which to implement the 1900 archaeological agreement signed by a Qajar king. Tension mounted when the new Iranian government openly refused to implement the eleventh point of the 1900 agreement, which stipulated that the Persian government would make clear the terms of said convention to all regional governments. On the one hand, the reformist elite perceived the treaty as unfair, having been signed by a monarch for whom they reserved little respect and whose dynasty they had overthrown. On the other hand, the French Republic did not want to abandon the monopoly, which cemented its colonial prerogative in Iran. The British controlled as much of the south as they could for its oil and access through the Persian Gulf, and the Soviets controlled the north via the long Soviet border with Iran. The French Republic wanted full hegemony over all aspects falling under the rubric of high culture, including archaeological sites and art museums. Matters came to a head in July 1923, when French authorities in Iran learned that locals were excavating an ancient site near Tehran. Maurice Dayet, the French chargé d'affaires in Tehran, cautioned his foreign minister in Paris that "the possession of a monopoly that we only exercise in Susa, renders our right illusive to the eyes of those who are particularly interested in smashing it into pieces; just the fact that a Persian pretends [to have] the authority to dig must attract our serious attention" (AFMFA 1923). However, it is important to recognize that the offending Persian to whom Dayet referred was the Iranian Minister of Public Works, Hasan Esfandiari. In fact, between 1923 and 1927, Esfandiari, along with Firuz Mirza, Teymurtash, and Foroughi, manipulated the situation so as to gain additional digging rights, because so much of the new discourse on Iran's archaeological heritage was underpinned by the management, ownership, and interpretation of these same archaeological sites.

In April 1925, in an attempt to persuade the French to abandon their archaeological control, local Iranian authorities invited Ernst Herzfeld to Tehran. Although he was later known as the man who excavated Persepolis, before that, he played a major role in helping Iranian authorities annul the 1900 treaty. As a result, the Great Powers and Reza Shah's government argued for

years over archaeological affairs, which were not settled until 1927: at this time,
the French Republic renounced its monopoly in exchange for the directorship of
the Antiquities Service as well as the Museum and Library in Tehran, positions
to which André Godard was appointed by the French. Even if the treaty "ruined
Herzfeld's official ambitions" for an official position in archaeological affairs in
Iran, the French continued to see in him a threat to their cultural hegemony in
the region. "Unfortunately," noted the French minister, "Herzfeld has represented
German science for a long time [in Iran]; [it is] a task that he carries out with
success, as his propaganda is as ferocious as his personality, [even if] on the sur-
face [both appear] tender and benign" (AFMFA 1928a). Bringing to the fore the
political significance of the archaeological dispute, the French underscored, "our
military attaché, Captain Bertrand, sees in him our most dangerous adversary...."

In preparing Godard for his new post, French diplomats told him to antici-
pate a struggle with the German archaeologist, Herzfeld: "[I]t is useful that Mr.
Godard be warned in advance and that while keeping a courteous and even cor-
dial relation [with Herzfeld], he should maintain his guard" (AFMFA 1928b).[1]
The French representative to Iran, A. Wilden, however, reassured Godard that
he would find the support that he needed among the "affluent" locals; that, as of
his arrival, he would ascertain that:

> the good majority of affluent Persians find Mr. Herzfeld a bit too stuffy. He
> makes too much dust, so to speak—the expression is singularly appropriate
> here! Wherever he goes—and he travels a lot—he unearths something. He has
> brought to light, near Persepolis, half a statue that he declares to be that of
> Cyrus. Since the head is missing, many have doubts ... they also reproach him
> of devoting a big part of his activities at the dealers. It is certain that he sends
> to the Berlin market numerous valuable art objects (AFMFA 1928c).

Upon his arrival in Tehran, Godard was notified of his role as representative
of the French presence in political and cultural matters in the country: he was
described as the scholar who would "very soon find a real Cyrus" (AFMFA
1928c). There is no doubt that had he discovered any archaeological evidence of
Cyrus the Great, the father of the nation, he would have gained real prominence,
elevating him over his rival, Herzfeld. While he never did unearth a real Cyrus,
Godard remained in Iran as head of the Antiquities Service and the Museum of
Archaeology (*muzey-e iran-bastan*) (Fig. 5.4) until the 1960s, leaving his mark on
modern Iranian architecture, archaeology, museology, and politics. Parallel to his
duties as the director of the Antiquities Service and the head of the national
Museum of Archaeology, Godard was responsible for the master plan, as well as
several individual buildings, on the new campus of Tehran University. He devel-

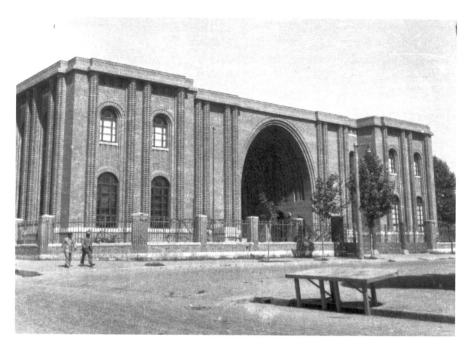

FIGURE 5.4. Archaeological Museum designed after the Sassanian palace at Ctesiphon; architect André Godard, Tehran, Iran, 1936–1939. Private collection; photo by Farokh Khadem.

oped and directed the architecture and fine arts curricula modeled after the Beaux Arts system, before becoming the Fine Arts Department's first dean. In those prominent positions, he not only exercised political power on local authorities but also, above all, profoundly affected three generations of Iranian architects by overseeing the very birth and evolution of modern architectural pedagogy in Iran.

While the 1927 treaty ended quarrels over excavation rights, it inflamed new animosities among the archaeological and diplomatic communities of Tehran. On leave of absence from the faculty of Berlin University, Godard's rival Herzfeld rented a "large house" in Tehran for "at that time there was hope that the establishment might become a German Archeological Institute; but … the political situation was soon to destroy such possibilities" (Freer Gallery and Archives 2000: 10).[2] Both the arbitrary and increasingly autocratic rule of Reza Shah after the mid-1930s and the systemic murders of the political elite, including the friends of Herzfeld, eliminated any chance for the German archaeologist to gain social power and prestige in Tehran. Thereafter, Herzfeld hitched his archaeological and

scholarly career in Iran to the remote site of Persepolis, away from the political
intrigues of the court and the government in Tehran.

Having negotiated with the Iranian government throughout 1929, Herzfeld
was finally granted the right to excavate at Persepolis in 1930. Funded in part by
the University of Chicago's Oriental Institute and in part by John D. Rockefeller,
official excavation began in 1931. In the meantime, Herzfeld continued to keep
a cordial friendship with Firuz Mirza and a courteous relation with the Teymur-
tash, who received him at the Sa'adabad Palace in July 1931 to "look over some
Persepolis drawings" (Ministry of Culture and Islamic Guidance 2001: 45, 480–
81). By 1934, exploration uncovered the Persepolis Terrace, the Eastern Stairway
of the Apadana, the Council Hall, as well as Xerxes' Harem. Persepolis would
not only preoccupy Herzfeld during the rest of his stay in Iran; he also guarded
it with "archaeological jealousy and suspicious glances" (Byron 1937: 52, 157–
69). British traveler Robert Byron, who spent eleven months in 1933 and 1934
photographing various historical monuments in Iran, complained on several
occasions to Shiraz's governor that the German archaeologist "has no right to
refuse people permission to photograph the old remains at Persepolis," adding
"that right has been expressly confirmed by the Ministry of Public Instruction"
(Byron 1937: 52, 157–69).[3] German archaeologist Erich F. Schmidt (1897–
1964), who followed Herzfeld as field director, carried on the general excavation
of the site and its surroundings until the outbreak of World War II.[4] In the post-
war era, research and excavations were conducted by the Iranian Antiquities
Service under local leadership, which worked in conjunction with the Italian
Institute of the Middle and Far East from 1964.

Herzfeld and Godard—serious scholars, architects, and archaeologists—
were caught in a complex web of colonial rivalry, local politics, and personal
ambitions in Iran. Each of their careers was contingent upon the intricate flow of
power on multiple levels: official negotiations between Iran, France, Germany,
and other states and their museums; power struggles between Iranian ministers
and foreign embassies; friendships between individual Iranian elites and these
scholars; and the often cordial but competitive relationship between Herzfeld
and Godard. The two became proxies of German–French colonial rivalries over
Iran's culture and history and, more specifically, the control of Iran's archaeolog-
ical artifacts and, thus, its civilizational narrative. The archaeological treaty of
1900 and the 1927 treaty, and the subsequent power struggles to reinforce or to
nullify these agreements, were specific manifestations of a post-colonial dis-
course that played out around Iranian archaeology. These manifestations were as
multi-level, multipurpose, and multi-faceted as the discourse on colonialism and
post-colonialism.

In 1929, American competition was added to the French assaults on Herzfeld. The American art historian and art dealer Arthur Pope, who had come to Iran four years earlier, openly expressed "serious concerns" about Herzfeld's archaeological activities in Persepolis to his good friend, Hosayn Ala, who had been the ambassador to France (Ministry of Culture 2001: 32, 476–78). In his rather long report, therefore, Ala cautioned the Pahlavi court that a certain "Mr. Breasted" (James Henry Breasted) from the Oriental Institute was interested in Herzfeld's excavations, underscoring that this was "not void of importance" (Abt 2011; Ministry of Culture and Islamic Guidance 2001: 32–33). However, according to Pope, "[I]f Iran agreed to sign a contract with the Institute . . . it should be very careful of the terms and conditions" (Ministry of Culture and Islamic Guidance 2001: 32–33). At the same time, Pope dismissed Godard's abilities as the director of the Antiquities Service with very harsh words; in contrast to Herzfeld, who considered Godard "as a man of distinguished record and ability with whom he expected to get on well," Pope relayed to David Williamson, the American chargé d'affaires, that "Godard is a third-rate man, not at all fitted to be the Director of Antiquities in Persia . . . if [he] should attempt such work, Persian art is doomed, because Godard does not know Persian art and is a small man" (US State Department Archives 1929).

The French government now perceived a threat in the nonexistent "Germano-American" cooperation between Herzfeld and Pope in efforts to export antique objects to the New York and Berlin markets. In Wilden's view, "America provides the money; Germany, the men" (AFMFA 1929). As late as 1930, French authorities remained convinced that they were the only ones looking after the true interests of "Persia's ancient civilization," with Godard as the head of that mission. In a confidential report, they cynically blamed "the Black Gang (la bande noire), which under the enlightened leadership of the German Herzfeld and the intermediary role of the antique dealer Pope, pillages, for years now, the artistic masterpieces of Persia and habitually elevates the price [of antiques] in the American market" (AFMFA 1930). Furthermore, the document implicated some locals, noting that "despite Mr. Godard's vigilance, the Herzfeld-s and Pope-s ... seem to be certain that with high-positioned [Iranian] accomplices, no effective control can be exercised upon their assignments" (AFMFA 1930). The same communiqué, the last of its kind addressing the archaeological ordeals of the 1920s and 1930s, concluded with cultural lamentation and political loathing on the part of the French:

> This poor country risks losing the last vestige of its artistic civilization after these [German and American] governments have destroyed all that remains of

its religion, its civility, its customs, and its writing. The old Persia is dead and
replaced by a young Persia, banal, hostile, and unbalanced to the point that only
defects can be recognized (AFMFA 1930).

As evident from contradictory letters and reports, contentious exchanges and
collaborations among these men, as well as those who sought to control them,
were very complex. Despite the cordial face of their interactions, Pope, Godard,
and Herzfeld each sought ways to consolidate their respective positions while
attempting to deny the others' advances. The simple matter of archaeology—the
study, collection, and interpretation of piles of ruins—had turned into a global
game of *Realpolitik*, which perhaps it always had been (Kohl and Fawcett 1996;
Trigger 1984).

It is important to note that whereas Pope and Herzfeld were hired by West-
ern states, universities, and museums, Godard was an employee of the Iranian
government and hence was accountable to it. This technical difference in their
employment seems to have strongly influenced their individual actions and atti-
tudes toward Iran's architecture, art, and archaeology. In the end, the many arti-
facts that Godard acquired for the Louvre were legal, from the Iranian perspec-
tive, in contrast to what "the Black Gang" smuggled out of Iran to benefit The
University of Pennsylvania Museum, among other foreign institutions. Further-
more, the achievements of Godard, who had been on the ground in Iran unin-
terrupted for over thirty years, proved more valuable to the national museum
and pedagogical economies than either Pope's occasional and, for him, highly
lucrative visits to Iran, or Herzfeld's short-term, equally lucrative, excavations at
Persepolis. Half a century later, while Godard's Iranian students described him
as "an extraordinary man," Pope and Herzfeld were seldom remembered by Iran-
ian contemporaries.[5] Despite appearances, specifically as represented in Pope's
Survey of Persian Art (Pope and Ackerman 1938), Godard's contribution
remains far more substantial, enduring, and ultimately beneficial for Iranian
archaeology. Although Godard's numerous publications on Iranian art, archae-
ology, and architecture that appeared between 1934 and 1965 are not as well
known to subsequent Western scholars as Pope's *Survey*, they do demonstrate
his long-term commitment to the study and protection of Iran's cultural patri-
mony. By 1970, urban Iran looked a lot like the vision of the early modernists
of the 1920s. By then, although the three Orientalists and their Iranian coun-
terparts were no longer around, they had left behind a cultural legacy of archae-
ology upon which a new generation of Iranian modernists could base their
work.

ARCHAEOLOGY AS NATIONAL ASSERTION

In October 1971, the king of Iran, Mohammad Reza Shah Pahlavi (r. 1941–79), celebrated the 2,500-year Anniversary of the Founding of the Persian Empire by Cyrus the Great. The king chose the famed ruins of Persepolis not only as the authentic site of historical reenactments but also as the ultimate symbol of Iran's monarchy and civilization (Lowe 1971: 6). By so doing, he left his mark—the mark of a modernist state, which made good use of archaeology to stage and perform the nation—on the archaeological site. Half a century after the struggles of the 1920s, modern technology had fused with ancient monuments; it was this fusion that made what became known as Persepolis '71 possible.

Through three days of royal celebrations, Persepolis became, according to official reportage, "the center of gravity of the world" (Showcross 1988: 39). International guests and sixty-nine heads of state included the rich and famous of the time: a dozen kings and queens, ten princes and princesses, some twenty presidents and first ladies, ten sheikhs, and two sultans, together with emperors, vice presidents, prime ministers, foreign ministers, ambassadors, and other state representatives. They witnessed a ritualistic speech by the king at Cyrus's tomb, an unparalleled sound and light spectacle over Persepolis, exquisite banquets in a tent city, and a fantastic parade of national history (Showcross 1988: 39). While the event was "the greatest show the world ha[d] ever seen," as the monarch promised, it also sparked the beginning of a mass revolutionary movement that was both anti-Shah and anti-Western (Mottahedeh 1985: 326–27). Yet, while the celebrations lasted, Persepolis and the adjoining Tent City permitted the staging of international political theatrics and provided the space in the national consciousness for a temporal leap from antiquity to modernity (Fig. 5.5). While intended to assert Iran's global cultural and political reputation, the neo-Achaemenid spaces and rituals used to re-create the entire history of the Persian Empire were in effect a thoroughly self-Orientalizing spectacle. It was Iranian mimicry that wholeheartedly embraced European and Western imperial tactics as described in Edward Said's *Orientalism* (1979).

Mohammad Reza Shah, who secured the throne in 1941 following his father's forced exile by the Allies, was committed to the rapid modernization of the country's economy and infrastructure; at the same time, however, he prevented the liberalization of its political institutions. Like his father, he was convinced that a better future for Iran was possible by maintaining cultural and religious links to Iran's pre-Islamic past; as for avoiding the pitfalls that had plagued Western modernization, he believed these could be preempted by concocting technological "shortcuts

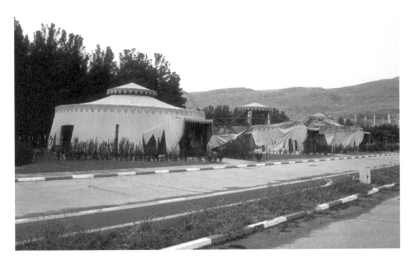

FIGURE 5.5. Tent City preserved in a state of ruin for post-revolutionary
propaganda purposes, Persepolis, Iran, 1990s. Photo by Talinn Grigor.

to the future."[6] Unlike his father, who had risen through the Iranian social and
military hierarchies, Mohammad Reza Shah remained disconnected from ordi-
nary Iranians and their values, aspirations, and visions for an Iranian future. Perse-
polis '71, therefore, is recorded in Iran's modern history as an explicit, exclusive,
and extravagant articulation of the king's attempt to perform the nation. It was a
display of the broader social engineering and cultural revivalism of the Pahlavi
reign, a manifestation of his utopian vision of Iran as the "Great Civilization."

Allusions to Iran's antiquity and the reproduction of its ancient cultural
mores were not a Pahlavi invention. Qajar kings and aristocrats had erected edi-
fices with pre-Islamic iconography since the beginning of the nineteenth century.
Described as "the first Persian monarch since antiquity to revive the Achaemenid
and Sassanian tradition of royal images cut into rock," Fath Ali Shah Qajar (r.
1797–1834) decreed the carving of his portraits and those of his heirs near the
Allah-o Akbar gate at Shiraz and in the grotto at Taq-e Bostan in the first two
decades of the nineteenth century (Lerner 1991: 31). Similarly, in 1823, his rock
reliefs at the Cheshmey-e Ali in Ray, while an expression of the king's status as
Persia's monarch rather than a glorification of the nation's pre-Islamic history,
were distinctly Sassanian in style and composition (Lerner 1991: 31, 36). The
first Persian-language translation of Darius I's cuneiform script at Bisotun, locat-
ed thirty kilometers northeast of Kermanshah, was presented to his grandson,
Mohammad Shah (r. 1834–48) by Sir Henry Rawlinson. Half a century later,

Naser al-Din Shah (r. 1848–96) had self-consciously redesigned Tehran's urban fabric with lucid awareness of both ancient Persian and modern Western aesthetics. In the late 1860s, he had destroyed parts of Tehran's city walls and had decreed the expansion of the royal palace, borrowing his design ideas from Achaemenid and European architectural repertoires.

By the mid-1930s, the sporadic tendencies among the Qajars to revive ancient forms and icons became the official architectural language of the Pahlavi state and underpinned an undeniably racist politics of homogenization and secularization. The king and his government rapidly erected Achaemenid simulacra in order to underline contemporary ties to Iran's pre-Islamic, pre-Arab history and point to the Indo-European linguistic and Aryan racial qualities of Iranians. The new architecture of the 1930s—often inspired by new archaeological data provided by excavation of Achaemenid sites, including, above all, Persepolis—aimed to represent the moral, racial, and historical valor of the nation, revived under the Pahlavi dynasty (Grigor 2007, 2009). Prominent examples of neo-Achaemenid and neo-Sassanian architecture in this period consisted of the first main post office, the building of the justice ministry, the first national bank, the main train station, as well as the different ministries, legislative headquarters, and secondary administrative buildings in the heart of Tehran. All were amalgams of Western modernist monumentality and Iran's pre-Islamic monarchical tradition. Other often cited but seldom analyzed examples include André Godard's Museum of Archaeology (*muzey-e iran-bastan*, 1939) and the French architect Maxime Siroux's National Library (ca. 1945), both fashioned after the last Sassanian palace at Ctesiphon, today located in modern Iraq, as well as the modern mausoleum of the medieval poet Ferdawsi erected in Tus and inaugurated by the king in October 1934 (Godard 1938). Throughout this period, Persepolis remained the main archaeological site to which architects and politicians alike returned for inspiration.

By 1971 and the 2,500-Year Anniversary, the buried fragments of Persepolis had been brought to the surface as a vast ancient city with royal palaces and throne halls, residential quarters and harems, as well as a sophisticated decorative program with exquisite examples of high reliefs. The complex was unanimously selected to house the festivities, which included five major events: the opening speech at the foot of the tomb of Cyrus at Pasargadae, two dinner banquets in the Tent City followed by fireworks over Persepolis, the viewing of "the Great Parade of Persian History" under the grand staircase of Persepolis, and, finally, the conclusion of the celebration in the modern capital of Tehran. Radical architectural and technological measures were undertaken not only to render Persepolis and Pasargadae user-friendly to dignitaries but also to provide them with a modern look without impairing their antique allure, imagined or otherwise

(Fig. 5.6). The fine-tuned synthesis of ancient and modern aesthetics was intended to guarantee the symbolic and practical success of the entire undertaking. On October 12 "at the crack of dawn," Mohammed Reza Shah launched the ceremonies with his famous address. Standing in front of Cyrus's empty tomb at Pasargadae, the king assured the father of the nation that "after the passage of twenty-five centuries, the name of Iran today evokes as much respect throughout the world as it did in thy days" and that he, Cyrus, should "rest in peace, for we are awake ... to guard thy proud heritage" (Hureau 1975: 60). Until those words, the tomb had been presented in official literature as "a lonely, plundered, almost

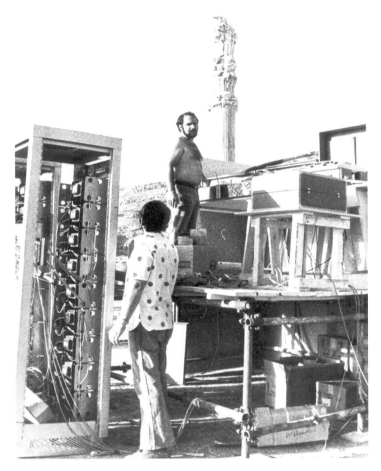

FIGURE 5.6. Technicians working on the light-and-sound system at Persepolis in preparation for the 2,500-year celebration ceremonies, Persepolis, Iran, September–October 1971. Photo by Vardkez Esrailian.

forgotten" place "left to lizards." Subsequently, it signified the beginning of official Iranian history.

After the initial ceremony at Pasargadae, the events continued at Persepolis. The biggest intervention on the site was the erection of the Tent City or Golden City, proposed by the French interior design firm of Jansen, on the ruins' southern section. The array was described by one invitee as "one hundred and sixty desert acres covered with some seventy tents, sumptuously decorated [...] with French crystal, china, and linens, and hung with red silk and velvet and glittering chandeliers" (Zonis 1991: 68). The king had insisted that his 600 foreign guests should camp outside Persepolis as had the ancient Assyrians, Lydians, Armenians, Arabs, and Babylonians in the time of Darius I. The star-shaped encampment was organized around a large fountain. The pairs of tents, totaling sixty residential villas, projected out to create five axes, each named after a continent. In turn, each tent of beige and royal blue fabric contained a sitting room, two bedrooms, two bathrooms, and a kitchen. At the end of the main axis, a large tent was erected as a banqueting hall to house the extravagant evening galas of October 14, catered by Chez Maxim's of Paris. While the first night's formal banquet exulted in Western aesthetics of architecture, entertainment, and cuisine, the following night's casual dinner was redesigned to leave an impression of "an oriental pleasure pavilion with low divans and plush pillows on the carpeted floor" (Lowe 1971: 30). The evening concluded with fireworks over the ruins, where actors, draped in ancient-style textiles, re-created the rituals of the ancient Achaemenid kings. Instead of washing his guests in sacred water as had been done in 500 BCE, Mohammad Reza Shah invited his modern audience to "watch the history of the Persian Empire's ceremonial city unfold in a sound and light spectacle" (Lowe 1971: 35). The production had a twofold teleological purpose: to prove that Iran could and had transcended its Orientalist traditions, while remaining true to its heritage. Ultimately, it could be as modern as the West and as ancient as the Orient. Therefore, to accommodate the high-tech spectacle, the ruins were equipped with amplifiers, loudspeakers, transmitters, projectors, hi-fi sets, recorders, television cameras, and other light and sound systems, all of which were concealed behind partitions and thus outside the view of journalists and their cameras.

These rather sophisticated theatrics of history, however, were mere prelude to the great parade of the following day, which involved a decade of preparation through scholarly research and production, rehearsal, and over six thousand men. With the help of famous French companies, including Jansen, Chez Maxim's, Lanvin, and Limoges, which had been hired to make the celebrations "something never [before] seen," the Iranian authorities concocted the costumes

for the parade of Persian history.[7] This spectacle showcased ten epochs in the military history of Iran, from the Achaemenid Empire to the Pahlavi state. Televised to "tens of millions around the world," each era was represented by contemporary soldiers dressed "exactly" as their counterparts from corresponding historical periods. Described as "a panorama of 2,500 years of history on the march ... in full splendor of their age," they represented the armies of the major dynasties that had ruled greater Persia: Achaemenid, Parthian, Sassanian, Safavid, Zand, Qajar, and Pahlavi. For several months, rehearsals were organized, soldiers were prohibited from shaving, benches were assembled, and the entire ruins of Persepolis were thoroughly refurbished. Shiraz, the city to which dignitaries were flown and from which they were driven to Persepolis, went through a meticulous state-sponsored facelift: streets were asphalted and cleaned up; major building facades were remodeled; lampposts were installed; squares were redecorated; avenues were blocked for security; and shopkeepers were provided with blue jackets. Thousands of Iranian lives were interrupted to guarantee the image of a monarch who insisted on looking thoroughly modern as well as genuinely ancient. During the parade at Persepolis '71, Pahlavi versions of cultural imperialism shaped a linear Persian history from Cyrus the Great to Mohammad Reza Shah. The procession at the foot of the ruins was the most ornate and costly manifestation of that history. Later historians would note, "At Persepolis, Mohammad Reza Shah remolded Persian history to his own heart's desire," for he had insisted that it "helped immeasurably to establish Iran anew in Western perceptions" (Showcross 1988: 46). However, many could but remark that the parade "surpassed in sheer spectacle the most florid celluloid imagination of the Hollywood epics" (Showcross 1988: 62).

The Pahlavi revivalism of Iran's archaeological past had for decades been rooted in Western theories of race. From its outset, the court's official discourse on Aryan race and its validity for Iran was amalgamated with the secular nationalism of Reza Shah's court. In the name of progress and modernization, Iranians were not only urged to give up Islam *in toto*, but were also impelled to feel and act as the Oriental branch of Germanic Aryans (Grigor 2007). As early as 1934, official newspapers had insisted that Iranians had "always been firm defenders of the Aryan race against the avalanche of Tartars, Arabs, Mongols, and other hordes hostile to our collective race."[8] Persepolis '71 was a reassertion of Iran's national confidence in its own cultural tradition, monarchical history, and above all, in its own racial superiority. In a 1975 interview conducted by American journalist Mike Wallace,[9] the king went so far as to caution the West about the imminent rise of the non-West, of a third force. "The men with blue eyes," Mohammad Reza Shah warned his Western audience, "have to wake up!" While ostensibly a simple

manifestation of the king's self-confidence in his political and military power, this was, above all, a post-colonial reassertion of the alleged civilizational and cultural superiority of Iran vis-à-vis the West. Persepolis '71 was orchestrated as a tour de force of this emerging (post-colonial) third way. Or, so it seemed to the king.

The juxtaposition of the ancient and the modern at the 2,500-Year Anniversary was the exhibition of progress under the Pahlavis. At the end of the third day of celebrations, the foreign dignitaries were flown back to Tehran. This change of location from Persepolis to Tehran spoke to the direct link between the ancient city of Persepolis as the capital of the Achaemenid Empire and the modern city of Tehran as the capital of the Pahlavi state, a conspicuous evocation of change and continuity—of antiquity and modernity. As put by one state spokesman, it was a jump "out of history into the nation's future" (Lowe 1971: 95). This was a utopic future in the making since February 21, 1921, when Reza Khan and his secularist collaborators orchestrated a coup d'état and ousted the last Qajar king, Ahmad Shah. Since then, rapid modernization was filtered through the practice of revivalism in an effort to endorse both international progress and national rootedness. The first indication of this official policy was revealed when Reza Khan took the ancient Iranian term of "Pahlavi" as a dynastic name. Decades later, like his father, Mohammad Reza Shah added to his name the title *Aryamehr* derived from Achaemenid inscriptions discovered by a nineteenth-century English archaeologist. In them, Darius I had referred to himself as *Aryamehr*, meaning "The Light of the Aryans" (Mottahedeh 1985: 326). When the second half of the celebration was launched in Tehran, the king dedicated a large-scale modernistic museum of linear Iranian history, the Shahyad Aryamehr Monument (Grigor 2003).

Designed especially for the occasion and commissioned to the then young Iranian-Baha'i architect, Hosayn Amanat, the white landmark of the Shahyad Aryamehr Monument in the western Tehran signaled the most ambitious and utopic reform-program of the king: the twelve points of his White Revolution, which began with land reforms policies, and extended to include theological and educational corps, labor unions, and women's suffrage. They would, inevitably, never materialize the way in which the king had imagined as a comprehensive system of top-down social justice. Until the dawn of the Iranian Revolution in 1979, Shahyad served as the architectural manifesto of the shah's monarchy, visions, ideologies, and ultimate aim. It became the symbol of the modern nation marching forward, captured in the dynamic form of the landmark that was connected to the past through its general plan and decorative details. In the nation like in the Shahyad, the new and the old were omnipresent: a gate to the king's Great Civilization.

Through the Shahyad's architecture, the nation was remembered and nar-rated: "Through that language, encountered at mother's knee and parted with only at the grave, pasts are restored, fellowships are imagined, and futures dreamed" (Anderson 1991: 154). As the Pahlavi dynasty longed to be the Achae-menid Empire and as modern Iran longed to return, symbolically, to ancient Per-sia, they had to cross the utopic arch of the Shahyad Aryamehr monument. On the final day of the celebrations following the inauguration of the Shahyad, addi-tional parades took place in the newly inaugurated 100,000-seat Aryamehr sta-dium. The celebrations concluded at the tomb of Reza Shah in Ray, south of the capital city. The fact that the events in Tehran were staged against the backdrop of modern architecture contributed in no small way to the impression of com-pressed time. These articulations of national history were meant to "show off Iran's considerable recent achievements to the outside world and at the same time show Iranians how respectfully the outside world would treat the official ideology" (Mottahedeh 1985: 326–27). While the court ministry insisted on $17 million, by the end of the week, the Iranian state had poured more than $300 million into the events (Mottahedeh 1985: 326–27).

While in official reportage, the Iranian state declared that "thousands of spec-tators … came from far and wide to witness today's great spectacle," only a hand-ful of the world's privileged aristocrats and diplomats were invited (Lowe 1971: 7). The Iranian masses, in whose name the events had been organized, were con-sistently excluded from the celebrations. For this reason, the events agitated ordi-nary Iranians and left the international community unimpressed. Local critics immediately began to express their opposition to the state and the royal court vis-à-vis Persepolis '71. The "Frantz Fanon of Iran," Ali Shariati, who had translated Fanon's anti-colonial works into Persian, insisted that the nation was being mold-ed through a return to the wrong roots. "[F]or us," he wrote, "return to our roots means not a rediscovery of pre-Islamic [Aryan] Iran, but a return to our Islamic, especially Shi'ia, roots" (Abrahamian 1982: 467). In his view, Persepolis '71 was the expression of this mistaken origin. For their part, the *ulama* quickly realized that if the Achaemenid Zoroastrian revival as manifested at Persepolis '71, suc-ceeded in wining the hearts and minds of the people, the representatives of Islam and Islam as a way of life would come under threat. On the eve of the celebrations, Ayatollah Khomeini issued a declaration from his exile in Iraq, calling it a "devil's festival" and condemning the entire event. His words were followed by action. In 1973, a radical Marxist-Islamist group, the Mojahedin, carried out a number of attacks on pro-shah and American-owned institutions in Tehran.

By the mid-1970s, the events at Persepolis were reassessed by the Western media as well as by Empress Farah Pahlavi. When the latter was asked by the

shah's devoted court minister, Amir Assadollah Alam, to approve a documentary film of the celebrations, she told him, "For goodness sake, leave me alone.... I want our names to be utterly dissociated from those ghastly celebrations" (Alam 1991: 245–46). In an interview with an American journalist in 1972, the shah defended himself on the basis of a Derridian *différance*:

> You Westerners simply don't understand the philosophy behind my power. The Iranians think of their sovereign as a father. What you call "my celebration" was to them the celebration of Iran's father. The monarchy is the cement of our unity. In celebrating our 2,500th anniversary, all I was doing was celebrating the anniversary of my country of which I am the father. Now, if to you, a father is inevitably a dictator, that is your problem, not mine.[10]

The rhetoric of ruins was intended to legitimize the policies of rapid and, at times, authoritarian modernization. A publication sponsored by the Celebration Committee maintained, "Only when change is extremely rapid, and the past ten years have proved to be so, does the past attain new and unsuspected values worth cultivating." It concluded that "the celebrations were held because Iran has begun to feel confident in its modernization" (Lowe 1971: 7). The celebrations served their purpose, which according to the king was, "to re-awaken the people of Iran to their past and re-awaken the world to Iran" (Lowe 1971: 95). When in March 1976, Mohammad Reza Shah decreed the substitution of the Muslim Solar Calendar with the Royal Calendar, the 2,500-Year Celebrations were recalled to endorse not only the gigantic temporal shift, but also its historical exactitude. Equating performance with political power and enactment with historical lineage, time itself was reset at Persepolis '71. Overnight, the Muslim Solar 1355 mutated into the Royal 2535 (Abrahamian 1982: 444; Zonis 1991: 82, 289). Prime Minister Fereydoun Hoveyda declared, "this is indeed a reflection of the historic fact that during this long period, there has been only one Iran and one monarchial system and that these two are so closely interwoven that they represent one concept" (Hoveyda 1980: 203). In response to public outrage, the king vowed that this reorientation of time would put Iran ahead of the West in terms of historical progress, since from now on, "they [1976 Europe] would look forward to us [2565 Iran]."

Through the modern use of Persepolis as a preserved site of ruins, the state enacted the nation at an authentic site of national origin, with all its ancient glamour and modern excesses (Grigor 2005). It also presented a moment in which Iran tried to reclaim civilizational superiority vis-à-vis the (Western) world, on the historical logic that it was Alexander who looted Persepolis and brought about the demise of the Achaemenid Empire, itself acknowledged by

Western (art) historical narratives as foundational to the development of civilization. The experiential, phenomenological immediacy of the ancient ruins was meant to intensify and authenticate the appearance of modernity at Persepolis '71. Such proximity instrumentalized the untimely preservation of time. The compression of history delineated the appropriation of fragmented antiquities as not only a thoroughly modern act, but also as the very manifestation of modernity. This process of endlessly becoming modern was achieved through the staging of fragments of architecture, which then lent themselves to the holistic vision of a reincarnated historical golden age and the promise of a great future civilization. These shortcuts into the extratemporal increasingly contributed to political decadence in Pahlavi Iran.

In his celebrations, Mohammad Reza Shah personified "being-as-playing-a-role," except in this case, he, along with his guests, played the role earnestly. In fact, Persepolis '71 was a pure example of "camp," which, according to Susan Sontag, is unintentional: those who employ camp "are dead serious" and do not "mean to be funny" (Sontag 1964: 280–82). The value of camp resides in irony and its performance, and claims legitimacy through an oppositional position to the status quo. The king's display of power at the ruins of Persepolis contributed in no ambiguous way to the undermining of his own political power at home and to Iran's oppositional stance to colonialism on the international stage. Historians of modern Iran often cite the origins of the 1979 Iranian Revolution, which shook the world and brought down the Pahlavi dynasty, as located at Persepolis '71. Had not the shah unveiled an elaborate form of self-Orientalization that would lend itself to revolt? Was not Persepolis '71 a genius reassertion of "Voilà! The Orient!" in a kind of authenticity that would reassert itself in the form of revolutionary slogans? (Sontag 1964: 282). At Persepolis, the nation was performed on the stage and narratives of archaeology.

During the Iranian Revolution of 1978–79, the masses attacked and vandalized the remains of the Tent City as an act of protest not only again the Pahlavi court, but also against all of Western civilization and its modern imperial history. Subsequently, the Islamic Republic of Iran, under the leadership of Imam Khomeini, determined to preserve the defaced tents as manifest expressions of royal overindulgence and wastefulness. By 2006, with no possibility for the return of the monarchy, these tents, too, were removed by Seyyed Mohammed Khatami's more liberal government (r. 1997–2005), which encouraged a rapprochement with the West and welcomed international tourists to Iran. On the site of Persepolis itself, however, traces of the celebrations remain (present/absent) today: outdated projectors, electrical cords, electrical panels, and so on. While they allude to what occurred in 1971, they defer the fixing of meaning(s). The deceptive banal-

ity of the presence of this technological debris on the ancient site renders it both invisible to present-day visitors and simultaneously visible as signifiers of the anxiety of Persepolis '71. Above all, it silently narrates a story of ancient imperial extravagance, anti-colonial performances, modernity unfulfilled, and post-revolutionary neglect. The once high-tech traces of Persepolis '71 have become an integral part of the ruins of Persepolis (Fig. 5.7).

Back in 1971, from the perspective of Western imperialism, Mohammad Reza Shah in the aura of his celebrations had become an unauthorized version of otherness—Naipaul's "mimic-man" and Fanon's "black skin/white masks." At Persepolis '71, he had emerged as an inept colonial subject, who had managed to reproduce a perfected blueprint of imperial mimicry that, from a colonial perspective, seemed

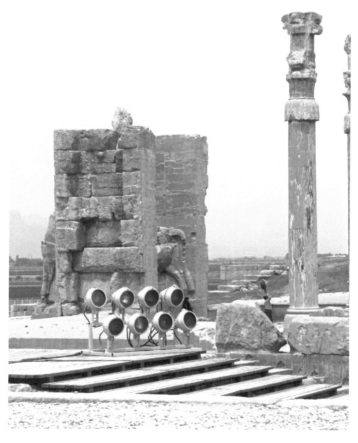

FIGURE 5.7. Then-high-tech technology left from the 1971 celebrations, Persepolis, Iran, 2007. Photo by Talinn Grigor.

an undesirable "vision of the colonizer's presence" (Bhabha 1995: 88). What the shah was doing to the Western imperial image of hegemony was to undermine its subjectivities, disturb its asserted centralities, and distort its civilizational purity. The shah's Iran was a "menace"—a post-colonial counter-narrative that was not based on a discourse of hybridity, but on a discourse of mimicry-as-camouflage (Bhabha 1995: 88; Lacan 1988). In explaining this camouflage, Mohammad Reza Shah insisted that "[his] reign [had] saved the country" (Pahlavi 1980: 32). Persepolis '71 was his own othering process of the West through resemblance: a historical, civilizational, and epistemic bid that aspired to *différance* through camouflage.

The extravagance of the celebrations, the use of archaeology to legitimize power, the theatrics of the performances, and the ultimate expression of elite aesthetics on the preserved ruins of Persepolis, in due course, came to contribute to the image of a corrupt monarch in the eyes of the Iranian masses. Few were persuaded by imperial theatrics; and even fewer understood its potential, yet perverse, counter-colonial underpinning. The king had by no means convinced his subjects of the symbolic truth of the events. At the time, however, the king's privileged Western audiences—aristocrats and the general public alike—had fully endorsed the seriousness of the events. This endorsement was abundantly expressed in major Western popular journals and newspapers. Ten days after the parade at Persepolis, next to the illustration of the rather bored Iranian soldiers dressed in Achaemenid military costume, *Paris Match* boldly claimed that "they have not changed in 2,500 years" (1971: 37).

NOTES

[1] Herzfeld knew, or at least was familiar with, Godard's work as early as 1926, as may be seen in his review of Godard's "Ghazni" (Syria, 1925): pp. 58–60, in *Deutsche Literaturzeitung* 47 (1926): 668–71. In fact, Godard and Herzfeld had met during Herzfeld's excavation in Samarra between 1911 and 1913. Thomas Leisten, "Achievement and Disaster: Ernst Herzfeld's Excavation at Samarra 1911–1913," lecture delivered at The Aga Khan Program for Islamic Architecture at MIT, "An Evening with..." Lecture Series, May 5, 2003.

[2] By "the political situation," the author probably means the increasingly despotic rule of Reza Shah and the elimination of his political elite with whom Herzfeld had dealings.

[3] There is a long discussion about the politics of photographing Persepolis by Byron and the attempts made by Herzfeld to prevent it. After a dispute over individual copyright of one's discovery and the universalism of ancient heritage, Byron "by force" managed to document Persepolis.

[4] See the University of Chicago's Oriental Institute website, http://oi.uchicago.edu/.

[5] Houshang Seyhoun, interview by author, June 29, 2000, Vancouver, Canada, tape 1, side B.

[6] "[Our Great Civilization's] avowed goal ... then ... will have to [be] invent[ing] unique programs to find *shortcuts* to the future." In *Art and Architecture* (1973: 140).

[7] "From Teheran to Persepolis: All the Glitter of the Empire," in *Glittering Royal Events*, © Royal Sites 2000–2004, available at http://www.angelfire.com/empire/imperialiran/persepolis1.html (accessed July 30, 2007).

[8] Editorial: Notre But, *Le Journal de Téhéran* 1, March 15, 1935: 1.

[9] Mohammad Reza Shah, interview by Mike Wallace, CBS, *Le Journal de Téhéran* 11.826, February 6, 1975: 1.

[10] Interview with the shah in 1972, quoted in Gérard de Villiers, *The Imperial Shah: An Informal Biography* (Boston: Little, Brown, 1976), p. 284.

REFERENCES CITED

Abrahamian, Ervand
 1982 *Iran between Two Revolutions.* Princeton University Press, Princeton, NJ.
Abdi, Kamyar
 2001 Nationalism, Politics, and the Development of Archaeology in Iran. *American Journal of Archaeology* 105(1): 51–76.
Abt, Jeffrey
 2011 *American Egyptologist.* University of Chicago Press, Chicago.
al-Ulumi, H. B.
 1976 *Karnameh-e Anjoman-e Asar-e Melli* [Report-book of the Society for National Heritage], #131, Society for National Heritage, Tehran.
Alam, Amir Assadollah
 1991 *The Shah and I: The Confidential Diary of Iran's Royal Court, 1969–1977.* St Martin's Press, New York.
Anderson, Benedict
 1991 *Imagined Communities: Reflections on the Origin and Spread of Nationalism.* Verso, London and New York.
Archives of the French Ministry of Foreign Affairs
 1900 Direction des Affaires politiques et commerciales Asie-Océanie 1919–1929 (DAPCA-O 1919–29), Perse 66, Fouilles archéologiques, E387-3, 17, 11, dated August 11, Paris.
 1923 DAPCA-O 1919–29, Perse 66, Fouilles archéologiques, E387-3, 23, dated July 22, Tehran.
 1928a DAPCA-O 1919–29, Perse 66, Fouilles archéologiques E387-3, 91, dated March 20, Tehran.
 1928b DAPCA-O 1919–29, Perse 66, Fouilles archéologiques E387-3, 92, dated March 20, Tehran.

1928c DAPCA-O 1919–29, Perse 66, Fouilles archéologiques E387-3, 97, dated July 16, Tehran.

1929 DAPCA-O 1919–29, Perse 66, Fouilles archéologiques E387-3, 107, dated November 30, Tehran.

1930 Direction des Affaires Politiques et Commerciales Asie 1918–29, Iran 131, Fouilles archéologiques E387-3, 12, dated July 27, Tehran.

Art and Architecture

1973 Iran Yesterday, Today, Tomorrow. *Art and Architecture* 18–19(June–November).

Bhabha, Homi

1995 *Location of Culture*. Routledge, London.

Byron, Robert

1937 *The Road to Oxiana*. Oxford University Press, London.

Daryaee, Touraj, Ali Mousavi, and Khodadad Rezakhani

2014 *Excavating an Empire: Achaemenid Persia in Longue Durée*. Mazda Publishers, Costa Mesa, CA.

de Morgan, Jacques

1895–96 *Mission scientifique en Perse*. Ernest Leroux Editeur, Paris.

de Villiers, Gérard

1976 *The Imperial Shah: An Informal Biography*. Little, Brown, Boston.

Freer Gallery of Art and Arthur Sackler Gallery Archives

2000 *Catalogue of the Herzfeld Archive*. Washington, DC.

Godard, André

1934–49 *Athar-e Iran: Annales du Service Archeologique de l'Iran*. Haarlem.

1938 Les Monuments de Feu. In *Athar-é Iran: Annales du Service Archéologique de l'Iran* 3: 7–80.

1950 *Persépolis*. Éditions de l'Institut Franco-Iranien, Tehran.

1962 *L'Art de l'Iran*. Arthaud, Paris.

Grigor, Talinn

2003 Of Metamorphosis: Meaning on Iranian Terms. *Third Text* 17(3): 207–25.

2005 Preserving the Modern Antique: Persepolis '71. *Future Anterior: Journal of Historical Preservation History Theory Criticism* 2(1): 22–29.

2007 Orient oder Rom? Qajar 'Aryan' Architecture and Strzygowski's Art History. *The Art Bulletin* 89(3): 562–90.

2009 *Building Iran: Modernism, Architecture, and National Heritage under the Pahlavi Monarchs*. Periscope Publishing, New York.

Hoveyda, Fereydoun

1980 *The Fall of the Shah*. Simon & Schuster, New York.

Hureau, Jean

1975 *Iran Today*. Iranian Ministry of Information and Tourism, Tehran.

Kohl, Philip L., and Clare Fawcett

 1996 *Nationalism, Politics, and the Practice of Archaeology.* Cambridge University Press, Cambridge.

Lecan, Jacques

 1988 *Seminar One: Freud's Papers on Technique.* W. W. Norton & Company, London.

Lerner, Judith

 1991 A Rock Relief of Fath 'Ali Shah in Shiraz. In *Ars Orientalis* 2: 31–43.

Lowe, Jacques

 1971 *Celebration at Persepolis.* Creative Communications, Geneva.

Miller, Naomi, and Kamyar Abdi

 2003 *Yeki Bud, Yeki Nabud: Essays on Iranian Archaeology in Honor of William M. Sumner.* The Cotsen Institute of Archaeology Press, Philadelphia and Los Angeles.

Ministry of Culture and Islamic Guidance

 2001 *Documents on Archaeology in Iran: Excavations, Antiquities and Historical Monuments.* Ministry of Culture and Islamic Guidance Publications, Tehran.

Mottahedeh, Roy

 1985 *The Mantle of the Prophet: Religion and Politics in Iran.* Simon & Schuster, London.

Niknami, Kamal Aldin

 2000 *Methodological Aspects of Iranian Archaeology.* British Archaeological Reports, Oxford.

Pahlavi, Mohammad Reza Shah

 1980 *Answer to History.* Stein & Day, New York.

Pope, Arthur Upham (editor), and Phyllis Ackerman (assistant editor)

 1938 *A Survey of Persian Art: From Prehistoric Times to the Present.* Oxford University Press, New York.

Paris Match

 1971 Persepolis: La fête d'un empereur et de son peuple. *Paris Match* 1172, October 23.

Reza Shah, Mohammad

 1975 Interview with Mike Wallace on CBS, cited in *Le Journal de Téhéran*, 11(826), February 6, p. 1.

Said, Edward

 1979 *Orientalism.* Vintage, New York.

Schmidt, Eric

 1939 *The Treasury of Persepolis and Other Discoveries in the Homeland of the Achaemenians.* Oriental Institute Communications 21. University of Chicago Press, Chicago.

 1953 *Persepolis I: Structures, Reliefs, Inscriptions.* University of Chicago Press, Chicago.

1957 *Persepolis II: Contents of the Treasury and Other Discoveries*. University of Chica-
 go Press, Chicago.

1970 *Persepolis III: The Royal Tombs and Other Monuments*. University of Chicago
 Press, Chicago.

Showcross, William

1988 *The Shah's Last Ride: The Fate of an Ally*. Touchstone, New York.

Sontag, Susan

1964 Notes on Camp. In *Against Interpretation: And Other Essays*. Farrar, Straus and
 Giroux, New York.

Trigger, Bruce

1984 Alternative Archaeologies: Nationalist, Colonialist, Imperialist. *Man* 19/3:
 355–70.

US State Department Archives

1929 David Williamson, Dispatch 852, 891.927/43, dated June 10, Tehran.

Zonis, Marvin

1991 *Majestic Failure: The Fall of the Shah*. University of Chicago Press, Chicago.

Section III

Indigenous Voices

In this section, our contributors address the complex interactions that occurred between imperial and colonial archaeologists and the Indigenous populations that inhabited the territories in which the ancient remains of interest were located. The exchanges that resulted were fraught: they occurred at the nexus between "science" and experience. The former term allowed imperial and colonial interlocutors to claim greater expertise and knowledge of these sites (despite their lack of previous interaction with them) than the people who had lived with them for hundreds or thousands of years. Consequently, imperial and colonial archaeologists often asserted not only the right to interpret these sites but also the right to occupy and appropriate them. In addition, they frequently dismissed Indigenous populations as ignorant or unappreciative of their value, banned them from entering or interfering with these locations, or commissioned them to excavate such sites even when, in some cases, they were uncomfortable at disturbing what they understood to be ancestral burial places.

In the first chapter in this section, Chip Colwell chronicles more than a century of Native American participation in archaeology in the American Southwest. While he observes that employment as archaeological laborers has been understood to suggest Indigenous peoples' consent to archaeology, he argues that on closer inspection, it becomes evident that their views of archaeology were and are far more complex. He thus uses this discussion to focus on the economic opportunities that archaeology presented to Native communities starting in the late 1800s. This history of labor relations points to how fieldwork was primarily valued as a source of wage labor in rural, impoverished communities; financial exigency thus

forced many individuals to disturb or violate deep-seated cultural prescriptions against violating the dead. As Colwell notes, this internal debate between jobs and beliefs illustrates a fundamental ambivalence about archaeology, and how it frequently divided communities between those who rejected the science and those who were willing to participate and collude with it for economic opportunity. This history shows colonialism and archaeology not as a simple process of imposition and extraction, but as a long history of an entangled relationship between archaeologists and source communities.

In Chapter 7, Wendy Doyon moves the history of archaeology beyond the analysis of imperialist, colonialist, and nationalist discourses by focusing on archaeological excavations as sites of power in their own right. Against the background of both the history of modern Egypt and the history of Egyptology, she examines the structure and organization of archaeological fieldwork in Egypt during the late nineteenth and early twentieth centuries. Based on archival correspondence, field journals, and archaeological diaries, she argues that archaeology played a major role in Egypt's integration into the modern world economy during this period, and suggests how the social relations of archaeology in the field can provide insights into the relationship between urban and rural societies in a globalized world. She is interested above all in the lived experience of archaeological fieldwork among the rural classes of Egypt, and their relations with archaeologists who, she argues, were closer to the edge of empire than the center. She also discusses the implications of these relationships for the history of archaeology, and, in particular, the importance of global capitalism and labor structures for our understanding of the development of archaeological thought in the twentieth century.

The third chapter in this section by Bonnie Effros addresses the ideological role of archaeology practiced mainly by French military officers during the early decades of the French conquest of Algerian territory and appropriation of the prehistoric and Roman past by French archaeologists in the newly created colony. By focusing on the period between 1830 and 1870, the period when colonial Algeria fell under the authority of the French minister of war and the military governor-general of Algeria, she draws attention to the inherent problems of the traditional telling of the history of classical archaeology in North Africa divorced from the context of the war since those most active in archaeology in this period also served as officers in the Armée d'Afrique. In particular, there was a marked absence of Arab and Berber witnesses from the history of archaeology in Algeria, which is much in contrast to recent studies of Egyptian and Tunisian excavations in roughly the same time period, where it is clear that locals played a much more active role. Given the violent nature of the French conquest, and the way in which documentation was selectively assembled in the French military archives, the lack

of Indigenous voices is not particularly surprising. Namely, they presented an obstacle to the image of the Roman past created by French officers and archaeologists since Arab and Berber villages and encampments offered an alternative interpretation of an enduring legacy. This essay thus explores the mechanisms by which these narratives about the North African past were silenced.

The concluding chapter in this section by Ann McGrath explores the crucial significance of discovery narratives as imperial and scientific tropes. The case of the cremation/burial of a woman who lived in Australia over 40,000 years ago, known by the Aboriginal people as Lady Mungo, provides an opportunity to consider the colonizing play of archaeology after her remains came to the surface in the 1960s. This story reveals the ways in which Aboriginal Australians have used archaeology to negotiate a place in Australian history both inside and outside modern discovery-based science. McGrath argues that inclusion of Indigenous voices in discovery narratives is logically problematic, if not impossible. She also suggests that certain repatriation initiatives that pass as decolonizing gestures potentially serve as new strategies for asserting discoverer identities. Discovery, heroic and scientific, is implicated in powerful reassertions of colonial and imperial sovereignty, and continues to be implicated in modernity's claims to colonial entitlement in contemporary nation-states.

CHAPTER 6

The Entanglement of Native Americans and Colonialist Archaeology in the Southwestern United States

Chip Colwell

INTRODUCTION

In recent years, Native Americans and archaeologists have begun to imagine a future in which Indigenous and scientific values, perspectives, and practices are brought together on equal terms to create new understandings of the material past. A key element of this forward-looking, post-colonial project is to understand the social context of archaeological practices, and specifically how archaeology operates within the historical legacy of colonialism (Atalay 2008; McGuire 1992; McNiven and Russell 2005; Preucel and Cipolla 2008). As Bruce G. Trigger (1984) so convincingly argued, colonialism is intimately bound to nationalism and imperialism, but presents a unique form of archaeology because it most basically operates in places where Native populations have been overrun by European migrants. Trigger went on to suggest that colonial archaeology is different because "[w]hile the colonisers had every reason to glorify their own past, they had no reason to extol the past of the peoples they were subjugating and supplanting" (1984: 360). He then described how the colonizers ultimately could define themselves as superior by rendering Native peoples as primitive, stagnant, and savage. Colonialist archaeologies defined the science in Canada, Australia, New Zealand, Zimbabwe, and beyond, but the "oldest and most complex example" of this type of archaeology, Trigger (1984: 360) wrote, is the United States.

One element of the history of colonial archaeology in the United States that makes it especially complicated—but has often gone unanalyzed—has been the participation of Native Americans. The collusion of Native peoples in colonialist

archaeology encourages us to reframe colonialism as a means of simple imposi-
tion and extraction to a history of entangled relationships between archaeologists
and source communities. Following from how Nicholas Thomas (1991) has
described how objects become entangled in colonial exchanges, I use "entangled"
here to point to how the science of archaeology over time has become less
imposed and more shaped by both Euro-American scholars and Native Ameri-
can participants. I suggest that through Native involvement archaeology is not a
fixed practice, but a fluid one with a shifting sense of social and moral purpose.

The goal of this chapter is to historically situate Native American rejection
of and participation in colonialist archaeology in the Southwestern United
States. I begin by looking at the first colonialist visions of Native American his-
tory in the Southwest, and then move on to the earliest scientific archaeological
expeditions in Arizona and New Mexico. As I demonstrate through a series of
stories and vignettes, Native American reactions ranged from acquiescence to
resistance. In the conclusion, I look at the field's longer historical trajectory and
how into the twenty-first century, colonialist frameworks began to collapse. I
point to several key ethical and methodological approaches that may enable the
final emergence of a post-colonial practice.

Because of the US Southwest's very long and evolving colonial context, it
presents an excellent region in which to consider colonialism and archaeology as
an entangled, fluctuating relationship between descendant communities and
archaeologists. The Southwest also presents an especially important case
study—particularly by the time scientific archaeology emerges as a formal prac-
tice in the late 1800s—of what can be termed "internal colonialism," in which
domination is not geographically situated at a core and periphery, but takes place
within a single national setting (Hechter 1975). Although competition between
local actors and more powerful institutions located on the East Coast definitive-
ly shaped Southwestern archaeology (Snead 2001), the emerging discipline's
relationship to Native America was not dramatically shaped by this East–West
tug-of-war. Rather, the Southwest provides a case study of how Native commu-
nities navigated the problems and opportunities archaeology created.

On the one hand, Native Americans largely viewed archaeology as negative
because its practices violated their cultural values, particularly beliefs surround-
ing the dead. On the other hand, archaeology provided Native Americans with
needed employment during a period in which they had shifted to the cash econ-
omy and yet lacked access to the job market. Given these two reactions, it might
be tempting to view them as the emergence of two forms of archaeology—one
colonial (where Native peoples reject archaeology) and one a nascent post-colo-
nial archaeology (where Native peoples themselves are archaeologists). However,

drawing on and recapping my previous work (Colwell-Chanthaphonh 2010), in this chapter I argue that both are forms of colonialist archaeology, because they proceeded as an extractive process that unfolded irrespective of Native American concerns or interests. In the case of clear conflict, archaeologists were occasionally stopped but just as often proceeded without having to fully address Native concerns. In the case of collusion, Native laborers mainly (and merely) provided the means by which professional archaeologists could more productively extract historical resources. In other words, the simple inclusion of Native peoples does not make archaeology post-colonial but requires fundamental transformations of archaeology's politics, ethics, and practices. Importantly, this chapter tracks this phenomenon in the Southwest; it can also be tracked in other regions and contexts, such as early twentieth-century archaeology in the Northeastern United States (Colwell-Chanthaphonh 2009). More broadly, post-colonial theory grew out of non-US contexts (Said 1978), and continues to have broad implications for archaeology around the globe (Benavides 2009; Liebmann and Rizvi 2008; Lilley 2000).

For nearly a century, then, archaeology in the American Southwest was colonialist—largely proceeding whether Native Americans objected to it or participated in it. Not until the 1970s, after a period of intense political pressure and a shifting legislative mandate, did archaeologists finally begin to address Native American values and viewpoints meaningfully. It would still be another several decades until Native Americans who wanted to participate in archaeology could change their role from collusion to collaboration. This history is a vital reminder of how long colonialist archaeology dominated the American Southwest, why change took place, and how far we still have to go to move to a post-colonial archaeology.

COLONIALISM AND THE ARRIVAL OF ARCHAEOLOGY

In 1519, Hernán Cortés conquered the Aztecs. The colonizers soon turned their attention to the mysterious northern frontier of Spain's budding empire. The riches discovered in the Aztec capital of Tenochitlán and elsewhere spurred fantasies of untold treasures to be found throughout the Americas (Thomas 2003). From Mexico City, both Cortez and his rival Nuño Beltrán de Guzmán pushed the Spanish realm northward as rumors swelled about unclaimed fortunes. In 1539, in search for the Seven Cities of Gold, the priest Marcos de Niza and the Moor slave Esteban (or Estevanico), led by Native guides, purportedly reached the Pueblo of Zuni in what is today northwestern New Mexico. The next year Francisco Vázquez de Coronado led a convoy of six hundred soldiers and Indian

allies, and a thousand slaves into the unknown north (Flint and Flint 2003). His expedition eventually arrived at the Zuni pueblo of Hawikku; contingents then explored westward to the Grand Canyon and eastward onto the Plains. During this journey, Coronado and his chroniclers often remarked on the presence of ruins—significant because even from the first European intrusion into this land, its ancient history was seen as an indelible part of it (McGregor 1941: 28).

In the centuries that followed, European travelers often noted and commented on the American Southwest's evident antiquity. In the 1850s, once the United States claimed and settled its Southwestern corner, the region's archaeological heritage was identified as a key resource for building the young nation's identity (Fowler 2000)—the beginnings of what Trigger would term a colonialist archaeology. In 1892, Casa Grande—a large Hohokam village south of Phoenix, Arizona dating from about CE 400–1450—was among the first archaeological sites the US government formally protected (Doelle 2010) (Fig. 6.1). When the Antiquities Act of 1906 became US law, which empowered the president to set aside important places of nature and culture, nine of the first ten national monuments created were in the American Southwest (Harmon et al. 2006).

Paradoxically, just as the US government was protecting Native American heritage for the benefit of the nation, it was concluding its project of genocide to annihilate Native American peoples and cultures (Brown 1970). In 1890, the

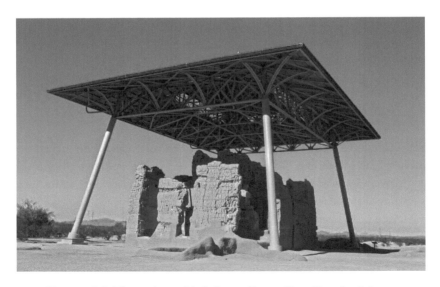

FIGURE 6.1. The main pueblo left standing at Casa Grande, Arizona.
Photo by Matt Peeples, Creative Commons Flickr.

Indian Wars ended with every Native American nation exterminated, assimilated, or confined to reservations controlled by the US government. By then, the population of Native Americans, once numbering in the millions, had been reduced to 250,000 people (Thornton 1987). In the early 1900s, just as archaeology was being celebrated as a new science to preserve and interpret the Native American past, living Native Americans were being forced to assimilate through programs that fundamentally sought to alter their political and social organization, languages, religions, and ways of life (Stannard 1992). In the US Southwest, although dozens of tribes had survived the waves of colonial settlers, by the 1900s their lives were greatly circumscribed by the territorial and then state and federal governments, which collectively controlled key resources, such as water, land, and educational institutions (DeJong 2004; Hoerig 2002; Sheridan 2006). In Arizona and New Mexico, Native peoples lived on reservations—all of them much smaller than their traditional land bases—but had little control over their own lives; the US government continued to undermine tribal sovereignty and attempted to control nearly every aspect of Native American culture and economy (Hagan 1988; Kelly 1988; Wilkens and Lomawaima 2002).

Into this complex political and cultural milieu—centuries of colonialism and conquest—the new science of archaeology arrived (Trigger 1989). Archaeology required, most basically, digging into the earth, as the excavation of ancient sites required moving mountains of dirt. The most ready supply of labor in the Southwest to aid in this work was nearby Native American communities. As a result, many of the first excavations involved Native Americans, even though they worked on the periphery as silent laborers, without any influence in the process of unearthing the ancestors of their own homelands.

Chaco Canyon, located in northwestern New Mexico, has a long history of Native laborers (Fig. 6.2). As early as 1896, during the Hyde expedition, about one hundred Navajo and Zuni laborers were hired (Elliott 1995: 104; Fowler 2000: 196). It is unrecorded how these first Native American archaeologists balanced their new trade with traditional taboos about disturbing the dead. As H. Barry Holt has written of the Navajo traditions:

> Looking upon the corpse of an animal or human, failing to conduct a proper burial, or disturbing a grave can provoke supernatural retribution.... As a result, some degree of fear of the dead and ghosts is ever-present within Navajo communities. Because Anasazi ruins [like Chaco Canyon] are burial places of enemies, or sometimes ancestors, any disturbance of them will antagonize the inhabiting spirits, which will result in retribution. In the same vein, all who view bones exposed from the unearthing of a prehistoric burial become vulnerable to "ghost sickness" (Holt 1983: 596).

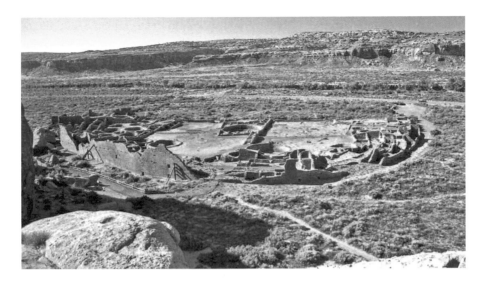

FIGURE **6.2.** Pueblo Bonito at Chaco Canyon, New Mexico.
Photo by mksfca, Creative Commons Flickr.

Nevertheless, when Niel M. Judd began his efforts at Chaco Canyon, he
again was able to hire several dozen Navajos, as well as Zunis (Elliott 1995: 114).
The Navajos would commute daily from surrounding areas, while the Zunis
traveled weekly from the reservation and camped at the edge of the excavations.

Between 1917 and 1923, about forty Zuni men were also hired as laborers
during the Hendricks-Hodge expedition, at the historic pueblo of Hawikku on
the Zuni reservation (Fig. 6.3). The men, it seems, mainly sought this work
because of the economic opportunity, a rare chance at wage labor on the rural
reservation. Melinda Elliott has noted that "[t]he Zunis took a serious interest in
the excavations, and they considered some of the artifacts important enough that
their medicine men came to see them" (Elliott 1995: 88). However, these visits
were likely less inspired by curiosity than by concerns about the dangerous power
of ancient places. Anthropologist Ruth Bunzel is quoted as telling her colleague
Triloki Nath Pandey that the "excavation aroused 'a good deal of discomfort at
Zuni, with their feelings about the contamination of the dead, their fear of ruins,
etc.' The conservative people of the pueblo, particularly, were opposed to the
excavation" (Pandey 1972: 331).

Pandey explains further that the excavation sowed hostility between two fac-
tions at Zuni. A Protestant faction supported Hodge and so the archaeologist
did not hire anyone from the Catholic faction. Hodge had already become deeply
involved in Zuni politics, distributing silver medals and decorative canes to Zuni

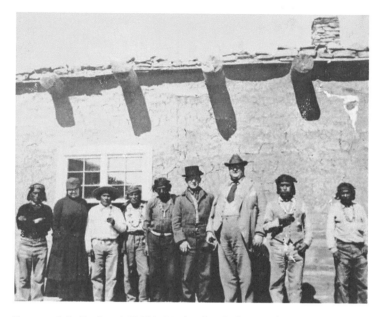

FIGURE **6.3.** Frederick Webb Hodge (sixth from left) and George Gustav Heye (seventh from left) pose with Zunis. Photo courtesy of the Smithsonian, Wikimedia Commons.

leaders as if he was an ambassador rather than a researcher, and interceding with an Indian agent about land disputes and the local government's functioning (Martinez and Wyaco 1998: 99, 104). The anger between these factions boiled over in 1923 when Hodge sought to film a series of ceremonials (Hodge 1924; Lucic and Bernstein 2008: 18; Miller 2007: 97).

> Many conservative Zunis were upset by the filming, especially of the cere-
> monies.... [W]hen Hodge's staff attempted to film the Shalako ceremony, many
> Zunis objected, and the priests confiscated the camera and film in a highly
> charged confrontation (Fowler 2000: 304).

Nine Zuni priests and tribal leaders, with a high priest named Seowtewa as spokesman, insisted that the excavations and other anthropological activities cease. On December 29, 1923, they wrote to the Commissioner of Indian Affairs:

> Please ask "Washington" ... to have no more confusion among us caused by
> white intruders excavating our dead ancestors, taking movies of our ceremoni-
> al dances, etc.... We are truthfully telling you that more than one-half of the
> Indians of Zuni join us in what we are telling you (Colwell-Chanthaphonh
> 2010: 69).

Less controversy faced the archaeologists at Snaketown, a massive Hohokam village outside Phoenix in southern Arizona. Excavated in 1934 by Harold Gladwin's Gila Pueblo Foundation, around twenty-five Akimel O'odham (Pima) were hired as laborers. Gladwin fondly recalled:

> We place the Pima in a class by themselves; they work harder, are more careful, and have a greater interest in their work, than any other people we have used. We regard many of them as personal friends (Elliott 1995: 143–144).

Emil Haury later said how the O'odham used to tell him stories about the site and their history—although he largely ignored these narratives in his scientific interpretations—and that they had their own names for the places being excavated (Elliott 1995: 144). "Bat Man's Dancing Place" was the name of Snaketown's colossal ball court. When Haury returned to Snaketown for additional research three decades later, more than twenty O'odham men returned to participate in the excavations.

Native Americans were specifically targeted for recruitment as part of Great Depression economic programs. While many Native Americans joined the Civilian Conservation Corps, a special CCC-Indian Division was also established (Hinton and Green 2008: 7). In 1933, Congress approved $6 million to establish seventy-two Indian camps on thirty-three reservations, mostly in the American Southwest (Hinton and Green 2008: 221–51). Enrollees were paid $1.50 a day and undertook 126 different project types, ranging from archaeological stabilization to building roads and trails providing access to remote sites, such as in Canyon de Chelly and Navajo National Monument. An all-Navajo CCC crew worked at Chaco Canyon National Monument, stabilizing and repairing structures (Hinton and Green 2008: 129).

In the 1930s, the Hopi in Arizona had their chance to participate in archaeology when the site of Awat'ovi was excavated. Awat'ovi was a Keresan pueblo constructed in the early 1200s CE on Antelope Mesa, just east of the modern-day Hopi villages (Brooks 2016). In 1629, Franciscan priests began building a church there. The pueblo's men and women were mistreated, and forced to convert to Christianity. Spanish oppression led to the Pueblo Revolt, when Awat'ovi villagers killed the priests and destroyed the church. During the Spanish reconquest, the church was rebuilt in 1700. But by the autumn, Hopis killed the priests and the pueblo's converts. No one ever lived in the village again.

Between 1935 and 1939, an archaeological expedition led by Harvard University's Peabody Museum hired around thirty Hopis as laborers (Davis 2008: 50; Smith 1984: 131, 172). Of these men, fifteen each were from First and Second Mesa, as a matter of diplomacy to avoid antagonizing either mesa. (Third

Mesa was considered too far away.) The project's director J. O. Brew wrote in 1935 that while they had no formal training, the Hopis were so

> familiar with the materials of the ancient constructions that they recognized plastered walls, adobe floors, etc., immediately.... They have sharp eyes, too, attested by the number of tiny square and other shaped pieces of turquoise we are getting which seem to have dropped out of turquoise mosaics (Davis 2008: 29).

Relations between the Anglo crew and the Hopi laborers seem to have been generally good: they got on together well, most of the laborers returned each year, and genuine friendships were formed (Davis 2008: 112–14, 120; Smith 1984: 169). Brew was especially respectful of Hopis' need to attend to business at home and their religious responsibilities. In turn, Brew was warmly received by Hopi families on the mesas. The excavations sparked an interest among Hopis, as, for example, First Mesa potters visited the site to see the old pottery and study books in the field camp that were used for inspiration for their own ceramic designs (Smith 1984: 170). Still, according to Hester Davis's recent history of the excavation:

> Brew's letter and journal say that he felt the [Hopi] men enjoyed the work, but ... some of the men were wary of digging at Awatovi.... "My dad always said he knew it was wrong [to dig there]," one man told me, "but he needed the money to feed his family" (Davis 2008: 51).

COLONIALISM AND RESISTANCE TO ARCHAEOLOGY

Native Americans were wary of digging in ancient places for four key reasons: many believed old places should be left untouched, few if any considered the excavation of graves acceptable, they believed that many archaeological sites are sacred, and they were generally mystified as to why outsiders needed to harm ancient places to understand them.

In 1907, the ambitious archaeologist Edgar L. Hewett decided to excavate Puyé, a pueblo on the Santa Clara reservation (Fig. 6.4). Hewett and his colleagues put fourteen Native Americans on the payroll. As James E. Snead recounts,

> Despite the fact that the project [at Puyé] represented needed income, concern over the handling of antiquities was evident among both the laborers themselves and the authorities at Santa Clara Pueblo. Puyé was an important ancestral site to the Santa Clara people.... On the fourth day of excavations a delegation from the pueblo visited the ruin to, in Morley's words, "protest against

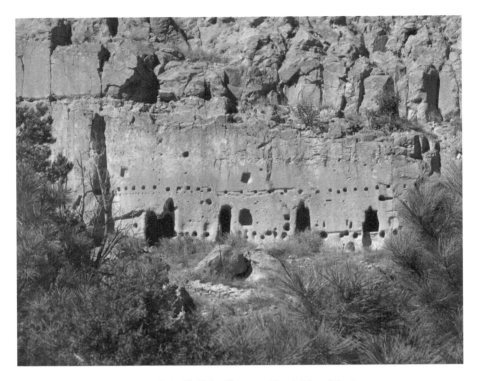

FIGURE 6.4. Cliff dwellings at Puyé, New Mexico.
Photo by Joseph j7uy5, Creative Commons Flickr.

our digging on their land," but Hewett managed to dissuade them from taking further action (2001: 88–89).

Snead continues:

> Excavations in the ruins were also disturbing to the local Tewa people because of cultural prohibitions concerning the dead. Folktales recorded by anthropologist Elsie Clews Parsons in the 1920s referred to people dying after digging up burials at Puyé.... Despite this underlying unease about the project and what it represented, cash wages proved sufficient enticement to maintain a workforce (2001: 89).

Similar concerns about illness caused by the dead would be a common theme in archaeology's early years. For example, a Ute man named Wap objected to the first excavations at Mesa Verde in southwestern Colorado, arguing that the excavation of Hopis' bodies made Utes sick (Chapin 1988: 117). During Alexander M. Stephen's explorations in Arizona's Canyon de Chelly in 1883, one of his

colleagues reported that as he looked down into a grave, "'George,' our chief [Navajo] guide, rode up and with an anxious manner called to me to come away saying 'kille! kille!' meaning that the dead lay there and my proximity was fraught with great danger" (Hieb 2009: 42–43).

In 1942, Tohono O'odham elders refused to grant permission for excavations at the cave site of Wihomki, "on the grounds that Lightning lived in this cave, that it was a sacred place and should not be touched" (Haury 1950: 44). Julian D. Hayden related the cave's power and danger as follows:

> The old men said further that the cave was sacred to them, that in the oldest man's memory of the oldest men, it was sacred, and that they were afraid that if the cave were molested trouble would come to the people of the Kaka district—not to us white men of different race and religion, but to them.... The spokesman of the group thanked us for consulting their wishes before we began to dig, and said that the people appreciated being consulted, but that they could not allow it (Hayden 1977: 32).

When archaeology came to the Hopi Mesas, Hopi participation was initially uneven. The Smithsonian's Jesse Walter Fewkes observed that "[t]he Hopi, like many other Indians, will not touch human bones, but showed no serious objection to excavating in the ancient cemeteries" (Fewkes 1895: 279). In 1887, Hopis reportedly helped a trader and collector named Thomas V. Keam excavate at Old Songòopavi, but then nine years later, when Fewkes attempted to do work at this site, he met a different result (quotes and details of this story are from Fewkes 1904: 112; Hieb 2009: 42–43). Fewkes hired twenty Hopis from First Mesa and a few from the village of Songòopavi on Second Mesa; in the first two days they removed more than one hundred burials. But then on the evening of the second day, Nacihiptewa, the Songòopavi chief, went to the Hopis' camp and forbade them from excavating. Fewkes met with leaders from all the Second Mesa villages hoping to assuage their concerns. But Nacihiptewa insisted that "he did not want the work to go on, fearing that it would cause great winds which would drive away the rain clouds." Fewkes stopped the work. Fewkes then turned to Sikyatki, an ancient village near First Mesa, but he was met with similar ambivalence. Fewkes later wrote:

> I employed [Hopi] Indian workmen at the ruin, and found them, as a rule, efficient helpers. The zeal which they manifested at the beginning of the work did not flag, but it must be confessed that toward the close of the excavations it became necessary to incite their enthusiasm by prizes, and, to them, extraordinary offers of overalls and calico. They at first objected to working in the cemeteries, regarding it as a desecration of the dead, but several of their number

overcame their scruples, even handling skulls and other parts of skeletons. The Snake chief, Kopeli, however, never worked with the others, desiring not to dig in the graves. Respecting his feelings, I allotted him the special task of excavating the rooms of the acropolis, which he performed with much care, showing great interest in the results. At the close of our daily work, prayer-offerings were placed in the trenches by the Indian workmen, as conciliatory sacrifices to Masauwûh, the dread God of Death, to offset any malign influence which might result from our desecration of his domain. A superstitious feeling that this god was not congenial to the work which was going on, seemed always to haunt the minds of the laborers, and once or twice I was admonished by old men, visitors from [the First Mesa village of] Walpi, not to persist in my excavations. The excavators, at times, paused in their work and called my attention to strange voices echoing from the cliffs, which they ascribed, half in earnest, to Masauwûh (Fewkes 1898: 641).

At Awat'ovi, Fewkes had experienced the same reaction. In 1892, he started digging there to test the validity of Hopi stories about the pueblo's infamous demise, but he was forced to stop "because the Hopi men who worked for him appeared upset at finding the bones" (Davis 2008: 11). He nevertheless resumed his excavations there three years later. The next year, when some sacred Hopi materials were exhibited at the World's Columbian Exposition, "the Hopis reacted strongly against this sacrilege" (Spicer 1962: 203).

In the 1930s, when Harvard's Peabody Museum sought to excavate Awat'ovi and a site named Kawàyka'a, it received permission from US government agents and Badger Clan leaders from the Second Mesa village of Musangnuvi. However, Awat'ovi was under the authority of Tobacco Clan leaders—not those of the Badger Clan. Many Hopis felt that the old pueblo should not be disturbed. As Eric Polingyouma explains:

> the excavation of Awat'ovi created a lot of opposition among Hopis. A destroyed village is a dead village. It is buried and should not be disturbed. Many bad events happened there, and bad memories should not be revived (Polingyouma 2008: xvii).

Despite some opposition to the excavations, Hopi men from the First Mesa village of Walpi and Musangnuvi participated as laborers.

When the archaeologists sought to extend their excavation permit in 1939, they ran into trouble. Prior to the Indian Reorganization Act (IRA) of 1934, tribes had little voice in the federal permit process for archaeological research. To receive a permit to dig on Indian lands, archaeologists only had to deal with non-Indian government officials. But with the passage of the IRA, tribes could estab-

lish constitutions and local governments, which would have direct input into the permit process, and so "the days when archaeologists could dig almost anywhere they wished were about to end. Researchers were going to have to become more accountable to the people whose ancestors they were studying" (Davis 2008: 26). By 1939, the Hopi had organized under the IRA, and when the Harvard archaeologists sought to extend their permit they "found that the Hopi Council did not want to act on a request for further excavation until it was clear which clan had jurisdiction over the work at Awatovi" (Davis 2008: 147).

The archaeologists tended to explain the permit problem exclusively as an internal battle between the Badger Clan and Tobacco Clan (Smith 1984: 172–73). Luke Kawanusea, a Badger Clan leader from Musangnuvi, gave his express support for the expedition, while Tobacco Clan leaders at Walpi, with the backing of other villages, refused to grant permission. In May, the US government acknowledged that the Hopi had jurisdiction over permits for excavation on their reservation, and without support from the newly formed Hopi tribal council, denied approval.

While not dismissing Hopi rights, the archaeologists had erroneously assumed that "tact and wages" would convince the Hopis that the project was worthwhile (Davis 2008: 26). Polingyouma, in fact, emphasizes that the archaeologists did not include all Hopis in decisions but only a small portion that offered support, did not acknowledge Hopi authority and roles as caretakers and owners of the land, and did not intend to share results openly with Hopis; instead, they pursued a permit through the Antiquities Act, dealt primarily with government agents, and focused on a distant academic audience on the East Coast (Polingyouma 2008: xvii). By emphasizing the disagreement between clans, the archaeologists further ignored fundamental questions about archaeology's purpose and what value it might offer to Native Americans. As one Hopi said in objection to the expedition,

> What good does it do to dig there? ... If it were on some other mesa, where no one was living, we might feel differently. But we are still alive. Our civilization is not dead. They are digging up our ancestors and they are touching things we have said shall not be touched (Davis 2008: 147–48).

Ironically, while Hopi concerns about the dead left the archaeologists unmoved, they promptly responded to non-Indian concerns about burials. The Indian bodies excavated at Awat'ovi were taken to the Peabody Museum in Cambridge. But when a Caucasian skeleton was discovered—presumably the remains of one of the murdered priests—arrangements were made to have the body immediately sent to Tucson for reburial beneath a cathedral. This kind of

agreement was not limited to Awat'ovi; the remains of European priests excavated in the 1930s at Tumacácori in southern Arizona were similarly reburied with due respect (Colwell-Chanthaphonh 2010: 79). "Harvard will be willing to cooperate with the Church in making the best disposal of any European skeletons we find," Brew wrote to Catholic authorities (Davis 2008: 132). The archaeologists agreed to return any bones of a "European physical type" to the Franciscan Order; in contrast, the Hopi would not have any say about their ancestors' reburial for another fifty years (Davis 2008: 133, 189). This agreement reveals much about the unequal power structure of twentieth-century colonialist archaeology, in which the interests and values of Native Americans could be so easily dismissed.

CONCLUSION

How could archaeologists systematically ignore Native interests and values for so long? How did the Navajo, Zuni, O'odham, Hopi, and other Southwestern groups respond to their lack of power? And what mechanisms need to be in place to shift these power assymetries, to remake colonialist archaeology into a post-colonialist science?

One reason for the delay in recognizing Native American values and rights is that legal instruments in the United States were developed to empower archaeologists to become the nation's stewards of its ancient past. Beginning with the Antiquities Act of 1906, only those with academic credentials and the institutional backing of museums could receive permits to excavate sites on private lands (Colwell-Chanthaphonh 2005; McLaughlin 1998a, 1998b). At the same time, unlike other countries that nationalized all heritage sites irrespective of land tenure, US law left archaeological sites on private land unmanaged and unprotected, thus further divorcing Native peoples from potential rights to ancestral places. Another key reason was late nineteenth- and early twentieth-century Indian policy. Although the IRA sought to enliven American Indian sovereignty, most federal policies sought to extinguish Native American culture. From the Dawes Act of 1887 to the Termination policies that did not end until the late 1960s, few government efforts actively sustained or reinforced Indian rights to their culture and history (Deloria 1985).

Furthermore, for most of the twentieth century, archaeology's emergent sense of professional ethics largely revolved around accountability to places rather than people—the need to preserve intangible sites rather than living cultures. Where archaeological ethics did address people, they largely focused on the responsibility of professionals to one another instead of to the myriad publics

invested in America's past (Wildesen 1984). The archaeological profession developed into an exclusive "moral community" that gained disproportionate power and resources by defining its role as the ultimate arbiter of the nation's heritage through its scientific practices and management strategies (Colwell-Chanthaphonh 2009: 164). This is not to say that Native Americans were mere tools of US internal colonialism, with no choice or zero agency. But it is clear that they often lacked power to exert their rights, and when they did have the chance to exert them, they often framed archaeology as antagonistic to their cultural values. Some clearly did embrace the economic opportunities archaeology afforded, and no doubt used the discipline to their own advantage. It is also possible (even if not documented) that aside from the issue of digging burials, some did genuinely enjoy the work, perhaps learning about this emerging science and the different window into their past it provided.

In the 1970s, the legacy of colonialist archaeology began to significantly change. Federal laws began to emphasize the rights of Native Americans to help manage their heritage, first with the American Indian Religious Freedom Act (1978), and then the National Museum of the American Indian Act (1989), Native American Graves Protection and Repatriation Act (1990), and amendments in 1992 to the National Historic Preservation Act, which established Tribal Historic Preservation Offices and explicitly made traditional cultural properties eligible for the National Register of Historic Places (Stapp and Burney 2002). As significantly, with the end of Termination policies—a policy implemented from the 1940s to the 1960s, which sought effectively to assimilate Indians into mainstream American society—the US government now emphasized sovereignty and self-governance (Burt 2008). No longer did the US government see one of its roles as undermining Native cultures (Cornell 1988). At the same time, the model of professional archaeology began to shift. Cultural resource management (CRM) and public archaeology grew to be the largest segments of the profession—archaeologists now understood their role to be in the service of the public (McGimsey 1972; McManamon 1991; Potter 1994). The rise of the CRM industry also encouraged tribes to take advantage of the economic opportunities presented by the new field, and also use this work as a way to assert tribal sovereignty. The Pueblo of Zuni was the first to create its own archaeology program in 1975 (Ferguson 1984). Dozens of tribes would follow (Anyon et al. 2000).

Whereas the Society for American Archaeology's (SAA) first major statement of ethics in 1961 emphasized inward accountability to other professionals and scientific methods (Champe et al. 1961), the SAA's revised principles finalized in 1996 looked outward (Lynott and Wylie 1995). The SAA's ethics emphasize

archaeologists' responsibility as stewards to protect archaeological resources. Public education and public reporting are also outlined as explicit principles. But the SAA equally outlines archaeologists' accountability to "affected groups" and the need to establish "a working relationship that can be beneficial to all parties involved" (Watkins et al. 1995: 33).

The end of archaeology built on colonial power structures has ushered in the emergence of collaborative archaeology. Many archaeologists now fully grapple with how archaeological places and objects are not mere tools of science, but tangible expressions of culture to which many descendant communities attach their sense of identity, belonging, and spirituality (Colwell and Joy 2015; Meskell 2009; Nicholas et al. 2011). Many archaeologists now fully acknowledge how their discipline is not practiced in a social vacuum, but impacts living people. Although pursued under various banners—Indigenous archaeology, tribal archaeology, covenantal archaeology—its heart is the methodology of collaboration, which provides a mechanism to approach past inequalities and shape new forms of accountability (Atalay 2012; Colwell-Chanthaphonh and Ferguson 2008; Kerber 2006; Silliman 2008). This shift is leading to positive changes (such as novel epistemological insights) and new challenges (such as which methods actually equalize relationships), but ultimately it is creating new forms of accountability that are altering the political economy of the discipline (Colwell-Chanthaphonh et al. 2010; Croes 2010; Silliman 2010). These features of twenty-first–century archaeology—seeing archaeology as heritage, acknowledging archaeology's effects, and new forms of accountability—are key to reshaping the discipline of archaeology beyond its colonial roots.

REFERENCES CITED

Anyon, Roger, T. J. Ferguson, and John R. Welch
 2000 Heritage Management by American Indian Tribes in the Southwestern United States. In *Cultural Resource Management in Contemporary Society: Perspectives on Managing and Presenting the Past*, edited by Francis P. McManamon and Alf Hatton, pp. 120–41. Routledge, London.

Atalay, Sonya
 2008 Multivocality and Indigenous Archaeologies. In *Evaluating Multiple Narratives: Beyond Nationalist, Colonialist, and Imperialist Archaeologies*, edited by Junko Habu, Claire Fawcett, and John M. Matsunaga, pp. 29–44. Springer, New York.

 2012 *Community-Based Archaeology: Research With, By, and For Indigenous and Local Communities.* University of California Press, Berkeley.

Benavides, O. Hugo

2009 Disciplining the Past, Policing the Present: The Postcolonial Landscape of Ecuadorian Nostalgia. *Archaeologies* 5(1): 134–60.

Brooks, James F.

2016 *Mesa of Sorrows: A History of the Awat'ovi Massacre.* W.W. Norton, New York.

Brown, Dee

1970 *Bury My Heart at Wounded Knee: An Indian History of the American West.* Bantam Books, New York.

Burt, Larry W.

2008 Termination and Relocation. In *Handbook of North American Indians*, Vol. 2, edited by Garrick A. Bailey, pp. 19–27. Smithsonian Institution, Washington, DC.

Champe, John L., Douglas S. Byers, Clifford Evans, A. K. Guthe, et al.

1961 Four Statements for Archaeology. *American Antiquity* 27(2): 137–38.

Chapin, Frederick H.

1988 *Land of the Cliff-Dwellers.* University of Arizona Press, Tucson.

Colwell-Chanthaphonh, Chip

2005 The Incorporation of the Native American Past: Cultural Extermination, Archaeological Protection, and the Antiquities Act of 1906. *International Journal of Cultural Property* 12(3): 375–91.

2009 *Inheriting the Past: The Making of Arthur C. Parker and Indigenous Archaeology.* University of Arizona Press, Tucson.

2010 *Living Histories: Native Americans and Southwestern Archaeology.* AltaMira Press, Lanham, MD.

Colwell-Chanthaphonh, Chip, and T. J. Ferguson (editors)

2008 *Collaboration in Archaeological Practice: Engaging Descendant Communities.* AltaMira Press, Lanham, MD.

Colwell-Chanthaphonh, Chip, T. J. Ferguson, Dorothy Lippert, Randall H. McGuire, et al.

2010 The Premise and Promise of Indigenous Archaeology. *American Antiquity* 75(2): 228–38.

Colwell, Chip, and Charlotte Joy

2015 Communities and Ethics in Heritage Debates. In *Global Heritage: A Reader*, edited by Lynn Meskell, pp. 112–30. Wiley-Blackwell, Malden, MA.

Cornell, Stephen

1988 *The Return of the Native: American Indian Political Resurgence.* Oxford University Press, New York.

Croes, Dale R.

2010 Courage and Thoughtful Scholarship = Indigenous Archaeology Partnerships. *American Antiquity* 75(2): 211–16.

Davis, Hester A.

 2008 *Remembering Awatovi: The Story of an Archaeological Expedition in Northern Arizona, 1935–1939*. Peabody Museum Press, Cambridge.

DeJong, David H.

 2004 Forced to Abandon Their Farms: Water Deprivation and Starvation among the Gila River Pima, 1892–1904. *American Indian Culture and Research Journal* 28(3): 29–56.

Deloria, Vine, Jr.

 1985 *American Indian Policy in the Twentieth Century*. University of Oklahoma Press, Norman.

Doelle, William H.

 2010 Hohokam Heritage: The Casa Grande Community. *Archaeology Southwest* 23(4): 1–4.

Elliott, Melinda

 1995 *Great Excavations: Tales of Early Southwestern Archaeology, 1888–1939*. School of American Research Press, Santa Fe.

Ferguson, T. J.

 1984 Archaeological Values in a Tribal Cultural Resource Management Program at the Pueblo of Zuni. In *Ethics and Values in Archaeology*, edited by Ernestene L. Green, pp. 224–235. Free Press, New York.

Fewkes, J. Walter

 1895 The Oraibi Flute Altar. *Journal of American Folk-Lore* 8(31): 265–84.

 1898 Archaeological Expedition to Arizona in 1895. In *Seventeenth Annual Report of the Bureau of American Ethnology for the Years 1895–1896*, pp. 527–742. Government Printing Office, Washington, DC.

 1904 Two Summers' Work in Pueblo Ruins. In *Twenty-Second Annual Report of the Bureau of American Ethnology for the Years 1900–1901*, pp. 3–195. Government Printing Office, Washington, DC.

Flint, Richard, and Shirley C. Flint (editors)

 2003 *The Coronado Expedition: From the Distance of 460 Years*. University of New Mexico Press, Albuquerque.

Fowler, Don D.

 2000 *A Laboratory for Anthropology: Science and Romanticism in the American Southwest, 1846–1930*. University of New Mexico Press, Albuquerque.

Hagan, William T.

 1988 United States Indian Policies, 1860–1900. In *Handbook of North American Indians*, Vol. 4, edited by Wilcomb E. Washburn, pp. 51–65. Smithsonian Institution, Washington, D.C.

Harmon, David, Francis P. McManamon, and Dwight T. Pitcaithley (editors)
 2006 *The Antiquities Act: A Century of American Archaeology, Historic Preservation, and Nature Conservation.* University of Arizona Press, Tucson.

Haury, Emil W.
 1950 *The Stratigraphy and Archaeology of Ventana Cave.* University of Arizona Press, Tucson.

Hayden, Julian
 1977 Wihom-ki. *The Kiva* 43(1): 31–35.

Hechter, Michael
 1975 *Internal Colonialism: The Celtic Fringe in British National Development, 1536–1966.* University of California Press, Berkeley.

Hieb, Louis A.
 2009 Ben Wittick and the Keam Pottery Collection. *American Indian Art Magazine* 34(3): 38–49.

Hinton, Wayne K., and Elizabeth A. Green
 2008 *With Picks, Shovels, and Hope: The CCC and Its Legacy on the Colorado Plateau.* Mountain Press Publishing, Missoula.

Hodge, Frederick W.
 1924 Motion-Pictures at Zuni. *Indian Notes* 1: 29–30.

Hoerig, Karl A.
 2002 Remembering Our Indian School Days: The Boarding School Experience. *American Anthropologist* 104(2): 642–46.

Holt, H. Barry
 1983 A Cultural Resource Management Dilemma: Anasazi Ruins and the Navajos. *American Antiquity* 48(3): 594–99.

Kelly, Lawrence C.
 1988 United States Indian Policies, 1900–1980. In *Handbook of North American Indians*, Vol. 4, edited by Wilcomb E. Washburn, pp. 66–80. Smithsonian Institution, Washington, D.C.

Kerber, Jordan E. (editor)
 2006 *Cross-Cultural Collaboration: Native Peoples and Archaeology in the Northeastern United States.* University of Nebraska Press, Lincoln.

Liebmann, Matthew, and Uzma Z. Rizvi (editors)
 2008 *Archaeology and the Postcolonial Critique.* AltaMira Press, Lanham, MD.

Lilley, Ian (editor)
 2000 *Native Title and the Transformation of Archaeology in the Postcolonial World.* Left Coast Press, Walnut Creek.

Lucic, Karen, and Bruce Bernstein

2008 In Pursuit of the Ceremonial: The Laboratory of Anthropology's "Master Collection" of Zuni Pottery. *Journal of the Southwest* 50(1): 1–102.

Lynott, Mark J., and Alison Wylie (editors)

1995 *Ethics in American Archaeology: Challenges for the 1990's.* Society for American Archaeology Special Report, Washington, DC.

Martinez, Natasha Bonilla, and Rose Wyaco

1998 Camera Shots: Photographers, Expeditions, and Collections. In *Spirit Capture: Photographs from the National Museum of the American Indian*, edited by Tim Johnson, pp. 77–106. Smithsonian Institution Press, Washington, DC.

McGimsey, Charles R., III

1972 *Public Archaeology.* Seminar Press, New York.

McGregor, John C.

1941 *Southwestern Archaeology.* John Wiley & Sons, New York.

McGuire, Randall H.

1992 Archaeology and the First Americans. *American Anthropologist* 94(4): 816–36.

McLaughlin, Robert H.

1998a The American Archaeological Record: Authority to Dig, Power to Interpret. *International Journal of Cultural Property* 7(2): 342–75.

1998b The Antiquities Act of 1906: Politics and the Framing of an American Anthropology and Archaeology. *Oklahoma City University Law Review* 25(1&2): 61–91.

McManamon, Francis P.

1991 The Many Publics for Archaeology. *American Antiquity* 56(1): 121–30.

McNiven, Ian J., and Lynette Russell

2005 *Appropriated Pasts: Indigenous Peoples and the Colonial Culture of Archaeology.* AltaMira Press, Lanham, MD.

Meskell, Lynn (editor)

2009 *Cosmopolitan Archaeologies.* Duke University Press, Durham, NC.

Miller, Darlis A.

2007 *Matilda Coxe Stevenson: Pioneering Anthropologist.* University of Oklahoma Press, Norman.

Nicholas, George P., Amy Roberts, David M. Schaepe, Joe E. Watkins, et al.

2011 A Consideration of Theory, Principles, and Practice in Collaborative Archaeology. *Archaeological Review from Cambridge* 26(2): 11–30.

Pandey, Triloki Nath

1972 Anthropologists at Zuni. *Proceedings of the American Philosophical Society* 116(4): 321–37.

Polingyouma, Eric

 2008 Awat'ovi, A Hopi History. In *Remembering Awatovi: The Story of an Archaeological Expedition in Northern Arizona, 1935–1939*, edited by Hester A. Davis, pp. xv–xviii. Peabody Museum Press, Cambridge.

Potter, Parker B.

 1994 *Public Archaeology in Annapolis: A Critical Approach to History in Maryland's "Ancient City".* Smithsonian Institution Press, Washington, DC.

Preucel, Robert W., and Craig N. Cipolla

 2008 Indigenous and Postcolonial Archaeologies. In *Archaeology and the Postcolonial Critique*, edited by Matthew Liebmann and Uzma Z. Rizvi, pp. 129–40. AltaMira Press, Lanham, MD.

Said, Edward W.

 1978 *Orientalism.* Vintage Books, New York.

Sheridan, Thomas E.

 2006 *Landscapes of Fraud: Mission Tumacácori, the Baca Float, and the Betrayal of the O'odham.* University of Arizona Press, Tucson.

Silliman, Stephen W. (editor)

 2008 *Collaborating at the Trowel's Edge: Teaching and Learning in Indigenous Archaeology.* University of Arizona Press, Tucson.

 2010 The Value and Diversity of Indigenous Archaeology: A Response to McGhee. *American Antiquity* 75(2): 217–20.

Smith, Watson

 1984 One Man's Archaeology. Manuscript on file, Arizona State Museum, Tucson.

Snead, James E.

 2001 *Ruins and Rivals: The Making of Southwest Archaeology.* University of Arizona Press, Tucson.

Spicer, Edward H.

 1962 *Cycles of Conquest: The Impact of Spain, Mexico, and the United States on the Indians of the Southwest, 1533–1960.* University of Arizona Press, Tucson.

Stannard, David E.

 1992 *American Holocaust: The Conquest of the New World.* Oxford University Press, Oxford.

Stapp, Darby C., and Michael S. Burney

 2002 *Tribal Cultural Resource Management: The Full Circle to Stewardship.* AltaMira Press, Walnut Creek, CA.

Thomas, Hugh

 2003 *Rivers of Gold: The Rise of the Spanish Empire, from Columbus to Magellan.* Random House, New York.

Thomas, Nicholas

1991 *Entangled Objects: Exchange, Material Culture, and Colonialism in the Pacific.* Harvard University Press, Cambridge.

Thornton, Russell

1987 *American Indian Holocaust and Survival: A Population History Since 1492.* University of Oklahoma Press, Norman.

Trigger, Bruce G.

1984 Alternative Archaeologies: Nationalist, Colonialist, Imperialist. *Man* (N.S.) 19(3): 355–70.

1989 *A History of Archaeological Thought.* Cambridge University Press, Cambridge.

Watkins, Joe, Lynne Goldstein, Karen D. Vitelli, and Leigh Jenkins

1995 Accountability: Responsibilities of Archaeologists to Other Interest Groups. In *Ethics in American Archaeology: Challenges for the 1990's*, edited by Mark J. Lynott and Alison Wylie, pp. 33–37. Society for American Archaeology Special Report, Washington, D.C.

Wildesen, Leslie E.

1984 The Search for an Ethic in Archaeology: An Historical Perspective. In *Ethics and Values in Archaeology*, edited by Ernestene L. Green, pp. 3–12. Free Press, New York.

Wilkens, David E., and K. Tsianina Lomawaima

2002 *Uneven Ground: American Indian Sovereignty and Federal Law.* University of Oklahoma Press, Norman.

CHAPTER 7

The History of Archaeology through the Eyes of Egyptians

Wendy Doyon

EGYPT, MOTHER OF THE WORLD

During Bonnie Effros's appointment to the Institute for Advanced Study in 2014, I had the tremendous pleasure of her invitations to lunch and the benefit of many wonderful conversations with her about the history of archaeology. One afternoon, as we were leaving the dining hall, Bonnie pointed out a series of Roman mosaics decorating the walls. We agreed that they were lovely, but were puzzled by the lack of any information about their archaeological or historical context that might explain their presence there or in the Princeton University Library. Next to the smiling photographs of Albert Einstein, they merely seemed to suggest an elegant counterpoint from antiquity, with nothing more to indicate where they had come from or why they were here. Months later, while digging in the American Schools of Oriental Research Archives (ASOR) in Boston, I discovered purely by chance, a diary labeled "Antioch, 1932," by Clarence Stanley Fisher. Fisher was an American archaeologist who excavated for many years in Egypt on behalf of the University of Pennsylvania Museum,[1] which made him a central figure in my dissertation research.[2] After leaving the University of Pennsylvania Museum, Fisher worked for many years in Syria, Palestine, and Transjordan excavating at various sites on behalf of ASOR and its affiliated institutions. While looking through the remains of his papers in Boston, I came across the diary from his first season as field director for the Committee for the Excavation of Antioch-on-the-Orontes, an expedition led by Princeton University from 1932 to 1939. Even before I realized that I had inadvertently stumbled onto

Princeton's mosaics in situ, this diary was intriguing for another reason. In spite of its being at a Roman site in French-mandate Syria, the excavation's footprint was so familiar it might as well have been Memphis or Thebes in British-colonial Egypt.

If we were to travel back to 1900 to visit the British excavation of Egypt's very first royal tombs at Abydos, stop in to see the American excavations at the Pyramids of Giza a few years later, continue on to the late Neolithic burial grounds of Jebel Moya in the deep south of the Anglo-Egyptian Sudan on the eve of World War I, then visit the ancient capital of Memphis during Egypt's struggle for national independence after the Great War, and finally make our way to the distant Roman city of Antioch in French-mandate Syria on the eve of World War II, we would find five very different expeditions (Figs. 7.1–7.5). However different they were, these five expeditions nevertheless shared one unifying feature. They were the most cutting-edge, scientific excavations of their time, thanks in large part to the special class of archaeological foremen, known as Quftis, who ran them. The skilled foremen common to each of these excavations came from a small town in southern Egypt called Quft (pronounced "guft"), where they had been refining and passing down their stock-in-trade since about 1895 (Doyon 2015; Petrie 1932). In the early twentieth century, excavations around the Middle East were conducted according to a strict division of labor, with educated Europeans, Americans, and a few men of the Indigenous upper classes working at the top level as field directors and inspectors, assisted by skilled classes of locals and foreigners, who were employed as expedition archaeologists, surveyors, artists, photographers, conservators, craftsmen, clerks, and foremen like the Quftis, who also supervised the poor and unskilled local workforces responsible for digging and moving dirt. The scientific reputation of excavations like these depended heavily on the Quftis' methods of careful and controlled excavation on a very large scale, which produced the highest level of empirical observation then known in archaeological research. Although they were not known to the world of archaeology outside of fieldwork in the Middle East, the Quftis did as much as anyone else at the time to define archaeological fieldwork as something scientific in nature, and they were central to the globalization of Egypt's cultural heritage.

There is a saying in Arabic that Egypt is the Mother of the World, *umm al-dunya*. The archaeological landscape is a very large part of what gives Egypt and Egyptians a sense of place and power in today's globalized world. Egypt's place in the world heritage movement is both a matter of pride and a key, multi-billion dollar industry. In practical terms, Egypt also gives the global science of archaeology an important field in which to work. The field shares certain geographical

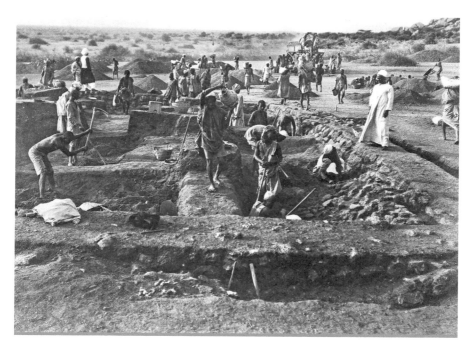

FIGURE 7.1. Wellcome excavations in the Sudan, 1912–1913. The Egyptian *reis* in this photograph, a Qufti, is identifiable by his traditional, long white robe (Arabic *gallabiya*) and tightly styled head wrap, and by his modern-style shoes (upper right). A second, less senior Qufti is identifiable by a black tunic worn over white pants with a white vest over top and a different style of head wrap (upper left). Photo by permission of the Wellcome Library, London, http://wellcomecollection.org/works, image M0013045.

and historical features with Egypt, but it is not entirely *of* Egypt. It does not map directly onto the geopolitical or social reality of Egypt's modern history as a regional empire, a colonial territory, or a nation-state. It is true, for example, that during the first wave of modern globalization, the field of Egyptian archaeology shared certain structural features with the British colonial economy, as it overlapped with British sources of law and policy, administrative ideology, theories of race and class, free trade imperialism, and wage labor. However, the structure of archaeological fieldwork also had roots in Egypt's earlier integration into the modern world economy going back to the beginning of the nineteenth century, and over the course of the next hundred and fifty years it rode on waves of Ottoman, French, and American imperialism, as well. Egyptian archaeology was never just "colonial archaeology," because it did more than serve the Egyptian

state and colonial administration, and, unlike the state, was not bound by terri-
torial interests. It was instead a global scientific endeavor with an international
division of labor supporting the creation of a world heritage. And like all goods
produced for the global marketplace, the value of that heritage carries a hidden
cost in the value of the labor that produces it.

MONEY IS THE GATE TO HELL[3]

Egypt's integration into the modern world economy was centered on the produc-
tion of cotton, which transformed the country in some of the most violent ways
imaginable from a decentralized network of regional farming and trading com-
munities loosely bound by Islamic institutions in Cairo and Istanbul, to an uneasy
nation-state with a struggling, semi-industrial plantation economy (Cuno 1992;
Owen 1993). From the early nineteenth century up to the 1870s, Egypt's Otto -
man viceroys led a massive state-building project, which claimed nearly all of the
country's land as the property of the state, set up a state monopoly on agriculture
and industry, and forcibly conscripted a large number of its people to modernize
the army and help build a new empire on their land. They enlarged and central-
ized an existing, localized system of corvée to mobilize Egyptian peasants for vast
public works projects on an unprecedented scale (Brown 1994). Egypt's rulers
also transformed the institutional base of the new economy by embracing Euro-
pean-style schools, courts, laws, and cultural institutions, and by welcoming for-
eign capital to develop Egypt's industrial infrastructure (Cuno 1992; Hunter
1999; Owen 1993). As part of these reforms, Egypt's most important ancient sites
also became the property of the state, and the village communities near these sites
were forced to invest their labor in the country's archaeological development. This
process also initiated a long struggle between traditional Islamic and secular insti-
tutions over the nature of the public sphere and the role of scientific authority in
Egypt. In a way, the institutional reforms that introduced European civil codes
and cultural norms weakened the public sphere of Islam in the interests of eco-
nomic and scientific development. As a consequence, this elite, political interest in
reproducing non-Muslim forms of moral authority excluded most of Egyptian
society from making competing claims on antiquity or participating in public dis-
course about their natural and cultural heritage. In terms of its impact on public
life, Egypt's ancient heritage was as much a part of its integration into the world
economy as cotton and, like cotton, had a tendency to marginalize and impover-
ish the vast majority of the Egyptian people.

The same processes that were driving the global market in tea, spices, and
textiles also transformed antiquities and specimens of all sorts into scientific

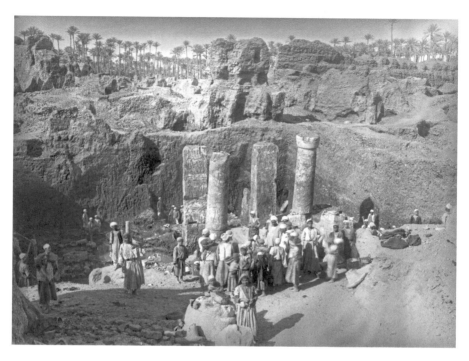

FIGURE 7.2. University of Pennsylvania Museum excavations at Memphis, Egypt, 1915. The Eckley B. Coxe, Jr. Egyptian Expedition, under the direction of Clarence S. Fisher, continued these excavations until 1923. Photo courtesy of the University of Pennsylvania Museum of Archaeology and Anthropology, image 33944.

commodities, which became sources of wealth for European trade empires, and a form of social capital for European collectors (Brockway 2002; Jasanoff 2005). Napoleon's famous Egyptian expedition of 1798, intended to gain control of trade markets in the East, also launched the scramble for antiquities in Egypt and the Middle East, which supplied many of the raw materials for scientific development in England, France, and Germany for the first part of the nineteenth century. Like other commodities, the materials generated by scientific expeditions tended to flow in a centralized direction, toward the public spaces of upper-class, European men, where they were integrated into new systems of meaning and power (Bailkin 2004; Young 2009). The great exhibitions that visualized that power throughout the century drove the creation of a world heritage industry with a monopoly on the global market for information about antiquity. When a truly public museum world for men and women of the middle and working classes appeared much later, it would not reach into the Egyptian countryside.

To promote foreign investment, Egypt's rulers granted numerous conces-
sions for the development of cities, ports, roads, canals, railways, factories, plan-
tations, and archaeological sites. When it was established in the 1850s, control of
the Egyptian Antiquities Service was granted to the French, who then enjoyed a
monopoly on excavation in Egypt for the next twenty-plus years (Bierbrier 2012:
355–57, on Auguste Mariette; Reid 2002). With this control, they were given
the right to levy forced labor to clear the tombs and temples at all of the most
prominent ancient sites along the Nile, sending a steady stream of boats loaded
with antiquities to Cairo. The French used a network of government overseers to
organize the workforces and run their excavations, and it was these men who ini-
tially defined what the field of archaeological exploration looked and felt like for
most Egyptians (Drower 1982: 11; Maspero 1914; Petrie 1932; Simpson 1974:
8–9). In the early years of the Antiquities Service, overseers extorted money from
villagers and drove the workers with the whip. But as the Egyptian government
moved closer and closer to bankruptcy in the 1870s, things began to change, and
by 1880, the British were moving in and Egyptian markets were opening up
much more rapidly. The field of archaeology was opening, too, and wage labor
gradually replaced the corvée. This resulted in a new kind of fieldwork that
increased the value of labor against the market value of antiquities, in part by
establishing forms of payment that were linked to the kind and volume of antiq-
uities discovered. The free labor market that grew with the capitalist expansion
in the 1880s and 1890s created new social classes throughout the country,
including a niche market for archaeological foremen to compete with the old net-
work of government overseers. This process radically altered the nature of field-
work and ultimately drove the development of empirical research methods in
archaeology.

The British occupied Egypt in 1882 and continued to rule the country indi-
rectly, in one way or another, until 1952, while the French remained in control of
the Antiquities Service. Up to the 1880s, the focus of excavations in Egypt had
been the discovery of art objects and museum specimens, with no attention to
recording finds in their original context. As new sources of British capital flooded
the Egyptian countryside, a Victorian faith in science and technology rode in with
them. It was a prominent Englishman, Sir Flinders Petrie, who developed system-
atic methods for excavating in Egypt, and with them revolutionized the field of
archaeology (Bierbrier 2012: 428–30, on Flinders Petrie; Drower 1982; Petrie
1904, 1932). But this is only one aspect of a much bigger reality. Advances were
due also to the diversification of the labor market, and the emergence of a new
class of skilled Egyptian foremen that fostered Petrie's methods and legitimized
archaeology's claim to scientific authority for most of the twentieth century.

On any excavation of this era, whether systematic or unsystematic, part of an overseer's job was to guard the scientific boundaries of archaeological sites. Their presence marked these sites as spaces of scientific investigation, and at the same time limited foreign influence on the local people to ensure cheap labor for maximum profit. Not only did overseers control the technical standards of excavation and negotiate new kinds of technology for workers, such as mechanized time-keeping, they also helped build the modern expedition houses, facilities, and infrastructure that slowly carved out a scientific space on the thin frontier between the desert and cultivated fields along the Nile. The most effective overseers were men who possessed and were willing to capitalize on a social commodity known as *baraka*, a powerful sort of charisma, which they exploited on behalf of both the government and private interests in rural areas of Egypt. One of the ways they accomplished this for the Antiquities Service, for example, was by keeping time on the excavations (Legrain 1914; Maspero 1914; Schaefer 1904). Overseers restructured the experience of time in the field by measuring the workday in shifts—industrial units of productivity, which normalized a new kind of clock time for rural workers (Atkins 1988). They did this by leading the work crews in chants and songs, which reminded them that time was money (Legrain 1914: 189–200; Maspero 1914: 173–85; Schaefer 1904: 27–38). At the same time, they used a similar catalog of folk songs to pace the work through prayer, which enforced more comfortable boundaries of time and place for Egyptians working in the company of strangers. In this capacity, they acted as spiritual leaders who performed religious exercises in which they reminded the workers that real wealth was transcendent (e.g., Legrain 1914: 197–98; Maspero 1914: 173–74). Certain kinds of songs were used to lead the young boys (and sometimes girls) who carried dirt from the excavation to the dumpsite all day long, and others to help the men who were digging, bailing mud and water, or hauling heavy stones.

As the excavation of antiquities became a new kind of fieldwork for Egyptians during the seasons between planting and harvesting on the Nile, new songs introducing themes that were specific to archaeology were added to an existing oral literature of popular folk tales and legends, love songs, spirituals, and work songs. As was the case with the collections of Georges Legrain (1914), Gaston Maspero (1914), and Heinrich Schaefer (1904), many of the folk songs that were written and performed on excavations of this era were recorded and published by European archaeologists in an ethnographic (and also somewhat Romantic) mode of science writing that characterized the early generations of fieldwork in Egypt. In a field long dominated by European languages—principally English, French, and German—the use of Arabic at archaeological field

sites, of which these songs are our earliest examples, reveals the active but publicly invisible role of Egyptians in the archaeological process. These collections also introduce us to the history of segregation in archaeological fieldwork, as the songs portray a world of extreme poverty and oppression for the Egyptians, which existed both within and outside of the Europeans' world of museums filled with the treasures they excavated. They often sang about the tyranny of fieldwork as a kind of living hell with death as its only relief.

THE VIEW FROM QUFT

With the growth of wage labor toward the end of the nineteenth century, the use of economic, rather than political influence in the field began to attract skilled craftsmen, who diversified the role of foremen on archaeological excavations. Regular wages that matched the commercial pull of the antiquities market offered an incentive to turn as many objects as possible over to scientific authorities instead of dealers. The increased sophistication of these excavations eventually led to specialization among skilled craftsmen who lacked more lucrative opportunities (Petrie 1904, 1932). Much of the attention to small objects, find context, and stratigraphy, which were the hallmarks of Petrie's scientific archaeology, was thanks to this new class of foremen who began to coordinate systematic excavations on a much larger scale than would otherwise have been possible. Before Petrie and his students could prove their relative dating methods and draw cultural histories from the archaeological record, objects had to be collected, information recovered, and maps drawn on a scale large enough to reflect cultural change over time. For these data to be recorded properly, the integrity of objects in their original context had to be preserved by skilled excavators. This economy of scale ultimately drove the development of empirical research methods and documentary practices in archaeology. Because of this, the paradigmatic shift that brought archaeology into the modern era inherently reflected the political economy of fieldwork.

The guild-like structure in which skills specific to archaeological excavation were controlled and imparted through traditional means such as kinship association, and which formed the basis for a new class of Egyptian foremen, appeared in at least two different places – one in the north and one in the south. Ultimately, it was the southern group from Quft that formed the only truly successful archaeological industry. British fieldwork expanded from the Delta in the north to Upper Egypt during the 1890s, and by the early 1900s the Quftis were managing excavations as far afield as the Levant in the north and the Sudan in the south (Addison 1949: 3–4; Crawford 1955: 97; James 1982; Petrie 1932; Reisner 1910: 253,

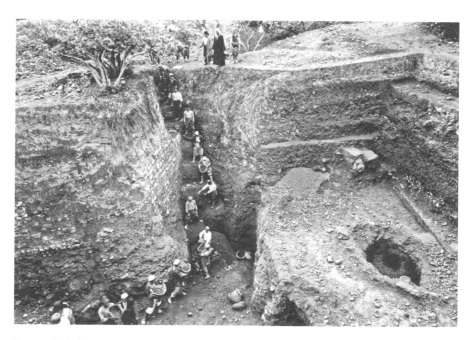

FIGURE 7.3. Princeton University excavations at Antioch, Syria, 1936. Trial trench in the area of the theater of Dionysus. As in Figs. 7.1 and 7.2, above, and Fig. 7.5, below, the Egyptian *reis* is here distinguished by his long robe and head wrap (upper center), in addition to the stick he carries to denote status and to direct the workers (a somewhat different function, it should be noted, than the walking stick belonging to the local figure on his right). Photo courtesy of Antioch Expedition Archives, Department of Art and Archaeology, Princeton University, image 2647.

1922). This was the beginning of a new era of American-sponsored expeditions, which placed an even greater emphasis on the empirical findings of archaeology than the British (Bierbrier 2012: 459–60, on George Reisner; Crawford 1955; Reisner 1905, 1925, 1939; Thomas 1995, 1996). The grand scale of these expeditions, funded by some of America's wealthiest businessmen and most prestigious museums and universities, was matched only by the Quftis' development of extremely fine skills in removing and recording stratigraphic layers on a massively complex scale. The level of empirical observation achieved by these expeditions depended heavily on the Quftis' careful and controlled methods of excavation, which allowed other archaeologists to improve on Petrie's methods of recording and interpreting ancient sites for publication. By 1914, as war was looming in Europe, American expeditions worth millions of dollars were expanding into a field of shrinking European money and influence. American patronage moved

into Egypt's most important archaeological concessions, and eclipsed England's scientific prominence in the field. These expeditions spent lavishly on field houses, libraries, and labs equipped with every modern technology. However, the majority of their budgets went directly into the costs of labor, and the Quftis claimed the largest share of those expenses by far. As far as their patrons at home were concerned, these expeditions were meant to form world-class museum collections, but out in the field it was a different story. There, the material value of everyone's labor, from the basket carriers to the foremen to the archaeologists, was rising against the value of museum specimens, and steadily transforming antiquities from art objects to artifacts with intact histories. If a single thread connected archaeological archives of this era, it was the practical relationship between the division of labor in the field and the discovery of artifacts with useful histories. This kind of archaeological research had the power to connect objects with real people in the past, which gave even the most humble artifacts a transcendental social value as world heritage.

Writing played an enormous role in this new era of archaeological professionalization. Unlike the more Romantic genres that preceded the Victorian age of science, a new documentary mode of writing became the central preoccupation of this new generation of archaeologists. They thought of their work as scientific in the sense that they were revealing the facts of history not just through objects themselves, but also through the process of recording reliable information from artifacts of all kinds—from the small and ordinary to the spectacular and monumental—and systematically documenting the context of those artifacts' discovery. New methods of recording the progress of excavations, including field diaries, photography, and artifact registration, were developed in order to preserve the information associated with objects and archaeological features in situ. This systematic documentation of find context transformed antiquities from valuable objects to meaningful artifacts, and meant that the huge archives generated by professionalized fieldwork were fundamental to the discipline.

What has not been acknowledged in this process of professionalization is how the role of Arabic and its relationship to writing in the field also changed. The fact that archaeology was transformed from unsystematic museum collecting to a modern field science and profession at the very same moment as the capitalist expansion of the 1880s and 1890s was no accident, as the economic specialization of archaeological foremen went hand in hand with the emergence of professional archaeologists. In the colonial context of the day, these two worlds remained segregated by class and racial differences. Yet, as the role of Arabic in the field went from a subject of passing anthropological interest to a fundamental tool of professionalism, they also overlapped in new and surprising ways.

In Petrie's time, before and around the turn of the century, both the use of Arabic on site and its appearance in the written record dealt primarily with the organization and control of Arabic-speaking workforces as a method of conducting properly scientific excavations. For Petrie and his students, Arabic was necessary for directing and, in his words, "studying" the workmen in order to "make the best use of them" (Petrie 1904: 6). As large work crews led by skilled foremen were essential to his aims as a scientist, the organization of local workforces was a key point in his field methodology, no different from the development of relative dating sequences, note taking, photography, or registration methods. For this reason, he considered Arabic ability to be equally if not more important for truly professional archaeologists than the study of ancient languages. Although Arabic was becoming an increasingly important part of doing archaeology in the field at this time, it was by no means considered a language of discourse, and as far as writing went, its function was limited to business transactions, payroll, and notes on the workers themselves.

By the time the First World War had come and gone, there was much more emphasis on Arabic as a language for managing not just people, but also finds and information. Professional field notes and diaries, along with letters, account books, and artifact registers kept in Arabic began to appear in the archival record at this time.[4] The largest and most important collection of these Arabic field records belonged to the Harvard University-Museum of Fine Arts, Boston Egyptian Expedition during the first half of the twentieth century (Reisner 1922, 1939; Harvard Crimson 1925).[5] This expedition was the heart of the new American paradigm in archaeology, and one of the longest-running excavations in Egypt. It boasted a state-of-the-art field laboratory and permanent staff, and unearthed an enormous collection of artifacts, from some of ancient Egypt's greatest royal masterpieces to warehouses full of pottery and tiny bones. This collection was matched by the scale of the expedition's archive of tomb records, photographs, drawings, maps, notebooks, and diaries documenting every last detail of every stratum of the vast excavation at the Pyramids of Giza, and several satellite excavations in southern Egypt, northern Sudan, and Palestine, as well. Unlike his predecessors, whose field notes were largely intended for individual use as aids to publication, the American director of the Harvard–Boston Expedition, George Reisner, intended the expedition's archive to stand as a permanent written record, as rich and irreplaceable as the material record itself. Reisner worked for forty years to develop improved methods of recording, photographing, and documenting sites, so that the volume of information produced by the excavations equaled its museum collections, and so that the history represented by those collections would not be lost in the process. His methods

ensured that the scholarly publication record resulting from these excavations was, in a sense, as monumental as the sites themselves, and would continue long after his own death (Crawford 1955: 92). A substantial portion of Egyptian archaeology to this day is derivative of the record produced by the Harvard–Boston Expedition.

Unsurprisingly, this was also the expedition on which the largest, wealthiest, and most successful Qufti network was built, and whose activities were responsible for transferring the new research paradigm, in whole or in part, to almost every other contemporary American, British, and German expedition up to the Second World War (Reisner 1922: 943). For a time the Quftis' influence extended to almost every major Egyptian expedition outside of the Antiquities Service and took them well beyond the borders of Egypt. Their considerable mobility as a class practically unto themselves was a testament to their control of workflow, stratigraphy, and find context on a breathtaking scale. At a time when nearly all rural Egyptians were illiterate and received little or no education and few public services, the degree of professionalism achieved by the Quftis was remarkable. Although they came from a small group of villages in one of the poorest regions of southern Egypt, where the vast majority of people worked on the land and only a handful of those—a few hundred at most—could read and write (Egyptian Government Ministry of Finance 1909, 1920–1921), the Quftis traveled far and wide, picked up various measures of English, French, German, and classical Arabic, and received paid holidays, medical benefits, and expense accounts. All of this was in contrast to the basic wages and tips that unskilled local workers received for a day's labor, somewhere in the neighborhood of ten cents. Their self-taught mastery of site stratigraphy, their ability to distinguish different types of deposits, and their skills in uncovering materials in situ, particularly in the case of burials, were so advanced that, in addition to managing expedition business, they often helped train novice archaeologists in the latest field methods.[6] Through their alliances with foreign archaeologists, they fashioned themselves into a class of rural elites with a hybrid identity, which conferred certain rights and privileges that were otherwise unattainable to most rural Egyptians. In spite of the Quftis' growing professionalism, however, life in the field remained strictly segregated.

In the instances where written records of their fieldwork have survived, they are important for both the depth of expertise they reveal and the context of social inequality in which that expertise was embedded. Arabic diaries were written in the same format as their English counterparts, with entries for each day detailing the progress of the excavations, unit by unit, level by level, and find by find, including technical sketches and drawings, precise descriptions of deposits and

materials in situ, notes on all objects found, and comments on the daily activities and business of the expedition members and workers. At the close of each day, sometimes late into the evening, the head foreman, or *reis*,[7] who supervised all of the actual digging and kept a notebook to record the work in progress, sat down with an expedition clerk and dictated the diary from his notes, which were recorded point by point in a more formal Arabic.[8] In both their content and syntax, the diaries juxtapose the formal, procedural aspects of diary writing in the field with various insights on the culture of fieldwork.

Practically speaking, these diaries served the same purpose as the field diaries kept by the American director and staff archaeologists, which was to provide as complete a record as possible of the process of excavation so that the cultural context of the discoveries could be reconstructed in field reports and publications. The integration of this bilingual system of record keeping into the complete field record, which required that the field director be able to read Arabic, added greatly to the scale and efficiency of data collection, which was the chief concern of professional archaeologists, and Reisner in particular, at this time. The Quftis' field notes sometimes included observations on the nature of site stratification and context, which conveyed a level of skill and intellectual independence on a par with the archaeologists. In contrast to the latter, however, the Arabic diaries were commonly addressed to Reisner himself, who was formally referred to as "His Excellency."[9] Needless to say, this convention was not shared by the staff archaeologists.

The limits on professional parity, no matter how far the Quftis' practices developed, were also reflected in the daily life of the excavations. Egyptian members of archaeological expeditions lived and ate in spaces separate from the Europeans and Americans, building their own camps that were adjacent to, but segregated from the main expedition camps. The Quftis, in turn, set themselves apart from the local working classes by the clothes they wore and the way they lived in the field. Apart from numerous other privileges associated with their work, the Quftis often had their own staffs for cooking and looking after their camps, and had their own food supplies imported from Quft at great expense to the expeditions, so as to avoid having to eat the local bread wherever they happened to be staying.

"Duties to Your Own Race"[10]

The innovation of using a bilingual record-keeping system on the Harvard–Boston Expedition was unique in its scope and vision, but it also had a wider influence on the role of bilingualism in field research during this period. Two

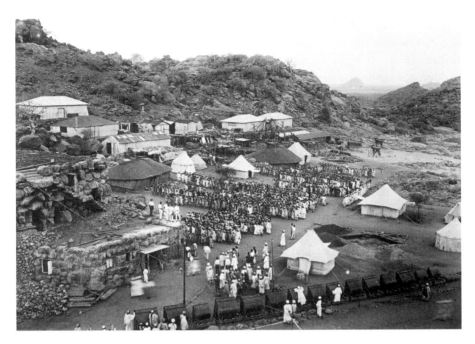

FIGURE 7.4. Wellcome excavations in the Sudan, 1912–1913. Camp and workers at Jebel Moya. Photo by permission of the Wellcome Library, London, http://wellcomecollection. org/works, image M0001530.

other expeditions of the time, which shared staff and methods with the Harvard–Boston Expedition, demonstrate the reach and potential of Arabic writing in the field, on the one hand, and its tensions and limits, on the other. The Wellcome excavations in the Sudan from 1910 to 1914 had the distinction of being the first archaeological excavations ever undertaken in southern Sudan—at a remote desert site called Jebel Moya, about as far south from Egypt's southern border as Cairo is to its north—as well as being perhaps the largest archaeological excavation ever undertaken anywhere (Addison 1949). Wellcome's expedition employed up to four thousand local workers in a single season! Although the primary aim of this expedition, which was sponsored and directed by Sir Henry Wellcome, was to provide employment for the local population, the excavations were conducted according to the most advanced methods available (Figs. 7.1 and 7.4). For this reason, Wellcome asked for a select group of the most experienced Quftis from the Harvard–Boston Expedition to run his field operations in the Sudan. They were led with great success by Reis Mahmud Ahmed Said Diraz "el-Mayyit" of Quft, brother of the head foreman for the Harvard–Boston Expedi-

tion, Reis Said Ahmed Said Diraz (Reisner 1922: 948–49).[11] The Wellcome Expedition also adopted the practice of keeping Arabic field diaries, along with those kept by the staff archaeologists, in order to produce a more complete record of the excavations.[12] For three seasons, the senior Quftis, who supervised the careful excavation and recording of more than 2,800 burials spread across five acres of barren, shadeless desert, plus three additional town sites nearby, worked on site from sunrise until five in the evening, after which they periodically wrote up their notes (Addison 1949).[13] Here, as elsewhere, the published results of these excavations were based largely on their work in the field, but in spite of their integration into the collective writing process, the extent of their contribution was not reflected in the final excavation reports.

Whereas it was relatively easy for the Quftis to claim their place in the social hierarchy of both traditional and colonial society in Egypt—as members of foreign expeditions with the rank and status of local notables—the situation in southern Sudan, which was ruled at the time by an Anglo-Egyptian condominium, was considerably more complex. At Jebel Moya, they felt their privileged status threatened not only by the working conditions at the site, but by the social conditions, as well. One archaeologist observed that the Quftis "were considerably chagrined at finding themselves in a place where there was no market, nor even water-jars … and were naturally blue, as they had to sift every particle of earth through their fingers."[14] Consequently, they went on strike during the 1911–1912 season, demanding better pay, more break time, and their own water supply, washing soap, and a canteen. In response to their complaints about the water, which was drawn from local wells and not to the Quftis' liking, the expedition arranged for a special supply to be brought some twenty miles from the Nile by train, and from the train station another two miles to the site by camel (Addison 1949: 10). For ideological as well as practical reasons, they also asked to be separated from the locals in their work, and refused to take orders from Wellcome's Sudanese interpreter, because he was African, preferring instead to receive direction from the supervising archaeologist on site, who was an American.[15] The excavations at Jebel Moya were racially segregated with separate trenches for Egyptians and Africans, each of the latter according to local tribal affiliations (Addison 1949: 3).

The Quftis' work at Jebel Moya lasted until the outbreak of the Great War, when Wellcome had to suspend his excavations in the Sudan. It was at this very moment, toward the end of 1914, that the newly appointed field director for the Eckley B. Coxe, Jr. Egyptian Expedition at the University of Pennsylvania Museum began organizing two new major excavations in Egypt (Fig. 7.2). The expedition's new director, Clarence Fisher, had also received his field training under

George Reisner. Now at the head of one of the richest expeditions in Egypt, he was in a strong position to hire the much praised Reis Mahmud el-Mayyit to lead the University of Pennsylvania Museum excavations with the closing down of the Wellcome Expedition (Fisher 1924: vii–ix).[16] Throughout the war, and for many years after, the Harvard–Boston and Coxe Expeditions had a close working relationship in the field, both using their considerable economic influence to advance their scientific ideals and field methods beyond anything the British had been able to accomplish in terms of scale.

Just as at Jebel Moya, Reis Mahmud was again central to the spectacular success of the Coxe Expedition's first three seasons of fieldwork in Egypt. However, by the third season serious tensions had arisen over the nature of his authority, including his responsibilities for keeping excavation records. Unlike Wellcome's adoption of the Arabic diary system, Fisher refused to allow Reis Mahmud to manage his own accounts and records, a decision that undercut Mahmud's status among the Quftis. Fisher and Mahmud disliked each other personally, and over time their mutual antagonism led to open conflict and the gradual breakdown of relations on the expedition in 1917. When Fisher began publicly belittling Mahmud's work, and Mahmud openly defied Fisher's authority by turning his back to him publicly and smoking a cigarette in front of him—a sign of extreme disrespect for one's superior in Egypt—it wasn't long before Reis Mahmud quit the expedition (or was dismissed, depending on whose version one is following) and returned to the Harvard Camp at Giza to appeal to Reisner for help.[17]

The bitter clash between the two field directors, which lasted over a year, made the boundaries of Egyptian and Arabic contributions to colonial-era archaeology perfectly clear. Fisher immediately appealed to the racist attitudes of the day by warning Reisner not to "let your inexplicable devotion to any black man blind you to your duties to your own race" and insisting that, since "it is usually accepted that the word of a white man is better than that of a native," such disloyalty "certainly will destroy any other white man's authority over these people" who, he believed, for the sake of future excavations must "understand that they are not the chosen people of Egypt."[18] Reisner, in turn, pointed directly to Reis Mahmud's demonstrated professionalism as a senior member of his expedition, and a respected member of other expeditions, who had worked exclusively in archaeology for more than twenty years. Fisher's outlook suggests that fear of Egyptians in positions of authority, where their advancement could somehow be perceived as a threat to professional archaeology, helped arrest the budding prospects of bilingual field practices developed by Reisner and the Quftis, and with it any future potential for southern, Arabic-speaking Egyptians to participate more fully in archaeological research. In the case of the Harvard–Boston

and Wellcome Expeditions, the exceptional nature of the Arabic diaries suggests that the Quftis' expertise in the field has not been sufficiently documented, even if it has sometimes been acknowledged in other ways. For the most part, it has been overlooked as a matter of record.

The Likeness of the Other

Like all rural classes of Egypt, the people of Quft have been marginalized by the process of Egyptian state and nation building in Cairo, from the time of Napoleon to the present. Yet instead of seeking representation in a nation born out of the ashes of three world empires, they achieved spectacular success, and a measure of wealth and status, by allying with foreign archaeologists *against* the interests of Egypt as a nation. They adopted a proudly cosmopolitan attitude toward their work, in which they self-identified as a class apart from what they considered inferior classes of other Egyptians, Arabs, and Sudanese. Their success was central to the way archaeology worked in the field throughout the twentieth century. Their position helps us to understand the mechanisms by which field-work served the private interests of the propertied classes in Egypt, and limited the free public space of archaeology to a very small elite of educated, Westernized, upper-class Egyptians and non-Muslim foreigners. The poorest Egyptians were forced to sell their labor on the antiquities market, some with greater success than others. The focus on the material value of their labor has long alienated the majority of unskilled workers from the social value of fieldwork. As part of the long-standing struggle between secular and Islamic institutions in Egypt, the nature of fieldwork restricted the circulation of scientific information and its public discourse to a predominantly non-Arabic-speaking world within Egypt. It impacted the meaning of cultural property for Egyptians by emphasizing the commercial value of their heritage as the property of the state and foreign archaeologists. In spite of their investment in Egypt's archaeological development, the Quftis also found themselves disenfranchised from the broader world heritage movement by the same barriers of class and ethnicity.

The Quftis' identity was a hybrid one, which complicates the categories of "colonial" and "indigenous" archaeology more broadly. They lived comfortably between a charismatic authority as rural elites, akin to religious figures and local notables, and a foreign knowledge of, and faith in science and technology. They set themselves apart from other rural classes by the clothes they wore and the symbols of relative wealth and power they exhibited with well-furnished camps and exclusive privileges. Although they did not collectively consider themselves archaeologists, the diaries that survive their work are an extraordinary record of

the Quftis' place between cultures. In spite of the fieldwork that united archaeologists and Egyptians like the Quftis in mutual professional interests, the segregated nature of that fieldwork kept the wider world of research off-limits to most Arabic speakers. Instead, for some Egyptians, fieldwork became an independent source of power with which they were relatively free to shape their own destinies as individuals and communities. Unlike modernizing elites of the same period in Cairo, who struggled for representation in the Western canon of archaeology and sought to nationalize its practices in Egypt, the Quftis used their experiences in the field to find meaning in other ways. A fascinating example of this is Reis Mahmud el-Mayyit's account of his pilgrimage to Mecca and Medina in 1929, which forms part of the same field archive as the Arabic Diaries at the Museum of Fine Arts, Boston.[19] In it, he used the same methods of observation and writing style with which he was familiar from his work in archaeology to give a day-by-day account of this momentous journey in his life. It is a unique example of personal diary writing in Arabic embedded in the context of a field archive. It is also a window onto his aspirations as an explorer in a traditional Muslim society, as seen through the eyes of someone who had lived half of his life as a different kind of explorer in the world of archaeology. This dual nature was expressed in one way or another in most of the Egyptian experiences that were documented in archaeological archives of this period, from the mundane to the urbane. There is, on the one hand, a sense of the adventure and privilege associated with life in the field, in descriptions of the Quftis' experiences as they traveled through Egypt, Syria, Palestine, and the Sudan. On the other hand, one also senses that they never really left their small town, often bringing it with them in a way, either because they did not want to leave it behind, or because there were no opportunities available for them to advance beyond the boundaries of the field. Had the Arabic diary tradition managed to cross the boundary between the field and the academic world, bringing Egyptians' own experiences of the archaeological landscape into the writing of history alongside English, French, and German, both the practices and the public sphere of archaeology in the Middle East would look very different today.

Given that archaeology meant different things to different Egyptians historically, and that Egypt's Islamic and, until recently, Christian heritage have largely been excluded from archaeological practice for structural reasons, a consensus on Indigenous priorities in Egyptian archaeology, such as one might find in North America today, is unlikely. There was a range of local meanings, memories, and cultural attitudes bestowed on the archaeological landscape before the arrival of archaeologists, but no primary cultural affiliation existed with pre-Christian or pre-Islamic Egypt (Reid 1985). In many ways archaeology imposed an unnatu-

ral distance between Egyptians and the landscape of antiquity, while at the same time, many Egyptians gained a more intimate knowledge of the ancient landscape through fieldwork.

A focus on "colonial" archaeology is equally fraught in the Egyptian case, because archaeologists, like the Quftis, had a hybrid identity in the field. In most cases, the power that archaeologists enjoyed in the field was greater than that which they enjoyed at home, as was true of the Quftis. When we focus on state-centered and institutional power structures in the history of archaeology, we too often overlook the importance of personal relationships. There is a strong case to be made for expanding our perception of archaeologists to include their role as actors inside of local contexts, rather than simply outsiders who could not or did not want to understand the social dynamics of their field sites, as post-colonial histories of archaeology often infer. In reality, at least half of the field records in archaeological archives from Egypt are concerned with local politics and the social complexities of running a field site over long periods of time. Deliberate engagement with the local culture is what built the structures that enabled archaeologists to ask deep and meaningful questions through long-term, continuous research. Some field sites were closer to colonial outposts than others, but all of them blended with the local political scene to one degree or another. For the most part they were closer to the edge of empire than the center. These structures were built on a foundation of bilingual interaction in the field, which changed over time, but which was not usually visible in the final published record. Nevertheless, archives have the power to reflect back on received knowledge about the ancient world. Through them, we can walk in the archaeologists' shoes and look through their eyes, out across the frontiers of knowledge, where their research depended on successive generations of continuous engagement and compromise with Egyptians.

THE MIRAGE OF POWER

From Abydos to Antioch and from the Pyramids to the Sudan, one notices something peculiar about the scale of power in the field. It comes close to the way we represent the scale of power in the ancient world, where a small elite of pharaohs, emperors, scribes, and viziers ruled over the poor and illiterate masses who built their tombs and temples. This is because the scale and structure of archaeological labor in places like Egypt has long determined the focus of most archaeological research. Egypt's political economy, in particular, has enabled archaeologists not only to tackle monumental sites, to the virtual exclusion of everything else, but in the context of global capitalism, it has also enabled them to match the scale of

those ancient sites with a monumental scale of information and scholarship. The political economy of Egyptian archaeology has resulted in the reproduction of an elite-centered research paradigm, which I think continues to blind us to other parts of the past, and to a broader view of power in, and the structure of ancient society. In the process of becoming scientific, archaeologists and their allied interests in the field have, in a certain sense, modeled ancient Egypt in their own image.

Part of the assumed knowledge about ancient Egypt today, based on the past two centuries of research, is that the absolute power of the pharaohs as semi-divine kings, together with the top tier of Egyptian society that was attached to royal institutions, determined virtually every important aspect of the lives of the ancient Egyptians. Because these god-kings commanded armies of workers to build monuments to their power, so the assumption goes, those monuments and the activities that took place in and around them tell us everything we need to know about ancient Egypt. One does not have to search too deeply in the literature of Egyptology to see that the political economy of ancient Egypt, and the lives of the people who supported it, have historically been of passing interest at best. Royal tombs, temples, centralized religion, and elite arts and literature continue to dominate most research agendas even now. Many modern historians, however, have come to realize that centralized control of political economies tends to be greatly overstated, while the historical importance of social interactions independent of state authority have been understated or ignored altogether (Curtin 1984). After all, state expansion and contraction represent only one sphere of interaction among many in all human societies, and it is often the people who move between different social worlds—leaving much harder-to-find traces—that determine the course of events.

The labor structure of Egyptian archaeology has played a major part in driving our top-down, center-out view of ancient society. The possibilities of scale presented by fieldwork have pushed archaeologists to study monumental sites, and the long time-scale of this monumental-type fieldwork—from the beginning of the nineteenth century to the present—has ensured that the biggest questions and the deepest part of our knowledge base have centered on the lives of kings. At the same time, the archival legacy that was central to the professionalization of archaeology in Egypt also allows us to challenge this received wisdom about the past, in part by revealing these biases of scale in the architecture of research.

The distance between archaeologists and workers that was created by this structure and its entrenched language barrier was, somewhat ironically, enforced by the role of the Quftis as go-betweens. Their position obviated the need for Arabic

discourse in field-based research, and kept the three levels of fieldwork—uncovering finds, preserving the context of finds, and interpreting finds—neatly separated. Thus the architecture of most Egyptian expeditions, often with European and American houses flanked by segregated camps for the Quftis, and bounded at the margins by the workers' villages, provided an ideal looking glass for gazing on the pharaonic past through modern eyes. Given the entangled history of archaeologists and workers in modern Egypt, is it any wonder that our image of ancient Egypt as a world full of poor and illiterate masses revolving around the absolute power of a semi-divine king and his courtiers has persisted for so long? Indeed, the roots of this idea run deep through the history of Egyptology.

Mosaic Vision

There are other important reasons to study the history of archaeological labor. We cannot fully appreciate the variety of issues facing archaeological practice today without some historical understanding of how the labor that supported field research developed in relation to the role of archaeology in public life. It is a great irony of history that the British Empire, which profited from the world's knowledge and cultural resources, also laid the foundations of a modern preservation movement with a focus on the public stewardship of cultural heritage (Hall 2011; Swenson and Mandler 2013). In practice, when it comes to the preservation and stewardship of our shared world heritage, in many parts of the world, the public sphere remains quite limited. Many Egyptians today work for archaeology—in the tourism industry, as day laborers or skilled contractors, and as antiquities inspectors—but archaeology cannot be said to work for most Egyptians. The ability of Egyptian archaeology to work in the public interest, and to protect its social value as world heritage, depends in part on acknowledging the labor of the people who produce it and on expanding the public sphere of archaeology to Arabic-speaking audiences.

The growth of Indigenous and community archaeology in North America and elsewhere has shown that archaeological field sites are more than just engines of research and publication for private individuals—they are also public spaces that can serve the communities around them (Bruchac et al. 2010; see also Colwell, this volume). In theory, most of these new models for practicing archaeology with, by, and for indigenous groups apply to communities that descend directly from the cultures of interest to archaeologists. They are not directly transferrable to places like Egypt, where centuries of Christian and Islamic history have shaped people's relationships with antiquity. Where theory is insufficient, however, history can be instructive.

Following the establishment of the first Egyptian Museum in Cairo (1858) to house pharaonic antiquities, three other satellite museums were later built to represent Greco-Roman (1892), Coptic (1908), and Islamic (1884) Egypt. Instituionally these four periods were represented as discontinuous and easily divisible, but as time went on the nature of Egyptian museum displays gradually began to reflect more cultural hybridity, and the long arm of Egyptology slowly began extending back into prehistory and forward into the Greco-Roman and Byzantine periods. While the discipline itself has never gone so far as to embrace Egypt's Islamic heritage, Egypt's national museums have indeed transformed their primary narrative in the second half of the twentieth century to reflect one long, continuous history from the prehistoric to the present (Doyon 2008). In some sense this trend addresses a long-standing lacuna in what has been considered properly "Egyptian" history, begging the question of what makes Egypt Egyptian. Why then have both academic and museum Egyptology embraced certain periods of hybridity, from Hellenistic culture to the Roman conquest to Christianity, while ignoring everything that came after the Islamic conquest in the seventh century? (On Algeria, see also Effros, this volume.) As I have already

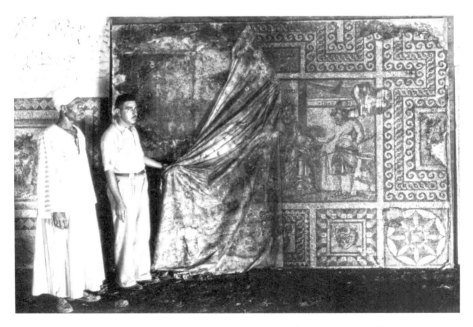

FIGURE 7.5. Princeton University excavations at Antioch, Syria, 1934. The final stage in the process of excavating a Roman mosaic. The *reis* from Quft is easily identifiable at left by the details of his dress. Photo courtesy of Antioch Expedition Archives, Department of Art and Archaeology, Princeton University, image 1651.

suggested, the roots of this structure may have less to do with a discontinuity of cultural forms, and more to do with the historical development of Egyptology. It is a remnant of the way that archaeology, as a secular concern, was separated from the public sphere of Islam during the nineteenth century.

Years after their initial contact with the Coxe Expedition from the University of Pennsylvania Museum, the Quftis' work at Memphis led to their work at Antioch in Syria (Fig. 7.5), an excavation that supplied at least thirty different museums around the world with portions of a very generous world heritage of exceptionally well-preserved Roman mosaics, including those now at Princeton (Jones 1981).[20] Connections like these in the history of Qufti fieldwork are almost too numerous to count, and their collective legacy in the record of humanity's past is considerable. From this legacy we learn that there is no universal ideology of imperialism masked by the pursuit of archaeology, for there is not one, but many perspectives from which to view the history of archaeology through the eyes of Egyptians. Theirs was a fluid and many-sided image made up of hundreds of pictures of archaeology in practice over time. If only we could hang this kind of mosaic on the wall to admire as we ponder the past.

NOTES

[1] For most of its history the University of Pennsylvania Museum of Archaeology and Anthropology, or Penn Museum, as it is now called, was referred to simply as the "University Museum." For the sake of clarity, I use the name "University of Pennsylvania Museum" when referring to the early twentieth century.

[2] The discussion of American expeditions during this period, in particular, draws primarily on original dissertation research supported by the University of Pennsylvania Department of History since 2010. I am especially grateful to the following archivists and curators for their guidance: Mr. Alex Pezzati at the University of Pennsylvania Museum of Archaeology and Anthropology; Dr. Lawrence Berman at the Museum of Fine Arts, Boston; Dr. Peter Manuelian at Harvard University; Ms. Joan Knudsen at the Phoebe A. Hearst Museum of Anthropology, University of California, Berkeley; Ms. Cynthia Rufo-McCormick at the American Schools of Oriental Research, Boston; and Ms. Trudy Jacoby at the Department of Art and Archaeology, Princeton University.

[3] This is my paraphrase of a line from "Chants des Manoeuvriers (6), Dans les Ruines" in *Louqsor sans les Pharaons*, a collection of southern Egyptian folk songs published by Georges Legrain in 1914 (Legrain 1914: 197–98). It comes from a set of songs and chants that were recited by the men who lifted and carried the heaviest stones from among the massive stone ruins at Karnak for the Service des Antiquités. In the context of their otherwise futile search for a livelihood in those days, the verse is a comment on the evils of such dreary work, and the absence of relief in an unjust world. It reads (as published):

A la porte du paradis
Se touve [sic] celui qui pardonne les fautes.

A la porte de l'enfer,

Il y a l'argent.

⁴ For example, Book of the Accounts, Samaria, 1909: Daftar Maṣr wa Filisṭīn wa muhamāt al-shaghāl fī Sabastiyya 1909 [in Arabic], Harvard Expedition to Samaria, 1908–1910, http://ocp.hul.harvard.edu/expeditions/reisner.html, Harvard University Library.

⁵ Arabic Diaries 1913–47, Egyptian Expedition Archives, Department of Ancient Egyptian, Nubian, and Near Eastern Art, Museum of Fine Arts, Boston.

⁶ O. G. S. Crawford, Report on Excavations at Abu Geili, 1914, MS Crawford 95, Bodleian Library Special Collections, University of Oxford.

⁷ Reis is the conventional spelling, in archaeological usage, of Arabic ra'īs (Eg. rayyis).

⁸ G. A. Reisner to C. S. Fisher, letter, July 4, 1922, George Andrew Reisner Collection, 1822–1983, EGP AC 13, Box 4, Archives of the Museum of Fine Arts, Boston.

⁹ Arabic janāb (as in janābak, "Your Excellency," or janāb al-mudīr, "His Excellency, the Director").

¹⁰ Clarence Fisher to George Reisner, May 16, 1917 (see n. 18).

¹¹ George Reisner and Henry Wellcome Correspondence, November 19, 1913 to June 29, 1918, and Mahmud Ahmed Said el-Mayyit to George Reisner, letter [in Arabic], October 27, 1913, Egyptian Expedition Archives, Department of Ancient Egyptian, Nubian, and Near Eastern Art, Museum of Fine Arts, Boston.

¹² Said Osman, Report on the Excavations at Aloa [Abu Geili] 1913–1914 [in Arabic], Wellcome Papers W/11, Griffith Institute, Oxford.

¹³ O. G. S. Crawford, Report on Excavations at Abu Geili, 1914, MS Crawford 95, Bodleian Library Special Collections, University of Oxford.

¹⁴ Oric Bates, Reports at Jebel Moya, December 11 and 15, 1911, Wellcome Papers W/2, Griffith Institute, Oxford.

¹⁵ Oric Bates, Reports at Jebel Moya, January 2 and 6, 1912, Wellcome Papers W/2, Griffith Institute, Oxford.

¹⁶ G. A. Reisner to H. S. Wellcome, letter, July 16, 1915, Egyptian Expedition Archives, Department of Ancient Egyptian, Nubian, and Near Eastern Art, Museum of Fine Arts, Boston.

¹⁷ C. S. Fisher to G. B. Gordon, letter, December 14, 1917, and G. A. Reisner to G. B. Gordon, letter and enclosures, March 21, 1918, Clarence S. Fisher Collection, Administrative Records, Egyptian Section, Boxes 3/13 and 4/1, University of Pennsylvania Museum Archives.

¹⁸ C. S. Fisher to G. A. Reisner, letters, May 16, May 20, June 14, 1917, and G. A. Reisner to C. S. Fisher, reply, May 16, 1917, George Andrew Reisner Collection, 1822–1983, EGP AC 13, Box 4, Archives of the Museum of Fine Arts, Boston; C. S. Fisher to G. A. Reisner, May 20, 1917, Clarence S. Fisher Memphis Expedition Records, Box 1/3, University of Pennsylvania Museum Archives.

¹⁹ Mahmoud El Meyyit's Account of His Pilgrimage to Mecca and Medina in 1929 [in Arabic], George Andrew Reisner Collection, 1822–1983, EGP AC 13, Box 6, Archives of the Museum of Fine Arts, Boston.

²⁰ Antioch Expedition Archives, Department of Art and Archaeology, Princeton University.

References Cited

Addison, Frank

 1949 *Jebel Moya (Text)*. The Wellcome Excavations in the Sudan, vol. I. Oxford University Press, London.

Atkins, Keletso E.

 1988 'Kafir Time': Preindustrial Temporal Concepts and Labour Discipline in Nineteenth-Century Colonial Natal. *The Journal of African History* 29: 229–44.

Bailkin, Jordanna

 2004 *The Culture of Property: The Crisis of Liberalism in Modern Britain*. University of Chicago Press, Chicago.

Bierbrier, Morris L. (editor)

 2012 *Who Was Who in Egyptology*, 4th rev. ed. The Egypt Exploration Society, London.

Brockway, Lucile H.

 2002 *Science and Colonial Expansion: The Role of the British Royal Botanic Gardens*. Yale University Press, New Haven, CT.

Brown, Nathan J.

 1994 Who Abolished Corvée Labour in Egypt and Why? *Past and Present* 144: 116–37.

Bruchac, Margaret M., Siobhan M. Hart, and H. Martin Wobst (editors)

 2010 *Indigenous Archaeologies: A Reader on Decolonization*. Left Coast Press, Walnut Creek, CA.

Crawford, O. G. S.

 1955 *Said and Done: The Autobiography of an Archaeologist*. Weidenfeld and Nicolson, London.

Cuno, Kenneth M.

 1992 *The Pasha's Peasants: Land, Society, and Economy in Lower Egypt, 1740–1858*. Cambridge University Press, Cambridge.

Curtin, Philip D.

 1984 *Cross-Cultural Trade in World History*. Cambridge University Press, Cambridge.

Doyon, Wendy

 2008 The Poetics of Egyptian Museum Practice. *British Museum Studies in Ancient Egypt and Sudan* 10: 1–37.

 2015 On Archaeological Labor in Modern Egypt. In *Histories of Egyptology: Interdisciplinary Measures*, edited by William Carruthers, pp. 141–56. Routledge, New York.

Drower, Margaret S.

 1982 The Early Years. In *Excavating in Egypt: The Egypt Exploration Society 1882–1982*, edited by T. G. H. James, pp. 9–36. University of Chicago Press, Chicago.

Egyptian Government Ministry of Finance

1909 *The Census of Egypt Taken in 1907*. National Printing Department, Cairo.

1920–1921 *The Census of Egypt Taken in 1917*, 2 vols. Government Press, Cairo.

Fisher, Clarence S.

1924 *The Minor Cemetery at Giza*. The Eckley B. Coxe, Jr. Foundation New Series, vol. I. The University Museum, Philadelphia.

Hall, Melanie (editor)

2011 *Towards World Heritage: International Origins of the Preservation Movement, 1870–1930*. Ashgate, Surrey.

The Harvard Crimson

1925 Found Tomb 4000 Years Old Only to Discover Undertaker Had Robbed It— Reisner Tells of Life of Archaeologist, March 18. Cambridge, MA.

Hunter, F. Robert

1999 *Egypt under the Khedives, 1805–1879: From Household Government to Modern Bureaucracy*. American University in Cairo Press, Cairo.

James, T. G. H. (editor)

1982 *Excavating in Egypt: The Egypt Exploration Society 1882–1982*. University of Chicago Press, Chicago.

Jasanoff, Maya

2005 *Edge of Empire: Lives, Culture, and Conquest in the East, 1750–1850*. Vintage Books, New York.

Jones, Frances F.

1981 Antioch Mosaics in Princeton. *Record of the Art Museum, Princeton University* 40(2): 2–26.

Legrain, Georges

1914 *Louqsor sans les Pharaons: Légendes et chansons populaires de la Haute Égypte, recueillies par Georges Legrain, Directeur des Travaux du Service des Antiquités a Karnak (Haute Égypte)*. Vromant, Brussels.

Maspero, Gaston

1914 Chansons populaires recueillies dans la Haute-Égypte, de 1900 à 1914, pendant les inspections du Service des Antiquités. *Annales du Service des Antiquités de l'Égypte* 14: 97–290.

Owen, Roger

1993 *The Middle East in the World Economy, 1800–1914*. I. B. Tauris, London.

Petrie, W. M. Flinders

1904 *Methods and Aims in Archaeology*. Macmillan, London.

1932 *Seventy Years in Archaeology*. Henry Holt, New York.

Reid, Donald M.

1985 Indigenous Egyptology: The Decolonization of a Profession? *Journal of the American Oriental Society* 105: 233–46.

2002 *Whose Pharaohs? Archaeology, Museums, and Egyptian National Identity from Napoleon to World War I.* University of California Press, Berkeley.

Reisner, George A.

1905 The Work of the Hearst Egyptian Expedition of the University of California in 1903–4. In *Records of the Past*, edited by G. Frederick Wright, vol. 4, pt. 5, pp. 131–41. Records of the Past Exploration Society, Washington, DC. http://www.gizapyramids.org/static/html/reisner_giza_bibl.jsp, accessed October 25, 2017.

1910 The Harvard Expedition to Samaria Excavations of 1909. *The Harvard Theological Review* 3: 248–63.

1922 The Harvard–Boston Egyptian Expedition. *Harvard Alumni Bulletin* 24: 943–49. http://www.gizapyramids.org/static/html/reisner_giza_bibl.jsp, accessed October 25, 2017.

1925 The Dead Hand in Egypt. *The Independent* 114: 318–24. http://www.gizapyramids.org/static/html/reisner_giza_bibl.jsp, accessed October 25, 2017.

1939 The American Archaeological Expeditions in Egypt and the Near East. In *American Activities in Egypt and the Near East*, special edition of *Journal du Commerce et de la Marine*, pp. 18–23. Alexandria, Egypt. http://www.gizapyramids.org/static/html/reisner_giza_bibl.jsp, accessed October 25, 2017.

Schaefer, Heinrich

1904 *The Songs of an Egyptian Peasant.* English edition by Frances Hart Breasted. J. C. Hinrichs, Leipzig.

Simpson, William Kelly

1974 *The Terrace of the Great God at Abydos: The Offering Chapels of Dynasties 12 and 13.* Publications of the Pennsylvania–Yale Expedition to Egypt No. 5. The Peabody Museum of Natural History of Yale University and the University Museum of the University of Pennsylvania, New Haven and Philadelphia.

Swenson, Astrid, and Peter Mandler (editors)

2013 *From Plunder to Preservation: Britain and the Heritage of Empire, c. 1800–1940.* Proceedings of the British Academy 187. Oxford University Press, Oxford.

Thomas, Nancy

1995 American Institutional Fieldwork in Egypt, 1899–1960. In *The American Discovery of Ancient Egypt*, edited by Nancy Thomas, pp. 49–75. Los Angeles County Museum of Art, Los Angeles.

Thomas, Nancy (editor)

 1996 *The American Discovery of Ancient Egypt: Essays*. Los Angeles County Museum of Art, Los Angeles.

Young, Paul

 2009 *Globalization and the Great Exhibition: The Victorian New World Order*. Palgrave Macmillan, Basingstoke, Hampshire.

CHAPTER 8

Indigenous Voices at the Margins: Nuancing the History of French Colonial Archaeology in Nineteenth-Century Algeria

Bonnie Effros

THE ATTRACTION OF ANCIENT RUINS

From at least the eighteenth century, the ruins of classical civilization drew European antiquarians to Tunis, where a few intrepid diplomats and travelers received the Ottoman Bey's authorization to visit the remains of Carthage (Díaz-Andreu 2007: 264–65; Gutron 2010: 24–25). Antiquarians like French geographer Jean-André Peyssonnel made their way farther west, too, stopping briefly at sites like the ruins of the Roman legionary camp of Lambaesis (modern Tazzoult) in the Aurès Mountains with permission of the Bey of Constantine (Dureau de la Malle 1838: 346–56). However, the French invasion and conquest of the territory of Algiers in July 1830 changed forever the thrust and tone of such exploratory activities in North Africa (Gutron 2005). In the territory that would become the colony of Algeria (Fig. 8.1), which came under French authority a full half-century before the creation of the Tunisian Protectorate, military officers played the most prominent role in the pursuit of archaeological exploration. In the post-invasion vacuum of civil governance during the conquest and re-settlement of Algeria, they became the mediators and destroyers of the region's patrimonial heritage (Oulebsir 2004: 18–19).

The barrage of military campaigns conducted between 1830 and 1872 cost Algeria nearly half of its precolonial inhabitants, many of whom died of cholera, typhus, or starvation induced by French appropriation of their modest resources (Brower 2009: 4; Gallois 2013: 56–58). The Armée d'Afrique relied upon ancient Roman stone structures for materiel and pillaged them with impunity.

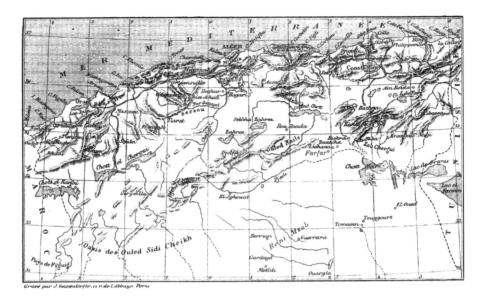

FIGURE **8.1.** Map of Algeria (Quesnoy 1888).

(Greenhalgh 2014). However, not only were these physical monuments integral to the success of their campaigns and infrastructure (Dondin-Payre 1991a: 47–48), but they also provided an ideological narrative for a war that lacked, at least at its start, a clear objective. To secure these resources as not only French possessions but also an historical inheritance from their Roman forebears (see McCarty, this volume), French archaeologists steadily delegitimized and decoupled the activities of the resident population from these ancient sites. Not only did French military officers and lay scholars allege that Arabs and Kabyles (as the Berbers of the region were known to the French) had little or no interest in monuments of the pre-Islamic past, but they suggested that local Muslims recognized the affinity between modern French and ancient Latin inscriptions as a basis for effective French historical claims to control of the region (Altekamp 2016).

FRENCH OFFICERS AND THE INSPIRATION OF ANCIENT ROME

Following the ignominy of French defeat at the end of the Napoleonic wars and the decline of the army during the Restoration Monarchy (Jourdy 1903: 2–6), Charles X launched an invasion of the Regency of Algiers as a desperate ploy to save his regime during the summer of 1830 (Sessions 2011). Although the successful campaign did not prevent his precipitous fall from the throne, it did

empower many of the aristocratic (and increasingly bourgeois) officers who were trained in elite academies like the École polytechnique and École spéciale militaire de Saint-Cyr. With a guarantee of actual fighting as opposed to peace-time duties, service in the Algerian territories offered French officers the opportunity to advance their careers rapidly (Fig. 8.2). They could be promoted as much as two times more quickly if commissioned in the French Armée d'Afrique than if they served on the European continent (Serman 1979: 20–21, 103–107). In addition to the promise of glory on the battlefield, their formal education ingrained in them the merits of classical military history. In the case of the École polytechnique, admission to the institution required mastery of Latin, and candidates who had received their baccalaureate were favored over those who had not (Bayle 1986: 62–66, 75–78, 136–45). These conditions cultivated more than passing interest in the ancient past among members of the military elite (Lorcin 2002: 298–99).

The reality of the imperial war in Algeria for French officers was quite different than many had imagined during the course of their education. They found themselves directing campaigns against elusive warriors on horseback and fighting

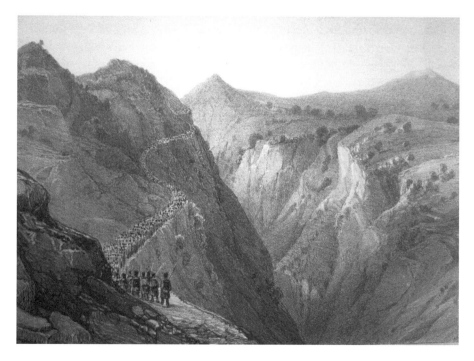

FIGURE 8.2. "Col de Ténia" (Rozet 1833: atlas).

a war with civilians rather than traditional armies; most of their own losses owed
to contagion and unpredictable and extreme weather conditions rather than com-
bat. In 1841, Major de Lioux, a battalion commander in the 53rd Infantry Regi-
ment, then stationed at the Camp of Tixeraïm (A. Birkhadem) several miles south
of Algiers, wrote to his senior colleague, General Boniface de Castellane, a veter-
an of Algeria then serving in the Pyrénées-Orientales (Brower 2009: 47–49).
With brutal candor, he described developments affecting the Armée d'Afrique and
the corrosive effects of these experiences on the soldiers under his command:

> I do not believe that in Algeria, one learns the art of war; it is a hunting party
> on a large scale, where the regiments are worn out and disappear in a short
> time; three months after their arrival, they no longer know how to fall into line;
> all that they were taught soon disappears; the hospitals devour half of them:
> and the state of things is truly deplorable, and a kind of demoralization, one
> must say … is the result (Castellane 1898: 221).

Faced with such dispiriting circumstances, officers in Algeria searched for greater
motivation for their military venture than they found from personal experience.
History, and its material correlates, offered just such motivation.

The choice of Roman history as the focus of military endeavors was almost
by default. While the Phoenicians, conquerors of North Africa and the founders
of ancient Carthage, had long attracted the attention of French antiquarians,
French officers faced significant impediments to exploring Punic remains. Access
to ancient Carthage was controlled by the Bey of Tunis, who, before the late
1850s, limited the number of Punic archaeological studies in North Africa by
French and British enthusiasts (Freed 2011: 13–23). By contrast, in Algerian
territory, there were far fewer ruins of this epoch than in neighboring Tunisia,
since Roman occupation had erased almost all traces of the Carthaginian pres-
ence (Albertini 1931: 102). Working against Carthaginian studies, too, was the
fact that the French viewed Roman civilization as superior. In the *Revue des deux
mondes* in 1841, Saint-Marc Girardin, a professor of poetry at the Sorbonne and
member of the Chambre des Députés, made the case that the Numidians and
Carthaginians exhibited less discipline than their Roman successors and thus
their civilization had less staying power.

Alternatively, other French officers queried the significance of the mega-
lithic remains found in many parts of Algeria, which some attributed to the
ancient Gauls. As will be discussed below, European prehistorians disputed this
interpretation, which connected French forces intimately to the Algerian terri-
tory. Lacking in concrete details, the purported Celtic invasion of North Africa
never took hold as a model for French governance (Dondin-Payre 1999: 184–

85; Effros 2017). By contrast, the Arab and Ottoman conquerors of North Africa, whom the French characterized as inept and inconsequential, had little chance of serving as an inspiration for the French colony: indeed, they represented the invasion's main target (Gaffarel 1883: 78). And, at least during the first four decades of French colonization, military officers who undertook excavations typically ignored Christian remains, ceramic fragments, and other remains not directly connected to the Roman army (Bayle 1985: 222–23).

Although most French officers in Algeria had not previously pursued archaeological activities, their educational background gave them sufficient familiarity to identify the ancient Roman ruins they encountered as they undertook military operations in the territory (Lorcin 1995: 99–102). When in the field with their men, French officers trained their attention on surviving stone vestiges of imperial Roman activity like aqueducts, arenas, cisterns, and temples that might serve the French soldiers' immediate needs. Once located with pick-axes and shovels, these structures were often reused or mined for cut stone necessary for the rapid construction of roads, barracks, fortifications, and other supports for the French military operation (Greenhalgh 2014). Charged with building military fortifications and barracks, officers of the Armée d'Afrique thus recognized more than anyone else the speed with which Roman ruins were disappearing. Although few were directed to do so by the minister of war or their commanding officers in the decades before the French state intervened effectively to conserve ancient monuments (Dondin-Payre 1991b: 141–45), some men voluntarily devoted time to exploring and documenting the sites that they encountered in the course of their duties (Dondin-Payre 2000: 353–56). During this period, and indeed well into the 1950s, French archaeology in Algeria consisted of uncovering and even restoring picturesque monuments that lent themselves to ceremonial purposes (Effros forthcoming; Oulebsir 2004: 85–91) and later tourism (Altekamp 2016).

From the French perspective, imperial Rome represented both a practical and attractive model for the conquest and colonization of Algeria (Girardin 1841: 424–33). Officers inspired by Roman history envisioned ancient vestiges as pilgrimage stations to the ancient past (Frémeaux 1984: 37–39). Such crumbling vestiges served as de facto evidence that the French military undertaking was part of a linear, continuous, and cumulative tradition of foreign colonial activity in North Africa (Bénabou 1980: 15–17). Notions of the historical connection between the ancient Romans and the modern French allowed them to silence or repackage the realities of their brutal assault on the Indigenous civilians of Algeria (Trouillot 1995: 70–107). It also allowed them to dismiss the Arab and Kabyle past as barbaric (Fanon 2004: 148–52). However, ideological dependence on the ancient Roman past was a double-edged sword for French

officers. Reliance on parallels between the Armée d'Afrique and that of the ancient Romans probably had a deleterious effect on their judgment. Comparisons with Rome sometimes made French officers and administrators overconfident and caused them to underestimate the challenges of conquering Algerian territory and settling it with farmers who might reap a profit for metropolitan France (Greenhalgh 1998).

ARCHAEOLOGY AND THE *ARMÉE D'AFRIQUE*

Although the succession of men who served as ministers of war in metropolitan France during the first forty years after the conquest of Algiers did not consider archaeological activity an integral part of French military strategy in North Africa, some aspects of the army's infrastructure supported such undertakings. At the advice of the Board of Health for the Armies, for instance, the Ministry of War encouraged officers to continue reading by offering them library facilities. Books, including works of classical history, housed at even the most remote outposts enabled them to conduct research on topics of scientific and historical inquiry in their free time (Castellane 1886: 211–12). Likewise, army equipment and soldiers allowed officers to pursue reconnaissance projects at ancient sites (Dondin-Payre 1996). French military resources thus facilitated archaeological undertakings even if metropolitan authorities had not given explicit license for personnel and hardware to be deployed to such ends. It was thus not unusual for French officers commissioned in the Algerian colony (sometimes accompanied by small numbers of their soldiers) to spend some portion of their time sketching ruins, copying Latin inscriptions, engaging in exploratory excavations, and collecting antiquities (Fig. 8.3).

As might be expected, some of those French officers who engaged with ancient remains were more talented and conscientious than others. One of the most skilled artists among them in the early decades of the colony was Captain Adolphe Hedwige Alphonse Delamare, a polytechnician who participated in the Commission d'Exploration Scientifique d'Algérie (1839–1842) and provided logistical and artistic support to the visiting French epigrapher Léon Renier in 1850 and 1851 (Dondin-Payre 1998). With the cartographic training they had received in the military academy, commissioned officers of the Armée d'Afrique recorded the locations of ancient ruins as they drew topographical maps essential to the movement of the army. One archaeological enthusiast, Jean-Joseph-Gustave Cler, lieutenant in the 21st light infantry regiment in the early 1840s, for instance, first came to the attention of military authorities and received coveted assignments because of the facility with which he composed topographical maps

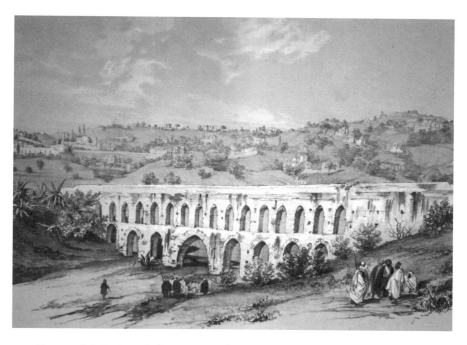

FIGURE **8.3.** Ruins of a Roman aqueduct near Algiers (Berbrugger 1843: 34).

(Service historique de l'armée de la terre, 1840). These exploratory efforts con-
tributed in the following decades to the compilation of detailed surveys of the
geography of Roman ruins throughout the Algerian colony (Vivien de Saint-
Martin 1863).

These aspects of military culture offer a window into the decentralized and
haphazard nature of the early decades of archaeological activity in Algeria, espe-
cially before the establishment of civilian rule in 1871. During this period, the
Ministry of War authorized very few archaeological ventures, with the exception
of the short-lived Commission d'Exploration Scientifique d'Algérie organized by
the Académie des Inscriptions et Belles-Lettres (Dondin-Payre 1994). With per-
mission of the minister of war, the civilian epigrapher Renier likewise made two
research visits to the Aurès Mountains in the early 1850s (Renier 1851–52).
Moreover, between 1830 and 1870, colonial authorities formulated few policies
on antiquities beyond the appointment in the mid-1840s of a single inspector-
general responsible for overseeing monuments, among other structures, through-
out Algeria. Although appointed by the minister of war, Charles Texier had a lim-
ited budget and little effective power to protect ancient structures against the

army's depredations (Dondin-Payre 2000: 355–57). The museums established in various colonial cities in the 1850s and 1860s offered testament to the toll of the war on Roman antiquities. For the most part, their displays, aimed exclusively at European colonists and visitors, showcased the fragmentary remains of ancient statues and inscriptions rescued from the French army (Effros 2016; Fig. 8.4). In Algeria, as in metropolitan France, the first real antiquities legislation to have any teeth was passed in1887; in the case of the Algerian colony, it arrived too late to save most of the ancient Roman monuments that had fallen victim to the rapacious demands of the Armée d'Afrique (Diehl 1892: 106).

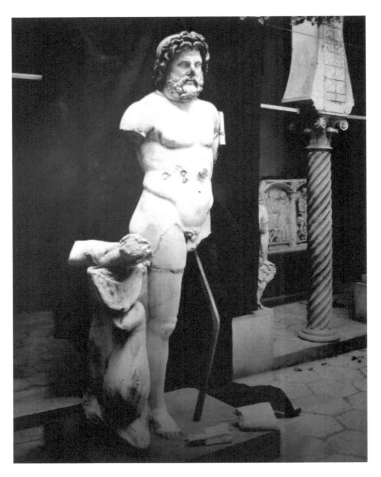

FIGURE 8.4. Like nearly all statues in the Musée d'Alger, this representation of Neptune from the French colonial city of Cherchel, which had once been the Romans' principal port and naval base in the region, was badly damaged (Leroux 1888–1892: 2).

Exploration and excavation in Algeria transpired for the most part at the inclination of officers on the ground rather than following a plan with preconceived objectives. The interests, responsibilities, and commissions of individual officers (and the extent to which they were freed from other obligations) dictated the extent to which they were able to document and preserve antiquities. Despite the fact that metropolitan authorities only sponsored a few archaeological projects and offered minimal protections for ancient monuments in the first forty years of the colonization of Algeria, this reconceptualization of the Roman past directly benefited the French regime. It offered them what Patricia Lorcin has described as an invaluable "cultural idiom for French domination" (Lorcin 2002: 295–97).

In their pursuit of inspiration for their activities, French officers-turned-archaeologists relied mainly on ancient Roman historical sources and epigraphy. Their exploration of these early works and subsequent excavations focused almost exclusively on the military and technological apparatus of the Roman imperial infrastructure (Mattingly 2011: 56). Working from this perspective, they imposed a foreign value system on Algeria's ancient patrimony that largely reflected colonial concerns with legitimacy rather than the reality of what was found on the ground (Sahli 1965: 11–13). Their writings, which mostly took the form of either reports for the military commanders to whom they reported or, from the 1850s, presentations and articles in the *Annuaire de la Société Archéologique de la Province de Constantine* or the *Revue Africaine* (Algiers), were aimed at fellow military officers and French colonists (Malarkey 1984: 140–43). As such, they neither accurately reported on the nature of Roman society nor did they address the full spectrum of ancient remains to be found in the territory (Dondin-Payre 2003: 145–47; Oulebsir 2004: 99–103). Although the dissemination in France of their research was limited as compared to metropolitan journals, editors of the *Revue Archéologique* periodically published important discoveries first featured in these colonial journals for a broader scholarly audience. Consequently, the conclusions reached by officer-archaeologists in the early decades of the nineteenth century had a lasting impact on contemporary scholars' approach to classical North Africa, and continue to distort classists' understanding of this epoch (Février 1989: 88).

SILENCING COMPETITION OVER ANCIENT ROME

When launching their exploration of Roman ruins, some French officers recognized that they were not the first to excavate these sites. In the early 1830s, Captain Claude-Antoine Rozet reported that the ancient monuments he encountered near Algiers were not in pristine condition but had been disturbed by digging that he attributed to local residents:

> We saw in the interior of Rustonium [a ruined Roman settlement on the promontory of Matifou, east of the bay of Algiers] many excavations of which some were still very recent: they were the result of excavations undertaken by the Arabs, either to extract the stones to build since they found them already cut, or to look for coins and other art objects, regarding which I was told that in different periods of time one had found a large quantity [of such items] (Rozet 1833: 3: 182–83).

Indeed, across the Maghreb, Arabs and Kabyles had long been familiar with Roman structures. In the case of aqueducts, cisterns, roads, and bridges, they maintained them for practical reasons. In other circumstances, they viewed ancient sites as quarries of worked stone for building mosques and palaces (Saadoui 2008), much like the French themselves would subsequently do on a larger scale in the period of the colonial conquest and settlement of Algeria (Greenhalgh 2009: 313–21, 447–68).

A small number of French officers of the Armée d'Afrique publicly recognized the degree to which they were dependent on engagement with the Indigenous people so that they might learn about antiquities in still-inaccessible regions. Before the *razzia* (punitive expeditions against Arab and Kabyle tribes that disproportionately affected civilian populations) were fully institutionalized by the French in the early 1840s (Gallois 2013: 92–93), those few officers who could speak some Arabic or Berber interrogated Muslim informants about not just natural features of the landscape also but ancient monuments. Colonel Franciade Fleurus Duvivier credited the Arab and Kabyle inhabitants he encountered with knowledge of ancient remains (Fig. 8.5). Duvivier wrote:

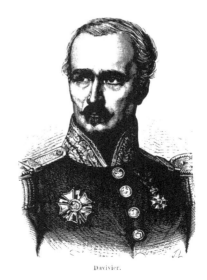

FIGURE **8.5.** Franciade Fleurus Duvivier (Quesnoy 1888).

A large number of indigenous people from all of the tribes came to Guelma [where he was stationed]. I asked them, and took note of all of their responses. Soon I saw that I could arrive at creating a map of many of the lands that we probably would not visit for a long time. This is the result that I now publish. It took me five months, working at least 18 hours per day (Duvivier 1841: 1).

As he compiled his atlas of Roman finds in the late 1830s in the subdivision of Guelma to the southeast of Constantine, he acknowledged the importance of their contributions since he had not been able to visit many relevant sites in his survey due to his primary responsibilities as commander of the subdivision. Great danger remained in doing so without a substantial military escort.

By the mid-1840s, however, it seems that the possibility of this sort of exchange had been mostly eliminated for officers. A combination of growing French distrust of non-Europeans, the continuing effects of the deadly *razzia*, and progressive *cantonnement* of the Muslim population that resulted in their segregation from civilian colonists, largely brought an end to such exchanges. Officers of the Bureaux Arabes, the administrative wing of the French army that shaped policy for Indigenous tribes and whose duties brought them into regular contact with the Muslim inhabitants of Algeria, were some of the few exceptions to the new status quo (Abi-Mershed 2010: 32–40). In the 1840s and 1850s, military officers (and especially those who served in the Bureaux Arabes) went to great lengths to distinguish their own activities from those of the Arabs and Kabyles whom they castigated as motivated by a desire for profit from stone ornaments and ancient coins. Archaeologists like Oscar MacCarthy, who later directed the Bibliothèque-Musée d'Alger, claimed that the Arabs and Kabyles they encountered were insistent that the French were exploring ancient sites mainly to find hidden gold and silver left by the ancient inhabitants (MacCarthy 1857: 364), an accusation that was also leveled against Egyptian natives on the other side of North Africa (Leask 2002: 143–51).

Instead of tapping local knowledge of monuments, French officers and officials voiced self-serving allegations about Indigenous residents' ignorance of or lack of interest in classical antiquities (Cherbonneau 1853: 112). They blamed Muslim inhabitants for their poor stewardship of Roman sites over the centuries (Malarkey 1984: 144–52). Some went further and claimed that Muslim Algerians resented, were hostile to, or fearful of monuments that predated Islam. Scholars like Renier argued that this neglect gave the French nation moral title to the territory (Renier 1851–52: 513). Although the French army had destroyed many ancient monuments (and civilian settlers continued to do so), most officers chose not to acknowledge their responsibility for these losses. The vilification of Arabs and Kabyles as barbarous peoples was part and parcel of broader attempts by the

French to marginalize Arab and Ottoman rule, with claims that their lack of responsible custodianship had left formerly fertile lands a desert (Davis 2007: 1–10; Heffernan 1991).

At the same time they castigated Arab and Kabyle treatment of ancient monuments, French military officers who served in Algeria drew parallels between Roman and French ingenuity and productivity. J.-A.-N. Périer, a medical officer who formed part of the official Commission Scientifique d'Algérie from the late 1830s, concluded that Roman monuments in even the most lifeless spaces demonstrated that:

> in the distant past, our conquest [Algeria] was the seat of flourishing colonies. The magnificent ruins that one finds at each step in certain provinces and that our arms will recover one day, attest to its prosperity in a different era. This land, then the object of powerful exploitation, was neither deforested nor depopulated as we see it today; along with Sicily and Africa proper, it was the abundant granary of Rome and of Italy, "Romam magnâ ex parte sustentabat Africae fertilitas". Ignorance, human degeneration [under Arab rule] created agricultural decadence and endemic invasions (Périer 1847: 29–30).

Contributions by metropolitan officers and civilians thus highlighted the superiority of Roman achievements to those who succeeded them and suggested that exclusively ancient material remains pointed the way forward. Topographical maps and surveys of ancient remains, like those of Ernest Carette (1838, 1848) and Charles de Vigneral (1867, 1868), which preceded the more comprehensive activities of the Brigades Topographiques by decades (Greenhalgh 2014: 250–54), allowed the French to convert Roman history and its monuments into a physical justification for their rule.

In the early years of the conquest, French visitors to North Africa sometimes alluded to the fact that they felt as if they were witnessing a drama in which live characters stepped out of an imagined tableau of classical antiquity. During an 1832 trip to Morocco, for instance, the Romantic artist Eugène Delacroix imagined that Cato, Brutus, and Cicero were brought to life by the people he saw pass by on the streets (Joubin 1936: 318–19, 327). Despite the easy elision of ancient and modern inhabitants, however, French officers and civilian travelers failed to take the next logical step of more closely observing or interviewing Indigenous witnesses to learn more about ancient life. These memoirs were not meant as scientific reports on ancient customs but instead highlighted the exoticism of such locales; French observers suggested that their subjects were frozen in time and unconscious of the circumstances that enlightened European observers (Béna-

bou 1975: 10). Such omissions conveniently allowed the French to maintain exclusive control over the narrative of the ancient past.

In subsequent decades, identification with ancient Rome was more likely to lead French officers and civilians, many of whom were advocates of Saint-Simonian precepts of modernization that became an integral component of the French *mission civilisatrice* under the Third Republic (Abi-Mershed 2010), to blur the line between contemporary "enemies" and ancient ones. They condemned Indigenous inhabitants as living primitives, a stance that allowed them to dismiss the peoples they encountered as inferior to themselves and suggest that they could not be active participants in the new French colony. As noted on June 7, 1838 by Captain Armand Jacques Leroy de Saint-Arnaud, at the time an officer in the Foreign Legion stationed in Algiers, in a letter written to his younger brother in metropolitan France:

> Among no other people, I believe, are there as many contrasts as among the Arabs, and there is no people that is less advanced, less changed than that group. Every day I see the days of Abraham, of Isaac, and of Jacob. I see the Numidians of Juba and of Massinissa. I saw, near Constantine, the war-bands of Jugurtha. The men are the same, the horses are the same, the dress is entirely the same. What have time and civilization brought them? (Saint-Arnaud 1855: 170)

Saint-Arnaud had no difficulty relegating the conquered population to the distant and even biblical past. Mixing historical events seamlessly, he suggested that these people were none other than the peoples conquered by the Phoenicians and the Romans in ancient times, and thus could adapt only with great difficulty to current conditions of French rule. French perceptions of Arabs and Kabyles as "ancients" denigrated the population as too primitive or lazy to appreciate the historical past (Féraud 1878: 5), and rendered them unqualified to be involved in the scientific exploration of Algeria's ancient monuments.

The enduring link between professional military and amateur archaeological activities pursued by officers thus had pernicious effects on both the interpretation of ancient remains and their relationship with Muslim inhabitants of North Africa. As noted by David Mattingly,

> If the European claim to be the rightful inheritors of North Africa was to carry weight it was necessary to disinherit the native peoples. An important corollary, then, to making a close identification between the modern imperial power and Rome was to reinforce the feeling of inferiority and separateness of the indigenous population. Drawing on the orientalist tradition, a crude stereotype of the

Berber populations emerged: they were barbarians, savages, incapable of living at peace or of organizing themselves at a polity level. It was their lot to be raised up periodically by indulgent colonizing powers—Carthage, Rome, the Vandals, Byzantium, the Arabs, the Ottomans.... (2011: 47–49).

The extent to which such claims were pressed grew over the course of the century. In 1891, at a meeting of the Congrès des sociétés savantes (Février 1989: 89), and again in 1897, Gaston Boissier exhorted his contemporaries:

The indigenous people call us *Roumis*; they regard us as descendants and the heirs of those who governed them for so long and of whom they confusedly retain a great memory; it is necessary for us to accept this heritage since we will find in it great profit. From the moment that we attach ourselves to this glorious past, we are no longer strangers, intruders, people who arrived yesterday, whom a happy venture tossed to an unknown land; we have there [in North Africa] predecessors, ancestors; we just continued a great work of civilization which was interrupted for centuries; we just took back possession of this ancient domain. And its old monuments, which Arabs cannot pass without feeling respect and fear, are precisely our title deeds (Boissier 1897: 18).

After six decades of rule, some French colonists unabashedly concluded not just that they were heirs of the conquerors of the Gauls but their direct descendants (McCarty, this volume).

IMAGINING THE PREHISTORY OF NORTH AFRICA

In only one contemporary category of archaeological exploration did the French acknowledge Arabs' and Kabyles' continued interaction with ancient remains. As early as the eighteenth century, visiting Europeans made note of monuments in North Africa that were thought to have preceded classical civilizations (Camps 1961: 13–14). Soon after the conquest of Algiers, French officers like Captain Rozet documented megalithic stone formations in several locations to the west of the city (Rozet 1833: 1: 11). Consequently, these early monuments formed the object of some of the earliest research papers presented to fellow members of the newly founded archaeological societies in Algiers and Constantine in the mid-1850s and early 1860s (Février 1989: 43; Oulebsir 2004: 104–105). Given overwhelming interest in imperial Roman ruin among the French, these studies of the so-called antediluvian past of North Africa were exceptional in terms of the subject but not in terms of their larger ideological imperatives (Effros 2017).

Because prehistoric monuments were enigmatic and initially lacked the more obvious connection to modern events exhibited by Roman ruins, standing stones garnered only passing comment with vague attributions to the ancient inhabitants of the region (Bayle 1986: 230–34). In April 1863, however, a French army interpreter, Laurent-Charles Féraud, visited the springs of Bou-Merzoug located thirty-five kilometers southeast of Constantine, on the route to the French military camp at Batna, with the British antiquarian Henry Christy. The two men viewed thousands of dolmens and ancient tombs and subsequently spent several days excavating with the help of some laborers. Alleging that these early remains had been left by the ancient Gauls, Féraud published his initial impressions in the journal of the Société Archéologique de Constantine (Féraud 1863: 215–17; Malarkey 1984: 153). A little more than a year later, he published a larger survey of prehistoric finds in the region of Constantine in the *Revue archéologique*, by then the leading archaeological journal in metropolitan France directed by Alexandre Bertrand (Féraud 1865: 202–17). Naturally, the attraction of his hypothesis was the opportunity it provided to suggest a close affinity to the French, who claimed descent from the ancient Celtic Gauls, with the early inhabitants of the region. Despite some hesitation in accepting all of Féraud's ideas, some leading French archaeological authorities like Bertrand were reluctant to reject his proposal outright (Bertrand 1863). As with discussions of Roman imperial remains, French archaeological interests coincided with the desire to see ancient ruins as a mirror of their history and a blueprint for conquest (Coye 1993).

However, Féraud's claims to the Celtic origins of Algerian megaliths quickly met with considerable resistance among the growing international body of scholars then studying prehistory. Few prehistorians, especially those outside of France, were convinced by Féraud's argument that these remains had a particular connection to France, since similar finds had been made as far north as Scandinavia (Troyon 1864). By the late 1860s, scholars dismissed Féraud's Celtic theory and replaced it with the view that the population responsible for constructing such prehistoric monuments represented the forebears of the Berber population who had mixed with European emigrants in this early period (Camps 1961: 15–20). This interpretation gained popularity among French authorities because it, in turn, fostered hopes that the Kabyles, who they now argued were descended from people like the ancestors of the French, might adapt more easily than Arabs to European conventions. The "Kabyle myth" suggested that Arabs, whose alleged fanaticism ruled out conversion to Christianity, could not easily assimilate, if at all (Lorcin 1995: 133–34).

Féraud's observations, however, did not end with his attribution of the megalithic remains to the very same Celts of ancient Gaul. As an officer of the

Bureaux Arabes with extensive contact with Indigenous communities, the army translator also seized the opportunity to criticize local inhabitants for their superstitious beliefs and what he described as their treasure hunting at ancient sites. He alleged that the only thing that had prevented the Indigenous population from pillaging such locales was their greater fear of the possible presence of vampires or ogres (*el-R'oul*), thought to live in nearby caves:

> The indigenous people believe that many of these monuments contain treasures, but a sort of superstitious fear paralyzes their cupidity and has always stopped them from touching what the hand of pagans (*djouhala*) built (Féraud 1863: 229–30).

From Féraud's standpoint, Native credulity was also revealed in Berber lore of El'Aroussa (The Fiancée), the local name given to a dolmen of gray limestone in eastern Kabylia. He noted that the Kabyles believed that these stones were the remains of an incestuous couple that had been divinely punished for seeking to consummate their relationship through marriage. The legend he conveyed attributed the surrounding megaliths to the remains of wedding guests and the *qadi* or judge who had agreed to officiate at the impious ceremony (Féraud 1863: 233–34).

There is no surprise that it was an officer of the Bureaux Arabes, a division of the French military administration that had considerable latitude in negotiating official directives of French authorities with Native tribes, who offered this testimony (Lorcin 1995: 116–20). Féraud was not the last to propose this interpretation. Following the establishment of the Protectorates of Tunisia and Morocco, in 1881 and 1912, respectively, ethnographers interviewing Indigenous peoples produced accounts with similarly fantastical explanations of megalithic remains (Doutté 1914: 380–81, 419–20). The testimony of scholars like Edmond Doutté, who surveyed Moroccans on their views of prehistoric remains, however, was tainted by the innate prejudices ingrained in their studies. Doutté's blunt admission that he viewed North Africa as having been plunged into barbarism by Islam, for instance, suggests that the French ethnologist was predisposed to seeing his informants as backwards or primitive and granting them little or no credit for their knowledge of the sites in question (Amster 2013: 68–71; Doutté 1914: 419). Unfortunately, some modern scholars have not been much more sensitive to these prejudices against Arabs and Berbers in Algeria. Rather than pointing to the extent to which colonial ethnographers like Doutté were embedded in the imperial project (Trumbull 2009: 147–67), they have continued to dismiss what they characterize as fantastical explanations motivated by superstition, ignorance, warped collective memory of earlier legends, and distaste for pre-Islamic remains (Dakhlia 1990: 42–49).

Legacies of Nineteenth-Century Colonial Archaeology

Although French officers and civilians denied the value of contributions by non-European residents to their own understanding of antiquities, such observations lived on in the margins of French military reports and archaeological studies of the first decades of the French conquest of Algeria. As thoughtfully theorized by Ann Stoler, "colonial archives were both transparencies on which power relations were inscribed and intricate technologies of rule in themselves" (Stoler 2009: 1–22). Local witnesses' interactions with ancient monuments that predated those of the French posed a challenge to the ideological thrust of archaeological campaigns that justified French conquest and settlement. The nagging presence of these comments in archaeological reports suggests that French officers and civilians interested in the ancient past needed an arsenal of negative anecdotes about Muslim interactions with ancient sites to justify not just their research but also the colonial enterprise more generally. Silencing Indigenous voices made possible the successful and complete appropriation of ancient monuments in conquered territory and thus supported the logic of the "civilizing mission."

Indeed, the case of Algeria was far from unique in the nineteenth century. Little incentive existed to accommodate contradictory narratives in the colonial context. Around the Mediterranean, historians exploring the practice of colonial archaeology have demonstrated that local inhabitants' relationships with remnants of the ancient Roman past were longstanding, complex, and an integral part of their beliefs and customs despite the fact that these usages were regularly belittled by Western European scholars and colonizers (Hamilakis 2011). Interest in the ancient past occurred in both Christian parts of the former Ottoman Empire and in Egypt, where conservation of ancient monuments was just one facet of emergent nationalism (Colla 2007: 10–20, 121–26). These examples suggest that great caution is necessary in judging the veracity of the repeated claims by colonizers that Muslim populations lacked any connection to the pre-Islamic past, a commonplace assertion even in recent studies (Huot 2008). In the case of colonial Algeria, French accounts support the conclusion that officers and civilians interested in antiquities were aware of the longstanding relationships of Arabs and Kabyles to ancient ruins yet continually denigrated them (Malarkey 1984: 152–57). Consequently, we have little understanding of the nature of these relationships among a largely illiterate population because such observations were not deigned sufficiently worthy of preservation or were categorized as ignorant or subversive by French officers-turned-archaeologists. While the interactions of Arabs and Kabyles with Roman sites in Algeria may not have been

"archaeological" in a traditional sense, Muslim inhabitants' co-existence with ancient remains in their environs was nonetheless meaningful and longstanding.

There is no doubt that the archaeological drawings and publications created by French officers in the nineteenth century are of variable quality and importance. As they were the arbiters of what was explored and destroyed, they privileged fortifications, "grands monuments," and inscriptions, while mostly ignoring more modest antiquities (Bayle 1985: 225). Unfortunately, however, these documents are, in many cases, the only extant record of monuments that were destroyed during French military operations and the expansion of European civilian settlement in nineteenth-century Algeria (Dondin-Payre 2003: 154–55). In addition to the destruction caused by colonial activities, the common excavation practice of stripping out post-classical levels to reach earlier, more valued remains further compromised Roman archaeological sites in Algeria (Wickham 2005: 635). These problems were magnified by French officers' habitual tendency to date remains to the classical period without any serious consideration of other possibilities (Lepelley 1996: 54). Efforts to link nineteenth-century French archaeological reports and publications in Algeria to their colonial context reveal the broad parameters of the prejudicial bias common in studies dating to this era. Historians and archaeologists of classical and post-classical North Africa ignore this legacy at their peril.

Acknowledgments

Research travel for this essay was funded by the Rothman Endowment at the Center for the Humanities and the Public Sphere at the University of Florida and a National Endowment for the Humanities Summer Stipend (2013). A George Kennan Membership in the School of Historical Studies at the Institute for Advanced Study, with additional funding provided by the Hetty Goldman Membership Fund (2013–2014), offered necessary resources, support, and feedback. I thank Matt Delvaux, Matt McCarty, fellow contributors to this volume, and the anonymous reviewers for their critical comments and suggestions.

References Cited

Abi-Mershed, Osama W.
2010 *Apostles of Modernity: Saint-Simonians and the Civilizing Mission in Algeria.* Stanford University Press, Stanford, CA.

Albertini, Eugène
 1931 L'Algérie antique. In *Histoire et historiens de l'Algérie*, Collection du centenaire de l'Algérie (1830–1930), vol. 4, pp. 89–109. Librairie Félix Alcan, Paris.

Altekamp, Stefan
 2016 Modelling Roman North Africa: Advances, Obsessions and Deficiencies of Colonial Archaeology in the Maghreb. In *Under Western Eyes. Approches occidentales de l'archéologie nord-africaine (XIXᵉ–XXᵉ siècles)*, edited by Hédi Dridi and Antonella Mezzolani Andreose, pp. 19–42. BraDypUS, Bologne.

Amster, Ellen J.
 2013 *Medicine and the Saints: Science, Islam, and the Colonial Encounter in Morocco, 1877–1956*. University of Texas Press, Austin.

Bayle, Nadia
 1985 Armée et archéologie au XIXᵉ siècle: Elements de recherche sur les travaux archéologiques des officiers français publiés entre 1830 et 1914. *Revue d'archéologie moderne et d'archéologie générale (RAMAGE)* 3: 219–30.

 1986 Quelques aspects de l'histoire de l'archéologie au XIXᵉ siècle: l'exemple des publications archéologiques militaires éditées entre 1830 et 1914 en France, en Afrique du Nord et en Indo-Chine, vol. 1. PhD diss., Université de Paris-Sorbonne (Paris IV).

Bénabou, Marcel
 1975 *La résistance africaine à la romanisation*, Librairie François Maspero, Paris.

 1980 L'impérialisme et l'Afrique du Nord: le modèle romain. In *Sciences de l'homme et conquête coloniale: Constitution et usages des sciences humaines en Afrique (XIXᵉ–XXᵉ siècles)*, edited by Daniel Nordman and Jean-Pierre Raison, pp. 15–22. Presses de l'École normale supérieure, Paris.

Berbrugger, Adrien
 1843 *Algérie historique, pittoresque et monumentale ou Recueil de vues, costumes, et portraits faits d'après nature dans les provinces d'Alger, Bône, Constantine et Oran*, Part 1: Province d'Alger. Chez J. Delehaye, Éditeur, Paris.

Bertrand, Alexandre
 1863 Monuments dits celtiques dans la province de Constantine. *Revue archéologique*, nouvelle série, 8: 519–30.

Boissier, Gaston
 1897 L'histoire en Tunisie. In *La France en Tunisie*, edited by Marcel Dubois, et al., pp. 17–21. G. Carré et C. Naud, Éditeurs, Paris.

Brower, Benjamin Claude
 2009 *A Desert Named Peace: The Violence of France's Empire in the Algerian Sahara, 1844–1902*. Columbia University Press, New York.

Camps, Gabriel
 1961 *Aux origines de la Berbérie: Monuments et rites funéraires protohistoriques.* Arts et métiers graphiques, Paris.

Carette, Ernest
 1838 *Précis historique et archéologique sur Hippone et ses environs.* Imprimerie Lange Lévy et Compagnie, Paris.
 1848 *Exploration scientifique de l'Algérie pendant les années 1840, 1841, 1842,* Sciences historiques et géographiques 5. Imprimerie nationale, Paris.

Castellane, Louis-Charles-Pierre, Comte de
 1886 *Souvenirs of Military Life in Algeria* 1, trans. by Margaret Josephine Lovett. Remington and Co., Publishers, London.

Castellane, Ruth Charlotte-Sophie de, Comtesse de Beaulaincourt-Marles (editor)
 1898 *Campagnes d'Afrique 1835–1848. Lettres adressées au Maréchal de Castellane.* Librairie Plon, Paris.

Cherbonneau, Auguste
 1853 Constantine and Her Antiquities. *Annuaire de la Société archéologique de la province de Constantine* 1: 102–36.

Colla, Elliot
 2007 *Conflicted Antiquities: Egyptology, Egyptomania, Egyptian Modernity.* Duke University Press, Durham, NC.

Coye, Noël
 1993 Préhistoire et protohistoire en Algérie au XIXe siècle: les significations du document archéologique. *Cahiers d'études africaines* 33(129): 99–137.

Dakhlia, Jocelyne
 1990 *L'oubli de la cité: la mémoire collective à l'épreuve du lignage dans le Jérid tunisien.* Éditions la Découverte, Paris.

Davis, Diana K.
 2007 *Resurrecting the Granary of Rome: Environmental History and the French Colonial Expansion in North Africa.* Ohio University Press, Athens.

Díaz-Andreu, Margarita
 2007 *A World History of Nineteenth-Century Archaeology: Nationalism, Colonialism, and the Past.* Oxford University Press, Oxford.

Diehl, Charles
 1892 Les découvertes de l'archéologie française en Algérie et en Tunisie. *Revue internationale de l'enseignement* 24: 97–130.

Dondin-Payre, Monique
 1991a De la Gaule romaine à l'Africa: à la recherche d'un heritage commun. In *Camille Jullian, l'histoire de la Gaule et le nationalisme français: Actes du colloque organisé à Lyon le 6 décembre 1988,* pp. 39–49. Société des amis de Jacob Spon, Lyons.

1991b *L'Exercitus africae* inspiratrice de l'armée française d'Afrique: *Ense et aratro.* *Antiquités africaines* 27: 141–49.

1994 *La Commission d'exploration scientifique d'Algérie: Une héritière méconnue de la Commission d'Égypte.* Mémoires de l'Académie des inscriptions et belles lettres, nouvelle série 14. Imprimerie F. Paillart, Paris.

1996 Réussite et déboires d'une oeuvre archéologique unique: le Colonel Carbuccia au nord de l'Aurès (1848–1850). *Antiquités africaines* 32: 145–74.

1998 La production d'images sur l'espace méditerranéen dans la Commission d'exploration scientifique d'Algérie. Les dessins du capitaine Delamare. In *L'invention scientifique de la Méditerranée: Égypte, Morée, Algérie*, edited by Marie-Noëlle Bourguet, Bernard Lepetit, Daniel Nordmann, and Maroula Sinarellis, pp. 223–38. Éditions de l'École des Hautes Études en Sciences sociales, Paris.

1999 L'entrée de l'Algérie antique dans l'espace méditerranéen. In *Enquêtes en Méditerranée: Les expéditions françaises d'Égypte, de Morée et d'Algérie: Actes du colloque Athènes-Napulie, 8–10 juin 1995*, edited by Marie-Noëlle Bourguet, Daniel Nordmann, Vassilis Panayotopoulos, and Maroula Sinarellis, pp. 179–91. Institut de recherches néohelléniques, Athens.

2000 La mise en place de l'archéologie officielle en Algérie, XIXe–début du XXe. In *Aspects de l'archéologie française au XIXe siècle. Actes du colloque international tenu à la Diana à Montbrison les 14 et 15 octobre 1995*, edited by Pierre Jacquet and Robert Péricon, pp. 351–99. Recueil de mémoires et documents sur Le Forez publiés par la Société de la Diana 28. La Diana, Montbrison.

2003 L'archéologie en Algérie à partir de 1830: une politique patrimoniale? In *Pour une histoire des politiques du patrimoine*, edited by Philippe Poirrier and Loïc Vadelorge, pp. 145–70. Travaux et documents 16. Comité d'histoire du Ministère de la culture, Paris.

Doutté, Edmond

1914 *En Tribu.* Paul Geuthner, Éditeur, Paris.

Dureau de la Malle, Adolphe

1838 *Peyssonnel et Desfontaines, Voyages dans les régences de Tunis et d'Alger* 1. Librairie de Gide, Paris.

Duvivier, Franciade Fleurus

1841 *Recherches et notes sur la portion de l'Algérie au sud de Guelma depuis la frontière de Tunis jusqu'au Mont Aurèss compris.* Imprimerie de L. Vassal et Cie., Paris.

Effros, Bonnie

2016 Museum-building in nineteenth-century Algeria: Colonial narratives in French collections of classical antiquities. *Journal of the History of Collections* 28(2): 243–59.

2017 Ancient Gauls and Vandals in Colonial Algeria: Archaeology, Craniology, and
 Berber Origins. *British Journal of History of Science* 50(1): 61-81. https://
 doi.org/10.1017/S0007087417000024.

Forthcoming *Incidental Archaeologists: French Officers and the Rediscovery of Roman
 North Africa.* Cornell University Press, Ithaca, NY.

Fanon, Frantz
2004 *The Wretched of the Earth*, translated by Richard Philcox. New York: Grove
 Press.

Féraud, Laurent-Charles
1863 Monuments dits celtiques dans la province de Constantine. *Recueil des notices et
 mémoires de la Société archéologique de la Province de Constantine* (1863):
 214–34.

1865 Recherches sur les monuments dits celtiques de la province de Constantine.
 Revue archéologique, n.s. 11: 202–17.

1878 *Exposition universelle de Paris en 1878. Algérie: Archéologie et histoire.* Typogra-
 phie et lithographie Adolphe Jourdan, Imprimeur-Libraire, Algiers.

Février, Paul-Albert
1989 *Approches du Maghreb romain. Pouvoirs, différences et conflits*, vol. 1. ÉDISUD,
 Aix-en-Provence.

Freed, Joann
2011 *Bringing Carthage Home: The Excavations of Nathan Davis, 1856–1859.* Oxbow
 Books, Oxford.

Frémeaux, Jacques
1984 Souvenirs de Rome et présence française au Maghreb: Essai d'investigation. In
 Connaissances du Maghreb: Sciences sociales et colonisation, edited by Jean-Claude
 Vatin, pp. 29–46. Éditions du Centre national de la recherche scientifique, Paris.

Gaffarel, Paul
1883 *L'Algérie. Histoire, conquête et colonisation.* Librairie de Firmin-Didot et Cie,
 Paris.

Gallois, William
2013 *A History of Violence in the Early Algerian Colony.* Palgrave Macmillan, New
 York.

Girardin, Saint-Marc
1841 De la domination des Carthaginois et des romaines en Afrique comparée avec la
 domination française. *Revue des deux mondes* 4(26): 408–45.

Greenhalgh, Michael
1998 The New Centurions: French Reliance on the Roman Past during the Conquest
 of Algeria. *War and Society* 16(1): 1–28.

2009 *Marble Past, Monumental Present: Building with Antiquities in the Mediaeval Mediterranean.* Brill, Leiden.

2014 *The Military and Colonial Destruction of the Roman Landscape of North Africa, 1830–1900.* E. J. Brill, Leiden.

Gutron, Clémentine

2005 L'abbé Bourgade (1806–1866), Carthage et l'Orient: de l'antiquaire au publiciste. *Anabases* 2: 177–91.

2010 *L'archéologie en Tunisie (XIX^e^–XX^e^ siècles): Jeux généalogiques sur l'Antiquité.* Karthala, Paris.

Hamilakis, Yannis

2011 Indigenous Archaeologies in Ottoman Greece. In *Scramble for the Past: A Story of Archaeology in the Ottoman Empire, 1753–1914,* edited by Zainab Bahrani, Zeynep Çelik, and Edhem Eldem, pp. 49–69. SALT, Istanbul, 2011.

Heffernan, Michael J.

1991 The Desert in French Orientalist Painting during the Nineteenth Century. *Landscape Research* 16: 37–42.

Huot, Jean-Louis

2008 L'archéologie dans le monde musulman. In *L'avenir du passé: Modernité de l'archéologie,* edited by Jean-Paul Demoule and Bernard Stiegler, pp. 183–95. La Découverte, Paris.

Joubin, André (editor)

1936 *Correspondance générale de Eugène Delacroix,* vol. 1: 1804–1837. Librairie Plon, Paris.

Jourdy, Général

1903 *L'Instruction de l'armée française de 1815 à 1902.* Félix Alcan, Éditeur, Paris.

Leask, Nigel

2002 *Curiosity and the Aesthetics of Travel Writing, 1770–1840: 'From an Antique Land'.* Oxford University Press, Oxford.

Lepelley, Claude

1996 The Survival and Fall of the Classical City in Late Roman North Africa. In *The City in Late Antiquity,* edited by John Rich, pp. 50–76. Routledge, London.

Leroux, Alexandre

1888–92 *L'Algérie illustrée,* vol. 2. A. Leroux, Algiers.

Lorcin, Patricia

1995 *Imperial Identities: Stereotyping, Prejudice and Race in Colonial Algeria.* I. B. Tauris Publishers, London.

2002 Rome and France in Africa: Recovering Colonial Algeria's Latin Past. *French Historical Studies* 25(2): 295–329.

MacCarthy, Oscar
 1857 Algeria romana: recherches sur l'occupation et la colonization de l'Algérie par les romains. *Revue africaine* 1(5): 346–69.

Malarkey, James
 1984 The Dramatic Structure of Scientific Discovery in Colonial Algeria: A Critique of the Journal of the 'Société archéologique de Constantine' (1853–1876). In *Connaissances du Maghreb: Sciences sociales et colonisation*, edited by Jean-Claude Vatin, pp. 137–60. Centre national de la recherche scientifique, Paris.

Mattingly, David
 2011 From One Colonialism to Another: Imperialism and the Maghreb. In *Imperialism, Power, and Identity: Experiencing the Roman Empire*, pp. 43–72. Princeton University Press, Princeton, NJ.

Oulebsir, Nabila
 2004 *Les usages du patrimoine: monuments, musées, et politique coloniale en Algérie (1830–1930)*. Éditions de la Maison des sciences de l'homme, Paris.

Périer, Jean-André-Napoléon
 1847 *Exploration scientifique de l'Algérie pendant les années 1840, 1841, 1842*. Sciences médicales 1. Imprimérie impériale, Paris.

Quesnoy, F.
 1888 *L'armee d'Afrique depuis la conquête d'Alger*. Librairie Furne Jouvet et Cie, Éditeurs, Paris.

Renier, Léon
 1851–52 Notes d'un voyage archéologique au pied de l'Aurès. *Revue archéologique* 8.2 (October 15, 1851–March 15, 1852): 492–513.

Rozet, Claude-Antoine
 1833 *Voyage dans la Régence d'Alger ou Description du pays occupé par l'armée française en Afrique*, 3 vols. and atlas. Arthus Bertrand, Libraire-Éditeur, Paris.

Saadoui, Ahmed
 2008 Le remploi deans les mosquées ifriqiyennes aux époques médiévale et modern. In *Lieux de cultes: aires votives, temples, églises, mosquées. IX^e colloque international sur l'histoire et l'archéologie de l'Afrique du Nord antique et médievale, Tripoli, 19–25 février 2005*, pp. 295–304. CNRS Éditions, Paris.

Sahli, Mohamed C.
 1965 *Decoloniser l'histoire. Introduction à l'histoire du Maghreb*. Cahiers libres 77. François Maspero, Paris.

Saint-Arnaud, Jacques Leroy de
 1855 *Lettres du Maréchal de Saint-Arnaud 1*. Michel Lévy Frères, Libraires-Éditeurs, Paris.

Serman, William
 1979 *Les origines des officiers français, 1848–1870*. Publications de la Sorbonne, Paris.
Service historique de l'armée de la terre (SHAT)
 1840 Letter dated November 14, 1840, from the Président de la Commission d'Etat-major to the Duc de Dalmatie, Président du Conseil, Ministre de la Guerre. SHAT 8 Yd 3356. Service Historique de l'Armée de la Terre, Vincennes.
Sessions, Jennifer E.
 2011 *By Sword and Plow: France and the Conquest of Algeria*. Cornell University Press, Ithaca, NY.
Stoler, Ann Laura
 2009 *Along the Grain: Epistemic Anxieties and Colonial Common Sense*. Princeton University Press, Princeton, NJ.
Trouillot, Michel-Rolph
 1995 *Silencing the Past: Power and the Production of History*. Beacon Press, Boston.
Troyon, Frédéric
 1864 Lettre à M. A. Bertrand sur l'attitude repliée dans les sépultures antiques. *Revue archéologique* n.s., 9: 289–99.
Trumbull, George R. IV
 2009 *An Empire of Facts: Colonial Power, Cultural Knowledge, and Islam in Algeria, 1870–1914*. Cambridge University Press, Cambridge.
Vigneral, Charles de
 1867 *Ruines romaines de l'Algérie, subdivision de Bône, cercle de Guelma*. Imprimerie de J. Claye, Paris.
 1868 *Ruines romaines de l'Algérie, Kabylie du Djurdjura*. Imprimerie de J. Claye, Paris.
Vivien de Saint-Martin, Louis
 1863 *Le Nord de l'Afrique dans l'antiquité grecque et romaine. Étude historique et géographique*. Imprimerie impériale, Paris.
Wickham, Chris
 2005 *Framing the Early Middle Ages: Europe and the Mediterranean, 400–800*. Oxford University Press, Oxford.

Critiquing the Discovery Narrative of Lady Mungo

Ann McGrath

The cremation burial of "Mungo I" was "discovered" by scientists in 1968–1969 near an ancient lake located in the southwest of what is now known as New South Wales, Australia (Fig. 9.1). During the Pleistocene era, the lake dried up, leaving behind an erosive landscape that was damaged by sheep farming from the 1860s. The burial of this woman, whose bones were partially cremated, then crushed, is currently dated at approximately 42,000 years BP (before the present). It is the earliest known human cremation in the world.

Rather than words like "discovery," "find," or the scientific classification of "Mungo I," Aboriginal people have called her Mungo Lady, Lady Mungo, and the Mungo Girl. The living ideology of discovery, however, is entangled in contemporary thinking to such a degree, and so inscribed in the practice of archaeology, that the term is difficult to avoid. Discovery is a colonial trope reflecting an ideology that is deeply ingrained and consequently taken to be common sense. Yet, discovery is a diffuse and multifaceted concept (Colwell-Chanthaphonh and Hill 2004; Thomas 2000). In a historical context, it refers to a stage in a process of colonial possession. Discovery precedes territories being taken over and has foreshadowed a series of Indigenous dispossessions. Discovery was the first premise upon which an imperial actor, representing a state, was entitled to assume domain over property, knowledge, and ontology. Discovery ideas, however, are not isolated from each other, from their locational context, or from their intellectual and political milieu. Through media, memory and history, discovery pasts live within us, and particularly so in settler societies such as Australia, Canada, New Zealand, and the United States. They are experienced in different ways

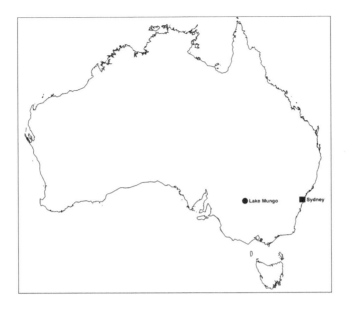

FIGURE **9.1.** Location map of Lake Mungo, Australia.

according to an individual's relation to various kinds of collective pasts (Morris-Suzuki 2005). Given their ongoing resonance, their endurance seems guaranteed.

A REVIVED DISCOVERY NARRATIVE?

The discovery of Australia's deep past might appear to be an opportunity to subvert the predominant historical narratives of imperial and national discovery and of European "firstness" (O'Brien 2010). As such, it might be seen as a decolonizing move: an uncovering and a recovery of a lost past, and more recently, offering the possibility of redemptive repatriation. In "discovering" the previously unrecognized, increasingly obscured Indigenous past, however, Australian scientists opened fresh ground for the development of new sets of colonizer discovery narratives. In this chapter, I am particularly interested in unmasking the vocabulary and symbols of late twentieth-century archaeology as a revived European discovery agenda. I explore how archaeological discovery narratives mirror and reinscribe the powerful tropes of imperial discovery.

Once uncovered, Lady Mungo's charred remains became the subject of research, leading to scientific breakthroughs of international significance (Bowler

et al. 1970). A modern human, a *Homo sapiens*, in other words, someone rather like us, Lady Mungo was notably "gracile" and fine-boned, without "robust" features such as a protruding forehead; she was a fully mature woman, though young—between eighteen years and early twenties. The muscular markings on her skull were delicate, revealing the patterns a physical anthropologist predicts for a woman's cranium. There were a few other skeletal remains, including part of the pelvis. It was an astonishing discovery for many reasons, and the Australian National University–based prehistorian John Mulvaney and the geomorphologist Jim Bowler lobbied successfully for the site at Lake Mungo to be awarded World Heritage status. In 1981, the wider lake system, known as the Willandra Lakes World Heritage area, was registered for its unique "natural," geological and "cultural" values, including its evidence of an "exceptional testimony to a past civilisation" (Australian Government Department of Environment, 2014).[1] Overriding the value-laden language of primitivism, the use of the term "civilisation" represented a radical move in its day, a respect for the ancient residents as fellow humans capable of a civil society. The nominators were too inclined to take the people's "pastness" for granted, however, failing to take into account the continuing connections of the Aboriginal people now living in nearby towns.

The stratigraphy of Mungo I's burial, eroded out of the dried out Pleistocene Lake landscape, was at first thought to be at least 20,000 years BP. Human remains were being scattered about by sheep, and were accidentally observed by geologists interested in the evidence of Pleistocene climate change (Allen 2012). Visiting the site in 1969, the scientists gathered together the human materials and prehistorian John Mulvaney placed them in his suitcase. These remains were then taken back to Canberra—famously to a party—where they were inspected by scientist John Calaby, a reputed "bones man." Following a long-running Aboriginal-led campaign, in 1992, Lady Mungo's remains were returned to "country"—the term used for traditional custodial territory of an Indigenous group, which denotes ownership and belonging—to land and polity over millennia. These particular lands are the common ground of at least three tribal groups. The return was organized by the Australian National University–based physical anthropologist Alan Thorne, who had reconstructed the cranium and had the remains in his care. Led by women elders, Aboriginal leaders organized a ceremony, and everyone present inspected the remains. It was considered a momentous and very moving event. To this day, Lady Mungo has not been reburied, but rests in a velvet-lined casket a few kilometers from where she originally lay. Her future resting place is uncertain.

I have heard many different versions of the "moment of discovery" story, with its fusion of happenstance and science (Fig. 9.2). It remains alluring, its iconic

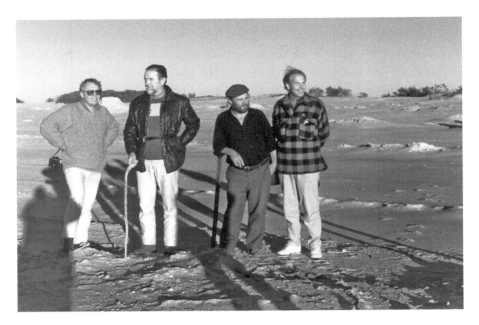

FIGURE 9.2. Investigators of the cremation burial of Mungo Lady: Thorne, Bowler, Jones and Allen at Joulni, on Lake Mungo Lunette, the location of Lady Mungo's remains in 1989, on the occasion of a research workshop meeting between researchers and local Aboriginal people to discuss past work and future research. Photograph by Isabel McBryde.

status growing with every retelling. One participant, Harry Allen, narrated this version of events on "discovery day" in March 1969 (Allen 2012):

> We were camping on Mungo Station and we were staying in the shearer's sheds and eating in the shearer's accommodations. So each day we'd travel around to different landscapes, hear the history from Jim [Bowler]; he had a number of soil scientists and other geomorphologists with us and we were listening to arguments about the interpretations and then each night we'd come back to the shearing shed and we'd have flagons of wine and [were] eating lamb chops—being on a pastoral station—and the argument would continue about what was going on: a new pastoral landscape, a newly discovered Pleistocene landscape.

> So on the last day at about lunchtime, we were out there on the south eastern end of the Mungo lunette, and we were walking across, and Jim was pointing out exposures of what he called calcrete, which was limestone and crustaceans and he was saying some of these exposures belong to the Lake Mungo period

25 to 40 thousand years. And one was a little outcrop and he said "I've been see-
ing some bones here, which I think might be kangaroo bones but, you know,
they're 25,000 years."

Now in my mind's reconstruction, the soil scientists were walking along and
to a degree were not being particularly careful about where they walked, and
certainly it seemed like one of these small pieces of calcreted bone was dis-
placed from the main area that we now recognise as the Mungo One spot. But
in that displacement, it was obvious that there was an exposure of bone, and
Rhys Jones looked down and said: "That looks like a human occipital bone—
the orbital bone of a human eye socket."

This was a game changer:

There we were, suddenly, instead of kangaroo bones and shell exposures and
small fireplaces and things like that at Mungo One, faced with that here. Right,
eroding out of the surface was [sic] the oldest human remains that had previ-
ously been discovered in Australia, by [at least] 10,000 years.... So here, sud-
denly, the age of antiquity of Aboriginal people in Australia, with that one kick
by a geologist, and that identification by Rhys Jones, went back 10,000 years.

Exhilaration, excitement, and stellar career trajectories followed. During the
late 1960s, the human remains exposed at Lake Mungo shifted thinking about
Australian occupation of the continent, revolutionizing its entire chronology.
Prior to the twentieth century, Europeans thought that Aboriginal people had
been on the continent for a few hundred years, then later, about a thousand or so.
As late as the 1950s, leading scientists had continued to argue that there was no
proof of Aboriginal antiquity. Assuming that Aboriginal culture was relatively
recent and had not changed over time, researchers had not even attempted to dig
in order to ascertain layers of occupation (Griffiths 1996a). By the 1960s, human
occupation of the continent was thought to date back 10,000 years. With Mungo
I, the stratigraphy indicated that this could be doubled to at least 20,000 years.
Astonishing in itself, this cremation burial meant that there were *Homo sapiens*
in Australia at a time when it was then thought that Neanderthals were the only
hominids living in Europe (Bowler et al. 1970; Chang 2014).[2]

Assumptions of a relatively short span of occupation had not meant a lack of
interest in Aboriginal "specimens." In the later nineteenth century, Australian
Aboriginal people were seen as a unique living exemplar of an antiquated form of
humanity—of humankind's ancient past. As "fossil man," they were stuck outside
time. A system of "ages," based on European evidence, systematized "man's rise
from the Stone Age"—the Paleolithic—to the Neolithic, and then onwards and

upwards to the Bronze Age until the pinnacle of European modernity was reached. Museums around the world still exhibit this periodization as representing the universal epochs and key timelines of human history. So, not only were Aborigines consequently situated outside "history," with its agricultural and industrial revolutions, they were at the baseline of human development, and considered living proof of unchanging "prehistoric man" (Allen 2012; Griffiths 1996a). Over the nineteenth century, Aboriginal skeletons and skulls were sought, collected, and sold to imperial museums by amateur collectors and scientists. Among Aboriginal Australians, the "skullduggery" of bone collectors and grave robbers left hurt, trauma, and a lasting distrust of science (Fforde et al. 2004; Griffiths 1996a).

WHAT IS A DISCOVERY?

Dictionary definitions of discovery vary. The *Shorter Oxford Dictionary* (2007: 700) emphasizes the following: to make known or divulge, to reveal one's secrets, to betray; to expose to view, to allow the unseen to be seen, to exhibit or display; to become aware of for the first time, to catch sight of, to obtain a view, to remove the covering from. These definitions seem apt descriptions for the physical action of unveiling the partially cremated burial remains of Mungo Lady. But they also refer to a situation where a particular individual can claim to be the first to observe a phenomenon (Butler 2013).[3]

Discovery is a central trope—possibly *the* central trope—of Western science. Expressed in many ways in popular culture, the *Discovery Channel* on cable TV is a case in point. In archaeology, and in science more generally, the discovery theme is ubiquitous. It sells books and it sells grants. Archaeological projects are devised with discovery and newness in mind, sometimes even creating an inbuilt impetus to overlook the research of predecessors. One of the Australian Research Council's key funding initiatives is called the Discovery Program, its model implying that new research rests on certain kinds of revelation. In archaeology, funded projects tend to involve new digs, new geographic information system (GIS) readings, and new finds ("discoveries"), followed by application of an experimental model and testing. The significance of what is found is often measured by its antiquity—that is, in its oldness rather than its newness. When involving human endeavor, a discovery cannot be based on a contention that nobody knew of it before. Rather, a "new discovery" concerns something that has been discovered anew, in the present generation—perhaps more correctly a "rediscovery." Newness of discovery is essential to the trope, however. Discovery actions and processes locate the moment of scientific discovery within the

"new"—within modernity and within its scientific ontologies—so the heroic entry of the present actor/discoverer intersects with and transforms the "oldness" of the past.

Archaeological "discovery narratives" cannot be entirely separated from the fertile ground of *historical* discovery narratives, which have served important legal and nationalistic functions in colonizer histories, especially since the nineteenth century (Kennedy 2013, 2014; Smith 2006). Both the disciplines of archaeology and history are implicated in imperial, colonizing, and nation-building agendas. Themes of British discovery, colonization, civilization, science, progress, and modernity have dominated mainstream Australian history in academic and popular narratives, only attracting scholarly critique from the 1970s (Grimshaw et al. 2006; Healy 1997, 2008; McGrath 1995; Smith 2006). Yet such interventions have not eroded the power of discovery; the word retains significant cultural and narrative weight, accumulated over time.

Perhaps this is not surprising, since, as many other chapters in this volume demonstrate, scientific enquiry has been tied up with imperialism and colonialism for more than two centuries (e.g., see Colwell, Díaz-Andreu, Doyon, Effros, Lai, and McCarty, this volume). A heritage of discovery is reflected in Australian place names. Joseph Banks's botanical enterprises gave Captain Cook's landing place in New South Wales the name Botany Bay (Gascoigne 1998, 2003, 2007; Nugent 2005). The process of systematic collection and formal classification of flora and fauna was called "natural history." Prestigious societies lauded Banks's collection when it was transported back in London. The Royal Society, the Linnean Society, and other elite scientific circles of the British and European imperial metropole guarded the domain of the practitioner's discovery. Newly encountered peoples were also observed and classified, although this phenomenon has a complex history I cannot describe in detail here. Imperial discovery of all kinds became less about casual finds and more about a retrospective intentionality associated with "the imperial project" and its evolving, utilitarian hierarchies. Discovery narratives in late nineteenth- and twentieth-century history writing became fundamental to colonizer histories both local and national (Besant 2015 [1903]; Thomas 2003, 2004).[4] Although these kinds of epic narratives went out of fashion in some quarters, their entrenched legacies live on.

How might discovery-related narratives of colonizer space permeate the way we see discovery in science, and specifically, in archaeology, today? While discovery narratives have been more fundamental to archaeological practice than to historical practice, archaeologists may have questioned them less. Perhaps this is not surprising, as archaeology today often emphasizes its practice as a science (Gould 1996; Schiebinger 1999). And in science, discovery is core. Fundamental to the

scientific method, discovery is the precept and goal of research (McNiven and Russell 2005).[5] In humanities research, uncovering new factual data is crucial, but interpretation and the exploration of meanings, often in contextualizing narratives, are recognized as being of equal importance.

Discovery narratives played a key role in formal legal and popular assertions and in the articulations of sovereignty that shape the territorial domains that make up today's settler-colonizer states. Australia's national day is celebrated every year as the first British colonization, January 26, 1788. This followed that other pre-eminent discovery date: navigator Captain Cook's landing in Australia, which he proclaimed at the pointedly named Possession Island (off current-day far North Queensland) in 1770. Australia's national day attracts controversy every year, for it reminds Indigenous Australians and their allies of the injustice of land takeover. Although Aboriginal rallies in the 1930s called it a Day of Mourning, and in 1988, Survival Day, the date continues to mark a hurtful reminder of invasion and dispossession (Attwood 1996; Griffiths 1996b; McGrath 2014). John Mulvaney's proposal to switch to a day that would instead mark Lady Mungo's discovery (Bonyhady and Griffiths 1996; Kennedy 2013; Mulvaney 2011) was appealing to some, as this change of the "national beginning dates" would acknowledge the extremely long Aboriginal occupation of the continent. After all, her cremation—also proof of a life lived—was evidence that took Australia's human history way beyond the beginnings of the Enlightenment, the Industrial Revolution, the Anthropocene, and the Holocene (McGrath 2015). The Mungo cremation burial predated the areas of great archaeological interest—Egyptian, Roman, and Greek archaeology and the chronological framings of Biblical creation stories. Yet, given scientific "ownership" of discovery events, reconfiguring of the national day to Lady Mungo's "discovery day" would potentially replace one discovery narrative with another.

The prevailing narratives of the Mungo discovery involve scientists. Like the discovery journal writers of old, they were motivated by noble causes, including patriotism and personal ambition. Like them, they participated in ensuring that their roles gained scientific and public recognition. To write themselves into this promising archaeological discovery narrative, the young men involved in Mungo research used scientific methods, academic and other publications, and engaged enthusiastically with a variety of popular media, including newspapers, film, and television. They also became involved in civic matters, and in the creation of new state and national legislation, as well as in the international arena of World Heritage accreditation. Via such actions, the Mungo story as discovery narrative has thrived.

In contrast, and despite their interest in knowledge of their past, the word "discovery" is rarely, if ever, used by the Aboriginal people from the region of Lake Mungo and surrounds. The Mutthis, the Nijaampa, and the Barkindji flatly refute the discovery plotline by refusing to engage in its language and its narrative trajectory (Fig. 9.3). Rather, they explain that Mungo Lady "came to the surface for a purpose." It is Lady Mungo who "brought the world's attention here—who showed everyone our plight, our suffering." She "emerged." She "surfaced." She was "taken away" by scientists, but she "came back to her country" (McGrath and Pike 2014). They are insulted by anyone talking about her as "evidence" or even as "bones." They prefer the terminology "human remains" or, better, "ancestral remains."

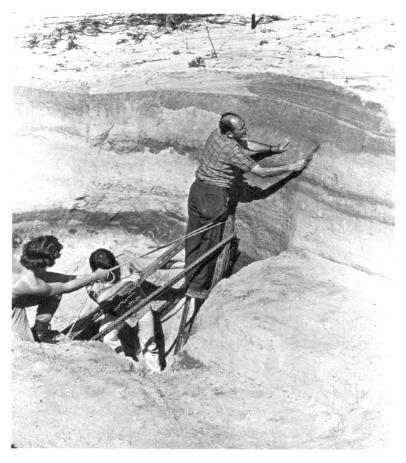

FIGURE 9.3. John Mulvaney preparing to take a latex peel of Mungo Lunette section in August 1974. Photograph by Isabel McBryde.

Western culture generally describes and considers scientific language as neutral. Scientific language promises objectivity, but it belongs to a very prescribed cultural and educational milieu that in fact is not neutral ground. For example, certain scientists still correct me when I say "Lady Mungo"—they reply "Do you mean Mungo I?"—preferring the term with the specificity required of scientific taxonomy. Historians and other humanities scholars are more likely than scientists to agree with Aboriginal people that such terminology is objectifying and dehumanizing. Whether academic or not, for Aboriginal people, the desire to correct a history of racism and the trauma of loss is a strong motivation to correct the language used.

The ubiquity of scientific discovery and naming practices requires reflection and explanation; it needs unmasking. Yet, as I write, I am still struggling to find verbs and nouns that enable me to escape its semantics. The discovery ideology is so culturally and intellectually entrenched that it is almost impossible to evade. Although wary of uncritically attaching myself to a flip-side narrative to counter discovery's all-pervasive conceptualizations, I find that Aboriginal framings, with their implicit anti-colonial critiques, are perhaps the best alternatives on offer.

The counter-discovery narratives devised and used by Aboriginal speakers are premised on an empowering sense of agency. As we have seen above, in these Lady Mungo surfaces and emerges with intentionality. Local Aboriginal spokespersons identify with, and are propelled by, a spiritual ontology of landscape connection and custodianship. Although deeply interested in learning about their ancestral past, they are relatively uninterested in the technicalities of scientifically verifiable dates.[6] Their narratives and understandings give primacy to continuity. Profoundly, when telling her story, they present no temporal gap between Lady Mungo and themselves; they speak about her and witness her presence today. Indeed, this lady who lived 40,000 years ago is treated like an aunty who died only yesterday. What is more, although deceased, she is not "gone" in any final sense; she is active in the landscape today—she brings the weather, thus permitting some people to travel on the sandy unsealed roads and blocking others. She can be heard crying. She is doing or not doing things for her people. She is a living, spiritual force, rendered particularly special because of the way she "came up" to the surface, and due to the profound impact of her arrival upon Aboriginal people locally and nationally.

At the same time, the regional Indigenous custodians worry about her; they feel they cannot care for her adequately, and that her spirit is not yet at rest (Hamilton 2009; Hammil and Zimmerman; Hill 1994; Thomas 2000).[7] Her bodily remains are situated today in an area that during her lifetime was under the lake, and in which she would have drowned.

Many Aboriginal people know stories of ancestral antiquity handed down to them through countless generations, yet when they went to school, their teachers taught them that British mariner Captain James Cook discovered Australia (McGrath 1995, 2014; O'Brien 2010). It was hurtful—as if the teachers were calling their grandmothers liars. As Ojibwe historian Jean O'Brien has convincingly demonstrated, New Englanders in the United States invented powerful local history narratives of "firsting" and "lasting" in which white pioneers did something or appeared first in a specific regional landscape. By the same token, the continuing presences of the "last of" the Native Americans were fondly remembered. Effectively these prevailing histories rendered Indigenous people invisible. Or they implied that their ancestors were not entirely human.[8]

In international law, discovery effectively delivered a sovereignty right, and although the negotiation of treaties with Indigenous inhabitants might be expected, they were easily broken. In both Australian and North American history, historians used British discovery narratives to forge a sense of collective purpose and identity, with ongoing resonance. Yet these had an even deeper impact in Australia. Because the British claimed the continent on the basis of occupation, not conquest, discovery had a particular utility. The justification was that the British had found a *terra nullius*—land belonging to no one or wasteland. No British-authorized treaties were entered into (Fitzmaurice 2014).[9] Australia is unusual in not recognizing the first occupants via formal treaties, as was the case in most other parts of the world, including the United States of America, Canada, and New Zealand. In Australia, the landed entitlements of whiteness became part of settler identity, as they had elsewhere. In its public institutions such as the War Memorial, the state still tends to deny the violence and outright warfare that ensured settler sovereignty was gained (Macintyre and Clark 2004; Moreton-Robinson 2004; Roediger 1991).

Disquiet continues, as the notion of territorial discovery in law, and in common sense, has been considered problematic for centuries. The seventeenth-century Dutch jurist Hugo Grotius noted: "[D]iscovery applies to those things which belong to no one" (Reynolds 1987: 9). He recognized that imperial-style discovery was limited to a claim over and above other European powers (Reynolds 1987: 11). In 1832, in the United States, Chief Justice Marshall made clear that colonial sovereignty did not hinge upon a previous lack of human occupation (Coates 2000).[10] As historian Henry Reynolds (1987: 9) explained: "The fundamental problem with discovery as a base for possession is that one can only discover that which is ownerless, that which doesn't belong to anyone. This principle was enshrined in European international law and in the Roman law on which it was based...." Without treaties, Australia was distinctive. *Terra nullius*

was only formally rejected in Australian law by its High Court in 1992, in the
Mabo Judgement, which declared it a "legal fiction." Under the Paul Keating
Labor government, this was followed by the introduction of the Native Title
Acts, which enabled Aboriginal groups to apply to civil courts to have their prior
land ownership officially recognized, albeit with limited associated rights.[11]
British Crown sovereignty, not to mention the occupation and discovery that
preceded it, was left tightly protected. Perhaps it was not entirely a coincidence
that 1992 was also the year of the scientific "handback" of Lady Mungo's remains.
In the same year in the United States, controversy surrounded celebration of the
quincentennial anniversary of Columbus's discovery of the Americas (Axtell
1992).

Territorial and scientific discovery have been entangled over at least the past
few centuries, and today they continue to present dilemmas. In philosophical
thinking, in the narrowest sense, discovery refers to "the purported 'eureka
moment' of having a new insight. In the broadest sense, 'discovery' is a synonym
for a 'successful scientific endeavor.'" As explained in the *Stanford Encyclopedia of
Philosophy*, throughout the nineteenth century "the generation of new knowledge
was clearly and explicitly distinguished from its validation, and thus the condi-
tions for the narrower notion of discovery as the act of conceiving new ideas
emerged." At the same time, while discovery relies on the empirical, it goes
beyond the eureka moment. Further investigation is required to explain the data
at hand. In more sociological accounts, discovery is a retrospective label, a sign of
accomplishment in certain scientific endeavors. Is there a logic of discovery, a
contingency, a methodology, or process that creates a discovery status? Sociolog-
ical theories put it this way: "[D]iscovery is a collective achievement and the out-
come of a process of negotiation through which 'discovery stories' are construct-
ed and certain knowledge claims are granted discovery status" (Schickore 2014).

DISCOVERY'S MOMENTS

A key problem with discovery is that it is almost impossible to identify a moment
of discovery, or the person who discovered something. Exactly who is the discov-
erer is often contested, even when it comes to the prestigious Nobel Prizes. To be
identified as the "discoverer" is some kind of prize in itself. Being "first" is crucial
to discovery. At Mungo, there is arguably no single discoverer. Let's look at some
who made claims to discovery. Primacy of different kinds has been asserted by or
on behalf of Jim Bowler, Alan Thorne, Rhys Jones, and John Mulvaney. Most
agree that Jim Bowler, then a doctoral student in geomorphology, was the first
there on the ground and the first to notice and direct others to something

unusual. His research had identified the landscape, with its series of lunettes or crescent-shaped sand dunes, as an ancient lake basin.[12] In late 1968, Bowler noticed some unusual bone-like objects appearing in what he had identified as a Pleistocene stratigraphy. But he was not looking for them.

Bowler was studying this landscape's stratigraphy and what it revealed about climate change. On one of his excursions, he noticed stone objects on the surface that looked like artifacts. Then, in an eroding layer, he found something encrusted in carbonate that he thought might be kangaroo bones. Although a junior scholar, he played a leadership role, inviting a team of young experts from Australian National University (ANU) to visit Mungo. One was Rhys Jones, a brilliant Welsh-born archaeologist and a beloved bon vivant, who was undertaking significant work on burials and cremations in Tasmania (Jones 1967: 55–67, 1971). Rhys was the first to recognize the carbonate-encrusted materials as human, and he immediately went about excavating them carefully with a fine implement. Prehistorian John Mulvaney was also present, but, as he stated, he was no expert on bones. He offered his suitcase to take the materials back to the ANU.[13] Later, John Calaby, who was present at the Canberra party, confirmed that they were definitely human. (Although Harry Allen, quoted earlier, was present at the discovery, he was a junior scientist, and appears to have been excluded from the narratives as one of the "discoverer party." He also informed me that the senior scientists dissuaded him from following a Mungo focus for his doctoral research.) In Canberra, the burial materials were then passed over to Alan Thorne, the physical anthropologist who was trained in cranial reconstruction. He took them into his keeping, spending six months piecing together the remains, which were in tiny fingernail size fragments. His physical role in creating and observing what they perceived to be new *scientific evidence*, was understood by his peers to confer a special intellectual property right over the findings—a scientific custodianship that meant he was entitled to have them in his personal keeping at the Australian National University from 1969 to 1992.

In 1970, a preliminary scientific report was published. Jim Bowler was lead author, with Rhys Jones, Harry Allen, and Alan Thorne as co-authors (Bowler et al. 1970). Bowler's primacy, confirmed by placing a "B" name ahead of an "A" in the author line-up, was awarded, at least in part, via the gift of discovery. Compared with the more recent scientific papers on Mungo's evidence and dating, this richly descriptive article reads more like a humanities piece. Its first mention of discovery appears in the article's conclusion section, although this, after all, is the location for the vital summation in most scientific journals of this type. According to the Cambridge-trained archaeologist Wilfred Shawcross, the publication of this article "suddenly put the *early discoveries* in Australia on the map, amazingly

effectively" [my italics] (Shawcross 2013). Bowler and the others continued to write additional reports and analyses, and to consolidate their reputations on the basis of this astonishing find. Bowler has been consistently involved in the site ever since. Alan Thorne was a discoverer in the sense that on the basis of reconstructive work in his laboratory, he was the first to recognize the remains as those of a *Homo sapiens*—and a gracile, modern one at that. From this example, he developed a multiple-migration, out-of-Africa hypothesis, credit for which he shared with eminent American academic Milford Wolpoff (Wolpoff et al. 1994).

In the aftermath of the Lady Mungo discovery, Mulvaney revised his high-impact book *The Prehistory of Australia*, which was first published in 1969. The 1974 Penguin paperback edition was reconfigured to incorporate dramatic new discoveries and perspectives of places such as Lake Mungo, which had overturned the story of Australia's archaeology (Mulvaney 1975).[14] Much of the new information included in the volume regarded measurement—of the human skull and the passage of time according to various scientific techniques. Using the lens of Mungo, Mulvaney explained the science behind the discovery in an accessible narrative style that linked the local find to its global significance.

Something of the "discovery group's" self-image emerges in a humorous send-up of the cowboy archaeologist-as-hero trope. Film director Tom Haydon concocted a scene where Mulvaney, Jones, Bowler, and Thorne are sitting at a bar like a bunch of cowboys. They rise from their chairs and move on to the open desert landscape, the shots alluding to the heroic, Wild West style of masculinity fashionable in the 1960s. Following the international acclaim and professional recognition that followed the scientific announcements, they were indeed cocky and self-assured (Haydon 1975). And as Harry Allen emphasized, "This was a *monumental discovery!*" (Allen 2012).

The late 1960s saw the pioneering days of an *Australian* archaeology, with the Department of Prehistory newly formed at the Australian National University, enhanced by a sparkling team of recent Cambridge-educated graduates and students. These young Australian men, freshly returned from or having migrated from the UK, were driven by a strong sense of purpose that included building a national research culture. Convinced that not all archaeology should be, as in the textbooks, primarily that of Europe, the archaeologist and young radical Harry Allen explained: "[W]e had a sense that we were discovering a continent, the past of a continent, and as Australians we regarded it as *our* continent" (Allen 2012).

A rather triumphalist, highly masculine vision thus turns once ordinary men into heroes (Douglas 2014). Discovery becomes a kind of initiation process, where graduates gain the status of adult men of stature in the world of science to which they aspire. They joined a terrific crew—Christopher Columbus, Captain

Cook, and Dr Livingston. Discovery made modernity. For it made the world and the globe as we know it; it mapped a modern "us," excluding a non-modern "them" (Chakrabarty 2011).

By this logic, primitive peoples had to be excluded for they could not discover. After all, that is what ostensibly kept them primitive and *prehistoric*. Much has been written about the people "without history," and Indigenous populations continue to be excluded; they are presumed to exist outside history's borders (Wolf 1982). In such thinking, modernity and history are closely entwined, as are the exclusionist traditions of the academicians who declare what history is and is not. Substantiated by contemporary journals of discovery voyages and their repeated retellings across many forms of media, narratives of discovery inform key understandings of imperial and colonizing history. These plotlines reify historical change, and thereby create a new ownership. The long durée (deep time) of earlier occupation stands outside history as understood in the Western academy, museums, and popular culture. Indigenous creation stories such as Aboriginal "dreaming stories" are viewed as "legendary tales" or myths. Without recourse to contemporary written documentation or other modes of inscription, they do not count as history (Hokari 2011; McGrath 2008). Indigenous people cannot pinpoint any one moment of discovery, or any single discoverer. They stand outside of, and lack the vital claims to, sovereignty contained within the (imperial) discovery narrative. By this logic, the lack of a discovery narrative becomes a kind of deficit, in turn conferring a lack of entitlement.

INDIGENOUS CHALLENGES TO DISCOVERY

Ahead of historians and literary scholars, it was Aboriginal activists, led by a Mutthi Mutthi woman named Alice Kelly, who first challenged the triumphal trope that had celebrated the discovery of Mungo Lady (Fig. 9.4). Despite her limited formal education and her people only being awarded full citizenship in 1967, Alice Kelly had the courage and forbearance to take on the scientists.[15]

More scholars were beginning to study the area, including archaeologist Wilfred Shawcross, an English-born Cambridge graduate who never lost his accent or demeanor. He recounts how, rather suddenly, the scientists' collective sense of unassailable achievement was disturbed. When challenged by local Aboriginal people for interfering with ancestral remains, Shawcross candidly explained the shock that the discoverers experienced:

> [We] had not remotely considered that the Aboriginal people would be concerned about what we were doing. In fact ... I suppose we felt rather righteous, *I felt rather righteous that here we were rediscovering their past, shouldn't they*

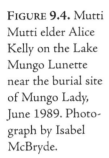

FIGURE 9.4. Mutti
Mutti elder Alice
Kelly on the Lake
Mungo Lunette
near the burial site
of Mungo Lady,
June 1989. Photo-
graph by Isabel
McBryde.

be *grateful*. You can detect some irony in my voice about my position at the
time. So it was a bit surprising to be then accosted and [they] said: "You know
you're taking our past from us." But of course it was a distinct truth about that.
Our careers internationally and so on were very much to do with the sense we
made of *somebody else's* past (Shawcross 2013).

There were exceptions: the archaeologist Isabel McBryde immediately react-
ed to Aboriginal concern, also recognizing it as an opportunity to enrich archae-
ological practice. Bringing a respectful research ethic to the enterprise, she set out
to explain her methodology and to share its possibilities for knowledge with local
Aboriginal leaders. Keen to build potential trust, she invited Alice and husband
Alf Kelly to a dig, and sought their considered permission to undertake research.
Sharon Sullivan, who served as a senior parks manager and director of the Aus-
tralian Heritage Commission, saw the opportunity to develop a collaborative sci-
entific research policy that included Aboriginal values and Aboriginal people
working in research. Such motivations themselves comprised a nationalistic goal

"for Australia," the nation. With Aboriginal custodians, under the auspices of government agencies such as national parks and World Heritage, a collaborative approach to parks management, and to research taking place within it, offered the hope of developing a reconciled history and consequently a more unified, reconciled nation.

After a lengthy process of consultation, negotiation, and discussion, from 1981 the Willandra World Heritage area developed a path-breaking inclusive governance structure (Fig. 9.5). Its committees represent the three main Aboriginal groups, the pastoralists and wider community, and scientific research. The National Parks authority of New South Wales manages the park with Commonwealth government support for its World Heritage functions. Many parks officers come from scientific backgrounds, with environmental science, ecology, and archaeology considered suitable training. The incorporation of Indigenous trainees and employees, and the exchange of Indigenous knowledge, conforms to the joint management structure and goals of the Willandra Lakes World Heritage Area.

FIGURE **9.5.** The Aboriginal Sites Committee of the New South Wales National Parks and Wildlife Service. Here they are being guided in 1981 to sites on the Lake Mungo Lunette by Peter Clarke, the Lake Mungo National Parks archaeologist. L–R: Carmelia Corowa, Peter Clarke, Kevin Cavenagh, Ronald Lampert, Sharon Sullivan, Gretchen Poiner, and Alice Kelly. Photograph by Isabel McBryde.

The few key scientists who proactively included participation by Indigenous custodians and elders did not enter the pantheon of "discoverers." These included archaeologist Isabel McBryde and parks officer Peter Clarke, who played key roles in research and negotiating with Indigenous elders. Some of the discoverer-scientists saw them as the enemies of research, and forecast their actions as the death knell for Australian archaeology. Although collaborative archaeologists were viewed reverently by the Aboriginal elders and those favoring such research practice, some archaeologists belittled their negotiations work with elders and the mutual development of inclusive new research models as mere "housekeeping work." McBryde's archaeological finds concerned such things as stone tools and trade exchanges and were not accorded the same status as research into human remains. Nor were successful efforts at training a number of Aboriginal archaeology students with university degrees always welcomed. Archaeologists such as Sullivan, McBryde, and Clarke are positioned outside the scientific discovery trope, which remains the preserve of an inner circle of male scientists invited to be present at celebrated discovery moments.[16]

For most of their careers, key scientists refused to relinquish the cultural property from the deep past—the bones and artifacts that were in their custodianship, and which constituted material proof of their intellectual domain. To hand them over for potential reburial was thought a travesty, a rebuttal to the international community of science, and counter to World Heritage principles. Alan Thorne only decided to return the remains of Lady Mungo in 1992, after sustained pressure from Aboriginal elders. Even then, scientific colleagues thought he was "mad" (McGrath and Pike 2014; Thorne 2013). Only those who actually held material evidence removed from "country" could organize "the return" of human remains. Eventually, Thorne's involvement in the return put him in very high standing with local Aboriginal people. Subsequently, Jim Bowler was active in lobbying for the return of Mungo Man (Mungo III), a full burial that he came across a few years after Mungo I. In late 2015, the Australian National University made a formal apology for their actions in holding these and other Willandra Lakes remains, all of which were officially returned to the Indigenous elders. They decided to place them in the vaults of the National Museum of Australia until a suitable keeping place "in country" could be built. However responsible and laudable these returns and attempted returns or repatriations have been, they inevitably reinscribe "discoverer" authority. They are also a strategically useful move for future science. At some point, the Willandra Lakes elders placed a caveat upon any scientific research, stating that there would be no more burial excavations, and no research on another significant burial exposed by erosion—known as Mungo Child[17]—until the other human remains were

returned. (No further research on Mungo Child has followed to date, and this burial site has deteriorated, likely diminishing the chances of future scientific work. Elders remain concerned about any disturbance of remains, and in particular, removal from their original burial sites.)

With various motivations, a new goal for the scientist-discoverer became that of being the scientist organizing a return—or repatriation, as it is known in legislation (Byrne 2003; Turnbull and Pickering 2010; Webb 1987; Zimmerman 1987). In an updated settler-colonizer nationalism, reconciliation work to redress past injustices became a valued goal, in which the repatriation of removed human remains was vital. However well intentioned, none of these contests over ancestral remains, intellectual authority, and property served to undermine the ongoing quests by certain individual scientists to shore up their discoverer status.

To an extent, holding onto discoverer status was tenuous; it required work that addressed changing times and modes of delivery. The claim had to be repeated, generally through scientific publications. If one's name was not acknowledged as co-author of an academic paper relating to a discovery—or over the remains for which one had scientific authority—a sense of betrayal and angst followed (Bentley and Butler 2013).[18] A contest over one's scientific domain could explode into turf warfare. Discovery assertions also needed to enter the popular media—in print, CDs, websites, tourism reels, television, and film. One of the journals in which Alan Thorne told the full story of Mungo in 2002 was entitled *Discover Magazine*. Print and other media repeatedly emphasize "a new discovery" as the key story line.

Lauded as a kind of decolonizing gesture, Thorne's return of Lady Mungo entered popular memory as an important *national* moment of reconciliation, an inspirational high point in scientist–Aboriginal relationships that might incorporate a kind of absolution for wrongs done. Being the initiator of a repatriation soon became a sought-after credential. The discoverer could be the returner—both the taker and the giver back—albeit amidst an inevitable retelling of the "discoverer" story. Despite being urged to expedite returns to mark the anniversary of removals, Aboriginal elders control the appropriate timing and placement of repatriations back to their custodial "country" (Lilley 2005; Smith and Jackson 2006; Smith and Wobst 2005).[19]

THE SPECTER OF THE PAST

Scientific practice has changed since the 1960s. Many scientists have been eager to include Aboriginal people in scientific research via university training and in community arenas. Local Aboriginal people are now included as supervisors and

advisors in much scientific research practice. A number of Indigenous university-based academics and archaeology-trained experts have integrated the two knowledge systems. An Aboriginal Archaeologists Association is active at Australian archaeology conferences developing a distinctive agenda.

With strong resonances to North American scenarios such as the Kennewick man case (Thomas 2000), many local Aboriginal people are skeptical about celebrating repatriation events. Numerous remains held by national and overseas institutions have not yet been returned to "country." Because of their attitudes to and about the dead, and a desire to control their ancestral past, many community-based people reject arguments that their ancestral remains should be exhumed in the interest of world science. They are often frustrated and confused by the changing scientific hypotheses and dating results. Some elders refute scientific narratives of global migration, citing their ancestral traditions: "We are not out of Africa. We have always been here."[20] Science can be an unwelcome intruder, not only because it challenges some traditional cultural knowledge systems, but because its findings could have negative political ramifications with possible material consequences. They are keenly aware of how changing scientific positions could provide fuel for opponents who argue against their hard-fought rights. Anti–land rights advocates take any opportunity to attest that Aboriginal people were not the first people on the Australian continent or the ancient residents of a particular locale. If skeletal remains from the deep past seemed unrelated according to current, often problematic, DNA research, this could be used to undermine Indigenous rights (Bardill 2014; Beckenhauer 2003; Elliott 2009; Wailoo et al. 2012). Having the potential to reduce their Indigenous sovereignty claims based on occupation since "time immemorial," science may not serve the interests of Aboriginal people. It not only undermines cherished narratives, but it could result in revived colonizer denials of their status as land proprietors with rights to sovereignty.

At the same time, many Aboriginal people do appreciate and embrace the global interest in their region's archaeology and are open to integrating relevant scientific knowledge where appropriate. Increasing numbers of Aboriginal Australians are being trained in field archaeology and graduate as fully qualified archaeologists. Many people value the scientific proof of their deep-time occupation of the land. They also cherish an identity as "the oldest continuing culture on the planet"—acknowledged by Australian prime ministers and other dignitaries since 2008—as empowering. But they do not necessarily feel the same way about science or the prevailing new discovery narratives. Elder Lottie Williams attends every scientific conference held in the Willandra/Mildura region, but she explains how she does not necessarily buy into the conceptual framings of the

Western academy: "I like the scientists because they've got one story and I got another.... I just like listening to the scientists because *they're the scientists* and they're supposed to know everything. And then when I think back to what I've been told [by elders/Indigenous knowledge holders], I'm comparing them all the time." She offers an assessment of the repatriation: "Bringing Mungo Lady back was good, but I wondered *why they took her away* for the first part. *That was the question unanswered*, and *what did they find out*, what were they trying to prove when me and all the rest of us *know* we were here all the time, so that wasn't *news* to us" (Williams 2012). Such hard-hitting, anti-discovery narratives critique the pervasive colonizer tropes that give primacy to European agency, and to certain kinds of knowledge and proof.

When offered gestures of inclusion in the discovery game, Aboriginal people have often proved ambivalent to receiving that "gift'" (Smail in McGrath and Jebb 2014). In a spirit of parity, in some instances, well-meaning non-indigenous scientists have encouraged Aboriginal people to be acknowledged as the "discoverer." This was the case of Steve Webb in regard to the Willandra trackway, with its astonishing set of ancient footprints. Unfortunately there is insufficient space to discuss this story in the current chapter (Webb et al. 2006). Yet some of the reasons for Aboriginal people's ambivalence are obvious. In historical writing and memorialization, discovery narratives have been used to create exclusive chronologies based around moments of seeing with imperial eyes. What proved both a useful concept and compelling narrative entered into the deepest recesses of European consciousness, crucially informing identities of whiteness, and of national and global community belonging. After all, only by seeing lands and landscapes with the white gaze, through European eyes, are they defined as having been "discovered" (Pratt 2007).

Although many historians might imagine that historical narratives of discovery have been discarded as now-passé exemplars of elitist, imperial, and colonizer histories, they remain omnipresent, imbricated in a pervasive ideology that requires much more unmasking work in the disciplines of history and archaeology, in other relevant scientific models of research, and in public forums. And even the most active advocates of Indigenous rights cannot escape discovery ideology entirely (Fig. 9.6). Discovery, as people today know it, and as we critique it, made the post-imperial world in which we all live. When new discovery narratives of return arise into a post-colonial world, we have to keep in mind that the world is not effectively "post" at all. Although engaging with the primitive and the ancient, the discovery trope emerges out of modernity and the idea of making something old new. Aboriginal people's standpoints and interpretations do, however, offer rich counter-narratives.

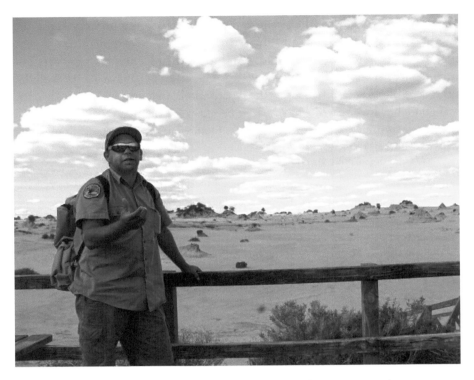

FIGURE **9.6.** Discovery Ranger Ernest Mitchell at the Lake Mungo site that is open to guided tourist visits, April 2013. Photograph by Ann McGrath.

But a quandary remains. Discovery is implicated in political and imperial assertions of territory—of land, intellectual property, and cultural meaning. Yet scientific discovery of the ancient past seems the only way to ascertain a deep continental human history that offers an antidote to an imperialist discovery history. In Australia the latter history began in 1770. More widely, notions of discovery permeate the disciplinary assumptions of history and archaeology, and they influence the foundations of Australian and British law. Discovery continues to permeate the practices of science, imperialism, and colonialism. Yet it is discovery in science that offers powerful methodologies by which to glean and test the proven facts (or likely facts) about civilizations that long precede the present. Through such means, we in the Western academy draw attention to, and thereby make research findings into "universal knowledge." It is through evidence and verifiable data that the histories of others become "history"—"owned" and participated in beyond the local (Byrne 1996).

A PERSON OF THE EVER-PRESENT PAST?

So we go back to that awesome moment where the present and past crossed over: when Lady Mungo surfaced for a reason.[21] Lady Mungo proved something to the world that now cannot be unproven. Had she not been the agent, had she not "come to the surface," could this have occurred? She haunts the collective psyche still. She challenges present value systems. She makes it imperative that researchers work in a truly collaborative fashion, across intersecting forms of knowledge (Colwell-Chanthaphonh and Ferguson 2008). Meanwhile, the stratigraphy of ancestral Indigenous action and colonizer ideology will continue to rise to the surface, scattering itself into temporal spaces that are at once of—and *not of*—the present and its peoples. When it comes to redressing colonialism, it appears there can be no satisfactory resolution, for settler-colonizer sovereignty is too secure. It is a false belief that one can completely ameliorate, bury, or rebury the past. A pressing question persists: what to do with Lady Mungo's remains—in her velvet-lined casket—where a scientist holds one key and an Indigenous representative the other. In regard to that woman who once walked the land that is now World Heritage, those "keys" are both real and ontological. For a problem that the present has brought to the past, will anyone discover exactly how to approach any re-covering, reburial, and recovery of the past and present? Were any solution possible, this might be one of the most important discoveries yet.

NOTES

[1] The Willandra Lakes Region was classified "as an outstanding example representing the major stages in the earth's evolutionary history; and as an outstanding example representing significant ongoing geological processes, bearing an exceptional testimony to a past civilisation" (Australian Government Department of Environment 2014). See also Bowler et al. (1970) and Allbrook and McGrath (2015). For a recent archaeological perspective, see Stern (2015).

[2] New dating research suggests Neanderthals may have died out 40,000 years ago in Europe (Chang 2014).

[3] The Australian Oxford Dictionary defines discovery as follows: "to find out or become aware of, whether by research or searching or by chance; be the first to find or find out; archaic; to make known; exhibit, manifest; disclose, betray" (Moore 2004).

[4] Note that the Penguin edition of Thomas's book on Cook's journeys was retitled *Discoveries*.

[5] In education, "the discovery method" pertains to a particular kind of self-driven learning.

[6] For most local Aboriginal people, the "archaeological" stories are not viewed as "scientific" at all. (I distinguish these from Indigenous university-based academics and archaeology-trained experts, who have integrated the two knowledge systems in different ways.)

[7] Many Native American groups have a similar perspective, believing that the spirits of the deceased are living in another dimension and are close by.

[8] Even recently, the Australian prime minister of the time, Tony Abbott, referred to Sydney Harbor as "nothing but bush" before the British arrived. He made this comment in a parliamentary address to the visiting British Prime Minister David Cameron (Henderson 2014).

[9] Although its meanings and origins have been debated, this implied a wasteland, not used in an agricultural or "modern" sense of using land expounded by John Locke or unoccupied altogether.

[10] America was not *terra nullius*. At the same time, the Marshall Judgements of 1831 and 1832 acknowledged presence and rights of Indigenous people and the feeble nature of discovery and sovereignty assertions (1832) (Coates 2000).

[11] Aboriginal Land Rights Acts had been enacted from the 1970s onwards as a benefit rather than a right.

[12] The dunes created an ominous landscape that inspired artists portraying the harshness of the Australian outback and attracted tourists.

[13] The suitcase is now housed in the National Museum of Australia.

[14] Published in an accessible format by Penguin books, Mulvaney (1975) was a comprehensive and well-written book that could be readily adopted for teaching Australian history as well as archaeology.

[15] This is a subject I do not have the time and space to recount here, but that I explore in my broader project. For an overview, see McGrath and Pike (2014).

[16] And this despite revelations of McBryde's work on extensive trade networks at Lake Arumpo (Mcfarlane et al. 2005; Tuniz et al. 2009).

[17] Although referred to as a child, the burial, which has not been researched, is more likely to be that of an adult.

[18] Note: Both Milford Wolpoff and Lewis Binford worked with Alan Thorne.

[19] The return of all remains from the Mungo area, including that of Mungo man, is to take place on November 17, 2017.

[20] This interpretation could be open to meaning that they "became Aboriginal" on this continent. From Lynette Russell, director of Monash Indigenous Studies Centre, Monash University, personal communication, 2014.

[21] Alternative historical causations and the cultural prioritizing of explanatory frameworks are explored in Chakrabarty (2000).

REFERENCES CITED

Allbrook, Malcolm, and Ann McGrath
 2015 Collaborative Histories of the Willandra Lakes. In *Long History, Deep Time: Deepening Histories of Place*, edited by Ann McGrath and Mary Ann Jebb, pp. 241–52. ANU Press and Aboriginal History Inc., Acton.

Allen, Harry
 2012 Interviewed by author. Video recording. Canberra, May 7.

Attwood, Bain

 1996 Making History, Imagining Aborigines and Australia. In *Prehistory to Politics: John Mulvaney, the Humanities and the Public Intellectual*, edited by Tim Bonyhady and Tom Griffiths, pp. 98–116. Melbourne University Press, Carlton.

Australian Government Department of Environment

 World Heritage Places, Willandra Lakes Region, World Heritage Values. New South Wales. Available at http://www.environment.gov.au/heritage/places/world/willandra/values, accessed August 24, 2014.

Axtell, James

 1992 *Beyond 1492: Encounters in Colonial North America*. Oxford University Press, New York.

Bardill, Jessica

 2014 Native American DNA: Ethical, Legal, and Social Implications of an Evolving Concept. *Annual Review of Anthropology* 43: 155–66.

Beckenhauer, Eric

 2003 Redefining Race: Can Genetic Testing Provide Biological Proof of Indian Ethnicity? *Stanford Law Review* 56(1): 161–91.

Bentley, Dean, and Martin Butler

 2013 *First Footprints*. Video recording. Australian Broadcasting Commission, Sydney.

Besant, Walter

 2015 [1903] *Captain James Cook: Life and Voyages of the Great Navigator*. Robert W. Strugnell, Reservoir.

Bonyhady, Tim, and Tom Griffiths (editors)

 1996 *Prehistory to Politics: John Mulvaney, the Humanities and the Public Intellectual*. Melbourne University Press, Carlton.

Bowler, Jim, Rhys Jones, Harry Allen, and Alan Thorne

 1970 Pleistocene Human Remains from Australia: A Living Site and Human Cremation from Lake Mungo, Western New South Wales. *World Archaeology* 2(1): 39–60.

Butler, Susan (editor)

 2013 *Macquarie Concise Dictionary*, 6th ed. Macquarie Dictionary Publishers Pty Ltd, Sydney.

Byrne, Denis

 1996 Deep Nation: Australia's Acquisition of an Indigenous Past. *Aboriginal History* 20: 82–107.

 2003 The Ethos of Return: Erasure and Reinstatement of Aboriginal Visibility in the Australian Historical Landscape. *Historical Archaeology* 37(1): 73–86.

Chakrabarty, Dipesh

 2000 *Provincializing Europe: Postcolonial Thought and Historical Difference*. Princeton University Press, Princeton, NJ.

2011 AHR Roundtable: The Muddle of Modernity. *The American Historical Review*
 116(3): 663–75.

Chang, Kenneth
2014 Neanderthals in Europe Died Out Thousands of Years Sooner Than Some
 Thought, Study Says. Available at http: //www.nytimes.com/2014/08/21/
 science/neanderthals-in-europe-died-out-thousands-of-years-sooner-than-
 some-thought-study-says.html?_r=1, accessed August 24, 2014.

Coates, Kenneth S.
2000 *The Marshall Decision and Native Rights*. McGill-Queens University Press,
 Montreal.

Colwell-Chanthaphonh, Chip, and T. J. Ferguson (editors)
2008 *Collaboration in Archaeological Practice: Engaging Descendant Communities*.
 AltaMira Press, Lanham, MD.

Colwell-Chanthaphonh, Chip, and J. Brett Hill
2004 Mapping History: Cartography and the Construction of the San Pedro Valley.
 History and Anthropology 15(2): 175–200.

Douglas, Bronwen
2014 *Sciences, Voyages, and Encounters in Oceania*. Palgrave Macmillan, Houndmills.

Elliot, Lisa
2009 Property Rights of Ancient DNA: The Impact of Cultural Importance on the
 Ownership of Genetic Information. *International Journal of Cultural Property*
 16(2): 103–29.

Fforde, Cressida, Jane Hubert, and Paul Turnbull (editors)
2004 *The Dead and Their Possessions: Repatriation in Principle, Policy and Practice*.
 Routledge, London.

Fitzmaurice, Andrew
2014 *Sovereignty, Property and Empire, 1500–2000*. Cambridge University Press,
 Cambridge.

Gascoigne, John
1998 *Science in the Service of Empire: Joseph Banks, the British State and the Uses of Sci-
 ence in the Age of Revolution*. Cambridge University Press, Cambridge.
2003 *Joseph Banks and the English Enlightenment: Useful Knowledge and Polite Culture*.
 Cambridge University Press, Cambridge.
2007 *Captain Cook: Voyager between Worlds*. Hambledon Continuum, London.

Griffiths, Tom
1996a *Hunters and Collectors: The Antiquarian Imagination in Australia*. Cambridge
 University Press, Melbourne.

1996b In Search of Australian Antiquity. In *Prehistory to Politics: John Mulvaney, the Humanities and the Public Intellectual*, edited by Tim Bonyhady and Tom Griffiths, pp. 42–62. Melbourne University Press, Carlton.

Grimshaw, Patricia, Marilyn Lake, Ann McGrath, and Marian Quartly

2006 *Creating a Nation*. API Network, Perth.

Gould, Stephen J.

1996 *The Mismeasure of Man*. Norton, New York.

Hamilton, Michelle D.

2009 Adverse Reactions: Practicing Bioarchaeology among the Cherokee. In *Under the Rattlesnake: Cherokee Health and Resiliency*, edited by Lisa J. Lefler, pp. 29–60. University of Alabama Press, Tuscaloosa.

Hammil, Jan, and Larry J. Zimmerman

1983 *Reburial of Human Skeletal Remains: Perspectives from Lakota Spiritual Men and Elders*. American Indians Against Desecration, Indianapolis.

Haydon, Tom

1975 *The Long, Long Walkabout*. Video recording. ABC Commercial, Sydney.

Healy, Chris

1997 *From the Ruins of Colonialism: History as Social Memory*. Cambridge University Press, Melbourne.

2008 *Forgetting Aborigines*. University of New South Wales Press, Sydney.

Henderson, Anna

2014 Prime Minister Tony Abbott Describes Sydney as "Nothing but Bush" before First Fleet arrived in 1788. Available at http://www.abc.net.au/news/2014-11-14/abbot-describes-1778-australia-as-nothing-but-bush/5892608, accessed August 24, 2014.

Hill, Rick

1994 Repatriation Must Heal Old Wounds. In *Reckoning with the Dead: The Larsen Bay Repatriation and the Smithsonian Institute*, edited by Tamara L. Bray and Thomas W. Killion, pp. 184–86. Smithsonian Institute Press, Washington.

Hokari, Minoru

2011 *Gurindji Journey*. UNSW Press, Kensington.

Jones, Rhys

1967 Middens and Man in Tasmania. *Australian Natural History* 15(11): 359–64.

1971 Rocky Cape and the Problem of the Tasmanians. PhD diss., University of Sydney, Sydney. Available at http://ses.library.usyd.edu.au/handle/2123/7894.

Kennedy, Dane (editor)

2013 *The Last Blank Spaces: Exploring Africa and Australia*. Harvard University Press, Cambridge.

2014 *Reinterpreting Exploration: The West in the World.* Oxford University Press, New York.

Lilley, Ian

2005 Archaeology and the Politics of Change in a Decolonizing Australia. In *Object Lessons,* edited by Jane Lydon and Tracy Ireland, pp. 89–100. Australian Scholarly Publishing, Melbourne.

Macintyre, Stuart, and Anna Clark

2004 *The History Wars.* Melbourne University Press, Carlton.

Mcfarlane, Ingereth, Mary-Jane Mountain, and Robert Paton (editors)

2005 *Many Exchanges: Archaeology, History, Community and the Work of Isabel McBryde.* Aboriginal History Inc., Canberra.

McGrath, Ann (editor)

1995 *Contested Ground: Aborigines under the British Crown.* Allen and Unwin, Sydney.

McGrath, Ann

2008 Translating Histories: Australian Aboriginal Narratives, History and Literature. *The Southern Hemisphere Review* 24: 34–47.

2014 Is History Good Medicine? *Journal of Australian Studies* 38(4): 396–414.

2015 Deep Histories in Time, or Crossing the Great Divide? In *Long History, Deep Time,* edited by Ann McGrath and Mary Ann Jebb, pp. 1–32. ANU Press, Canberra.

McGrath, Ann, and Andrew Pike

2014 *Message from Mungo.* Video recording. Ronin Films, Canberra.

McNiven, Ian, and Lynette Russell

2005 *Appropriated Pasts: Indigenous Peoples and the Colonial Culture of Archaeology.* AltaMira Press, Lanham, MD.

Moreton-Robinson, Aileen

2004 *Whitening Race: Essays in Social and Cultural Criticism.* Aboriginal Studies Press, Canberra.

Moore, Bruce (editor)

2004 *The Australian Oxford Dictionary.* Oxford University Press, Melbourne.

Morris-Suzuki, Tessa

2005 *The Past within Us: Media, Memory, History.* Verso, London.

Mulvaney, John

1975 *The Prehistory of Australia.* Penguin, Ringwood.

2007 Interviewed by author. Video recording. Canberra, November 21.

2011 *Digging Up a Past.* University of New South Wales, Sydney.

Nugent, Maria

2005 *Botany Bay: Where Histories Meet.* Allen and Unwin, Crows Nest.

O'Brien, Jean M.

 2010 *Firsting and Lasting: Writing Indians Out of Existence in New England.* University of Minnesota Press, Minneapolis.

Pratt, Mary Louise

 2007 *Imperial Eyes: Travel Writing and Transculturation.* Routledge, London.

Reynolds, Henry

 1987 *Law of the Land.* Penguin, Ringwood.

Roediger, David

 1991 *The Wages of Whiteness: Race and the Making of the American Working Class.* Verso, New York.

Schickore, Jutta

 2014 Scientific Discovery: *Stanford Encyclopedia of Philosophy.* Available at http://plato.stanford.edu/archives/spr2014/entries/scientific-discovery.

Schiebinger, Londa

 1999 *Has Feminism Changed Science?* Harvard University Press, Cambridge.

Shawcross, Wilfred

 2013 Interviewed by author. Video recording. Canberra, May 17.

Shorter Oxford English Dictionary

 2007 *Shorter Oxford English Dictionary*, 6th ed., edited by Angus Stevenson. Oxford University Press, Oxford.

Smith, Claire, and Gary Jackson

 2006 Decolonizing Indigenous Archaeology: Developments from Down Under. *American Indian Quarterly* 30(3–4): 311–49.

Smith, Claire, and Hans Martin Wobst (editors)

 2005 *Indigenous Archaeologies: Decolonizing Theory and Practice.* Routledge, London.

Smith, Laurajane

 2006 *The Uses of Heritage.* London: Routledge.

Stern, Nicola

 2015 The Archaeology of the Willandra. In *Long History, Deep Time: Deepening Histories of Place*, edited by Ann McGrath and Mary Ann Jebb, pp. 221–40. ANU Press and Aboriginal History Inc., Acton.

Thomas, David Hurst

 2000 *Skull Wars: Kennewick Man, Archaeology, and the Battle for Native American Identity.* Basic Books, New York.

Thomas, Nicholas

 2003 *Cook: The Extraordinary Voyages of Captain James Cook.* Walker and Company, New York.

 2004 *Discoveries: The Voyages of Captain Cook.* Penguin, London.

Thorne, Alan
 2013 Interviewed by author. Video recording. Canberra, March 21.
Tuniz, Claudio, Richard Gillespie, and Cheryl Jones
 2009 *The Bone Readers: Atoms, Genes and the Politics of Australia's Deep Past.* Allen
 and Unwin, Crows Nest.
Turnbull, Paul, and Michael Pickering (editors)
 2010 *The Long Way Home: The Meaning and Values of Repatriation, Museums and
 Collections,* Vol. 2. Berghahn Books, New York.
Wailoo, Keith, Alondra Nelson, and Catherine Lee (editors)
 2012 *Genetics and the Unsettled Past: The Collision of DNA, Race, and History.* Rut-
 gers, New Brunswick, NJ.
Webb, Stephen
 1987 Reburying Australian Skeletons. *Antiquity* 61(232): 292–96.
Webb, Stephen, Matthew L. Cupper, and Richard Robins
 2006 Pleistocene Human Footprints from the Willandra Lakes, Southeastern Aus-
 tralia. *Journal of Human Evolution* 50: 405–13.
Williams, Lottie
 2012 Interviewed by author. Video recording. Mildura, May 12.
Wolf, Eric
 1982 *Europe and the People without History.* University of California, Berkeley.
Wolpoff, Milford, Alan Thorne, Fred H. Smith, David Frayer, and Geoffrey Pope
 1994 Multiregional Evolution: A World-wide Source for Modern Human Popula-
 tions. In *Origins of Anatomically Modern Humans,* edited by M. Nitecki and D.
 Nitecki, pp. 175–99. Plenum Press, New York.
Zimmerman, Larry J.
 1987 Webb on Reburial: A North American Perspective. *Antiquity* 61(233): 462–63.

SECTION IV

ARCHAEOLOGY, ART, AND EXOTICISM

Since Edward Said's seminal work in the late 1970s, numerous studies have amplified, modified, and rectified the theoretical framework for historical discussions of Orientalism. The most noticeable is Suzanne Marchand's *German Orientalism in the Age of Empire: Religion, Race and Scholarship* (2009), which has significantly nuanced our understanding of Western Orientalism. In a similar vein, the three contributors in this section address complexities in the practice of imperial archaeology and art history in Russian Buryatiia, Mongolia, and the Republic of China, and ask whether all research conducted by foreigners in these regions was influenced to the same degree by imperialist and Orientalist objectives.

Unlike many European powers, Russia's imperialist activities were focused on expansion in neighboring regions rather than in distant lands. Some members of the Imperial Geographical Society played an important role in the intense rivalry between the British and Russian Empires in Central Asia. By taking a closer look at the institutional framework of archaeological research in the Russian Empire, and two case studies of Pyotr Kuzminich Kozlov's imperial expedition in Central Asia and Iulian Tal'ko-Gryntsevich's archaeological discoveries in Buryatiia, Ursula Brosseder concludes that Russian archaeology in the imperial period was shaped by many complex and competing factors that cannot be reduced handily to a single objective or ideology.

In the second essay, Jian Xu re-evaluates the expeditions, surveys, and excavations conducted by the French explorer Victor Segalen in southwest China during the early twentieth century. Famous for his contributions to exoticism in art and literature, Segalen is not as well known for his engagement in French

Sinology. Xu contends that Segalen's work as an artist and poet had a significant impact on his work as an archaeologist and ethnographer. Building from this case study, Xu discusses the intellectual context of French archaeological missions in China and proposes the term of "exoticist archaeology" to accommodate some of the features of Segalen's exploration. Xu argues that the work of Segalen does not fit neatly in the category of imperialist scholarship and should be reassessed on its own terms even if exoticism itself was a product of nineteenth-century imperialism.

The last essay in this section by Lothar von Falkenhausen discusses the life, scholarship, and legacy for Chinese studies of four German Orientalists during the first half of the twentieth century: Gustav Ecke, Victoria Contag, Eleanor von Erdberg-Consten, and Max Loehr. Although tangential to "imperial archaeology," since all the four protagonists self-identified as art historians rather than archaeologists, this essay provides an important and often neglected aspect of what may be termed a "imperialist narrative." Gathering bits and pieces of information from personal memoirs, scholarly writings, and archival materials, von Falkenhausen begins with the four scholars' academic preparation and intellectual lineage and the circumstances and motivations that brought them to China. A particularly interesting period was during the second Sino-Japanese War that broke out in 1937, and the political entanglement of Germany with both China and Japan. The essay ends with the collapse of Nazi Germany and Imperial Japan, when the victorious Allies insisted on the repatriation of German citizens and these four scholars departed from China. The individual experiences of the four German art historians and their intellectual legacy exemplify a range of possibilities for adaptation and acculturation in China during the first half of the twentieth century.

In the Shadow Zone of Imperial Politics: Archaeological Research in Buryatiia from the Late Nineteenth Century to the 1940s

Ursula B. Brosseder

After Edward Said argued in *Orientalism* (1978) that interest in the Orient served political and colonial goals, there was much debate about the extent to which geographical societies and their proponents were actively involved in these activities and to what extent they served the imperatives of colonialism and imperialism in the nineteenth and early twentieth centuries. Unlike other "-isms," however, colonialism is difficult to grasp as an idea and program. It produced a wide array of visions and doctrines of justification but these were rarely accepted as binding (Osterhammel and Jansen 2012: 111). Rather than searching for adequate theories to explain colonialism, and by extension Orientalism, it seems more worthwhile to explore the mentalities that existed in particular colonial and/or imperial situations. Three basic tenets of colonial thinking in this period included construction of the inferiority of otherness, which offered, in turn, support for the view that subject people needed leadership. Finally, it is evident that Europeans anticipated that they would find chaos and this outlook offered an excuse for implementing the organizational renewal of the lands they occupied (Osterhammel and Jansen 2012: 112–17).

Russia represents something of a special case in comparison with other contemporary empires. After it had established itself as an imperial power in the early modern period, its expansion took place in neighboring regions rather than in distant lands (Díaz-Andreu 2007: 248). By the end of the seventeenth century, southern Siberia was under the control of the Russian Empire and subsequently was quickly colonized. By the eighteenth century, the proportion of Russians who

immigrated to this region outnumbered the Indigenous people of various ethnic groups, many of which no longer exist today.

During the nineteenth century, Russia, together with the British Empire, was one of the great players in the struggle to control Central Asia. The duel over Central Asia by both powers is commonly known as the "Great Game," which is generally regarded as having run from roughly the Russo-Persian Treaty of 1813 to the Anglo-Russian Convention of 1907. By the end of the nineteenth century, the Russians were winning, and Russia had imposed its rule over large areas of Central Asia. Today, however, the narrative of the Great Game has been repeatedly challenged and is today seen in a much more nuanced manner that emphasizes the ideological over the strategic importance of Russia's rivalry with Britain (Morrison 2014).

While there is a large body of literature on the questions of whether and to what extent Oriental studies, archaeology, and ethnology were among the sciences implicated in colonialism and imperialism, scholarly consensus has not been reached. If, however, one field may be named as an intimate accomplice of European expansion, it would be the discipline of geography (Osterhammel 2009: 1163–64). The entangled nature of geographical research with the needs of the Russian state is evident as in other contemporary empires and has been the subject of much research related to Oriental studies (Schimmelpenninck van der Oye 2010: 121, 198). The ties that existed between the Russian military and its elite, the General Staff, and Oriental studies become evident in the emergence of a distinct Asiatic cadre of military Orientalists (*voennye vostokovedy*) who gave their reports not only to the Imperial Geographic Society but also to the General Staff (Marshall 2006: 75).

In Russia, some members of the Imperial Geographical Society were also members of the General Staff, such as Nikolai M. Przhewalskii (in Polish, Przewalski), who was a strong supporter of Russian expansion in Asia. Given such institutional and personal interdependence, Alexander Morrisson has pointed out that:

> the personal hostility or indifference of individual scholars to the imperial enterprise is less important than the use which the state can make of the knowledge they produce and the people they train in its colonial enterprises, and in this respect Russia would appear not only to conform to the Saidian paradigm, but—given the much greater role played by the state in intellectual life than in Western Europe—to do so more thoroughly than either Britain or France (2011: 560).

D. Schimmelpenninck von der Oye (2014) has argued, however, that although these institutions were closely linked, the Geographic Society's objectives were

not to carry out military reconnaissance. Not many members of the Geographic Society were inveterate imperialists who subordinated their scientific projects to the goals of the conquest in Asia. Many studied Asia for the sake of what they viewed as pure research (Schimmelpenninck von der Oye 2014: 390). And, even when the Geographic Society collaborated closely with the military for the realization of specific expeditions, this cooperation did not automatically imply that the society was an instrument of Russian imperialism. Schimmelpenninck therefore has proposed a more nuanced view of the field of Oriental studies. Whereas some Russian Orientalists fit the mold described by Edward Said, others did not (Schimmelpenninck van der Oye 2011: 42).

In this case study of Russian research in areas of imperial interest, I concentrate on the history of archaeological research of Inner Asia, especially Buryatiia and to a lesser degree Mongolia, an area that lies outside the focal point of the Great Game in Central Asia. My focus is how archaeological research and its protagonists figured in this shadow zone of imperial politics and interests in the late nineteenth and early twentieth centuries. Their history suggests that the story is much more complex than the theory of Orientalism and the history of scientific imperialism would lead us to believe (see also von Falkenhausen, this volume; Xu this volume).

THE INSTITUTIONAL FRAMEWORK OF ARCHAEOLOGICAL RESEARCH IN THE RUSSIAN EMPIRE

With the colonization of Siberia, the Russian government used the region for a variety of ends. In the eighteenth century, Siberia attracted significant attention as the source of some of the earliest archaeological treasures and gold artifacts collected by the tsars from the opening of huge burial mounds of the Scythian period, many of which are today the core and pride of the State Hermitage in St Petersburg and housed in the treasure gallery (Díaz-Andreu 2007: 252). Suzanne Marchand (2015) has described this interest as symptomatic of the "antiquities rush" in this period. Moreover, Siberia was used by the Russian government as a punitive destination for undesirables. In addition to criminals, Russian authorities sent political prisoners to Siberia. By the nineteenth century, the latter highly educated elite played an important role in the development of research on indigenous culture and archaeology as well as the foundation of museums (Forsyth 1992: 42–43; Grøn 2005: 104). In Buryatiia, intellectual Decembrist (Dekabrist)[1] Nikolai A. Bestuzhev, who was sent along with several hundred other revolutionaries of the failed 1825 uprising to Siberian exile, initiated ethnographic and archaeological research of this region (Istoriia Buriatii 2011: 18).

During the so-called Great Game in the late nineteenth century, the Russian Empire sent numerous archaeological expeditions to Central Asia that were conducted by the Russian Geographical Society. The learned association, which was first named the Imperial Geographical Society, was established in 1845 by Tsar Nikolai I. Because it belonged to the Ministry of the Interior, it was state financed, receiving 10,000 rubles per annum from the Ministry of Finance. In the period before 1900, several additional branches of the society were founded in other Russian cities besides St Petersburg. The official goal of the association was research in distant lands. However, it sponsored missions "to investigate strategic questions as much as to expand geographical knowledge" (Marshall 2006: 24). The society also "served as a tool through which the Asiatic Department of the Foreign Ministry spread its influence" (Marshall 2006: 24). Certainly, the most important nineteenth-century military department responsible for geographers, translators, and ethnographers was the Asiatic Department of the Russian General Staff (Marshall 2006: 25). Many officers of the General Staff were also members of the Imperial Geographic Society, as was the case of Pyotr Kozlov, a military Orientalist. After the Revolution of 1917, however, the Geographical Society lost its status as the leading institution for archaeological research. From 1919, the Academy of Material Culture[2] took the lead in archaeological undertakings (Lebedev 1992: 421).

A decade after foundation of the Russian Geographical Society, the Imperial Archaeological Commission was established in 1859 during the reign of Tsar Alexander II. Based in St Petersburg, it was a state institution under the Ministry of the Court (Klein 2014: 48; Szczerba 2010). The main objectives of the Commission were to gather data on all kinds of antiquities in the territory of the Russian Empire and conduct a scholarly assessment of their importance (Medvedeva et al. 2009). For this reason, the Commission was engaged in archaeological excavations, which it could organize on state, public, and church properties. By contrast, it required landowners' permission to conduct excavations on private lands (Szczerba 2010). One of the major tasks of the Commission was to ensure a steady "flow" of antiquities to the Hermitage at St Petersburg. Naturally, many of the antiquities that today make up the largest body of the State Hermitage collection were those excavated by members of the Commission. Soon after its establishment, the Commission also issued an appeal calling for antiquities to be sent to its offices. In order to attract potential benefactors, financial rewards were offered to donors. Whereas rare and valuable artifacts were transferred to the Hermitage or other institutions selected by the tsar, those that were considered to be of no interest to any scholarly institution were returned to their owners or finders. By decree of the tsar in 1889, the Com-

mission obtained the exclusive right to conduct archaeological excavations. It also had the ability to grant permission to other individuals or groups to conduct excavations, which it did by issuing licenses called "open lists" (*otkrytii list*) for which, in return, a report had to be sent to the Commission. This system of granting permissions for excavations is still in effect today (Imperatorskaia Arkheologicheskaia Kommissia 2009).

The decree of 1889 made the Commission the central archaeological institution in Russia since it thereafter had authority for all archaeological work conducted in the Russian Empire. The rationale behind the 1889 decree was to stop all uncontrolled excavations. In practice, however, archaeological sites and findings were protected only when it was convenient for the Commission or when the Commission found the antiquities in question to be of considerable value (Szczerba 2010). In order to conduct archaeological research in regions as distant from St Petersburg as Siberia, the Commission contacted local teachers, officers, and other learned people and offered them financial aid in exchange for excavations (Dluzhnevskaia and Lazarevskaia 2009). A good example of such activity is V. Radloff, who lived in the Altai and whom the Commission offered financial aid for conducting excavations and sending reports to St Petersburg.

Imperial Endeavor: Pyotr Kuzminich Kozlov's Expeditions

As a military officer, Pyotr Kuzminich Kozlov (1863–1935) accompanied his mentor Nikolay Przhevalsky on his expeditions to Asia and continued his work after Przhevalsky's death. Overall, between 1883 and 1926, Kozlov (Fig. 10.1) participated in six and led three expeditions that brought him to western and northern China and eastern Tibet and Mongolia. In the first decade of the twentieth century, when the rivalry between Britain and Russia reached its peak, Kozlov, leading the Russian expedition, rivaled Sven Hedin and Aurel Stein as one of the foremost researchers of Xinjiang. For his achievements, he was awarded the Constantine medal, the highest award of the Imperial Russian Geographical Society in 1902. Although he was on good terms with Hedin and other foreign explorers, the British government, as represented by George Macartney, monitored Kozlov's movements closely across Central Asia. In 1905, he visited the Dalai Lama in Ulaanbaatar—named Urga at that time. In 1904, the Dalai Lama had fled from Tibet where he normally resided, when troops of the British Empire—as a measure in the Great Game to gain control over Tibet—moved toward Lhasa. Since Russia, the other opponent in the Great Game, was unable to protect Tibet due to a war it was fighting against Japan, Kozlov tried to persuade the Dalai Lama to move to Russia where he could more easily be protected. In 1906, Kozlov was

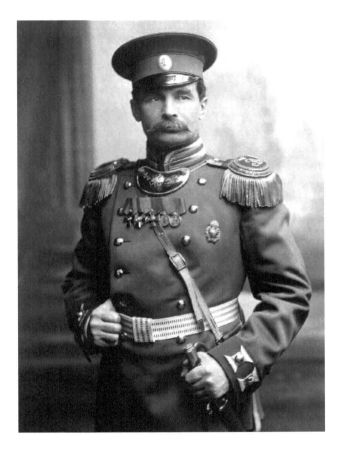

FIGURE **10.1.** Pyotr Kuzminich Kozlov. Reproduced with permission from Polos'mak et al. (2011: 25, fig. 1.18).

"assigned on detached service at the Chief Directorate of the General Staff and put at the disposal of the Chief of the General Staff Lieutenant General F. F. Palitsyn" (Andreev and Yusupova 2015: 137). During his expedition of 1907–1909, Kozlov explored the Gobi Desert and discovered the ruins of Khara-Khoto, a Tangut city destroyed by the Ming Chinese in 1372. It took him several years to excavate the site and thereafter he brought no less than two thousand books in the Tangut language to St Petersburg. In 1911, Kozlov received the Founder's medal of the Royal Geographical Society of England.

It has been argued that Kozlov was politically aware but not a proponent of "conquistador imperialism" (Andreev and Yusupova 2015: 137; Schimmelpenninck van der Oye 2001: 41). He managed to survive the restructuring of the country during the October Revolution of 1917 and the civil strife that transpired between 1918 and 1922. He was able to seek the influential patronage of the Bolshevik elite as well as the Academy of Sciences (Andreev and Yusupova 2015:

144–45). In 1920, Kozlov went to Siberia to inspect the local branches of the Geographical Society. His last expedition, the Mongol-Tibetan expedition, between 1923 and 1926, was aimed at returning to Khara Khoto, where he hoped to excavate again, and reaching Lhasa in Tibet. However, because of intrigue against Kozlov by the Secret Service, his expedition was halted in Urga (i.e., Ulaanbaatar) (Fig. 10.2) and forced to remain in Mongolia (Polos'mak et al. 2011: 10–51). He reduced the number of his staff and excavated with his team in Noyon Uul (Noin-Ula), Mongolia, where he investigated richly furnished princely tombs of the Xiongnu (Polos'mak et al. 2011: 10–51). Soon after returning to St Petersburg (Petrograd) with some remarkable samples of 2000-year-old Bactrian textiles, Kozlov retired from scientific work and settled in a village near Novgorod.

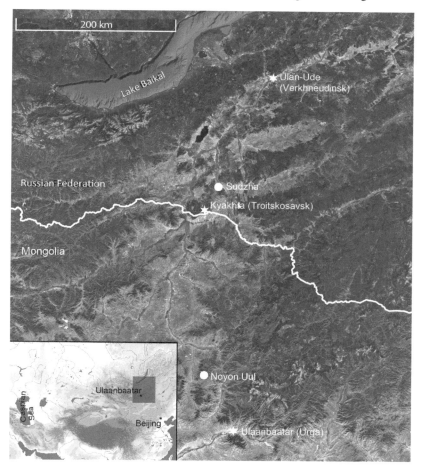

FIGURE 10.2. Map of Buryatiia and northern Mongolia with modern towns and excavation sites mentioned in the text.

ARCHAEOLOGICAL RESEARCH IN THE SHADOW ZONE: BURYATIIA
AND IULIAN TAL'KO-GRYNTSEVICH (TALKO-HRYNCEWICZ)

In Buryatiia, the start of archaeological research differed significantly from the
work of Kozlov in Inner Asia and is closely linked with the name of Iulian Tal'ko-
Gryntsevich (Fig. 10.3). Buryatiia, today an autonomous republic in the Russian
Federation, is located just south of Lake Baikal (Fig. 10.2). Kyakhta, the border
city between the Russian Empire and the Chinese Qing Empire, was a flourish-
ing trading post in the early nineteenth century. Its decline began as a consequence
of the development of alternative trade routes in the late nineteenth and early
twentieth centuries. Kyakhta also served as a transit station for several Russian
expeditions into Asia (Istoriia Buriatii 2011: 19; Tal'ko-Gryntsevich 2000: 64).
The Buryats held a special place within the Russian Empire. Of all of the Indige-
nous people in the region, they were one of the two Mongol nations in the Empire
that—in the Russian view—represented a higher stage of human development in
comparison with other "primitive" shamanistic people of Siberia. The Buryats had
a differentiated societal structure with a highly visible, and, in the eyes of the
Russian Empire, "useful" aristocracy (Osterhammel 2009: 530). Despite the
intrusiveness of the colonial administration and missionary activities in the
region, the Buryats managed to earn respect and freedom of action that, for exam-
ple, no Indigenous groups were able to retain in North America or Australia (see
Colwell and McGrath, this volume). The Buryats even managed to generate
something like a modern educated elite who articulated their interests publicly
(Osterhammel 2009: 530). Despite these circumstances, archaeological research
only began when the Polish medical doctor Iulian Dominikovich Talko-Gryntse-
vich decided to live in Kyakhta.

Tal'ko-Gryntsevich was born in Warsaw in 1850 and studied medicine in St
Petersburg from 1870. After moving to Kiev, he took the medical exam in 1876.
Although he started to work as a medical doctor in Kiev, he subsequently worked
in hospitals in Paris and Vienna. When he returned to Kiev, his special interest
became the study of diverse populations based on their physical appearance. He
took tours in the local countryside and often visited the site of the Ryzhanov *kur-
gans* (burial mounds) in the vicinity. He also studied anthropological collections
of excavations (Eilbart 2003: 65). His interest in the *kurgans* was to conduct
research the ancient population and to see whether one could determine the ages
and sex of the deceased, along with other important elements of their identity. A
key tool for his research was the measurement of bones found in the mounds.
Since burial mounds were located on private property owned by one of his
cousins, Tal'ko-Gryntsevich was able to excavate one *kurgan* in 1884. His main

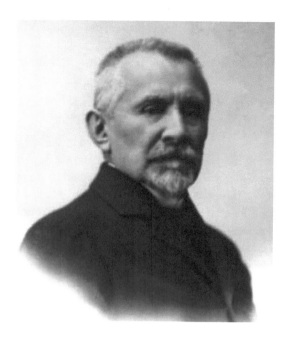

FIGURE 10.3. Iulian Tal'ko-Gryntsevich. Photo: Janmad/ Wikimedia Commons.

interest was in studying the skeleton of a young woman he found buried there. Pursuant to his interest in this topic, he then collected all available information on bone remains from Ukraine and turned to the study of living populations of Ukrainians, Poles, the Baltic people, and Jews. For his studies, he travelled through thirty cities and assessed the features of about six thousand people. He summarized his research in a book published in 1893 devoted to anthropological comparisons of nations entitled *Folk Medicine of Southern Russia* (Talko-Hryncewicz 1893). In addition to this volume, he published numerous works and became a well-known anthropological and archaeological scholar.

Between 1892 and 1908, Tal'ko-Gryntsevich lived in Kyakhta/Troitskosavsk, the Russian border town in Buryatiia. In his own words, his main goal in living in Buryatiia was to study the people in the east, now that he had completed his studies of populations in the west (Eilbart 2003: 72). Two years after Tal'ko-Gryntsevich's arrival in Kyakhta, the Troitskosavsk-Kiakhtinskii branch of the Russian Geographical Society was founded in June 1894 and he became its head. The local heritage museum, which had been founded in Kyakhta in 1890 by rich merchants, was likewise incorporated into the society, and Tal'ko-Gryntsevich became its administrator. Tal'ko-Gryntsevich suggested that he conduct archaeological excavations to further his anthropological study of ancient bones. His goal was to compose a monograph on the people of Central Asia. Looking back at his time in Transbaikalia he wrote:

[T]he goal of anthropology is to study all aspects of the life of people includ-
ing their physical appearance, their expression of the spiritual sphere, and phys-
iological processes.... I was so lucky to come to Troitskosavsk, which was
important for anthropology since different people (in the sense of populations)
lived there: the local Siberian people, the immigrated Russians, but also Polish,
Germans, and the local Asiatic people, like the Buryats, Mongols and the Chi-
nese (Eilbart 2003: 61).

In 1896, Tal'ko-Gryntsevich began his excavations in the cemetery of
Sudzha, twenty kilometers northeast of Kyakhta, which he learned about from
local Buryats. Out of the 212 graves he found at the site, he excavated 33 (Eilbart
2003: 75). For each grave he studied, he made a sketch, gave a short description
of the grave structure, noted the placement of each object, and measured the
bones (Tal'ko-Gryntsevich 1999: 16–62). His analysis presented a comprehen-
sive evaluation of the skeletal material found, the subject of which made up the
largest part of his report. In his conclusions, he compared his finds, the grave
form, and the grave objects, with all materials that were known to this date from
other places in Siberia, namely from the Minusinsk Basin and the Altai. It rap-
idly became apparent to Tal'ko-Gryntsevich that the graves and their inventory
from the cemetery he excavated did not compare to finds made elsewhere. More-
over, the characteristics of the skeletons indicated an ancient and mixed race, a
type that he believed was different from the Mongols. He observed that the dead
of Sudzha were strong and tall people, and the skulls of the men were somewhat
more elongated while the skulls of the women were shorter (Tal'ko-Gryntsevich
1999: 32). He suggested that this racial mix was caused by a migration of people
from Central Asia. In this sense, Tal'ko-Gryntsevich's focus reflected widespread
interest in the category of race among intellectuals around 1900 (Osterhammel
2009: 1217).

After he excavated graves of another similar cemetery with which he could
compare Sudzha, Tal'ko-Gryntsevich published his first comprehensive analysis
in 1905. He interpreted the oldest remains of this cemetery at Dyrestui—those
in coffins—as relics of a "Khun-Khu" state mentioned in Chinese sources
(Tal'ko-Gryntsevich 1905: 46). His source for the term is unknown as are the
Chinese sources to which he referred, because the term "Khun-Khu" does not
relate to any known ethnonym from Chinese texts. While these points remain
unclear, Tal'ko-Gryntsevich was the first to raise the question of the internal
chronological differentiation of these grave types and their "ethnic" interpreta-
tion. He specifically mentioned in this context the "Hunnic state" (Tal'ko-Grynt-
sevich 1905: 46; Tal'ko-Gryntsevich 1928: 9).[3] However, because the Chinese
wuzhu coins found in the graves were minted until the sixth century, Tal'ko-

Gryntsevich attributed the burials to a similarly late period. Despite the fact that today the Xiongnu are dated earlier than Tal'ko-Gryntsevich's estimate, his cultural attribution was fairly accurate. Although he published the results of his work in the journal of the Troitskosavsk section of the Geographical Society that was printed in St Petersburg, it appears that not much attention was paid to his research on Buryatiia at this time.

Let us turn briefly to the financing of Tal'ko-Gryntsevich's archaeological expeditions. As head of the Troitskosavsk-Kyakhta filial department of the Imperial Geographical Society, he received financial support for his excavations. In order to undertake his research, he needed to obtain a permit, as is still current practice, issued by the Imperial Archaeological Commission. In 1900 and 1902, the local branch of the Imperial Geographical Society asked for excavation permits that were granted and the work was performed by Tal'ko-Gryntsevich (Dluzhnevskaia and Lazarevskaia 2009: 626–27). The excavations were conducted with the help of local members of the Geographical Society and local workers. No military officers were involved in any of these undertakings. In 1908, Tal'ko-Gryntsevich received an offer to become head of the anthropological department of the Jagellonian University in Kraków and left Buryatiia to live in Kraków, Poland, where he died in 1936 (Eilbart 2003: 139).

For his work, Tal'ko-Gryntsevich was awarded medals by several societies. The most distinguished of these included the gold medal of the Imperial Geographic Society in 1905. However, his findings did not resonate in the centers of knowledge and research of St Petersburg. Only after 1923 did interest grow in the work of Tal'ko-Gryntsevich, since his publications offered comparative materials for studying the aristocratic Noyon Uul burials that had been excavated by the above-mentioned Mongolian-Tibetan expedition under Kozlov.

LEGACY OF THE KOZLOV AND TAL'KO GRYNTSEVICH EXPEDITIONS

Immediately after the discovery of the Noyon Uul aristocratic burials in the early 1920s, Gregorii Borovka (Fig. 10.4), one of the expedition members, attempted the first cultural-historical evaluation of the materials. He related them to Scytho-Siberian art and saw them as a local variant (Borovka 1925, 1926). Without employing relevant written records, he connected the materials found at the site to Siberia, China, Central Asia, the Near East, and the Greek colonies in the Black Sea. His colleague, Sergei Teploukhov, another member of the Kozlov expedition, not only connected Noyon-Uul to the materials unearthed by Tal'ko-Gryntsevich but also analyzed the imported materials from China. Teploukhov concluded that these finds belonged to the Han dynasty. He thus

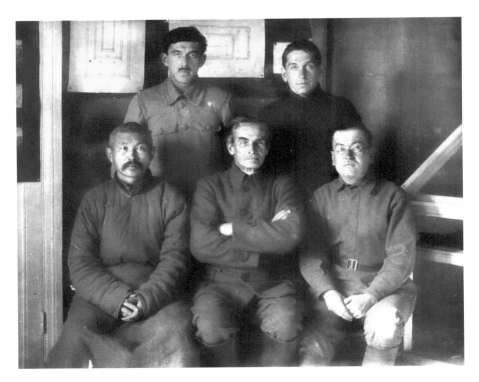

FIGURE 10.4. In Urga 1924. Members of the Mongol-Tibetan expedition led by Pyotr Kozlov. From left to right: Seated—Ts. Zh. Zhamtsarano, P. K. Kozlov, S. A. Teploukhov. Standing—S. A. Kondrat'ev, G. I. Borovka. Reproduced with permission from Polos'mak et al. (2011: 34, fig. 1.25).

indirectly corrected Tal'ko-Gryntsevich's chronology without directly mentioning this (Teploukhov 1925: 21–22). He continued his argumentation by pointing out that numerous foreign imports from China, but also from Central Asia, suggested a very powerful group of people, perhaps even the "Huns."[4] It was known that their political and religious leader—Chanyu—received numerous presents from the Chinese emperor (Teploukhov 1925: 22).

Four years later, in 1929, research in Buryatiia was continued by Georgii Sosnovskii. He was a young specialist of Siberian archaeology and a graduate student in Moscow who moved to St Petersburg in 1927, when he became senior researcher in the GAIMK (Gosudarsvennaia Akademiia Istorii Material'noi Kul'tury). At the initiative of the Buryat-Mongol research committee, the GAIMK and the Academy of Sciences organized an archaeological expedition to Buryatiia in 1929 with Sosnovskii at its head (Sosnovskii 1936). In 1935, he

explicitly corrected the dating of the simpler graves excavated by Tal'ko-Gryntse-vich and dated them to the same period as the graves of Noyon Uul around the start of the common era. He also connected them to the Xiongnu of the recorded historical sources (Sosnovskii 1935: 172–73).

In recent collections on the history of research on the Xiongnu (Polos'mak et al. 2011), the achievement of Kozlov and his expedition is mentioned and honored. Undoubtedly without him, the expedition would not have taken place. However, they give little attention to the fact that the actual research, analyses, and the publication of the cutting-edge research was done by Tal'ko-Gryntse-vich, Borovka, Teploukhov, and Sosnovskii, names that are usually considered of secondary significance. This legacy is no doubt due in part to the events that succeeded the archaeological expeditions in question. While Tal'ko-Gryntsevich was not affected by the political purges of the Stalin era during the 1930s and 1940s, since he had returned to Poland long before, and Kozlov died in 1935, the other leading archaeologists, including Borovka, Teploukhov, and Sosnovskii did not survive this period. They suffered the fate of many archaeologists who were targeted during the Stalin era.

Overall, we must conclude that the history of archaeological research in Buryatiia and its protagonists cannot be tied to imperial politics in a direct way. If there was any connection at all, one may observe that the start of archaeological research in Siberia was tied indirectly to politics since intelligentsia prisoners were sent to Siberia. Moreover, in the late nineteenth and early twentieth centuries, archaeological research in Buryatiia prospered because of Tal'ko-Gryntse-vich's professional and personal interest as an anthropologist and doctor. In contrast, although Kozlov was one of the military Orientalists, his last expedition to Mongolia almost failed because of the complete political change over the course of the 1917 October Revolution, when his early association with the General Staff and the state in general were seen as suspicious. Moreover, the fruits of his research in these archaeological expeditions were made clear only by the combined efforts of a number of young outstanding researchers working on related topics. Although connected with the political centers of research, their archaeological discoveries were not used as arguments to justify political actions. On the contrary, they were among the victims of the purge that killed most archaeologists among the intelligentsia in the 1930s and 1940s, a loss that is still felt today in Russian archaeological research. The history of Russian archaeology has been shaped by numerous underlying currents that make it impossible to reduce its complexity to a single concept such as Orientalism or to tie it into a simple scheme of contemporary political interests.

NOTES

[1] The Decembrists are named after an incident that took place in 1825, when Russian army officers refused to take an oath to the new tsar, Nikolai I, and protested against the autocratic regime, serfdom, police arbitrariness, and censorship. Because the revolt took place in December, it was called the Decembrist revolt.

[2] First named Rossiiskaia Akademia Material'noi Kul'tury (RAIMK), it was re-named Gosudarstvennaia Akdemia Material'noi Kul'tury (GAIMK) in 1926.

[3] Since the first translation of Chinese sources into French in the late eighteenth century, there has been a long debate over a possible relation between the Xiongnu (third century BCE–second century CE) known from Chinese texts and the European Huns (late fourth to mid-fifth century CE). While today the terms are no longer confused, in older Russian literature often the term "gunny," that is, Huns, has been employed. From the context, however, it is clear that Tal'ko-Gryntsevich referred here to the Xiongnu mentioned in the Chinese texts.

[4] Teploukhov employs the term "гунны" (gunny = Huns), but the context makes clear that he is talking about the Xiongnu of the Chinese written sources.

REFERENCES CITED

Andreev, Alexander I., and Tatiana I. Yusupova
 2015 Pyotr Kuz'minich Kozlov. Geographers. *Biobibliographical Studies* 34: 128–64.

Borovka, Georgii I.
 1925 Kul'turno-istoricheskoe znachenie arkheologicheskikh nakhodok ekspeditsii. In *Kratkie otchety ekspeditsii po issledovaniiu Severnoi Mongolii v sviazi s Mongolo-Tibetskoi Ekspeditsii P. K. Kozlova*, pp. 23–50. Akademia Nauk SSSR, Leningrad.
 1926 Die Funde der Expedition Koslow in der Mongolei 1924/25. *Archäologischer Anzeiger*, 341–68.

Díaz-Andreu, Margarita
 2007 *A World History of Nineteenth-Century Archaeology: Nationalism, Colonialism, and the Past.* Oxford University Press, Oxford.

Dluzhnevksaia, Galina V., and Natal'ia A. Lazarevskaia
 2009 Arkheologicheskie pamiatniki Sibiri v issledovaniiakh imperatorskoi arkheologicheskoi komissii. In *Imperatorskaia Arkheologicheskaia komissiia (1859–1917). K 150-letiiu so dnia osnovaniia. U istochnikov ochestvennoi Arkheologii i okhrany kul'turnogo naslediia*, pp. 594–636. Dmitri Bulnin, St Petersburg.

Eilbart, Natalia
 2003 *Iulian Dominikovich Tal'ko-Gryntsevich.* Nauka, Moscow.

Forsyth, James
 1992 *A History of the Peoples of Siberia: Russia's North Asian Colony, 1581–1990.* Cambridge University Press, Cambridge.

Grøn, Ole

2005 Archaeology and the study of indigeneous peoples in Siberia. In *Conservation, Identity and Ownership in Indigenous Archaeology*, edited by Bill Sillar and Cressida Fforde, special issue. *Public Archaeology* 4(2/3): 103–107.

Klein, Leo S.

2012 *Soviet Archaeology: Trends, Schools, and History*. Oxford Studies in the History of Archaeology. Oxford University Press, Oxford.

2014 *Istoriia Rossiskoi Archeologii*. Ucheniia, shkoly i lichnosti 1. Obshchii obzor I dorevolutsionnoe vremia. EVRAZIA, St Petersburg.

Lebedev, Gleb S.

1992 *Istoriia otechestvennoi arkheologii*. 1700–1917 gg. SPBGU, St Petersburg.

Marshall, Alex

2006 *The Russian General Staff and Asia, 1800–1917*. Routledge Studies in the History of Russia and Eastern Europe 4. Routledge, London, New York.

Marchand, Suzanne L.

2009 *German Orientalism in the Age of Empire: Religion, Race, and Scholarship*. Cambridge University Press, Cambridge.

2015 The Dialectics of the Antiquities Rush. In *Pour une histoire de l'archéologie XVIIIe siècle–1945*. In *Hommage de ses collègues et amis à Ève Gran-Aymerich*, edited by Annick Fenet and Natacha Lubtchansky, pp. 191–206. Ausonius, Bordeaux.

Medvedeva, Maria V., L. M. Vseviov, Aleksandr E. Musin, and Igor L. Tichonov

2009 Ocherk istorii deiatel'nosti imperatorskoi archeologicheskoi Komissii v 1859–1917 gg. In *Imperatorskaia Arkheologicheskaia komissiia (1859–1917)*, pp. 21–247. K 150-letiiu so dnia osnovaniia. U istochnikov ochestvennoi Arkheologii i okhrany kul'turnogo naslediia, St Petersburg.

Morrison, Alexander

2011 Review of Schimmelpenninck van der Oye, David. *Russian Orientalism: Asia in the Russian Mind from Peter the Great to the Emigration* (Yale University Press, New Haven, CT and London, 2010). *The Slavonic and East European Review* 89(3): 558–60.

2014 Introduction: Killing the Cotton Canard and Getting Rid of the Great Game: Rewriting the Russian Conquest of Central Asia, 1814–1895. *Central Asian Survey* 33(2): 131–42.

Osterhammel, Jürgen

2009 *Die Verwandlung der Welt: Eine Geschichte des 19. Jahrhunderts*. Historische Bibliothek der Gerda Henkel Stiftung. Beck, Munich.

Osterhammel, Jürgen, and Jan Jansen

2012 *Kolonialismus: Geschichte, Formen, Folgen*. 7th ed. C. H. Beck, Munich.

Polos'mak, Natalia V., Evgenii S. Bogdanov, and Damdinsüren Tseveendorzh

2011 *Dvatsatyi Noin-Ulinskii kurgan*. INFOLIO, Novosibirsk.

Said, Edward

1978 *Orientalism*. Penguin, London.

Schimmelpenninck van der Oye, David

2010 *Russian Orientalism: Asia in the Russian Mind from Peter the Great to the Emigration*. Yale University Press, New Haven, CT, London.

2011 The Imperial Roots of Soviet Orientology. In *The Heritage of Soviet Oriental Studies*, edited by M. Kemper and St. Conermann, pp. 29–46, Routledge Contemporary Russia and Eastern Europe Series 25. Routledge, New York.

2014 Agenty imperii? Russkoe geograficheskoe obshchestvo i Bol'shaia igra. In *Rossiiskoe izuchenie Tsentral'noi Azii: istoricheskie i sovremennye aspekty (k 150-letiiu P. K. Kozlova)* [The Russian Exploration of Central Asia in Historical Perspectives and Its Contemporary Aspects (in commemoration of the 150th anniversary of Petr K. Kozlov)], pp. 383–92. Politekhnika-servis, St Petersburg.

Sosnovskii, Georgii P.

1935 Derestuiskii mogil'nik. *Problemy istorii dokapitalisticheskikh obshchestv* 1/2: 168–76.

1936 Itogi raboty Buriat-Mongol'skogo arkheologicheskogo otriada Akademii nauk SSSR v 1928–1929 gg. In *Problemy Buriat-Mongols'koi ASSR* 2, pp. 318–21. Akad. Nauk SSSR, Moscow, Leningrad.

Szczerba, Adrianna

2010 The Role of the Imperial Archaeological Commission in the Protection of Archaeological Sites and Findings on the Territory of the Russian Empire. *Analecta. Studia i Materiały z Dziejów Nauki* 19:(1/2): 7–21

Tal'ko-Gryntsevich, Iulian D.

1905 Drevnie aboriginy Zabaikal'ia v sravnenii s sovremennymi inorodtsami. *Trudy Troitskosavkso-Kiakhtinskogo otdeleniia Priamurskogo otdela Imperatorskogo Russkogo geograficheskogo obshchestva* 8(1): 32–51.

1928 *Naselenie drevnikh mogil i kladbishch Zabaikal'skikh*. Izd. Buriat-Mongol'skogo nauchnogo obshchestva imeni D. Banzarova i Buriat-Mongol'skogo uchenogo komiteta, Verkhneudinsk.

1999 *Materialy k paleoetnologii Zabaikal'ia*. Arkheologicheskie pamiatniki Siunnu 4. AziatIKA, St Petersburg.

2000 *Sibirskie stranitsy zhizni*. Trans. from Polish by N. V. Eilbart. Zabgpu, Chita, Russia.

Talko-Hryncewicz, Julian D.

1893 *Zarysy Lecznictwa ludowego na Rusi południowej*. Akad. Umiejętności, Kraków.

Teploukhov, Sergei A.

1925 Raskopka kurgana v gorakh Noin-Ula. In *Kratkie otchety ekspeditsii po issledovaniiu Severnoi Mongolii v sviazi s Mongolo-Tibetskoi Ekspeditsii P. K. Kozlova*, pp. 13–22. Akad. Nauk SSSR, Leningrad.

CHAPTER 11

Imperial Archaeology or Archaeology of Exoticism? Victor Segalen's Expeditions in Early Twentieth-Century China

Jian Xu

In the history of Chinese archaeology, the image of Victor Segalen (1878–1919), probably the most experienced but nonetheless an unconventional French investigator, is still fragmentary and ambiguous. Thanks to the rapid translation and publication of the field report of Segalen's second archaeological mission in China in 1914 by historian Feng Chengjun 馮承鈞 (1885–1946), Segalen was sporadically mentioned by Chinese scholars in reviews of early archaeological surveys and research in western China (Feng 1930). However, while his contribution to the literary movement associated with exoticism is still widely recognized in Europe and North America (Segalen 2002), his activities, discoveries, and, more importantly, intellectual legacy in archaeology have largely been neglected in both China and his homeland.

Born in Brest, Brittany, and serving as an interpreter in the French navy, Victor Segalen undertook three major expeditions in China from 1909 to 1917, a level of contact that few, if any, other French Sinologists or explorers of his day—or in following decades—could rival. Moreover, he spent most of his last decade in China and was actively involved in the political and social life of the early years of the Republic. By the same token, his life was more multi-faceted than has been conveyed by his brief appearance in the history of Chinese archaeology. A passionate explorer, self-cultivated archaeologist, and sensitive artist, in addition to being a leading poet and an advocate of exoticism in turn-of-the-twentieth-century France, Segalen deserves a more systematic and synthetic reevaluation than he has received to date. His contributions to Chinese archaeology should be seen from a broader and more nuanced perspective than has been the case thus far.

It is regrettable that Segalen's reputation, like those of other French Sinologists involved in archaeological missions of the early twentieth century, has been so heavily and uncritically stigmatized in China. In a 1960s reprint of a collection on the historical geography of northwestern China and the South China Sea by French Sinologists, the anonymous editor, while admitting their undeniable contributions, denounced the authors and their works as the product of "imperialist" scholarship (Zhonghua 1962: 1). Although the challenging ideological circumstances that prevailed in China a half-century ago help to explain this outlook, this point of view remains prevalent today. Many Sinologists of the late nineteenth and early twentieth centuries have been accused of "imperialist" scholarship or of being agents of imperialism. While some scholars maintained close connections with imperial powers, and frequently served imperial objectives, this general accusation purports that all of their scholarly activities were politically oriented. This seems not to have been the case. Nor were they all unanimous in their opinions of imperial intervention. In the case of Segalen, he was charged with being a spiteful treasure hunter even in his lifetime: during the second expedition, he was attacked by local gentry and peasants in Sichuan. In a recent edition of a local gazette, Segalen is still depicted as an infamous thief and smuggler, based on widespread but unconfirmed rumors (Guangyuan 1994: 793). However, the meaning of this charge of "imperialist" scholarship is vague and questionable, and it demands more thorough examination from a diversity of perspectives. Segalen and his archaeological expeditions therefore offer a case study that helps us to understand the complexity of imperial archaeology in early twentieth-century China.

Significant murkiness exists as to the nature of imperial archaeology in China (however, see Lai, this volume, and von Falkenhausen [on German art historians], this volume), and a more subtle reassessment of the archaeological activities of Segalen is long overdue. Various combinations of personal motivation, academic and cultural background, social milieu, and relations with Chinese villagers might cause an identical or similar action to be perceived in remarkably different ways, depending upon the circumstances. An analysis written from a historical and cultural perspective—that is, one that provides a fuller context for Segalen—offers the possibility of greater insight into his activities and contributions, showing where their intended objective(s) differed from such blunt allegations of "imperialist" archaeology. To this end, it is necessary to reconstruct Segalen's various connections, both practical and intellectual. Such an undertaking must consider Segalen's archaeological contributions in a matrix comprising his major expeditions as well as the archaeological activities of other French scholars in this period and since. An analysis of the provenance of his concepts

and practice must link Segalen with other major French scholars and writers who influenced him, especially the poet and dramatist Paul Claudel (1868–1955) and the Sinologist Édouard Chavannes (1865–1918). Finally, Segalen's archaeological undertakings must be understood in connection with his literary output, since this juxtaposition yields a deeper understanding of the motivations for and preferences expressed in his expeditions.

The Segalen case demonstrates that the term "imperialist" archaeology (or more accurately, "imperial" archaeology in the case of China), like its counterpart "nationalist" archaeology, is affected greatly by the context in which it occurs. In particular, this discussion focuses on the contrast between Segalen's portrayal of his own activities and their reception among local communities. Only by this means is it possible to expose the unsubstantiated foundation for the harshest accusations of Segalen's practice of "imperialist" archaeology. I argue here that it is more appropriate to label his archaeology "exoticist," a term derived from Segalen's favorite literary theme and most significant contribution to literature. In French literature, "exoticism" refers to a movement in the late nineteenth and the early twentieth centuries that took on foreign or "exotic" subjects from Africa, Asia, and Oceania in particular, as the backdrop or theme. Occupying a leading role in the late exoticist literature, Segalen differed from the first generation of its practitioners, who were driven by the passion for curiosities and expressed it in an exaggerated and discriminatory manner. By contrast, Segalen treated exotic writing as a spiritual *voyage* by which he might search for *"le divers."* With this approach, he conveyed respect and appreciation for civilizations other than those in the West (Segalen 2002: 18–25). Segalen's archaeology in China reflects the approach of his literary undertakings more than an "imperialist" agenda.

Segalen's Excavation of the Bao Sanniang Tomb: Conflict between the Exotic and the Indigenous

The small town Zhaohua 昭化 in northern Sichuan unexpectedly turned out to be a kind of Chinese Waterloo for Victor Segalen. During his second cross-country expedition in 1914, Segalen conducted a minor excavation in Zhaohua that triggered social unrest. The excavation itself lasted only two days, from April 2 to 3, soon after his expedition team had traveled from Guangyuan 廣元 to Zhaohua. As an amateur archaeologist, Segalen kept very limited records, which are inadequate for a modern reconstruction of the full excavation process. However, according to his brief description, the tomb, constructed of bricks, was rectangular in plan and covered by an arched ceiling. It measured 5.4 meters long and 1.9 meters wide. The fact that the excavators entered the chamber through the

collapsed northern wall indicates that it had been at least partly disturbed for unknown reasons prior to Segalen's arrival (Feng 1930: 15–16). This tomb had been recorded prior to this date in the *Sichuan Tongzhi* (General Gazetteer of Sichuan Province):

> [T]he tomb, situated south of the Quhui Dam and on the west bank of Bai River, is huge. A long time ago, the entrance, similar to a city gate, was exposed when the tomb collapsed. It is so tortuous and dark inside that nobody dares to enter. Now it is sealed again (Chengdu 1733: 45.6a).

It is thus reasonable to assume that the tomb had been visited, and probably looted as well, long before Segalen's survey.

Within the tomb, the expedition team observed that the floor was covered by layers of sludge, leaving nothing appreciable on the surface. After cleaning the surface, excavators still failed to discover any artifacts other than a small fragment of a human skull. However, Segalen seemed not to have been frustrated by the empty chamber. Instead, he was fascinated to find surviving tomb bricks with bas-reliefs and line drawings with recognizable images and decorative motifs, including coinage, horses, a chariot, and an animal with four legs. In a preliminary report, Segalen observed that whereas sculptures and carved images above the ground were already well known to scholars, he wondered what those inside tombs looked like. This tomb offered precisely the kind of detail that Segalen sought for his study (Feng 1930: 15; Segalen, Voisins, and Lartigue 1915: 40).

This minor, two-day excavation, which would have been seen as nearly fruitless if ranked on the basis of the quantity of artifacts found, nonetheless got Segalen into great trouble. It seems that he did not recognize the difficulty until the last minute. While he was at least vaguely aware that the tomb was attributed to Madame Bao Sanniang 鮑三娘, a legendary female general of the Shu kingdom (221–263 CE) in the Three Kingdoms period (221–280 CE), he was clearly oblivious of, or underestimated, what Bao Sanniang meant to the local community in Zhaohua. On the second day of Segalen's excavation, the expedition team was suddenly surrounded by furious members of the local gentry and peasants, who accused Segalen of treasure hunting. They demanded that Segalen's team surrender all looted treasure and then leave immediately. The frightened excavators claimed that they did not find any "treasure" in the common sense of the word, but the angry villagers were not convinced. The team had to wait on site until guards from Zhaohua County rescued them from the crowd. The excavation of Bao Sanniang's tomb thus ended in disgrace (Fig. 11.1). The tale of Victor Segalen's disreputable treasure-hunting and theft is still widely believed in Zhaohua (Guangyuan 1994: 793). Local people are convinced that the tomb, full of

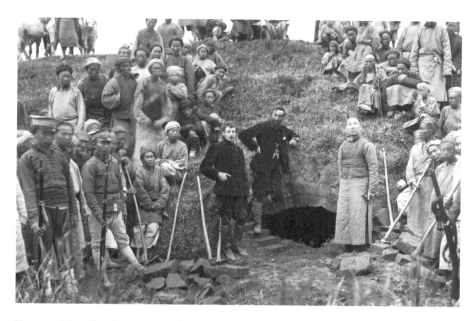

FIGURE 11.1. Segalen's team and locals in front of the tomb attributed to Bao Sanniang. Photo courtesy of Musée Guimet, Paris, Dist. RMN-Grand Palais/Image Musée Guimet/ Imaginechina.

treasure, had been left untouched until being looted by Segalen. The looted treasures are said to have been exhibited thereafter at the Musée Guimet and later stored securely somewhere else in Paris. Presently, the tomb is included among historical locations used for patriotic education; an imaginative sandstone statue of a female warrior is installed in a nearby park. The legend of Bao Sanniang has thus had a twofold impact: on the one hand, it has supported patriotic causes that make use of her alleged fight to the death against the invasion of the Wei kingdom (220–266 CE), and on the other, it has inspired condemnation of Segalen's alleged "imperialist" crime of stealing Zhaohua's treasures and historical heritage.

In his preliminary report, Segalen lamented that it was both difficult and hazardous to excavate in China (Feng 1930: 35). Although excavations by foreigners had been conducted before the era of professionalized archaeology and the passage of national laws to protect antiquities, such projects were prone to being seen as suspect, as they were thought to violate important cultural properties. Local residents resented and objected to such interventions for various reasons, from practical to ideological. In particular, digging an ancient tomb was seen as

offensive to a civilization with a strong tradition of ancestral worship and, for this reason, could provoke local anger and potentially a violent reaction. These complaints stemmed from ethical and political issues rather than from concerns related to scientific aspects of archaeological practice. With notable exceptions—such as J. G. Andersson (1874–1960), who, on behalf of the National Geographic Survey of China, excavated in Mianchi 澠池, Henan, and Shaguotun 沙鍋屯, Liaoning, or Aurel Stein (1862–1943) and Sven Hedin (1865–1952), who worked in the northwestern frontier of China—foreign archaeologists in the first half of the twentieth century largely avoided excavating in China (Jacobs 2014; see also Lai, this volume). As a foreign archaeologist who was neither affiliated with a Chinese organization nor in possession of a permit or endorsement from the government, Segalen was unusual. As the episode of Zhaohua demonstrates, unsanctioned tomb excavations could be risky, carrying a potential for conflict. However, what was at stake here was local resentment of an intrusion at a site the villagers understood as having cultural as well as economic value, rather than a challenge to Segalen's archaeological method or lack of official sanction.

It is important to recognize that the overarching goals of the expedition predetermined the general characteristics of Segalen's archaeological activities, including his excavation in Zhaohua. It was Segalen's most thoroughly prepared and fruitful journey in China. The expedition team consisted of two central investigators besides Segalen: the novelist Augusto Gilbert de Voisins (1877–1936) and the naval officer Jean Lartigue (1886–1940). The presence of the former was predicated on his lifelong friendship with Segalen, while the latter participated with the parallel objective of a scientific or military survey on behalf of metropolitan France. However, Segalen and his archaeological objectives dominated the entire expedition. Its itinerary was designed in accordance with Segalen's preference for certain subjects and specific ways of undertaking archaeological research.

The Segalen-Voisins-Lartigue team departed from Peking on February 1, 1914, and reached Zhengzhou by train. In Zhengzhou, the team recruited a caravan consisting of seventeen Chinese nationals, including coolies and Jean Lartigue's Chinese tutor, before heading westward. In late February the team arrived in Xi'anfu 西安府, the ancient capital of the Western Han dynasty (202 BCE–8 CE) and the Tang dynasty (618–907 CE). Spending more than two weeks in Xi'anfu to visit Han imperial and elite tombs and sculptures and steles in the surrounding region, the team then split up and traveled to Baojixian 寶雞縣 along two separate routes: Segalen in the south and Lartigue and Voisins in the north. After another brief period of traveling together, the team divided again on its way southward: Segalen and Voisins took an easterly route and Lartigue traveled to

the west. They reunited in Baoningfu 保寧府 on April 6 and arrived in Chengdu 成都 on May 2. During the following month, as they had done at Xi'anfu, the team surveyed historical interests in the surrounding region as far as Mianzhou 綿州 and Zitong 梓潼. In early June, the team traveled along the Min River, passing Pengshanxian 彭山縣, Jiading 嘉定, and Qianwei 犍為. Embarking on Jiading on June 18, the team continued to travel westward. Taking the route toward Yazhou 雅州, they arrived in Lijiangfu 麗江府 on August 11. With news of the outbreak of World War I, the team abandoned the unfinished expedition and headed for Saigon, taking the route via Yunnanfu 雲南, Amizhou 阿迷州, and Haiphong, where they boarded a ship to return to France (Musée Guimet 2004: 199–211).

Similar to other expeditions conducted by foreigners in early twentieth-century China, Segalen's expedition entailed long-distance and speedy travel on horseback, moving at an average speed of roughly forty-three kilometers per day. The team typically made brief on-site surveys whenever they stopped. When they sojourned in a city center for more than two weeks, they conducted extensive surveys in an array of locations within the range of one day's travel from the center. Surveys normally involved taking notes, measuring dimensions of sites, and photographing or making rubbings of monuments and objects. By contrast, the team seldom arranged excavations, which, when they were conducted, were completed in just a few days. For instance, it was during the stop just prior to Guangyuan that Segalen and Voisins rapidly excavated the tomb of Bai Shilang (Musée Guimet 2004: 204).

Among Segalen's three major expeditions in China, the second was unusual in several ways. Due to generous support from the French Ministry of Public Instruction and the Académie des Inscriptions et Belles-Lettres, in addition to assistance from the French Embassy in China, Segalen was able to design an itinerary that covered as many sites of archaeological and scientific interest as possible (Segalen, Voisins and Lartigue 1915). In both subject and method, this expedition was a continuation of two previous surveys undertaken by other French scholars: Édouard Chavannes' survey of the archaeology and history of northern China, and Captain Louis Audemard and Jacques Bacot's survey of the topography and hydrology of the Yangtze River. Whereas Segalen and Voisins followed Chavannes' interest in archaeology, Lartigue resumed Audemard and Bacot's unfinished topographic project on the Upper Yangtze River. With the exception of offering financial support, however, neither the Ministry of Public Instruction nor the Académie was directly involved in the actual undertaking. Nonetheless, following in the tradition of the French military-scientific expeditions to Egypt, the Peloponnese, and Algeria that preceded it (see

Effros, this volume), it is likely that French civil and military administrators'
backing for Segalen's second expedition meant that the information collected
during the voyage was potentially valuable to the French state.

What did Segalen and his team actually find in Zhaohua? Although the
archaeological excavation cannot be reproduced, its specific contents and circum-
stances (which normally were not extensively recorded in early excavations) can be
reassessed against parallel examples of more recently excavated sites (Xu 2012:
24–27). Brick tombs were the predominant type of Han tomb in Sichuan, and
thousands of similar burial sites have been excavated since Segalen's expeditions.
Professor Luo Erhu at Sichuan University proposes a complex classification system
for tombs of this type (Luo 2001). Since most of the buried artifacts were missing
by the time of Segalen's excavation in 1914, the tomb of Bao Sanniang can be
reevaluated only with respect to its structural features. Size is a key criterion in
Luo's classification system. Measured by its length and width, the tomb of Bao San-
niang was of medium size, a category that ranges from 5.5 to 8.5 meters in length.
However, the tomb attributed to Bao Sanniang lacks many of the features typical
of this category that might suggest the social status and wealth of the deceased,
such as a division between the front and rear chamber of the tomb, and niches for
displaying buried artifacts. Furthermore, brick tombs, some of which date as late as
the Three Kingdoms period, mostly come from between the last phase of the
Western Han dynasty (202 BCE–8 CE) and the end of the Eastern Han dynasty
(25–220 CE). Compared with other examples of brick tombs studied via scien-
tific excavation, the tomb attributed to Bao Sanniang is a modest medium-sized
one and is unlikely to have been filled with treasure. A more serious criticism is that
the tomb probably predates the lifetime of the attributed occupant.

Indeed, on the whole, the historical authenticity of Bao Sanniang and her
husband, Guan Suo 關索, is somewhat suspect. In his own study of the subject,
Segalen noted that Bao Sanniang was rarely mentioned in historical resources,
but he did not challenge directly the existence of the female general of the Shu
kingdom. However, neither Bao Sanniang nor her husband, Guan Suo, the
alleged second son of the general Guan Yu 關羽, was recorded in the official his-
tory of the Three Kingdoms period. Instead, legends of the brave and patriotic
couple emerged as a very popular theme on the stage of local shamanistic cere-
monies, which were developed no earlier than the Ming dynasty (1368–1644
CE) (Chengjiang 1992; Inoue et al. 1989). Some scholars rightly suggest that the
figure of Guan Suo was created on the basis of a misreading of the name of a
drama performed in local ceremonies, *guansuoxi* 關索戲. The same misreading
of the vernacular "acting a drama," *huaguansuo* 花關索, led local authors to fab-
ricate romantic stories of the hero Guan Suo to satisfy illiterate audiences. Bao

Sanniang was therefore presented as a heroine who embodied both personal romance and public loyalty.

It is therefore clear that the characterization of Victor Segalen as a grave robber was a product of the fraught circumstances in which he excavated, where foreigners were viewed with significant suspicion. During his short visit to Zhaohua, based on his enduring interest in stone carvings, Segalen excavated a medium-sized Han tomb that had been disturbed long before his arrival. Moreover, although local inhabitants were not aware of this fact, the tomb at Zhaohua was likely built before the alleged lifetime of its attributed owner, who in fact was a mythical figure created no earlier than the Ming dynasty. With hindsight, we can see that Segalen was accused of robbing a treasure that never existed and was thus innocent of the alleged crime. However, it is necessary to see the incident at Zhaohua not just as a question of physical treasure but as a site of great symbolic meaning to the local people. In this sense, Segalen provoked the strong nationalist sentiments of the local community, a development that rendered the question of the tomb's authenticity a secondary issue. Considered from this perspective, the sudden appearance of Segalen's expeditionary team, its unauthorized excavation of a tomb that was highly regarded in local tradition, and the connection of this activity with intervention by a foreign government, all contributed to Segalen's reputation in China as an "imperialist" archaeologist.

Segalen's Excavation of Cliff Tombs: The Archaeology of "Others"

When reconsidering Segalen in the context of archaeology at the turn of the twentieth century, the heyday of colonial and imperial archaeology, it is necessary to explore whether his fieldwork and publications in China reveal features that might be identified as "imperialist" scholarship. Although innocent of such intentions in the case of Bao Sanniang's tomb excavation (even if his unauthorized excavation inflamed local animosity toward foreign intervention at a widely popular ancient tomb), Segalen did offer a typical imperial interpretation in another case, one concerning the origins of cliff tombs in Sichuan. In this case, Segalen proposed a diffusionist origin, attributing to the Near East the source for both cliff tombs and sculptures in China—an interpretation for which, interestingly, he has never been criticized. This silence is in large part a consequence of local understanding of these remains as non-Chinese, or barbaric. The sharp contrast between Segalen's involvement in the case of Bao Sanniang's tomb versus that of the cliff tombs draws attention to some of the critical considerations necessary for a more accurate definition of imperial archaeology in early twentieth-century China.

In this case, scarcely a month after the conflict in Zhaohua, Segalen performed a detailed investigation of some cliff tombs along the Min River from Chengdu to Jiading and along the Jialing River in Baoning and Mianzhou 綿州. Cliff tombs are a special form of what we presume to be familial group burials in the shape of a multi-chambered sandstone "house," typically with an entrance that opens on a riverside cliff. Dating from the first to fifth centuries, they are widely distributed along branches of the Yangtze River, mainly in Sichuan, Chongqing, Guizhou, and Yunnan (Luo 1988: 133). As one of the modern pioneer investigators of cliff tombs, Segalen proposed the earliest systematic scheme of their distribution. In contrast to earlier Chinese authors and Western travelers such as Alexander Wylie (1815–1887), Segalen did not adopt the local opinion that these constructions on cliffs were allegedly the Yao minority's modest dwellings. (In fact, the Yao are now thought not to have been active in the region.) Instead, Segalen accurately identified the cliff tombs as burials but remained uncertain as to when and for whom they were built. Partly due to the lack of sufficient evidence, Segalen proposed that the appearance of cliff tombs in Sichuan as well as the art of stone carving in China probably both could be attributed to artistic influences from the Near East (Feng 1930: 40–41; Segalen, Voisins, and Lartigue 1915).

Cliff tombs were one of the major objects of Segalen's expedition in Sichuan. The Segalen-Voisins-Lartigue team divided into two groups in Hanzhong 漢中 to enter Sichuan by different routes, and reunited in Baoning in late March. Thereafter the team traveled to Pengan 蓬安 by boat along the Jialing River. After spending several days in Qu'an 渠安, the team arrived in Chengdu in late April. When surveys in Mianzhou and Zitong 梓潼 were done, the team left Chengdu and arrived in Jiading along the Min River. The itinerary shows that it was probably in Baoning, Mianzhou, Jiangkou, and Jiading that Segalen undertook extensive surveys of the cliff tombs in April and May 1914 (Musée Guimet 2004: 204–207).

Because cliff tombs are located above ground and may include (and did, in the tombs discussed here) some unmovable features such as stone coffins and pedestals, Segalen, like many others, investigated them through archaeological survey instead of excavation (Feng 1930: 23–24; Luo 1988; Nanjing 1991; Segalen, Voisins, and Lartigue 1915; Torrance 1910, 1930; Xu 2012: 339–67). Accompanied by local guides, Segalen visited various tombs and recorded the major features of each one, especially the stone carvings, but did not excavate. Probably driven by his interest in bas-reliefs and sculptures, he chose not to measure or draw layout diagrams of any of the structures, but photographed and drew details of interior decorations as well as those on the entrance frames (Fig. 11.2).

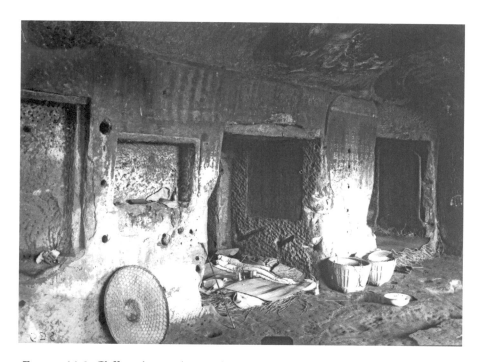

FIGURE 11.2. Cliff tomb at Jiading, Sichuan. Photo courtesy of Musée Guimet, Paris, Dist. RMN-Grand Palais/Image Musée Guimet/Imaginechina.

Segalen clearly situated himself in the tradition established by those who had studied the cliff tombs before him. He claimed thorough knowledge of research on cliff tombs conducted by Wylie, Chavannes, Thomas Torrance, and Edward Colborne Baber (1843–90). Segalen paid particular attention to the last, owing to his groundbreaking work *Travels and Researches in Western China* (1882). In this book, the British diplomat Baber, then serving as the British consul-general in Chongqing, discussed at length the cliff tombs encountered during his round-trip journey between Chongqing and Chengdu in July 1877. His observations from the trip, mainly in the section of Min River between Pengshan and Jiading, were supplemented by additional cases from the suburbs of Chongqing (Baber 1882: 141). Unlike others who had observed these sites from a distance and merely jotted down brief notes about them, Baber undertook a detailed on-site study by entering the cliff tombs and accurately recording their general layout and observable technical details. Despite his incorrect identification of the tombs, Baber's maps remained reliable for a century, even if modifications have been made recently to his original renderings.

Following the guidelines provided by Baber, Segalen revisited some cliff tombs in the lower branches of the Min River. He even attempted to locate the famous tomb of Zhang Bingong 張賓公, which was recorded in *Lishi* 隸釋 by Hong Kuo 洪适 (1117–84), though he failed to find it (Feng 1930: 38–39; Hong 1190: vol. 13; Nanjing Museum 1991: 11–14; Chengdu 1733: vol. 60). Segalen disagreed with Wylie, Baber, the British explorer and diplomat Alexander Hosie (1853–1925), and many others, who uncritically accepted that these sandstone constructions were attributable to the Yao people. Instead, he followed the observations made by Torrance and Chavannes and cautiously concluded that they were ancient burials (Feng 1930: 24; Torrance 1910). Recent excavations have proven that Segalen was correct (Nanjing Museum 1991). However, Segalen's knowledge was not as thorough as he claimed. The eminent Japanese ethnographer and archaeologist Torii Ryūzō 鳥居龍藏 (1870–1953) had surveyed the same cliff tombs during his famous expedition in southwest China in 1902–1903 and had reached similar conclusions; Torii published his diaries as well as research articles in both Japanese and French (1904), publications of which Segalen seems to have been unaware.

Despite conducting fieldwork in much the same way as he had earlier in the trip, Segalen received considerably better treatment here than at Zhaohua. Since the memory of the conflict was still fresh in his mind, Segalen was alert to possible negative reactions by locals to his explorations of the cliff tombs. To his surprise, Segalen was met with tolerance and even cooperation from residents near the tomb: "Local villagers worked for me every day, peacefully. . . . [When I asked the reason], they answered calmly, 'These are caves for barbarians!'" (Feng 1930: 35). The local residents in Sichuan identified the cliff tombs as belonging to the Yao people, "barbarians" in their eyes. Therefore, unlike the encounter in Zhaohua, Segalen's archaeological exploration of cliff tombs was not seen by residents as invasive or offensive at all.

Segalen's two archaeological undertakings, thus placed in context, raise a pivotal question for our understanding of the term "imperialist" archaeology. It is clear from Segalen's two very different experiences that the accusation of imperialism was made without reference to the specific content of his research or the way it was then undertaken. In essence, while the archaeologist's motivations, preconceptions, and even biases might have mattered, they were not the decisive factors in the way he was perceived. Neither Segalen's deduction of the western origin of cliff tombs, which was clearly a diffusionist interpretation, nor the conduct of his survey in the course of his expedition was regarded as offensive or challenged by local residents. What seems to have been the key factor behind the locals' condemnation was what they perceived as the subject of the archaeologi-

cal activity in question. For the local community, in other words, the key criterion in identifying the practice of imperialism was the cultural identity of the subjects under study. While Bao Sanniang was a cultural icon for local villagers (even if her historical authenticity remained unconfirmed), the cliff tombs were thought to belong to "others." The sensitive distinction between "self" and "others" played a subtle but critical role in defining what activities were labeled as "imperialist" archaeology. Indeed, from this perspective, the conduct and thinking of the archaeologist played a subordinate role in these considerations.

French Archaeological Missions: Expeditions as Intellectual Context

An expedition was not a private venture, nor was it a privilege reserved for Segalen. To the contrary, it was a collective undertaking favored by European explorers, scholars, and their government sponsors in the early twentieth century. Segalen had undertaken three major expeditions in China during the period between 1909 and 1917. At the same time, for various reasons, other French investigators had traveled along different routes. How do the individual features of Segalen's expeditions compare with those of his contemporaries? Were they unique to their leaders, or were they shaped to a larger extent by disciplinary traditions and conventions of the period? To answer these questions, we must situate not only Segalen's two minor excavations but also the entire expedition in 1914 in the general context of all French archaeological missions in China during this period.

In all of his expeditions, Segalen was not a lonely bard, either practically or intellectually. In the expedition in 1914, as mentioned above, Segalen was accompanied by Augusto Gilbert de Voisins and Jean Lartigue, who also played a major role in other French expeditions in early twentieth-century China. Voisins was the de facto sponsor for Segalen's first trip to China in 1909, when Segalen was merely an interning interpreter in the French navy. However, after Segalen's sudden death in 1919, the team was disbanded. Voisins never participated in another expedition, while Lartigue contributed to one subsequent expedition on topography and hydrology of the Yangtze River in 1923 (Musée Guimet 2004: 216–20).

Segalen's two other expeditions, both of which were private in nature, were not as significant as the second in 1914. Nonetheless, they remain valuable in demonstrating the consistent manner, preferences, and objectives that Segalen maintained throughout all his expeditions. Segalen's first expedition in China occurred soon after his arrival in Peking in 1909. In the interval before the arrival of his family, Segalen traveled to west China with Voisins, who arrived in Peking

a few months later. Segalen and Voisins departed Peking in early August, heading westward along the historical road through Shanxi and Shaanxi. Months later, they reached as far as Lanzhou 蘭州 and Min county 岷縣 where they turned southward, traveled along the periphery of the Tibetan Plateau, and finally arrived in Chengdu. In order to meet his family traveling from France to Japan by sea, Segalen left for Nagasaki after transferring in Shanghai. The entire journey lasted nearly six months (Musée Guimet 2004: 188–95). This first expedition should hardly be identified as academic, although Segalen and Voisins gave priority to visiting ancient tombs and sculptures along the route. The two men also made abundant records in the form of notes, drawings, and photographs. It is likely that Segalen's first expedition was a warm-up, or preparation, for his major undertaking in 1914.

In 1917, Segalen undertook his last expedition in China, which was restricted in both time and scale because it was affiliated with Segalen's French military mission. After having been stationed briefly with the French navy in Belgium and occupying an administrative post at a hospital in his hometown of Brest, Segalen returned to China in February 1917 to recruit labor for a munitions factory in France. Since recruitment was mainly arranged in Nanjing, Segalen took the chance to visit mausolea of the Southern Dynasties (420–589 CE) in Danyang 丹陽, Hanjiang 邗江, and Jiangning 江寧 in his spare time in March 1917. In May, Segalen took another archaeological tour in Shanghai, Hangzhou 杭州, and Wuxi 無錫, in addition to giving lectures at the Royal Asiatic Society in Shanghai (Musée Guimet 2004: 211–15).

Details from Segalen's two other expeditions highlight the impact of his interests and preferences on shaping the choice of routes and accompanying surveys and excavations. These included Segalen's particular enthusiasm for medieval Chinese history. Moreover, as an artist, Segalen was interested in sculpture and bas-relief, initially items displayed above ground and later remains buried under the earth.

In the heyday of French Sinology, Segalen and his expeditions were not unique in the sense that contemporary European scholars and explorers did emphasize the importance of on-site observations and adopted expedition-style surveys in China. The French archaeological missions in China started with Chavannes' trip in North China in 1907. Except for the expedition undertaken by Henri Maspero (1882–1945) in the Yangtze Delta area in 1914, all the rest were carried out by the Voisins-Segalen-Lartigue team. It is evident that adherence to the model established by Chavannes determined the preference in topics, the working approach of the expedition, and the formal government sponsorship for all subsequent French archaeological missions in China.

Although he visited China as early as 1889 as a diplomatic intern, Chavannes was not able to realize his dream of an archaeological voyage in China until 1907, supported by the Ministry of Public Instruction, the Académie des Inscriptions et Belles-Lettres, and the l'École Française d'Extrême Orient. Excluding the time-consuming journey between France and China, Chavannes spent less than seven months, from April to November, on his favorite themes and at carefully chosen sites. Chavannes arrived in Moukden (present-day Shenyang 沈陽) by the Trans-Siberian express. After surveying Qing imperial tombs in Liaoning and Koryo remains in Jilin, Chavannes arrived in Peking in mid-May. Over the following months, Chavannes, accompanied by V. Alexeieff of St. Petersburg University, visited Hebei, Shandong, Henan, Shaanxi, and Shanxi, in that order. Two years later, Chavannes started to publish his masterpiece, a multi-volume catalog entitled *Mission archéologique dans la Chine septentrionale*, containing more than ten thousand photographs and rubbings taken along the trip, which were previously not well known in the Western world (Chavannes 1909–15). In the years that followed, Chavannes added two additional volumes to the series: *La sculpture à l'époque des Han* (1913) and *La sculpture bouddhique* (1915). His visit to Tai Mountain in June 1907 facilitated the research presented in "Le T'ai Chan, Essai de monographie d'un culte chinois" (1910). As an early French scholar of Sinology, Chavannes introduced French archaeological conventions to the study of China, including surveying and photographing above-ground historical remains during the expeditions.

Following Chavannes, Henri Maspero, son of the famous Egyptian archaeologist Gaston Maspero, who despite his limited interest in Sinological fieldwork, spent the entire summer of 1914, from May to August, surveying Buddhist remains in China. Maspero restricted himself to the Yangtze Delta region, covering cities such as Hangzhou, Shaoxing 紹興, Ningbo 寧波, and Taizhou 台州. Although Maspero expressed many of the same interests in religions of ancient China as did Chavannes, he paid more attention to temples and rural worship in small villages in Zhejiang. He did not include the mausolea of the Southern Dynasties or any material of "artistic" interest in his survey (Musée Guimet 2004: 195–98).

Considered in the framework of French archaeological missions in China in the early half of the twentieth century, Segalen's expeditions operated in the same manner as those of forerunners and contemporaries. However, Segalen was revolutionary in that he was probably the only French Sinologist who actually excavated in China as opposed to simply surveying ancient monuments. Although Segalen's excavation method was crude (due to lack of professional training), his approach was distinguishable in many ways from treasure hunting. For instance,

he never calculated his findings according to prices on the antiquities market, nor are we aware of his involvement in any illegal dealings. More interesting is the fact that although he was an amateur in French Sinology, Segalen's research revealed that he was strongly influenced by Chavannes. His interest in monuments and inscriptions clearly echoed that of Chavannes, and this interest was maintained and developed throughout his career.

CONSUMMATE EXOTICISM:
SEGALEN AS ARTIST, ARCHAEOLOGIST, POET, AND MORE

Because of the divide among academic disciplines, Segalen has been studied by experts in the fields of archaeology, ethnography, literature, and cultural criticism. Each has looked mainly at one facet of his work. Few of these research projects have made reference to conclusions achieved independently in another field. Such a situation makes a holistic approach all the more necessary in studying Segalen.

Strictly speaking, Segalen was a marginal figure in French Sinology. Like many other explorers in China and other countries in the early twentieth century, Segalen was a self-cultivated archaeologist. Regrettably, his three major expeditions did not yield any remarkable new finds. Aside from the field report discussed here, he did not publish anything in an academic context, not even an article in a scholarly journal. The only loose connection that Segalen maintained with the community of French Sinologists was a consequence of his linguistic training. At the l'École des langues orientales and the Collège de France, Segalen became acquainted with Chavannes, who helped him consolidate financial support from the French state for his second expedition. Segalen expressed unfailing admiration for Chavannes throughout his life. Both Segalen's rapid style of fieldwork and his interest in monuments and sculptures also seem to suggest the strong influence of Chavannes on his archaeological activities. With this exception, however, the work of Segalen was generally distant from that of other French Sinologists.

Relative to his achievements in archaeology and Sinology, Segalen's contributions to prose and poetry are far better recognized. In France, Segalen is regarded as the representative of exoticism in literature in the early twentieth century (Segalen 2002). Exotic emotion was not new in French literature, but Segalen considered writers from earlier generations, such as Rudyard Kipling, Lafcadio Hearn, and Pierre Loti, as less than full-fledged practitioners of exoticism as a genre. He remarked:

(Exoticism) cannot be about such things as the tropics or coconut trees, the colonies or Negro souls, nor about camels, ships, great waves, scents, spices, or

enchanted islands. It cannot be about misunderstandings and native uprisings, nothingness and death, colored tears, oriental thought, and various oddities, nor about any of the preposterous things that the word "Exoticism" commonly calls to mind (Harootunian 2002: xiii).

Therewith, Segalen proposed that those who wished to write in an exoticist mode "escape from the contemptible and petty present." For Segalen, exoticism meant "going back" both geographically and temporally (Segalen 2002: 24, 28). Therefore, from his perspective, ancient China was the perfect host for his contemplation of exoticism and thus became his adopted spiritual homeland.

The hallmark of Segalen's poetry, a style of composition that imitated stone steles in China, clearly resulted from his first expedition in 1909 (Fig. 11.3). Having never composed poetry before, Segalen tried his hand at this new genre soon after arriving in Peking. Segalen unambiguously admitted the influence of Chinese steles, which were widely distributed and distinctive in northern China, on his own poetic productions. Standing above the ground or half-buried in earth, partly ruined but with the dominant shape still visible, these steles impressed Segalen in the same way that European ruins affected romantic authors of the late nineteenth century. In correspondence addressed to Henry Manceron and Jules de Gaultier, Segalen admitted that he was really interested in the form rather than the content of the steles. He stated that "once disbanding its original meanings in Chinese culture, (the steles) can be a new genre of literature" (Segalen 2004: 399).

For Segalen, the steles represented a complicated metaphorical system by which to convey the ideas of exoticism. In 1912, Segalen published a collection of poems entitled *Stèles*, which was printed in Peking in a pure "Chinese" way— that is, on superior cotton paper, in the traditional Chinese format and binding, and with a wooden cover. The silhouette of the book imitates that of the famous stele, Transmission of Luminous Teaching of Roman to China 大秦景教流行中國碑. The Chinese-Syriac bilingual stele, inscribed in the late eighth century, particularly stimulated Segalen's engagement with exoticism soon after his visit to Xi'anfu. Each poem was written in a single frame, like the surface of a stele. Most of these poems concerned the poet's Chinese experience. For each poem, bilingual titles were presented at the top. Some of Chinese titles were selected from Chinese classics, while the rest were invented by Segalen himself (Segalen 1982).

Similar to steles, China and Chinese experience served as vehicles by which to express Segalen's exoticism. China was not the first exotic option available for Segalen, who traveled in Tahiti and Hiva-Oa in French Polynesia from 1902 to 1904 and made a debut in French literature with *Les Immemoriaux* (1907, under the pseudonym Max Anély), which addressed the decline of Maori civilization (Clifford 1988: 154–55; Musée Guimet 2004: 37). In his trip around the world

DÉPART

Ici, l'Empire au centre du monde. La terre ouverte au labeur des vivants.
 Le continent milieu des Quatre-mers. La vie enclose, propice au juste,
 au bonheur, à la conformité.
Où les hommes se lèvent, se courbent, se saluent à la mesure de leurs rangs.
 Où les frères connaissent leurs catégories; et tout s'ordonne sous
 l'influx clarificateur du Ciel.

O

Là, l'Occident miraculeux, plein de montagnes au-dessus des nuages ; avec
 ses palais volants, ses temples légers, ses tours que le vent promène.
Tout est prodige et tout inattendu: le confus s'agite; la Reine aux désirs
 changeants tient sa cour. Nul être de raison jamais ne s'y aventure.

O

Son âme, c'est vers Là que, par magie, Mou-wang l'a projetée en rêve.
 C'est vers là qu'il veut porter ses pas.
Avant que de quitter l'Empire pour rejoindre son âme, il en a fixé, d'Ici, le
 départ.

FIGURE 11.3. A page from Segalen's *Stèles*.

in 1902, Segalen encountered Chinese people in real life for the first time: he witnessed the Chinese lifestyle when disembarking in San Francisco. This first contact did not drive him to visit China immediately. It was not until six years later, when the focus of his exoticism shifted from the tropics to ancient civilization,

that Segalen chose China as his destination. At first glance, Segalen realized that ancient China was such a suitable venue that Peking became his "spiritual homeland" (Segalen 1967: 58). As a member of the French delegation to China, Segalen had a unique chance to interview the royal family and get a bird's-eye view of the Forbidden City from the city wall, on which two of Segalen's famous fictions, *Le Fils du Ciel* and *Rene Leys*, were based. In 1912, Segalen published his first collection of poetry, *Stèles*. This was when Segalen conceived of the idea to write French in the Chinese way, to present modern ideas in the ancient form, and to print on paper imitating Chinese carved stone. Four years later, his collection of prose and poetry *Peinture* was published. This time, the imaginary paintings provided another medium for exoticism.

In the last part of his life, Segalen wrote but did not complete *Chine: La grande statuaire* and *Thibet*, the former of which unambiguously resulted from his three Chinese expeditions. Considered from the perspective of exoticism, one can see that Segalen's archaeology and expedition provided the raw material he needed to contrast an ancient, fossilized, underground, and non-Western entity with the modern, lively, above-ground, and Western world to which Segalen belonged. He ultimately viewed his creative writings as the means by which to protect this unique region against obliteration. Strangely, a close reading of Segalen's writing concerning China and Chinese experience reveals that all Chinese elements, including calligraphy, painting, steles, the stories of the young emperor and the empress dowager, and even the author's self-portrait, were rich and marvelous illusions created from minute observations. In other words, the "China" presented by Segalen's writings was not a real one, despite the fact that he lived in this country for years. Such an observation provides Segalen's exoticism a third dimension: *l'imaginaire contre le réel*.

No matter how highly regarded his archaeological expeditions and creative writings are by modern researchers outside of China, they are just two minor facets of Segalen's career. In an important sense, they might be seen as "exotic" in the context of the rest of his life. Although coming to China as an interpreter, Segalen was trained as a physician at the École de médecine navale de Bordeaux from 1895 to 1898. In the following decade, except for the brief period he spent fighting in Belgium in 1915, Segalen and his entire family were supported by various jobs relating to health care, either in China or in France. He once served as the private doctor to Yuan Keding 袁克定 (1878–1955), the second and talented son of President Yuan Shikai 袁世凱 (1859–1916). Indeed, Segalen may well have accepted the position with the purpose of gaining the president's favor for his ambition of establishing an art museum in the center of the capital, a plan that eventually failed (Hsieh 1996: 64). He also joined the medical team addressing the plague

epidemic in northeastern China. For a period of three years, he taught at the Imperial Medical Academy in Tianjin (1911–14).

Curiously, however, this professional experience is virtually undetectable in Segalen's writings, and the only connection seems to have been that his full-time jobs provided the financial support for his archaeological and literary undertakings. Segalen spent nearly a decade in China, much longer than previous and contemporary Sinologists like Chavannes, the explorer and linguist Paul-Eugène Pelliot (1878–1945), or Maspero did, and one might presume he could have launched more enduring, detailed, and profound *voyages*. However, Segalen resumed his calling as a physician in the intervals between expeditions, and kept his distance from archaeological activities in his daily life. And though he surely had acquired a more accurate image of contemporary Chinese society during his travels, such a view is totally absent from his novels and poems, subtly but precisely reflecting his preference for "the imaginary" over "the real."

Segalen's expeditions shed new light on the nationalist-imperial-colonial trichotomy in archaeological practice identified by Bruce Trigger. Trigger noticed the close connection between these paradigms, including the fact that colonial archaeology was readily transformed into national archaeology in many newly independent, post-colonial states (Trigger 1984: 368; see Schmidt, this volume). However, Segalen's case reveals other facets of the triad of national, imperial, and colonial archaeologies, which typically exist synchronously and are defined by their counterparts. Like national archaeology, imperial and colonial archaeology are politically oriented but can have an impact far beyond the realm of desired or actual colonies. In China, colonial archaeology existed in real colonies, such as northeastern China, Korea, and Taiwan during the era of Japanese occupation (see Pak, this volume). In addition, in non-colonial settings, some practices and discourses among those associated with an imperial regime might fit with the paradigms of colonial archaeology. However, as may be seen with Segalen, an archaeologist's nationality or origin was not necessarily determinative, and one should not rightfully be charged with "imperialist" practices solely on the basis of national origins. In Segalen's case, at least, the receptor's interpretation was more significant than the actor's action or motivation. That is, the charge of "imperialist" archaeology against Segalen reflected the development of national identity that was linked to patrimonial remains in China. Indeed, the stronger the nationalist emotions were among members of the local community, and the more closely they were linked to specific monuments, the more likely it was that local residents might accuse an archaeological intruder of "imperialist" crimes if he attempted to disturb them.

We must thus be careful about placing the archaeological expeditions of Segalen in an over-simplified framework of "imperialist" archaeology. Segalen

was innocent, not because he was free from a European imperial perspective—which was indeed the shared context for all scholars in the generations at the turn of the twentieth century—but because he was not a tomb robber or plunderer, as were many of his European contemporaries (see Brodie and Fehr, this volume). Rather, the stigma that is still associated with Segalen's name resulted from growing nationalistic identification in China with monuments linked to historical events, whether accurately or not; and it is from this perspective that Segalen's intentions were perceived as "imperialist" and his actions as misdeeds. Segalen would have been greatly chagrined at being so labeled. While employed by a French imperial institution—namely, the navy—he did not share its ideology. Instead, he denounced European colonialism as a "monolithic whole," which he sought to force into surrender to the "perception of diversity" via the instrument of exoticism. If we must classify Segalen's archaeology at all, it is best to look to his literary undertakings: "exoticist" archaeology is probably the most suitable term to define Segalen's self-identity as a scholar and archaeologist.

ACKNOWLEDGMENTS

I would like to thank Professor Bonnie Effros and Professor Guolong Lai for inviting me to participate the workshop, reading my earlier drafts, and providing so many valuable comments and assistance.

REFERENCES CITED

Baber, Edward C.
 1882 *Travels and Researches in Western China.* John Murray, London.
Chavannes, Édouard
 1909–15 *Mission archéologique dans la Chine septentrionale.* Imprimerie Nationale, Paris.
 1910 Le T'ai Chan: Essai de monographie d'un culte chinois. In *Le dieu du sol dans la Chine antique.* Ernest Leroux, Paris.
 1913 *La sculpture à l'époque des Han.* Ernest Leroux, Paris.
 1915 *La sculpture bouddhique.* Ernest Leroux, Paris.
Chengdu
 1733 *Sichuan Tongzhi* 四川通志 (General Gazetteer of Sichuan Province). Woodblock printed in Chengdu.
Chengjiang
 1992 *Guangsuoxi Zhi* 關索戲志 (History of Guansuo Drama). Wenhua yishu chubanshe, Beijing.

Clifford, James

 1988 *The Predicament of Culture: Twentieth-Century Ethnography, Literature, and Art.* Harvard University Press, Cambridge, MA.

Feng, Chengjun 馮承鈞

 1930 *Zhongguo Xibu Kaogu ji* 中國西部考古記 (Archaeology in West China). Commercial Press, Shanghai.

Guangyuan

 1994 *Guangyuan Xianzhi* 廣元縣志 (Gazetteer of Guangyuan County). Sichuan cishu chubanshe, Chengdu.

Harootunian, Harry

 2002 The Exotics of Nowhere. Foreword in *Essay on Exoticism: An Aesthetics of Diversity*, by Victor Segalen, pp. vii–xx. Duke University Press, Durham and London.

Hsieh, Yvonne Y.

 1996 *From Occupation to Revolution: China through the Eyes of Loti, Claudel, Segalen and Malraux (1895–1933)*. Summa Publications, Birmingham, AL.

Inoue, Taizan 井上泰山 (editor)

 1989 *Kakansakuden no Kenkyu* 花關索傳の研究 (*Research on Huaguansuo zhuan*). Kyuko Shoin, Tokyo.

Jacobs, Justin M.

 2014 Nationalist China's "Great Game": Leveraging Foreign Explorers in Xinjiang, 1927–1935. *Journal of Asian Studies* 73: 43–64.

Luo, Erhu 羅二虎

 1988 Sichuan Yamu de Chubu Yanjiu 四川崖墓的初步研究 (Preliminary Research on Cliff-tomb in Sichuan). *Kaogu Xuebao* 2: 133–67.

 2001 Sichuan Handai Zhuanshimu de Chubu Yanjiu 四川漢代磚室墓的初步研究 (Preliminary Research on Brick-tombs of Han Dynasty in Sichuan). *Kaogu Xuebao* 4: 453–82.

Museé Guimet

 2004 *Missions archéologiques françaises en Chine*. Les Indes savants, Paris.

Nanjing Museum 南京博物院

 1991 *Sichuan Pengshan Handai Yamu* 四川彭山漢代崖墓 (Han Cliff-Tombs in Pengshan, Sichuan). Wenwu chubanshe, Beijing.

Segalen, Victor

 1967 *Lettres de Chine*. Librairie Plon, Paris.

 1982 *Stèles*. Edited by Henry Bouillier. Mercure de France, Paris.

 2002 *Essay on Exoticism: An Aesthetics of Diversity*. Translated and edited by Yael Rachel Schlick. Duke University Press, Durham and London.

Segalen, Victor, Augusto Gilberto de Voisins, and Jean Lartigue

1915 *Mission archéologique en Chine.* Librairie Orientaliste Paul Geuthner, Paris.

Torii, Ryūzō 鳥居龍藏

1904 *Jinruigaku ue yori mitaru shina seinan* 人類学上よに見たる支那西南 (Anthropology of Southwestern China). Tsukiji Shokan, Tokyo.

Torrance, Thomas

1910 Burial Customs in Sz-chuen. *Journal of the Northern-Branch of the Royal Asiatic Society* 41: 504–47.

1930 Notes on the Cave Tombs and Ancient Burial Mounds of Western Szechuan. *Journal of Western China Border Research Society* 4: 88–96.

Trigger, Bruce G.

1984 Alternative Archaeologies: Nationalist, Colonialist, Imperialist. *Man*, n.s., 19(3): 355–70.

Xu, Jian 徐堅

2012 *Anliu: 1949 Nian Zhiqian Anyang Zhiwai de Zhongguo Kaoguxue Chuantong* 暗流： 1949年之前安陽之外的中國考古學傳統 (Alternative Traditions in Pre-1949 Chinese Archaeology). Kexue chubanshe, Beijing.

Zhonghua Shuju 中華書局

1962 *Xiyu Nanhai Shidi Kaozheng Yicong* 西域南海史地考證譯叢 (Translations of Research on Historical Geography of Chinese Central Asia and South China Sea). Zhonghua Shuju, Beijing.

Four German Art Historians in Republican China

Lothar von Falkenhausen

The Chinese sojourns of the four scholars discussed in this chapter took place in the context of a steadily growing scholarly and popular interest in East Asian art in Germany during the early decades of the twentieth century (Erdberg 1985; Falkenhausen 2017; Goepper, Kuhn, and Wiesner 1977; Ledderose 1989; Schütte 2002: 75–87; Walravens 1983–85). This tendency, which paralleled developments elsewhere in Europe and North America, forms part of a complex and politically entangled process of opening toward exotic cultures. The consequences of this engagement for the academic and intellectual makeup of today's world have recently commanded a great deal of scholarly attention, and this conference volume, as well as the present study, form part of this important inquiry.

In the early twentieth century, it was highly uncommon for professional art historians from Europe and North America to settle in a "non-Western" country and engage with its intellectual traditions. The four scholars featured here—Gustav Ecke (Fig. 12.1) (1896–1971; in China from 1923 to 1949 [T. Y. Ecke 1991; Jaquillard 1972; Walravens and Kuwabara 2010: 99–175]), Victoria Contag (Fig. 12.2) (1906–1973; in China from 1934 to 1946 [Shi Mingli 2016; Spee 2008: passim]),[1] Eleanor von Erdberg (Fig. 12.3) (1907–2002; in China from 1936 to 1950 [Avitabile 2004; Avitabile and Lienert 1997; Gabbert-Avitabile and Lienert 1984]),[2] and Max Loehr (Fig. 12.4) (1903–88; in China from 1940 to 1949 [Brinker 1989; Cahill 1975])[3]—are, as far as I know, the only German art historians who settled in China for lengthy periods of time during the Republican period (1911–49).[4] The first-rate training they had received in Germany enabled all of them—even those who had no background in East Asian art history per

FIGURE 12.1. Gustav Ecke. In the 1947 edition of the Furen University annual report, *Furen Daxue Niankan*. Courtesy of Dr. Ye Gongping.

FIGURE 12.2. Victoria Contag-von Winterfeldt. Courtesy of Clarissa von Spee.

TABLE 12.1. Prosopographical Chart

Name	Gustav Ecke	Victoria Contag	Eleanor von Erdberg	Max Loehr
Full/alternative names	Gustav Emil Wilhelm ("Gösta")	von Winterfeldt; Contag-von Winterfeldt	von Erdberg-Consten; Consten	Max Johannes Joseph
Year of birth and death	1896–1971	1906–1973	1907–2002	1903–1988
City of birth	Bonn	Berlin	Graudenz (now Grudziądz, Poland)	Chemnitz
Father's profession	Professor of theology	?	Teacher, organizer of adult education	Textile merchant
Military service	1914–1918	—	—	1938–1939
Spouse	Tseng Yu-ho (Betty)	[Sigmund] Rudolf von Winterfeldt	Hermann Consten	Irmgard Kistenfeger
Spouse's year of birth and death	1925–2017	1897–1954	1878–1957	1905–1995 (?)
Spouse's profession	Artist	Diplomat	Mongolist; ex-secret service operative; riding instructor	Homemaker
Year of marriage	1945	1936	1936	1928
Children	—	Beatrix, now Freifrau von Riedelsel (b. ?)	—	Klaus (b. 1936), Thomas (1939–2010)
University education (*doctorate)	*Bonn, Berlin, Erlangen	Vienna, Frankfurt, Berlin, *Hamburg	*Bonn, Vienna, Berlin	*Munich, Berlin
Main teachers (*supervisor)	*Worringer, Clemen, Curtius, Goldschmidt	Strzygowski, Kümmel, Lessing, R. Wilhelm, *Forke	*Clemen, Delbrück, Strzygowski, Kümmel, Goldschmidt	Bachhofer, Buschor, *Pinder (?), Kümmel
Year of PhD	1922	1932	1931	1936 (submitted 1935)
PhD published	1923	1933	1936	1936
Habilitation	—	—	1955	—
Professional work experience before travel to China	Kaiser-Friedrich Museum Berlin, Municipal Museum Bonn (early 1920s)	Museum of Ethnography, Berlin (1932–1934)	Harvard University, Fogg Museum (1931–1934)	Museum of Ethnography, Munich (1936–1940)
Dates of residence in China	1923–1949	1934–1946	1936–1950	1940–1949

Continued on following page

TABLE **12.1.** Prosopographical Chart, continued

Name	Gustav Ecke	Victoria Contag	Eleanor von Erdberg	Max Loehr
Professional employment in China	University of Amoy, Xiamen, 1924–1928; Tsinghua University, Beijing, 1928–1933; Fu-jen University, Beijing, 1935–1947; University of Amoy, 1947–1948	(Independent scholar)	Peking University, Beijing, 1938–1945; Yenching University, Beijing, 1938–1941; Fu-jen University, Beijing, 1946–1950	Deutschland-Institut, Beijing, 1940–1945; Tsinghua University, Beijing, 1945–1949
Affiliations in China	Institute for Research in Chinese Architecture	National Palace Museum	National Palace Museum	National Palace Museum
Edited series	*Monumenta Serica*	—	—	*Sinologische Arbeiten*
Sojourns in Japan	Tokyo, Nara, 1928	?	Tokyo and Kyoto, 1934–1936, 1939	Japan, 1943
European leave during stay in China	Paris, 1933–1934	(late 1930s?)	—	—
Membership in National Socialist (NS) organizations	NS Teachers' Federation (?)	?	NS Women's League	NSDAP
Professional employment after China	Honolulu Academy of Arts, 1949–1966; University of Hawai'i 1950–1966	University of Mainz, 1951–1968	Technical University, Aachen, 1951–1971/77; University of Cologne, 1965–1968; University of Bonn, 1968–1976	Museum of Ethnography, Munich, 1949–1951; University of Michigan, 1951–1960; Harvard University 1960–1974
Naturalization in the United States	1955	—	?	1957
Post-retirement activities	Guest professor (Bonn 1966–1968, Munich 1968–1969)	—	—	—
Honors	—	—	Three *Festschriften* (1984, 1989, 1997)	Guggenheim Fellowship, 1957; Freer Medal, 1983

FIGURE **12.3.** Eleanor von Erdberg-Consten. In the 1948 edition of the Furen University annual report, *Furen Daxue Niankan*. Courtesy of Dr. Ye Gongping.

FIGURE **12.4.** Max Loehr, 1955, in *The Michiganensian*, the yearbook of the University of Michigan.

se—to make important contributions to Chinese art history, and they all went on to distinguished academic careers in Germany (Erdberg, Contag) or in the United States (Ecke, Loehr).[5] How did each of them adapt to China? How did they deploy their art historical background in the Chinese academic context? How did they interact with Chinese scholars? What was their impact on China? How did their sojourns in China influence their later work?

Such a direction of inquiry is admittedly somewhat tangential to "colonial archaeology." This is true not only because China was never formally a "colony," or because our four protagonists self-identified as art historians rather than as archaeologists. More pertinently, neither the lives they were leading in China nor their scholarly practices had overtly colonial characteristics. In both respects, the

contrast vis-à-vis the pre–World War I German expeditions to Xinjiang (Hopkirk 1980: 125–47; Marchand 2009: 416–26), which certainly fall under the rubric of colonial (or imperialist) archaeology, could hardly be greater. By the 1920s, the psychological and sociopolitical dynamics between the Chinese and foreign inhabitants of China had changed greatly; it was, for instance, completely normal for all our four protagonists to work with Chinese-run institutions and in direct association with Chinese colleagues. The two main factors shaping this new situation were the founding of the Chinese Republic (1912) and Germany's defeat in World War I (1918) (Steen and Leutner 2006). In its 1921 peace treaty with China, Germany had explicitly renounced all the extraterritorial rights that citizens of many other countries continued to enjoy until the mid-1940s. To be sure, there were still asymmetries. Our four protagonists and their families were part of the international community, and their lifestyles were rather privileged—not merely by comparison with ordinary Chinese but also with their compatriots in Germany, especially during and after World War II. All in all, however, their existence in China resembled that of expatriates in today's globalized world, rather than that of colonial overlords in the age of imperialism.

For basic biographical information, see Table 12.1. It seems unlikely that Ecke, Erdberg, Contag, and Loehr had met in Germany; and although they did come to know one another in China, they never formed a close-knit group. Instead, their individual experiences exemplify a range of possibilities for acculturation, inviting comparisons that I shall pursue in the following through a series of topical explorations.

FAMILY BACKGROUND AND UPBRINGING

The family backgrounds of the four protagonists—with the possible exception of Contag, about whose early life I have been unable to learn any details—may be described as *impecunious upper-middle class*. Technically, Erdberg belonged to, and Contag married into, the lower nobility; and Ecke's mother, Elisabeth von Lepel-Hattenbach (1861–1910), was a baroness, born into a landowning family in Hesse. Ecke's father, also named Gustav Ecke (1855–1920), was a well-known professor of Protestant theology at Bonn University (Ecke 1964). Erdberg's father, Robert von Erdberg-Krzenciewski (1866–1929), of Baltic German aristocratic origin, is remembered as one of the founding figures of adult education in Germany, and Erdberg's mother, Amy Wesselhoeft (1876–1972), a musician, hailed from Cambridge, Massachusetts, her ancestors having emigrated from Germany in the early nineteenth century. (Although both of Erdberg's parents identified as ethnically German, her father had been born a subject of the Russian czar and her

mother was an American citizen.) Ecke's and Erdberg's parents' marriages are representative of the gradual merging of the intellectual elite and the lower nobility in pre–World War I Germany. But both the Erdbergs and the Eckes lived as urban bourgeois, and their circumstances presumably became severely straitened after World War I. By then, Erdberg's paternal relatives' landed estates, located in present-day Latvia, had been lost. About Contag I know only that she hailed from the West Prussian town of Graudenz (now Grudziądz), which became part of Poland in 1919; here, too, there may have been economic losses.

Under the Weimar Republic, it was still unusual for women to finish the gymnasium, let alone to attend university. That Contag and Erdberg were able to do so indicates certain socioeconomic aspirations, as well as relatively enlightened attitudes, on the part of their families; it also necessitated considerable willpower of their own.

Max Loehr, whose father had a clothing business in Chemnitz (Saxony), came from a commercial-professional milieu. But he also had a connection to twentieth-century Germany's leading literary family: his uncle, Josef ("Jof") Löhr (1862–1922), a successful banker in Munich, in 1890 had married Julia Mann (1877–1927), the younger sister of the writers Heinrich Mann (1871–1950) and Thomas Mann (1875–1955) (for reminiscences of the wedding, see Katia Mann 1974: 32; Victor Mann 1949: 165–80). When Loehr's father's business went bankrupt during World War I, the family moved to Augsburg to be close to their Bavarian relatives. His father's early death forced Loehr to leave the Gymnasium at the age of seventeen and to take up a job in a bank (one would like to surmise, but I have not been able to ascertain, that it was in Josef Löhr's bank). Having earned his high-school diploma in night courses, Loehr entered university at the age of twenty-eight.

As teenagers, both Ecke and Loehr came under the influence of the poet Stefan George (1868–1933), who mesmerized many young men with his elitist, homoerotically tinged cult of beauty, undergirded by fantasies of a secret worldwide fraternity of like-minded spirits (see Böschenstein et al. 2005; Raulff 2009). George, who became increasingly Germanocentric over time, is sometimes apostrophized as a trailblazer of Nazism; but some of his closest associates were Jews, and while many of his followers did become Nazis, others turned decisively against the Nazi regime, and several of the main conspirators in the July 20, 1944, assassination attempt on Hitler had been members of George's inner circle. It is uncertain whether either Ecke or Loehr ever met George in person, but his influence remained palpable in various ways, not least in their handwriting, which both adapted to the idiosyncratic letter-forms George had imposed on his disciples.[6] Ecke, in the aftermath of World War I, served as the

co-founder and charismatic leader of the Nibelungenbund, a boy-scout-like association (suffused with what a modern sensibility would characterize as thinly veiled gay undertones) of male teenagers under strong influence from George, ostensibly striving for Germany's spiritual renewal (Krusenstjern 2009: 72–74).

Our four protagonists belong to a generation whose world view was shaped by World War I. Ecke, a few years older than the others, fought in northern France through the entire length of the war, rising to the rank of lieutenant. Even in China, he would still occasionally identify himself by his former army rank (Franke 1995: 157). His three colleagues suffered the deprivations that the war brought to the civilian population, and they shared the feeling of profound national shame in the wake of Germany's defeat. As with many of their contemporaries from once-comparable backgrounds, their political orientations tended toward the right.

ACADEMIC PREPARATION AND INTELLECTUAL LINEAGES

Ecke and Erdberg both attended Bonn University, but their sojourns did not overlap. Ecke double-majored in art history and French literature and wrote his dissertation on the nineteenth-century Parisian engraver Charles Méryon (1821–1862) (Ecke 1923).[7] The art historian Wilhelm Worringer (1881–1965) became his *Doktorvater*. In a seminal book on Islamic art (Worringer 1908), Worringer had established a theoretical basis for the understanding of non-representational art. He was a vociferous advocate of expressionism—a term that he may have invented—at a time when that style was still highly controversial. His ideas played a major role in the emancipation of non-Western art as a legitimate subject of art historical inquiry. Erdberg, who also studied with Worringer briefly before his 1928 move to Königsberg, reported that he offered a seminar on East Asian art (in Erdberg's words: "He knew nothing about it, but he understood it!"), and she credited him for encouraging her to specialize in that field (Erdberg 1994: 92).

Ecke, under Worringer's tutelage, developed a resolutely modernistic art-historical sensitivity. Two of his fellow students, Paul Ortwin Rave (1893–1962) and Walter Holzhausen (1896–1968), eventually became major promoters of modern art in post–World War II Germany as directors of, respectively, the National Gallery in Berlin and Bonn's Municipal Art Museum; Ecke, as well, trained for museum work at the Kaiser-Friedrich-Museum (now Bode-Museum) in Berlin as well as at the Municipal Museum in Bonn. In Bonn, he made a point of interacting with the painters of the "Rhenish Secession," as well as, allegedly (T. Y. Ecke

1991), with some Russian constructivist painters who had fled the Bolshevik revolution.[8] Ecke continued his practice of engaging with living artists once he got to China; it may be surmised, furthermore, that his familiarity with German avant-garde art of the 1920s helped open his mind to East Asian aesthetics.

Ecke learned architectural analysis from the medieval art historian Paul Clemen (1866–1947). This experience was to prove useful when Ecke started working on Chinese architecture. Clemen himself was sympathetic to East Asian art. In 1920—just at the time when Ecke was in Bonn—he supervised Alfred Salmony's (1890–1958) dissertation on the comparison of European and East Asian medieval sculpture (Salmony 1922), one of the first art history degrees ever awarded on an East Asian subject (Falkenhausen 2017; Orell 2015; Walravens 1983–85, vol. 2: 1–66). A decade later, Erdberg, too, became Clemen's advisee. Her dissertation, "Chinese Influence on European Garden Structures" (Erdberg 1936), was a compromise, as she did not feel she knew enough to take on a fully East Asian subject (Erdberg 1994: 104–105).

Following custom, Ecke and Erdberg each spent a couple of semesters sampling the offerings of other universities: Ecke at Berlin and Erlangen, Erdberg at Vienna and Berlin. Unlike Ecke, who still had to get France out of his system, Erdberg used these sojourns to seek instruction in East Asian art from specialists (Erdberg 1994: 94–96). She studied with Otto Kümmel (1874–1952), the founder of East Asian art history as a serious academic discipline, then director of Berlin's new Museum of East Asian Art and adjunct professor (*Honorarprofessor*) at Berlin University (Walravens 1983–85, vol. 3; 1987; Walravens and Kuwabara 2010: 9–11, 13–94). Moreover, at the Technical University of Berlin, she took classes with the architectural historian Ernst Boerschmann (1873–1949) (Kögel 2015; Walravens and Kuwabara 2010), who had undertaken extensive architectural surveys in China before World War I.

In Vienna in 1929, Erdberg was both fascinated and ever so slightly repelled by the idiosyncratic teachings of Josef Strzygowski (1862–1941). The irascible Strzygowski, who had broken away from the Art History Department and established his own institute within the university, zealously propagated the importance of "Oriental" (Near Eastern, Egyptian, Indian) influences on medieval European art, thereby aiming to decouple northern Europe from the Greco-Roman heritage. Though himself an extreme pan-German nationalist (late in life he even lobbied to be appointed as Adolf Hitler's art-historical advisor), Strzygowski was also a pioneer in expanding the reach of art-historical inquiry beyond Europe (Marchand 2009: 403–10). Erdberg (1994: 103) irreverently summarized her impressions as follows: "Strzygowski's theories are always correct, but his proofs are always wrong."

Contag, as well, started out as a pupil of Strzygowski in the mid-1920s. Later she held a job and learned Chinese at the China-Institut in Frankfurt, a private organization founded by the missionary Sinologist Richard Wilhelm (1873–1930). She continued her Sinological training in Berlin under Ferdinand Lessing (1882–1961), then curator at the Museum of Ethnography and professor of Chinese at the Institute for Oriental Languages run by the German Foreign Ministry. She also studied with Kümmel, who by then was beginning to have a sizable cohort of advisees. But for some reason, Contag obtained her doctorate under the Sinologist Alfred Forke (1867–1944) at the University of Hamburg, with a dissertation on the Ming-dynasty painter Dong Qichang 董其昌 (1555–1636) (Contag 1933).

After completing her degree, Contag worked as Kümmel's (probably unremunerated) assistant at the Museum of Asian Art in Berlin, translating inscriptions on Chinese paintings. An avid fencer, she was training for the upcoming Berlin Olympic Games. It was during this period that Hitler came to power, and in 1934, Kümmel, who was a member of the Nazi party, was appointed director-general of the Berlin museums. Notwithstanding a certain hagiographic tendency on the part of his successors, who mention only his epoch-making achievements on behalf of the East Asian art history field, it cannot be ignored today that Kümmel became involved early on with some of the nastier aspects of Nazi politics.[9] During World War II, he took a leading role in organizing the despoliation of art treasures from German-occupied territories (Haase 1991: 198–202; Petropoulos 2000: 56–57). But by then, Contag had long left his ambit.

Loehr, the last of the four to start his career in East Asian art history, studied at the University of Munich, except for a semester spent in Berlin in 1934, where he worked with Kümmel. His main exposure to non-European art came from Ludwig Bachhofer (1894–1976) (Vanderstappen 1978–78; Walravens 1983–85, vol. 1, F1–23, vol. 2: i–ix). Bachhofer had been a student of Heinrich Wölfflin (1864–1945), arguably the twentieth century's most influential art historian, during the latter's stint as a professor in Munich; in 1920, he had written a doctoral dissertation on Japanese woodblock prints (Bachhofer 1922) and in 1926, he had passed his *Habilitation* (probably on the Buddhist art of Gandhāra), the additional academic degree after the PhD that is the precondition for becoming a professor in the German university system. When Loehr first met him, Bachhofer was working at Munich's Museum of Ethnography and teaching without salary as a *Privatdozent* at the university while waiting for a professorial chair to become available. In 1933, he was approved for a supernumerary professorship (*Extraordinariat*), but the Nazi administration rescinded the appointment because of his wife's Jewish descent; they emigrated in 1935. Loehr

therefore obtained his doctorate under Wilhelm Pinder (1878–1947), a specialist in German art and one of the most notorious promoters of art history in the spirit of the Nazi regime (Halbertsma 1985).[10] But throughout his life, Loehr preferred to trace his intellectual lineage through Bachhofer to Wölfflin, who had left Munich for Switzerland back in 1924. (Whether Loehr ever met Wölfflin in person is uncertain.)

The conception of art history Loehr absorbed in Munich was extremely different from, and much less forward-looking than, what Ecke and (perhaps to a lesser extent) Erdberg had taken away from Bonn not so many years earlier. Together with a solid mastery of the Wölfflinian formalist method, Loehr acquired a racially focused view of material culture. These two ingredients he deftly applied in his dissertation on the chronology of early Chinese bronzes (Loehr 1936). Subsequently, Loehr worked for four years in Bachhofer's former job at the Museum of Ethnography, interrupted by voluntary military service in 1938–39 with an elite unit of mountain troopers in the German Alps.[11] He started to develop a research interest in Chinese painting (Loehr 1939); but a planned *Habilitationsschrift* on Yuan-dynasty painting (mentioned in his 1940 curriculum vitae[12]) never came to fruition.

Erdberg, thanks to her mother's family connections, was able to go to the United States for post-doctoral work. She spent three years at Harvard University as a research assistant to Langdon Warner (1881–1955), a noted specialist on Asian religious art who is excoriated today for having despoiled the Dunhuang caves in 1924 (Cohen 1992: 78–100 et passim; Hopkirk 1980: 209–22). She put the photograph and slide collections of the Fogg Art Museum in usable order,[13] and translated her PhD thesis into English for publication by Harvard University Press, an endeavor in which she was helped by the prominent landscape architect and Harvard professor Bremer Whidden Pond (1884–1959). Subsequently she was awarded a grant from the American Council of Learned Societies that enabled her to spend two years in Tokyo and Kyoto to study Japanese language and culture. It was from Japan, at the end of 1934, that she first traveled to China.

One is impressed with the speed with which Ecke, Erdberg, and Loehr completed their doctorates: including temporary stays away from their home universities, they each finished in the minimum time of four years. The reason for the haste, obviously, was lack of funds. Even so, it would be wrong to imagine their academic achievement as equivalent to that of an American four-year college graduate. Their Gymnasium education may be assumed to have brought them close to that level. In university, they were able to specialize in their chosen subject without onerous distribution requirements, and their dissertations were

expected to constitute original contributions to knowledge. The constraints of their personal situations compelled them not only to work with tremendous discipline but also to seek out opportunities for practical training in the hope of eventually making a living as scholars. Thus, all of our four protagonists acquired significant museum experience during or shortly after their time in university. By the time they arrived in China, they were broadly and solidly trained art history professionals.

There was one aspect, however, in which a relatively short time spent in university likely had a negative effect: language training. In this respect, Contag may have been privileged: she seems to have spent as many as eight years in university (perhaps indicating that she was financially better off than the others), emerging as a first-rate Sinologist. In her dissertation and other early writings, she translated several difficult and highly subtle Ming- and Qing-period texts on art theory. Her linguistic competence was undoubtedly one major factor—besides introductions from powerful people—for the ease with which, once in China, Contag was accepted into the circles of leading artists and connoisseurs.

Erdberg and Loehr, though both started university intending to become East Asia specialists, had a more difficult time with language preparation. Erdberg made several attempts to learn Chinese, but her performance was substandard and she almost failed her PhD exams as a result (Erdberg 1994: 111–12). She subsequently learned Japanese tolerably well—during the war, she gave courses in the language to other Westerners in Japanese-occupied Beijing (Erdberg 1994: 254)—but she admits that her Chinese was insufficient to sustain an academic conversation. Tellingly, her publications contain few references to Chinese sources.

Although there was a tradition of Chinese studies in Munich going back to the first half of the nineteenth century, neither Sinology nor the Chinese language were being taught there in Loehr's time. Georg Reismüller (1882–1936), director-general of the Bavarian State Library, is mentioned as Loehr's first Chinese teacher,[14] but it seems that his instruction, such as it was, was limited to classical Chinese, and that Loehr started learning Mandarin only after his arrival in China (Merker 1998a: 33, n. 30). Ecke, who seems to have had no China-related academic preparation, acquired whatever he did of the language entirely in country.

TO CHINA: CIRCUMSTANCES AND MOTIVATIONS

None of our four protagonists was a refugee. Their removal to China was not part of the Nazi-induced exodus of large parts of Germany's intellectual elite (Kern 1988; Martin and Hammer 1999; Wendland 1998). Ecke and Erdberg left Ger-

many years before the Nazi takeover; Contag shortly thereafter, but under no pressure; and Loehr was actually sent to Japanese-occupied Beijing as an official emissary of the Nazi regime.

For Ecke, the main motivation for leaving was no doubt the dismal academic job prospects in Weimar Germany. The invitation to go to China was probably arranged through his older cousin, Ruth Wang, née Kettner, who was married to Wang Yintai 王蔭泰 (1888–1961), a German-educated lawyer and politician.[15] At the University of Amoy (Xiamen), which had been founded only in 1921 as a private institution by the Singaporean-Chinese tycoon Tan Kah Kee (Chen Jiageng 陳嘉庚, 1874–1961), Ecke could realize his dream of being a professor—albeit for German language and literature, not art history. An added inducement of settling in China may have been the greater freedom—at least for a foreigner—to conduct his personal life in accordance with the proclivities of the George circle and the Nibelungenbund.[16]

For Erdberg and Contag, the dearth of professional opportunities for women in Germany surely played a role in their decision to leave. In China, they could work fruitfully while enjoying a relatively privileged status. For both, however, the immediate reason to stay in China was their marriage to expatriate German husbands already established there.

Erdberg, during two trips to Beijing from Japan in 1934 and 1935, became acquainted with the much older Mongolist and explorer Hermann Consten (1878–1957) (Götting 2012), who had been stranded in Beijing after losing his fortune in the crash of 1929 (Fuchs 2010: 33; Schmitt-Englert 2012: 506). Consten operated a horse-riding outfit for tourists; Erdberg was one of his customers. In 1936, Consten visited Erdberg in Japan, where they married. Since she had no further prospects at Harvard, they returned to Beijing, where they lived precariously for the next fifteen years.

Contag traveled to China in a semi-official capacity. In 1933–34, she had been involved in curating an exhibition of modern Chinese art in Berlin (Gesellschaft für Ostasiatische Kunst and Preußische Akademie der Künste 1934; Shi Mingli 2016). This exhibition had been organized under the aegis of the former Minister of Education Cai Yuanpei 蔡元培 (1868–1940), Republican China's leading liberal intellectual (Ts'ai 1934). It was Cai who invited Contag to conduct research on Chinese scroll paintings at the Palace Museum in Beijing. She arrived in mid-October, 1934. The following year, in Shanghai, she met Sigmund Rudolf von Winterfeldt (1897–1954), a highly decorated World War I veteran who had been working in the banking business in Shanghai and was about to be appointed to the newly created position of trade expert (*Handelssachverständiger*) at the Shanghai Branch Office of the German Embassy (Freyeisen 2000: 45; on

his activities in that capacity, see Leutner, Adolphi, and Merker 1998: 341; Ratenhof 1987: 419 et passim; Schmitt-Englert 2012: 151, n. 57 et passim). They were married in 1936 and remained in Shanghai throughout World War II; their daughter Beatrix (now Freifrau von Riedesel) was born there. It was presumably her husband's diplomatic position that provided the economic and social basis for Contag's highly productive stay in China.

Loehr was dispatched to Beijing by the German Foreign Office in 1940 to take over the directorship of the Deutschland-Institut. Founded in 1931, this was ostensibly a Chinese-run institution dedicated to the dissemination of German culture; but by the mid-1930s, it had come to be financed and controlled by the German government (Ding and Li 1996; Franke 1995: 60–68 et passim, 2000; Jansen 1999; Kreisler 1989: 184–95). At a time when World War II was already raging, and when most men Loehr's age were being conscripted and sent to the front, to be dispatched to Beijing must have constituted a tremendous privilege. Loehr made the trip to Beijing by train, his wife and two infant sons following in early 1941. Two other Sinologists were sent to the Deutschland-Institut at that time: Alfred Hoffmann (1911–97) (Martin 1998; Merker 1998b) and Ilse Martin (later Ilse Martin Fang, 1914–2008) (Fang 2005; Walravens 2010). Martin, who was delayed by the need to complete her doctorate at the Berlin School of Foreign Studies, arrived just before Germany's attack on the Soviet Union on June 22, 1941, which interrupted rail communication. Having planned to stay two or three years, all of them were now stuck in Beijing indefinitely.

The Chinese sojourns of our four protagonists, though lengthy, were not entirely uninterrupted. Ecke, after his first five-year contract at Xiamen came to an end in 1928, spent several months in Japan, where he was affiliated with the Maison Franco-japonaise. After another five years at Tsinghua (Qinghua) University 清華大學 in Beijing, he returned to Europe for almost a year. Well connected with French academia, he spent most of that time in Paris, conducting research at the Louvre and working with the archaeologist Joseph Hackin (1886–1941). He had intended to seek academic employment in Germany but was so appalled by the realities of life under the Nazi regime that he departed once again for Beijing. Somehow he secured a lecturership at Fu-jen (Furen) University 輔仁大學 financed by the German Academy in Munich, the forerunner of today's Goethe Institute (Franke 1995: 61, 68). Furen was (and, now in Taiwan, remains) China's leading Catholic university—a somewhat ironic affiliation for the son of a leading Protestant theologian.

Contag and her diplomat husband were presumably entitled to go on home leave at least once before war made travel difficult, but the details are not recorded. Erdberg took one more trip to Japan, in 1939, to recuperate from an illness (Erd-

berg 1994: 254). Loehr also undertook an intensive, officially sponsored research trip to Japan from April to June, 1943.[17]

ACTIVITIES IN CHINA

Of our four protagonists, Ecke, though the least prepared for China, spent the longest time in the country. Starting right after he got to Xiamen, he took advantage of every opportunity to undertake field trips to the region's architectural monuments. Initially he was most comfortable studying stone-built architecture (T. Y. Ecke 1991), which he felt was similar to the Rhenish medieval architecture he had learned to analyze under Clemen. His first major China-related publication was a monograph on the twin Song-period stone pagodas of the Kaiyuansi temple in Quanzhou (Fujian) 福建泉州開元寺, co-authored with the Swiss-born French Sinologist Paul Demiéville (1894–1979), who was then based at the École Française d'Extrême-Orient in Hanoi (Ecke and Demiéville 1935); the book remains seminal today. Additionally, Ecke published five shorter articles on stone buildings and sculptures in Fujian (Walravens and Kuwabara 2010: 161, nos. 2, 4–6; 162, no. 11), one of which (Ecke 1931) was soon translated into Chinese (Liang Sicheng 1933).

Recognizing that wooden structures constituted the mainstay of East Asian architectural traditions, Ecke used his 1928 stay in Japan for in-depth on-site study of the temples of Nara. In China, serious research into architectural history by Chinese scholars was just then getting underway. In 1930, the ex-minister of transport of the defunct Beijing-based Beiyang 北洋 regime of the early Republican period, Zhu Qiqian 朱啓鈐 (Chu Ch'i-ch'ien, 1872–1964), founded the Institute for Research in Chinese Architecture (*Yingzao xueshe* 營造學社) with the dual purpose of republishing traditional architects' manuals and scientifically documenting extant monuments. The new institution's most prominent staff member was the American-trained architect Liang Sicheng 梁思成 (1901–1972) (Fairbank 1994). Ecke, by then teaching at Qinghua, became one of the members of the *Yingzao xueshe*, and in 1937 he published a report on its work in English (Ecke 1936–37); one of the other members of the institute, Liu Dunzhen 劉敦楨 (1897–1968), published an article explicitly responding to an (apparently unpublished) inquiry by Ecke (Liu 1933). Although Ecke does not seem to have participated in any of Liang Sicheng's epoch-making survey trips, which led to the discovery of many of the country's most important extant ancient buildings, he studied ancient architecture on his own in those parts of China that were then accessible (Hebei, Henan, Shandong, and the Jiangnan area). He also collaborated extensively with Boerschmann, who returned to

China repeatedly during the 1930s to resume his ambitious project of document-
ing the traditional architecture of China in all its complexity (for their correspon-
dence, see Walravens and Kuwabara 2010: 101–60). But while Boerschmann's
interest was in the traditional architectural environment, and consequently con-
cerned chiefly with relatively recent buildings, Ecke and his colleagues at the
Yingzao xueshe were busy developing methods for dating and periodizing the ear-
lier stages of Chinese architectural history; and while Boerschmann documented
vernacular architecture and still-functioning religious structures in his search for
what was culturally typical, Ecke zeroed in on major monuments from the past.
In contrast to Boerschmann's more anthropological approach, Ecke's was very
much that of an art historian.

The 1937 Japanese invasion put an end to research travel by foreigners. The
Yingzao xueshe joined the exodus of Nationalist government-run institutions to
the unoccupied areas of China; it ceased operations in 1946. Left behind in Bei-
jing, Ecke shifted his interest to the study of traditional furniture, as he had
noticed that the joinery techniques employed by furniture-makers were largely
analogous to those used by carpenters. Ecke was particularly interested in how
the development of these techniques determined stylistic changes. Chinese fur-
niture had never previously been touched by art historians. But unlike build-
ings, pieces of furniture could easily be obtained and taken apart; Ecke and his
collaborator, the architect Yang Yüeh (*recte* Yang Yao 楊耀, 1902–78), did this
and recorded their observations in exactly measured drawings. Straightforward
as it seems, this procedure constituted a major methodological breakthrough.
The book Ecke and Yang produced together, *Chinese Domestic Furniture*, first
published under difficult conditions in 1944, became a classic (Ecke and Yang
1944).

With their elegant proportions, sparse decoration, and explicit revelation of
structural components, East Asian architecture and furniture spoke to Ecke's
modernist sensibilities. He displayed his collection of Ming and Qing furniture
in his own Beijing courtyard house, where he lived like a traditional Chinese
scholar. His hospitality was legendary, and he was esteemed as a tastemaker by
the expatriate community. In this respect, his influence also extended to his Chi-
nese friends, such as the poet and epigrapher Chen Mengjia 陳夢家 (1911–66)
(Wang Shimin 2015), and the aesthete, connoisseur, bon-vivant, and (later on)
cultural-relics administrator Wang Shixiang 王世襄 (1914–2009), who assem-
bled distinguished furniture collections of their own (Ye Gongping 2014).

In Beijing, Ecke moved in an international circle of scholars, artists, and
intellectuals that included leading Chinese figures alongside the *crème de la crème*
of expatriate Sinologists. The Manchu specialist Walter Fuchs (1902–79), who,

like Ecke, had been living in China since the 1920s, wrote of a "Sinologists' circle" in the early 1930s (Fuchs 2010: 38), where he and Ecke mixed with the German-educated Fu Sinian (1896–1950), founder of the Institute of History and Philology at Academia Sinica (in 1928) and the first to inaugurate China's large-scale archaeological campaigns (see Lai, this volume); the American-educated director of the National Library in Beijing, Yuan Tongli (1895–1965); the Nazi Sinologist Ernst Schierlitz (1902–40), Loehr's predecessor as the director of the Deutschland-Institut; the anti-Nazi emigré Hellmut Wilhelm (1905–90), later professor of Chinese literature at the University of Washington, and others. Ecke and Wilhelm remained close, even as much of the German expatriate community in Beijing increasingly kept Wilhelm at arm's length because of his wife's Jewish descent (a situation alluded to in Wilhelm 1960: vii).

The rise of the Nazis brought other Asia scholars to Beijing as refugees, such as the Sanskritist and Buddhologist Walter Liebenthal (1886–1982), and Rudolf Löwenthal (1904–96), a specialist on the modern Chinese press as well as on Chinese Jews and Muslims. Unlike Ecke, both relocated with their host institutions to unoccupied China when the Japanese invaded in 1937. Other expatriates in Ecke's Beijing circle included the curators George N. Kates (1895–1990) from the Brooklyn Museum, and Laurence Sickman (1907–88) from what is now the Nelson-Atkins Museum in Kansas City; Wolfgang Franke (1912–2007), later professor of Sinology at Hamburg; Walther Heissig (1913–2005), later professor of Mongolian studies at Bonn; the Harvard scholars Wilma Fairbank (1909–2002), John King Fairbank (1911–91), Francis W. Cleaves (1911–95), and J. Robert Hightower (1915–2006); and many others.

In 1937–38, Adam von Trott zu Solz (1909–44), who had known Ecke in the early 1920s through the Nibelungenbund, lodged with Ecke for a year (Krusenstjern 2009: 286–87; 331–73). Trott, trained in law and philosophy, intended to integrate Chinese ideas into an ambitious design of a new political order—an alternative to both Western democracy and Nazi ideology. Inasmuch as it can now be reconstructed, his vision, based on relationships of mutual responsibility between the rulers and the ruled, amounted to a heady combination of traditional Prussian and Confucian values. In Beijing, Trott worked through key philosophical texts with a Chinese assistant and consulted with leading Sinologists (Lukens 2008). After his return to Germany, he entered the German diplomatic service; during a later trip to Beijing in 1940, he unsuccessfully attempted to involve Republican China in the German resistance against Hitler (H.-H. Liang 1978: 148–53). He took a leading role in the July 20, 1944, assassination attempt on Hitler and was executed after it failed. Trott was arguably the best mind of the German resistance. One can only imagine what his

conversations with Ecke and his colleagues must have been like during the intense months they spent together in Beijing.

On the Chinese side, since his days in Xiamen, Ecke was acquainted with twentieth-century China's greatest modernist writer, Lu Xun 魯迅 (Zhou Shuren 周樹人, 1881–1936), who mentioned him in his diary (Ye Gongping 2014) and owned his book on Méryon (Lu Xun Bowuguan n.d., Xiwen bufen: 10), and with the eminent classical poet Chen Yan 陳衍 (1856–1937). In Beijing, he interacted with such luminaries as the French-trained painter Xu Beihong 徐悲鴻 (1895–1953); the German-trained poet and literary scholar Feng Zhi 馮至 (1905–93); the Columbia University–educated aesthetician Deng Yizhe 鄧以蟄 (1892–1973); and the promising Buddhologist and Sanskritist Lin Liguang 林藜光 (1902–45), among others. Moreover, he was friends with three princes of the Qing imperial family who were teaching art at Furen University: the painters Pu Jin 溥伒 (1879?–1966) and Pu Quan 溥佺 (1913–91) (Vainker and Lin 2004) and the calligrapher Qi Gong 啟功 (1912– 2005). Among Ecke's students at Qinghua, the best known today is Ji Xianlin 季 羨林 (1911–2009), twentieth-century China's leading Sanskritist (Ye Gongping 2014; q.v. for further references). Ji, originally a student of Western literature, credited Ecke for inspiring him to specialize in Sanskrit and go to Germany for further study (he was in Göttingen from 1935 to 1946). He reports that Ecke taught German through English, with less-than-satisfactory results.

In spite of his friendships with many Chinese colleagues and his involvement with Chinese-run institutions, Ecke by no means "went native." It is not even certain that he spoke, let alone read, Chinese fluently. Much of his scholarly activity, as well as large parts of his social life, took place in a worldwide frame of reference, and his experience illustrates how completely the intelligentsia of Republican-era Beijing was integrated into international networks. As a case in point, when in 1935 Furen University launched a new Western-language Sinological journal, *Monumenta Serica*, Ecke was appointed associate editor. Thanks in large measure to his strong and sensitive leadership, *Monumenta Serica* soon became, as it remains today, a prestigious vehicle for scholarship. Ecke himself published as many as fifteen pieces in it during his time in China.

Expatriate solidarity may also have played a part in impelling Ecke to apply his art-historical skills to Chinese archaic bronzes. Two German collectors whom he knew in Beijing asked him to publish their collections: Oskar Trautmann (1877–1950), Germany's ambassador to China from 1935–1938 (Merker 1998a: 21 et passim), and Hans-Jürgen von Lochow (1902–89), a railway expert who had worked for the Chinese government (Schlombs 1997: 62–63). Bound in the traditional Chinese manner and illustrated with high-quality photographs

on rice paper, the catalogs were published through Furen University Press (Ecke 1939, 1943–44).[18] The Trautmann catalog elicited positive reviews from leading Chinese scholars such as Chen Mengjia (1940) and Qu Duizhi 瞿兌之 (1894–1973) (Qu 1942).[19]

According to Wolfgang Franke (1995: 68), Ecke was "a strongly marked, genial, willful personality, but uneven, moody, and sometimes difficult to relate to for others." He remained a bachelor well into middle age but in 1945 married his student Tseng Yu-ho (Zeng Youhe 曾幼荷; a.k.a. Betty Ecke, 1925–2017),[20] an immensely gifted painter. Despite the age difference, the marriage was a true meeting of minds. With his well-honed art-historical judgment, Ecke was able to provide Tseng Yu-ho with important guidance as she developed into an internationally renowned artist (Sullivan 1989: 203; Thompson 2001).

Erdberg's life in Beijing was very different from Ecke's (and, for that matter, Loehr's). Above all, she had to make a living. Complementing her husband's business, she worked as a tourist guide, developing considerable expertise about Beijing and its sights. She gave lectures on Chinese art to interested groups of expatriates and made money as a restorer (and, allegedly, as a dealer)[21] of antiques.

Erdberg had little time for scholarship; during her stay in Beijing, she only published one brief study of a medieval Taoist sculpture in *Monumenta Serica* (Consten 1942b), as well as a half-dozen popular articles. Although she was known to members of the German and international academic community, they did not regard her as a colleague (Erdberg 1994: 246). And while her husband was well connected to Mongolian-speaking intellectual circles, Erdberg's limited command of Chinese prevented her from cultivating the acquaintance of Chinese scholars in her field of interest. She did interact—albeit in a rather subaltern position—with two very senior foreign scholars: she provided editorial services to the Japanese ethnographer and archaeologist Torii Ryūzō 鳥居龍藏 (1870–1953), who resided in Beijing at the American missionary-run Yenching (Yanjing) University 燕京大學 during the war (Erdberg 1994: 247–48; see also Egan 1987: 150–153, 159, 176–77); and she worked intermittently as a typist for John C. Ferguson (1866–1945), a Canadian-born former missionary turned art expert and government advisor (Erdberg 1994: 244–45; Netting 2013). The latter source of income dried up after Pearl Harbor, when Ferguson and his fellow US citizens were interned by the Japanese.

It was another expatriate German collector of archaic bronzes, Werner Jannings (1886–after 1954), a prosperous merchant in Tianjin (Schmitt-Englert 2012), who, in 1944, gave Erdberg her first opportunity for major scholarly work. Jannings had entrusted Loehr with the publication of his extensive holdings of bronze weapons, and he turned to Erdberg to publish his bronze vessels.

Erdberg, only too aware that "Loehr was better" than she (Erdberg 1994: 269), felt very honored. But in January 1946, the Nationalist government, once again in control of Beijing, strong-armed Jannings to "donate" his collection to the Palace Museum. Loehr and Erderg were hired to install its display there (Fig. 12.5). The person instrumental in bringing about the transaction was Ecke's former student Wang Shixiang, then a low-ranking government official attached to the Ministry of Education. Through the good offices of Zhu Qiqian, Wang had obtained the intercession of no less a personage than T. V. Soong (Song Ziwen 宋子文, 1894–1971), Chiang Kai-shek's 蔣介石 brother-in-law, to overcome Jannings's initial resistance (Chen Zhou 2002: 49–54; Elliott and Shambaugh 2006: 91; Erdberg 1994: 281–86; Li Hui 2001: 59–66; Li Jingguo 2007: 147–51, 162–67).[2] Wang happened to be Loehr's next-door neighbor at Fangjiayuan Hutong 芳嘉園胡同 in Dongcheng District, Beijing, and Loehr's cooperation in this affair may well have helped to make him *persona grata* with the Republican authorities. (As to Jannings, the Communists after 1949 sentenced him to hard labor as a punishment for his largesse to the Republican regime; he was finally repatriated in 1954.) Today, the Jannings collection constitutes an important part of the Beijing Palace Museum's holdings of bronzes, the former imperial bronze collections having been removed to Taiwan.

In connection with his work on the Jannings collection, Loehr wrote several articles on bronze weapons. Much later, he published his part of the catalog as a book, which was illustrated only with his own drawings, as the photographs had been lost (Loehr 1956). Erdberg, too, as of 1984 was still planning to publish her portion of the catalog, but that plan never materialized. A new effort at cataloging the collection is currently underway in Beijing.[23]

Loehr, at the Deutschland-Institut, inaugurated a German-language journal of Chinese Studies, *Sinologische Arbeiten*, three issues of which appeared before the end of the war. His own publications from the war years are scant and very preliminary; perhaps he was holding back his best work for later. He undertook research trips into some Japanese-occupied areas in north China—Manchuria and northern Shanxi—most memorably to the Buddhist cave temples at Yungang 雲岡 in Datong (Shanxi) 山西大同, which were being recorded by Japanese scholars.

Until 1945, Loehr's life in Beijing contrasted with Ecke's in its apparent lack of gregariousness. Perhaps because he did not yet know enough Chinese, he kept his distance from expatriate Sinological circles. Wolfgang Franke (1995: 114) notes in his memoirs that Loehr was uninterested in interacting with Chinese people; one cannot exclude the fact that his attitude was influenced by Nazi racial prejudices. Perhaps, as an official representative of the German government, Loehr identified

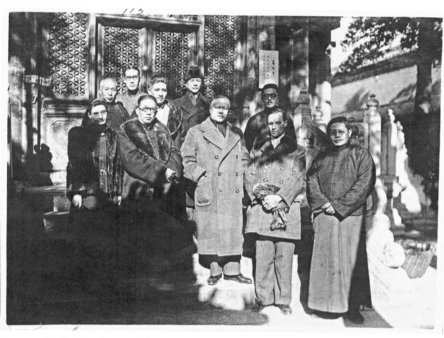

FIGURE 12.5. Handover of the Werner Jannings Collection at the Jiangxue xuan at the National Palace Museum, Beijing, January 22, 1946, including Eleanor Consten-von Erdberg (front row, first from left), Shen Jianshi (first row, second from left), Max Loehr (front row, second from right), Wang Shixiang (front row, first from right), and Yu Xing-wu (second row, first from left). Courtesy of the Palace Museum, Beijing.

with the Japanese occupiers. If one may believe later retrospective accounts, such a pro-Japanese stance was not widely held among German expatriates, especially among those who had lived in Beijing before the Japanese invasion. In any case, even during the war, Loehr cultivated some contacts with Chinese specialists who shared his interest in archaic Chinese art. Since much of the Chinese scholarly elite had left Beijing, the choice was limited, but Loehr found two old-style antiquarians, Rong Geng 容庚 (1894–1983) (Huang Yifei 2015) and Sun Haibo 孫海波 (1911–72), with whom to study bronze inscriptions.

Loehr's social life changed drastically at war's end, when the international scholarly community suddenly became important for him as a source of support. Ironically, it was through the good offices of none other than Hellmut Wil-helm—with whom he had heretofore been afraid to associate openly—that he obtained a teaching post at the once-again Chinese-run Qinghua University. Equally ironically, his former tutor Rong Geng, who had chosen not to go to

unoccupied China out of concern for his collections and personal library, was ignominiously dismissed from Peking University for having allegedly "collaborated" with the Japanese. Instead, Loehr now became friendly with Feng Zhi, Chen Mengjia, and Wang Shixiang, who had returned to Beijing from the south.

Contag's work on literati painting, in contrast to the antiquities-and-monuments–focused scholarship of her colleagues, not only demanded very different methods of study but also took place in a completely different culture of research, imbricated in very different modes of socializing. In Republican China, paintings were for the most part held by private collectors. Even the Palace Museum did not regularly exhibit its paintings. But it so happened that, around the time Contag arrived in China, two teams of researchers were taking comprehensive stock of the Palace Museum's holdings; and through a combination of uncommon talent and an extraordinary stroke of good luck, Contag was allowed to participate in both endeavors.

The first viewing project was occasioned by a scandal involving the former director of the Palace Museum, Yi Peiji 易培基 (1880–1937). In 1933, one of the Museum's board members had denounced Yi for replacing artworks with fakes and selling off the originals for his own profit (Elliott and Shambaugh 2005: 75–78; Roberts 2007).[24] To investigate these allegations—which ultimately turned out to be baseless—the judicial authorities mandated a comprehensive check of the Museum's paintings. The person in charge of that effort was Ye Gongchuo 葉恭綽 (1881–1968), a railway expert and former vice minister of communications of the Beiyang government as well as a major art collector and calligrapher, who at that time was semi-retired but still politically influential. To head the committee of experts, Ye prevailed upon Huang Binhong 黄賓虹 (Huang Zhi 黄質, 1865– 1955), twentieth-century China's greatest traditional-style painter, who was also a leading connoisseur, and whose work had been prominently shown in the 1934 Berlin exhibition. At the recommendation of Cai Yuanpei, Ye had the recently arrived Contag appointed as an advisor to the committee. She was by far the youngest, as well as the only female, member of the group; but she was not the only foreigner: Ferguson, as well, participated during the project's initial stages. First in Beijing, then in Shanghai (where much of the Palace Museum's painting collection had been removed for safekeeping in anticipation of a Japanese invasion of north China), Contag, as part of the committee, was privileged to view thousands of normally inaccessible works from the former Imperial collections.

The second viewing project took place in preparation for the great exhibition of Chinese art that was held in London from November 1935 to March 1936. As part of its effort to generate goodwill for China in its looming war with Japan,

the Nationalist government had agreed to lend masterworks from the Palace Museum. The person charged with selecting the paintings was the collector and painter Wu Hufan 吳湖帆 (1894–1968). Again, Contag was invited to join (Spee 2008: 50–51).

As documented in their letters and diaries, both Huang Binhong and Wu Hufan were positively impressed with Contag: they appreciated her seriousness as a scholar and her lack of arrogance (Huang Binhong, letter to Xu Chengyao, February 19, 1936, in Huang Binhong 1999: 147; translated in Roberts 2005: ch. 4. 130–31; Spee 2008: 58, also in Shi Mingli 2016). They introduced her to other members of their vast circle of old-style literati painters, collectors, and connoisseurs in the Jiangnan region (Qiu Zhuchang 1985: 181; Wang Zhongxiu 1995: 352, 356), and Contag soon developed a deep understanding of their aesthetic and moral values. Huang Binhong dedicated a painting to Contag with an inscription that brings this out (Roberts 2005: ch. 4, 132, ill. 4:10). Respect developed into friendship. At Contag's wedding, Wu Hufan and his wife, Pan Jingshu 潘靜淑 (1892–1939), an accomplished artist in her own right, presented her with a painted fan (Shi Mingli 2016).

Contag proposed to Wu Hufan to collaborate on a much-needed comprehensive reference work on Ming and Qing-period painters' and collectors' seals. Since Wu, an opium addict, lacked the energy to do this himself, he recommended his student and protégé Wang Jiqian (Wang Chi-ch'ien 王季遷 / 王己千; a.k.a. Wang Chi-ch'üan 王季銓, C. C. Wang; 1907–2003) (Spee 2008).[25] The project, which occupied them for three years, provided a unique opportunity to view most of the region's major private painting collections in their entirety (Wang 1977; Silbergeld 1987: 21). Embellished with calligraphic prefaces by Ye Gongchuo and Wu Hufan, the dictionary was published in Shanghai in 1940, reconstituted and slightly reduced in size after a Japanese air raid in October 1937 had destroyed the original galley (Contag and Wang 1940). It was innovative for providing full-size photographic renditions of the seals together with transcriptions into standard script and German translations. The book was seriously, and quite positively, reviewed by leading Chinese scholars and artists (Fu 1942; Rong 1940). Reissued several times (sometimes under an English title and with a new preface by the American art historian James Cahill [1926–2014], yet retaining Contag's German text unchanged [Contag and Wang 1966]),[26] it remains an indispensable tool for the authentication of literati paintings from Late Imperial China. Aside from the dictionary, Contag also published a substantial journal article during her time in China (Contag 1937) as well as a book on Qing literati painting that was later translated into English (Contag 1941).

WARTIME AND POLITICAL ENTANGLEMENTS

When the Second Sino-Japanese war broke out in July 1937, both Beijing and Shanghai were occupied by Japanese troops. Germany at first conducted a somewhat inconsistent foreign policy vis-à-vis China, maintaining relations with both Japan and Chiang Kai-shek's Nationalist government in Chongqing. Diplomatic correspondence from the early years of the war records plans to move the Deutschland-Institut from Beijing to unoccupied Kunming, where many academic institutions had relocated (Politisches Archiv, Aktienbestand R 9208/3385, 3386, 3387). Only in 1941, following the signing of the tripartite alliance that established the "Axis Berlin-Rome-Tokyo," did Germany recognize Wang Jingwei's 汪精衛 (1883–1944) Japanese-dominated puppet regime in Nanjing and break off relations with Chongqing. The Deutschland-Institut remained in Japanese-occupied Beijing. As allies of the Japanese, German nationals in occupied China enjoyed a relatively privileged position, while Allied nationals were cruelly interned after Pearl Harbor. The tables were turned after the Allied victory.

If Ecke had still been teaching at Qinghua in 1937, he presumably would have joined in that institution's exodus. In a letter to Trott from September 2, 1937 (cited in Krusenstjern 2009: 337), Ecke wrote: "All the genuine Chinese are leaving us, for crying out loud!" (Alle echten Chinesen aber verlassen uns, es ist zum Heulen!) But Furen University, where he was now a professor, stayed put in Japanese-occupied Beijing. Shielded to some extent by the special status of the mostly German missionaries who were running it, Furen maintained a modicum of autonomy, and Ecke's life in Beijing continued under a semblance of normalcy. Since his salary was paid in part from official German sources, Ecke had to be careful "to veil his otherwise quite pronounced anti-Nazi attitude in the company of other Germans who were not completely reliable" (Franke 1995: 68). Like most expatriate German academics at the time, he may have been compelled to join the National Socialist Teachers' Federation (Nationalsozialistischer Lehrerbund).[27]

Since the Nazi takeover in 1933, all German nationals living abroad had been coopted to some extent by the new regime. In Beijing, too, the Nazi party's Foreign Organization (Auslandsorganisation) had increasingly tightened its stranglehold over the German Community (Deutsche Gemeinde), which had previously functioned as a loose and entirely voluntary organization representing the interest of German nationals (Merker 1998a; Schmitt-Englert 2012: 493–501). All of Beijing's approximately 275 Germans were now theoretically obliged to join the Deutsche Gemeinde and attend its activities, which included political

indoctrination by Nazi party functionaries.[28] In practice, if one may believe the recollections of Erdberg and others, the officials in charge of enforcing the new order in Beijing were comparatively benign, and social interactions between Nazis and non-Nazis, "Aryans" and Jews, Germans and other foreigners, as well as Germans and Chinese, went on more or less as before (Franke 1995: 66; Schmitt-Englert 2012: 265).

Nazi-imposed strictures were particularly onerous when it came to getting married, even abroad. Erdberg (1994a: 165–68) and Contag (Schmitt-Englert 2012: 151, n. 57), in order for their marriages to be recognized under German law, had to proffer proof that both they and their fiancés were of pure "Aryan" descent. Assembling the necessary documentation—especially for Erdberg with her far-flung background—caused considerable difficulties. As to Ecke, he dared not marry Tseng Yu-ho until February 27, 1945, when the German defeat was imminent—for marrying a non-"Aryan" would have constituted "racial abomination" (*Rassenschande*) under Nazi anti-miscegenation laws and would have entailed severe punishment in the event of a return to Germany (Franke 1995: 139; the same considerations delayed Franke's own marriage as well).[29] Even so, Ecke felt obliged to report the marriage to the German consulate, and on March 4, he wrote to the official in charge, Felix Altenburg (1889–1970)—who himself was under a cloud for having a Chinese girlfriend—apologizing for having married without official permission.[30] As mitigating factors, he mentioned that Tseng Yu-ho had "connections to Japan and to Manchukuo," presumably referring to the Manchu princes who were her teachers at Furen University. One of the latter, Pu Jin, had conducted the marriage, the other, Pu Quan, serving as master of ceremonies. Also present were the Swiss consul and seven other Germans, including Wilhelm, Fuchs, and Loehr (whose presence at this occasion may signal an incipient opportunistic reorientation away from National Socialist orthodoxy), as well as Ecke's cousin Ruth Wang, whose husband, Wang Yintai, by then was serving as head of the collaborationist North Chinese government. On March 16, 1945, Altenburg notified the German embassy in Nanjing of the marriage, pointing out that it was valid under Chinese law and expressing the conviction that Ecke's and Tseng's artistic collaboration would be positive for German–Chinese cultural relations. In a marginal note, the local Nazi party boss agreed that no action was needed.[31]

Contag, as the wife of a diplomat, was part of the official German presence in China. Since the German Community in Shanghai, some 2000 strong, was under far stricter Nazi control than the one in Beijing (Freyeisen 2000), she inevitably had to participate, at least sometimes, in activities organized under Nazi auspices. But neither Contag nor her husband appears to have been prominently involved

in such goings-on. Winterfeldt, in spite of his prominent official position, is not named even once in Freyeisen's (2000) detailed treatment of Nazi activities in Shanghai. However, one 1941 source (cited in Leutner, Adolphi, and Merker 1998: 222) hints that he may have been involved in intelligence gathering. Like virtually all German diplomats, he applied to join the Nazi party, but it is unclear whether he actually joined (Schmitt-Englert 2012: 151, n. 57). In any case, when Franke much later referred to Contag as "a somewhat controversial personage" (*eine etwas umstrittene Persönlichkeit*; Franke, letter to Walter Fuchs, September 6, 1973, in Walravens 2013: 141), the reference is unlikely to have been a political one.

Erdberg, by her own frank admission (1994: 226), benefited from the Japanese invasion. For as the Japanese occupying authorities made it a *point d'honneur* to keep open the universities whose faculty and students had fled, they faced a dire staffing shortage, enabling Erdberg to land a teaching position for the first time. Until the end of the war, she taught at the newly founded Faculty of Medicine of what later came to be called "Fake Peking University" (Wei Beida 偽北大, in counterdistinction to the "Real" Peking University that had relocated to Kunming). She also taught at Yanjing University until the entry of the United States into the war forced its closure. At some point, Erdberg writes, she "had to join the National Socialist Women's League" (Frauenschaft), whose Beijing chapter she describes as a "knitting club that met once a month to make warm clothes for the freezing Germans at home—including, naturally, soldiers' socks" (Erdberg 1994: 226). Erdberg evidently intended to convey that she never went so far as to join the Nazi party. Her husband, on the other hand, had become a member of the party as early as 1933, even serving as the leader of its Beijing chapter until 1934 (Schmitt-Englert 2012: 500–501).[32] In her memoirs, Erdberg (1994: 148–49) claimed that he had early on become disenchanted with the Nazis and had provoked his expulsion from the party, triggering social and professional repercussions; but this account may not be accurate.

As to whether Loehr was a member of the Nazi party, published opinion has been divided. Wolfgang Franke, who knew him well in China, denies it (1995: 113),[33] but Peter Merker (1998b), based on extensive archival research, considers it certain.[34] Indeed, the Political Archive of the German Foreign Ministry preserves a printed invitation to a lecture by Loehr on "New Art in Germany" on September 26, 1941, on which Loehr's name is explicitly preceded by the abbreviation for "Party Comrade" (*Pg = Parteigenosse*); this should clinch the matter.[35] Corroborating this, Merker notes that Loehr won his job at the Deutschland-Institut over two dyed-in-the-wool Nazi scholars, Werner Speiser (1908–65) and Hans O. Stange (1903–78); that his subordinate in Beijing, Hoffmann, was

a staunch party member; and that both Loehr and Hoffmann, before being sent to Beijing, had to be officially exempted from military service—a tall order under wartime conditions. That the exemption was granted signals the importance with which their mission was viewed by the highest authorities. Ilse Martin, before being sent to China, had worked as an employee for the German military for two years (according to the autobiographical statement in her dissertation cited in Walravens 2010). Franke (1995: 114) alleges that she was "not a party member, but quite naïve," but in this case, too, he may be misremembering. In any case, all three were obviously regarded as politically reliable.

On the other hand, there is the following evaluation by an unnamed Nazi official (Freyeisen 1999: 213, n. 41; cited from Krüger and Wulff 1994):

> Dr. Löhr [sic], as to his professional qualifications, keeps himself mainly orient-ed aesthetically and is considered to be little interested in politics.

Be that as it may, the presence in China of Loehr, Hoffmann, and Martin almost certainly constituted part of the German war effort. It is hardly an accident that their arrival coincided with a significant expansion of the German cultural and media presence in East Asia under the aegis of the "Axis Berlin-Rome-Tokyo." Most of this expansion took place in Shanghai, which even under Japanese occu-pation was a far more important node in the international communication net-work than Beijing. In 1940–41, Shanghai saw the establishment of the Deutsches Informationszentrum dedicated to the dissemination of pro-German propagan-da to the general public as well as to the press; a German-run radio station; as well as a fancy monthly periodical directed at an educated readership, *The XXth Cen-tury* (Freyeisen 2000: 266–353). As Astrid Freyeisen's careful archival research has revealed (2000: 351–56, 367–89), the Nazi functionaries who directed each of these operations were simultaneously involved in clandestine intelligence gath-ering; in fact, that very probably was their main preoccupation, their respective "day jobs" merely serving as fronts. It would be naïve not to assume that plans existed to use the Deutschland-Institut in Beijing for espionage purposes, and it is known that one of its associates, the Mongolist Walter Heissig, was engaged in such activities.[36] This became an issue when Loehr approached Heissig to con-tribute to *Sinologische Arbeiten*: the latter's superiors in the German military were slow in giving their assent.[37] Rumors that Loehr himself had been a spy circulated in Beijing after the war, and he is said to have been investigated by US Army intel-ligence on that account, but nothing of substance seems to have come to light (Rudolph 1985: 97–98). The institute's (actual or potential) role as a front for covert operations might explain its tendency, noted by Françoise Kreissler (1989: 195), of "multiplying its activities to excess, without always following through on

them."[38] But the archival materials currently accessible do not directly attest to such a role.

Even so, there are signs that, back in Germany, Loehr and his two companions had been given a mission that included other tasks besides their ostensible pursuit of Sinology. If we may believe Wolfgang Franke, who had been in charge of the daily operations of the Deutschland-Institut for more than a year before their arrival, none of the three took much interest in the institute. Instead, Hoffmann devoted himself to "the German Community and the party, where he was put in charge of political indoctrination and also of the Hitler Youth" (Franke 1994: 113). Ilse Martin, though more of a presence at the Deutschland-Institut than the other two, engaged herself in organizing women and became the leader of the Beijing Branch of the League of German Girls (Bund der Mädels), the female equivalent of the Hitler Youth (Franke 1994: 114). About Loehr, Franke writes (1994: 113; similarly 114 et passim):

> He was glad to be in Beijing and to be able to pursue his scholarly interests there. To us he showed himself as an easygoing person. He had no interest in the Deutschland-Institut and its work, even though he took over its directorship in August 1941. He essentially limited himself to representing the Institute toward the outside, especially vis-à-vis the German authorities; he virtually ignored the Chinese members and staff. . . . He was exclusively concerned to satisfy the higher German authorities and to avoid anything that could possibly have provoked their criticism. . . . Caution was his utmost priority.

While Franke continued to serve as "managing director" (*Geschäftsführer*) of the Institute (by his own estimate, he did about 90% of the routine administrative work [Franke 1995: 114]), Loehr showed up there only "two or three times a week for a couple of hours" (Franke 1995: 116).

Franke generously assumes that Loehr made use of his ample free time to pursue his scholarship. And it is true that between 1943 and 1945, Loehr published a piece in each annual issue of *Sinologische Arbeiten*. These include a description of Shang-period grey ceramics (Loehr 1943a), the first installment of a series of translations of bronze inscriptions that he had worked on with Rong Geng (Loehr 1944a), and the partial translation of a bibliography on oracle bone inscriptions compiled by Rong (1945a). But these pieces, which constitute the sum total of Loehr's published scholarly output during his years at the Deutschland-Institut, strike one as, frankly, perfunctory; they bear no comparison with the brilliance of his own later work or, indeed, of the two journal articles he had published in Germany before departing for China (Loehr 1936, 1939). During the same time span, Franke published considerably more, in spite

of being kept busy managing the institute and by an active social life. One cannot help suspecting that Loehr had time on his hands for other occupations on which the sources are largely silent.

A glimpse into the nature of these activities may be obtained if one compares the non-scholarly articles that Loehr and Erdberg, respectively, contributed to the propaganda periodical *The XXth Century*, which was published in Shanghai between 1941 and 1945 under the editorship of Klaus Mehnert (1906–1984) (Freyeisen 2000: 286–306).[39] Erdberg's six articles (Consten 1942a; 1944; Consten and Hammer 1942; B. von Erdberg 1943, 1944a, 1944b) are innocuous disquisitions on aspects of East Asian traditional culture, such as the lotus flower, brush calligraphy, landscape painting, and Mongolian folk art. One notes that only three pieces were published under her own name, while the others appeared under the pseudonym "Beata von Erdberg." Was she afraid of overexposing herself in a venue of obviously partisan political character? Or did the editors wish to convey the impression that they could muster a wider roster of contributors than was actually the case?

By contrast, the two articles on contemporary German painting and sculpture that Loehr contributed to *The XXth Century* (Loehr 1943b, 1944b) can only be described as hard-core Nazi propaganda. In them, Loehr excoriates "Degenerate art," criticizes the Italian fascists for their tolerance of modernist painting, and waxes eloquent about how carefully the German authorities were in selecting the kind of art that befitted the new order. He even approvingly cites Adolf Hitler verbatim.[40] To exemplify recent German artistic achievements, he chose artworks that were utterly banal but "politically correct." The comparison with Erdberg's pieces shows that, even at the height of the war, following the Nazi party line to such an extreme extent was not a necessary precondition to getting one's work published. Moreover, publishing in a venue like *The XXth Century* was not obligatory. Erdberg, perpetually short of money, quite possibly did it for the honorarium. One notes with interest that Contag, even though she lived in Shanghai and must have known Mehnert, successfully avoided ever publishing anything in his journal.

Diplomatic correspondence concerning Loehr's work at the Deutschland-Institut shows that at least some of his time was taken up with political hackwork; an article on "Sun Yat-sen, Truth and Legend" that he had written—apparently under protest—for publication in *The XXth Century* was returned, presumably because it was considered too sensitive (letter from Felix Altenburg to German Embassy in Nanjing, dated May 18, 1945 [Politisches Archiv, Aktienbestand R 9208/3389, item 3]). Elsewhere, Loehr is asked to coordinate a translation of Chiang Kai-shek's book *China's Destiny* (letter from Loehr to

Kordt, dated June 28, 1944[41]—a task he tried to foist onto Fuchs. Apparently acting on his own initiative, Loehr reorganized along Nazi lines an exhibition of high-quality reproductions of German artworks organized by the Deutschland-Institut. That exhibition had been shown in several Chinese cities before Loehr's arrival, but Loehr promptly saw to it that all works by "degenerate" (i.e., expressionist) and Jewish (e.g., Max Liebermann [1847–1935]) artists were eliminated (Merker 1998b: 34). Also due to Loehr's intervention was the inclusion of a poem by Baldur von Schirach (1907–74), founder of the Hitler Youth, as the final climax of an anthology of German poetry published by the Deutschland-Institut—the only institute publication Loehr and Hoffmann actively helped to compile. Franke considered this "a bow before the Nazi régime that would not have been necessary" (Franke 1995: 113).[42] But this formulation assumes a distance between Loehr and the Nazi regime that may have been nonexistent. In fact, it is difficult to avoid the impression that Loehr's role in wartime China was that of a Nazi operative and cultural enforcer.

Giving Loehr the benefit of doubt, one may imagine that his main goal in going to Beijing was his own professional advancement, and that he regarded the compliance with his (overt and possibly covert) official tasks as a sacrifice worth making in exchange for the opportunity of pursuing his scholarship. To his superiors in Berlin, on the other hand, his scholarship may have been no more than a smoke screen. It seems fair to say that, during his first four years or so in China, Loehr was what his German compatriots at that time called a "golden pheasant" (*Goldfasan*): a privileged functionary of the Nazi regime, affable, cultivated, and seemingly open-minded, eminently presentable, but completely loyal to his superiors and ready to execute their commands ruthlessly if called upon. But Loehr, as far as we know, was never seriously called upon, and he may have deployed considerable ingenuity to keep it that way.

DEPARTURE

Following the collapse of Nazi Germany and Imperial Japan, the victorious Allies insisted on the repatriation of German citizens, but this took time. Contag, as part of the former diplomatic community, was interned in Shanghai and sent back to Germany as early as 1946. Loehr sent his family ahead (according to Fuchs [2010], they were living in the resort town of Bad Aibling in Bavaria as of 1947; see also Franke 1995: 167); but Loehr himself—very likely in order to avoid being caught up in bothersome denazification proceedings—went to teach at Qinghua University and stayed until 1949, when denazification had begun to ebb. Remarkably, he was even able to make the Hong Kong–Paris leg of his

homeward journey by airplane, rather than having to go by ship like most others. Back in Munich, he resumed his old position at the Museum of Ethnography.

Ecke continued at Furen as before. Perhaps because of his Chinese wife, he was able to eschew repatriation. He left Beijing with his wife in 1948 to teach once more at the University of Amoy, which in the meantime had become a state-run institution. The following year, just before the Communists overran Xiamen, he accepted the offer of a curatorship for Asian art at the Honolulu Academy of Arts and left China forever.

In her memoirs, Erdberg (1994: 297–98) claims that the Honolulu position had originally been offered to her, but—very possibly because of her husband's Nazi party affiliation, which was well known to the American Secret Service (Erdberg 1994: 278)—she had been unable to get her immigration papers on time. Without naming Ecke anywhere in the book, she gave free rein to her jealousy. This seems somewhat small-minded, considering that it had probably been none other than Ecke who had helped Erdberg find employment at Furen University after the institutions where she had previously taught had reverted to Chinese control. She and her husband were still in Beijing when the Communists took the city; it was only after more than a year filled with uncertainties and bureaucratic harassment that they were able to board an overcrowded steamer out of Tianjin. They reached Hamburg on December 31, 1950.

Later Careers

The later professional trajectories of all our four protagonists attest that they had profited immensely from their stays in China. Ecke and Contag, even though both continued publishing, had done their best work while in China. Ecke's book on furniture and Contag's book on seals—each, significantly, written together with a Chinese co-author—remained their most significant achievements. For Erdberg and Loehr, on the other hand, their academic careers only truly took off after they left China.

The East Asian art collection Ecke built at the Honolulu Academy of Arts is his monument. Most of his publications after 1950 were short pieces on artworks in the museum; he also co-authored a catalog of Chinese paintings in Hawaii with Tseng Yu-ho (Ecke and Ecke 1965; Ecke's other *opuscula* from his time in Hawaii are listed in Walravens and Kuwabara 2010: 164–68, nos. 32–67). From 1951 onward, he concurrently taught at the University of Hawai'i. By all accounts he was a beloved teacher, but he did not train any graduate students, and none of his undergraduates went on to specialize in East Asian art. Gradually he receded behind Tseng Yu-ho, who not only exhibited her paintings

all over the world but also trained for her PhD in art history at New York University and, in a somewhat unusual maneuver, succeeded her husband on the University of Hawai'i faculty after his retirement in 1966. Ecke subsequently returned to Germany, where he taught at Munich and Bonn as a visiting professor for three years. He died in Honolulu in 1971.

Contag and her family settled in Wiesbaden. From 1951 onward, she taught as an adjunct at the nearby University of Mainz. But Mainz had no Chinese studies department, and Contag never succeeded in acquiring the *Habilitation*.[43] Rather than art history, she taught mainly Chinese literature and philosophy (on her strict and conservative teaching style, see Shi Mingli 2016); none of her students specialized in a China-related field. She published two more insightful monographs on Chinese painting (Contag 1950, 1955) and one on the impact of Confucianism on Chinese culture (Contag 1964). She died in 1973.

Erdberg and her husband relocated to the latter's hometown of Aachen, where she found a job as part-time lecturer and librarian in the Architecture Department of that city's Technical University (Rheinisch-Westfälische Technische Hochschule). She taught a wide spectrum of courses, spanning European and general art history in addition to her East Asian specialty. Encouraged by her colleagues, she passed her *Habilitation* in 1955; three years later she was appointed supernumerary professor, and in 1961 her title was changed to "academic counselor and professor." Even though she never held a full chair, she was now one of an infinitesimally small number of German female scholars of her generation who had the legal right to be addressed as "Frau Professor." She trained dozens of PhDs, most of whom went on to practice as architects, though some continued to work on East Asian art while holding jobs at museums or galleries. Her last PhD finished in 1984.

Erdberg's scholarly life was a busy one. Aside from Aachen, she also taught as an adjunct at the universities of Cologne and Bonn, and she traveled abroad for visiting professorships at Mills College (1960–61), the University of the Philippines (1968), and the State University of New York at Buffalo (1970). Although she never visited Beijing again, she undertook research and conference trips to other parts of Asia. Since her mother and her second husband—her first cousin Robert von Erdberg (1906–89), whom she married in 1961—both lived in the United States, she spent considerable amounts of time there as well. She lived to the age of 95.

Erdberg published prolifically on Chinese bronzes (the subject of her *Habilitationsschrift*), textiles, and other applied arts, as well as general art history. She was a popularizer rather than a profoundly original thinker, and most of her work, though useful in its time, is now out of date. Her general introductions to

ancient Chinese art (Consten 1958) and traditional East Asian architecture (Speiser and Consten 1964) were disseminated in French, Italian, Spanish, and Portuguese translations. (For a bibliography through 1984, which does not list all the translations, see Fischer and Klein-Bednay 1984: 17–24.)

Without question, the most successful of our four protagonists was Loehr. In 1951, he had the choice of the directorship of his museum in Munich and a professorship at the University of Michigan, for which his former teacher Bachhofer—now at the University of Chicago—had recommended him. Possibly because prospects for a proper professorial appointment in Germany still seemed slim at the time for a former Nazi functionary (attitudes did relax later on), or perhaps because the American system did not require the *Habilitation*, which he had never obtained, Loehr chose Michigan. In 1960, he moved to Harvard as the inaugural Abby Aldrich Rockefeller Professor of Asian Art and Curator of Oriental Art at the Fogg Museum. Here he was reunited with Ilse Martin and her husband, the literary scholar Achilles Fang (1910–95), another former staff member of the Deutschland-Institut, who had settled in Cambridge, Massachusetts.

During the two decades preceding his retirement in 1974, Loehr was the leading scholar of Chinese art in the Western hemisphere. A number of his former PhD students went on to distinguished careers in the United States, Europe, and Asia. He published numerous important works on archaic Chinese bronzes and jades, as well as on prints, paintings, and Buddhist art. His basic approach, formed during his student days in Munich, never changed, and his mature scholarship arguably bears fewer marks of the impact of his long stay in China than does that of his three compatriots. Loehr's influence has decisively shaped the American practice of Chinese art history (see Bagley 2008 and the uncritical review of that book by Miao Zhe and Wang Haicheng 2011). A critical assessment of his intellectual legacy is overdue, but that task must be left to a future study.

Even though he became a US citizen in 1957, Loehr maintained excellent connections with German academia. Efforts to call him back—for example, to Berlin in 1958, as documented in letters by Walter Fuchs to Wolfgang Franke from May 29 and June 7 of that year (Walravens and Gimm 2011: 185)—never came to fruition, however; nor did he retire to Germany, as had apparently once been his plan. Suffering from Parkinson's disease, he died at his home in Lexington, Massachusetts, in 1988.

COLLECTIONS

The Republican period is often said to have been a golden age of Chinese art collecting. Prices were low, and many masterpieces left the country and entered

museums and private collections in Japan, Europe, and North America (Cohen 1992; Netting 2013; Ruchivacharakul 2011; Steuber and Lai 2014). Many foreign residents of China collected curios, and our four protagonists, with their well-trained art historians' eyes, were in a particularly advantageous position to do so. Given the fluctuations in the value of local currencies, investing in antiques could also be a way of protecting one's wealth. In spite of strict laws governing the export of cultural relics that had been put into place in the 1930s (see Lai, this volume), all of our four protagonists managed to take the bulk of their collections with them when they left China.

Ecke owned many of the splendid Ming and Qing furniture pieces he had published in his book, as well as numerous priceless paintings and other antiques. He was very worried about them as the Communists closed in on Beijing. He sacrificed the bulk of his extensive library but got his most important artworks safely out of China, partly via Xiamen and partly, later on, with the help of friends in the Western diplomatic community (Rudolph 1985: 98; Thompson 2001: 63–64, 72–73). Some of them—notably the Ming painter Wen Zhengming's 文徵明 (1470–1559) masterpiece, "Seven Junipers"—are now in the Honolulu Academy of Art. When Tseng Yu-ho moved back to Beijing in 2006, she donated seven of the best furniture pieces to the Chinese government, which exhibits them at the Prince Gong Mansion 恭王府 in Beijing.

Contag, advised by her Jiangnan friends, acquired an exceptionally fine collection of more than one hundred Ming and Qing literati paintings, as well as a large number of contemporary works, all of which she was able to take back to Germany. She organized exhibitions in Hamburg in 1949 (Contag 1949) and in Düsseldorf in 1950 (Contag and Speiser 1950). After her husband's death, she sought to sell the collection. Unable to find a buyer in Germany, she sent the paintings to the United States, where, thanks to her old friend Sickman, they were stored for some time at the Nelson-Atkins Museum in Kansas City. After a failed attempt to sell the collection in toto to the Asian Art Museum of San Francisco, the paintings were sold off separately. The best pieces, including an important album by Shitao 石涛 (1642–1707), ended up in the hands of C. C. Wang, who had emigrated to the United States (Cahill n.d. [unfortunately, Cahill does not specify the time when the events he recalls took place]; Spee 2013). An important large painting by Mi Wanzhong 米萬鍾 (1570–1628) is in the Stanford Art Museum. Harrie Vanderstappen (1921–2007), Bachhofer's successor at the University of Chicago, acquired twelve others for what is now the David and Alfred Smart Museum of Art (Vanderstappen et al. 1989: nos. 101–104, 109, 110, 113, 114, 116, 118, 119); another forty items are in Berlin, on loan to the Museum of Asian Art from the MCH Hammonds foundation in

Dallas, Texas. Contag's archives—folder after folder of painstakingly collected images of works by all the major classical painters of China—are in the Museum für Ostasiatische Kunst, Cologne.[44]

Erdberg's collection, put together under conditions of penury, was more eclectic but still quite extensive—it filled most of the twenty-four boxes that she and her husband were allowed to take with them when they left Beijing in 1950. In particular, she possessed some remarkable textiles and ceramics. The most important pieces were eventually purchased by the Aachen-based collectors Peter (1925–1996) and Irene Ludwig (née Monheim, 1927–2010), major patrons of modern international art in post–World War II West Germany, who became interested in China late in their lives (Schlombs 1997: 64–65). These works are now in the Museum für Ostasiatische Kunst, Cologne.

Loehr, too, though he also had to leave behind a large part of his personal library, left China with a collection that included archaic bronzes, jades, and ceramics, as well as paintings. He intermittently sold or donated objects. A group of nineteen early jades was acquired by the University Museum at the University of Michigan in 1960[45] (the Museum also owns a painting by Hanabusa Itchō 英一蝶 [1652–1724], donated by Loehr in 1958). What remained was sold at auction after his death (Lally 1993).

The Puzzling Lack of an Echo

In contrast to the deep imprint China left on each of our four protagonists, their sojourns do not seem to have exerted much of an influence on the study of the visual arts in China. This unfortunate situation can be explained from several angles.

To begin with, the Republican period was the time when modern archaeology was being established in China. The large-scale excavations at Anyang and elsewhere undertaken by the Institute of History and Philology at Academia Sinica in Nanjing after 1928 aroused much excitement and lastingly changed the nation's self-perception of its ancient past. The Beiping Academy in Beijing was involved in similar research, and some of its members participated in Sven Hedin's (1865–1952) Sino-Swedish Expedition (1927–1935). As early as 1922, Peking University established an Archaeology Research Institute, and other universities made fledgling efforts in a similar direction. From the mid-1920s, the government established national museums, such as the Palace Museum and the National Museum of History, both in Beijing; these were complemented by provincial and local institutions. The *Yingzao xueshe*, as well, was part of this flurry of institution-building.

The four German art historians featured in this article, in spite of their pro-
fessional competence, were but tangentially involved in these developments. Ecke
probably was closest to the pulse of things as a member of the *Yingzao xueshe* in
the 1930s; the other three, too, were temporarily part of the system when they
were working—Contag in the mid-1930s, Loehr and Erdberg in the late
1940s—with the Palace Museum. But their involvement was marginal. The rea-
son for this was probably not xenophobia but a general lack of comprehension in
Republican China's official and intellectual circles of the aims and potential ben-
efit of art history as an academic discipline. Some of the tasks that fall within the
purview of art historians, such as the documentation, classification, and conser-
vation of artifacts and monuments, had been relegated to the above-mentioned
archaeological and museum institutions; but an understanding of art history's
ability to process visual evidence into an independent body of source material for
social and intellectual history never developed. (This incomprehension contin-
ues in today's China, where the Ministry of Education still does not recognize art
history as a "core subject," even as some universities are beginning to establish art
history departments.)

There was thus a palpable disconnect with what Ecke, Contag, Erdberg, and
Loehr were capable of doing and what was possible in China under the condi-
tions of the time. Their presence, in that sense, was premature. And historical cir-
cumstances hardly lent themselves to the contemplative study of art history. For
most Chinese intellectuals, the Republican period—especially the long war with
Japan—was a time of national struggle, during which art history could easily
appear ephemeral, if not irrelevant.

Another reason for our four protagonists' failure to transfer their skills in
German-style academic art history to China may have been the lack of appropri-
ate counterparts on the Chinese side. To my knowledge, only one Chinese intel-
lectual went to Germany to study art history during the Republican period: Teng
Gu 滕固 (1901–42), who obtained his PhD in 1932 at the University of Berlin.
Even before departing for Germany, under the influence of Japanese scholarship,
he had authored the first modern synthesis of Chinese art history in Chinese
(Teng 1926). Back in China, he became a high-ranking art-school administrator,
but tragically he died young. It is uncertain whether Teng was acquainted with
any of the four protagonists of this study—all except Ecke were in Berlin at one
time or another when he was a student there—or whether he met them in
China.[46] Several other Chinese students in Germany during the Republican
period studied philosophical aesthetics—the most well known being Zong
Baihua 宗白華 (1897–1986), later professor of philosophy at Peking Universi-
ty—but the concerns of art history remained alien to their scholarship. One

wonders what circumstances could have fostered the development of a synergy conducive to launching the art-historical discipline in Republican China's academia. If any such opportunities existed, they were missed.

None of our four protagonists appears to have taught specialized classes in art history during their time in China. Contag, as far as I know, did not teach at all. The others supported themselves by teaching language and literature—German of course, but also English, including Anglo-Saxon! (Erdberg)—as well as Greek, Latin, and (probably in translation) Russian (Ecke). Upholding a long-standing tradition in Catholic institutions of higher learning, Ecke at Furen also taught rhetoric. He included some art history in his general introductions to European culture;[47] and Erdberg for a while inserted coverage of the subject in the courses on interior design she taught in the Home Economics Department at Yanjing (Erdberg 1994: 230–31). Otherwise, the separation of their teaching from their own research interests was complete.

One probably should not underestimate the extent to which simple logistical difficulties were a factor in the absence of art history from university curricula in Republican China. Few if any Chinese institutions at the time are likely to have had the necessary library holdings, to say nothing of slide collections and the projection equipment needed in order to use them for instruction purposes. Teaching literature as an entryway into the humanities required fewer resources, and it may also have appealed more strongly to the text-centered sensitivities of the Chinese academic audience.

The most fundamental factor impeding the flow of ideas was long-standing incompatibilities in dealing with material culture. On the Chinese side, there was the persistence of traditional connoisseurial and antiquarian modes of scholarship, which made their practitioners complacent vis-à-vis the more systematic (or, as the four protagonists themselves would undoubtedly have put it, more *scientific*) approaches that German-trained art historians espoused. There was, in other words, no demand for this kind of intellectual import on the Chinese side. If anything, the influence flowed in the opposite direction: Ecke and Contag— even though their respective studies of furniture and seals were unprecedented in their systematic grasp—largely succumbed to the inducements of Chinese traditional connoisseurship. This seems particularly true in the case of Contag, who excelled at communicating to Western readers the traditional emic (or, as one would have said at the time, "native") concepts undergirding the practice of literati painting.

With Loehr, on the other hand, it was always his German art-historical training that determined his mode of investigation into Chinese art history. Throughout his career, he rigidly adhered to a watered-down version of Wölfflinian

formalism. There is no sign whatsoever that this impressed anyone in China at the time—but it is also doubtful that Loehr ever even tried to explain his methods to Chinese scholars. To the contrary: with him and his school, one senses that they imagined themselves in exclusive possession of a system of hegemonic knowledge (*Herrschaftswissen*): a superior means for establishing tight methodological control over their subject, unfathomable to the "natives," whom, in any case, they considered unworthy of it. This mind-set bears a strong and probably not coincidental resemblance to that of Stefan George's secret cliques of initiates.

One comes away with the impression that the life these four German art historians led in Republican China was, essentially, a parasitic one. They took away much and gave back little. In spite of what has been said above about the essentially non-colonial context of their sojourns, scrutiny reveals a residually colonial conjuncture in their interactions with the country and its inhabitants—one that did not inhere in their legal status but in geopolitical realities. For all their goodwill toward China, the four scholars are likely to have felt comfortable with this asymmetry. Whether the balance was eventually redressed by their subsequent efforts to build up East Asian art history and thereby to contribute to a deeper understanding of China in the West will have to be left up to future generations to decide.

ACKNOWLEDGMENTS

I would like to thank Bonnie Effros and Guolong Lai for inviting me to present this paper as the keynote lecture at the conference "Unmasking Ideology: The Vocabulary and Symbols of Colonial Archaeology" (University of Florida, Gainesville, January 8, 2015). I would like to express my sincere thanks to Clarissa Gräfin von Spee and especially to Ye Gongping for helping me obtain hard-to-find publications, and to Lothar Ledderose for helpful comments. Finally, I must express my admiration and gratitude to someone I have never met in person: without Hartmut Walravens's decades-long efforts to unearth and make accessible materials pertaining to the history of Asian studies in and outside Germany, this chapter could never have been written.

AUTHOR'S NOTE

Beijing was officially called Beiping 北平 from 1928 to 1949; herein I nevertheless use the more familiar "Beijing," which corresponds to "Peking," the name most commonly used at the time for the city. For the sake of economy, references have

been reduced, omitting information that can be easily cross-checked on the Web or in such readily accessible resources as *Neue Deutsche Biographie*, the *Biographical Dictionary of Republican China* (Howard L. Boorman, editor; New York: Columbia University Press, 1967–1979), or Michael Sullivan's *Modern Chinese Artists: A Biographical Dictionary* (Berkeley and Los Angeles: University of California Press, 2006). Several of the scholars mentioned herein are treated in Kern (1988) and/or Wendland (1998). All translations are mine.

NOTES

[1] Many details of Contag's life remain unclear, but Spee's planned biography will hopefully remedy this situation.

[2] Erdberg is the only one among the four to have written her memoirs (Erdberg 1994) and—since she was also the only one to become a professor in the German university system—to have been the dedicatee of Festschriften (Fischer and Klein-Bednay 1984; Holländer 1989; and a double issue of *Mitteilungen der Deutschen Gesellschaft für Ostasiatische Kunst* 21–22 [1997]).

[3] Merker (1998b), though mainly concerned with another scholar, sheds important light on Loehr's activities in Beijing during the 1940s. Following Merker's leads, I consulted relevant archival material at the German Foreign Ministry (Politisches Archiv, Aktienbestand R 9208, Deutsche Botschaft China) in September 2008.

[4] I may be making a mistake by not including Otto Burchard (1892–1965), a leading Berlin art dealer well known for his sponsorship of the avant-garde, who relocated to Beijing in 1932 and rebuilt his business there, becoming a well-reputed connoisseur of Chinese art (Jirka-Schmitz 1995). Burchard had earned his PhD in Sinology in Leipzig in 1917 under August Conrady (1864–1925) on a philological topic with ramifications in the visual arts. To my knowledge, however, he published no scholarly works on East Asian art history. In Beijing during the 1930s, he served as mentor to Laurence Sickman (Cohen 1992: 113); he is mentioned in Erdberg's memoirs (Erdberg 1994).

[5] For full disclosure: the only one of the four scholars I ever encountered in person, albeit very fleetingly, was Loehr, at Harvard during the early 1980s. I briefly corresponded with Erdberg in the 1990s, but we never met. As a child I occasionally heard tales about Ecke, who had been a comrade-in-arms during World War I, as well as a close friend (they founded the *Nibelungenbund* together in 1922), of my maternal grandfather Lothar Freiherr von Biedermann (1898–1945); but by then the family was no longer in touch with him. I did meet Ecke's widow twice, many years after his death, but we only talked superficially. With Contag I have had no contact, although distant collateral kin relationships could probably be traced between her husband's family and mine.

[6] Ecke's George-style handwriting appears, for example, on his 1948 German colophon on the painting "Eighty-seven Immortals," now in the Xu Beihong Memorial Museum in Beijing; the colophon ends with a quotation from George's poetry. (I am grateful to Dr. Ye Gongping for sharing Professor Li Song's photo of the colophon.) Loehr's handwriting that I have seen in the archival materials is also George-influenced.

[7] Ecke's interest in French culture may have been awakened less by his wartime experience in the country than by the fact that he had well-placed relatives in France on his mother's side (Thompson 2001: 109–10).

[8] I have not been able to find out who these artists were.

[9] Through vicious political denunciations, Kümmel destroyed the careers of colleagues he disliked. One of his victims, as early as 1933, was the Leipzig Sinologist Eduard Erkes (1891–1958); see Lewin (1999). On Kümmel's dictatorial behavior even before the Hitler era, see With (1997: 120).

[10] A complete listing of Loehr's academic teachers is in his 1940 curriculum vitae (Politisches Archiv, Aktienbestand R 9208/3387, items 184–86).

[11] As indicated in Loehr's CV (Politisches Archiv, Aktienbestand R 9208/3390, item 327), this service was voluntary, coming at a time when Loehr was already twice the age of ordinary army recruits. Due to Germany's partial demilitarization, imposed by the Treaty of Versailles (1919), Loehr's generation had been exempt from mandatory conscription.

[12] See n. 10.

[13] Langdon Warner, letter of recommendation for Erdberg, dated September 5, 1951, available at http: //www.archiv.rwth-aachen.de/web/online-pionierinnen/objektevitrine4.htm (last accessed January 10, 2016).

[14] Brinker (1989: 283) characterizes Reismüller, who had visited China, as an "enthusiastic China lover" rather than a China scholar.

[15] Ruth Wang was the daughter of a Protestant minister from Leipzig (Harnisch 2004: 117; for her family relationship to Ecke, see Politisches Archiv, Aktienbestand R 9208/3389, items 19–21). Her husband, who had held senior positions under the Beiyang regime, collaborated with the Japanese during World War II, was subsequently convicted of treason, and died in prison. Thompson (2001: 42), probably relying on Ecke's wife's recollections, claims—implausibly, in my opinion—that Ecke had befriended some unnamed Chinese students in Germany who arranged for his invitation.

[16] On the gay imbrications of the Stefan George circle, see Raulff (2009). On the charmed lives of Western gays in Republican China, see Brady (2013), Brown (2013), and Mungello (2012). Persistent allegations by individuals of his acquaintance that Ecke was gay should be weighed against the fact that he eventually did get married.

[17] See Politisches Archiv, Aktienbestand R 9208/3389, items 191–94.

[18] Walravens and Kuwabara (2010: 164, n. 26) believe that the second volume of the latter work is not by Ecke.

[19] I am grateful to Ye Gongping for sharing copies of these reviews.

[20] Franke (1995: 106) alleges that his own wife, Hu Chün-yin 胡雋吟 (1910–89), had previously been courted by Ecke. This, like several other things in Franke's memoirs, is difficult to believe. Thompson (2001: 45–47, 63 et passim), in recounting Ecke's courtship and marriage to Zeng, relies heavily on the heavily romanticized account by Eyre (1966).

[21] J. Robert Hightower, personal communication, 1982.

[22] Wang's official title at the time was "Deputy Delegate from the [Tian]jin-[Bei]ping Special District to the Ministry of Education's Commission for Sorting Out Cultural-Relics Losses during the War" 教育部清理戰時文物損失委員會平津特區副代表. Li Jingguo (2007: 162–67) cites original documents pertinent to the Jannings donation that are now in the Palace Museum's archives (including a letter from Wang Shixiang to T. V. Soong's representative in Beijing, Tan Boyu 譚伯羽 [1900–1982], in which he recommends Loehr

and Erdberg [referred to as Kangsidun 康思頓 = Consten] for their "scientific method" [*kexue fangfa* 科學方法] in approaching bronzes); a photo of the handover of the bronzes (Li Jingguo 2007: 166); as well as (Li Jingguo 2007: 149) a contemporary newspaper account from *Huabei ribao* 華北日報 on January 25, 1946. Li Hui (2001: 64–65) fills in some details with Wang's later autobiographical recollections.

23 Su Rongyu, personal communication, 2016.

24 Also implicated in the scandal was Yi's French-educated son-in-law, Li Zongtong 李宗侗 (1895–1974), later professor of history at National Taiwan University and influential on East Asian archaeology as teacher of the late Prof. K. C. Chang (1931–2001).

25 On Wang Jiqian as an artist, see Cahill (1986), Silbergeld (1987), and Wang (1977). On his collections, see Barnhart (1983), Hearn and Fong (1999), Juliano (1988), and Yang (2010).

26 Cahill visited Contag in Wiesbaden in 1956.

27 Dietrich Seckel (1981: 61), who was in a similar situation in Japan, describes that organization as "a rather harmless club."

28 One German resident of Beijing who vociferously resisted this was the eccentric poet and printer Vincenz Hundhausen (1878–1955); see Walravens and Bieg 1999.

29 As recounted by Thompson (2001: 47–48), there was also severe opposition to the marriage from Tseng's family, as well as, for religious reasons, from the leadership of Furen University.

30 See Politisches Archiv, Aktenbestand R 9208/3389, items 19–21.

31 Ibid. See also Thompson (2001: 48 n. 64 and fig. 5, wedding photograph).

32 Another obviously semi-fictionalized account of Consten's activities for the Nazi party appears in Mohr 1985: 95 (as cited in Merker 1998a: 19).

33 Franke relates (1995: 123) that one day he and Loehr submitted their applications for membership in the Nazi party with the head of the Beijing chapter (*Ortsgruppenleiter*) of the Nazi party, Herbert Wobser, who was simultaneously the consular secretary at the Beijing Branch Office of the German Embassy. (This must have been before Wobser's transfer to Shanghai in 1941.) Franke claims that the applications were never processed, and he himself was later prevailed upon to withdraw his application (1995: 139). Schütte (2002: 330–32) tabulates information in an official 1942 report from which it may appear that Max Loehr (here referred to as "Johannes Löhr") was not a party member. But Schütte cautions (2002: 126) that the information in this report, especially concerning Nazi party membership, is often incorrect.

34 Franke (2000) strongly objected to this, but Hartmut Walravens (2000–2001), whose judgment should count for a lot, lists Merker's article among those he considers "high-quality and even-minded" (*qualitätsvoll und abgewogen*).

35 Politisches Archiv, Aktenbestand R 9208/3386, item 21. The original text runs: "Die Ortsgruppe Peking der Auslands-Organisation der N. S. D. A. P./ veranstaltet im Gemeindehaus/ Mittwoch, dem [sic] 26. November 1941, 8.30 Uhr abends/ einen Gemeinschaftsabend/ Dienstag, dem [sic] 9. Dezember 1941, 8.30 Uhr abends/ eine Versammlung/ Sprecher: Pg. Dr. Loehr ueber [sic] 'Neue Kunst in Deutschland'. Alle Mitglieder der Deutschen Gemeinde und ihre Gaeste [sic] sind zu diesen Veranstaltungen eingeladen./ F. Petzschke/ Stellv. Ortsgruppenleiter." It is extremely unlikely that someone in Petzschke's position would not have known who among the residents of Beijing was or was not a party member. The fact that the correspondence preserved in the Foreign Office archive was with

German government rather than with Nazi Party entities may explain why Loehr's party membership is not made explicit more frequently.

36 Heissig's covert activities are only tangentially touched upon in Walravens 2012.

37 See Politisches Archiv, Aktienbestand R-9208/3389, items 134, 138–39.

38 Kreissler herself more modestly suggests that the institute engaged in "silent cooperation" with the Nazi regime and that, rather than truly representing German culture to its Chinese clientele, its leadership mainly aimed to satisfy the German official authorities.

39 Mehnert later became a prominent rightist political pundit and professor of political science in West Germany. His own recollections of his time in China (Mehnert 1981: 258–60) are quite unreliable.

40 An anonymously published article on Nazi architecture (*The XXth Century* Editorial Staff 1944) may also be at least partly from Loehr's pen. A third article published in the journal under Loehr's name, on Bronze Age weapons (Loehr 1945b), is unpolitical.

41 See Politisches Archiv, Aktienbestand R 9208/3389, item 119.

42 Schirach's poem was highlighted in a press report (*Ostasiatischer Lloyd*, December 24, 1942; Politisches Archiv, Aktienbestand R 9208/3389, item 304).

43 Sometime in the 1960s, Contag allegedly did submit a *Habilitationsschrift* to the University of Munich, where she was planning to move and to teach as a *Privatdozentin*; but due to an intrigue, her submission was rejected by the Munich faculty, forcing Contag to remain in Mainz (Lothar Ledderose, personal communication, 2016).

44 Thanks to the hospitality of Dr. Adele Schlombs, I was able to view the archives on May 14, 2016.

45 See http://quod.lib.umich.edu/m/musart?type=boolean&view=thumbnail&rgn1= ic_all&from=index&q1=loehr&rgn9=musart_iod&sel9=ic_exact&op9=And (accessed November 26, 2015).

46 Teng's name is mentioned once in connection with the above-mentioned exhibition of reproductions of German artworks in 1937–38 (Politisches Archiv, Aktienbestand R 9208/3552, item 22).

47 Thompson (2001: 35, 47 et passim) claims that Ecke offered art history courses at Furen and indeed (citing C.-t. Li 1992: 17) earlier at Xiamen, but this contradicts other available accounts and archival documentation.

REFERENCES CITED

Avitabile, Gunhild
 2004 In Memoriam Eleanor von Erdberg. *Ostasiatische Zeitschrift*, n. F. 7: 53.
Avitabile, Gundhild, and Ursula Lienert
 1997 Laudatio auf Eleanor von Erdberg zu ihrem 90. Geburtstag. *Deutsche Gesellschaft für Ostasiatische Kunst, Mitteilungen* 21: 4–10.
Bachhofer, Ludwig
 1922 *Die Kunst der japanischen Holzschnittmeister*. Kurt Wolff, Munich.

Bagley, Robert W.

 2008 *Max Loehr and the Study of Chinese Bronzes: Style and Classification in the History of Art.* Cornell East Asia Series, Ithaca.

Barnhart, Richard M.

 1983 *Along the Border of Heaven: Sung and Yüan Paintings from the C. C. Wang Family Collection.* Metropolitan Museum of Art, New York.

Böschenstein, Bernhard, Jürgen Egyptien, Bertram Schefold, and Wolfgang Vitzhum (editors)

 2005 *Wissenschaftler im George-Kreis: Die Welt des Dichters und der Beruf des Wissenschaftlers.* De Gruyter, Berlin.

Brady, Anne-Marie

 2013 Adventurers, Aesthetes and Tourists: Foreign Homosexuals in Republican China. In *Foreigners and Foreign Institutions in Republican China*, edited by A.-M. Brady and D. Brown, pp. 146–68. Routledge, London.

Brinker, Helmut

 1989 Max Loehr (1903–1988). *Münchener Beiträge zur Völkerkunde* 2: 283–90.

Brown, Douglas

 2013 Sissywood vs. Alleyman: Going Nose to Nose in Shanghai. In *Foreigners and Foreign Institutions in Republican China*, edited by A.-M. Brady and D. Brown, pp. 169–87. Routledge, London.

Cahill, James

 1975 Max Loehr at Seventy. *Ars Orientalis* 10: 1–10.

 1986 *C. C. Wang, Landscape Paintings.* University of Washington Press, Seattle.

 n. d. Responses and Reminiscences: 32. What Became of the Contag Collection. Available at: http://jamescahill.info/the-writings-of-james-cahill/responses-a-reminiscences/154-32what-became-of-the-contag-collection (last accessed November 13, 2015).

Chen Mengjia 陳夢家 [pseudonym Mengjiashi 夢甲室]

 1940 Review of Ecke 1939. *Tushu jikan*, N.S. 1(2): 165.

Chen Zhou 晨舟

 2002 *Wang Shixiang: Zhongguo wenbo mingjia huazhuan* 王世襄：中國文博名家畫傳. Wenwu Chubanshe, Beijing.

Cohen, Warren I.

 1992 *East Asian Art and American Culture.* Columbia University Press, New York.

Consten, Eleanor (= Eleanor von Erdberg-Consten)

 1942a Landscape Painting East and West. *The XXth Century* 2(2): 120–25.

 1942b A Statue of Lao-tzu in the Po Yün Kuan. *Monumenta Serica* 7: 235–41.

 1944 The Lotus. *The XXth Century* 6(1): 54–61.

1958 *Das alte China.* Große Kulturen der Frühzeit (several re-editions). Klipper, Stuttgart.

Consten, Eleanor, and Hedda Hammer

1942 Brush and Hand. *The XXth Century* 3(6): 422–26.

Contag, Victoria

1933 Tung Ch'i-ch'ang's 'Hua Ch'an Shih Sui Pi 畫禪室隨筆' und das 'Hua Shuo 畫說' des Mo Shih-lung. *Ostasiatische Zeitschrift* 19(3/4): 83–97; 19(5): 147–87.

1937 Das Mallehrbuch für Personenmalerei des Chieh Tzû Yüan. *T'oung Pao* 33(1): 15–90.

1940 *Die sechs berühmten Maler der Ch'ing Dynastie.* E. A. Seemann, Leipzig. (English edition: *Chinese Masters of the 17th Century.* Lund Humphries, London; Tuttle, Rutland, VT, 1970).

1941 Schriftcharakteristiken der Malerei, dargestellt an Bildern Wang Meng's und anderer Maler der Südschule. *Ostasiatische Zeitschrift* 27: 46–61.

1949 *Chinesische Malerei der letzten vier Jahrhunderte.* Museum für Kunst und Gewerbe, Hamburg.

1950 *Die beiden Steine: Beitrag zum Verständnis des Wesens chinesischer Landschafts-malerei.* Hermann Klemm, Braunschweig. (Republished in 1955 as *Zwei Mei-ster chinesischer Landschaftsmalerei, Shih-t'ao and Shih-ch'i: Ein Beitrag zum Ver-ständnis des Wesens chinesischer Landschaftsmalerei.* Woldemar Klein, Baden-Baden.)

1955 *Chinesische Landschaften.* Der Silberne Quell, Vol. 27. W. Klein, Baden-Baden.

1964 *Konfuzianische Bildung und Bildwelt.* Artemis, Zürich. (New edition 2008: *Gespräche in der Morgenstille: Lehren des Meisters Konfuzius.* Albatros, Düsseldorf.)

Contag, Victoria 孔達, and Wang Chi-ch'üan 王季銓

1940 *Maler- und Sammerstempel aus der Ming- und Ch'ingzeit / Ming Qing huajia yinjian* 明清畫家印鑑 (numerous reprints). Commercial Press, Shanghai.

Contag, Victoria 孔達, and Wang Chi-ch'ien 王季遷

1966 *Seals of Chinese Painters and Collectors / Ming Qing huajia yinjian* 明清畫家印鑑. Hong Kong University Press, Hong Kong, and Oxford University Press, Oxford.

Contag, Victoria, and Werner Speiser

1950 *Ausstellung Chinesische Malerei: 15.–20. Jahrhundert.* Kunstsammlungen der Stadt Düsseldorf, Düsseldorf.

Ding Jianhong and Li Xia

1996 Das 'Deutschland-Institut' und die deutsch-chinesischen Kulturbeziehungen. In *Politik-Wirtschaft-Kultur: Studien zu den deutsch-chinesischen Beziehungen,* edited by M. Leutner, pp. 307–28. LIT Verlag, Hamburg and Münster.

Ecke, Gösta (= Gustav Ecke)

1923 *Charles Méryon, peintre-graveur.* Klinkhardt & Biermann, Leipzig.

Ecke, Gustav

1931 Two Ashlar Pagodas at Fu-ch'ing in Southern Fu-chien: With Some Additional Notes on Prime Minister Yeh Hsiang-kao. *Bulletin of the Catholic University of Peking* 8: 264–318.

1936–37 The Institute for Research in Chinese Architecture. *Monumenta Serica* 2: 448–74.

1939 *Frühe chinesische Bronzen aus der Sammlung Oskar Trautmann.* Furen Daxue Chubanbu, Beiping.

1943–44 *Sammlung Lochow: Chinesische Bronzen.* 2 vols. Furen Daxue Chubanbu, Beijing.

1964 *Ein Loblied auf das alte Bonn.* Privately published, Honolulu. (Reprinted in Walravens and Kuwabara 2010: 171–76.)

Ecke, Gustav, with Betty Tseng Ecke

1965 *Chinese Painting in Hawai'i.* Honolulu Academy of Arts, Honolulu.

Ecke, Gustav, and Paul Demiéville

1935 *The Twin Pagodas of Zayton: A Study of Later Buddhist Sculpture in China.* Harvard-Yenching Institute Monograph Series, Vol. 2. Harvard University Press, Cambridge, MA.

Ecke, Gustav, and Yang Yüeh

1944 *Chinese Domestic Furniture in Photographs and Measured Drawings.* Henri Vetch, Beijing (several reprints).

Ecke, Tseng Yuho

1991 Gustav Ecke. *Orientations* 22(11): 68.

Egan, Susan Chan

1987 *A Latter-Day Confucian: Reminiscences of William Hung (1893–1980).* Harvard University Press, Cambridge, MA.

Elliott, Jeannette S., with David Shambaugh

2005 *The Odyssey of China's Imperial Treasures.* University of Washington Press, Seattle and London.

Erdberg, Beata von (= Eleanor von Erdberg-Consten)

1943 The Surge of the Renaissance in Europe. *The XXth Century* 5(2/3): 147–61.

1944a Art in Mongolia. *The XXth Century* 7(2/3): 125–34.

1944b The Youngest Model. *The XXth Century* 7(6): 332–35.

Erdberg, Eleanor von

1936 *Chinese Influence on European Garden Structures.* Harvard University Press, Cambridge, MA. (Reissued in 1985 by Hacker Art Books, New York.)

1985 Die Anfänge der ostasiatischen Kunstgeschichte in Deutschland. In *Kategorien und Methoden der deutschen Kunstgeschichte 1900–1930,* edited by L. Dittmann, pp. 185–209. Franz Steiner, Stuttgart.

1994 *Der strapazierte Schutzengel: Erinnerungen aus drei Welten.* Siebenberg-Verlag, Waldeck.

Eyre, Cynthia

1966 Courtship in Peking. *Honolulu,* September.

Fairbank, Wilma

1994 *Liang and Lin: Partners in Exploring China's Architectural Past.* University of Pennsylvania Press, Philadelphia.

Falkenhausen, Lothar von

2017 The Study of East Asian Art History in Europe: Some Observations on Its Early Stages. In *Bridging Times and Spaces: Festschrift for Gregory E. Areshian on the Occasion of his Sixty-Fifth Birthday,* edited by P. S. Aretisyan and Y. H. Grekyan, pp. 89-102. Archaeopress, Oxford.

Fang, Ilse Martin

2005 Erinnerungen an meine Zeit in Peking Juni 1941 bis August 1946. *StuDeO Info* (Studienwerk Deutsches Leben in Ostasien), December: 18–21.

Fischer, Klaus, and Ildikó Klein-Bednay (editors)

1984 *Prof. Dr. Eleanor von Erdberg und ihre Schüler: Schülerfestschrift zu ihrem 77. Geburtstag am 23. XI. 1984.* Seminar für Orientalische Kunstgeschichte, Rheinische Friedrich-Wilhelms-Universität Bonn, Bonn.

Franke, Wolfgang

1995 *Im Banne Chinas: Autobiographie eines Sinologen, 1912–1950.* Edition Cathay, Vol. 11. Projekt Verlag, Dortmund.

2000 Einige Bemerkungen zu Helmut Martin und Christiane Hammer (Hg.), *Chinawissenschaften: Deutschsprachige Entwicklungen. Asien* 76: 105–18.

Freyeisen, Astrid

1999 Chinakunde oder Mittel zum Zweck für Propagandisten? Zur Funktion deutscher kulturpolitischer Institutionen in Shanghai während des Dritten Reiches. In *Chinawissenschaften—Deutschsprachige Entwicklungen: Geschichte, Personen, Perspektiven,* edited by H. Martin and C. Hammer, pp. 202–21. Mitteilungen des Instituts für Asienkunde, Vol. 303. Institut für Asienkunde, Hamburg.

2000 *Shanghai und die Politik des Dritten Reiches.* Königshausen & Neumann, Würzburg.

Fu Baoshi 傅抱石

1942 Ping 'Ming Qing huajia yinjian' 評《明清畫家印鑑》. *Xuedeng* 學燈 (Weekly Supplement to *Shishi xinbao* 時事新報 [Chongqing]), 161 (January 26, 1942)

and 162 (February 2, 1942). Reprinted in 2003 in *Fu Baoshi meishu wenji* 傅抱石美術文集 (pp. 324–39). Shanghai Guji Chubanshe, Shanghai.

Fuchs, Walter

2010 Erinnerungen aus China. In *Wei jiao zi ai* 為教自愛, *"Schone dich für die Wissenschaft": Leben und Werk des Kölner Sinologen Walter Fuchs (1902–1979) in Dokumenten und Briefen*, edited by H. Walravens, pp. 21–39. Sinologica Coloniensia, Vol. 28. Harrassowitz, Wiesbaden.

Gabbert-Avitabile, Gunhild, and Ursula Lienert

1984 Laudatio auf Eleanor von Erdberg zu ihrem 75. Geburtstag. In *Prof. Dr. Eleanor von Erdberg und ihre Schüler: Schülerfestschrift zu ihrem 77. Geburtstag am 23. XI. 1984*, edited by K. Fischer and I. Klein-Bednay, pp. 9–13. Seminar für Orientalische Kunstgeschichte, Rheinische Friedrich-Wilhelms-Universität Bonn, Bonn.

Gesellschaft für Ostasiatische Kunst and Preußische Akademie der Künste

1934 *Chinesische Malerei der Gegenwart*. Würfel-Verlag, Berlin.

Goepper, Roger, Dieter Kuhn, and Ulrich Wiesner (editors)

1977 *Zur Kunstgeschichte Asiens: 50 Jahre Lehre und Forschung an der Universität Köln*. Franz Steiner, Wiesbaden.

Götting, Doris

2012 *Etzel: Forscher, Abenteurer und Agent. Die Lebensgeschichte des Mongoleiforschers Hermann Consten (1878–1957)*. Klaus Schwarz Verlag, Berlin.

Haase, Günther

1991 *Kunstraub und Kunstschutz: Eine Dokumentation*. Olms, Hildesheim.

Halbertsma, Marlite

1985 *Wilhelm Pinder en de Duitse kunstgeschiedenis*. Forsten, Groningen. (German translation: [1992] *Wilhelm Pinder und die deutsche Kunstgeschichte*. Werner, Worms.)

Harnisch, Thomas

2004 *Chinesische Studenten in Deutschland: Geschichte und Wirkung ihrer Studienaufenthalte in den Jahren von 1860 bis 1945*. Mitteilungen des Instituts für Asienkunde Hamburg, Vol. 300. Institut für Asienkunde, Hamburg.

Hearn, Maxwell K., and Wen C. Fong

1999 *Along the Riverbank: Chinese Paintings from the C. C. Wang Family Collection*. Metropolitan Museum of Art, New York.

Holländer, Hans (editor)

1989 *Gedanken in die Ferne: Vorträge und Laudationes anläßlich des 80. Geburtstages und des Goldenen Doktorjubiläums von Frau Prof. Dr. Eleanor von Erdberg*. Schmetz, Aachen.

Hopkirk, Peter

1980 *Foreign Devils on the Silk Road: The Search for the Lost Cities and Treasures of Chinese Central Asia.* John Murray, London.

Huang Binhong 黃賓虹

1999 *Huang Binhong wenji: shuxin bian* 黃賓虹文集：書信編. Unnumbered volume in *Huang Binhong wenji*, edited by Wang Zhongxiu 王中秀. Shanghai Shuhua Chubanshe, Shanghai.

Huang Yifei 黃益飛

2015 Rong Geng 容庚. In *20 shiji Zhongguo zhiming kexuejia xueshu chengjiu gailan: Kaoguxue juan* 20 世紀中國知名科學家學術成就概覽：考古學卷, edited by Wang Wei 王巍, Vol. 1, pp. 56–63. Kexue Chubanshe, Beijing.

Jansen, Thomas

1999 Einige Hinweise und Fragen zur Arbeit des Deutschland-Instituts in Peking 1933–1945. In *Chinawissenschaften—Deutschsprachige Entwicklungen: Geschichte, Personen, Perspektiven*, edited by H. Martin and C. Hammer, pp. 185–201. Mitteilungen des Instituts für Asienkunde, Vol. 303. Institut für Asienkunde, Hamburg.

Jaquillard, Pierre

1972 In Memoriam: Gustav Ecke 1896–1971. *Artibus Asiae* 43(2/3): 114–18.

Jirka-Schmitz, Franziska

1995 Otto Burchard (1892–1965): Vom Finanz-Dada zum Grandseigneur des Pekinger Kunsthandels. *Mitteilungen der Deutschen Gesellschaft für Ostasiatische Kunst* 12: 23–38.

Juliano, Annette

1988 *Bronze, Clay and Stone: Chinese Art in the C. C. Wang Family Collection.* University of Washington Press, Seattle.

Kern, Martin

1988 The Emigration of German Sinologists 1933–1945: Notes on the History and Historiography of Chinese Studies. *Journal of the American Oriental Society* 118.4: 507–29.

Kögel, Eduard

2015 *The Grand Documentation: Ernst Boerschmann and Chinese Religious Architecture (1906–1931).* De Gruyter, Berlin.

Kreissler, Françoise

1989 *L'action culturelle allemande en Chine.* Édition de la Maison des sciences de l'homme, Paris.

Krüger, Joachim, and Imke Wulff (editors)

1994 Bericht des Reichsministeriums über die Lage der Sinologie und Japanologie in Deutschland. *Newsletter Frauen und China* 7: 1–17 [not seen].

Krusenstjern, Benigna von

 2009 *...daß es Sinn hat, zu sterben—gelebt zu haben. Adam von Trott zu Solz (1909–1944): Biographie.* Wallstein, Göttingen.

Lally, J. J.

 1993 *Chinese Archaic Jades and Bronzes from the Estate of Max Loehr and Others.* Privately published, New York.

Ledderose, Lothar

 1989 Kunstgeschichte und Weltkunstgeschichte. *Saeculum* 40(2): 136–41.

Leutner, Mechthild, with Wolfram Adolphi and Peter Merker (editors)

 1998 *China und Deutschland 1937–1949. Politik—Militär—Wirtschaft—Kultur. Eine Quellensammlung.* Akademie-Verlag, Berlin.

Lewin, Günter

 1999 Eduard Erkes und die Sinologie in Leipzig. In *Chinawissenschaften—Deutschsprachige Entwicklungen: Geschichte, Personen, Perspektiven,* edited by H. Martin and C. Hammer, pp. 449–73. Mitteilungen des Instituts für Asienkunde, Vol. 303. Institut für Asienkunde, Hamburg.

Li, Chu-tsing

 1992 Tseng Yuho: Unusual Life, Unusual Art. In *Dsui-hua: Tseng Yuho,* pp. 15–19. Hanart Gallery, Taipei and Hong Kong.

Li Hui 李輝

 2001 *Wang Shixiang: Zhao yipian ziji de tiandi* 王世襄：找一片自己的天地. Daxiang Chubanshe, Zhengzhou.

Li Jingguo 李經國

 2007 Zhuihui guobao jian shugong, Mengyuan heri de zhaoxue: Wang Shixiang xiansheng yu Gugong Bowuyuan 追回國寶建殊功,蒙冤何日得昭雪：王世襄先生與故宮博物院. In *Qiren Wang Shixiang: Mingjia bixia de Lisongju Zhuren* 奇人王世襄：名家筆下的儷松居主人, by Zhang Zhonghang 張中行 et al. (Li Jingguo, editor), pp. 146–79. Sanlian Shudian, Beijing. (Originally published as "Wenguangbojia de Wang Shixiang zhui guobao" 文廣博家的王世襄追國寶, *Yanhuang chunqiu* 2003.12 [not seen].)

Liang, Hsi-Huey

 1978 *The Sino-German Connection: Alexander von Falkenhausen between China and Germany.* Van Gorcum, Assen.

Liang Sicheng 梁思成

 1933 Fuqing liang shita 福清兩石塔 (translation of Ecke 1931). *Zhongguo Yingzao Xueshe huikan* 4(1): 14–21.

Liu Dunzhen 劉敦楨

 1933 Fu Aike jiaoshou lun Liuchao zhi ta 覆艾克教授論六朝之塔. *Zhongguo Yingzao Xueshe huikan* 4(1): 138–47.

Loehr, Max

1936 Beiträge zur Chronologie der älteren chinesischen Bronzen. *Ostasiatische Zeitschrift* 22 (1936): 3–41.

1939 Studie über Wang Mong: Die datierten Werke. *Sinica* 14(5/6): 27–90.

1943a Neue Typen grauer Shang-Keramik. *Sinologische Arbeiten* 1: 53–86.

1943b Germany's Contemporary Painters. *The XXth Century* 5(1): 58–63.

1944a Bronzetexte der Chou-Zeit: Chou I (1). *Sinologische Arbeiten* 2: 59–70.

1944b Contemporary German Sculpture. *The XXth Century* 6(2): 113–18.

1945a Jung Keng: Eine Bibliographie der wichtigen Werke über die Orakeltexte der Shang-Zeit. *Sinologische Arbeiten* 3: 114–51.

1945b The Animal Art of the Eurasian Steppes. *The XXth Century* 8(4/5): 209–13.

1956 *Chinese Bronze Age Weapons: The Werner Jannings Collection in the Chinese National Palace Museum, Peking.* University of Michigan Press, Ann Arbor, and Oxford University Press, London.

Lu Xun Bowuguan 魯迅博物館

n.d. *Waiwen cangshu mulu, disanji: Riwen bufen, Ewen bufen, Xiwen bufen* 外文藏書目錄，第三集：日文部分、俄文部分、西文部分. Internally published, Beijing.

Lukens, Nancy

2008 Reading China, Resisting Hitler: Adam von Trott's Engagement with Chinese Political Philosophy and Culture 1935–44. *Colloquia Germanica* 41(2): 141–54.

Mann, Katia

1974 *Meine ungeschriebenen Memoiren*, edited by E. Plessen and M. Mann. S. Fischer, Frankfurt.

Mann, Viktor

1949 *Wir waren fünf: Bildnis der Familie Mann.* Südverlag, Constance.

Marchand, Suzanne

2009 *German Orientalism in the Age of Empire: Religion, Race, and Scholarship.* Cambridge University Press, Cambridge.

Martin, Helmut

1998 Wendung nach Innen: Der Bochumer Sinologe Alfred Hoffmann (23.3.1911–22.1.1997). In *Der Sinologe Alfred Hoffmann (1911–1997): Zwei biographische Beiträge*, edited by H. Martin and P. Merker, pp. 7–23. Cathay Skripten vol. 8. Ruhr-Universität, Bochum.

Martin, Helmut, and Christiane Hammer (editors)

1999 *Chinawissenschaften—Deutschsprachige Entwicklungen: Geschichte, Personen, Perspektiven.* Mitteilungen des Instituts für Asienkunde, Vol. 303. Institut für Asienkunde, Hamburg.

Mehnert, Klaus

1981 *Ein Deutscher in der Welt: Erinnerungen 1906-1981.* Deutsche Verlags-Anstalt, Stuttgart.

Merker, Peter

1998a *Deutschlands amtliche Auslandsvertreter in China während der Zeit des National-sozialismus: Anmerkungen zu ihrer Tätigkeit und chinakundlichen Kompetenz.* Cathay-Skripten, Vol. 7. Ruhr-Universität, Bochum.

1998b Anmerkungen zum Wirken von Alfred Hoffmann am Deutschland-Institut in Peking, 1940–1945. In *Der Sinologe Alfred Hoffmann (1911–1997): Zwei biographische Beiträge,* edited by H. Martin and P. Merker, pp. 25–50. Cathay Skripten Vol. 8. Ruhr-Universität, Bochum. Also in *Chinawissenschaften— Deutschsprachige Entwicklungen: Geschichte, Personen, Perspektiven,* edited by H. Martin and C. Hammer, pp. 474–97. Mitteilungen des Instituts für Asien-kunde, Vol. 303. Institut für Asienkunde, Hamburg.

Miao Zhe and Wang Haicheng

2011 Review of Bagley 2008. *Journal of Art Historiography* 5: 1–8.

Mohr, Ernst Günther

1985 *Die unterschlagenen Jahre: China vor Mao Tse-tung.* Bechtle, Esslingen and Munich.

Mungello, D. E.

2012 *Western Queers in China: Flight to the Land of Oz.* Rowman & Littlefield, Lan-ham.

Netting, Lara J.

2013 *A Perpetual Fire: John C. Ferguson and His Quest for Chinese Art and Culture.* Hong Kong University Press, Hong Kong.

Orell, Julia

2015 Early East Asian Art History in Vienna and Its Trajectories: Josef Strzygowski, Karl With, Alfred Salmony. *Journal of Art Historiography* 13: 1–32.

Petropoulos, Jonathan

2000 *The Faustian Bargain: The Art World in Nazi Germany.* Oxford University Press, New York.

Qiu Zhuchang 裘柱常

1985 *Huang Binhong zhuanji nianpu hebian* 黃賓虹傳記年譜合編. Renmin Meishu Chubanshe, Beijing.

Qu Duizhi 瞿兌之

1942 Review of Gustav Ecke 1939. *Zhonghe yuekan* 12(3): 140–41.

Ratenhof, Udo

1987 *Die Chinapolitik des Deutschen Reiches 1871 bis 1945: Wirtschaft—Rüstung— Militär.* Wehrgeschichtliche Forschungen. Harald Boldt, Boppard.

Raulff, Ulrich

2009 *Kreis ohne Meister: Stefan Georges Nachleben*. C. H. Beck, Munich.

Roberts, Claire

2005 The Dark Side of the Mountain: Huang Binhong (1865–1955) and Artistic Continuity in Twentieth-Century China. PhD diss., Australian National University. http://hdl.handle.net/1885/11334 (accessed November 18, 2015).

2007 Questions of Authenticity: Huang Binhong and the Palace Museum. *China Heritage Quarterly* 10. http://www.chinaheritagenewsletter.org/scholarship.php?searchterm=010_HBH-Palace.inc&issue=010 (accessed November 16, 2015).

Rong Geng 容庚 (courtesy name Xibai 希白)

1940 Review of Contag and Wang 1940. *Yanjing xuebao* 28: 285–87.

Ruchivacharakul, Vimalin (editor)

2011 *Collecting China: The World, China, and a History of Collecting*. University of Delaware Press, Newark.

Rudolph, Richard; Kenneth D. Klein (interviewer)

1985 *Creating an Oriental Languages Department and Library*. Unpublished manuscript. Oral History Program, University of California, Los Angeles.

Salmony, Alfred

1922 *Europa—Ostasien: Religiöse Skulpturen*. Gustav Kiepenheuer, Potsdam.

Schlombs, Adele

1997 Portraits of Three Collectors: Hans Jürgen von Lochow, Hans Wilhelm Siegel, and Peter Ludwig. *Orientations* 28(1): 62–65.

Schmitt-Englert, Barbara

2012 *Deutsche in China 1920–1950*. Ludwigshafener Schriften zur Asienkunde, Vol. 1. Ostasien-Verlag, Gossenberg.

Schütte, Hans Wilm

2002 *Die Asienwissenschaften in Deutschland: Geschichte, Stand und Perspektiven*. Mitteilungen des Instituts für Asienkunde, Vol. 353. Institut für Asienkunde, Hamburg.

Seckel, Dietrich

1981 Mein Weg zur Kunst Ostasiens. In *Schriftenverzeichnis. Mit einem autobiographischen Essay*, edited by D. Seckel, pp. 45–136. Heidelberger Schriften zur Ostasienkunde, Vol. 2. Haag + Herchen, Frankfurt.

Shi Mingli 史明理 (= Clarissa Gräfin von Spee)

2016 *Wu Hufan: Deguo xuezhe ji shoucangjia Weiduoliya Kongda de liangshi yiyou* 吳湖帆：德國學者及收藏家維多利亞·孔達的良師益友. In *Wu Hufan de shou yu yan* 吳湖帆的手與眼, edited by Shanghai Bowuguan 上海博物館, pp. 202–13. Beijing Daxue Chubanshe, Beijing.

Silbergeld, Jérôme

1987 *Mind Landscapes: The Paintings of C. C. Wang.* Henry Art Gallery and University of Washington Press, Seattle and London.

Spee, Clarissa Gräfin von

2008 *Wu Hufan: A Twentieth Century Art Connoisseur in Shanghai.* Reimer, Berlin.

2013 Setting Milestones: Collecting Chinese Paintings in Europe. In *Masterpieces of Chinese Painting, 700–1900*, edited by Zhang Hongxing, pp. 65–78. V&A Publishing, London.

Speiser, Werner, and Eleanor Consten-von Erdberg

1964 *Ostasiatische Kunst: Die Baukunst Chinas und Japans.* Ullstein, München. (Numerous translations.)

Steen, Andreas, and Mechthild Leutner (editors)

2006 *Deutsch-chinesische Beziehungen 1911–1927: Vom Kolonialismus zur "Gleichberechtigung": Eine Quellensammlung.* Akademie-Verlag, Berlin.

Steuber, Jason, and Guolong Lai (editors)

2014 *Collectors, Collections and Collecting the Arts of China: Histories and Challenges.* University Press of Florida, Gainesville.

Sullivan, Michael

1989 *The Meeting of Eastern and Western Art.* Second, expanded ed. University of California Press, Berkeley and Los Angeles.

Teng Gu 滕固

1926 *Zhongguo meishu xiaoshi* 中國美術小史. Shangwu Yinshuguan (numerous reprints), Shanghai.

Thompson, Melissa J.

2001 *Gathering Jade and Assembling Splendor: The Life and Art of Tseng Yu-ho.* PhD diss., University of Washington, Seattle.

Ts'ai, Yüan-p'ei

1934 Einführung. In *Gesellschaft für Ostasiatische Kunst and Preußische Akademie der Künste 1934*: 10–13.

Vainker, Shelagh, and James C. S. Lin

2004 *Pu Quan and his Generation: Imperial Painters of Twentieth-Century China.* Ashmolean Museum, Oxford.

Vanderstappen, Harrie A.

1977–78 Ludwig Bachhofer (1894–1976). *Archives of Asian Art* 31: 110–12.

Vanderstappen, Harrie A., Richard A. Born, and Sue Taylor (editors)

1989 *Ritual and Reverence: Chinese Art at the University of Chicago.* David and Alfred Smart Gallery, University of Chicago, Chicago.

Walravens, Hartmut

1983–85 *Bibliographien zur ostasiatischen Kunstgeschichte in Deutschland*, 4 vols. C. Bell, Hamburg.

1987 Otto Kümmel: Streiflichter auf Leben und Wirken eines Berliner Museumsdirektors. *Jahrbuch Preußischer Kulturbesitz* 24: 137–49.

2000–2001 Review of Martin and Hammer (1999). *Mitteilungen der Gesellschaft für Natur- und Völkerkunde Ostasiens* 167–170, https://www2.uni-hamburg.de/oag//noag/noag_2000_rez_22.html (consulted December 1, 2015).

2010 Ilse Martin Fang (1914–2008) in Memoriam. *Monumenta Serica* 58: 395–98.

Walravens, Hartmut (editor)

2010 *Wei jiao zi ai* 為教自愛 *"Schone dich für die Wissenschaft": Leben und Werk des Kölner Sinologen Walter Fuchs (1902–1979) in Dokumenten und Briefen*. Sinologica Coloniensia, Vol. 28. Harrassowitz, Wiesbaden.

2012 *Walther Heissig (1913-2005), Mongolist,, Zentralasienwissenschaftler, Literaturwissenschaftler und Folklorist: Leben und Werk*. Harrassowitz, Wiesbaden.

2013 *"Heu, me beatum!" Der Kölner Sinologe Walter Fuchs im Briefwechsel mit Wolfgang Franke und Martin Gimm*. Sinologica Coloniensia, Vol. 33. Harrassowitz, Wiesbaden.

Walravens, Hartmut, with Lutz Bieg

1999 *Vincenz Hundhausen (1878–1955): Leben und Werk des Dichters, Druckers, Verlegers, Professors, Regisseurs und Anwalts in Peking*. Orientalistik Bibliographien und Dokumentationen, Vol. 6. Harrassowitz, Wiesbaden.

Walravens, Hartmut, with Martin Gimm

2011 *Ume heoledere, "Vernachlässige (deine Pflicht) nicht:" Der Ostasienwissenschaftler Walter Fuchs (1902–1979)*, Band II. Sinologica Coloniensia, Vol. 30. Harrassowitz, Wiesbaden.

Walravens, Hartmut, with Setsuko Kuwabara

2010 *"Und der Sumeru meines Dankes würde wachsen": Beiträge zur ostasiatischen Kunstgeschichte in Deutschland (1896–1932)*. Harrassowitz, Wiesbaden.

Wang, Chi-ch'ien

1977 An Interview with C. C. Wang. In *Mountains of the Mind: The Landscape of C. C. Wang*, exhibition catalog, unpaginated. Arthur M. Sackler Foundation, Washington, DC.

Wang Shimin 王世民

2015 Chen Mengjia" 陳夢家. In *20 shiji Zhongguo zhiming kexuejia xueshu chengjiu gailan: Kaoguxue juan* 20 世紀中國知名科學家學術成就概覽：考古學卷, edited by Wang Wei 王巍, Vol. 1: 253–65. Kexue Chubanshe, Beijing.

Wang Zhongxiu 王中秀

2005 *Huang Binhong nianpu* 黃賓虹年譜. Shanghai Shuhua Chubanshe, Shanghai.

Wendland, Ulrike

1998 *Biographisches Handbuch deutschsprachiger Kunsthistoriker im Exil: Leben und Werk der unter dem Nationalsozialismus verfolgten und vertriebenen Wissenschaftler*, 2 vols. K. G. Saur, Munich.

Wilhelm, Hellmut

1960 *Change: Eight Lectures on the I Ching.* Trans. Cary F. Barnes. Harper Torchbooks, New York.

With, Karl

1997 *Autobiography of Ideas: Lebenserinnerungen eines außergewöhnlichen Kunstgelehrten*, edited by Roland Jaeger with Gerda Becker-With. Gebr. Mann, Berlin.

Worringer, Wilhelm

1908 *Abstraktion und Einfühlung: Ein Beitrag zur Stilpsychologie*. Piper, Munich. (English translation: (1953). *Abstraction and Empathy*, trans. Michael Bullock, International Press, New York.)

The XXth Century Editorial Staff

1944 Buildings of Tomorrow. *The XXth Century* 6(3): 187–95.

Yang, Kathleen

2010 *Through a Chinese Connoisseur's Eye: Private Notes of C. C. Wang.* Zhonghua Book Corporation, Beijing.

Ye Gongping 葉公平

2014 Lu Xun riji zhong de liangwei Deguo shoucangjia 魯迅日記中的兩位德國收藏家. *Xin wenxue shiliao* 新文學史料 2014(2): 139–44.

SECTION V

COLONIAL AND
POST-COLONIAL LEGACIES

The final section of this collection addresses the aftermath of colonial archae-ological interventions in four discrete case studies in the Maghreb, Uganda, North and South Korea, and Peru. Each of our contributors identifies the unique tensions and challenges that derived from the way in which archaeologi-cal research was undertaken and framed initially by external interlocutors. They also capture the evolving reactions that archaeology engendered among Indige-nous peoples during and after the period of imperial or colonial rule. While the legacy of these archaeological undertakings has varied in the way it has played out in post-colonial contexts, it has without exception shaped the structure, prac-tice, and embrace (or rejection) of modern archaeology in the independent states and, in fact, the modern global order, that resulted from these developments.

In the first chapter in this section, Matthew McCarty argues that if most accounts of French archaeology in the Maghreb focus on the deployment of Roman monuments as *exempla* for French imperialism, archaeology in colonial-period Tunisia was instead fitted into a variety of historical frames and narratives, each of which harnessed material remains of the past differently. Driven by larg-er meta-narratives, he observes that Roman sites were reduced to backdrops against which arguments about inheritance might be made; many Christian sites were converted into places of worship whose remains persisted through time; and Punic sites were (until the 1920s) largely swept to the side as curiosities from a long-dead civilization. Yet in the post-independence period, as archaeological enquiry became more central to the nascent Tunisian state and an official (rather

than an amateur) endeavor, the government adopted the same historical premises about inheritance that the French had invoked for the Romans. McCarty argues that archaeology in Tunisia has never fully been de-colonized, even if earlier narratives have been transformed.

Taking on the case of Uganda, Peter Schmidt argues in the second chapter of this section that the nation's modern history draws deeply on the archaeological constructions and historical manipulations of oral traditions and archaeology during the colonial period. He chronicles the ways in which colonial administrators initiated interpretations of the massive Bigo earthworks of western Uganda by publishing and repeatedly valorizing a pastiche of oral traditions that incorporated tales told by the Baganda, who lived outside the region and were used to administer territory they helped the British capture from the Bunyoro kingdom. Thereafter archaeologists and historians uncritically accepted these traditions as linked to Bigo, which came to be characterized as the capital of Kitara or the Bacwezi-led empire. Nonetheless, he observes that analyses of the oral traditions do not sustain the idea of a Bacwezi empire centered at Bigo nor does archaeology conducted at Bigo affirm it as a capital site. Despite the absence of evidence for such associations, colonial interpretations have been reified by academics and have gradually come into wide popularity, even being appropriated by the president of Uganda to underwrite the ideas of a powerful unitary state in Uganda's past. He concludes that the head of state's use of this colonial history occurs in a contemporary setting where the centrifugal forces of multiple and powerful kingdoms are found troublesome and deficient when measured against an idealized, united Bacwezi-led empire of the mid-second millennium CE at Bigo.

In the third chapter in this section, Yangjin Pak analyzes the roles, outlooks, and methodologies of the Japanese archaeologists who conducted their archaeological research in the Korean Peninsula in the first half of the twentieth century. He subsequently divides the practice of Japanese colonial archaeology in Korea into five proposed phases and summarizes the characteristics of each phase in terms of the legal frameworks of archaeological practice, the institutions and individuals involved, and archaeological methodologies and interpretations. By addressing the legacy of Japanese colonial archaeology, Pak suggests the extent of colonial influence on the early development of post-colonial archaeology in North and South Korea in the second half of the twentieth century.

In the final chapter in this section, Maya Stanfield-Mazzi notes that the territory of modern Peru has been part of three empires: the Wari, the Inca, and the Spanish. After Peru gained independence from Spain, the country was affected by cultural imperialism on the part of other world powers, especially those of the Global North. She notes that one constant among all of these far-flung situations,

however, is that each regime highly esteemed and encouraged the production or collection of tapestry-woven cloth. She thus traces the fate of Peruvian tapestries across these varied situations of colonialism, observing that tapestry is a unique lens through which to understand power relations across Peruvian history. But in recognizing the constant presence of Peruvian tapestries across colonial regimes, she argues that we also realize that despite varying situations of imposition, pastoralists, dyers, spinners, and weavers in Peru continued to create works of art that grew from a closely guarded cultural tradition. Furthermore, she concludes that tapestries have often been looked to, whether by Peruvians or foreigners, as tangible proof of Peruvian history and identity.

French Archaeology and History in the Colonial Maghreb: Inheritance, Presence, and Absence

Matthew M. McCarty

INTRODUCTION

Despite its claims to empiricism and scientific positivism, and a historiography that has traditionally focused on internal developments within a hermetically sealed field, archaeology—like any discipline concerned with the production of knowledge—is never independent from the social, political, intellectual, and moral power relationships that surround it. In colonial situations, the discrepant degrees of power held by various actors are part and parcel of how objects and sites are freighted with, or denied, significance. The colonial institutional and ideological contexts in which archaeology is practiced shape the knowledge created, while this knowledge in turn reinforces and naturalizes colonial control in the present.

The French colonial Maghreb (modern Tunisia, Algeria, and Morocco) was no exception: archaeological investigation was simply one arena in which the identities of colonizer and colonized were set and performed in a historical frame (Memmi 1957). From the conquest and settlement of Algeria (1830 onward) to the annexation of Tunisia (1881) and continuing well beyond the dates of each modern nation-state's political independence, the practice of excavating and publicizing archaeological sites reinforced and made tangible grand historical narratives that naturalized real or aspirational political situations. The broad outlines of how archaeological investigations were used to promote colonial agendas will be familiar to those working in other colonial contexts (cf. Díaz Andreu 2007) and have been analyzed elsewhere in detail (Dondin-Payre 1994b; Dridi and

Mezzolani 2016; Effros, this volume, forthcoming; Gutron 2010; Mattingly 1996; Oulebsir 2004). French archaeologists promoted a special bond that France had to Roman antiquity as a way of justifying French presence and practices in Africa (Bénabou 1980; Dondin-Payre 1994a, 1994b; Effros, this volume; Greenhalgh 2014; Lorcin 2002). Archaeological projects were also closely tied to gaining knowledge and control over territory, through their links to cartographic surveys and natural-history investigations (Effros forthcoming).

More than the content of the historical narratives in which archaeological remains were implicated, and how these tales were marshaled to support projects of territorial and institutional control, I want to pose two closely related questions: what premises underpinned the imagined connections between distant past and present, and how were archaeological materials mobilized to draw such connections?

Drawing lines from peoples in the past to peoples in the present does not follow any fixed course or trajectory; contemporary conflicts over legitimate control of human remains are but one index of the instability surrounding claims of connection and descent.[1] Indeed, when dealing with the remote past, that such a connection to the present exists at all—let alone what form it takes—is never naturally obvious. Communities identified in the past are as likely to be understood as Neanderthal "dead ends," specimens to be studied without direct rapport with modernity, as they are to be connected to the present. When links between ancient peoples and those of modernity are drawn, however, these can come in many forms: as persistence or presence (akin, perhaps, to the way Roman historians such as Livy saw them), as spiritual or moral models, as foils, as members of a common imagined community, or as biological ancestry.

Similarly, the ways in which archaeology, either its practice or the objects it turns up, interfaces with these narratives are not fixed. The pots, statues, walls, and bones unearthed by archaeologists are objects; they only become "things," subjects in their own right, when significance is placed upon them or contexts of interpretation woven around them as they are set in various discourses or museum displays (Brown 2001). Archaeological finds do not automatically demonstrate connections between past peoples and modernity; they do so only when framed with interpretations or valorized for particular reasons.

In the case of North Africa, the French relationship to the Roman past is most often seen in terms of abstract moral models, ideological or civilizational ancestors, or "how-to" handbooks for military control and economic development (Bacha 2013; Davis 2007; Lorcin 2002; Mattingly 1996). Instead, I will argue in my first section that French excavators in Africa created a more direct relationship with Rome: that of blood descendants. Heritage and patrimony

were concepts freighted upon ruins not in a metaphorical sense but in their legal and literal sense as developed in the wake of the French Revolution (Poulot 2006). Of course, proving kinship and descent was not as directly demonstrable from ruins as was a more abstract moral and civilizational descent; as a result, Roman sites played a greater role as backdrops for performances that made this case rhetorically, rather than as bodies of evidence in their own right.

Yet this notion of descent, as applied to Roman material in Africa, was hardly the only paradigm of the relationship between past and present operative in colonial Africa. My second section turns to examine different models applied to other archaeological "cultures" and the different treatments of sites and objects that resulted. Christian archaeology, especially in Carthage, was more than a backdrop for arguments of heritage: it was an animated means of creating an imagined and persistent community of faith. In a third model, the pre-Roman, Punic past was portrayed in terms of civilizational history, as a historical dead end whose objects could be recorded or put into cabinets of curiosities as scientific samples with no bearing on the present. Punic archaeology was not (as is often assumed) used to draw links between ancient Carthaginians and the "Arabs" of colonial Tunisia—at least not until 1921, a turning point in the archaeological rhetoric surrounding ancient Punics and modern North Africans.[2]

With these different models at play, it is striking that only the notion of patrimony-by-descent left a lasting mark on constructions of the significance of archaeology in Tunisia following independence, as I argue in my final section. In this premise, at least, Tunisian archaeology has never been "de-colonized" to explore alternative notions of how and why archaeological remains carry significance in the present. The main differences between the colonial and post-colonial periods sit in the simple transvaluation of Roman descent, downplayed in favor of parading Punic or Libyo-Phoenician ancestry, as well as in the intended audiences for such performances.

FRENCH AND ROMAN: COLONIAL NARRATIVES OF INHERITANCE

In many ways, the material remains of the past in North Africa were, like archaeological monuments across the world, exploited primarily to confirm "consensus whiggish histories" (or at least, those to which colonial powers might consent: Kehoe 1989: 105). Rather than offering alternative narratives or being sources for historical inquiry in their own right, the archaeological sites were primarily stage sets and backdrops which allowed such histories to be performed and revivified, much the way artists in colonial Algeria used Roman ruins to dot their landscape

paintings. Moreover, the archaeological histories written during the colonial period focused especially on the period of Roman conquest and control of the Maghreb; like excavations themselves, they largely ignored Islamic (or post-Byzantine) periods (for the European interest in Islamic architecture in the Maghreb, though, see Oulebsir 2004). Islamic archaeology, after all, only became a recognized department of the Tunisian Antiquities Service in 1948, and struggled for decades to gain significance (Gutron 2010: 132–36). And the narratives about the past spun around and put upon monuments and objects in French North Africa presuppose a particular relationship between that past and the colonial present: Roman Africa was not simply a model to be imitated, or an abstract civilizational or moral progenitor, but a direct genealogical ancestor for individuals and the French people more broadly. It was not a metaphorical matter of spiritual or civilizational "descent" but a lineage couched in strongly racial and genealogical terms.

The roots of this view, grounded in nineteenth-century ideas about race, appear in the generations prior to direct French control of Tunisia. In 1861, two decades before the largely independent Ottoman province of Tunisia became a French protectorate, Charles-Ernest Beulé, a former professor at the École Française d'Athènes (and future French minister of the interior), published an account of his short campaign to explore the site of ancient Carthage, which was the first archaeological excavation at the site (Freed 2011: 188–203). The opening of the work presages arguments made two decades later when France took control of the Tunisian regency; reflecting on the desolation wrought by the Arab conquest and the seeming emptiness of the landscape (a trope useful for justifying colonial land-grabs), Beulé (1861: 15) asks, "Who can say that she [Carthage] won't rise up again some day and that a civilized people, who understand the advantage of her placement, will not imitate the Romans?" In this call for conquest, Rome is imagined as a potential model for action: an attitude that also drove archaeology in neighboring Algeria (Lorcin 2002). Yet Beulé (1861: 143) strikes a very different note at the closing of his work:

> Sometimes, I would stop in front of an Arab who was destroying a tomb to make lime. I would say to him that the people whose final repose he was violating were of the same race as him, perhaps his ancestors. He would stop, look at me with uncertainty, reflect, and then ask me if these fathers of his fathers knew Mohammed and the true God. When I responded that they did not know them, he would let out a guttural exclamation, grab his pickaxe, and continue, with a tranquil heart, his work of destruction.

In spite of the Orientalist rhetoric—the conflation of many supposed encounters into one in order to confirm a stereotype: the Arab who, denying a connection to the past, descended to a nearly bestial state, letting out unintelligible, animal-like noises—Beulé's account foregrounds some of the problems confronting understandings of the past and its material correlates as heritage. For the Frenchman, the operative categories for attributing significance to the ancient tomb are race and ancestry. And although it is unclear what type of tomb Beulé encountered (prehistoric? Punic? Roman? post-antique?), he makes the case for its value on the grounds that the Arab farmer might be a direct descendent of the grave's occupant: claims of descent were not, in Beulé's day, the exclusive preserve of Europeans. Nor were Indigenous populations denied potential connections to the past and its remains, even when their lack of "proper" understanding of the value of such sites was denigrated (cf. Effros, this volume).

Beulé's views fit well within the French academic community of the mid-nineteenth century; two years before Beulé published his account, Paul Broca had founded the Société d'anthropologie de Paris, whose very mission was to establish the racial lineages of all humanity (which reached their pinnacle in the French people: Demoule 1999). While it would be overly simplistic to attribute Beulé's entire agenda and interpretive framework strictly to institutional factors, it is nevertheless clear that he was an active participant in the period's structures of knowledge production, and that racial descent played a central role in shaping how moderns might relate to various imagined pasts in the French colonial world. And Beulé was hardly alone in conceiving the elision between past and present in terms of direct lineage: this model permeated nearly every archaeological project undertaken in Africa during the late nineteenth and early twentieth centuries.

In Algeria, French commanders cast themselves as the direct progeny of Roman officers using archaeological monuments as both backdrops and props. The commander of a Foreign Legion detachment at Batna, Jean-Luc Carbuccia, excavated the Roman fort at nearby Lambaesis, using the exercise to boost the morale of his troops and uncover a portion of antiquity (Dondin-Payre 1996). Yet Carbuccia went further: his unit reconstructed the tomb of a Roman centurion, reburied the Roman with French military honors, and added an inscription to the monument celebrating the Foreign Legion's work (Renier 1850). Such reburials were not the norm in nineteenth-century archaeology; instead, human remains were generally objectified and fetishized as specimens of a past people only vaguely connected to modern observers, even in France itself (Pardoe 2013: 750). This was more than simply finding Roman presence in the region just north of the Aurès (something that had been doubted by previous generations)

and from there positing an inherited claim on the land (*pace* Mattingly 2006). Carbuccia did not act as though the centurion's bones were a sample to be collected, or the man an exemplum to be copied; he acted as an heir might, protecting and augmenting the tomb of his forefather.

This same logic of descent was also portrayed as persuasive justification of French territorial control to Indigenous populations in Algeria. The epigraphist Léon Renier (1851: 513) recounts an encounter with a sheik at Zana, impressed that Renier could understand Latin inscriptions when he could not:

> The sheik replied by addressing the Arabs who accompanied him: "It is true; the *Roumis* [foreigners, French] are the sons of the *Roumâns*; when they took this land, they were simply retaking the property of their fathers (*le bien de leurs pères*)."

If the tale itself is likely heavily embellished (if not altogether fantastical), it reveals the means by which Renier and his contemporaries gestured to their connection with Roman ruins. The French tie to Rome was explicitly hereditary, which guaranteed their claim to territory via testamentary law. Renier's inscriptions did gain the status of irrefutable and persuasive proof of this claim, though only via his rhetorical performance in front of the sheik.

In Tunisia, by contrast, where the French presence was both later and less militarized, the focus of archaeological inquiry lay on cultural and economic installations, tracing Roman roads and irrigation systems to understand how the pre-desert had been a flourishing breadbasket (and olive mill) of the entire Roman empire (Davis 2007). Still, if officers such as Carbuccia rebuilt and reanimated legionary monuments as a means of stressing descent and the continuities between Roman military domination and French military control, archaeologists in Tunisia used rebuilt Roman cultural structures in a similar manner, to highlight Roman/French cultural domination and descent. Focusing especially on theater buildings (indeed, the Institute of Carthage was famous for its predilection for restoring Roman theaters), these ancient stages again became backdrops for performances of descent (Dridi and Mezzolani 2012).

Louis Carton, an amateur archaeologist, for example, not only worked to excavate and restore the Roman theater at Carthage, but organized a grand festival of Roman antiquity on the partially excavated theater's stage in 1906 (Fig. 13.1). There, Carton (1924: 417) proclaimed that the Romans were his "predecessors in this land," and the French "spectators of the Latin race, gathered here to attend the resurrection of the genius of our ancestors." That is, they were simply renewing old traditions in a line of direct genealogical, racial, linguistic, and cultural descent. Again and again, Carton stressed that not only were the French

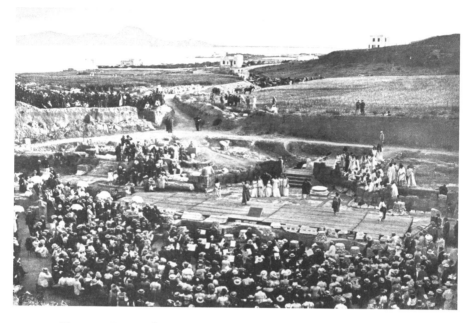

FIGURE 13.1. Performance of patrimony play in theater of Carthage.
From Carton (1906, n.p.).

legal heirs to Rome, but that the ruins uncovered by archaeological works were precisely the inheritance that "the ancients left to us" (Carton 1906: 433). Archaeological remains were not just a matter of discovering this heritage, but *biens* actively willed to the French. For one viewer of the performance that followed, featuring classically draped personifications and mytho-historical personages, the performance evoked a feeling of "filial right" to reclaim both the space and "radiant Latin Antiquity" (Gung'l 1906: 436).

The ruins, though, were but a backdrop to this rhetorical performance. Descent from the Romans was accepted a priori; monuments and materials were not cited as direct evidence for this but were invoked simply as tangible corollaries to the wider narrative of identity.

And such arguments for direct descent as part of a claim to territorial control were by no means confined to the period of the protectorate but have an afterlife in French scholarship on North African history and archaeology. In 1961, for example, Marcel Le Glay published *Les Gaulois en Afrique* (1962), an onomastic study of the origins of individuals living in Roman Africa. Contrary to his predecessors, Le Glay argued that Gauls did not come to Africa strictly on temporary military service but "planted themselves there, seduced by the sun and

the natural charm of the land" (Le Glay 1962: 6). The claim is one of lasting Gallic settlement in Africa, the result of Roman hegemony—and a direct, shared ancestry (for how megalithic monuments were similarly harnessed in Algeria, see Coye 1993; Effros, this volume).

These two notions—that connections to the past were primarily based on genealogical descent, and that archaeology was a rhetorical prop to make the case for such lineages—stem from the intellectual projects prompted by the French Revolution. Although aspects of these ideas were spread through Europe (and even into Ottoman Turkey) through the transnational connections that shaped the intellectual history of the nineteenth century, as a package, they were distinctly French (to contrast these concepts with those in nineteenth-century Britain, see Hingley 2000). Indeed, the very concept of patrimony, the valorized connection between "things" from the past and a people in the present, has often been attributed to France in the 1790s and the development of museums, archaeological sites, and spaces like the Panthéon that celebrated national heroes (Pommier 1991). Still, the particular notions of *patrimoine* and *heritage* embodied in these monuments were primarily metaphorical (Poulot 1993, 2006). Yet the example of North Africa suggests that patrimony and heritage in such a colonial context could also be taken in a far more literal sense, employed to speak of monuments handed down from a past generation to descendants linked by blood—a concept of lineage espoused by the burgeoning "racial sciences" of the late nineteenth century (as we shall see below; cf. also Bernasconi 2011).

Despite the parallel growth of genealogical projects in France, the rhetoric of Roman ancestry and connection by descent was still somewhat of a stretch for the military officers and settlers who freighted monuments with such significance. Such claims of descent may have been easier to make and to accept in the intellectual milieu of mid- to late nineteenth-century France, given the much wider preoccupations with parentage and inheritance that filled the period's cultural imaginary. The plots of a host of nineteenth-century French novels center on wills and testaments, from Honoré de Balzac's *La Rabouilleuse* (1842) to Émile Zola's *La Terre* (1887), and (perhaps most famously), the early to mid-twentieth-century oeuvre of François Mauriac. The reforms to testamentary law made by the Napoleonic Code (1804) sparked a host of court cases concerned with what constituted legitimate descent; prior to the Code, only eldest sons needed to inherit. The end result of the Code and these cases was what Andrew Counter has called the "opening-out . . . of the patrilinear paradigm" in French culture, a broadening that, alongside developing ideas of heritage, allowed imagined leaps from a Roman past to a French colonial present (Counter 2010). Legal, literal inheritance was no longer as tightly bounded as it once was; every-

one from jurists to novelists were rethinking how *biens* might be handed on to a much broader group of heirs; could contemporary France not, then, be legal heir to Rome? With a widespread fascination in France over family and inheritance, and expanding concepts of who could be considered an heir, the claims of archaeologists like Carbuccia and Carton sat squarely within period discourses. Perhaps, too, the angst generated by colonial endeavors fueled literary and legal attempts to craft legitimate claims to land and goods.

DIFFERENT MODELS: CHRISTIANS AND CARTHAGINIANS IN THE COLONIAL PERIOD

In the tale about the Arab destroying a tomb at Carthage, Beulé's local interlocutor makes a very different conceptual step to link past and present. Ties to the past through material were conceived in terms of religious knowledge: belonging not to a racial community but to one based around confession. At least two distinct notions of heritage were at play here: one racial, the other religious, via an imagined community of faith. Indeed, as Jean-Louis Huot (2008) has argued, the very absence of archaeological investigations in the Muslim world prior to European endeavors bespeaks radically different (rather than nonexistent) notions of time, history, and identity than those of nineteenth-century European nation-states (though see the cautionary notes in Effros, this volume).[3] Not only did the tombs of Carthage that Beulé encountered raise the question as to whose heritage they might belong, but how ties between past and present peoples themselves might be constructed—whether along racial, ethnic, civic, personal, confessional, or other lines. Archaeology, in other words, might not automatically be about identity via descent, at least outside some of the intellectual programs of France.

The uniqueness of genealogy and inheritance as a way of drawing a connection between France and Rome in Africa becomes even sharper in light of how the archaeologies of pre-Roman and Christian Carthage were fitted into wider historical models by French scholars in the late nineteenth and early twentieth centuries. The peoples of ancient Africa were generally slotted into three distinct categories, both by classical authors and their modern counterparts: Libyans, the Indigenous tribes of Africa; Carthaginians or Punics, settlers from the coastal cities of Phoenicia (modern Syria-Lebanon/northern Israel); and the Romans. Ancient Christians were sometimes grouped with the Romans, sometimes bracketed as a distinct group. Each group was slotted into a different type of narrative: there was not one model of history at play in the colonial Maghreb, but a multiplicity, and this had a deep impact on the treatment of archaeological remains.

In rhetoric and the treatment of monuments, ancient Christians somehow persisted as part of an imagined community in the present through the material traces they left, reanimated via contemporary cult. By contrast, there was no direct line drawn between Punic past and French colonial present, or between Punics and the non-French inhabitants of Tunisia. With rare exceptions (Temple 1835: 58), lineage simply did not come into play when thinking about Punic Carthage until after 1921, when the discovery of Carthage's child-sacrifice sanctuary sparked new narratives about the origins of modern Tunisians. Although afforded the status of a world civilization, the scant ruins left by Punics relegated them to the status of civilizational Neanderthals—historical dead ends, though impressive in their day.

Some of the largest sustained archaeological investigations of Christian and Punic sites in French colonial Tunisia were driven by the Society of the Missionaries of Africa based in Carthage, dubbed the Pères Blancs for their white robes. Cardinal Charles Lavigerie, primate of Africa, gave the Pères Blancs a second mission, which he ranked as high as their charitable endeavors: archaeological research (Delattre 1907: 8). Lavigerie himself was said to tell young clergymen, "May our efforts every day resuscitate Christian life in these sacred ruins!" (Bertrand 1926: 116). For Lavigerie, such archaeological remains brought the Christians of antiquity back to life for their modern counterparts, creating a bond and common community.

Alfred-Louis Delattre, the priest who led most of the excavations, similarly saw his work as a quasi-spiritual affair, meant to develop the city as a reliquary stuffed with traces of early martyrs (Freed 2008; Gutron 2010: 114–17). The one time he speaks of "notre Afrique" is in discussing a basilica and the Christians of Carthage—demonstrating a sense of continued possession rather than inheritance (Delattre 1886: 3). The traces of early Christian Carthage excavated by Delattre were closely linked to an ecumenical community in his present, and his excavations were driven by a notion of religious persistence. In one case, he says he was quite literally sent a Byzantine seal by the Virgin Mary (Delattre 1907: 17).

Here, too, the sites and objects themselves fared differently than their Punic and Roman counterparts. Rather than being rebuilt and displayed as props for performance of lineage, Christian monuments were loci where the gap between past and present was simply elided. Delattre converted the *ergastalum* of the Carthage amphitheater, where the Christian martyrs Perpetua and Felicitas were supposedly kept prior to their execution in the arena in 203 CE, into a chapel. To do so, he collected a selection of inscriptions and reliefs, which were built into the walls of the chapel. For example, at the top of the staircase leading down to the chapel, he set up two Roman-period reliefs of dolphins (Delattre 1903: 49).

Stripped from archaeological context, such objects were harnessed for aesthetic effect in the present. Celebrating the 1,700th anniversary of Perpetua's martyrdom in the amphitheater with a grand festival, the priest invited spectators (and those who could not attend in person) to experience Perpetua's martyrdom as though it were happening right in front of them in that place (Fig. 13.2; Pillet 1903). Through such rhetorical performance and the sense of place curated by Delattre, an event that happened centuries ago was made present.

Even photographs of the amphitheater create this elision of time. Delattre's view of the entrance to the chapel shows a Père Blanc standing rigidly amid the ruins, his bright white body echoing both the white frame of the stairway down and the partially standing marble columns (Fig. 13.3). The modern priest is as much an integral part of the architecture and sense of place as the ruins around him. Unlike the photographs in Delattre's guide to Carthage that show non-Christian sites (Roman cisterns, Punic tombs), each Christian monument (amphitheater, Damous el-Karita basilica, Chapel of Saint Monica, Christian tombs) is populated by Pères Blancs, the site reanimated rather than desolated

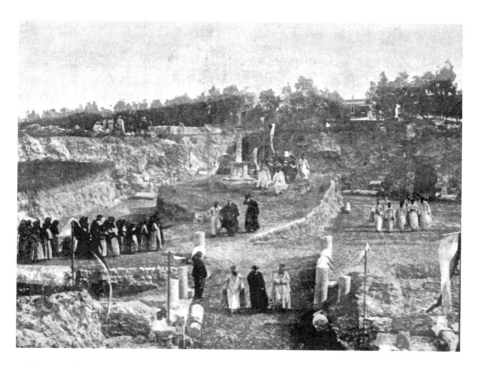

FIGURE 13.2. Festival to celebrate martyrdom of Perpetua and Felicitas in Carthage amphitheater, 1901. From Delattre (1902: 21).

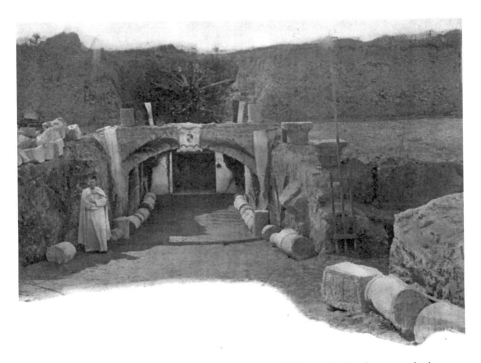

FIGURE 13.3. Entrance to Chapel of Perpetua and Felicitas in Carthage amphitheater. From Delattre (1902: 13).

(Delattre 1902). More than simply backdrops, the Christian sites of Carthage were rebuilt as places of pilgrimage for modern worshippers where encounters with past Christians might take place and where centuries of time were erased.

In addition to his work making the Christian past persistent in the present through things and spaces, Delattre also excavated a wealth of Punic material in Carthage—finds that he and his contemporaries set into a third, and again markedly different, vision of the past and its materials. Prior to 1921, Punic archaeology in the French protectorate of Tunisia was mostly incidental and accidental: Rome was the focus. Beulé (1861), for example, discusses almost no Punic material. Indeed, French archaeologists prior to 1921 seem to have suffered from a kind of "punicophobia" (Alexandropoulous 2000). Part of this was simply the product of what was visible: early travelers concentrated on the standing Roman monuments and largely ignored the Punic world, save mention of Carthaginian conflicts with Rome (e.g., Pellissier de Reynaud 1856). And although many travelers of the eighteenth to the mid-nineteenth centuries (including literary and political luminaries from Gustave Flaubert to Sir Grenville

Temple) visited Tunis seeking Punic Carthage, they were disappointed with the lack of material that could evoke "Dido's City" (Bacha 2013: 17–36). Even those monuments that could, even if only tangentially, be linked to Carthaginian history were of interest primarily as novelties. The British consul at Tunis, Sir Thomas Reade, famously had the pre-Roman mausoleum at Dougga destroyed to cart its bilingual Punic-Libyan inscription back to the British Museum (Poinssot 1910). This period was simply a quarry from which curiosities might be collected.

The mid- to late nineteenth-century cultural imaginary of Carthage rested primarily on classical texts and Flaubert's 1862 *Salammbô*, whose place within Orientalist rhetoric has long been recognized (Daguerre de Hureux 1995; Said 1978). What may be most striking is how little the few Punic finds in Carthage were mobilized to support these narratives and practices of Othering contemporary Tunisians. From the moment of *Salammbô's* publication, archaeologists set themselves in opposition to Flaubert's portrait of the Carthaginians, itself heavily influenced by Flaubert's view of contemporary Tunisians during his stay in Tunis (though less negative than Said and others have assumed: Bacha 2013: 17–60; Beschaouch 1997). These archaeological critiques not only disputed individual points, but also emphasized that their role was as a corrective for Flaubert's general misrepresentation of Carthaginian civilization (e.g., Audollent 1901: 24; Fröhner 1862). The literary Orientalism of Flaubert moved in a very different direction than the rhetoric and aims of the archaeological community in the Maghreb.

In fact, ancient Carthage was not brought back to life through objects, or linked to modern peoples by nineteenth-century explorers and archaeologists. Those who did engage with Punic monuments echoed the classical authors who emphasized the total destruction of Carthage by Roman forces in 146 BCE: Punic Carthage was a lifeless and unproductive ruin (Audollent 1901: ix–x). For one of the first scholars who tried to map the ancient city, Adolphe Dureau de la Malle (1835: 5–6), Carthage and its culture were naught but a ruinous reminder of how a civilization could die, apparently without heirs. Even when parallels were drawn between past and present, these were not cast in terms of lineage, but as echoes and historical patterns. For example, Ernst Babelon (1896: 60), in his synthetic account of Carthaginian archaeology, describes Carthage as the "*avant-garde* of Oriental civilizations in the West. In her, as she was at Marathon ... and would be again at Poitiers." For Babelon, Carthage was simply one in a string of repeated "Oriental" defeats at the hands of European armies.

Indeed, with no one to claim them as ancestors, the pre-Roman finds of Carthage were valued almost entirely for the topographic questions they could

answer (where was the Punic city? how large was it?), historicized and bracketed from the present (e.g., Dureau de la Malle 1835). When Delattre (1899: 11–15) excavated hundreds of Punic tombs across Carthage in the last decades of the nineteenth century, his only analytic additions to the descriptive texts he published concerned the urban shape of the ancient city. His work is explicitly cast as primarily documentary, with such a wealth of minute detail that he several times apologizes. There is no mention of descent at all: the ancient Carthaginians have no direct ties to the present (Delattre 1899). For Delattre, Punic remains were objects of the past rather than ancestors who lived on in some progeny or things experienced in the present; if they provided edification to the public, it was not by showing off ancestry. The Carthaginians had apparently reached a historical dead end.

This ideological treatment of Punic archaeology as a ruined shell of a past culture finds a close parallel in the physical treatment of sites excavated. Almost every site deemed "Punic" was simply left exposed, or reburied, in contrast to the vast *mise-en-valeur* projects developed around Roman sites. The "Punic" sanctuary at Thinissut was abandoned (now lost entirely; even its exact emplacement is uncertain), as were those at el-Kénissia, Thuburnica, and (closer to Carthage) Sidi Bou Saïd—all excavated in the late nineteenth century and first decades of the twentieth. Meanwhile, rebuilding and curating sites was confined almost entirely to Roman and late antique structures, including villas, the theater, the odeon, and baths at Carthage—the types of places that could be backdrops for events like Carton's staging of French patrimony described above. Even a guide to Carthage published by Delattre's own order almost entirely ignores Punic tombs to focus instead on the Roman theater, amphitheater, baths, and cisterns as well as on the Christian sites (Vellard 1896). Punic monuments were not, apparently, as central to reconstructing and performing notions of patrimony or connection with the past as their Roman counterparts.

The contrast between the treatment of Punic finds and their Roman or Christian counterparts is clear in the displays and guidebook of Musée Lavigerie, the archaeological museum that the Pères Blancs founded in Carthage in 1875 to house the fruits of their excavation campaigns. While the Christian objects are lavishly illustrated in Delattre's (1902) guide to the museum, not a single Punic object appears in a drawing or photo. Delattre also describes the entrance to the museum, where pieces of Christian reliefs from sarcophagi and other contexts had been dramatically redisplayed. Each Christian piece in the main room of the museum is treated to a detailed *ekphrasis*, though when he lights upon a pagan object, its importance comes solely through its ties to Christianity; a Latin inscription mentioning a festival for an imperial birthday, for example, is cited as

a similar occasion to "that birthday when . . . Perpetua, Felicitas, and their companions were given over to the beasts," while a Punic ring is cited only because "it is referred to in the Bible under the term *nézem*" (Delattre 1902: 44, 48). In the short paragraph devoted to the Punic room, it is the age of the objects, their "curiousness," and the fact that they are "little known" that make them important (Delattre 1902: 48–49): they are, in other words, simply unusual specimens distanced from the present and stuffed into a cabinet of curiosities. Photos of the museum from the period give a similar impression: unlike the striking Christian rooms, the Punic room is a Wunderkammer chock-a-block with objects (Fig. 13.4; Sayadi 2007).

There was one exception to this general historicizing of the Punics prior to 1921: the anthropological work of Lucien Bertholon, which tried to establish the racial lineage of contemporary Tunisians via the Punics of the past. One of Paul Broca's students, Bertholon founded the Institut de Carthage in 1893 and issued the first volume of its main publication, the *Revue Tunisienne* (one of the main venues for the publication of Punic material), the following year. His interests lay precisely in establishing racial descent through craniometry—Delattre's tombs furnished most of Bertholon's samples—and his publications cover topics ranging from the genetic ties between Phoenicians and Basques to the origins of the Berber race. For Bertholon, the skulls of ancient Carthaginians demonstrated

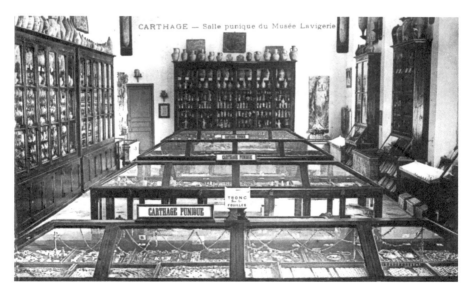

FIGURE 13.4. Punic room in Musée Lavigerie, ca. 1900. Postcard, author's collection.

that "the population of the Carthage-Tunis region has remained identical from the fourth century BC to our own day" (Bertholon 1911: 164). Rather than being of Phoenician descent, though, the Carthaginians were descendants of an Aegean race who also inhabited Neolithic France (Bertholon 1911: 166). The Carthaginians of antiquity, like the Tunisians of the present day, shared the same ancestors as the modern French, despite the fact that they were pronounced "first Phoenicians, then Romans, then Arabs" (Bertholon 1911: 167). But why had Africa and Mediterranean Europe (or rather, France, which had "perfected" the potential of this race) developed differently? To answer this, Bertholon attributed the "decline" of Africa in the post-Roman period to Arabic cultural assimilation, and sounded a clarion call for France to help her Tunisian cousins achieve the racial perfection that the French had attained (Bertholon 1911: 168).

If Bertholon's arguments were the products of racism and pseudo-science, they are at least unique in how they harnessed archaeological remains in this period. More than a backdrop, the bones of Carthage were a source of evidence that could debunk the standard narrative of Levantine colonization and the "Orientalness" of North Africa. Still, despite his perch as director of the Institut de Carthage, a foundation that sponsored a range of excavations, Bertholon's ideas never drew the interest of archaeologists or historians: his arguments were only ever picked up by those working on the anthropology of race. For Bertholon's contemporaries in Tunisia, there were no heirs to Carthage.

The treatment of Punic and Christian archaeology in Carthage suggests that there was no one model used to thread seemingly distinct moments and cultures of the past along a string that extended (in some cases) to the present. Even in the same work, an author such as Delattre could vacillate between models of archaeology and history as he talked about the Christian versus the Punic past. Three different notions of how past peoples, and their material correlates, related to the present were thus operative in nineteenth- and early twentieth-century Tunisia, and such notions affected how monuments were curated. With the Romans, the primary model invoked was one of direct lineage and descent, building upon intellectual (anthropological, patrimonial) and legal shifts to claim inheritance. Rome was less a moral or civilizational precedent than a direct ancestor; the archaeology could not prove this but could serve as an illustration upon which such significances were freighted in rhetorical performances. With Christians, an imagined community of faith was created, one that was not simply ancestral but alive and persistent in the present. The Punics, though, were cast almost entirely in terms of civilizational history, as a dead end without link to the present, save perhaps in the repetitive patterns of East–West conflict that shaped history.

Denying the *indigènes* of Tunisia a past and a connection to monuments may not be surprising when set alongside the histories and archaeologies of colonialism (see, e.g., Effros, this volume; and Stanfield-Mazzi, this volume). What is striking, though, is the way in which this changed after independence, despite invoking the types of patrimony-by-descent models that were so closely linked to nineteenth-century France.

COLONIAL LEGACIES IN TUNISIAN ARCHAEOLOGY

The genealogical, racial model of descent through archaeological materials became ingrained in the archaeological projects of Tunisia in the generations following independence: archaeology in Tunisia has never been de-colonized. Alternative ways of valuing the past and ascribing significance to monuments, or drawing connections between past and present, fell by the wayside, and the entire post-independence impetus for producing archaeological knowledge owes much to colonial ideologies (cf. Gutron 2008). The government of independent Tunisia simply transvalued the Roman past and its remains, instead focusing on Punic archaeology.

Punic archaeology has been one of the cornerstones of the cultural-identity politics of the post-independence period in Tunisia, especially during the reign of Zine el Abidine Ben Ali, the president ousted during the Arab Spring of 2011 (Altekamp and Khechen 2013). From the "Pour Sauver Carthage" project that brought international teams to work in the ancient metropolis to the annual excavation and seminar-festival at the Punic town of Kerkouane to the archaeological fantasy park at "Carthageland," the government has worked to project direct identification with the Punic period via descent to both internal and international audiences (Gutron 2010: 220–36; Lafrenz Samuels and van Dommelen forthcoming). For the director of national museums, excavation at Carthage was itself an inherited right; like exhuming the body of a parent, the practice of Carthaginian archaeology was the proper preserve of "its own children" (Ben Younès 1987: 55).

Not only are such concepts of descent derived from French ideas about the intersections of archaeology, history, and race, but the institutions that promoted these ideas were themselves calqued on French paradigms. Tunisia's Ministry of Culture, founded shortly after independence in 1961, was directly modeled on André Malraux's newly organized Ministry of Cultural Affairs in France, established by Charles de Gaulle two years earlier. Although the first minister of culture, Chedli Klibi, described the goal of his office as rejecting the cultural model imposed by France on its protectorate, he was himself a graduate of the Sorbonne

and lecturer at the École Normale Superieure in Paris, and has frequently voiced the idea that archaeological patrimony demonstrates modern Tunisia's (mixed) descent from the peoples of the past, including the Punics (Klibi and Moll 1999: 134–45, 258–59).

Still, the way archaeological materials are invoked in these arguments about descent are markedly different than in the colonial period: objects and assemblages are attributed with new evidentiary value. In the broadest terms, the hybrid archaeological assemblages at inland sites demonstrate that Carthage and her inland "empire" (itself part of a questionable historical narrative that often places the borders of Carthaginian control roughly along those of modern Tunisia) were part of a cultural and genetic mélange of Semitic Phoenicians and Native Libyans (e.g., Krandel-Ben Younès 2002: 460–64). These Punic, or Libyo-Phoenician, peoples were the lineal ancestors by blood of the modern Tunisian people (Klibi and Moll 1999). Of course, such arguments often depend on a direct correspondence between objects and ethnicity and the kind of "culture history" archaeology that has been problematized by post-colonial archaeology.

The other main differences in ideas of lineage imposed on archaeological remains in the French colonial and Tunisian post-independence periods are situated in the champions of this rhetoric and their audiences. In the colonial period, such discussions were led primarily by amateur archaeologists (such as Carbuccia and Carton) within a public sphere; this sphere, though replete with first-person plurals in the Francophone literature, comprised those supposed descendants of Romans. Post-independence, such claims were promoted by the government itself and were aimed as much externally as internally: from the employment of foreign archaeological teams, publications in English and French by foreign presses, and international exhibitions.

One measure of the foreign audience for these semi-official claims about Punic-Tunisian lineage might be the reception and lack of internalization of these governmental claims. From the state-sponsored archaeological projects to museum and education initiatives, this top-down, official promotion of lineage has met with skepticism and apathy in many quarters. As the Tunisian essayist Tahar Fazaa (2004: 7) writes, "The Tunisians, they don't give a damn about their past; the proof is that they call the Bardo Museum 'Dar Laâayeb,' or the house of foreign things, and archaeological sites 'Hjar et-tourist' or the stones of tourists" (Ben Younès [2001: 19] makes a similar point). Even if Fazaa accepts that such ruins are part of a past that *ought* to be considered the inheritance of modern Tunisia, for most, such ruins are foreign and not part of some inheritance.

The official embrace of conceptual links between past and present that are rooted in biological lineage and inheritance is very much a product of nineteenth-century French intellectual projects, constructions of patrimony, and colonialism. Perhaps it is fitting that such rhetoric is aimed primarily not at internal audiences (at least, not successfully), but at contemporary European cultural programs and tourists.

CONCLUSIONS

Narrativizing the past and its material remains requires not only selecting the moments, peoples, and objects to be linked but selecting the specific thread that ties them together. In the French colonial Maghreb, different threads and models of how peoples fitted into history were chosen for different types of archaeological material. For the Pères Blancs, Christian remains in Carthage were mystically reanimated; the martyrs of ancient Carthage and spaces they had experienced were brought into the present to create an imagined community that elided two millennia of time. Punic ruins were (at least until 1921) just that: desolated remains of a past civilization that, like the ruins themselves, was forgotten and unconnected to modernity. The Roman past, by contrast, was linked quite directly to the present in racial and genetic terms; the lands and monuments of Roman antiquity were a legal inheritance and a backdrop in front of which such claims could be made. In almost all cases, however, archaeological monuments were primarily just props.

The same premises remain central to supposedly "de-colonized" archaeological programs in contemporary Tunisia, where, along with institutional models, they have become part of a governmental effort (with limited success) to promote Libyo-Phoenician descent. Such genealogies freighted upon archaeological remains are hardly confined to North Africa but continue to structure archaeological agendas across the world. Genealogies might be genetically provable via the increasing number of DNA-analysis projects, or based instead on myth and folklore; and if privileging the former over the latter is frequently where conflicts arise between archaeologists and Indigenous communities in North America, the basic principle of what connects past material to present people is the same (Harris 2005). And if these narratives of descent could be crafted and sustained in the absence of archaeological remains, such material traces have consistently offered useful props, backdrops, or illustrations, even if the types of materials paraded cannot make genetic claims.

NOTES

[1] If the models promoted by NAGPRA and other "Indigenous peoples'" claims are rarely challenged, the Council of British Druidic Orders' demands to rebury prehistoric remains suggest that seemingly natural concepts of descent and ancestry are themselves constructed and contestable (see Wallis and Blain 2011).

[2] Matthew M. McCarty, "Colonialism and Child Sacrifice: Carthage's Tophet and New Models of French History in Africa," in preparation.

[3] It is telling that Ottoman archaeological work was not only calqued on European endeavors—and the father of archaeology in the Ottoman world, Osman Hamdi Bey, studied in Paris—but tied to the rise of European-style nationalism and imperial ideals in the Ottoman world (Shaw 2003).

REFERENCES CITED

Altekamp, Stefan, and Monique Khechen
 2013 Third Carthage: Struggles and Contestations over Archaeological Space. *Archaeologies* 9(3): 470–505.

Alexandropoulous, Jacques
 2000 De Louis Bertrand à Pierre Hubac: images del'Afrique antique. In *La Tunisie mosaïque: diasporas, cosmopolitisme, archéologies de l'identité*, edited by Jacques Alexandropoulous and Pierre Cabanel, pp. 457–78. Presses universitaires de Mirail, Toulouse.

Audollent, Auguste
 1901 *Carthage romaine: 146 avant Jésus-Christ–698 après Jésus-Christ*. A. Fontemoing, Paris.

Babelon, Ernest
 1896 *Carthage*. E. Leroux, Paris.

Bacha, Myriam
 2013 *Patrimoine et monuments en Tunisie: 1881–1920*. Presses universitaires de Rennes, Rennes.

Ben Younès, Habib
 1987 Trente années d'archéologie et d'histoire ancienne en Tunisie (1956–1986). *Institut des belles lettres arabes* 159: 11–59.

 2001 Les musées archéologiques et historiques en Tunisie face à la biculturalité. *ICOM Cahiers d'étude* 2001: 19–20.

Bénabou, Marcel
 1980 L'imperialisme et l'Afrique du Nord, le modèle romain. In *Sciences de l'homme et conquête coloniale. Constitution et usages des sciences humaines en Afrique, XIX^e–XX^e siècles*, edited by Daniel Nordman and Jean-Paul Raison, pp. 15– 22. École Normale Supérieure, Paris.

Bernasconi, Robert

2011 The Philosophy of Race in the Nineteenth Century. In *Routledge Companion to Nineteenth Century Philosophy*, edited by Dean Moyer, pp. 498–521. Routledge, London.

Bertholon, Lucien

1911 Étude comparée sur des crânes de Carthaginois d'il y a 2400 ans et de Tunisois contemporains. *Revue Tunisienne* 18: 161–68.

Bertrand, Louis

1926 *Devant l'Islam*. Plon-Nourrit et Cie, Paris.

Beschaouch, Azedine

1997 Les archéologues dans la reconstruction de l'identité patrimoniale pré-islamique. In *Patrimoine et passions identitaires*, edited by Jacques Le Goff, pp. 327–36. Fayard, Paris.

Beulé, Charles Ernest

1861 *Fouilles à Carthage*. Imprimerie Impériale, Paris.

Brown, Bill

2001 Thing Theory. *Critical Inquiry* 28(1): 1–22.

Carton, Louis

1906 Discours. *Revue Tunisienne* 13: 432–36.

1924 *Pour visiter Carthage*. J. Barlier, Tunis.

Counter, Andrew

2010 *Inheritance in Nineteenth-Century French Culture: Wealth, Knowledge and the Family*. Legenda, London.

Coye, Nöel

1993 Préhistoire et protohistoire en Algérie au XIX^e siècle: les significations du document archéologique. *Cahiers d'études africaines* 33: 99–137.

Daguerre de Hureux, Alain

1995 Salammbô: entre l'Orient des romantiques et l'Orientalisme fin-de-siècle. In *Carthage: L'histoire, sa trace, et son écho*, pp. 128–37. Musées de Paris, Paris.

Davis, Diana

2007 *Resurrecting the Granary of Rome: Environmental History and the French Colonial Expansion in North Africa*. Ohio University Press: Athens.

Delattre, Alfred Louis

1886 *Archéologie chrétienne de Carthage: Fouilles de la basilique de Damous-El-Karita (1884)*. Bureaux des Missions Catholiques, Lyon.

1899 *Carthage: Nécropole punique, voisine de Sainte-Monique. Second mois des fouilles (février 1899)*. Cosmos, Paris.

1902 *Un pèlerinage aux ruines de Carthage et au Musée Lavigerie*. Jevain, Lyon.

1903 A l'amphithéatre de Carthage. *Bulletin de la Société archéologique de Sousse* 4: 45–49.

1907 *Le culte de la sainte Vierge en Afrique.* Société de Saint Augustin, Paris.

Demoule, Jean-Paul

1999 Ethnicity, Culture and Identity. French Archaeologists and Historians: Theory in French Archaeology. *Antiquity* 73(279): 190–98.

Díaz-Andreu, Margarita

2007 *A World History of Nineteenth-Century Archaeology: Nationalism, Colonialism, and the Past.* Oxford University Press, Oxford.

Dondin-Payre, Monique

1994a *Le capitaine Delamare: la réussite de l'archéologie romaine au sein de la Commission d'exploration scientifique d'Algérie.* De Boccard, Paris.

1994b *La commission d'exploration scientifique d'Algérie.* De Boccard, Paris.

1996 Réussites et déboires d'une oeuvre archéologique unique: le Colonel Carbuccia au nord des Aurès. *Antiquités Africaines* 32: 145–74.

Dridi, Hédi, and Antonella Mezzolani

2012 "Ranimer les ruines": l'archéologie dans l'Afrique latine de Louis Bertrand. *Les Nouvelles de l'archéologie* 128: 10–16.

2016 *Under Western Eyes. Approches occidentales de l'archéologie nord-africaine (XIXᵉ–XXᵉ siècles).* Université de Neuchâtel, Bologna.

Dureau de la Malle, Adolphe Jules César Auguste

1835 *Recherches sur la topographie de Carthage.* Didot Frères, Paris.

Effros, Bonnie

Forthcoming *Incidental Archaeologists: French Officers and the Rediscovery of Roman North Africa.* Cornell University Press, Ithaca.

Fazaa, Tahar

2004 *Ulysse au pays des merguez.* Apollonia, Tunis.

Freed, Joann

2008 Le père Alfred-Louis Delattre (1850–1932) et les fouilles archéologiques de Carthage. *Histoire et Missiones Chrétiennes* 8: 67–100.

2011 *Bringing Carthage Home: The Excavations of Nathan Davis, 1856–1859.* Oxbow Books, Oxford.

Fröhner, Guillaume

1862 Le roman archéologique en France. *Revue Contemporaine* 30: 853–70.

Greenhalgh, Michael

2014 *The Military and Colonial Destruction of the Roman Landscape of North Africa, 1830–1900.* Brill, Leiden.

Gung'l, Jean-Nicolas

1906 Discours. *Revue Tunisienne* 13: 436–42.

Gutron, Clementine

2008 La mémoire de Carthage en chantier. *L'année du Maghreb* 4: 45–65.

2010 *L'archéologie en Tunisie (XIX^e–XX^e siècles): jeux généalogiques sur l'Antiquité.* Karthala, Paris.

Harris, Heather

2005 Indigenous Worldviews and Ways of Knowing as Theoretical and Methodological Foundations for Archaeological Research. In *Indigenous Archaeologies: Decolonising Theory and Practice*, edited by Claire Smith and Hans Martin Wobst, pp. 33–41. Routledge, London.

Hingley, Richard

2000 *Roman Officers and English Gentlemen: The Imperial Origins of Roman Archaeology.* Routledge, London.

Huot, Jean-Louis

2008 L'archéologie dans le monde musulman. In *L'avenir du passé: modernité de l'archéologie*, edited by Jean-Paul Demoule and Bernard Stiegler, pp. 183–95. Découverte, Paris.

Kehoe, Alice Beck

1989 Contextualizing Archaeology. In *Tracing Archaeology's Past: The Historiography of Archaeology*, edited by Andrew L. Christenson, pp. 97–106. Southern Illinois University Press, Carbondale.

Klibi, Chedli, and Geneviève Moll

1999 *Orient-Occident: la paix violente.* Sand, Paris.

Krandel-Ben Younès, Alia

2002 *La présence punique en pays numide.* Institut national du patrimoine, Tunis.

Lafrenz Samuels, Kathryn, and Peter van Dommelen

Forthcoming Punic Heritage in Tunisia. In *Oxford Handbook of the Phoenician and Punic Mediterranean*, edited by Carolina López-Ruiz and B. Doak. Oxford University Press, Oxford.

Le Glay, Marcel

1962 *Les Gaulois en Afrique.* Latomus, Brussels.

Lorcin, Patricia M.

2002 Rome and France in Africa: Recovering Colonial Algeria's Latin Past. *French Historical Studies* 25(2): 295–329.

Mattingly, David J.

1996 From One Colonialism to Another: Imperialism and the Maghreb. In *Roman Imperialism: Postcolonial Perspectives*, edited by Jane Webster and Noah Cooper, pp. 49–69. School of Archaeology, Leicester.

Memmi, Albert

1957 *Portrait du colonisé; portrait du colonisateur.* J. J. Pauvert, Paris.

Oulebsir, Nabila
 2004 *Les usages du patrimoine : monuments, musées, et politique coloniale en Algérie (1830–1930)*. Éditions de la Maison des sciences de l'homme, Paris.

Pardoe, Colin
 2013 Repatriation, Reburial, and Biological Research in Australia: Rhetoric and Practice. In *The Oxford Handbook of the Archaeology of Death and Burial*, edited by Sarah Tarlow and Liv Stutz, pp. 733–62. Oxford, Oxford University Press.

Pellissier de Reynaud, Ernest
 1856 La Régence de Tunis. Le gouvernement des beys et la société tunisienne. *Revue des deux mondes* 2(3): 123–49.

Pillet, Albert
 1903 Les martyrs de Rome & de Carthage. *Revue des sciences ecclésiastiques* 4: 289–309.

Poinssot, Louis
 1910 *Les inscriptions de Thugga*. Imprimerie nationale, Paris.

Pommier, Édouard
 1991 *L'art de la liberté: doctrines et débats de la Révolution française*. Gallimard, Paris.

Poulot, Dominique
 1993 Le sens du patrimoine: hier et aujourd'hui (note critique). *Annales. Économies, sociétés, civilisations* 48(6): 1601–13.
 2006 *Une histoire du patrimoine en Occident, XVIIIᵉ–XXIᵉ siècle: du monument aux valeurs*. Presses universitaires de France, Paris.

Renier, Léon
 1850 Notice sur le tombeau de T. Flavius Maximus. *Revue Archéologique* 7: 186–87.
 1851 Voyage archéologique au pied de l'Aurès. *Revue Archéologique* 8: 492–513.

Said, Edward
 1978 *Orientalism*. Vintage Books, New York.Sayadi, Skander
 2007 *A travers les cartes postales: Carthage, 1895–1930*. Alif, Tunis.

Shaw, Wendy
 2003 *Possessors and Possessed: Museums, Archaeology, and the Visualization of History in the Late Ottoman Empire*. University of California Press, Berkeley.

Temple, Grenville
 1835 *Excursions in the Mediterranean: Algiers and Tunis*. 2 vols. Saunders and Otley, London.

Vellard, A.
 1896 *Carthage autrefois, Carthage aujourd'hui: description et guide*. V. Ducoulombier, Lille.

Wallis, Robert, and Jenny Blain
 2011 From Respect to Reburial: Negotiating Pagan Interest in Prehistoric Human Remains in Britain, through the Avebury Consultation. *Public Archaeology* 10(1): 23–45.

CHAPTER 14

The Colonial Origins of Myth and National Identity in Uganda

Peter R. Schmidt

In the western part of central Uganda, deep within the bush, are massive earthworks known as Bigo. Long a topic of speculation and national pride, the earthworks show evidence of deep "ditches" and contiguous mounds or rampart-like features. Bigo is the alleged capital site for a "white" foreign dynasty that supposedly ruled a vast empire from Bigo in western Uganda, known as Kitara or the Bunyoro-Kitara Empire, in about the mid-second millennium CE (Fig. 14.1). Known as the Bacwezi (hereafter Cwezi) kings, the history of this mythical capital dominates national consciousness today in Uganda—hundreds of years after its abandonment. Who were the Cwezi? What is their association with Bigo? Why did they suddenly disappear? These and many other questions infuse historical discourse today in Uganda and the wider region in which the Cwezi are still venerated as ancestors (Walz and Schmidt 2008).

A central problem in the historiography of Eastern Africa is the indelible imprint that colonial archaeology and history have had on metanarratives about the early history of Uganda (Schmidt 2006; Schmidt and Walz 2007). Colonial constructs arose directly from the need to validate British colonial rule in territories that were contested between the two primary kingdoms of Uganda, Buganda, and Bunyoro. Once embedded as part of Ugandan interpretive history, these constructs have taken on a life of their own, enduring postcolonial critiques and being adopted as virtually sacred texts that underwrite the validity of the modern nation-state. I will illustrate here how this transformation of Uganda's ancient history occurred under the aegis of colonial rule and the key role that archaeology played in that enterprise. In this particular case the very materiality of archaeology, when

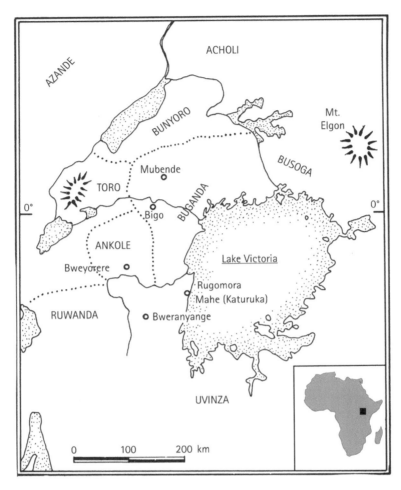

FIGURE 14.1. Key sites associated with oral traditions in Uganda and
Tanzania. Map by Peter Schmidt.

marshaled on behalf of weak and doubtful interpretations of oral traditions, has
ensured that a manifestly uncertain narrative has endured to be used as a val-
orization of contemporary political life. This is a story fraught with sleights of
hand, incomplete and inadequate research, and an uncritical acceptance of
sources that cannot sustain scrutiny. Yet, today it is stronger than ever in its hun-
dred-year evolution, reaching the vaunted status of unchallengeable history, or a
condition that Trouilllot (1995) identifies as "unthinkable" to challenge.

The Colonial Invention of History in Uganda

My first focus is an examination of local oral traditions that were initially utilized during the first three decades of colonial history to serve the political *and cultural* agendas of the colonial regime, a purposeful political manipulation. Colonial authorities in Uganda privileged an odd collection of oral traditions to underwrite the legitimacy of local authorities, their agents in indirect rule. This story unveils how the creation of an elaborate historical illusion—the Kitara Empire ruled by the Cwezi from their capital at the enormous Bigo earthworks with its ten kilometers of ditches in Western Uganda—implicates archaeology in what is now a central pillar of colonial and post-colonial history in East Africa. The Bigo site, long the most famous of all earthwork sites in Eastern Africa, is at the same time relatively unexplored archaeologically since a spate of activity about sixty years ago. This condition has ensured the perpetuation of the myth of a Kitara Empire led by the Cwezi (later manifested as spirits that possessed those of the Cwezi-kubandwa cult; see Doyle 2007).

This potent colonial construct was forged in the field by a British colonial administrator and later reified in the academy. It has endured for a full century, achieving widespread popularity and acting as a rallying point in declarations of national identity by the Ugandan head of state, who still uses references to the Cwezi to establish his social, geographical, and historical legitimacy. Used in this manner, the Cwezi remain very visible and recognized players in the political arena of contemporary Uganda, particularly when they are invoked to undergird the power of origins and the legitimacy of a Cwezi-led empire, the quintessential unitary state. These potent images of Cwezi grandeur, today shared across ethnicity and geography, are linked to a majestically imagined Cwezi capital at the Bigo earthworks.

When a colonial construct gains such widespread acceptance, we may also expect that alternative histories have been forced underground, to become subaltern and slowly fade away, a process accelerated by the erosion of oral traditions during the HIV/AIDS crisis and globalization (Schmidt 2010, 2014a). It is also hardly surprising that postcolonial critiques applied to these essentialized histories and their scholastic deficiencies have had negligible effect so that alternative histories continue to remain hidden beneath the carapace of political expediency. That such colonial manipulations have endured after fifty years of post-colonial history making—still setting the scene for conventional history in eastern Africa—is testimony to a resiliency derived from the power of print media during the peak of colonialism during the 1930s as well as later academic valorization of and participation in such treatments.

Within the context of decolonizing archaeological practice, such legacies summon us, begging our attention to explain: how did this construct unfold, take on additional value, and become legitimized as history? (Schmidt 1990, 2006). Perhaps the most continuous and abundant abuse in colonial-era archaeology is the citation of insubstantial and confusing ^{14}C dating results at Bigo, a practice that continues to exacerbate serious interpretive problems relative to the dating of Bigo, initially attributed to the fourteenth to fifteenth centuries. This dating scheme fits a late colonial and early post-colonial paradigm (Oliver 1953, 1955, 1963) that arose from the initial manipulation of oral traditions. However, we now have incontrovertible evidence, readily available although assiduously ignored, that the oral texts supposedly linking the Cwezi to Bigo are in fact ethnically heterogeneous. They are dominated or influenced by Ganda accounts in a region that had been under Bunyoro hegemony for hundreds of years until removed as part of territorial losses codified in the 1900 Uganda agreement (following the defeat of the Bunyoro Kingdom by a British-Ganda alliance and the loss of many Bunyoro counties to Buganda). As a collection, these texts are at best a hasty bricolage that helped to sustain British indirect rule over the Lost Counties, territories in eastern Bunyoro awarded to Buganda under the Uganda Agreement.

After the British employed Ganda administrators to oversee territories ruled by the Banyoro for centuries, the Lost Counties presented awkward and difficult administrative conditions to British colonial officers posted to areas where the Bigo earthworks and other alleged Cwezi sites were located. Indirect rule implemented by British colonial officers presented a vexing complication that ignored local identities as well as official policy. The local population self-identified as Banyoro, not Ganda. The British-appointed administrators, however, were Ganda chiefs and nobles, a condition that contributed significantly to political tensions with the subject Banyoro (Lanning 1970). Indirect rule was intended to employ and co-opt local leaders, not the elite of a neighboring rival group, in this case the Ganda, who were "winners" in the internal colonial war. In his oversight of tension-filled governance, the local British district commissioner, D. L. Baines, reached into his grab-bag of local knowledge to fabricate a narrative that reached far back in time and valorized Bigo as an iconic genesis of the Cwezi Empire located in the midst of the Lost Counties. This narrative, drawn from a reservoir of metaphors found in both Ganda *and* Banyoro testimonies, valorized hegemonic Ganda testimony about Bigo, privileged past rulers of Bunyoro-Kitara (thus also affirming Bunyoro hegemony over Bigo), and validated vague Cwezi associations with Bigo.

When D. L. Baines (1909) published his collection of oral tradition about the Cwezi at Bigo, he did so in a colonial newspaper, the *Official Uganda*

Gazette—intended for other colonial officials in Uganda who read and referenced its accounts. While he had reason to go to the trouble of compiling the accounts and publishing them to legitimize British governance through (false) ties to a grand and glorious past, his role in this affair terminated with the 1909 publication. Baines's selections of these particular oral traditions resonated with British sensibilities and notions of hierarchy. They drew on deep-time metonymies on behalf of Cwezi rule—the golden age of antiquity, the period of consolidation and centrality at Bigo, when much of contemporary Uganda was united under one rule. These were familiar values to British administrators, who thoroughly understood ruling houses, royal lineages, and the importance of imperial palaces on the landscape. This colonial imprint of imperial grandeur was to prove enduring. It was a rewriting of East African history that displayed an extraordinary resiliency. The original construct continues to dominate contemporary imaginations about the past, present, and future (Schmidt 2014b).

AN HISTORICAL ETYMOLOGY OF THE CWEZI AT BIGO

Once in print, Baines's stories took on their own agency, potency, and authority as the printed word.[1] Imbuing the colonial landscape with deep imperial characteristics, Baines's historical bricolage not surprisingly featured a Ganda oral tradition.[2] "The most generally accepted tradition amongst the Ganda attributes the construction of this place [Bigo] to the 'stranger' (Mugenyi)[,] a personage who is supposed to have entered Uganda from the north ... roughly 600 years ago" (Baines 1909: 138). In the Runyoro language of Bunyoro, Mugenyi means 'stranger,' a name occasionally mentioned in some Cwezi narratives but not associated with a major Cwezi figure. Baines's account lay unmentioned for eleven years until it was recapitulated in Pere Gorju's (1920) widely cited and influential book, *Entre le Victoria, l'Albert et l'Edouard*, about interlacustrine societies and one of the first syntheses of the early history of the Great Lakes region. With the advantage of nearly one hundred years of hindsight, we now understand that it was Gorju's reiteration of Baines's treatments that launched their reification in Eastern African historiography. Gorju did not affirm that there were oral traditions about the Cwezi at Bigo, but he importantly asserted that Mugenyi of Bigo (mentioned in the Ganda account) was the Cwezi figure of that name.

The matter of Cwezi association with Bigo then rested until resurrected by another colonial functionary, E. J. Wayland. A geologist and head of the Uganda Geological Survey who took a keen interest in Bigo and other earthwork sites of western Uganda, Wayland (1934) published a report in the *Uganda Journal* based on notes about Bigo from a 1921 report by a fellow geologist, A. D.

Combes. He wrote a short commentary based on his colleague's report and reprinted the Baines article in its entirety (Wayland 1934). By this action, Wayland repositioned Bigo and its alleged oral traditions back onto the center stage of Ugandan colonial discourse, as the *Uganda Journal* was an avidly read publication in both colonial and academic circles.

It did not take long for the colonial literati to notice and take up the issue in greater detail. Sir John Gray, later knighted for his colonial service as a judge in Zanzibar, was then in colonial service as a lawyer in Uganda. Having a very scholastic bent,[3] John Gray expanded upon Wayland's key observations about supposed Cwezi associations with Bigo in another *Uganda Journal* article the next year (Gray 1935). Using a definitive tone and cast in scholarly language, Gray's "Riddle of Biggo" imbued the issue with authority and a degree of finality it had not possessed before.

When examined closely, we find that Gray's essay is hardly a model of scholastic rigor, a conclusion buttressed by the absence of citations for many of his claims. For example, he says, "one of the many traditions regarding the earthworks is that their constructor, Mugenyi, was buried there" (Gray 1935: 229); he does not cite the origins of this information—either personal research in the area or some other source. Perhaps Gray's most misleading treatment is his use of Ganda oral traditions to make his case for the Cwezi at Bigo, something that amplifies Baines's use of Ganda traditions. This doubtful claim plus his assertion that there are *many tales* associated with Bigo weaken confidence in the veracity of his arguments. A paucity of Cwezi evidence and a privileging of stories derived from Ganda—not previously associated with this region—demonstrate a bias toward Ganda perspectives with the effect, if not the intent, of sustaining Ganda hegemony over the Lost Counties. Gray mentions Apolo Kaggwa (1901), a Ganda author of Buganda history and an important political figure in colonial Buganda, citing Kaggwa's reference to one of the early kings of Buganda having lived at Bigo. Kiwanuka (1971) later convincingly challenged this idea in his detailed analysis and translation of Kaggwa's history. Kiwanuka shows that the "Bigo" location mentioned by Kaggwa is an altogether different place from the Bigo earthworks (Schmidt 2006).

Gray also cites an article published in a 1923 issue of *Munno*, a local Uganda newspaper, about a story recounting how a prince from Kiziba (a Haya state in northwestern Tanzania, just south of the Uganda border) recovered stolen cattle during the sixth Bunyoro reign from Kagago, a site that supposedly neighbors Bigo. It is important to stress that this tradition does not pertain to the Cwezi at Bigo; it simply mentions, in passing, a later Bunyoro link to Bigo long after the passing of the Cwezi. Gray was unable to attach any direct association of the

Cwezi to Bigo. In drawing his case for the Cwezi at Bigo, Gray also favored Gorju's translation of the phrase "Biggo by Mugenyi" as "the forts of Mugenyi" rather than the "forts of the stranger," a treatment that emphasizes the Cwezi name rather than the generic meaning of the word. Gray also cites a local Munyoro author, Bikunya (1927), as affirming the same point, but does not acknowledge that Gorju's interpretation of Mugenyi was certainly known to Bakunya at a time when literate Ugandans were quickly adopting print media and using previously published material in an uncritical manner. Even Gray admits that the argument is shaky: "Mugenyi was one of these Cwezi, but, apart from his name, tradition does not associate him with the regions of Biggo and does not picture him as a fighting man" (Gray 1935: 232).

Despite this accurate analysis, Gray was not inhibited from concluding the contrary, that "alone of all the traditional rulers of the land, the Cwezi, of whom Mugenyi was one, seems to fit in with the evidence afforded by the earthworks themselves" (Gray 1935: 233). This tautology concludes the colonial transformation of what started as a careless political pastiche in 1909. Over the next quarter century, it became a concretized rendering of local history and landscape. Its publication in the *Uganda Journal*, soon to become a widely circulated journal in academe,[4] assured that these fabricated "historical" renderings received a receptive audience two decades later, when the academic community "rediscovered" them, only to privilege and propagate the colonial construct.

The Academic Reification of the Cwezi at Bigo: Archaeology Enters Center Stage

The transformation of the Cwezi from local leaders and religious figures—best represented as politico-religious figures—to a major political dynasty quartered at Bigo occurred at the end of the colonial period within the halls of the School of African and Oriental Studies at the University of London. There, Roland Oliver led the way in establishing African history as a new subject field within history. One of his primary interests was the role of the Cwezi in Uganda history, a topic he took up in a 1953 article in which he planted the idea that archaeology might be able to sort out the antiquity of the Cwezi "capital" sites. That is, "the earlier Bachwezi capitals ... if found and excavated along with sites in Bwera and Mubende, would surely add a wealth of material evidence *to support and qualify the allegations of traditions*" (Oliver 1953: 137; emphasis mine). Although he does not specifically mention what traditions he means, there is little doubt that the earlier publications about Bigo form the backdrop to this statement. Oliver in this early period appears incautiously eager to make a case for the Cwezi at Bigo, going

so far as to accept uncritically a pre-publication claim by two local Ugandan historians (Katate and Kamugungunu 1955) that Ruyanga—almost universally called Ruhanga (the supreme god)—lived opposite Bigo on the Katonga River and was a Mucwezi. This claim contradicts all known Cwezi myth, in which Ruhanga is not incorporated into the Cwezi pantheon (see Tantala 1989).

This treatment of Ugandan history is only the first chapter in Oliver's handling of the subject, followed by his subsequent claim six years later that the Cwezi were an historical dynasty and the makers of Bigo (Oliver 1959). There was no oral evidence to support this claim, but it remained unchallenged. Hidden behind the scenes, unmentioned by Oliver until his 1997 autobiography, was his personal familiarity with Bigo based on a 1958 visit during which he recalled: "It was immediately apparent to us that the two curved embankments in the centre of the site had at one time formed part of a single U-shaped enclosure on the pattern of the royal enclosures in Ankole" (Oliver 1997: 212). This observation allowed him to conclude that Bigo was a royal capital. Also left in the background was Oliver's knowledge that archaeologist Peter Shinnie had excavated at Bigo in 1957, expressly to examine the question of historical problems connecting with "legends." While Shinnie's excavations led him to conclude in his 1960 publication that the Cwezi problem was no closer to being solved, Oliver took a more tendentious position in his 1959 treatment (prior to Shinnie's publication and after his 1958 site visit to Bigo), because he apparently assumed that archaeology done at Bigo would support the idea of the Cwezi at Bigo. Not surprisingly, he ignored Shinnie's conclusions that the Bigo excavations were inconclusive regarding Bigo being a capital site for the Cwezi.

Merrick Posnansky was the next archaeologist to excavate at Bigo in 1960 (Posnansky 1966, 1969) (Fig. 14.2). There he excavated a large number of trenches over a six-week period, first reporting, without details, in a synthetic article titled "Kingship, Archaeology, and Historical Myth" (Posnansky 1966). An important factor of the Bigo excavation was the little-recognized inclusion of Roland Oliver as an archaeological "trainee," provided with his own laborers to assist him. This experience evidently conferred on Oliver a sense of ownership of the Bigo excavations, during which he described his participation in a letter to his wife:

> It just seems a great mass of incomprehensible detail. I have marked out and started to open up three little trenches, 15′ × 3′, on top of the central mound. In the course of three hours I suppose we have gone down six or seven inches, taking off the top layer with a hoe, and then forking and shoveling two more layers of top-soil, taking us down to the red laterite of which the mound was built. The only result was half a bag of pottery shards and bones of a goat or small antelope (Oliver 1997: 241).

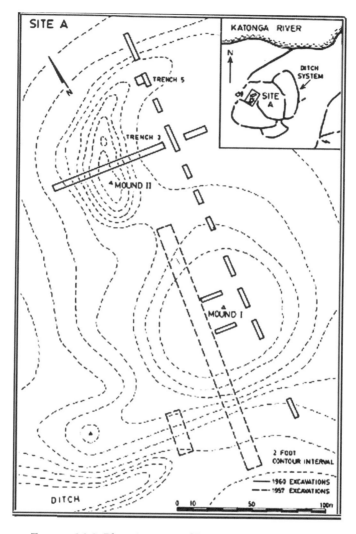

FIGURE 14.2. Plan view map of Bigo excavations in 1960.
Redrawn from Posnansky (1969).

Given the long interval between the excavations and the final report (Posnansky 1969), it appears that Oliver may have grown discouraged with the pace of the write-up and drew on his personal participation in the 1960 excavations to arrive at his own conclusions. Still eager to claim physical evidence for his thesis placing the Cwezi capital at Bigo, Oliver wrote a key chapter in the 1963 *Oxford History of East Africa*, a volume he edited and that became a seminal work

for subsequent East African history.[5] Oliver argued with much more rigor, but
no evidence, that many versions of oral tradition had identified Bigo as the Cwezi
capital: "According to tradition, the last capital centre of the last of the Chwezi
kings was in the celebrated entrenched earthwork site at Bigo on the Katongo
river" (Oliver 1963: 181). Oliver also cited archaeological evidence to buttress his
thin argument regarding "traditions," viz: "Recent archaeological investigations
have tended to confirm the traditional evidence that Bigo was the seat of a Hima
dynasty" (181), and that "[t]he original layout of the central embankments was
almost certainly similar to that of the typical *orirembo*, or royal town, of the early
Hinda kings of Ankole" (182). In fact, however, the archaeological evidence is
fraught with ambiguity over the central layout: much of the so-called U-shaped
enclosure was destroyed by a later mound (Posnansky 1969; Fig. 14.3). Privi-
leged knowledge of the archaeological evidence—regardless of its particulars and
its accuracy—was enough for Oliver to link ephemeral oral traditions to a sup-
posed capital site, a spurious construct dating back to 1909.

Oliver's sanguine interpretations of Bigo, selectively using the 1960 excava-
tion data, placed Posnansky in an awkward position. He did not want to offend a
friend and colleague who was by then perhaps the most visible historian of Africa
in the Western world. His assessment was notably more tempered than that of
Oliver, although he accepted the interpretations of his more senior and influential
colleague about the oral tradition evidence. He concluded that "on the basis of the
tradition, [I] would date the Bigo culture at 1350–1500 and would also accept the
correlation of the Bigo culture with the Cwezi" (Posnansky 1966: 4). This is an
important caveat by Posnansky, for he was associating the Cwezi only with Bigo
culture as defined by a distinctive ceramic assemblage found at Bigo as well as
other nearby sites such as Ntusi earthworks. Yet, as entrapped as he was by the
prior and incautious interpretations of Oliver, Posnansky understandably came
down on the side of Bigo as the Cwezi capital site, to wit: "At the centre of Bigo an
enclosure bank … has been interpreted as a royal enclosure (irirembo) … [and]
supports the further suggestion that Bigo was the capital of this state" (Posnansky
1966: 5). He further added that the preliminary radiocarbon dates "reinforce the
view that the occupation period was short and provide a date for that occupation
of around 1350–1500 AD. The date is identical to that for the Cwezi worked out
from the traditional history" (Posnansky 1966: 5). Thus the Cwezi/Bigo con-
struct finally had its material affirmation, despite the fact that the structural evi-
dence cited—the so-called crescent-shaped mound at Bigo signifying a royal res-
idence—was ephemeral if not imaginary. Based on the supposition that part of
the mound had been previously destroyed (Posnansky 1969), the mound shape
was projected into a crescent shape without any structural evidence to substanti-

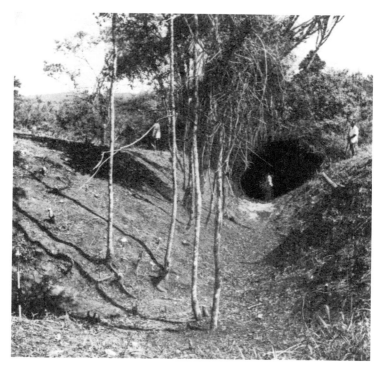

FIGURE 14.3. Bigo entrenchment after clearing and before excavations in 1960.
Photo by Merrick Posnansky, with permission.

ate such an interpretation. The shakiness of the structural evidence must also be
juxtaposed to Posnansky's increasingly equivocal interpretations of the oral tra-
ditions in the final 1969 report: "Though Bigo is mentioned in various traditions
including those of Bunyoro and Ankole and is connected with Cwezi tales, there
are no descriptive accounts about the site itself and many of the traditions would
appear to have been invented later to explain the presence of such earthworks"
(Posnansky 1969: 143). True to the fashion of not citing the specific oral tradi-
tions that supposedly pertain to Bigo, this history is left with vague attributions
undermined by the suggestion that many of these tales are later fabrications.
These were hardly a solid basis on which to underwrite faith in Bigo as a Cwezi
capital site.

The second archaeological issue to emerge from the 1969 report is the dat-
ing marshaled to support the idea that the Cwezi occupied this and other near-
by sites just before the mid-second millennium CE. Without delving into the

details (see Schmidt 2006: 239–40, 244), the radiocarbon dates were adjusted between the 1966 and 1969 publications to change the occupation period at Bigo from 1350–1500 CE to 1290–1575 CE, with no explanation as to why such a change was necessary. My calculations show that the dates range from (1) 850 to present and (2) two dates (GXO 516 and 519) range from 1365 to 1750 CE with a 95-percent level of confidence and 1435 to 1660 CE with a 65-percent level of confidence. When GXO 517 (850 CE to the present) and GXO 518 (recent) are included, the range becomes even more recent. This is much too late to fit the Cwezi paradigm, which places the Cwezi at Bigo during the fourteenth to fifteenth centuries.[6] The most critical date in terms of establishing the antiquity of the crescent-shaped "royal" mound was GXO 519: 1570 ± 90 CE, a date mis-published in 1966 that should be *1370* ± 90 (Robertshaw and Taylor 2000). As is often the case in discussions about the Cwezi vis-à-vis Bigo, evidence is not closely examined for its accuracy. My conclusion favoring a later, post-1500 occupation at Bigo is made even stronger by the dating within the so-called crescent mound. Not accounted for in the revised argument that Bigo existed earlier (Robertshaw and Taylor 2000) is a blatant discontinuity in the dating: underlying GXO 519 (1370 ± 90 CE) is a more recent date, GXO 516 (1505 ± 70 CE), located on the original ground surface. This more recent date invalidates any attempt to maintain Bigo within the Cwezi orbit—setting to rest this most recent effort to fit Bigo into the royal house of cards first erected in 1909.

CONTINUING MISREPRESENTATIONS AND MISUNDERSTANDINGS

The effect of these various positions privileging a colonial fabrication has been to drive contrary accounts to the margins, making them subaltern within the literature of East African history and archaeology. Here I use subaltern in a manner that resonates with Mignolo's (2000) usage, when hegemonic academic influences suppress and marginalize alternative ways of knowing. Also, the long absence of any rigorous, direct research into the oral traditions that pertain to Bigo has created a subaltern space in East African historiography. It is now too late in a setting in which the Cwezi feature almost daily in the national discourse to find uncontaminated accounts, let alone those that were pushed into the background and made subaltern as colonial functionaries and scholars rushed to valorize the colonial bricolage and memorialize Bigo.[7] As Doyle (2007: 562) observes in a recent review of the Cwezi, "[The texts] associated with diverse shrine-based networks have largely unraveled, and local community patterns can only be pieced together with difficulty. A century of repression and a longer tradition of distortion require a degree of caution in any analysis of this religion." The caution that

Doyle enjoins us to exercise must be applied as well to uncritical rehashing and acceptance of the colonial myth of the Cwezi at Bigo seen in both local and foreign scholarship.

Archaeological research has continued in the region that was supposedly subject to Cwezi hegemony, though the paradigm has had to be adjusted when sites do not fit the image of capitals. Once Bigo had been disclosed as problematic (Schmidt 1990), then attention turned to another major site, Mubende Hill, more securely associated with Cwezi oral traditions as a capital of the first Cwezi King, Ndahura. Excavations there, however, did not confirm the presence of a capital (Robertshaw 1991, 1994; Robertshaw and Taylor 2000), forcing a significant readjustment of ideas about the Cwezi presence on the western Ugandan landscape. Robertshaw now favors, correctly I believe, Cwezi being associated with chiefship, a characteristic I further imagine to be deeply imbued with ritual authority and divination as the Cwezi have been through deep time. The dating of Mubende Hill, with only two unsealed and patently inadequate radiocarbon dates to the fourteenth and fifteenth centuries, leaves many open and unanswered questions about its role in ritual and history, not to mention the purposefully diminished presence of an Early Iron Age occupation that is much more significant than the "ephemeral" characterization than it has been given (Schmidt and Rhodes 2006).

The task of decolonizing the history and archaeology of Uganda may be beyond the capacity of our contemporary tool kit. Constant iterations, academic and popular, of the "orthodox" position have virtually assured the perpetuity of its distortions, a phenomenon captured by Tosh and Lang when they write:

> In societies where literacy is a recent accomplishment and is associated with the ruling group, the written word carries immense and indiscriminate prestige. In Africa the earliest published versions of oral tradition, regardless of quality, acquired authority at the expense of other versions, and they often become the standard forms in which the tradition was repeated orally. The outcome was a *permanent distortion*.... (Tosh and Lang 2006: 329; emphasis mine).

Long after the unattributed accounts of Baines, Sir John Gray, and Roland Oliver, we find that similar treatments continue to distort academic studies of the Cwezi and Bigo. Misrepresentations arise from multiple sources including historians of East Africa with little familiarity with archaeology. Brigitta Ferelius (2008), in an otherwise exhaustive study of the Cwezi and kingship in East Africa, not only misunderstands dating at Bigo but refers repeatedly to Bigo as the Cwezi capital, reifying its supposed role without evidence. Particularly telling is her query (2008: 193), "But one wonders why scholars dismiss the

Cwezi connection with the impressive archaeological remains with the frame-
work of an ancient state in this part of the world, when local historians and eld-
ers agree on the issue." Her answer to this question comes from her field research
in the region when she proffers and examines *only one oral text*, a short answer to
a direct question that pertains to areas, such as Ntusi, that were supposedly con-
trolled by the Cwezi as grazing lands. Even more problematic is to claim, as does
Ferelius, that *"Bahima* specialized herders in the former kingdom of Nkore know
Cwezi traditions told about a perceived Cwezi 'dynasty' they connect with *Bigo
bya Mugenyi"* (Ferelius 2008: 239; emphasis mine). This assertion, not sustained
by publication of texts, is rolled into one authoritative claim based on the famil-
iar trope of "oral traditions say…" that was seen long ago under colonialism in
Uganda. It cannot be accepted as credible (cf. Schmidt 2006).

BIGO AND THE CWEZI ON THE UGANDA NATIONAL STAGE

The contemporary role of the Cwezi and Bigo in Ugandan political life comes to
light often when President Y. Museveni of Uganda invokes their presence as a
means of rallying support of a united Ugandan state that resembles the envelop-
ing Bunyoro-Kitara Empire. A more recent and potent expression of this histor-
ical invocation occurred in a speech given at the sixteenth-anniversary celebration
of the coronation of the Mukama (king) of Bunyoro, held June 21, 2010, when
Museveni set out his vision without ambiguity when he turned to lecture the
Mukama:

> Now … the people who briefed you about the history of this place were wrong.
> The kingdoms here are much older than 1400 [AD]. The excavations which
> were done in Ntuusi, in Bwera Sembabule which the Omukama was talking
> about, show that those sites were active in 900 AD and before. It is [the] Babi-
> ito dynasty which started in 1400. Before that, there were the Cwezi and before
> that, the Batembuuzi. When the clay pot ware and cattle bones excavated from
> Bigo bya Mugenyi and Ntuusi were examined, it was established that the set-
> tlements at Ntuusi were in 900 AD and Bigo bya Mugenyi in 900–1350.
> Therefore, the kingship here dates far back.[8]

This is an intriguing use of historical citation to affirm the legitimacy and
antiquity of Bunyoro-Kitara and the Cwezi. We rarely find heads of state citing
historical genealogies and archaeological evidence—right down to clay pots and
cattle bones. Their materiality potently supports the arguments that President
Museveni wants to make about the ancient hegemony of the Cwezi—a mirror of
what he wants modern Uganda to be. The setting is filled with ritual potency: the

president had already devoted considerable time to a discussion of ritual callings and the need for those with ritual callings (priests, kings, etc.) to stick to their prescribed duties. He cast the Mukama into the role of a *ritually committed* person who does not stray from expectations by involvement in national politics.

This recent politically loaded event, with the president addressing the role of the current kingdom within a unified nation-state, marks Uganda's uneasy but necessary support of endogenous political entities like Bunyoro. The state needs the loyalty and cooperation of the kingdoms, their kings, and the people who hold them in respect. Thus, Museveni's mission at this important ritual was to pitch a unitary state made up of critical parts, including the kingdoms. He stressed repeatedly that working together would ensure the prosperity of the people, the kingdom, the state, and East Africa. The quoted paragraph opens with a blunt admonishment to the Mukama, informing him that he needs to know more about the history of his country and his kingdom: "Now ... the people who briefed you about the history of this place were wrong." He leaves absolutely no doubt—this is the head of state speaking—that what he will relate next will be the right or correct history. Museveni quickly took on the guise of a historian and archaeologist, and archaeologists and historians would have no trouble following his narrative and his meanings: "The kingdoms here are much older than 1400. The excavations which were done in Ntuusi, in Bwera Sembabule which the Omukama is talking about, show that those sites were active in 900 AD and before." Clearly, he mastered his subject in referencing the antiquity of Ntusi to 900 and likely read or had his speechwriter read the archaeological reports that scholars such as Andrew Reid (e.g., 1991) and Peter Robertshaw (e.g., 1991, 1994, 2001) produced over the years.

At this point in his short history lesson, Museveni had his facts right. Upon reaching this point successfully, however, it was virtually inevitable that he would draw on Bigo as a national icon of unity to make his political point—that Bunyoro is marvelous and that the Kitara-Bunyoro Empire provides a model for a united, common, prosperous Uganda. He did not disappoint with his next reference to genealogy: "It is [the] Babiito dynasty which started in 1400. Before that, there were the Cwezi and before that, the Batembuuzi." Here Museveni related *conventionally* accepted periods in Uganda history. He then took an unusual tack when he drew from the archaeological record to substantiate his points: "When the clay pot[s] ware and cattle bones excavated from Bigo bya Mugyenyi and Ntuusi were examined, it was established that the settlements at Ntuusi were in 900 AD and Bigo bya Mugyenyi in 900–1350.[9] Therefore, the kingship here dates far back." Until he unveiled this surprise, Museveni was on track for a high score in historical accuracy. Ntusi has indeed been dated to a 900 CE start (Reid

1991; Sutton 1998). But, and here is where the manipulation of dates can signif-
icantly change historical meanings linked to political potency, *Bigo does not date
to 900–1350 CE*. It dates to the post-1500 period, with the alternative claim for
a 1350–1500 occupation discredited (Schmidt 1990, 2006; Sutton 1998). Per-
haps President Museveni or his speech writer misunderstood the "850–present"
date at Bigo (Posnansky 1966), an archaeologically meaningless result that a lay
person could easily misinterpret. Whatever the source of the misinformation,
this and other citations of early dating for Bigo provide a chilling warning about
how a few unreliable and discredited dates have come to support a powerful
interpretive superstructure. Bigo is not contemporary to the beginnings of Ntusi.
President Museveni went unchallenged in this characterization, and Bigo sud-
denly grew six hundred years older to fit the presidential argument.

One additional event at the same coronation anniversary ties in tightly with
the hegemony of the Bunyoro-Kitara empire and the make-up of the Bunyoro
kingdom before the British colonial administration assigned the Lost Counties
to Buganda in 1900. Present at the ceremonies was Baker Kimeze, the leader
(Sabanyala) of the Banyala people of Bugerere, one of the Lost Counties. At the
ceremonies, in the presence of the president, he declared: "We are the prodigal
sons of Bunyoro and not Buganda; so, we have come home." As the *Observer*
newspaper reported, "His declarations didn't go unrewarded, as Bunyoro King-
dom handed him a traditional robe and the head of the Babito (royal clan) in the
kingdom wrapped a barkcloth around the Sabanyala, saying it is a ritual that
Bunyoro performs for all kings who have ties with Bunyoro" (Ssekika 2010).
This symbolic political ritual, performed in the presence of the head of state,
returned a Lost County ruler to the dominion of Bunyoro while simultaneously
making a point against the Kabaka (king) of Buganda, with whom the president
was feuding over what he saw as threats by Buganda to the unity of the state.

Part of President Museveni's public persona is now linked to his repeated
declarations of unity affirmed by the deep-time history of the Cwezi at Bigo. The
widespread popularity of the colonial design and its use as an umbrella concept
for nationalistic proclamations about Ugandan unity is now part of everyday dis-
course in Uganda. Witness this discussion on a safari website: "It's important to
note that the British were not the first people to unite Uganda. Before the British
united Uganda, the Cwezi dynasty controlled parts of Uganda between 1100 AD
and 1600 AD. This is evidenced by historical sites like Bigo bya Mugenyi and
Omunsa in Bunyoro (Hoima)."[10] We see in this pronouncement how deeply
indebted contemporary, popular discourse is to District Commissioner Baines

(1909) and his successors as well as how dates are now commonly projected from other sites onto Bigo, conferring greater antiquity and enhancing political capital. In the face of such popular and political legitimacy, scholarship advancing critical perspectives on the Cwezi at Bigo appears destined to stay subaltern for the immediate future.

Notes

[1] Seven years later Baines was assigned to the first British administration in Bukoba, just south of Uganda in Tanganyika, where he was the first British DC. He immediately alienated the king of the largest kingdom by accusing him of murder and slapping him in a public rebuke—driving him to suicide—and demonstrating an uncanny ability to misunderstand local history and power relations. His machinations in Uganda appear to have prepared him well for his subsequent historical errors in Tanganyika.

[2] Ganda is an abbreviation of Baganda, the people of Buganda kingdom. The Banyoro are people identified with the kingdom of Bunyoro. Until the twentieth century, Bunyoro and Buganda were the most dominant political entities in Uganda.

[3] M. Posnansky, personal communication with author, November 7, 2012.

[4] A number of university libraries in the United States have had collections of the *Uganda Journal* from the earliest days of its publication.

[5] Uganda obtained its independence in 1962, the year when Oliver's volume was being compiled and one year before its publication.

[6] It does fit with more recent histories of the site.

[7] This assessment is not changed or affected by Farelius (2008: 202), who argues that the testimony (1992) of one informant links the name of an area near Bigo with the name of the hole in which Wamara drowned with his white cow. Ferelius's interpretation is highly speculative—much like previous attempts to link the Cwezi to Bigo. Given the voluminous national discourse about this matter over the last two decades, testimonies linked to Bigo—and particularly opaque testimonies of this genre—are likely contaminated and lack the specificity and symbolic weight to sustain such an interpretation.

[8] Translation of a speech given by President Y. Museveni at the coronation anniversary of Omukama of Bunyoro Kitara, Solomon Gafabusa Iguru, published in the *Observer*, a Uganda newspaper, as "What Museveni Said in Bunyoro." Available at http://observer.ug/news/headlines/8948-what-museveni-said-in-bunyoro, accessed October 31, 2017.

[9] The use of "ware" does not fit into the syntax and appears to be a leftover element from reports that discuss ceramic wares and clay pots; a non-archaeologist might not understand that they are equivalent and hence the inclusion of "ware." Alternatively, the redundancy may have crept in during translation.

[10] "A Brief History of Uganda: Uganda before Colonisation (Pre-colonisation)," Primate Watch Safaris Ltd website, www.primatewatchsafaris.com/uganda/uganda-history.html, accessed November 12, 2011. The reference to Omunsa is to Robertshaw's (2001) dating of the earliest occupation or use of Munsa to approximately 900 CE.

REFERENCES CITED

Baines, D. L.
 1909 Ancient Forts. *Official Uganda Gazette*. May 15: 137–38.

Bikunya, P.
 1927 *Ky'Abakama ba Bunyoro*. Shelton Press, London.

Doyle, S.
 2007 The Cwezi-kubandwa Debate: Gender, Hegemony and Pre-colonial Religion in Bunyoro, Western Uganda. *Africa* 77(4): 559–81.

Farelius, B.
 2008 *Origins of Kingship Traditions and Symbolism in the Great Lakes Region of Africa*. Historia religionum 29. Uppsala Universitet, Uppsala.

Gorju, J. L.
 1920 *Entre le Victoria, l'Albert et l'Edouard: Ethnographie de la partie anglaise du Vicariat de l'Uganda*. Oberthur, Rennes.

Gray, J. M.
 1935 The Riddle of Biggo. *Uganda Journal* 2: 226–33.

Henige, D. P.
 1980 "The Disease of Writing": Ganda and Banyoro Kinglists in a Newly Literate World. In *The African Past Speaks*, edited by J. Miller, pp. 240–61. Folkestone, UK, Dawson.

Kaggwa, A.
 1971 [1901] *Basekabaka be Buganda*. Uganda Bookshop, Kampala.

Katate, A. G., and L. Kamugungunu
 1955 *Abagabe b'Ankole*. Kampala.

Kiwanuka, M. S. M. (translator)
 1971 *The Kings of Buganda*. By Apolo Kaggwa. Introduction by M. S. M. Kiwanuka. East Africa Publishing House, Nairobi.

Lanning, E. C.
 1970 Ntusi: An Ancient Capital Site in Western Uganda. *Azania: Archaeological Research in Africa* 5: 39–54.

Mignolo, W. D.
 2000 *Local Histories/Global Designs: Coloniality, Subaltern Knowledges, and Border Thinking*. Princeton University Press, Princeton, NJ.

Oliver, R.
 1953 A Question about the Bachwezi. *Uganda Journal* 17: 135–37.
 1955 The Traditional Histories of Buganda, Bunyoro, and Nkole. *Journal of the Royal Anthropological Institute* 85: 111–17.
 1959 Ancient Capital Sites of Ankole. *Uganda Journal* 23(1): 51–63.

1963 Discernible Developments in the Interior, c. 1500–1840. In *History of East Africa*, edited by R. Oliver and G. Mathew, pp. 169–211. Clarendon Press, Oxford.

1997 *In the Realms of Gold: Pioneering in African History*. University of Wisconsin Press, Madison.

Posnansky, M

1966 Kingship, Archaeology, and Historical Myth. *Uganda Journal* 30: 1–12.

1969 Bigo bya Mugenyi. *Uganda Journal* 33: 125–50.

Reid, A. M.

1991 The Role of Cattle in the Later Iron Age Communities of Southern Uganda. PhD diss., University of Cambridge.

Robertshaw, P.

1991 Recent Archaeological Surveys in Western Uganda. *Nyame Akuma* 36: 40–46.

1994 Archaeological Survey, Ceramic Analysis, and State Formation in Western Uganda. *African Archaeological Review* 12: 105–31.

2001 The Age and Function of Ancient Earthworks of Western Uganda. *The Uganda Journal* 47: 20–33.

Robertshaw, P., and Taylor, D.

2000 Climate Change and the Rise of Political Complexity in Western Uganda. *Journal of African History* 41: 1–28.

Schmidt, P. R.

1978 *Historical Archaeology: A Structural Approach in an African Culture*. Greenwood Press, Westport, CT.

1990 Oral Traditions, Archaeology and History: A Short Reflective History. In *A History of African Archaeology*, edited by Peter Robertshaw, pp. 252–70. James Currey, London.

2006 *Historical Archaeology in Africa: Representation, Social Memory, and Oral Traditions*. AltaMira, Lanham, MD.

2010 Trauma and Social Memory in NW Tanzania: Organic, Spontaneous Community Collaboration. *Journal of Social Archaeology* 10(2): 255–79.

2014a Hardcore Ethnography: Interrogating the Intersection of Disease, Human Rights, and Heritage. *Heritage and Society* 7(2): 170–88.

2014b Deconstructing Archaeologies of Colonialism: Making and Unmaking the Subaltern. In *Rethinking Colonial Pasts through Archaeology*, edited by N. Ferris, R. Harrison, and M. Wilcox, pp. 445–65. Oxford University Press, Oxford.

Schmidt, P. R., and K. Rhodes

2006 The Cwezi Myth of Statehood: Its Resurrection and Demise. In *Historical Archaeology in Africa: Representation, Social Memory, and Oral Traditions*, pp. 246–59. AltaMira, Lanham, MD.

Schmidt, P. R., and J. R. Walz

 2007 Re-Representing African Pasts through Critical Historical Archaeologies. *American Antiquity* 72(1): 53–70.

Shinnie, P.

 1960 Excavations at Bigo. *Uganda Journal* 14: 16–28.

Ssekika, E.

 2010 Museveni to Mengo: I'll Cut Off Your Head. *Observer.* June 14. Available at www.observer.ug/index.php?option=com_content&view=article&id=8856: museveni-to-mengo-ill-cut-off-your-head&catid=78:topstories&itemid=79, accessed November 11, 2011.

Sutton, J. E. G.

 1998 Ntusi and Bigo: Farmers, Cattle-herders and Rulers in Western Uganda, AD 1000–1500. *Azania: Archaeological Research in Africa* 33: 39–72.

Tantala, R.

 1989 The Early History of Kitara in Western Uganda: Process Models of Religious and Political Change. PhD diss., University of Wisconsin.

Tosh, J., and S. Lang

 2006 *The Pursuit of History: Aims, Methods, and New Directions in the Study of Modern History.* Fourth edition. Pearson Education, London.

Trouillot, M.-R.

 1995 *Silencing the Past.* Beacon Press, Boston.

Walz, J. R., and P. R. Schmidt

 2008 How Archaeological Practices Transform Indigenous Histories into Subaltern Histories in Eastern Africa. Paper presented at Annual Meeting of the American Anthropological Association, San Francisco, November 19–23.

Wayland, E. J.

 1934 Notes on the Bigo bya Mugenyi. *Uganda Journal* 1: 21–32.

CHAPTER 15

Japanese Colonial Archaeology in Korea and Its Legacy

Yangjin Pak

INTRODUCTION

Before the introduction of modern archaeology to Korea, some Confucian scholars of the Chosŏn Dynasty (1392–1910) were curious about ancient sites (e.g., dolmens, mounded tombs) and artifacts (e.g., polished stone tools), and left speculative comments for posterity (Yi Sŏnbok 2002). However, their curiosity never developed into formal scientific research. What we would consider modern archaeological investigation in Korea was initiated with the surveys and excavations undertaken by Japanese archaeologists in the early twentieth century and during the Japanese colonial occupation of Korea between 1910 and 1945.

Archaeology itself is a scientific discipline that developed in the Western intellectual traditions during the eighteenth and nineteenth centuries (Trigger 1989). China and Japan were the first countries in East Asia to which European traditions of archaeology and anthropology were introduced (Díaz-Andreu 2007: 188–201; see also Lai and Xu, this volume). As the discipline grew, Japanese archaeologists were eager to explore archaeological sites not only in Japan but also in other areas of East Asia, including Taiwan, Korea, and Manchuria. After its victories in the Sino-Japanese (1894–95) and Russo-Japanese (1904–05) wars, Japan gained access to their newly acquired colonies in Taiwan and on the Liaodong peninsula and used them as a base for various kinds of archaeological expeditions.

In 1910, Korea was fully annexed to imperial Japan and remained under Japanese rule until the Japanese surrendered in 1945. Even before the thirty-five-year occupation, however, the Japanese colonial government was involved in every aspect of archaeological research of ancient sites and the management of cultural heritage. In this chapter, I analyze the scope of exploration and the roles adopted by the Government-General of Korea (GGK), Chōsen Sōtokufu 朝鮮 總督府, and the Japanese archaeologists hired by the GGK to conduct archaeological investigations on the Korean peninsula. I begin by summarizing the development of Japanese colonial archaeology in Korea in five proposed phases, and then analyze characteristics of Japanese colonial archaeology as practiced in Korea in terms of legal frameworks, institutions and individuals, methodologies, and interpretations. In addition to discussing the legacy of Japanese colonial archaeology in Korea, I conclude with a brief discussion of the influence of these historical developments on the early history of archaeology in both North and South Korea.

Japanese Colonial Archaeology in Korea

The practice of Japanese colonial archaeology in Korea during the first half of the twentieth century may be divided into five general phases. These developments reflected important contemporary factors, including major political and cultural events, the promulgation of laws and regulations concerning the management of archaeological heritage, major governmental policy changes, the rise of funding agencies for archaeological works, and the creation of institutions that supported and empowered archaeologists.

The initial phase of Japanese colonial archaeology, 1900 to 1910, is the earliest period of archaeological research conducted by Japanese scholars before official annexation of Korea to Japan. In 1900 and 1901, the first known archaeological survey by a Japanese scholar was carried out by Yagi Sōzaburō 八木奘三郎 (1866–1942) (Ko Jung-yong 1996; Ch'oe Sŏk-yŏng 2015). A graduate student of Tokyo Imperial University, Yagi was dispatched to Korea by the Tokyo Anthropological Society and his advisor, Tsuboi Shōgorō 坪井正五郎 (1863–1913), a pioneer in Japanese anthropology and archaeology. Yagi's research goals were described as the study of racial makeup, archaeology, and ethnography of Korea (Pai 2013: 110). His first survey lasted for more than four months and the Korean government sent notes to local county chiefs to provide him with assistance. Yagi surveyed prehistoric as well as historic sites, Buddhist temples, and fortresses in Pyŏngyang, Pusan, Kimhae, and Kyŏngju areas and was able to collect pottery shards that he transported to Japan (Ch'oe Sŏk-yŏng 2015).

In 1902, Tokyo Imperial University also sent Sekino Tadashi 關野貞 (1868–1935) and his team to Korea in order to investigate archaeological and architectural remains located in and around Kyŏngju, Kaesŏng, Pyŏngyang, and Seoul. His team's survey lasted for about two months and was given official permission and assistance by the Korean government (Yi Sunja 2009: 33–35). With the history of the peninsula divided into three temporal periods of Silla (traditionally from 57 BCE to 935 CE), Koryŏ (918–1392), and Chosŏn (1392–1910), Sekino's report (1904) was one of the first comprehensive accounts of palatial architecture, royal tombs, Buddhist temples, stone monuments, and other ancient remains in Korea. In 1906, Imanishi Ryū 今西龍 (1875–1932), another student trained in ancient history at Tokyo Imperial University, surveyed tombs in Kyŏngju and discovered a shell mound site in Kimhae in 1907 (Imanishi 1907).

During this decade-long period, most of the archaeological investigations in Korea were conducted by faculty members and graduate students of Tokyo Imperial University. Most of the work took the form of a general survey and did not involve large-scale excavation. It was during this period, however, that many important archaeological sites were plundered by Japanese commercial looters, treasure hunters, and antiquity dealers. The most significant damage occurred in the royal tombs of the Koryŏ Dynasty in the Kaesŏng area, as they were not as well protected as the Chosŏn royal tombs and contained valuable grave goods. The high-quality Koryŏ celadon vessels taken from these looted tombs were already highly sought after by Japanese collectors (Yi Sunja 2009: 15–31). It is also noteworthy that in November 1909, the Imperial Museum, or *Chaesil Bangmulgwan* 帝室博物館, was opened to the public by the last king of the Chosŏn Dynasty, Sunjong, at the site of Ch'anggyŏng-gung Palace in Seoul. This date is regarded as the beginning of the history of Korean museums (Editorial Committee 2009).

The second phase of Japanese colonial archaeology lasted five years from 1910 to 1915. Beginning a year earlier in 1909, however, the first systematic survey of archaeological sites and relics was undertaken by Sekino Tadashi at the request of the Japanese Residency-General of Korea (which preceded the creation of the GGK at the time of Japan's official annexation in 1910), and continued until 1911 (Takahashi 2001; Yi Sunja 2009). One of the reasons that Sekino, an architect by training, was hired for this project was because the colonial government wanted him to evaluate large traditional buildings and their suitability for government use (Yi Sunja 2009: 40–41). In the midst of this survey, imperial Japan officially annexed Korea on August 29, 1910. As then constituted, the GGK involved itself in the planning and execution of all archaeological surveys

and excavations throughout the Korean peninsula. At the request of the GGK, another general survey was carried out from 1910 to 1911 by Torii Ryūzō 鳥居 龍藏 (1870–1953), an anthropologist by training. His research was intended to complement Sekino's survey and offer ethnographic and anthropological data that supplemented the perspective of the architectural research already underway (Yi Sŏngsi 2014). These surveys were intended to provide necessary information for colonial rule of the newly acquired territories in Korea and Manchuria.

The three-year survey (1909–1911) by Sekino Tadashi and his team produced a two-volume report with an inventory that ranked 579 ancient buildings, monuments, tombs, and other remains that they had surveyed (Sekino 1910, 1911). The highest rank of his four-tier classification system was reserved for remains that demonstrated superior artistic workmanship and therefore, in his opinion, should be preserved. The second and third ranks could also be considered for preservation or protection, but the lowest rank was a tentative category that was open to further evaluation and possible re-classification (Pai 2013: 117; Yi Sunja 2009: 42). In addition to conducting archaeological surveys, Sekino Tadashi and his assistants Yatsui Seiichi 谷井濟 (1880–1959), Torii Ryūzō, and Kuroita Katsumi 黑板勝美 (1874–1946) excavated many tombs. Most of the excavated materials were subsequently taken to Japan.

The information collected from the archaeological surveys and excavations conducted during this phase aided the GGK colonial administration. When Sekino and his team ranked their surveyed ancient buildings, monuments, and tombs and other remains, they recommended some for preservation. However, some of the lower-ranked structures were later turned into administrative buildings for the colonial government, and thereby lost their original function and meaning (Yi Sunja 2009: 61). The focus of archaeological investigation during this phase was on ancient sites in and around Pyŏngyang, the presumed location of the Han Chinese Lelang Commandery. The archaeologists' objective was to prove the presence of a Han Chinese colony in the northern part of the Korean peninsula from the late second century BCE to the early fourth century CE and use this evidence as justification for the contemporary Japanese colonial occupation.

At the end of this phase, on December 1, 1915, the Government-General Museum of Korea (GGMK), Chōsen Sōtokufu Hakubutsukan 朝鮮總督府博 物館, was opened at the former main palace grounds of the Chosŏn Dynasty's Kyŏngbok-gung (Fig. 15.1). A "Japanese neo-Renaissance" style building—constructed to house the first colonial exposition in Seoul for the promotion of industry—was its setting. The use of this modern-looking building for the GGMK transformed the palace compound into a mundane space for tourism.

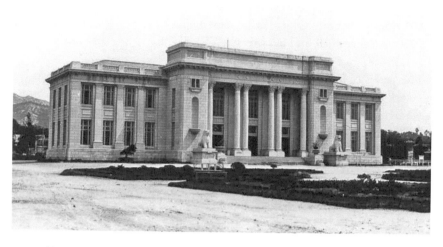

FIGURE **15.1.** Government-General Museum of Korea (1915–1945, demolished in 1997). Courtesy of the National Museum of Korea.

The venue hosted the exhibition of various artifacts excavated and collected by Japanese colonial archaeologists, and thus lost its original symbolism as a sanctified and exclusive space of the Korean dynasty. This degrading transformation of the royal seat of the Chosŏn Dynasty was initiated mainly by Kuroita Katsumi, a Tokyo Imperial University professor, who had long wanted to establish a national museum in colonial Korea. The first governor-general of Korea, Terauchi Masatake 寺内正毅 (1852–1919), fully supported and helped realize this goal (Pai 2013; Yi Sŏngsi 2014; Yi Sunja 2009).

The third phase of Japanese colonial archaeology in Korea lasted from 1916 to 1920. In July 1916, the GGK promulgated the Conservation Rules of Ancient Sites and Relics. These measures included eight articles that represented the Japanese empire's first set of preservation laws governing archaeological remains; it was only three years later that the Act of Historic Remains, Famous Places, and Natural Monuments was promulgated in Japan on the strong recommendation of Kuroita Katsumi (Yi Sŏngsi 2014). At the same time, the GGK also established the Commission for the Investigation of Ancient Sites, *Koseki Chosa Iinkai* 古蹟調査委員會, and set up a five-year plan for exploration of ancient sites in Korea. The following list summarizes archaeological investigations over the next five years (Yi Sunja 2009: 98–139):

1916: Four Han Chinese commanderies and Koguryŏ
1917: Three Han, Kaya, and Paekche

1918: Silla and the prehistoric period
1919: Silla, Yemaek, Okjŏ, Parhae, and Yŏjin
1920: Kimhae shell midden site, Couple's Tomb in Yangsan

This series of legal and administrative actions by the GGK laid a basic legal framework for colonial management of cultural heritage and initiated a comprehensive archaeological survey of prehistoric and historical sites of colonial Korea. The focus of the survey was mainly on sites of the Han Chinese commanderies and historic sites of Silla, Paekche, and Kaya. Their intention was to highlight the colonial experience of ancient Korea and underline the passive and impotent nature of the ancient Korean kingdoms.

During this phase and in subsequent years, the GGMK published a series of books related to its archaeological investigations and museum displays, including the *Album of Korean Ancient Sites* (15 vols., 1915–1935), *Investigation Report of Ancient Sites* (16 vols., 1920–1937), *Catalogue of Korean Treasures and Ancient Sites* (2 vols., 1938, 1940), *Special Investigation Report of Ancient Sites* (7 vols., 1919–1933), and *Catalogue of Museum Collection* (17 vols., 1926–1943). The first five volumes of the *Album* were published both in Japanese and English to demonstrate the strong influence of Chinese culture on ancient Korea. The first governor-general of Korea, Terauchi Masatake, was so eager to propagate this information and advertise the achievement of his colonial government that he frequently presented these publications as gifts to visiting foreign dignitaries (Yi Sŏngsi 2014).

The fourth phase of archaeological development in colonial Korea lasted from 1921 to 1930. Entering into the second decade of colonial rule, the GGK established the Department of Investigation of Ancient Sites in 1921. The aim of this institutional change was to integrate all the bureaucratic works related to archaeological investigation, heritage management, and conservation of ancient sites into the colonial government. This department and its staff, including Yatsui Seiichi and Fujita Ryōsaku 藤田亮策 (1892–1960), played a major role in the planning, organization, support, and execution of systematic archaeological surveys and excavations in Korea.

In 1922, the GGK also established the Commission for the Compilation of Korean History, or *Chōsensi Hensan Iinkai* 朝鮮史編纂委員會, which in 1925 became a larger and independent organization called the Society for the Compilation of Korean History, or *Chōsensi Henshukai* 朝鮮史編修會. This organization included as its members leading Japanese colonial archaeologists and historians, including Kuroita Katsumi, Oda Shōgo 小田省吾 (1871–1953), Fujita Ryōsaku, Imanishi Ryū, and Inaba Iwakichi 稲葉岩吉 (1876–

1940). It engaged in the collection of Korean historical materials and the compilation of Korean history. Members' research on ancient Korea focused mainly on the influence of the Han Chinese commanderies and attempted to prove the existence of a Japanese-controlled Mimana colony in southern Korea from the fourth to sixth century CE.

During the 1920s, a series of Silla royal tombs with splendid burial goods were excavated in Kyŏngju, the former capital of the Silla kingdom, including the Tomb of Golden Crown (1921), the Tomb of Golden Bells and the Tomb of Golden Shoes (1924), and the Tomb of the Swedish Phoenix, which was named as such in honor of the visit and a short participation in excavation by Crown Prince Adolf Gustaf VI (1882–1973) of Sweden in 1926 (Fig. 15.2). These excavations were financed by a private fund of the governor-general of Korea, Saitō Makoto 斎藤實 (1858–1936), setting a precedent for later fund-raising efforts for archaeological investigation during the fifth phase of archaeological development (Kim Tae-hwan 2016). After these excavations, local Korean leaders were strongly opposed to the Japanese plan to remove precious artifacts from Kyŏngju to Seoul. They collected contributions to establish a museum and built a small gallery inside the Kyŏngju Society for Conservation of Ancient Sites. In 1926, this facility became the Kyŏngju branch of the GGMK. Its creation appeased those who demanded that the Silla archaeological remains be stored locally (Yi Sunja 2009: 395–418).

The fifth phase of Japanese colonial archaeology in Korea from 1931 to 1945 coincided with the series of wars initiated by imperial Japan as well as the

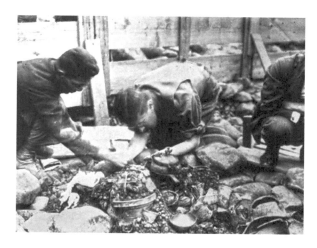

FIGURE 15.2. Excavation of Sŏbong-ch'ong (Tomb of the Swedish Phoenix) in 1926. Courtesy of the National Museum of Korea.

Great Depression. These events had an important impact on archaeological investigation during the remaining years of the Japanese colonial occupation of Korea. More specifically, in September 1931, Japan invaded Manchuria and established a puppet regime to rule the region. This occupation of northeastern China eventually led to the Second Sino-Japanese War (1937–45) and then to the greater conflict of World War II. Colonial Korea then became a logistical station and a source of human and material resources exploited by the Japanese military in order to expand into the entire Asia-Pacific region.

In the 1930s, however, a series of budget cuts affecting the GGK resulted in suspension of official financial support for archaeological investigations in Korea. With the aggressive initiatives and campaigns of Kuroita Katsumi for semi-official and private contributions, the Society for the Research of Korean Ancient Sites, *Chōsen Koseki Kenkyūkai* 朝鮮古蹟研究會, was established in 1931 to finance the research and publication of archaeological works, which continued until 1943. The society essentially took over and replaced the role of the GGK's Commission for the Investigation of Ancient Sites. Its annual budget ranged from 6,000 yen to 22,000 yen for direct support of archaeological excavations. The Imperial Household Agency, Japanese Society for the Promotion of Science, and the Prince Yi Family Household were among the leading contributors (Yi Sunja 2009).

During the 1930s, three major campaigns of archaeological investigation (1931–32, 1933–35, and 1936–43) were carried out with a focus mostly on the Silla sites in Kyŏngju, the Paekche sites in Kongju and Puyŏ, and the Lelang sites in Pyŏngyang. The Society also eventually established branches in Kyŏngju, Puyŏ, and Pyŏngyang, each being stationed in respective branches of the GGMK. In the case of sites at Paekche, most of the archaeologists' attention was focused on the Buddhist temples of Puyŏ, as Paekche was seen as the most probable source of the Japanese Asuka culture (Lee Pyŏng-ho 2011, 2016). Following the example of the Kyŏngju branch of the GGMK, Kaesŏng Municipal Museum was opened in 1931 and Pyŏngyang Municipal Museum in 1933. In 1939, the Puyŏ branch of the GGMK was established. In the same year, the Paekche Museum was founded in Kongju in order to display the relics of Paekche discovered in the Kongju area.

In 1933, a set of rules and regulations known as the Preservation of Korean Treasures, Ancient Sites, Famous Places, and Natural Monuments was promulgated by the GGK. The measures remedied the shortcomings of the earlier conservation rules of 1916 and strengthened preservation of the so-called famous places and natural monuments. In the following year, the GGK established the Commission for Preservation of Treasures, Ancient Sites, Famous Places, and

Natural Monuments and appointed as its members, among others, Japanese colonial archaeologists Kuroita Katsumi, Ikeuchi Hiroshi 池内宏 (1878–1952), and Harada Yoshito 原田淑人 (1885–1974) of Tokyo Imperial University; Hamada Kōsaku 濱田耕作 (1881–1938), and Umehara Sueji 梅原末治 (1893–1983) of Kyoto Imperial University; and Fujita Ryōsaku of Keijō (Seoul) Imperial University (for the complete list of the commission members from 1934 to 1939, see Yi Sunja 2009: 236–38).

One of the most important works of the preservation commission was to designate a number of archaeological and other cultural and natural monuments for preservation. From 1934 to 1943, the commission designated 419 treasures, 145 ancient sites, 5 ancient sites/famous places, 146 natural monuments, and 2 famous places/natural monuments as being in need of preservation (Pai 2013; Yi Sunja 2009). This designation system is still used today, more or less in the same manner, in South Korea (Pai 2013); a new system is being proposed and discussed for implementation in the near future.

Nature of Japanese Colonial Archaeology in Korea

During the colonial occupation of Korea, Japanese archaeologists working for the GGK had an ironclad monopoly over archaeological surveys, investigations, salvage and research excavations, and the registration and preservation of ancient sites and remains. Not a single Korean was allowed to participate as a researcher in any survey or excavation. Only a few Korean scholars, including Ch'oi Namsŏn 최남선 (1890–1957) and Yi Nŭnghwa 이능화 (1869–1943), who were pro-Japanese collaborators, were appointed as members of the Society for the Compilation of Korean History and the Preservation Commission, in addition to the inclusion of a few low-ranking Korean bureaucrats. Only a few Korean scholars, including Son Chintae 손진태 (1900–?), Han Hŭngsu 한흥수 (1909–?) (see Han Hŭngsu 1935), and To Yuho 도유호 (1905–1982), discussed archaeological sites and artifacts in their written works during the colonial period. Their research, however, remained necessarily speculative since they were unable to engage in archaeological fieldwork during the period of Japanese rule.

One notable exception to the absolute monopoly over archaeological work by the GGK was Garube Shion 輕部慈恩 (1897–1970), who was a graduate of Waseda University and a high school teacher stationed in Kongju, one of the Paekche capitals. In the late 1920s and 1930s, he personally managed to plunder more than 700 Paekche royal and elite tombs in Kongju. He subsequently took many artifacts to Japan, and donated only a part of his collection to Tokyo National Museum (Lee Pyŏng-Ho 2011; Yi Sunja 2009). Although the GGK

had a virtual monopoly over archaeological investigation, it is quite striking that
Garube was somehow able to carry out "private excavation" (according to
Arimitsu Kyōichi 有光敎一, cited in Lee Pyŏng-Ho 2011: 130–31) for many
years and get away with destroying invaluable archaeological information from
these ancient tombs for his personal gain.

The exclusive engagement of Japanese archaeologists in Korea was reflected
in every aspect of archaeological investigation, including the selection, survey,
excavation, and interpretation of archaeological sites in colonial Korea. Archaeo-
logical work was conducted in the interests of the GGK, which provided all of
the necessary resources and had a strong political agenda for the colonial rule of
the Korean population. The GGK paid for all expenses associated with archae-
ological investigation until the early 1930s; the expenses likely ranged between 2
and 4 million yen in 1910–1919, 7 and 16 million yen in the 1920s, and 16 and
17 million yen in 1930–1934 (Yi Sunja 2009: 201–202; 16 million yen in 1920
was worth roughly the equivalent of 100 billion won in 2015).

The impetus for archaeological investigation in Korea was to provide legiti-
macy for the colonial occupation from an archaeological and historical point of
view. The colonial experience of ancient Korean history was highlighted in the
case of the Han commanderies or fabricated in the case of the Mimana colony.
Using archaeological data, the prominent role of Chinese influence and the pas-
sive and impotent nature of Korean indigenous culture was emphasized (Yi
Sunja 2009). Japanese scholars depicted Koreans as having degenerated into a
weak and ineffectual people by the time of the late Chosŏn Dynasty after more
than two thousand years of subordination (Pai 2013: 138).

While the close relationship between prehistoric and early historical cultures
of the Korean peninsula and Japanese archipelago was not in doubt, Japanese
archaeologists proposed the idea of a common Japanese/Korean cultural and
racial lineage (Pai 2013: 112). Japanese authorities utilized this theory of "shared
origins" to claim Korean antiquity in support of their colonial rule. This interpre-
tation also served as a tool to push the assimilationist policy of "Korea and Japan
are one" in the 1930s.

The investigation and management of archaeological sites in Korea by
Japanese archaeologists was touted as one of the greatest achievements of the
Japanese cultural administration in Korea not only by the GGK but also by par-
ticipating Japanese archaeologists (Pai 2000; Yi Sŏngsi 2014). However, the colo-
nial government's purpose was to claim Korean archaeological sites and remains
as the spoils of colonial rule. A series of high-quality excavation reports, muse-
um catalogs, and albums of ancient sites were published in order to advertise
Japan's colonial power to a mostly Western audience (Yi Sŏngsi 2014).

There were several reasons that the Korean peninsula was the field of choice for young Japanese archaeologists such as graduates of Tokyo Imperial University (Pai 2013: 114–16). From 1874, the excavation of most tombs in Japan was banned by the Meiji government. Therefore, colonial Korea offered new career opportunities for young archaeologists who needed field experience. Colonial Korea was experimental ground not only for archaeologists but also for ruling bureaucrats. The GGK was much more open to experimentation with new rules concerning archaeological artifacts, sites, and human remains without either the bureaucratic hassles typical of Japan or the interference of the Imperial Household Agency (Yi Sŏngsi 2014). As a result, the conservation rules were enacted in Korea in 1916, three years earlier than the preservation legislation in Japan. Japanese colonial archaeologists were also experimenting with new field methodologies in Korea. For example, Hamada Kōsaku and Umehara Sueji of Kyoto Imperial University adopted plane table mapping and the modern technique of cross-section and profile diagrams in their excavation of Kaya tombs in 1918. This mapping and recording convention later became standard practice in Japanese Kofun-period archaeology (Yoshii 2006).

In addition, many of those who participated in Korean archaeological investigation were leading archaeologists of the time. Prominent faculty members and graduates of Tokyo, Kyoto, and Keijō (i.e., Seoul) imperial universities were involved in the fieldwork, laboratory work, and writing and publication of archaeological reports of Korea. There is thus no reason to believe their scholarship was inferior to that of the archaeologists who were working in the Japanese archipelago.

After the promulgation of the conservation rules in 1916, most of the excavated artifacts from the archaeological investigation by the GGK stayed in Korea as collections in its museums. Kuroita Katsumi propounded this policy as the "on-site" principle (Yi Sŏngsi 2014), in which he emphasized the importance of storing collections in the areas where they originated. Japanese archaeologists could take field notes and drawings to their institutions in Japan in order to prepare for excavation reports, but excavated materials and photographic gelatin dry plates most often stayed with the GGMK (Yoshii 2013). It was only after the Society for the Research of Korean Ancient Sites took over archaeological research in Korea in the 1930s that some excavated archaeological artifacts were taken to Japan to be shown to semi-official and private donors to the society (Yi Sunja 2009).

Considering the harsh nature of Japanese colonial rule in Korea, it is not surprising that there was no strong native resistance to Japanese appropriation of ancient sites and archaeological investigations. The archaeological excavation and

documentation of ancient sites and establishment of the GGMK to house archaeological collections were praised as a major cultural achievement of Japanese colonial rule. At the same time, however, it brought a sense of incompetence even to prominent collaborators like Chʼoi Namsŏn (Yi Sungsi 2004). The only organized actions by Koreans were to petition for the establishment of local museums as a means of protesting the transport of extraordinary artifacts from respective sites, including the Silla royal tombs and other capitals of the Three Kingdoms, to the GGMK in Seoul.

Japanese colonial rule of Korea resulted in the removal of tens of thousands of cultural artifacts and their transport to Japan. During the US occupation of Japan, the issue was raised as to whether these articles should be repatriated to Korea, but General McArthur took no such initiatives and was reported to have opposed the idea of restitution (Pai 2013: 173). In 1965, as part of the Treaty on Basic Relations between Japan and the Republic of Korea, Japan returned roughly 1,400 artifacts to Korea and considered the diplomatic matter to have been officially resolved. According to recent data compiled by the Overseas Korean Cultural Heritage Foundation, however, there are about 67,700 known Korean cultural artifacts that either remain in the permanent collection of the Tokyo National Museum or are held in other public and private collections. In 2010, Japanese Prime Minister Naoto Kan expressed "deep remorse" about the removal of artifacts. He arranged for the return of the Royal Protocols of the Chosŏn Dynasty and over 1,200 other books to Korea, the fulfillment of which was achieved in 2011. Since there is no official diplomatic relationship between North Korea and Japan, the repatriation of archaeological artifacts taken to Japan from the northern half of the peninsula has not been resolved and continues to be an obstacle to normalizing relations between the two countries.

The Legacy of Japanese Colonial Archaeology in Post-War Korea

After the surrender of Japan on August 15, 1945, the Korean peninsula was divided into a northern half under the control of the Soviet Union and a southern half under the control of the United States. This temporary and ad-hoc division led to the establishment of separate governments in North and South Korea in 1948 and then the Korean War (1950–53). It took many years for North and South Korea to recover from the destruction of the war. In the 1950s, archaeological work on the Korean peninsula began in earnest and took different paths in North and South Korea.

The influence of Japanese colonial archaeology in Korea was strong not only in both Koreas but also in Japan (Yoshii 2013). Among others, Hyung Il Pai has documented extensively the continuing influence of Japanese colonial archeology, racial theories, and cultural interpretations on the development of post-war Korean archaeology, especially on South Korea's narratives concerning the origins of Korean state formation (Pai 2000). Here, I briefly discuss the colonial legacy of Japanese archaeology followed by a short update of recent archaeological developments in both North and South Korea.

After the end of World War II, the communist regime in North Korea made an extensive effort to purge pro-Japanese collaborators. In 1946, the North Korean Temporary People's Committee implemented land reform by confiscating private property and Japanese and pro-Japanese–owned facilities and factories and placing them under state ownership. It also tried to erase narratives of history and archaeology established by the colonial regime and other elements of the Japanese legacy as quickly as possible (Pak 1998). Just after the liberation, in December 1945, Pyŏngyang Municipal Museum was turned into Chosŏn Central Museum of History. In April 1946, the North Korean Temporary People's Committee promulgated the Law for the Preservation of Treasures, Ancient Sites, Famous Places, and Natural Monuments, which replaced earlier Japanese colonial law. In 1947, it also established museums in five different locations and added another six in 1948. They became the institutional foundation for the research, conservation, and management of archaeological and historical relics in North Korea.

Although no Korean had been allowed to participate in Japanese colonial archaeology during the occupation, two prominent scholars with an archaeological background chose to stay in North Korea after division of the Korean peninsula. To Yuho and Han Hŭngsu, both trained in Europe, laid the groundwork for development of North Korean archaeology and excavated a few archaeological sites before the Korean War broke out (Han Ch'anggyun 2013). After the war, To Yuho became the leading authority in North Korean archaeology for more than a decade before he was removed in a political purge in the early 1960s (Yoo 2017). Under his leadership, North Korean archaeologists had criticized the Japanese interpretation of archaeological data, and particularly the evidence dated to the prehistoric period. Since Japanese colonial archaeologists denied the existence of the Bronze Age in Korea and proposed instead that relevant archaeological material dated from the Chalcolithic period, the initial focus of research was on prehistoric sites in North Korea. After a series of excavations in the second half of the 1950s, North Korean archaeologists were able to confirm the presence of Paleolithic sites in the Korean peninsula and distinguish the Neolithic period

from the Bronze Age based on archaeological data (Pak 1998). By these means, they were able to repudiate definitively the earlier prejudices of Japanese colonial archaeology (Yi Kisŏng 2011).

In subsequent decades, North Korean archaeology took many different turns in its interpretation of archaeological data. These reflected contemporary political ideologies as well as economic and academic conditions (Pak 1998). Until the 1960s, historical materialism and the unilinear cultural evolutionary theory of Lewis H. Morgan were the dominant interpretive frameworks for archaeological data. In the 1970s, the political ideology of *juche*, or self-reliance, made a major impact on archaeological interpretation and thus North Korean archaeology took on a more nationalist and sometimes chauvinistic perspective (Yi Kisŏng 2015). The economic hardships of the 1980s and later decades halted most archaeological fieldwork and publication of many books and journals in archaeology was discontinued. One exception is the publication of sixty-one volumes of the *Compendium of Korean Archaeology* in 2009, which presented a comprehensive summary of achievements in North Korean archaeology, covering the prehistoric, early historic, and medieval periods, as well as anthropology and paleontology (Institute of Archaeology 2009).

In 1993, the tomb of Tangun, a mythical and legendary common ancestor for all Koreans, was allegedly discovered in the vicinity of Pyŏngyang. According to the current North Korean official view, Tangun established the first state in the Taedong River valley about five thousand years ago and the Taedong River civilization flourished for millennia with supporting bureaucratic institutions, written communication, and craft specialization. North Korea also claims that the archaeological remains formerly attributed to the Chinese Han commandery of Lelang by Japanese colonial archaeologists are in fact those of the Nangnang kingdom, a society of Indigenous peoples with close interactions to the Han empire.

In sum, North Korean archaeology has clearly separated itself from the legacy of the Japanese colonial archaeology. Current archaeology in North Korea is also unlike the more scientific discipline it tried to espouse with a cultural historical approach in the 1950s and 1960s. Due to limited financial resources, archaeological fieldwork is now rare and the publication of archaeological reports and books is much reduced. Archaeological data are often fabricated, manufactured, or disregarded in order to be utilized as a "scientific and objective" tool of government propaganda and ideology. As a result, the northern half of the Korean peninsula has become an enormous vacuum, without reliable archaeological data and information contributing to our understanding of the prehistory and early history of northeast Asia.

In the southern half of Korean peninsula, after three years of political and economic chaos, Syngman Rhee 이승만 (1875–1965) was elected the first president and proclaimed the founding of the Republic of Korea on August 15, 1948. Because the Japanese surrender came about suddenly, the GGMK in Seoul had no evacuation plan for its collection. With the intervention of the US Army military government in Korea, the GGMK, its branches, and their entire collections were transferred to the National Museum of Korea. This peaceful transition occurred, at least in part, thanks to the cooperation of three individuals: Eugene Knez (1916–2010), a US Army captain; Arimitsu Kyōichi (1907–2011), the last director of the GGMK; and Kim Jaewon 김재원 (1909–1990), first director of the National Museum of Korea (Pai 2013: 173–75).

Thus, one of unexpected dividends of the GGK's cultural policy was that most of the collection of its colonial-era museums was inherited intact by South Koreans. These included not only some of the excavated artifacts and photographic gelatin dry plates from excavations, but also administrative documents; acquisition, purchase, and donation records; collection and exhibition inventories; records for classification of historical monuments; commission minutes; and staff business trip reports. Most of these records have been digitized and are readily available on the National Museum's website (www.museum.go.kr). In addition, the Otani collection of Buddhist mural paintings of Central Asia ended up in the GGMK, result of a series of fortuitous circumstances, and became a part of the National Museum's collection (National Museum of Korea 2013).

Despite the fortuitous circumstances by which the National Museum of Korea inherited the rich collections of the museums of the Japanese colonial government, there was not a single trained Korean field archaeologist at the time of independence. Thus, the last director of the GGMK, Arimitsu Kyōichi, was asked to remain in Korea, lead a few excavations, and teach Koreans how to excavate. The first excavations by the Republic of Korea were carried out at the Howu Tomb and the Tomb of Silver Bells in Kyŏngju in 1946 under his guidance (National Museum of Korea 1948).

The outbreak of the Korean War in 1950, and the destruction and continuing economic hardship it caused, hindered archaeological research for more than a decade. Excavations that were carried out by the staff of National Museum and some university museums focused primarily on historical-period tombs. Professional training of archaeologists did not start in South Korea until establishment of the Department of Archaeology and Anthropology at Seoul National University in 1961. Progress since then, however, has been swift. As of 2015, there were more than forty public or private universities in South Korea that have at least

one full-time faculty member teaching archaeology. Besides being based in depart-
ments of archaeology, anthropology, and archaeology and art history, others work
in general history or Korean history departments. As a national organization, the
Korean Archaeological Society has a membership of about 1,500 with more than
400 fully accredited members. There are half a dozen regional associations of
archaeologists as well as another half a dozen theme-focused scholarly associations.

Archaeology in South Korea now is practiced by diverse institutions and
personnel. The National Museum of Korea and its dozen or so regional branch-
es and the National Research Institute of Cultural Heritage and its own branch-
es are major public institutions that conduct research-oriented archaeological
surveys and excavations. In addition, there are about a hundred cultural heritage
institutions that specialize in the salvage of archaeological sites in South Korea.
Public and private university museums and institutions also engage in both
research-oriented works as well as small-scale archaeological rescue projects.
Indeed, since a new archaeological heritage law and its ordinances were passed in
1999, an archaeological survey and excavation, if necessary, must be carried out
before any type of construction begins in an area of over 30,000 square meters,
and it must be funded by the entity, public or private, that initiates the construc-
tion. In the last two decades or so, this legislation has led to an explosion of
archaeological rescue work. For instance, in 2009, there were more than 1,500
archaeological excavations at future construction sites nationwide at a cost of
approximately US $500 million (Figs. 15.3 and 15.4). The continuous develop-
ment of salvage and research-oriented archaeological work has contributed to
rapid progress in our understanding of prehistoric and proto-historical Korea.

The legacy of Japanese colonial archaeology nonetheless continues to be felt
in many facets of Korean archaeology. Many of the legal frameworks for archae-
ology and cultural heritage management, including registration of archaeological
sites, remain largely unchanged from the colonial period. Moreover, a historical-
ly oriented interpretation of archaeological data still dominates in archaeological
research in Korea, as in many countries in Asia and Europe. For a variety of rea-
sons, the initial antagonism against Japanese colonial archaeology has subsided
with each passing year. No doubt, the exponential growth of Korean archaeolo-
gy in the past two decades has made Korean archaeologists feel confident enough
to stand shoulder to shoulder with their Japanese colleagues. Evidence of this
change can be seen at the bi-annual joint meetings of the Yŏngnam Archaeolog-
ical Society and the Kyushu Archaeological Society, which have been hosted
alternately in Japan and Korea since 1994. It is also noteworthy that an increas-
ing number of Japanese graduate students have undertaken postgraduate study
in Korean archaeology in Korean universities.

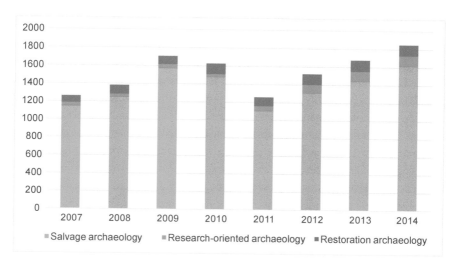

FIGURE 15.3. Number of archaeological excavations in South Korea, 2007–2014.

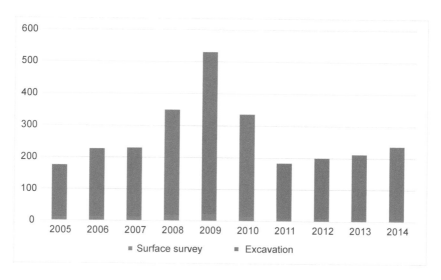

FIGURE 15.4. Total spending on archaeological work in South Korea
(in billion won), 2005–2014.

CONCLUSION

In addressing the legacy of Japanese colonial archaeology in Korea, there are two opposing responses: the first is that Japanese rule contributed to the modernization and development of Korea and the second is that Japan's rule was harsh, tyrannical, and inhumane, and only served the interests of imperial Japan. It is quite understandable that most Koreans, and most Korean archaeologists as far as archaeology is concerned, take the latter position. Professor Hyung Il Pai (2001, 2013) is one of only a few to take the former position in her appraisal of Japanese colonial archaeology in Korea and its legacy. A few surviving Japanese archaeologists who had participated in archaeological work in colonial Korea were also proud of their accomplishments with only a few regrets and excuses (Fujita 1963; Umehara 1969). In recent years, however, a number of scholars have published monographs and articles that have joined Pai's in a frank discussion of the legacy of Japanese colonial archaeology, including Yi Sunja (2009), Chŏng Insŏng (2006, 2011), Yang Siŭn (2010), the Yŏngnam Archaeological Society (2013), and Lee Pyŏng-ho (2011, 2016). Most of these reviews offer an even-handed assessment of works by Japanese colonial archaeologists and discuss the contributions as well as limits of their theories, methodologies, and interpretations.

It is impossible to deny the fact that Japanese colonial archaeology in Korea laid the groundwork for the earliest archaeological research in the Korean peninsula. As there had not been any archaeological research whatsoever before the arrival of the Japanese, their works could be called pioneering, monumental, or ground-breaking. However, it is important to note that their works were carried out in an exclusionary environment that did not permit native Koreans to participate in meaningful archaeological roles for almost half a century until the end of the Japanese occupation. All of their works were financed and supported logistically and administratively by the GGK until the early 1930s. When the GGK could no longer directly afford to pay for the archaeological investigation, it still provided other necessary support. Archaeological research was an integral part of the ruling apparatus and ideology of the Japanese colonial government. It is thus important to recognize this historical legacy and avoid legitimizing the destructive consequences of Japanese colonial archaeology by suggesting that they somehow saved the cultural heritage of Korea.

In many ways, colonized Korea was a playground not only for Japanese looters, plunderers, and antiquity collectors, but also for Japanese bureaucrats and archaeologists, who worked more or less freely away from interference by the Imperial Household Agency and Japan's ruling establishment. That may be one of the reasons that conservation legislation was enacted first in Korea in 1916,

three years before similar legislation in Japan. Korea served not only as a training ground for young Japanese archaeologists but also a testing ground for the policies and rules of cultural heritage management and conservation by Japanese policy-makers and bureaucrats.

It is clear that in order to understand the early societies of the Korean penin-sula and the Japanese archipelago, cross-cultural knowledge of both Korean and Japanese archaeology is essential, and thus moving beyond current political and national boundaries is also important . The increasing intensity of the two-way interaction between Korean and Japanese archaeologists in many different forms and fora is encouraging. A small sign that South Korea may be well over the hump of the Japanese colonial legacy is that the National Museum of Korea now catalogues its collection of about 600 volumes of various administrative records and 38,000 photographic gelatin dry plates from the Japanese colonial period as among its "artifacts."

REFERENCES CITED

Ch'oe, Sŏk-yŏng 최석영

 2015 *Ilche-ŭi chosŏn singminji kogohak-gwa gŭ ihu* 일제의 조선 '식민지 고고학'과 식민지 이후 (Japanese "Colonial Archaeology" in Korea and Post-colonial Korea). Sŏgang University Press, Seoul.

Chŏng, Insŏng 鄭仁盛

 2006 Sekino Tadashi-ŭi Nangnang yujŏk chosa yŏngu-ŭi chaegŏmt'o 關野貞의 낙랑 유적 조사 연구의 재검토 (Sekino Tadashi's Research and Investigation of the Remains of Lelang). *Honam Kogo Hakbo* 호남고고학보 (Journal of Honam Archaeological Society) 24: 139–56.

 2011 Ilche gangjŏmgi Nangnang kogohak 일제 강점기 낙랑고고학 (Lelang Archaeology during the Japanese Colonial Occupation). *Hanguk Sanggosa Hakbo* 韓國上古史學報 (Journal of the Korean Ancient Historical Society) 71: 149–70.

Díaz-Andreu, Margarita

 2007 *A World History of Nineteenth-Century Archaeology: Nationalism, Colonialism and the Past.* Oxford University Press, Oxford.

Editorial Committee (National Museum of Korea) 한국박물관100년사편찬위원회

 2009 *Hanguk Pangmulgwan Paeknyŏnsa 1909-2009* 한국박물관100년사 (The 100-Year History of Korean Museums), National Museum of Korea, Seoul.

Fujita, Ryōsaku 藤田亮策

 1963 *Chōsengaku ronkō* 朝鮮學論考 (Essays on Korean studies). Fujita Ryōsaku Sensei Kinnen Jigyōkai, Nara (Kangsai, Japan).

Han, Ch'anggyun 한창균

 2013 To Yu-ho-wa Han Hŭng-su: gŭdŭl-ŭi haengjŏk-gwa haksul nonjaeng (1948–1950) 도유호와 한흥수: 그들의 행적과 학술논쟁 (1948–1950) (To Yu-ho and Han Hŭng-su: Their Activities and Academic Debates, 1948–1950). *Hanguk Kogo Hakbo* 한국고고학보 (Journal of Korean Archaeological Society) 87: 76–118.

Han, Hŭngsu 한흥수

 1935 Chosŏn-ŭi kŏsŏk munhwa yŏngu 朝鮮의 巨石文化研究 (A Study of Korean Megalithic Culture). *Chindan Hakgo* 震檀學報 (Journal of Chindan Society) 3: 132–47.

Imanishi, Ryū 今西龍

 1907 Chōsen nide hakkenseru kaizuka ni tsuide 朝鮮にで発見せる貝塚について (On the Discovery of a Shell Mound in Korea). *Tokyo Jinrui Gakkai Zasshi* 東京人類學會雜誌 (Journal of the Tokyo Anthropological Society) 23 (259): 6–13.

Institute of Archaeology, Academy of Social Sciences 사회과학원고고연구소

 2009 *Chosŏn Kogohak Chŏnsŏ* 조선고고학전서 (Compendium of Korean Archaeology). 61 vols. Institute of Archaeology, Academy of Social Sciences, Pyongyang.

Kim, Tae-hwan 김대환

 2016 Chosŏn ch'ongdokpu kojŏkchosa saŏb-esŏ Fujita Ryosaku-ŭi yŏkhal 조선총독부 고적조사 사업에서 후지타 료사쿠의 역할 (The Role of Fujita Ryosaku in the Archaeological Investigation of the Japanese Government-General of Korea). *Hanguk Sanggosa Hakbo* 韓國上古史學報 (Journal of the Korean Ancient Historical Society) 91: 121–41.

Ko, Jung-Yong 高正龍

 1996 Yagi Sōzaburōno Kangoku chosa 八木奘三郎の韓国調査 (Yagi Sōzaburo's Fieldwork in the Korean Peninsula). *Kogokakushi Kenkyu* 考古學史研究 (Studies in the History of Japanese Archaeology) 6: 34–44.

Lee, Pyŏng-Ho 李炳鎬

 2011 Ilche kangjŏmgi paekche koji-e daehan kojŏk chosa saŏp 日帝強占期 百濟 故地에 대한 古蹟調查事業 (A Study of the Investigation of Historical Sites in Paekche's Former Territory during the Japanese Colonial Period). *Hanguk Kodaesa Yŏngu* 韓國古代史研究 (Journal of the Korean Ancient Historical Society) 61: 113–55.

 2016 Singminjigi Puyŏ Chiyŏk p'yaesaji chosa-wa ilbonin kogohakja 식민지기 부여 지역 폐사지 조사와 일본인 고고학자 (Excavation of Puyŏ Temple Sites and Japanese Archaeologists: The Case of Ishida Mosaku and Fujisawa Kazuo). *Hanguk Kogo Hakbo* 한국고고학보 (Journal of the Korean Archaeological Society) 98: 168–99.

National Museum of Korea

1948 *Howuch'ong gwa ǒnryǒngch'ong* 壺杅塚과 銀鈴塚 (Howu Tomb and Tomb of the Silver Bell). National Museum of Korea, Seoul.

2013 *Central Asian Religious Paintings in the National Museum of Korea.* National Museum of Korea, Seoul.

Pai, Hyung Il

2000 *Constructing "Korean" Origins: A Critical Review of Archaeology, Historiography, and Racial Myth in Korean State-Formation Theories.* Harvard University Press, Cambridge, MA.

2013 *Heritage Management in Korea and Japan: The Politics of Antiquity and Identity.* University of Washington Press, Seattle.

Pak, Yangjin 박양진

1998 Pukhan kogohak-ŭi myǒt kaji t'ŭkjing 북한고고학의 몇 가지 특징 (A Few Characteristics of North Korean Archaeology). *Chungnam Daehakgyo Inmungwahak Yǒnguso Nonmunjib* 忠南大學校人文科學研究所論文集 (Journal of the Humanities Research Institute, Chungnam National University) 25(2): 79–92.

Saotome, Masahiro 早乙女雅博

2001 Shiragino kogogaku chōsa '100nen'no kenkyu 新羅の考古學調査'100年'の研究 (A Century of Archaeological Research on Silla). *Chosensi Kenkyukai Ronbunshu* 朝鮮史研究會論文集 (Bulletin of the Society for Study of Korean History) 39: 53–106.

Sekino, Tadashi 関野貞

1904 *Kankoku kenchiku chōsa hōkoku* 韓國建築調査報告 (Investigative Report of Korean Architecture). Department of Engineering Research Report, vol. 6. Tokyo Imperial University, Tokyo.

1910 *Chōsen geijutsu no kenkyū* 朝鮮芸術の研究 (A Study of Korean Art). Chōsen Sōtokufu, Keijō (Seoul).

1911 *Chōsen geijutsu no kengkyū zokuhen* 朝鮮芸術の研究續編 (A Study of Korean Art, A Sequel). Chōsen Sōtokufu, Keijō (Seoul).

Takahashi, Kiyoshi 高橋潔

2001 Sekino Tadashio chūshinto shita Chōsen koseki chōsa kōtei 關野貞を中心とした朝鮮古蹟調査行程 (Routes of Japanese Investigation of Korean Ancient Sites with Sekino Tadashi as a Central Figure). *Kogogakushi Kenkyu* 考古學史研究 (Studies in the History of Japanese Archaeology) 9: 3–48.

Trigger, Bruce

1989 *A History of Archaeological Thought.* Cambridge University Press, Cambridge.

Umehara, Sueji 梅原末治

1969 Nichikan henkōno kikanni okonawareta hantōno koseki chōsato hogo jigyōni tazusawatta ichi kōgogakutono kaisōroku 日韓併合の期間に行われた半島

の古蹟調査と保護事業にたずさわつた一考古學徒の回想録 (An Archaeologist's Remembrance of Archaeological Investigations and Preservation of Korean Sites during the Japanese Colonial Period). *Chōsen gakuhō* 朝鮮 學報 (Korea Journal) 51: 95–148.

Yang, Siŭn 양시은

2010 Ilche kangjŏmgi Koguryŏ Parhae yujŏk chosa-wa gŭ ŭimi 일제강점기 고구려 발해 유적조사와 그 의미 (A Study of the Research at Koguryŏ and Parhae Sites during the Japanese Colonial Occupation and Its Meaning). *Koguryŏ Parhae Yŏngu* 高句麗渤海研究 (Research of Koguryŏ and Parhae) 38: 155–92.

Yŏngnam Archaeological Society 영남고고학회

2013 *Ilche Kangjŏmgi Yŏngnam Chiyŏk-esŏŭi Kojŏk Chosa* 일제강점기 영남지역에 서의 고적조사 (Investigation of Ancient Sites in Yŏngnam during the Japanese Colonial Occupation). Hakyŏn Munhwasa, Seoul.

Yi, Kisŏng 이기성

2011 Cho'gi Pukhan kogohak-ŭi sinsŏkki ch'ŏngdonggi sidae kubun 초기 북한 고고 학의 신석기, 청동기시대 구분 (Establishing the Neolithic and Bronze Age in the Incipient Phase of North Korean Archaeology). *Hosŏ Kogohak* 호서고고 학 (Journal of Hosŏ Archaeological Society) 25: 4–29.

2015 Pukhan sŏnsa kogohak-ŭi paerŏdaim 북한선사고고학의 패러다임 (The Paradigm of North Korean Prehistoric Archaeology). *Kogohak* 고 고 학 (Archaeology) 14(3): 5–32.

Yi, Sŏnbok 이선복

1992 Pukhan kogohaksa siron 북한 고고학사 시론 (A Preliminary Study of the History of North Korean Archaeology). *Tongbanghakji* 東方學志 (Journal of Oriental Studies) 74: 1–74.

2002 "Thunder-axes" and the traditional view of stone tools in Korea. *Journal of East Asian Archaeology* 4(1–4): 293–306.

Yi, Sŏngsi 이성시 李成市

2004 Chosŏn wangjo-ŭi sangjing konggan-gwa pangmulgwan 조선왕조의 상징 공 간과 박물관 (Symbolic Space of the Chosŏn Dynasty and Museum). In *Kuksa-ŭi sinhwarŭl nŏmŏsŏ* 국사의 신화를 넘어서 (Beyond the Myth of National History), 265–95. Humanist, Seoul.

2014 Chosŏn ch'ongtokpu-ŭi kojŏk chosa-wa ch'ongtokpu pangmulgwan 조선총독 부의 고적조사와 총독부박물관 (Archaeological Survey of the Government-General of Korea and the Government-General Museum of Korea). In *Proceedings of the 2014 International Conference Collecting Asian Objects in Colonial Korea, 1910–1945*, 7–25. National Museum of Korea, Seoul.

Yi, Sunja 이순자

2009 *Ilche Kangjŏmgi Kojŏk Chosa Saŏb Yŏngu* 일제강점기 고적조사사업 연구 (A Study of the Investigation Project of Ancient Sites during the Japanese Colonial Period). Kyŏngin Munhwasa, Seoul.

Yoo, Yongwook

2017 A Story of Their Own: What Happened and What Is Going on with North Korean Archaeology? In *Archaeology of the Communist Era: A Political History of Archaeology of the 20th Century*, edited by Ludomir R. Lozny, 275–93. Springer, New York.

Yoshii, Hideo 吉井秀夫

2006 Shokuminchi Chosenni okeru kogogakudeki chosano saikentō 植民地朝鮮における考古學的調査の再檢討 (Re-analysis of Archaeological Investigation in Colonial Korea). Research Report Supported by Scientific Research Fund of Ministry of Culture 2003–2005. Kyoto University, Kyoto.

2013 Chōsen koseki chosa jigyoto Nihon kogugaku 朝鮮古蹟調査事業と日本考古學 Investigation Project of Korean Ancient Sites and Japanese Archaeology. *Kokogaku Kenkyu* 考古學研究 (Archaeological Research) 60(3): 17–27.

CHAPTER 16

The Cloth of Colonization: Peruvian Tapestries in the Andes and in Foreign Museums

Maya Stanfield-Mazzi

Today, tapestries from the Andes are known around the world. Even when these objects are more than 500 years old, they retain rich colors, bold patterns, and a fineness of thread that is unique among the world's textile traditions. Their patterns speak to us of the Wari and Inca empires and to Spain's subsequent conquest and colonization of Peru. Their beauty and portability has made them both the fruit and the object of various colonial practices, from ancient times to the present. These practices can be identified in all stages of the objects' existence, from their commissioning and production to their possession and repossession. In this chapter I outline what is known about the colonial situations in which these tapestries arose and were collected, arriving at the present time in which we find the great majority of these works housed in museums and private collections of the Global North, not in the Andes, and inaccessible to the descendants of those who created them. This is an account of how colonialism has affected the territory of the Andes, but it is also a medium-centered approach that explains from one vantage point the ways in which fine cloth is a uniquely colonizing, and *colonizable*, material object.

Today "archaeology" is simply defined as the study of material culture. But the "archaeology" that is most relevant in the story of Andean tapestries is the particular Western scientific practice of excavating objects buried by ancient cultures, under the supposition that the descendants of those peoples have no valid claim to the objects. This definition is relevant not because the majority of Andean tapestries were excavated archaeologically. On the contrary, while there are examples of Peruvian tapestries that were archaeologically excavated, often

these items were simply "collected" or purchased from their original owners. Their exact origins are almost always unclear, as they may have been looted from tombs or purchased from prior custodians. Yet when they were transported to foreign museums, the scholarship about them developed under misconceptions that the works *had* been excavated. The activity of collecting was part and parcel of the earliest archaeological expeditions in Peru, and the early association between archaeology and collecting gave rise to these misconceptions.

I also employ a wide definition of the term "colonial" in this case study, one that points to power imbalances and intentions on the part of powerful entities to benefit materially and ideologically from those under their control (Dean and Leibsohn 2003). I am not only concerned with states' expanding territorially into colonized regions, but also consider imperialist cases in which states, as well as individuals and institutions, exert power over the material cultures of places that are not their own. These definitions are suited to a consideration of the role of cloth in colonial processes, and help us understand that colonial mechanisms are variable and shifting. Taking a long view of these processes also demonstrates the ways in which the relations of colonizer–colonized oscillated over time.

My approach can be characterized as post-colonial, insofar as I argue that the primary process I address, in which Andean tapestries were divorced from their countries of creation, is bound up with northern imperialism. Other scholars have looked at these tapestries (and other types of cloth created in colonial settings) and considered how their imagery and use contested colonial hierarchies around the time they were created (Phipps 2004c; Thomas 2002). I contend that studying these cloths today cannot be done in a vacuum without considering how they have come down to us and how we can (or cannot, depending on who we are) access them. I urge recognition of the continued material inequalities that prevail in the post-colonial present (San Juan 1998: 13), inequalities that make it difficult for people outside of the northern imperial centers to participate in dialogue on these surviving treasures.

WARI TAPESTRY TUNICS: OSTENSIBLY FROM TOMBS TO MUSEUMS

The Andean region has a long and rich textile tradition, and environmental factors, especially the desert climate of the Peruvian coast, have led to excellent preservation of much ancient material. The region boasts some of the world's oldest cotton textiles, and the camelid fiber embroideries of Paracas in southern Peru are rightly famous (Dimitrijevic Skinner 1986; Lavallée 2008; Stone 1992). But it was not until territorially expansive states began to arise in the Andes around 500 CE that the textile form of the tapestry—a double-sided cloth woven on an

upright loom with closely packed weft threads that create its visible patterning—became widespread and important, especially as the form for entire garments. The male tapestry tunic, a long sleeveless shirt created of one or two pieces of cloth, became the uniform of colonization in the Andes (Fig. 16.1). The Wari state (ca. 600–1000 CE), centered near modern-day Ayacucho but expansive throughout central Peru and onto the coast, is thought to have assigned specifically patterned tunics to office holders in its administration (Bergh 2009; Cook 1992). Tunics bearing images of animal-headed staff bearers, or those repeating the "profile face and stepped fret" motif, were, scholars think, the regalia of certain classes of bureaucrats in the Wari hierarchy. The Wari had a large state

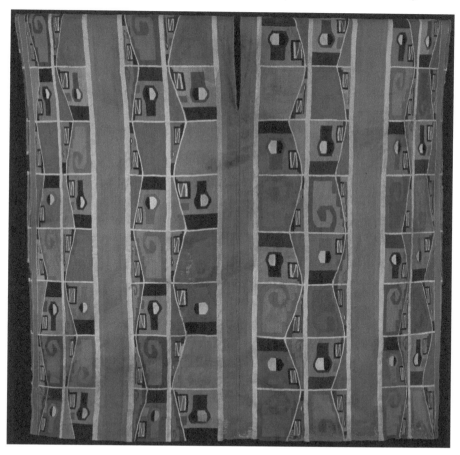

FIGURE 16.1. *Tapestry Tunic with Profile Face and Stepped Fret Motifs*, Wari, ca. 600–1000 CE. Los Angeles County Museum of Art, M.2000.59. Photograph courtesy of the Los Angeles County Museum of Art.

administration interested in standardizing its presence in controlled territories. The state managed great herds of camelids and established irrigation and road systems that would later be used by the Incas (Isbell and Young-Sánchez 2012: 253). When it occupied new territories, it constructed grid-planned administrative sites that dominated the landscape, disregarding natural contours (Stone-Miller and McEwan 1990–91). The production of tapestries for bureaucrats must also have been a state enterprise, although we do not know exactly how this was organized. The imagery on Wari tapestries is also organized based on grid plans, fitting their perpendicular warp-and-weft thread structures. These tapestries show a high degree of standardization in their quality and the repetition of design templates.

The amount of work that must have gone into the creation of Wari tapestries is staggering, and speaks to a complicated system of labor organization. Fiber was shorn from highland camelids, cleaned, spun, and plied. Both organic and mineral dyestuffs and mordants were then sourced, and the yarns dyed in stages, especially in the cases of difficult dyes such as indigo. Cotton fiber was cultivated in lowlands, cleaned, and spun. Then cotton thread was placed on upright built looms as the warp, and camelid fiber was woven in complicated patterns as the weft threads. Once a length of cloth in the shape of a wide rectangle was removed from a loom it was sewn to a matching partner, folded in half, and sewn up the sides to create a finished tunic, its imagery rotated ninety degrees from how it was seen on the loom. Clearly this was a multi-stage process that involved the coordination of resources and labor across the large territory of the Andes. Scholars have recently shown that cochineal, a dyestuff made from scale insects (Coccoidea) that yields a rich and durable red color, only became widespread in the Andes at the time of the Wari Empire (Boucherie et al. 2013; Deviese and Higgitt 2013). Thus it appears that Wari textile practices, and labor organization, were spread across the Andes as the empire grew.

The tapestry-woven male tunic accompanied Wari imperialism to its far-flung territories. Yet the archaeological remains of Wari sites are now divorced from the tapestries that their administrators must have worn. Instead, amateur collectors and archaeologists in the late nineteenth and early twentieth centuries are thought to have collected the tapestries from the burials of Wari elites along the coast, the only subterranean environment in which such tapestries can have survived. Collectors sold the tapestries to international buyers, and archaeologists deposited them in foreign collections, so that most of the roughly 300 surviving tapestries of this genre are in collections outside of Peru (Stone-Miller and McEwan 1990–91: 62, n. 10). An exception to the rule is the *Lima Tapestry*, the only tapestry purported to have come from Ayacucho, the Wari heartland. This

work, which due to its rich coloration and advanced abstraction may have been worn by a Wari ruler, was collected in Larcay, Ayacucho, in the early twentieth century and is now at the Museo Nacional de Antropología y Arqueología in Lima, Peru (Stone 1986: 138; Taullard 1949: fig. 19).

Scholars have uniformly stated that all surviving Wari tapestries were excavated from tombs by modern explorers, whether context-conscious archaeologists or profit-driven tomb looters. This is in spite of such examples as the *Lima Tapestry*, which, considering the periodic rains and higher humidity in the highlands, can hardly have survived in a mountain tomb. No one has entertained the possibility that such tapestries might have been kept as heirlooms by descendants of the Wari. As discussed in the following section, scholars have only recently recognized that many of the surviving Inca and Spanish colonial tunics came into international museums because they were kept as relics until the nineteenth century by people who wished to maintain a connection to the Inca past. But, in terms of the Wari, scholars have allowed the Western concept of "archaeology," however nascent the science may have been when the tapestries were supposedly excavated, to obscure our understanding of this art form. The work of late nineteenth-century volcanologists-cum-archaeologists Wilhelm Reiss and Alphons Stübel and the subsequent archaeological work of Max Uhle, which both led to several detailed publications illustrating tapestries in their original contexts, certainly did contribute to widespread knowledge of ancient Peru and included objects from the Wari culture (Reiss and Stübel 1880–87; Uhle and Shimada 1991 [1903]). But these and later archaeologists' work, coupled with an assumption that Western archaeology was the most correct and empirical discipline for studying the past, led to a rejection of non-archaeological sources for understanding the Wari that prevails to the present (Lumbreras 2012: 1). As "archaeological" as Wari tapestries were thought to be, they were excluded from analysis. John H. Rowe and his predecessors at the University of California at Berkeley (the "Berkeley School") established a chronology for Andean prehistory based on ceramic seriation from the South Coast of Peru (Moseley 2013; J. Rowe 1960). Although this seriation was established on the basis of grave goods, tapestries were not included in the data sets. To date, we still have no sense of the chronological or regional variation of Wari tapestries.

While Wari tapestries were not used in archaeologists' analyses, the assumption that all Wari tapestries were excavated from Wari-era tombs has prevailed. Another cause for this assumption is the Eurocentric postulation that only the West collects and preserves art for use in the living world, as opposed to the afterlife (Bounia and Pearce 2000). Bound up in this notion is the idea that only the West is capable of writing history. And if non-Western societies are not interested

in history, why would they be interested in collecting art? On the contrary, we now realize that many non-Western societies had unique ways of conceiving of the past, in which physical objects played an important role. An example of this is the Aztecs' interment in their Great Temple of objects from the Olmec and Teotihuacán cultures, civilizations that predated the Aztecs by centuries. These objects appear to have played an important role in the Aztecs' conception of their empire's place in space and time (López Luján 1994).

Returning to the Wari and their tapestries, it is very likely that the subsequent pan-Andean state of the Incas had close knowledge of the Wari Empire and built its own empire based on Wari precedents and, literally, Wari foundations. And though still unproven, it may have been the Wari's Inca descendants who cared for some of the Wari tapestries that still survive today. The Incas used Wari roads, irrigation canals, and systems of taxation to create their own empire (Isbell and Young-Sánchez 2012). They also based their writing system, which took the form of sets of knotted cords known as *khipus*, on Wari precedents (Conklin 1982). Similarly, the Incas made the male tapestry tunic the centerpiece of their imperial aesthetic and political economy.

INCA TAPESTRIES: STATE GIFTS, COLONIAL POSSESSIONS, AND ANTIQUARIES' ARTIFACTS

Though Inca tapestries do not display the same patterns as Wari tunics, they are similar in their sleeveless form, interlocked tapestry technique, and color palette achieved with dyes such as cochineal (Fig. 16.2). They share an abstract geometric aesthetic, but the Incas surpassed Wari virtuosity in terms of thread count and the size of looms they used to create tunics out of single webs of cloth. Due to Spanish conquistadors' interest in Inca statecraft and taxation, and their subsequent written accounts, we know much about the importance of tapestries for the Inca state (Murra 1962). Fine tapestry tunics woven in the colors of the rainbow were created in state workshops and given to elite subjects as ways to secure their loyalty (Cummins 2002: chapters 4 and 5; J. Rowe 1979). But only Inca elites were able to wear tunics with the distinct geometric motifs known as *tocapu*—and the Inca ruler was the only one allowed to wear a tunic covered in these motifs (Fig. 16.2; Stone 2007).

Spanish conquistadors wrote that Inca soldiers also wore patterned tunics, most famously those they described as "chessboards" (Xerez 1985 [1553]: 110). Scholars have been able to connect these textual descriptions to the main surviving Inca tunic types, located, again, in foreign museums. The tunic type that must correspond to the conquistadors' "chessboard" is one of which at least seven

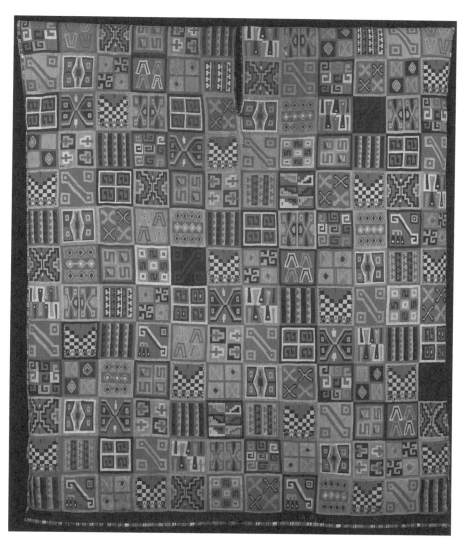

FIGURE **16.2.** *Tapestry Tunic with Tocapu Motifs*, Inca, ca. 1530 CE. Dumbarton Oaks, Pre-Columbian Collection, Washington, DC, P.C.B.518. Photograph © Dumbarton Oaks.

examples are known, and which appears to have been a very standardized state-issued uniform (J. Rowe 1979: 245–48; Stone 1992: plate 63). This tunic type features a black-and-white checkerboard on its lower section, set off by a red V-shaped section around the neck opening. John Rowe found that the surviving examples of these tunics are all very standardized in terms of size, arrangement

of squares, and finishing, which often features a zigzag line embroidered along the bottom. The zigzag line appears on other tunics of standardized types identified by Rowe, including the "Inca key" checkerboard tunic, the diamond waistband tunic, and the *tocapu*-waistband tunic (J. Rowe 1979: 251–57). All of these tunics were used by the Inca state apparatus to support its territorial expansion and cohesion, since they served as uniforms for Inca captains and elites and were given as gifts to the leaders of rival polities that accepted Inca subjugation (Cummins 2002: 80). The tapestries were also demanded as tribute from peoples under Inca control (Murra 1962), and it is possible that the embroidered zigzag line was used to mark such pieces.

Only one complete all-over *tocapu* tunic, the type thought to have been reserved for the Inca ruler, is extant today (Fig. 16.2). Its absolute finery, with a vivid range of colors, expert interlocking between color areas, and thread counts averaging 100 threads per centimeter, supports that view. The piece, which has no known provenience, was purchased by the American collector Robert Woods Bliss prior to 1950 and is now in the Dumbarton Oaks Collection in Washington, DC (Benson 1993). Bliss's advisor, the Harvard University archaeologist Samuel Lothrop, suggested that it may have come from the South Coast of Peru, in seeming reference to the excavations that were so important to the Berkeley School's theories (J. Rowe 1979: 258; Tantaleán and Stanish 2014: 27, 32, 34). But, the stunning preservation of this piece suggests other possibilities, most immediately that this tunic's real origins have been obscured by archaeological assumptions. As seen with Wari tapestries, the primacy given to archaeology over other disciplines in Andean prehistory during the early twentieth century gave rise to such assumptions, which may have stepped into the vacuum created by collecting practices that disregarded the recording of acquisition proveniences.

What *are* the possible origins of the surviving Inca tunics, the all-over *tocapu* and checkerboards alike, and what processes may have led to their acquisition for and preservation in foreign museums today? There is one Inca checkerboard tunic that survives as clothing for a mummy, likely excavated from a coastal tomb (Cummins 2007: fig. 21). But in regard to royal tunics such as the Dumbarton Oaks piece, it is useful to know that Inca hegemony only lasted for roughly eighty years, from the time of imperial consolidation in about 1450 to the Spanish conquest in 1533. Also, the Incas housed the bodies of their royal dead in a complex in their capital of Cusco (Vargas 2007), since the mummies of Inca rulers were believed to be semi-divine beings that were consulted as oracles. It is thus unlikely that very extensive royal Inca cemeteries existed anywhere else in Peru, especially ones sufficiently intact to be identified and excavated in the twentieth century. Instead, the collecting of Inca tapestries was done in the sixteenth century by Spaniards,

at the beginning of their implantation of a new colonial order in Peru, and by Indigenous elites in remembrance of Inca greatness.

We should recall that Spanish conquistadors remarked on the patterning of Inca soldiers' tunics. After the battles of the conquest, in the city of Cajamarca, in the capital of Cusco, and in the Inca redoubt of Vilcabamba, Spanish soldiers might have collected these tunics as war trophies. They may also have removed and kept the clothing on the royal Inca mummies that were destroyed after the conquest, as part of the concerted obliteration of Inca religion (Bauer 2004: 159). None of these possibilities has yet been proven. However, there is documentary evidence that certain Spanish conquistadors, as well as later administrators, collected Inca tunics and other regalia and sent them back to Spain as curiosities and as proof of the conquest. A first group of items, which included various tunics (*camisas*) described as having cross-like patterns and feather embellishments, was in the possession of Charles V, king of Spain, as early as 1545. Based on a wealth of circumstantial evidence and comparison with other known lots of Inca treasure sent to Spain, Paz Cabello Carro hypothesizes that these items were sent to Spain as part of a group of objects that were given to Francisco Pizarro in 1533 by the ruler Manco Inca, before the end of the conquest (Cabello Carro 1994: 45). Following Inca patterns, Manco Inca may have understood his bestowal of rich tunics (called *capac*, or royal, tunics by later chroniclers) on Pizarro as an act that would secure Pizarro's submission to his rule. But Pizarro probably understood the opposite, seeing the items as signs of Manco's submission to Charles V and Spanish rule (Cabello Carro 1994: 46). Pizarro's particular understanding of the exchange appears to have motivated him to send the items to Spain, where they could serve as proof of the Incas becoming Spanish subjects. Thus, by the mid-sixteenth century, new, pristine Inca tapestry tunics arrived in Spain. Unfortunately, however, documentary descriptions of them do not permit their identification as any surviving pieces, and we must assume they were destroyed in fires at the Royal Palace of Madrid in the early eighteenth century.

Later in the sixteenth century, Viceroy Francisco de Toledo, the leader of a second wave of colonization that defeated the last claimant to the Inca throne, also sent Inca tapestries back to Spain. Several Inca tunics are described in the inventories of his estate and that of Philip II, to whom Toledo gifted much of his collection (Julien 1999). In Toledo's own collection were three tunics (*camisetas*) of *cumbi*, the Quechua word for fine multicolored (and likely tapestry-woven) cloth. According to a 1582 inventory, there were also various other *cumbi* cloths, appearing to be of colonial manufacture (Julien 1999: appendix 1, 86). A second inventory created after Philip II's death in 1598 states that among his items from

Viceroy Toledo was a *cumbi* tunic "of diverse colors and figures, which are armorial signs of the provinces that the Inca possessed" (Julien 1999: appendix 2, 89). The inventory seems to refer to a tunic with *tocapu* symbols, and its interpretation of the symbols is not too far from most modern scholars' understanding of them. Unfortunately this and another tunic were said to be moth-eaten and filled with holes, and no surviving pieces appear to correspond to them.

Whereas archival traces can enlighten us about Inca tunics, we have no similar sources of information to inform us about Wari tapestries, since the Wari fell from power before the Spanish conquest. Legal writing was a cornerstone of Spanish colonization practices, and literacy (or access to it) separated the powerful from the powerless (Burns 2010; Rappaport and Cummins 2012). Documents provide vital contextual information on Inca and, as we will see, colonial tapestries. These references also highlight the fact that from the Spanish conquest onward, the Andean tapestry was imbricated in a new colonial order.

As the Inca order dissolved, the fine *cumbi* tunic became significant for not only Spaniards, but for Indigenous Andeans of both Inca and non-Inca background. Written testaments and estate lists of Indigenous elites in Cusco testify to the retention of Inca tunics, especially those of a standardized type bearing a large motif of four rectangles known as *caxana* or *casana* (Ramos 2010: 134–36; J. Rowe 1979: fig. 15). The tunics were passed down within families but also exchanged for large quantities of goods, suggesting that they were important status symbols within colonial society and held significant economic value. Under the new colonial order these tunics served both people of Inca descent, who could hark back to their ancestors' prestige, and non-Incas, perhaps members of groups who had sided with the Spaniards and were benefiting from the new government (Dean 1999: chapter 8; Ramos 2010: 123, 132). Thus for the three centuries of Spain's colonial rule of the Andes, Inca tunics were treasured in the homes of Andeans themselves.

In the wake of the anti-colonial Túpac Amaru Rebellion of 1780–ca. 1782, however, the Spanish government prohibited the use of symbols of Inca power including the tapestries, since they were believed to incite revolutionary thinking (Bacacorzo 1980: 630–38). The Indigenous elites also lost other important supports for their power, including governmental posts and freedom from tribute obligations. After Peru gained independence from Spain in 1823, Simón Bolívar abolished the use of noble titles for Spaniards and Andeans alike (Gänger 2014: 37). In the following decades, these conditions eroded the true worth of "Incaness" for surviving descendants. However, a new class of people in Cusco, Lima, La Paz, and Buenos Aires emerged who were interested in the Andean past for less personal and more scientific reasons. Although the practice of

archaeology had yet to penetrate the Andes, these wealthy individuals of both European and Indigenous descent began to amass great collections of ancient Andean artifacts (Gänger 2014: chapters 1 and 2, fig. 1.3). Within their collections were many textile items, including tapestries. While these antiquaries often conducted amateur excavations to find objects for their collections, they also purchased items from "Indians" in the region. Considering the unlikely preservation of textiles in highland burials, it is likely that these antiquaries gained most of their tapestries by the method of purchase or trade in Cusco. Thus, the state gifts and elite garb of Inca times, which constituted heirlooms in the colonial era, now became artifacts in the antiquarian pursuit of knowledge. The final step in this process occurred when wealthy foreign institutions, in their pursuit of universal knowledge, arrived in Peru and purchased bits and pieces as well as entire collections from the antiquaries.

For example, the Cusco collector Emilio Montes, who began to amass a substantial collection of Inca antiquities in 1860, sold his collection to the Field Museum of Chicago in 1893 (Bauer and Stanish 1990: 2; Gänger 2014: 52, 86–87). It is likely that one object in this collection was the museum's checkerboard tunic with butterflies, certainly an Inca piece (Pillsbury 2002: fig. 16). Another important Cusco collection, that of Ana María Centeno de Romainville, which included a royal Inca headdress, was sold to the Berlin Ethnological Museum in 1887 (Gänger 2014: 88–89). The headdress has been lost, but the museum still holds a colonial tunic from the Centeno collection. Private travelers to Peru also purchased items from the same antiquaries, who published catalogues of their collections for potential buyers (Gänger 2014: 99–100). Many of these items also eventually made their way into international museums, as donations from the wealthy collectors. According to its publicly available provenance notes (see accession numbers 33.149.44 and 33.149.100), in 1933 the Metropolitan Museum of Art in New York City received several Inca tunics and tapestry fragments from George D. Pratt, from Glen Cove, New York. Several other private collectors also bequeathed Inca textiles to the museum in the first half of the twentieth century.

As Stefanie Gänger shows, nineteenth-century antiquaries, especially in Cusco, were an important and forgotten link in the chain of possession for many Andean objects, including tapestries. Although their activities predated those of archaeologists arriving at the turn of the century in Peru, people like Hiram Bingham were able to tap into the knowledge of these antiquaries to "discover" Inca sites such as Machu Picchu (Gänger 2014: 98; on discovery narratives, see McGrath, this volume). This last link in the chain, that of foreign collectors, was not so much a territorial or even economic colonization of the Andes, but an

attempt at the colonization of knowledge. In particular, prominent international institutions supported by powerful states effectively colonized Andean material patrimony, at a time when the Andean nations had not yet developed similarly powerful institutions of their own (Barnet-Sánchez 1993; Boone 1993: 341–42; Williams 1993). These foreign institutions, competing with one another (Benson 1993: 22; Gänger 2014: 89; Williams 1993: 134), relied on the expertise of the antiquaries, whose knowledge was inspired by European positivism but took a very local perspective. In the absence of strict legislation on the part of the Peruvian government prohibiting the sale and export of cultural heritage, and with Peru facing a difficult economic climate due to its loss of the War of the Pacific (1879–84), foreign museums were able to make off with the majority of Andean tapestries known today. Beyond acquiring Wari and Inca tapestries, they collected tapestries, which while often categorized as Inca, were actually woven during the Spanish colonial period. We must, then, return to that period in order to account for the final flowering of the Andean tapestry tradition and the whereabouts of its surviving remnants today.

COLONIAL TAPESTRIES:
ECCENTRICITIES OF COMMISSION AND POSSESSION

One of the most fascinating aspects of the story of Andean tapestries and colonization is the fact that the production and collection of these works continued after the Spanish conquest. As suggested by the collections of Inca tapestries that were sent to Spain after the conquest, Spaniards were very impressed with the products of Andean looms and how they compared with European tapestries (Phipps 2004c: 74). In sixteenth-century Europe, tapestries were often commissioned to adorn the walls of homes and frequently featured large-scale figural scenes based on paintings (Campbell 2006). Though European tapestries were larger and more illusionistic in their imagery than Inca ones, their colors were more muted, their thread count was inferior, and they lacked the silk-like sheen and warmth offered by Andean camelid (alpaca and vicuña) fibers. Shortly after the conquest Spaniards thus began to commission tapestries from Inca weavers for their own purposes—as bedspreads, carpets, and wall hangings.

Since armorial hangings were popular in Spain (usually made of appliquéd silk), and the Spaniards recognized the heraldic nature of the symbols on Inca tunics, they commissioned such hangings from Andean weavers (Fig. 16.3). Some of these works, like the one illustrated here, were created with extremely high thread counts and retained the Inca color palette of reds, yellows, and white. But the style of the imagery managed to combine the Inca geometric aesthetic

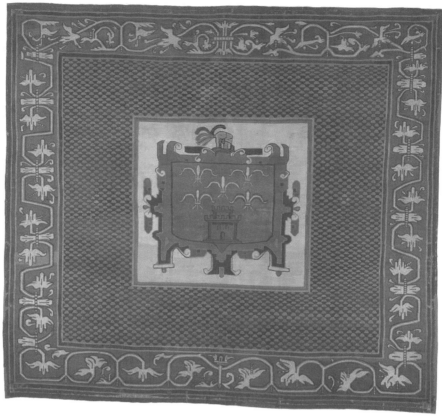

FIGURE **16.3.** *Tapestry with Coat of Arms and Vair Pattern,* Spanish colonial, sixteenth century, The Textile Museum, Washington, DC, 1963.38.1A, museum purchase. Photograph courtesy of the museum.

with the Renaissance preference for curvilinear forms. The images themselves were based on European precedents but the compositions featured patterns that could also have been drawn from the Inca repertoire. In order to create the curving contours of the new style, weavers had to fight the perpendicular warp and weft structure of the tapestry, inserting weft threads that curved and meandered along the edges of color areas and nudging warp threads to the right or left. Weavers also adopted a different technique of joining threads at the meeting of color areas, known as dovetailing. As Inca tapestries were forced to conform to colonial aesthetics, their very structure was altered.

While private Spanish patrons represented an important new impetus for Andean weaving, the Catholic Church also became a major consumer of local

tapestries during the first century of colonization (Stanfield-Mazzi 2015: 83–89). Priests commissioned altar frontals, altar carpets, hangings, and covers of various types to adorn newly built Christian churches in the Andes. These items were created with background colors that matched the tones of the liturgical year, and with imagery that imitated European textiles and expressed Christian tenets (Stanfield-Mazzi 2014: 57–65). Andean weavers were highly adaptable in transforming their known techniques, materials, and imagery to church patronage. But one of the most popular textile types in the mid-sixteenth century was the altar frontal, or antependium, whose dimensions were almost the same as those of an Inca tunic when created on a loom (Phipps 2004b; J. Rowe 1979). Weavers creating altar frontals could use exactly the same looms they did during Inca times; they simply began to work under the strictures of the new Spanish regime (Cobo 1964 [1653]: 259). I have only found six surviving Inca-style pieces that were undoubtedly altar frontals. All but one are in foreign museums or private collections. Of these six, two have virtually identical imagery of skulls and the wounds of Christ on a black background, and were surely meant to be used for masses for the dead (Phipps 2004b; Stanfield-Mazzi 2014). Two other pieces (both somewhat fragmentary) show the same pattern of roses and small animals on a red background (Fig. 16.4). These correspondences in such a small sample suggest that some of the same standardization established by the Inca state apparatus also carried over into the colonial period, though with very different imagery.

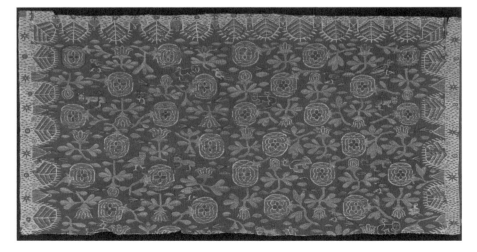

FIGURE **16.4.** *Tapestry Altar Frontal with Roses and Animals*, Spanish colonial, ca. 1600 CE. Museum of Fine Arts (MFA), Boston. Denman Waldo Ross Collection, 07.844. Photograph © MFA Boston, 2018.

Weavers also continued to create tapestry tunics, and began to weave the important women's garment, the mantle (in Quechua, *lliclla*), on their looms. But here, in the absence of state strictures and working for private patrons on commission (Ramos 2010: 126), weavers took great liberties with traditional Inca imagery, including *tocapu* motifs (Jiménez 2002; Phipps et al. 2004: catalogue entries 19, 22, 24, 26, 27, 38–42, 46; Pillsbury 2002, 2006). Inca *tocapu* (or creative versions of them) were scattered all over tunics and placed in rows on mantles, even though they had not appeared on women's clothing in Inca times. And weavers combined these motifs liberally with curvilinear European figural imagery. Imported European or Asian silk threads were used occasionally, as were silver-wrapped threads. These garments appear to have been treasured and worn on festive occasions by people wishing to articulate their identities as members of the Inca nobility (Dean 1999). The people that commissioned and used these colonial products may have been the same as those who treasured Inca tunics. Perhaps the earlier Inca examples were even referred to as prototypes or inspiration for the new colonial examples.

In 2004 the Metropolitan Museum of Art, with textile curator Elena Phipps, held the exhibition "The Colonial Andes: Tapestries and Silverwork, 1530–1830." This stunning show and its accompanying extensive catalogue (Phipps et al. 2004) brought together most of the known surviving examples of colonial Andean tapestries. A survey of the catalogue proves the point that nearly all of these works are either in foreign museums or private collections, whose locations are not specified. In fact many of the pieces had, until the mid-twentieth century, been misidentified as coming from other parts of the world (Zimmern 1944). The scholars who wrote for the catalogue offered excellent analyses of the pieces based on their physical and visual features. Nevertheless, they were unable to determine the precise geographical origin or original physical context of any of the pieces on display.

Other scholars, myself included, have been turning to the Spanish documentary archive to improve our understanding of colonial tapestries and their original values and usage. Thanks to Spanish bureaucratic writing in the form of testaments, dowry lists, estate lists, church inventories, and church account books, much more is now known about colonial Andean tapestries. We have learned of their popularity in the sixteenth century and the decline in their production around the mid-seventeenth century, due to changes in taste, Spanish disdain for Inca-esque imagery, and the breakdown of the systems of quality control that had survived from Inca times (Stanfield-Mazzi 2015). We have also discovered that being a tapestry weaver in the colonial Andes was not the same as being a worker in one of the state-run textile factories known as *obrajes*, in which poor

Andeans were forced to labor to earn coin to meet Spanish tribute obligations. Instead, weavers worked on commissions in people's homes, where they were often given room and board. Classified as artisans, named *cumbicamayocs* or *cumbi* masters as in Inca times, these weavers enjoyed freedom from tribute obligations (Ramos 2010: 126; Stanfield-Mazzi 2015: 8). So colonial Andean tapestries were just as implicated in colonial practices and desires as those of the Wari and Inca empires. But the study of Spanish documents, which are more consistently preserved in Andean archives, allows us to understand the subtleties of the role of tapestries under Spanish colonial rule.

Returning to our central concern, how did most of the surviving tapestries end up in foreign museums and collections? For the Spanish colonial, yet Inca-inspired tunics and mantles, the process was similar to that which I have outlined for Inca tunics per se. Due to Spanish protection of its textile industry, Andean tapestries never became an official export good of the Viceroyalty of Peru. Nonetheless, we know that in a few cases, the Spanish government collected them during the colonial period. As mentioned above, Viceroy Toledo appears to have sent both Inca and colonial Inca-esque tunics back to Spain at the end of the sixteenth century (Julien 1999: appendix 1, 86). He also sent tapestries that must have been created more to Spanish taste, such as table covers and a bedspread. At the end of the eighteenth century, the Frenchman Joseph Dombey, part of the Spanish botanical expedition led by José Antonio Pavón and Hipólito Ruiz, purchased in Lima the stunning tunic now in the Museo de América in Madrid. Even at that time the sellers claimed archaeological origins for the piece, stating it had been disinterred from the religious shrine of Pachacamac near Lima. But elements of its preservation, including its safeguarding in a special cedar box, suggest that it had also been kept as an heirloom and was never buried (Jiménez 2002). Any traces of other tapestries sent to Europe or elsewhere during the colonial period have been lost. As the documents attest, many other colonial tapestries were kept as heirlooms by elite families, now of Indigenous, Spanish, and mixed heritage (Dean and Leibsohn 2003: 5, n. 1).

After Peru gained independence, the same process occurred in which antiquaries purchased colonial tunics and mantles and eventually offered them for sale to foreign institutions and collectors. The collector Miguel Garcés sold an extremely important set of six tunics to the American Museum of Natural History in 1896 (Gänger 2014: 87; Pillsbury 2006). Several museums had already been competing for Garcés's collection. The ethnologist Adolph Bandelier was in charge of their purchase, so the tunics are now known as the Bandelier Set. These items were plagued with archaeological assumptions from the time of their purchase, as Garcés, whose family owned a hacienda on the Island of Titi-

caca in the lake of the same name, had reported that one of the tunics, with *toca-pu* designs on its front as well as figural motifs and a jaguar pelt design on the back, was dug up in a stone box on that island (Phipps 2004a: 159). Four of the other tunics were also reportedly exhumed from the island, including one with clearly European-inspired designs around the neck (Fig. 16.5). North American scholars then assumed for years that the tunics were all from the Inca period. It is now believed that most, if not all, are from the colonial period and were passed

FIGURE 16.5. *Tapestry Tunic with Flowers, Butterflies, and Jewels*, Spanish colonial, ca. 1600 CE. American Museum of Natural History (AMNH), New York, #B/1502. Photograph courtesy of the Division of Anthropology, AMNH.

down as heirlooms until Garcés acquired them (Pillsbury 2006; A. P. Rowe 1978: 243–44). Several other colonial-period tunics were acquired by foreign museums around this time. Fortunately, the collection of José Lucas Caparó Muñíz, including several colonial tunics, was sold to Cusco's San Antonio Abad University and served as the foundation for the Museo Inka in Cusco (Gänger 2014: fig. 1.3, 99).

The processes by which other secular textiles such as carpets and bedspreads made their way into foreign collections appear to have been similar, with families treasuring them as heirlooms until tempted to sell to wealthy foreign collectors. The removal of sacred tapestries from churches obeyed a somewhat different logic, though the timeline was comparable. After Peru's independence, ideological and economic support for the Church was greatly reduced (Klaiber 1992). Liberals criticized the Church's economic power and supported a number of reforms to curtail it: in 1833, the wealth of monasteries and other religious houses was nationalized, and in 1859 the collection of tithes was abolished. Confraternities, the bastions of lay devotion and perhaps the custodians of many church tapestries, were disempowered in 1865 and their wealth was transferred to municipal charitable associations. As the alliance between church and state dissipated, there was a shortage of religious functionaries across the Church hierarchy. Cusco was without a bishop between 1826 and 1843, and many rural parishes stood without a resident priest for decades. Thus, during the course of the nineteenth century, many liturgical tapestries may have been sold to private collectors by cash-strapped churches. However, it does not appear that there was as much demand for these items as for Inca-esque tapestries, since they did not speak to the Inca past but were instead relics of a disdainful colonial era. As foreign collectors arrived in the late nineteenth century and early twentieth century, they purchased church tapestries from both collectors and church guardians.

Three church tapestries featuring large Biblical scenes, made in the Cusco region following European design precedents, made their way into private collections in these varied ways. The tapestry known as the *Creation of Eve* was given to Francisco Madero, an Argentine politician involved in post-independence negotiations to create the Peru-Bolivia Confederation. He was given the tapestry in Potosí, Bolivia (to which city it had likely been sold in colonial times) in 1841, and his daughter donated it to the social club Círculo de Armas in Buenos Aires, Argentina. The tapestry called *Original Sin* was taken to Munich at an unknown time and then sold to an Argentine collector, whose family retains it in Buenos Aires. The piece known as *King David* was purchased from a church in Cusco, where it was being used as an altar carpet, and was located in a private collection in Sucre, Bolivia, by 1920. As seen in a photograph taken of that collection, it was placed between an Inca checkerboard tapestry and a Confederation-era armorial

hanging featuring the coats of arms of Bolivia and Peru (Phipps 2004c: fig. 89). By the end of the twentieth century, *King David* was in a private collection in La Paz, Bolivia, but it was recently transferred to a collection in the United States (Iriarte 1992: 85, 2004a, 2004b; Phipps 2004c: fig. 76).

Other church tapestries were similarly removed from churches and taken out of South America. Of the known frontals, another piece surely used in masses for the dead was purchased by George Hewitt Meyers in the early twentieth century and became part of the collection of the Textile Museum in Washington, DC. Fortunately, provenience notes suggest it came from a mortuary chapel in the town of Juli, also in the Lake Titicaca region (Kelemen 1977: 35). The two skull-and-wounds frontals mentioned above are now in the same private collection in the United States that holds the *King David* tapestry. The piece at the Museum of Fine Arts, Boston, which I have recently identified as a frontal, was likely collected by Denman W. Ross in the 1890s (Fig. 16.4; Stanfield-Mazzi 2015: 86–87; Zimmern 1944: 27). This item is rarely exhibited, since Ross's bequest stipulated that the tapestries not be lent to other museums. No provenance information is available about its matching piece, at the Royal Museum of Art and History in Brussels.

A number of tapestry carpets with church imagery are also in foreign collections, probably having been used originally in front of altars like the *King David* piece. In the last fifty years, despite Peru's strengthening of its cultural patrimony laws, economic inequality and the lack of security for churches has led to the theft of many surviving tapestries. Tragically one of two carpets associated with the revolutionary leader Túpac Amaru (Busto 1981: 55) appears to have been stolen from the church of Surimana, where it had been held as a treasure for more than two centuries. Peru's Ministry of Culture in Cusco has taken custody of the second carpet. The stolen carpet is now probably in foreign, private hands. The only colonial church tapestry preserved in a Peruvian museum is a large cross-embellished hanging at the Museo Nacional de Antropología y Arqueología in Lima, soon to be featured in the dissertation of Peruvian scholar Mónica Solórzano. A few pieces also survive in church hands, remarkably still in their original contexts (Romaña et al. 1987: 180).[1] It is only in these cases that we can tie textile creations back to their original production and usage, and understand the religious contexts in which they had meaning.

CONCLUSIONS

We have seen that tapestries were created in the Andes at the behest of three colonial regimes: Wari, Inca, and Spanish. The wide webs of resources that needed to

be marshaled to obtain their raw materials and the great amount of specialized labor involved in their creation made these works especially suited for the upper levels of colonial hierarchies. Their bold and beautiful imagery proclaimed status and communicated imperial ideologies, especially when worn on the bodies of the elite. As tapestries, their designs could easily be made to adapt to patrons' wishes, since new and non-repeating figures could be introduced when needed. The figures could be rectilinear (as in Wari and Inca tapestries) or curvilinear (as preferred by Spaniards).

After independence Andean tapestries began to separate from their original contexts of possession, associated as they had been with the previous regimes. They first came into the collections of Andean antiquaries, and were intended to serve as building blocks in modern Peruvians' conceptions of their history. By the end of the nineteenth century, however, these collectors' goals were subordinated to those of imperial institutions looking to contribute to their encyclopedic collections of world culture. Once the tapestries made their way into foreign museums they were largely ignored or misidentified until the mid-twentieth century. Collectors were not generally consulted as scholars developed the teleologies of pre-Columbian and Spanish colonial art. It was only in the last third of the twentieth century that a new generation of scholars, working with museums holding the early Peruvian archaeological collections, looked to Wari, Inca, and colonial tapestries for a deeper understanding of Andean art (Bergh 1999; Oakland 1986; Stone 1987). By that time, the archaeological assumptions about the tapestries had been enshrined, and it is only more recently that we are coming to understand the full histories of these objects. For example, the ways in which Andean tapestries made meaning within constellations of objects, including ceramics and metalwork, and within architectural contexts, are only now being realized (Cummins 2007; Stanfield-Mazzi 2014). It is now important to add the more recent histories of these objects to their biographies, and clear away misconceptions about their discovery and possession. It will never be possible, nor is it desirable, to free these objects fully from their colonial pasts. But, in order to safeguard them into the future, it is important to recognize the colonial conditions under which they were created and collected. In the latter case of collecting Andean tapestries, it is important to recognize both that Andeans likely preserved these items as treasures for many centuries, and also understand how and why they have come into foreign collections. Finally, a serious imperative is to facilitate access to these objects for researchers from the Andes and elsewhere, keeping in mind the privileges from which researchers in imperial centers still benefit.

Note

[1] Blenda Femenias, Catholic University of America, Washington, DC, personal communication (e-mail), 2013.

References Cited

Bacacorzo, Gustavo (editor)
 1980 *Colección documental del bicentenario de la revolución emancipadora de Túpac Amaru.* 2 vols. Comisión Nacional del Bicentenario de la Revolución Emancipadora de Túpac Amaru, Lima.

Barnet-Sánchez, Holly
 1993 The Necessity of Pre-Columbian Art in the United States: Appropriations and Transformations of Heritage, 1933–1945. In *Collecting the Pre-Columbian Past: A Symposium at Dumbarton Oaks, 6th and 7th October 1990,* edited by Elizabeth Hill Boone, pp. 177–207. Dumbarton Oaks, Washington, DC.

Bauer, Brian S.
 2004 *Ancient Cuzco: Heartland of the Inca.* University of Texas Press, Austin.

Bauer, Brian S., and Charles Stanish
 1990 Killke and Killke-Related Pottery from Cuzco, Peru, in the Field Museum of Natural History. *Fieldiana* n.s. 15: 1–17.

Benson, Elizabeth P.
 1993 The Robert Woods Bliss Collection of Pre-Columbian Art: A Memoir. In *Collecting the Pre-Columbian Past: A Symposium at Dumbarton Oaks, 6th and 7th October 1990,* edited by Elizabeth Hill Boone, pp. 15–34. Dumbarton Oaks, Washington, DC.

Bergh, Susan E.
 1999 Pattern and Paradigm in Middle Horizon Tapestry Tunics. PhD diss., Columbia University.
 2009 The Bird and the Camelid (Or Deer): A Ranked Pair of Wari Tapestry Tunics? In *Tiwanaku: Papers from the 2005 Mayer Center Symposium at the Denver Art Museum,* edited by Margaret Young-Sánchez, pp. 225–45. Denver Art Museum, Denver.

Boone, Elizabeth Hill
 1993 Collecting the Pre-Columbian Past: Historical Trends and the Process of Reception and Use. In *Collecting the Pre-Columbian Past: A Symposium at Dumbarton Oaks, 6th and 7th October 1990,* edited by Elizabeth Hill Boone, pp. 315–350. Dumbarton Oaks, Washington, DC.

Boucherie, Nathalie, Witold Novik, and Dominique Cardon
 2013 Dyeing Techniques and Dyestuffs used in the Nasca Culture (Peru): Research
 on Forgotten Lore. Paper presented at the 6th International Conference on
 Amerindian Textiles, Musée du quai Branly, Paris.
Bounia, Alexandra, and Susan M. Pearce (editors)
 2000 *The Collector's Voice: Critical Readings in the Practice of Collecting*. 3 vols. Ashgate,
 Aldershot, Hampshire, England and Burlington, Vermont.
Burns, Kathryn
 2010 *Into the Archive: Writing and Power in Colonial Peru*. Duke University Press,
 Durham, NC.
Busto Duthurburu, José Antonio del
 1981 *José Gabriel Túpac Amaru antes de su rebelión*. Pontificia Universidad Católica
 del Perú, Lima.
Cabello Carro, Paz
 1994 Los inventarios de objetos incas pertenecientes a Carlos V: Estudio de la colec-
 ción, traducción y transcripción de los documentos. *Anales del Museo de Améri-
 ca* 2: 33–61.
Campbell, Thomas P. (editor)
 2006 *Tapestry in the Renaissance: Art and Magnificence*. Metropolitan Museum of Art
 and Yale University Press, New York and New Haven, CT.
Cobo, Bernabé
 1964 [1653] Historia del Nuevo Mundo. In *Obras del P. Bernabé Cobo de la Compa-
 ñía de Jesús*, edited by P. Francisco Mateos, vols. 91 and 92. Ediciones Atlas,
 Madrid.
Conklin, William J.
 1982 The Information of Middle Horizon Quipus. In *Ethnoastronomy and Archaeoas-
 tronomy in the American Tropics*, edited by Anthony Aveni and Gary Urton, vol.
 385, pp. 261–82. New York Academy of Sciences, New York.
Cook, Anita G.
 1992 The Stone Ancestors: Idioms of Imperial Attire and Rank among Huari Fig-
 urines. *Latin American Antiquity* 3(4): 341–64.
Cummins, Thomas B. F.
 2002 *Toasts with the Inca: Andean Abstraction and Colonial Images on Quero Vessels*.
 University of Michigan Press, Ann Arbor.
 2007 Queros, Aquillas, Uncus, and Chulpas: The Composition of Inka Artistic
 Expression and Power. In *Variations in the Expression of Inka power: A Sympo-
 sium at Dumbarton Oaks, 18 and 19 October 1997*, edited by R. L. Burger, et al.,
 pp. 267–311. Dumbarton Oaks Research Library and Collection, Washington,
 DC.

Dean, Carolyn

 1999 *Inka Bodies and the Body of Christ: Corpus Christi in Colonial Cuzco, Peru*. Duke University Press, Durham, NC.

Dean, Carolyn, and Dana Leibsohn

 2003 Hybridity and Its Discontents: Considering Visual Culture in Colonial Spanish America. *Colonial Latin American Review* 12(1): 5–35.

Deviese, Thibaut, and Catherine Higgitt

 2013 HPLC-PDA Study of Colorants in Andean South Coast Textiles Drawn from the Collections of the British Museum and the Musée du Quai Branly. Paper presented at the 6th International Conference on Amerindian Textiles, Musée du Quai Branly, Paris.

Dimitrijevic Skinner, Milica

 1986 Three Textiles from Huaca Prieta, Chicama Valley, Peru. In *The Junius B. Bird Conference on Andean Textiles, April 7th and 8th, 1984*, edited by Ann P. Rowe, pp. 11–18. The Textile Museum, Washington, DC.

Gänger, Stefanie

 2014 *Relics of the Past: The Collecting and Study of Pre-Columbian Antiquities in Peru and Chile, 1837–1911*. Oxford University Press, Oxford.

Iriarte, Isabel

 1992 Tapices con escenas bíblicas del Perú colonial. *Revista Andina* 10(1): 81–105.

 2004a The Creation of Eve. In *The Colonial Andes Tapestries and Silverwork, 1530–1830*, edited by Elena Phipps, Johanna Hecht, and Cristina Esteras Martín, pp. 282–84. The Metropolitan Museum of Art, New York.

 2004b King David. In *The Colonial Andes Tapestries and Silverwork, 1530–1830*, edited by Elena Phipps, Johanna Hecht, and Cristina Esteras Martín, pp. 284–86. The Metropolitan Museum of Art, New York.

Isbell, William H., and Margaret Young-Sánchez

 2012 Wari's Andean Legacy. In *Wari: Lords of the Ancient Andes*, edited by Susan E. Bergh, pp. 251–67. Thames & Hudson and the Cleveland Museum of Art, New York and Cleveland.

Jiménez Díaz, María Jesús

 2002 Una "reliquia" inca de los inicios de la colonia: El *uncu* del Museo de América de Madrid. *Anales del Museo de América* 10: 9–42.

Julien, Catherine J.

 1999 History and Art in Translation: The *Paños* and Other Objects Collected by Francisco de Toledo. *Colonial Latin American Review* 8(1): 61–89.

Kelemen, Pál

 1977 *Vanishing Art of the Americas*. Walker, New York.

Klaiber, Jeffrey L.
 1992 *The Catholic Church in Peru, 1821–1985: A Social History.* Catholic University of America Press, Washington, DC.
Lavallée, Danièle (editor)
 2008 *Paracas: Trésors inédits du Pérou ancien.* Musée du Quai Branly and Flammarion, Paris.
López Luján, Leonardo
 1994 *Offerings of the Templo Mayor of Tenochtitlán.* University Press of Colorado, Niwot, Colorado.
Lumbreras, Luis G.
 2012 Introduction. In *Wari: Lords of the Ancient Andes*, edited by Susan E. Bergh, pp. 1–3. Thames & Hudson and the Cleveland Museum of Art, New York and Cleveland.
Moseley, Michael
 2013 Stylistic Variation and Seriation. In *Visions of Tiwanaku*, edited by Alexei Vranich and Charles Stanish, pp. 11–25. Cotsen Institute of Archaeology Press, Los Angeles.
Murra, John V.
 1962 Cloth and Its Functions in the Inca State. *American Anthropologist* 64: 710–28.
Oakland, Amy Sue
 1986 Tiwanaku Textile Style from the South Central Andes, Bolivia and North Chile. PhD diss., University of Texas at Austin.
Phipps, Elena
 2004a Man's Tunic (*Uncu*) with Tocapu and Feline Pelt Design. In *The Colonial Andes Tapestries and Silverwork, 1530–1830*, edited by Elena Phipps, Johanna Hecht, and Cristina Esteras Martín, pp. 156–59. Metropolitan Museum of Art, New York.
 2004b Tapestry with Skulls and the Five Wounds of Christ. In *The Colonial Andes Tapestries and Silverwork, 1530–1830*, edited by Elena Phipps, Johanna Hecht, and Cristina Esteras Martín, pp. 230–32. Metropolitan Museum of Art, New York.
 2004c Cumbi to Tapestry: Collection, Innovation, and Transformation of the Colonial Andean Tapestry Tradition. In *The Colonial Andes Tapestries and Silverwork, 1530–1830*, edited by Elena Phipps, Johanna Hecht, and Cristina Esteras Martín, pp. 72–99. The Metropolitan Museum of Art, New York.
Phipps, Elena, Johanna Hecht, and Cristina Esteras Martín (editors)
 2004 *The Colonial Andes Tapestries and Silverwork, 1530–1830.* Metropolitan Museum of Art, New York.

Pillsbury, Joanne

2002 Inka *Unku*: Strategy and Design in Colonial Peru. *Cleveland Studies in the History of Art* 7: 68–103.

2006 Inka Colonial Tunics: A Case Study of the Bandelier Set. In *Andean Textile Traditions: Papers from the 2001 Mayer Center Symposium at the Denver Art Museum*, edited by Fronia W. Simpson and Margaret Young-Sánchez, pp. 120–68. Denver Art Museum, Denver.

Ramos, Gabriela

2010 Los tejidos en la sociedad colonial andina. *Colonial Latin American Review* 29(1): 115–49.

Rappaport, Joanne, and Tom Cummins

2012 *Beyond the Lettered City: Indigenous Literacies in the Andes*. Duke University Press, Durham, NC.

Reiss, Wilhelm, and Alphons Stübel

1880–87 *The Necropolis of Ancon in Perú*. Translated by A. H. Keane. A. Asher & Co., Berlin and London.

Romaña, Mauricio de, Jaume Blassi, Jordi Blassi, and Mario Vargas Llosa

1987 *Descubriendo el Valle del Colca = Discovering the Colca Valley*. Cromoarte, Barcelona.

Rowe, Ann Pollard

1978 Technical Features of Inca Tapestry Tunics. *The Textile Museum Journal* 17: 5–28.

Rowe, John H.

1960 Cultural Unity and Diversification in Peruvian Archaeology. In *Men and Cultures: International Congress of Anthropological and Ethnological Sciences*, edited by A. F. C. Wallace, pp. 627–31. University of Pennsylvania Press, Philadelphia.

1979 Standardization in Inca Tapestry Tunics. In *The Junius B. Bird Conference on Andean Textiles*, edited by Ann Pollard Rowe, Elizabeth P. Benson, and Anne-Louise Schaffer, pp. 239–61. The Textile Museum and Dumbarton Oaks, Washington, DC.

San Juan, E.

1998 *Beyond Postcolonial Theory*. St. Martin's Press, New York.

Stanfield-Mazzi, Maya

2014 El complemento artístico a las misas de difuntos en el Perú colonial. *Allpanchis* 77: 49–81.

2015 Weaving and Tailoring the Andean Church: Textile Ornaments and Their Makers in Colonial Peru. *The Americas* 72(1): 77–102.

Stone, Rebecca R.

1986 Color Patterning and the Huari Artist: The "Lima Tapestry" Revisited. In *The Junius B. Bird Conference on Andean Textiles*, edited by Anne Pollard Rowe, pp. 137–49. The Textile Museum, Washington, DC.

1987 Technique and Form in Huari-Style Tapestry Tunics: The Andean Artist, A.D. 500–800. PhD diss., Yale University.

1992 *To Weave for the Sun: Ancient Andean Textiles in the Museum of Fine Arts, Boston.* Museum of Fine Arts, Boston.

2007 "And All Theirs Different from His": The Inka Royal Tunic in Context. In *Proceedings of the 1997 Dumbarton Oaks Conference "Variability in the Expression of Inka Power"*, edited by Richard Burger, Craig Morris, and Ramiro Matos, pp. 385–422. Dumbarton Oaks, Washington DC.

Stone-Miller, Rebecca, and Gordon F. McEwan

1990–91 The Representation of the Wari State in Stone and Thread. *Res: Anthropology and Aesthetics* 19/20: 53–80.

Tantaleán, Henry, and Charles Stanish

2014 *Peruvian Archaeology: A Critical History.* Left Coast Press, Walnut Creek, CA.

Taullard, Alfredo

1949 *Tejidos y ponchos indígenas de Sudamérica.* G. Kraft, Buenos Aires.

Thomas, Nicholas

2002 Colonizing Cloth: Interpreting the Material Culture of Nineteenth-Century Oceania. In *The Archaeology of Colonialism*, edited by Claire L. Lyons and John K. Papadopoulos, pp. 182–98. Getty Research Institute, Los Angeles.

Uhle, Max, and Izumi Shimada

1991 [1903] *Pachacamac: A Reprint of the 1903 Edition.* University Museum of Archaeology and Anthropology, University of Pennsylvania, Philadelphia.

Vargas P., Ernesto

2007 *Kusikancha: Morada de las momias reales de los inkas.* Instituto Nacional de Cultura, Cusco.

Williams, Elizabeth A.

1993 Collecting and Exhibiting Pre-Columbiana in France and England, 1870–1920. In *Collecting the Pre-Columbian Past: A Symposium at Dumbarton Oaks, 6th and 7th October 1990*, edited by Elizabeth Hill Boone, pp. 123–40. Dumbarton Oaks, Washington, DC.

Xerez, Francisco de

1985 [1553] *Verdadera relación de la conquista del Perú.* Crónicas de América, vol. 14, edited by Concepción Bravo. Historia 16, Madrid.

Zimmern, Nathalie Herman

1944 The Tapestries of Colonial Peru. *Brooklyn Museum Journal*, 27–52.

Index

Note: Page numbers in *bold italics* indicate illustrations or tables.

Abbott, Tony, 250n8
Abydos, 174
Academia Sinica, 83–84, 101, 110n14, 315
 Institute of History and Philology, 60
Académie des Inscriptions et Belles-
 Lettres, 207, 289
Achaemenid dynasty, 124
action anthropology, 19–20
Africa, 9, 16, 18–19. *See also specific*
 countries
Ahnenerbe (Inherited from the
 Forefathers), 35–36, 39, 43, 45
Akimel O'odham, 158
Alam, Amir Assadollah, 139
al-Din Shah, Naser, 124, 133
al-Dowleh, Motamed, 124
Alexander II of Russia, 262
Alexander the Great, 124
Alexeieff, V., 289
Algeria, 10, 16, 201, *202*, 359. *See also*
 Maghreb, French colonial
 archaeology and, 206–209, *207–208,*
 217–218
 military campaigns and, 201–202
 prehistory in, 214–216

 Rome and, 202–206, 209–214,
 363–364
Algiers, invasion of, 201–205
Allah-o Akbar gate, 132
Allen, Henry, 230–231, 239–240
Alsace, 41–42
al-Tahtawy, Rifa'a, 11
Altböhmen und Altmähren (Ancient
 Bohemia and Moravia), 50
Altenberg, Felix, 323
American Indian Religious Freedom Act,
 165
American Indians. *See* Native Americans
Andersson, J.G., 92, 280
Anglo-Russian Convention, 260
Antioch, 174, *181, 194,* 195
antiquarianism, 7
Antiquities Act of 1906 (United States),
 154, 163–164
Apadana Hall, 124, 128
Arabic, in Egyptian archaeology,
 179–180, 183
Arab Spring, 375
Archaeological Museum (Tehran), *127,*
 133

Arimitsu Kyōichi, 417
Armée d'Afrique, 206–209, **207–208**
art historians. *See* Contag-von
 Winterfeldt, Victoria; Ecke,
 Gustav; Erdberg, Eleanor von;
 Loehr, Max
Aryans, 136
Atlantic Charter, 16
Australia
 decolonization and, 228
 "discovery" concept and, 233, 237–238
 timeline of Aboriginal occupation of,
 231–232
Awat'ovi, 158, 162–164
Aztecs, 153

Babelon, Ernst, 371
Baber, Edward Colborne, 285
Bachhofer, Ludwig, 308–309
Bacwezi. *See* Cwezi
Badger Clan, 162–163
Baines, D. L., 386–388, 395, 398–399,
 399n1
Balewa, Abubakar Tafawa, 17
Balzac, Honoré de, 366
Bandelier, Adolph, 442
Baoningfu, 281
Bao Sanniang, 277–283, **279,** 282–283
Barkindji, 235
Batavian Society, 9
Beijing University, 91
Belgium, 41, 48, 50
Beltrán de Guzmán, Nuño, 153
Ben Ali, Zine el Abidine, 375
Bengal, 12
Benin, 59–60. *See also* Nigeria
 bronzes and ivories, 67–68, 71–76, **78,**
 78–79
 invasion of, 62–67
Berkeley School, 431, 434
Berlin State Museum, 123
Bertholon, Lucien, 373–374

Bertrand, Alexandre, 215
Bestuzhev, Nikolai A., 261
Beulé, Charles-Ernest, 362–363, 370
Bey, Hamdi, 12
Bezirksamt für die Vor- und Früh-
 geschichte Weißrutheniens, 49
Bigo, 385–394, **391, 393,** 395–399
bilingualism, 185–186
Bingham, Hiram, 437
Bishop, Carl, 60, **93,** 93–96, 104,
 108n5
Biskupin, 44
Bliss, Robert Woods, 433
Boas, Franz, 93–94
Boisragon, Alan, 67
Boissier, Gaston, 214
Bolivar, Simón, 436
Bolivia, 444–445
Boone, Willem de, 47
Borovka, Gregorii, 269, **270**
Bou-Merzoug, 215
Bowler, Jim, 230, **230,** 238–239
Breasted, James Henry, 129
Breuer, Jacques, 48
Brew, J.O., 159
Britain, 59–60
 and Benin bronzes and ivories, 67–68,
 71–76, **78,** 78–79
 Egypt and, 178
 and occupation of Benin, 66–67
 oil palm trade and, 62–66
 Uganda and, 386
Broca, Paul, 373
Brugsch, Heinrich, 11
Brussels, 50
Brussels Declaration, 71
Bunyoro, 386
Bunyoro-Kitara empire, 383
Burchard, Otto, 337n4
Burma, 16
Burra Charter, 20
Bursch, Frans Christiaan, 39, 47

Buryatiia, 261, **265,** 266–270
Byron, Robert, 128, 142n2

Cai Yuanpei, 99, 101, 311, 320
Calaby, John, 229
Cameron, David, 250n8
Canyon de Chelly, 158, 160–161
Caparó Muñíz, José Lucas, 444
Carbuccia, Jean-Luc, 363
Carcopino, Jérôme, 48–49
Carcopino laws, 48–49
Carette, Ernest, 212
Carro, Paz Cabello, 435
Carthage, 201, 204, 361, 364–365, **365,**
 367–375, **369–370**
Carton, Louis, 364–365
Casa Grande, 154, **154**
Catholic Church, 439–440
Cavenagh, Kevin, **243**
Centeno de Romainville, Ana Maria, 437
Ceylon, 16
Chaco Canyon, 155–156, **156,** 158
Chang, K. C., 96–97
Chanyu, 270
Charles V of Spain, 435
Charles X of France, 202–203
Chavannes, Édouard, 277, 281, 285,
 288–290
Chengdu, 281
Chen Mengjia, 314, 317, 320
Chen Yan, 316
Chen Yinke, 97
Chen Yuan, 103
Cherchel, **208**
Cheshmey-e Ali, 132
Chiang Kai-shek, 83, 99, 104–105, 318,
 322, 327–328
Chile, 10
China, 11–12, 60, 72, 88–92
 archaeology in language of, 89
 cliff tombs in, 283–287, **285**
 cultural internationalism and, 92–97

"Doubting Antiquity" school in, 88, 91,
 97–103, 107
France and, 277, 287–290
Germany and. *See* Contag-von
 Winterfeldt, Victoria; Ecke,
 Gustav; Erdberg, Eleanor von;
 Loehr, Max
introduction of archaeology into, 88–92
nationalism in, 83–84, 87–88, 97–103
New Cultural Movement in, 88, 91
"New History" in, 88–92
"Reconstructing Antiquity" movement
 in, 97–103
Russia and, 268–269
and war with Japan, 322–328
Yinxu site in, 83–88, **85, 87,** 102–105,
 107–108
Ch'oi Namsŏn, 411, 414
Chŏng Insŏng, 420
Chōsen Sōtokufu, 404
Chosŏn Dynasty, 403, 405, 407, 412, 414
Christianity, 67, 190–191, 367–375,
 439–440
Christy, Henry, 215
Civilian Conservation Corps, 158
Civil War (American), 71
Clarke, Peter, **243,** 244
Claudel, Paul, 277
Cleaves, Francis W., 315
Clemen, Paul, 307
Cler, Jean-Joseph-Gustave, 206–207
cliff tombs, in China, 283–287, **285**
Cold War, 16
colonialism
 defined, 30
 "discovery" and, 227–228, 233–234
 French colonial Maghreb and, 367–375
 ideological dimension of, 31
 informal, 21
 internal, 4, 19, 152
 National Socialist Germany and,
 31–35, **33**

Native Americans and, 153–164
Orientalism and, 259
in Peru, 438–445, *439–440, 443*
principal traits of, 30–31
Russia and, 259–260
Tunisian archaeology and, 375–377
Uganda and, 385–387
Combes, A.D., 387–388
Commission d'Exploration Scientifique
 d'Algérie, 207
community archaeology, 193
Conrady, August, 337n4
Conservation Rules of Ancient Sites and
 Relics (Korea), 407
Constantinople, 12
Consten, Hermann, 311
Contag-von Winterfeldt, Victoria,
 300–302
 academic background of, 308
 in China, 311–312, 320–321,
 323–324, 328
 collection of, 332–333
 later career of, 330
 personal background of, 305
Coronado, Francisco Vázquez de,
 153–154
Corowa, Carmelia, *243*
Cortés, Hernán, 153
Council Hall (Persepolis), 128
Coutts-Smith, Kenneth, 77
Crimea, 13, 34, 46–47
Ctesiphon, 133
cultural internationalism, 74–77, 92–97
cultural nationalism, 75
cultural resource management (CRM),
 165
Cuno, James, 59
Cwezi, 383, 385–394, *391, 393*, 395–399
Cyrus II the Great, 60, 124, 131, 134–135
Czechoslovakia, 34, 39, 41

Dai Jitao, 99–100

Darius I, 124, 132, 135, 137
Davar, Ali Akbar, 122
Davis, Hester, 159
Dawes Act, 164
Dayet, Maurice, 125
Decembrists, 261, 272n1
decolonization, 15–17, 19–20, 228
de Gaulle, Charles, 375
Delacroix, Eugène, 212
Delamare, Adolphe-Hedwige-Alphonse,
 206
Delattre, Alfred-Louis, 368–369,
 372–374
Demiéville, Paul, 313
Deng Yizhe, 316
Deutsche Größe (German Greatness)
 (exhibition), 50
Dieulafoy, Jane, 124
Dieulafoy, Marcel, 124
Ding Wenjiang, 12, 94
Diraz, Reis Mahmud Ahmed Said,
 186–188
Diraz, Reis Said Ahmed Said, 187
"discovery," as narrative, 227–228,
 232–245
Dombey, Joseph, 442
Dongfang kaoguxue xiehui 東方考古學
 協會 (Oriental Archaeological
 Society), 102
Dong Qichang, 308
Dong Zuobin, 84–86, **85,** 102–104
"Doubting Antiquity" school, 88, 91,
 97–103, 107
Doujitai, 106
Doutté, Edmond, 216
Dunhuang, 90, 309
Dureau de la Malle, Adolphe, 371
Duvivier, Franciade Fleurus, *210,*
 210–211
Du Zhengsheng, 98, 109n7–109n8,
 109n11
Dyrestui, 268

Ecke, Betty. *See* Tseng Yu-ho
Ecke, Gustav, *300–302*
 academic background of, 306–307
 in China, 310–312, 313–317, 322, 329
 collection of, 332
 later career of, 329–330
 personal background of, 304–306
Ecke, Gustav, Sr., 304
Eckley B. Coxe, Jr. Egyptian Expedition,
 187–188, 195
Effros, Bonnie, 173
Egypt, 11, 124
 American expeditions in, 181–182
 bilingualism and archaeology in,
 185–186
 Britain and, 178
 Eckley B. Coxe, Jr. Egyptian Expedition,
 187–188, 195
 Harvard-Boston Expedition, 183–189
 integration of, into modern world,
 175–176
 labor structure of archaeology in,
 192–193
 overseers at excavations in, 179, *181*
 Quftis, 174, *175,* 180–185, *181,*
 184–187, 189–190, 192–193
 Wellcome excavations in, *175, 186,*
 186–188
Egyptian Antiquities Service, 178
Egyptian Museum, 194
Einsatzkommando D, 47
Einsatzstab Reichsleiter Rosenberg
 (Reich-Leader Rosenberg
 Taskforce), 36, 42, 51
El'Aroussa, 216
el-Kénissia, 372
Elliott, Melinda, 156
el-Mayyit, Reis Mahmud, 190
England. *See* Britain
Erdberg, Eleanor von, *301–303, 319*
 academic background of, 306–307,
 309–310

 in China, 310–311, 317–318, 323–
 324, 327, 329
 collection of, 333
 later career of, 330–331
 Nazis and, 324
 personal background of, 304–305
Erdberg-Krzenciewski, Robert von, 304
Esfandiari, Hasan, 125
excavations, control of, 42–47, *45,* 84,
 179, 263
exhibitions, under Nazi Germany, 47–51,
 50–51
exoticism, 290–295

Fairbank, John King, 315
Fairbank, Wilma, 315
Fang, Achilles, 331
Fazaa, Tahar, 376
Feng Chengjun, 275
Feng Yuxiang, 104, 109n10
Feng Zhi, 316, 320
Fenollosa, Ernest F., 94
Féraud, Laurent-Charles, 215–216
Ferdawsi, 133
Ferelius, Brigitta, 395–396
Ferguson, John C., 94, 317
Fett, Harry, 48
Fewkes, Jesse Walter, 161–162
First Mesa, 161
Firuz Mirza, Firuz, 122, 125, 128
Fisher, Clarence Stanley, 173, 187–189
Flaubert, Gustave, 370–371
Forke, Alfred, 308
Forughi, Mohammad Ali, 122, 125
France. *See also* Maghreb, French colonial.
 archaeology and, 206–209, *207–208*
 China and, 277, 287–290
 Egypt and, 178
 and invasion of Algiers, 201–205
 Iran and, 124–126, 128–130, 135–136
 Musée Napoléon, 68–71
 Nazi Germany and, 41–42, 48–49

Rome and, 202–206, 209–214,
 361–367
Frank, Hans, 34
Franke, Wolfgang, 315, 317–318,
 324–327, 331, 339n33
Freer, Charles Lang, 92–93, 108n4
Freer Gallery of Art, 60, 86–87, 93, 103,
 107, 108n5
Freyeisen, Astrid, 325
Fuchs, Walter, 314–315, 323–324, 328,
 331
Fujian, 313
Fujita Ryōsaku, 408, 411
Fu Sinian, 84, 86, **87,** 90, 97–98, 100–
 103, 105–107, 109n7–109n9, 315

Gallia (journal), 49
Gallwey, Henry, 64, 68
Ganda, 386–388, 399n2
Gänger, Stefanie, 437
Garcés, Miguel, 442–444
Garube Shion, 411
George, Stefan, 305
German Archaeological Institute (DAI),
 35–36, 42
Germanerbe im Weichselraum (Germanic
 Heritage in the Vistula Region)
 (exhibition), 50, *51*
Germany, National Socialist
 archaeology in, 35–37
 China and, 315, 322–323
 colonialism and, 31–34
 local archaeologists and, 39–40
 heritage management, 47–51, *50–51*
 organization of heritage management,
 publications, and exhibitions
 under, 47–51, *50–51*
 publications in, 47–51, *50–51*
 research institutions in, 40–42
 robbery of collections and control of
 excavations by, 42–47, **45,** 74
 universities and, 40–42

Viking Age and, 38–39
Giffen, Albert Egges van, 39
Girardin, Saint-Marc, 204
Giza Pyramids, 174, 183
Gladwin, Harold, 158
Godard, André, 122–123, 126–130,
 142n1
Government-General Museum of Korea
 (GGMK), 406–407, **407,**
 408–413, 417
Gray, John, 388–389
Great Depression, 158
"Great Game," 260, 262
Great Yu, 91
Grotius, Hugo, 237
Gu Jiegang, 90–92, 98, 100–102, 108n6,
 109n7–109n8, 110n14
Guomindang (GMD), 83, 99–100, 103
Gushibian 古史辨 (Critiques of Ancient
 History), 91

Hackin, Joseph, 312
Hague Convention, 77
Hall of One Hundred Columns, 124
Hamada Kōsaku, 102, 411, 413
Han Hŭngsu, 411, 415
Harada Yoshito, 102, 411
Harvard-Boston Expedition, 183–189
Haury, Emil, 158
Hawikku, 154
Hayden, Julian D., 161
Haydon, Tom, 240
Hedin, Sven A., 102, 263, 280, 333
Heissig, Walther, 315, 325
Henry, Patrick, 97
Herero people, 32
He Rizhang, 104–105, 109n11
Herzfeld, Ernst Emil, 122–123, 125–130,
 142n1
Hewett, Edgar L., 159–160
Heye, George Gustav, *157*
Hightower, J. Robert, 315

Himmler, Heinrich, 36, 46–47
History of China (textbook), 98–99
Hitler, Adolf, 31–32, 307, 315
Hodge, Frederick Webb, 156–157, *157*
Hoffmann, Alfred, 312, 324–325
Hohokam, 158
Holocaust, 19, 32
Holt, H. Barry, 155
Holzhausen, Walter, 306
Homo erectus pekinensis, 97
Hopi, 158–163
Hosie, Alexander, 285
Hoveyda, Fereydoun, 139
Huang Binhong, 320–321
Huot, Jean-Louis, 367
Hu Shi, 91–92, 98–100
Hu Zhaochun, 106, 110n13
hyper-diffusionism, 93
Hyung Il Pai, 415, 420

ICOMOS (International Council on
 Monuments and Sites), 20
Ikeuchi Hiroshi, 411
Imanishi Ryū, 405, 408
Imperial Archaeological Commission
 (Russia), 262–263
Imperial Geographic Society, 260–261,
 263, 269. *See also* Russian
 Geographical Society
imperialism
 "discovery" and, 227–228
 narratives of, 12–15
 of Russia, 259–260
 Sinology and, 276
 World War II and, 32–35, *33*
Inaba Iwakichi, 408
Inca tapestries, 432–438, *433*
India, 16, 18, 124
Indian Reorganization Act (IRA) (United
 States), 162–163
Indochina, 9, 13
Indonesia, 9, 16

Institut für Deutsche Ostarbeit (Institute
 for Eastern German Research), 42,
 49
Iran
 export of artifacts from, 123–124
 Pasargadae in, 123, *123,* 133–135
 Persepolis in, 60, *122,* 123, *123,* 124,
 128–129, 131, 133–134, *134,*
 136, 138–142, 142n3
 revolution in, 140–141
 Susa in, 123–126
Italy, 16
Ivories, Benin, 67–68

Jankuhn, Herbert, 39, 48
Jannings, Werner, 317–318
Japan, 309, 311–312
 annexation of Korea by, 404
 China and, 86, 89, 102, 322–328
 and colonial archaeology in Korea,
 404–418, *407, 409, 419*
 decolonization and, 15, 19
 Russia and, 263
Jebel Moya, 174, 186, *186,* 187
jinshixue (studies of bronzes and inscribed
 stones), 88, 105–106
Ji Xianlin, 316
Jones, Rhys, 238–239

Kagago, 388
Kaggwa, Apolo, 388
Kaiyuansi temple (Quanzhou, China),
 313
Kampfbund für Deutsche Kultur, 35
Kates, George N., 315
Kawanusea, Luke, 163
Kawàyka'a, 162
Keam, Thomas V., 161
Keating, Paul, 238
Kelly, Alice, 21, 241–242, *242–243*
Kennewick man, 246
Kenya, 18–19

Khan-Ku, 268
Khara-Khoto, 264–265
Khatami, Seyyed Mohammed, 140
Khmer, 13
Khomeini, Imam, 140
Kidder, Alfred V., 110n12
Kiev, 46, 49, 266. *See also* Ukraine
Kitara, 383
Klibi, Chedli, 375
Kontrat'ev, S. A., *270*
Korea
 annexation of, 404
 Japanese colonial archaeology in,
 404–418, *407, 409, 419*
 spending on archaeology in, *419*
Korean War, 19, 414
Koryŏ Dynasty, 405
Kostrzewski, Józef, 40–41, 44, 49
Kozlov, Pyotr, 263–265, *264, 270*, 271.
 See also Russian Geographical
 Society
Kreissler, Françoise, 325, 340n38
Kümmel, Otto, 307, 338n9
Kunstschutz. *See* Militärischer Kunst-
 schutz des Heeres (Art Protection
 Service of the German Army)
Kuroita Katsumi, 407–408, 411, 413

Lady Mungo, 227, *228, 230*
 Aboriginal challenges of, 241–243
 Aboriginal conceptions of, 235
 biology of, 229
 "discovery" of, 227–231, 238–240
 "handback" of, 238, 244–245
 stratigraphy of, 229
Lambaesis, 201
Lampert, Ronald, *243*
Ländesämter für Vorgeschichte, 49
Landesinstitut für Bodendenkmalpflege,
 49
Lartigue, Jean, 280–281, 287
Latin America, 13–14, 16

Lavigerie, Charles, 368
Law on the Protection of Ancient Relics
 (China), 84
Leakey, Louis, 18–19
Lee Pyŏng-ho, 420
Le Glay, Marcel, 365–366
Legrain, Georges, 179, 195n3
Lhasa, 263
Liang Qichao, 89–92, 96, 110n12
Liang Sicheng, 313
Liang Siyong, 110n12
Libya, 376
Liebenthal, Walter, 315
Lieber, Francis, 71
Li Ji, 60, 84, 86, *87*, 88, 94–96, 102–106,
 108n4
Lima Tapestry, 430–431
Lin Liguang, 316
Li Shizeng, 110n14
Liu Dunzhen, 313
Liverpool, 62
Liverpool Museum, 62, 66, 78–79
Livingstone, David, 67
Li Xuanbo, 91, 100–101
Li Zongtong, 339n24
Lochow, Hans-Jürgen von, 316
Locke, John, 250n9
Lodge, John Ellerton, 93, 107
Loehr, Max, *301–303, 319*
 academic background of, 308–310
 in China, 312, 317–320, 323–329
 collection of, 333
 later career of, 331
 Nazis and, 324–325
 personal background of, 305–306
Loftus, William Kenneth, 124
Löhr, Josef, 305
looting, 36, 42, 73. *See also* robbery; theft
Louvre, 123, 130. *See also* Musée
 Napoléon
Löwenthal, Rudolf, 315
Lü Dalin, 89

Ludwig, Irene, 333
Ludwig, Peter, 333
Luo Zhenyu, 84–86, 90, 109n11
Lusatian culture, 44
Lu Xun, 316

Mabo Judgement, 238
Macalister, R. A. S., 89
MacCarthy, Oscar, 211
Macdonald, Claude, 64–65, 67
Machu Picchu, 437
Madero, Francisco, 444
Maghreb, French colonial. *See also* Algeria;
 Morocco; Tunisia
 Christianity and, 367–375
 colonialism and, 367–375
 Rome and, 360–367
Ma Heng, 102–103, 107
Maikop, 47
Malarkey, James, 10
Manchuria, 15
Mann, Heinrich, 305
Mann, Julia, 305
Mann, Thomas, 305
Manual of Military Law (Britain), 72–73
Mariette, Auguste, 11
Marshall, John, 237, 250n10
Martin, Ilse, 312, 325–326, 331
Maspero, Gaston, 179
Maspero, Henri, 288–289
Mattingly, David, 213–214
Mauriac, François, 366
Maya, 13
May Fourth Movement (China), 88,
 90–91, 100–101
McBryde, Isabel, 242, 244
Mehnert, Klaus, 327, 340n39
Mélida, José Ramón, 11
Memphis (Egypt), *177*, 195
Merker, Peter, 324
Merryman, John, 59, 74–75, 95
Metropolitan Museum of Art, 441

Mexico, 13–14
Meyers, George Hewitt, 445
Mianzhou, 281
Militärischer Kunstschutz des Heeres
 (Art Protection Service of the
 German Army), 35
Miller, Mikhail, 40, 47
Minsk, 49
Mitchell, Ernest, *248*
Mitra, Rajendra Lal, 12
Mi Wanzhong, 332
Möbius, Hans, 43
Mongolia, 265, *265*, 271
Monroe Doctrine, 15
Montelius, Oscar, 106
Montes, Emilio, 436
Monumenta Serica (journal), 316–317
Moor, Ralph, 65, 67
Morgan, Jacques de, 124
Morgan, Lewis H., 416
Morocco, 16, 18, 216. *See also* Maghreb,
 French colonial
Morrisson, Alexander, 260
mosaics, 173–174, **194**, 195
Müller, Friedrich Max, 11
Mulvaney, John, 229, *235*, 238–239,
 250n14
Mungo I. *See* Lady Mungo
Mungo III, 244
Musangnuvi, 162–163
Musée Cinquantenaire, 48
Musée Lavigerie, 372, **373**
Musée Napoléon, 68–71, 77
Muséum Français, 69
Museveni, Y., 396–398
Mutthis, 24, 235

Nacihiptewa, 161
Nama people, 32
Namibia, 19, 32
Nanjing decade, 83, 88, 98
Naoto Kan, 414

Napoleonic Code, 366–367
Nara, 313
National Archaeological Museum
 (Warsaw), 43–44
nationalism
 archaeology and, 3, 17–18, 21, 87–88,
 103–108
 in China, 83–84, 97–103
National Library (Tehran), 133
National Museum of the American Indian
 Act, 165
National Register of Historic Places
 (United States), 165
Native American Graves Protection and
 Repatriation Act, 165
Native Americans, 20
 and arrival of archaeology, 153–159
 colonialism and, 153–164
 genocide of, 154–155
 reservations for, 155
 and resistance to archaeology, 152–153,
 159–164
Native Title Acts (Australia), 238
Navajo, 155–156
Navajo National Monument, 158
New Cultural Movement (China), 88, 91
"New History" (China), 88–92
Niebuhr, Carsten, 124
Niger Coast Protectorate, 65–67
Nigeria, 17–19, 59, 67, 73–74. See also
 Benin
Nijaampa, 235
Niza, Marcos de, 153
Noin-Ula, 265
North Africa. See Algeria; Egypt; Libya;
 Maghreb, French colonial;
 Morocco; Tunisia
North Atlantic Treaty Organization
 (NATO), 16
Northern Expedition (China), 99
North Korea, 19, 414–416. See also Korea
Norway, 48

Noyon Uul, 265
Ntusi, 392

O'Brien, James, 237
October Revolution (Russia), 264, 271
Oda Shōgo, 408
oil palm, 62–66
Oil Rivers Protectorate, 64–65
Old Songòopavi, 161
Oliver, Roland, 389–392
Oriental Institute (Chicago), 123,
 128–129
Orientalism (Oriental studies), 131, 259,
 260–261, 363, 371
Osterhammel, Jürgen, 30–31, 40
"Other," the, 13–14, 189–191, 283–287
Ovonramwen, 62, *63*, 64, 66, 73
Oxford Manual of the Laws of War on
 Land, 71–72

Pahlavi, Farah, 138–139
Pahlavi, Reza Shah, 60, 122, 124–126,
 129, 131–132, 134–137, 139,
 141–142
Pakistan, 16, 18
Palitsyn, F. F., 264
palm oil, 62–66
Pandey, Triloki Nath, 156
Pan Jingshu, 321
Paracas, 428
Pasargadae, 123, *123*, 133–135
Paulsen, Peter, 43
Pavón, José Antonio, 442
Peking Man, 97
Pelliot, Paul-Eugène, 294
Pères Blancs, 368–369, 372, 377
Périer, J.-A.-N., 212
Persepolis, 60, *122*, 123, *123*, 124, 128–
 129, 131, 133–134, *134*, 136,
 138–140, *141*, 141–142, 142n3
Persepolis '71, 131, *134*, 134–135, 138,
 140

Peru, 10, 14
 Catholic Church and, 443–444
 colonialism in, 438–445, *439–440, 443*
 Inca tapestries, 432–438, *433*
 Wari tapestry tunics, 428–432, *429*
Peru-Bolivia Confederation, 444–445
Petrie, Flinders, 178, 180, 183
Peyssonnel, Jean-André, 201
Philadelphia Museum of Art, 123–124
Philip II of Spain, 435–436
Phillips, James, 65
Phipps, Elena, 441
Pima, 158
Pinder, Wilhelm, 309
Pinnock, James, 65
Pizarro, Francisco, 435
Pointer, Gretchen, *243*
Poland, 34–35, *38*, 43–44, *45*, 46, 49–50
Polingyouma, Eric, 162–163
Pond, Bremer Whidden, 309
Pope, Arthur Upham, 123, 129–130
*Posener Jahrbuch für Vor- und Früh -
 geschichte* (Poznań yearbook for
 Pre- and Proto-history), 50
Posnansky, Merrick, 390, 392
Pratt, George D., 437
Prehistory of Australia, The (Mulvaney),
 240
Przhewalskii, Nikolai M., 260, 263
Pueblo Revolt, 158
Pu Jin, 316
Pu Quan, 316, 323
Puyé, 159–160, *160*
Pyramids of Giza, 174, 183

Qajar, Fath Ali Shah, 132
Qi Gong, 316
Qing dynasty, 85
Qing Summer Palace, 72
Qiu Shanyuan, 96
Quatremère de Quincy, Antoine C., 70,
 77

Quftis, 174, *175*, 180–185, *181*, 184–
 187, 189–190, 192–193, 195

Rabouilleuse, La (Balzac), 366
Radig, Werner, 42
Ranke, Leopold von, 90
Rave, Paul Ortwin, 306
Rawlinson, Henry, 124, 132
Reade, Thomas, 371
"Reconstructing Antiquity" movement,
 97–103
regionalism, 103–108
Reichsbund für Deutsche Vorgeschichte,
 35
Reid, Andrew, 397
Reinerth, Hans, 35–36, 46
Reismüller, Georg, 310
Reisner, George, 183–184, 188–189
Reiss, Wilhelm, 431
Renier, Léon, 364
Reynolds, Henry, 237
Rhys, Jones, 238
robbery, of archaeological collections,
 42–47, *45. See also* looting; theft
Robertshaw, Peter, 397
Rockefeller, John D., 128
Roman empire, 13, 202–206, 209–214,
 360–367
Rong Geng, 319–320
Roosevelt, Theodore, 15
Rosenberg, Alfred, 35–36, 46
Ross, Denman W., 445
Rowe, John H., 431, 433, 436
Rozet, Claude-Antoine, 209, 214
Ruiz, Hipólito, 442
Russell, Lynette, 250n20
Russia, 7, 13, 36, 46–47. *See also*
 Buryatiia; Siberia; Soviet Union
 archaeology in, institutional framework
 of, 261–263
 other empires vs., 259–260

Russian Geographical Society, 261, 266.
 See also Imperial Geographic
 Society
Russo-Persian Treaty, 260

Said, Edward, 30, 131, 259
Saint-Arnaud, Jacques Leroy de, 213
Saitō Makoto, 409
Sakhalin, 15
Salammbô (Flaubert), 371
Saleh, Raden, 12
Salmony, Alfred, 307
Santa Clara reservation, 159–160, *160*
Saudi Arabia, 18
Schaefer, Heinrich, 179
Schierlitz, Ernst, 315
Schimmelpenninck von der Oye, D.,
 260–261
Schirach, Baldur von, 328, 340n42
Schleiermacher, Wilhelm, 42
Schmidt, Erich F., 128
Schneider, Laurence, 90
Seckel, Dietrich, 339n27
Second Mesa, 162
Seeberg, Wolf von, 46
Segalen, Victor
 background of, 275
 Bao Sanniang and, 277–283, *279*,
 282–283
 cliff tombs and, 283–287, *285*
 imperialism and, 276–277, 286
 Lartigue and, 280–281
 literature and poetry of, 290–291, 293
 reputation of, 276
 Voisins and, 280–281, 287–288
 at Xi'anfu, 280
Sekino Tadashi, 405
Seowtewa, 157
Sevastopol, 46
Seven Cities of Gold, 153
Shah, Mohammad, 132
Shah Jahan, 124

Shah of Iran. See Pahlavi, Reza Shah
Shahyad Aryamehr Monument, 137–138
Shariati, Ali, 138
Shawcross, Wilfred, 239–242
Shen Jianshi, *319*
Shinnie, Peter, 390
Shionoya On, 108n6
Shiraz, 132, 136
Shitao, 332
Siberia, 261–263, 265, 271
Sickman, Laurence, 315
Sidi Bou Saïd, 372
Sikyatki, 161
Silla, 405
Simferopol, 46
Siroux, Maxime, 133
Snaketown, 158
Snead, James E., 159–160
Society for American Archaeology
 (SAA), 165–166
Solórzano, Mónica, 445
Son Chintae, 411
Sonderstab Vorgeschichte (Special Task
 Force for Prehistory), 45–46
Song dynasty, 89
Sontag, Susan, 140
Soong, T. V., 318
Sosnovskii, Georgii, 270–271
South Korea, 19
Soviet Union, 44–47. See also Russia;
 Siberia
Spain, 435–437
Speiser, Werner, 324
SS-Sonderkommando Jankuhn (SS
 Special Task Force Jankuhn),
 46–47
Stein, Aurel, 11, 263
Stephens, Alexander M., 160–161
Stolze, Frantz, 124
Strzygowski, Josef, 307–308
Sudan, *175*, 180, *186*
Sudzha, 268

Sullivan, Sharon, 242–243, *243,* 244
Sun Haibo, 319
Sun Yat-sen University, 90. *See also* Zhongshan University
Susa, 123–126
Swainson, John Henry, 62, *63,* 64–65
Sweden, 409
Syngman Rhee, 417

Tackenberg, Kurt, 41
Taiwan, 15, 403
Talko-Gryntsevich, Iulian Dominikovich, 266–269, *267,* 271
Tangut, 264
Tan Kah Kee, 311
Tanzania, 18
tapestries, Andean
 church, 444–445
 colonialism and, 438–445, *439–440, 443*
 Inca, 432–438, *433*
 Wari, 428–432, *429*
Taq-e Bostan, 132
Tax, Sol, 19–20
Tazzoult, 201
Temple, Grenville, 370–371
Teng Gu, 106, 110n13, 334
Tenochtitlán, 153
Tent City (Persepolis), 131, *132,* 133, 135, 140
Teploukhov, Sergei, 269–270, *270,* 272n4
Terauchi Masatake, 407–408
Terre, La (Zola), 366
Texier, Charles, 207–208
Teymurtash, Abd al-Hosayn, 122, 125
theft, of archaeological collections, 42–47, *45. See also* looting; robbery
Thomas, Nicholas, 152
Thorne, Alan, 238–239, 244
threshold principle, 4–5
Thuburnica, 372
Tibet, 263

Tobacco Clan, 163
Tohono O'odham, 161
Toledo, Francisco de, 435, 442
Torii Ryūzō, 286, 317
Torrance, Thomas, 285
To Yuho, 411, 415
Trautmann, Oskar, 316–317
Tribal Historic Preservation Offices, 165
Trigger, Bruce G., 103, 151, 154, 294
Trott zu Solz, Adam, 315–316, 322
Truilhier, Hilarion, 124
Tseng Yu-ho (Betty Ecke), 317, 323, 329, 332
Tsuboi Shōgorō, 404
Tunis, 201
Tunisia, 16, 359, 364, 368, 375–377. *See also* Maghreb, French colonial
Tunisian Protectorate, 201
Túpac Amaru, 445
Túpac Amaru Rebellion, 436
Tus, 133

Uganda, *384*
 Bigo in, 385–394, *391, 393,* 395–399
 Britain and, 386
 colonial invention of history in, 385–387
 Cwezi in, 383, 385–394, *391, 393,* 395–399
Uhle, Max, 10, 431
Ukraine, 36, 39, 46–47, 51. *See also* Kiev
Umehara Sueji, 411, 413
UNESCO Convention on the Means of Prohibiting and Preventing the Illicit Import, Export and Transfer of Ownership of Cultural Property, 74
United Kingdom. *See* Britain
University of Pennsylvania Museum, 130, 187
University of Strasbourg, 41–42
Ute, 160

Vanderstappen, Harrie, 332
Vichy France, 41–42, 48–49
Vietnam War, 16
Vigneral, Charles de, 212
Viking Age, 38–39, 43
Voisins, Augusto Gilbert de, 280–281,
 287–288

Wallace, Mike, 136
Wang, Ruth, 311, 337n15
Wang Fansen, 90, 102, 109n8, 109n11
Wang Guowei, 90, 92, 97
Wang Jingwei, 322
Wang Jiqian, 321
Wang Rongbao, 89
Wang Shixiang, 314, 318, *319*, 320,
 337n22
Wang Yintai, 311, 323
Wang Zhongqi, 98
Wang Zhongxiu, 321
Wari state, 429–430
Wari tapestry tunics, 428–432, *429*
Warner, Langdon, 309
Warsaw, 43–44
Warsaw Pact, 16
Washington Conference Principles on
 Nazi-Confiscated Art, 74
Wayland, E. J., 387
Webb, Steve, 247
Wellcome excavations, *175, 186,* 186–188
Wesselhoeft, Amy, 304
Westlake, John, 72
White Revolution (Iran), 137
Wiadomości Archeologiczne (journal), 49,
 50
Wihomki, 161
Wilden, A., 126, 129–130
Wilhelm, Hellmut, 315, 323
Willandra Lakes World Heritage area,
 229, 243–247, *248,* 249n1
Willandra trackway, 247

Williams, Lottie, 246–247
Williamson, David, 129
Winckelmann, Johann, 69
Winterfeldt, Sigmund Rudolf von, 311,
 324
Wölfflin, Heinrich, 308–309
World Museum Liverpool, **78,** 78–79
World War I, 15, 31–32, 43
 China and, 304
World War II, 16, 19. *See also* Germany,
 National Socialist
 as colonialist war, 32–35, **33**
Worringer, Wilhelm, 306
Wu Hufan, 321
Wu Zhihui, 99, 105
Wylie, Alexander, 284–285

Xerxes' Harem, 128
Xia Nai, 88
Xi'anfu, 280
Xinjiang, 90, 263, 304
Xinzheng, 94
Xiongnu, 265, 269, 271, 272n3
Xiyincun, 86, 96–97
Xu Beihong, 316
Xun Lu, 108n6
Xu Xusheng, 102, 106

Yagi Sōzaburō, 404
Yalta Conference, 16
Yangshao Culture, 86, 96–97
Yang Siŭn, 420
Yang Yüeh, 314
Yanxiadu, 106
Yan Xishan, 96
Yatsui Seiichi, 408
Ye Gongchuo, 320
Yi Byŏngho, 412
Yi Nŭnghwa, 411
Yinxu site, 83–88, **85, 87,** 102–105,
 107–108

Yi Peiji, 320, 339n24
Yi Sunja, 420
Yu Xing-wu, *319*
Yuan Fuli, 86, 96, 109n11
Yuan Keding, 293
Yuan Shikai, 293
Yuan Tongli, 315

Zhamtsarano, Ts. Zh., *270*
Zhang Binglin, 92, 108n3
Zhang Bingong, 285
Zhang Ji, 109n11
Zhang Xueliang, 103

Zhaohua, 281–283
Zheng Shixu, 106
Zhongshan University, 90, 99–102. *See also* Sun Yat-sen University
Zhoukoudian, 97
Zhu Qiqian, 313, 318
Zimmerer, Jürgen, 30
Zitong, 281
Zola, Émile, 366
Zong Baihua, 334
Zuni, 156–157, *157*
Zuni Pueblo, 153–154